# TWELVE
# CAESARS

# THE TWELVE CAESARS

## JULIO-CLAUDIAN DYNASTY

| **Julius Caesar** | **Augustus** | **Tiberius** | **Caligula** | **Claudius** | **Nero** |
|---|---|---|---|---|---|
| 'Dictator' | Ruled | Ruled | Ruled | Ruled | Ruled |
| 48–44 BCE | 31 BCE—14 CE | 14 CE—37 CE | 37 CE—41 CE | 41 CE—54 CE | 54 CE—68 CE |
| Assassinated | Rumours of poisoning by his wife Livia (previously named Octavian) | Rumours of assassination | Assassinated (officially named Gaius) | Rumours of poisoning by his wife Agrippina | Forced to suicide |

| **Galba** | **Otho** | **Vitellius** | **Vespasian** | **Titus** | **Domitian** |
|---|---|---|---|---|---|
| Ruled June 68 CE— January 69 CE | Ruled January 69 CE— April 69 CE | Ruled April 69 CE— December 69 CE | Ruled December 69 CE—79 CE | Ruled 79 CE—81 CE | Ruled 81 CE—96 CE |
| Assassinated | Forced to suicide | Lynched | Died in his bed | Rumours of poisoning by his brother Domitian | Assassinated |

PRINCETON UNIVERSITY PRESS
Princeton and Oxford

THE A. W. MELLON LECTURES IN THE FINE ARTS

NATIONAL GALLERY OF ART, WASHINGTON
Center for Advanced Study in the Visual Arts
Bollingen Series xxxv: 60

# TWELVE CAESARS

IMAGES OF POWER FROM THE
ANCIENT WORLD TO THE MODERN

MARY BEARD

*For the American Academy in Rome*
*with gratitude and happy memories*

Published by Princeton University Press, 41 William Street, Princeton, New Jersey 08540

In the United Kingdom: Princeton University Press, 6 Oxford Street, Woodstock, Oxfordshire OX20 1TR

press.princeton.edu

Jacket art (front): Shutterstock, (back): Edition of Suetonius's *Twelve Caesars*, printed in Rome, 1470; the binding c. 1800, with Augsburg enamels c. 1690 after Sadeler's Twelve Caesars inset into the inside front cover. Collection of William Zachs, Edinburgh. Photo courtesy of Sotheby's London.

Jacket design by Faceout Studio, Molly Von Borstel

Library of Congress Cataloging-in-Publication Data

Names: Beard, Mary, 1955- author.
Title: Twelve Caesars : images of power from the ancient world to the modern / Mary Beard.
Description: Princeton : Princeton University Press, [2021] | Series: The A.W. Mellon lectures in the fine arts ; 2011 | Includes bibliographical references and index.
Identifiers: LCCN 2021012740 (print) | LCCN 2021012741 (ebook) | ISBN 9780691222363 (hardcover) | ISBN 9780691225869 (ebook)
Subjects: LCSH: Kings and rulers—Portraits. | Power (Social sciences) in art. | Emperors—Rome—Portraits. | Art, Roman—Influence. | BISAC: HISTORY / Ancient / Rome | ART / History / General
Classification: LCC N7575 .B38 2021 (print) | LCC N7575 (ebook) | DDC 709.02/16—dc23
LC record available at https://lccn.loc.gov/2021012740
LC ebook record available at https://lccn.loc.gov/2021012741

This is the sixtieth volume of the A. W. Mellon Lectures in the Fine Arts, which are delivered annually at the National Gallery of Art, Washington. This volume is based on lectures delivered in 2011. The volumes of lectures constitute Number XXXV in the Bollingen Series, supported by the Bollingen Foundation.

British Library Cataloging-in-Publication Data is available

Designed by Jeff Wincapaw

This book has been composed in Janson Text

Printed on acid-free paper. ∞

Printed in Italy

10 9 8 7 6 5 4 3 2 1

# Contents

# Tables

# Preface

We are still surrounded by Roman emperors. It is now almost two millennia since the ancient city of Rome ceased to be capital of an empire, but even now—in the West at least—almost everyone recognises the name, and sometimes even the look, of Julius Caesar or Nero. Their faces not only stare at us from museum shelves or gallery walls; they feature in films, advertisements and newspaper cartoons. It takes very little (a laurel wreath, toga, lyre and some background flames) for a satirist to turn a modern politician into a 'Nero fiddling while Rome burns', and most of us get the point. Over the last five hundred years or so, these emperors and some of their wives and mothers, sons and daughters, have been recreated countless times in paint and tapestry, silver and ceramic, marble and bronze. My guess is that, before 'the age of mechanical reproduction', there were more images in Western art of Roman emperors than of any other human figures, with the exception of Jesus, the Virgin Mary and a small handful of saints. Caligula and Claudius continue to resonate across centuries and continents in a way that Charlemagne, Charles V or Henry VIII do not. Their influence goes far beyond the library or lecture room.

I have lived more intimately than most people with these ancient rulers. For forty years now they have been a large part of my *job*. I have scrutinised their words, from their legal judgements to their jokes. I have analysed the basis of their power, unpicked their rules of succession (or lack of them), and often enough deplored their domination. I have peered at their heads on cameos and coins. And I have taught students to enjoy, and to interrogate closely, what Roman writers chose to say about them. The lurid stories of the emperor Tiberius's antics in his swimming pool on the island of Capri, the rumours of Nero's lust for his mother or of what Domitian did to flies (torture with them with his pen nib) have always gone down well in the modern imagination and they certainly tell us a good deal about ancient Roman fears and fantasies. But—as I have repeatedly insisted to those who would love to take them at face value—they are not necessarily 'true' in the usual sense of the word. I have been by profession a classicist, historian, teacher, sceptic and occasional killjoy.

In this book, I am shifting my focus, onto the modern images of emperors that surround us, and I am asking some of the most basic questions about how and why they were produced. Why have artists since the Renaissance

chosen to depict these ancient characters in such large numbers and in such a variety of ways? Why have customers chosen to buy them, whether in the form of lavish sculptures or cheap plaques and prints? What do the faces of long-dead autocrats, many more with a reputation for villainy than for heroism, *mean* to modern audiences?

The ancient emperors themselves are very important characters in the chapters that follow, especially the first 'Twelve Caesars', as they are now often known—from Julius Caesar (assassinated in 44 BCE) to the fly-torturing Domitian (assassinated in 96 CE), via Tiberius, Caligula and Nero, among others (Table 1). Almost all the modern works of art that I discuss were produced in dialogue with the Romans' own representations of their rulers, and with all those ancient stories, far-fetched though they might be, of their deeds and misdeeds. But in this book the emperors themselves share the spotlight with a wide range of modern artists: some, like Mantegna, Titian or Alma-Tadema, are well known in the Western tradition; others are drawn from generations of now anonymous weavers, cabinet-makers, silversmiths, printers and ceramicists who created some of the most striking and influential images of these Caesars. They share the spotlight too with a selection of the Renaissance humanists, antiquarians, scholars and modern archaeologists who have turned their energies to identifying or reconstructing—wrongly or rightly—these ancient faces of power, and with the even wider range of people, from cleaners to courtiers, who have been impressed, enraged, bored or puzzled by what they saw. In other words, I am not only interested in the emperors themselves or in the artists who have recreated them, but in the rest of us who *look*.

There are, I hope, some surprises in store, and some unexpectedly 'extreme' art history. We shall be meeting emperors in very unlikely places, from chocolates to sixteenth-century wallpaper and gaudy eighteenth-century waxwork. We shall be puzzling over statues whose date is even now so disputed that no one can agree whether they are ancient Roman, modern pastiches, fakes or replicas, or creative Renaissance tributes to the imperial tradition. We shall be reflecting on why so many of these images have been imaginatively re-identified or persistently confused over hundreds of years: one emperor taken for another, mothers and daughters mixed up, female characters in the history of Rome (mis)interpreted as male, or vice versa. And we shall be reconstructing, from surviving copies and other faint hints, a lost series of Roman imperial faces from the sixteenth century, which are now almost universally forgotten, but which were once so familiar that they defined how people across Europe commonly imagined the Caesars. My aim is to show why images of these Roman emperors—autocrats and

tyrants though they may have been—still *matter* in the history of art and culture.

The origins of this book lie in the A. W. Mellon Lectures in the Fine Arts that I delivered in Washington, DC, during the spring of 2011. Since then I have discovered new material, drawn new connections and explored some of my case studies in greater detail (and in different directions). But the book starts, and ends, as the lecture series did, with a curious object that once stood just a stone's throw from the auditorium in the National Gallery of Art, where I was speaking: not a portrait of an emperor, but a large Roman marble coffin, or sarcophagus, which—so it was believed, and hyped, by some—had once served as an emperor's last resting place.

# I

# THE EMPEROR
# ON THE MALL
## AN INTRODUCTION

## A Roman Emperor and an American President

For many years, an imposing marble sarcophagus was a fixture, and a curiosity, on the Mall in Washington, DC, standing on the grass just outside the Smithsonian's Arts and Industries Building (Fig. 1.1). It had been discovered in Lebanon, one of two sarcophagi found together on the outskirts of Beirut in 1837 and brought to the United States a couple of years later by Commodore Jesse D. Elliott, the commander of a squadron of the US navy on patrol in the Mediterranean. The story was that it had once held the remains of the Roman emperor Alexander Severus, who ruled between 222 and 235 CE.[1]

Alexander has not remained a household name, despite a rather florid Handel opera, *Alessandro Severo*, woven around his life, and an overblown reputation in some parts of early modern Europe as an exemplary ruler, patron of the arts and public benefactor (Charles I of England particularly enjoyed comparison with him). A Syrian by birth, and a member of what was by this date a decidedly multi-ethnic Roman elite, he came to the throne aged thirteen, after the assassination of his cousin Elagabalus—whose legendary excesses outstripped even those of Caligula and Nero, and whose party trick of smothering his dinner guests to death under piles of rose petals was brilliantly captured by the nineteenth-century painter, and re-creator of ancient Rome, Lawrence Alma-Tadema (Fig. 6.23). Alexander was the youngest Roman emperor ever up to that point, and most of the twenty or so surviving ancient portraits of him (or believed to be of him)

depict a rather dreamy, almost vulnerable, youth (Fig. 1.2). Whether he was ever as exemplary as later ages imagined is doubtful. Nonetheless, ancient writers saw him as a relatively safe pair of hands, largely thanks to the influence of his mother, Julia Mamaea, the 'power behind the throne', who plays a predictably sinister role in Handel's opera. In the end, while on military campaign together, mother and son were both assassinated by rebellious Roman troops; whether the soldiers' anger was provoked by Alexander's economic prudence (or meanness), his lack of martial skills or the influence of Julia Mamaea depends on which report you believe.[2]

All this happened more than a century after those first, and more familiar, Twelve Caesars. But Alexander was still an emperor very much in their style, even down to the seedier stories and allegations (the slightly too close relations with his mother, the danger of the soldiers, the outrageous predecessor and the brutal assassination). In fact, modern historians have often seen him as the last in the traditional line of Roman rulers, which had begun with Julius Caesar; and one sixteenth-century printmaker and publisher, by some creative counting and strategic omissions, managed to double the original Twelve and end up with a diagram of imperial succession that placed Alexander conveniently as emperor number Twenty-Four.[3] What followed his murder was very different. It was decades of rule by a

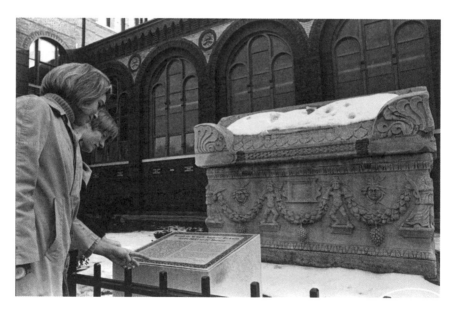

1.1 Visitors in the late 1960s reading the information panel in front of the Roman sarcophagus outside the Arts and Industries Building on the Mall in Washington, DC: the 'Tomb in which Andrew Jackson REFUSED to be Buried'.

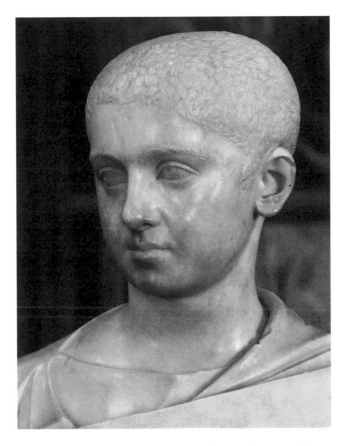

1.2 Portrait bust of Alexander Severus from the line-up of Roman emperors in the 'Room of the Emperors' in the Capitoline Museums in Rome. The identification of individual emperors is rarely certain, but the incised pupils in the eyes of this statue, and the treatment of the close-cropped hair are typical of sculpture of the early third century, and there is a plausible match with some of Alexander's images on coins.

series of military adventurers, many holding command for a couple years only, some of them barely setting foot in the city of Rome, despite being 'Roman' emperors. It is a change of character in Roman power nicely symbolised by the frequent claim—true or not—about Alexander's immediate successor, Maximinus 'the Thracian': on the throne for three years between 235 and 238 CE, he has gone down in history as the first Roman emperor who could not read or write.[4]

The story of the sarcophagus makes a vivid introduction to some of the twists and turns, debates, disagreements and edgy political controversies in

my wider story of Roman imperial images, both modern and ancient. Alexander's name was found nowhere on the coffin that he was supposed to have occupied, nor were there any other identifying marks on it; but the name 'Julia Mamaea' was clearly inscribed on the other one. For Jesse Elliott, that made almost irresistible the connection between the pair of coffins he had acquired and the unfortunate young emperor and his mother. They had been murdered together and then must have been buried side by side, in appropriately imperial grandeur close to Alexander's birthplace, in what is now Lebanon. Or so he managed to convince himself.

He was wrong. As sceptics were soon pointing out, the assassination was supposed to have taken place some two thousand miles from Beirut, in Germany or even Britain (a geographical link that appealed to the court of Charles I, even if the murder did not); and, anyway, one ancient writer claimed that the body of the emperor was taken back to Rome for burial.[5] If that were not enough to scotch the idea, the 'Julia Mamaea' commemorated in the inscription was firmly stated to have died at the age of thirty, making it impossible for her to have been Alexander's mother—unless, as one of Elliott's own junior officers later tartly observed, she had 'given birth to her son, when she was but three years old, which is, to say the least, unusual'. The woman who had once occupied the coffin was presumably one of the many other inhabitants of the Roman Empire with that same common name.[6]

Besides, none of the people engaged in these debates appear to have realised that there was at least one rival candidate for the burial place of the imperial couple; or if they did realise, they kept quiet about it. An elaborate marble sarcophagus over four thousand miles away in the Capitoline Museums at Rome—celebrated in a notable engraving by Piranesi and well known to keen eighteenth- and nineteenth-century tourists—was supposed to have been shared by Alexander and Julia Mamaea, shown reclining together in imperial splendour on its lid (Fig. 1.3). There was even a connection with the blue-glass 'Portland Vase', which is now one of the highlights of the British Museum—famous for its exquisite white cameo decoration, and also for being attacked by a drunken visitor in 1845. If the story is true (a big 'if') that this vase was rediscovered in the sixteenth century actually inside the sarcophagus, then maybe it was the original receptacle that had once contained the emperor's ashes (even though lodging a small vase of ashes inside a vast coffin obviously designed to hold an intact, uncremated body seems a little odd). In this case, the burial place just outside Rome is a better fit with some of the historical evidence. But overall, as the more scrupulous nineteenth-century tourist guidebooks con-

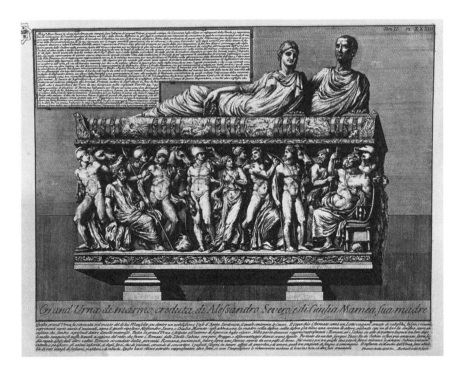

1.3 An alternative candidate for the last resting place of Alexander Severus. Piranesi's 1756 engraving of the sarcophagus, in the Capitoline Museums in Rome, shows the figures of the dead reclining on the lid, with scenes from the story of the Greek hero Achilles carved underneath.

ceded, this identification too was a combination of wishful thinking and outright fantasy.[7]

Unfounded as they were, the imperial associations of Elliott's sarcophagi lingered longer. That is largely because of the strange and slightly gruesome history of these trophies after they arrived in America. Elliott did not intend them to become museum pieces. That of 'Julia Mamaea' he planned to re-use as the last resting place of the Philadelphia philanthropist Stephen Girard; but, as he had long been dead and interred elsewhere, it passed into the collection of Girard College, and in 1955 was loaned to Bryn Mawr College, where it still stands in the cloister. After an abortive attempt to have 'Alexander's' re-used for the remains of James Smithson (illegitimate child of an English aristocrat, scientist and founding donor of the Smithsonian Institution), Elliott presented it in 1845 to the National Institute, a major collection of American heritage housed in the Patent Office, in 'the fervent hope' that it would shortly contain 'all that is mortal of the patriot and hero, Andrew Jackson'.

Despite his failing health (he died a few months later), President Jackson's reply to the letter from Elliott outlining this offer was famously robust: 'I cannot consent that my mortal body shall be laid in a repository prepared for an Emperor or King—my republican feelings and principles forbid it—the simplicity of our system of government forbids it. Every monument erected to perpetuate the memory of our heroes and statesmen ought to bear evidence of the economy and simplicity of our republican institutions and the plainness of our republican citizens . . . I cannot permit my remains to be the first in these United States to be deposited in a Sarcophagus made for an Emperor or King.' Jackson was in a difficult position. The accusations levelled against him of behaving like a 'Caesar'—in a style of autocratic populism that a few of his successors have copied—may have had added to the intensity of his refusal. He was certainly not going to risk an imperial burial.[8]

No practical use found for it, in the 1850s the sarcophagus went from its temporary lodgings in the Patent Office to the Smithsonian, where it remained on display outside on the Mall until finally demoted to storage in the 1980s. But even when the archaeological connection with Alexander Severus had been universally debunked (this was actually a typical East Mediterranean product of the Roman Empire, and could have belonged to anyone with enough ready cash), Jackson's rejection of it, as 'made for an Emperor or King', remained part of the object's history and mythology. In the 1960s, his words were incorporated into a new information panel placed next to the sarcophagus itself, headed 'Tomb in Which Andrew Jackson REFUSED to be Buried' (as the couple in Fig. 1.1 are attentively reading).[9] It stood, in other words, as a symbol of the down-to-earth essence of American republicanism and its distaste for the vulgar bric-a-brac of monarchy or autocracy. Whatever taint of 'Caesarism' might have clung to Jackson, it is hard not to be on his side, against Elliott's 'fervent hope' of acquiring a celebrity occupant for his celebrity sarcophagus.

## From Coffin to Portraits

Such stories of discovery, misidentification, hope, disappointment, controversy, interpretation and reinterpretation are what this book is about. The rest of this chapter will move beyond a couple of marble coffins, an over-eager collector and an uncompromising president. It will offer a first look at the vast and surprising range of portraits of emperors that once covered the ancient Roman world (in pastry and paint as well as marble and bronze), and at some of the art and the artists that have re-imagined and re-created

these emperors since the Renaissance. It will challenge some of the usual certainties about these images—exploring the very fuzzy boundary between ancient and modern portraits (what does, or does not, separate a marble bust made two thousand years ago from one made two hundred years ago?), and getting a taste of some of the political and religious *edginess* of these ancient rulers in modern art. And it will introduce Gaius Suetonius Tranquillus ('Suetonius' for short), the ancient writer who bequeathed to the modern world the very category of 'the Twelve Caesars' and who hovers over the chapters that follow.

But the tale of Elliott's trophy has already raised some important guiding principles for my subject as a whole. First, it is an important reminder of just how crucial it is—obvious as that might seem—to get things right. Ever since antiquity, images of Roman emperors have travelled across the known world, been lost, rediscovered and confused one with another; we are not the first generation who find it difficult to tell our Caligulas from our Neros. Marble busts have been re-carved, or carefully adjusted, to turn one ruler into the next, and new ones continue to be produced, even now, in an endless process of half-accurate copying, adaptation and re-creation. And, in more cases than it is comfortable to acknowledge, modern scholars and collectors from the Renaissance on have tendentiously re-identified portraits of anonymous worthies as bona fide Caesars, and given run-of-the-mill coffins or ordinary Roman villas a spurious imperial connection. The sarcophagus of 'Alexander' offers a classic example of the complicated trail of needless falsehood and fantasy that comes with attaching the wrong name to the wrong object.

Equally, it is a reminder that misidentifications cannot so easily be swept aside, and that archaeological purism can be taken too far. The mistaken identity at the heart of the story of the sarcophagus of 'Alexander' is historically significant in its own right (without it, after all, there *is* no story). And it is only one of many such mistaken identities—'emperors' in quotation marks—that have played a leading part over the centuries in representing to us the face of Roman power and in helping the modern world to make sense of ancient dynasts and dynasty. Piranesi's confident labelling of the Capitoline sarcophagus gave it an association with the imperial couple that was not entirely overturned by the fact that it was simply 'wrong'. My guess is that a number of the important and influential images in this book have no closer connection with their historical subjects than the real-life Alexander had with 'his' coffin(s). They have been no less important or influential for that. This is a book both about emperors and about 'emperors' in quotation marks.

The most striking aspect, though, of the story of the President and the sarcophagus is that, for Jackson, that lump of ancient marble so obviously *meant* something. Its imagined links with a Roman emperor signified autocracy and a political system at odds with the republican values that he himself claimed to espouse and it was the cause of as much fulmination as the dying man could muster. This is a powerful prompt for us, even now, not to take the representations of Roman emperors too much for granted. After all, just under a century after Jackson's death, Benito Mussolini conscripted the faces of Julius Caesar and his successor, the emperor Augustus, to his fascist project, as well as restoring Augustus's imposing mausoleum in the centre of Rome, as a monument—indirectly at least—to himself. This was not just window dressing.

It is true that most of us (myself included on occasion, I confess) tend to pass by the rows of emperors' heads on museum shelves without much more than a glance (Fig. 4.12). Even now, when the significance of some public statues has become increasingly—and sometimes violently—disputed, the sets of the Twelve Caesars that since the fifteenth century have decorated the homes and gardens of the European elite (and later, *pace* Jackson, of

1.4 German wallpaper, c. 1555. Two imperial heads in their roundels are supported by fantasy creatures among extravagant foliage. The sheet (about thirty centimetres high) was intended to be cut into strips and attached to walls or furniture to form a border, adding a touch of class.

the American elite too) are often assumed to have been little more than a convenient off-the-peg badge of status, an easy link with the supposed glories of the Roman past, or expensive 'wallpaper' for aristocratic or aspirational houses. Sometimes that is exactly what they were, quite literally. Even as early as the mid-sixteenth century paper prints were being produced with imperial heads ready to be cut out and pasted onto otherwise undistinguished pieces of furniture or walls, to give a ready-made veneer of class and culture (Fig. 1.4); and you can still buy something very similar from upmarket interior decorators, by the roll.[10] But that is not all there is to it.

Throughout their history, images of ancient emperors—like some of those of more recent soldiers and politicians—have raised more awkward and more loaded questions. They have been as much a cause of controversy as they have been bland status symbols. Far from being merely a harmless link with the classical past, they have also pointed to uncomfortable issues about politics and autocracy, culture and morality and, of course, conspiracy and assassination. The reaction of Andrew Jackson (whose own statues are, as I write, being threatened with toppling for his connections with slavery, not Caesarism) prompts us to be alert to the destabilising edge of these imperial figures, dressed though they often are in apparently familiar clichés of power.

## A World Full of Caesars

Representing Roman emperors kept ancient artists and craftsmen inspired, in business and, no doubt, occasionally bored or repulsed for hundreds of years. It was production on a vast scale, thousands upon thousands of images, going far beyond those marble heads or colossal full-length bronzes that the phrase 'imperial portrait' usually suggests.[11] They came in all shapes and sizes, materials, styles and idioms. Some of the most intriguing archaeological discoveries, found across the Roman world, are fragments of humble pastry moulds. At first sight their design is hard to make out, but a careful look shows that they feature images of the emperor and his family. Once part of the equipment of Roman kitchens or confectioners, they must have turned out biscuits and treats that put the face of imperial power straight into the mouths of Roman subjects (emperors that were good enough to eat).[12] But there were also exquisite cameos, cheap wax or wooden models, paintings on walls or portable panels (much like the modern painted portrait); not to mention all those miniature heads on coins in gold, silver and bronze.

Ancient artists were responding to different markets and to a wide range of patrons and consumers. They filled imperial residences, and imperial tombs, with the faces of dynastic power; they supplied images of the emperor and his family for the Roman authorities to send out to those distant subjects who would never see them in the flesh; they catered to local communities who wanted to erect imperial statues in their temples or town squares to demonstrate their loyalty to Rome (while also revealing their own sycophancy); and they provided for all those ordinary individuals who shopped for miniature emperors to take away as souvenirs or to display at home on the ancient equivalent of mantelpieces and dining room tables.[13]

Only a tiny proportion of these images has survived, even if, thanks to the efforts of antiquarians and archaeologists, considerably more have come to light by the twenty-first century than had done so by the fifteenth. That said, the raw numbers are impressive and ought to surprise us more than they usually do. Such is the peril of familiarity that we tend to take for granted our ability, a couple of millennia on, to look so many of these ancient rulers in the eye. Those twenty or so portraits of Alexander Severus (plus another twenty of Julia Mamaea) are only a small part of it. In the case of the emperor Augustus, who reigned for forty-five years, from 31 BCE to 14 CE, leaving aside coins and cameos, and plenty of *mis*identifications, the number of fairly certainly identified contemporary or near contemporary images in marble or bronze, found across the Roman Empire from Spain to Cyprus, is more than two hundred, plus around ninety of his (even longer-lived) wife Livia (Figs 2.9; 2.10; 2.11; 7.3). One reasonable guess, and it can be no more than a guess, puts these figures at one per cent, or less, of the original total—perhaps between twenty-five thousand and fifty thousand portraits of Augustus in all.[14]

Whether that is roughly right or not, what we have today is certainly not a representative sample of what there once was. Dilapidation and destruction do not strike evenly. Statues in metal are always vulnerable to being re-used; and, by definition, the more ephemeral the medium, the fainter the archaeological trace it leaves. Augustus refers in his *Autobiography* to 'about eighty' silver statues of himself in the city of Rome alone. But rows of marble heads now take a disproportionate place in imperial portraiture for the simple reason that almost all the gold and silver versions that once existed, as well as many of the bronze, were sooner or later melted down and recycled. They ended up as new works of art, hard cash or, in the case of the bronze, military machines and munitions.[15]

Other materials, such as paint, disappeared, without any such aggressive intervention. Painted portraits in general are one of the greatest

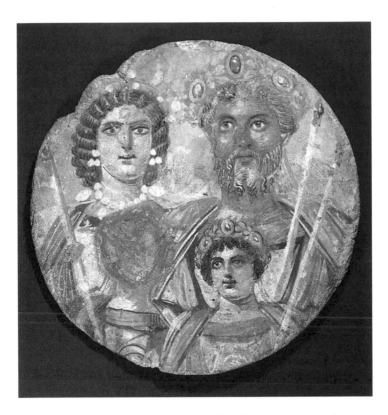

1.5 The family of Septimius Severus, the first Roman ruler from the continent of Africa (emperor 193–211): Septimius himself, back right; his wife Julia Domna, the great-aunt of Alexander Severus, back left; his elder son Caracalla, bottom right; and his younger son Geta (bottom left). The panel has had an eventful history. Currently about thirty centimetres in diameter, it has been cut down from a larger piece. The face of Geta, murdered on the orders of Caracalla in 211, has been deliberately erased.

casualties of classical art, surviving only in rare conditions—such as the dry sands of Egypt, which preserved those evocative, and often disconcertingly 'modern', faces that memorialised the dead on the decorative casing of Roman mummies.[16] Also from Egypt comes a striking image of the emperor Septimius Severus and his family. Painted around 200 CE, this might easily be taken as an unusual imperial one-off, if a few written texts did not hint that it was part of a much wider, though now almost entirely lost, tradition (Fig. 1.5). One ancient inventory preserved on a fragmentary papyrus, for example, appears to list several 'little paintings' of emperors on display in the third century CE in a group of Egyptian temples; and the tutor of the emperor Marcus Aurelius on one occasion mentioned the

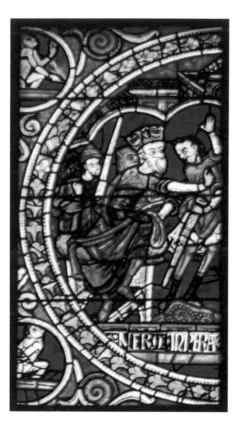

1.6 Nero on a small panel in the large, twelfth-century, east window (eight and a half metres high) in Poitiers Cathedral in France. Dressed as a medieval king, but labelled underneath (in what is a modern restoration of the original lettering) 'Nero Imperator' (Emperor Nero) he seems oblivious of the devil on his back. He is gesticulating towards the centre of the window, where Saint Peter is shown being crucified on his orders.

1.7 [FACING PAGE] This precious cross (half a metre high) is still used in ceremonies in Aachen Cathedral. It is a complicated composite. The base dates from the fourteenth century. The cross itself was made around the year 1000, incorporating a slightly earlier seal of King Lothar below and at the centre a first-century cameo of the emperor Augustus.

'badly painted' and the laughably unrecognisable portraits of his pupil that he saw 'at the money lenders, in shops and stalls . . . anywhere and everywhere'. In doing so, he not only revealed his snobbish disdain for popular art, but also offered a fleeting glimpse of the once ubiquitous presence of emperors in paint.[17]

Most of the images of these rulers that we see today, however, are not 'Roman' in the chronological sense of the word, but were produced many centuries after the collapse of the Roman Empire in the West. They include some striking medieval portrayals: the emperor Nero with a little blue devil on his back in a stained glass window in Poitiers Cathedral, for example, is a memorable vignette from the twelfth century (Fig. 1.6); and, in a wonderful process of creative re-invention, around 1000 CE the makers of the 'Lothar Cross' breathed new life into a cameo of Augustus, by incorporating it into an entirely new setting, and 'rhyming' it with a portrait below of the Carolingian King Lothar (hence the modern name), who ruled in the ninth century (Fig. 1.7).[18] But it is since the fifteenth century, across Europe and then outside it, that emperors have been recreated, imitated

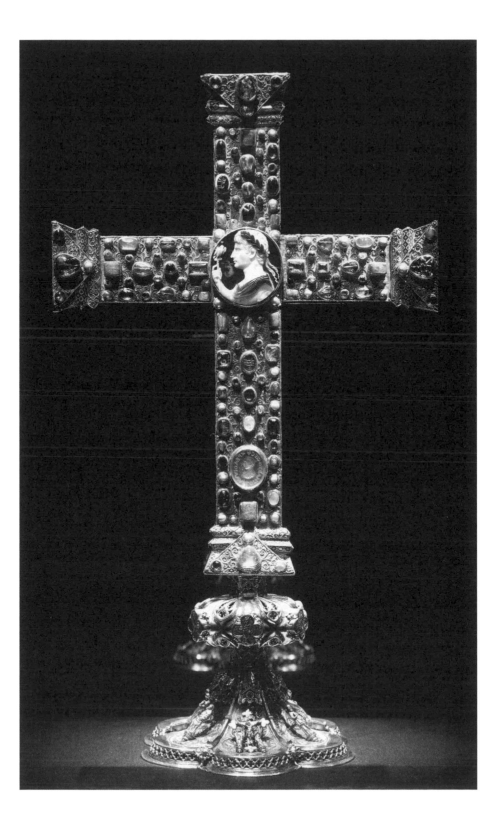

1.8 Once considered authentic ancient pieces, the two groups of Twelve Caesars at Versailles were created in the seventeenth century. On the left, Augustus from one of those series, bought by King Louis XIV from Cardinal Mazarin's collection; on the right, an even more ostentatious Domitian, with gilded drapery, from the other series.

and re-imagined in numbers that cannot be far short of the ancient scale of production, and in yet more colourful variety.

Arrays of marble busts were certainly one element of this. Sculptors and patrons took their cue from some of the best-known survivals of Roman imperial portraiture, and kitted out palaces, villas, gardens and country houses with their own Caesars in stone: from the ostentatious porphyry and gilded creations that decorated Louis XIV's state rooms at Versailles (Fig. 1.8); to the more modest context of the Long Gallery at Powis Castle in Wales, where the display of emperors' busts seems to have come at the cost of basic amenities, such as carpets, decent beds and wine ('I should exchange the Caesars for some comforts' observed one grumpy visitor in 1793) (Fig. 1.9); or to the quirkier setting of Bolsover Castle in northern England, where a large seventeenth-century fountain featured eight solemn emperors around its edge, standing guard over (or ogling) a naked Venus and four urinating *putti*.[19]

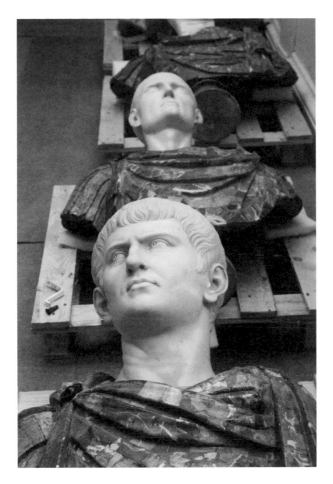

1.9 More than three hundred years after they had first been installed, the emperors at Powis Castle were removed from their pedestals in the early twenty-first century for conservation: here, these substantial marble busts, more than a metre tall, are in mid-transport. There is a striking contrast between the emperors displayed as art objects and their transformation on these 'stretchers' into almost human hospital patients.

At the same time, painters lined the walls and ceilings of rich houses with imperial portraits in fresco and on canvas—none more influential, as we shall see (Chapter 5), than Titian's set of eleven *Caesars* painted for Federico Gonzaga of Mantua in the 1530s. And they re-imagined key moments in the history of imperial rule. These moments were not drawn from any ancient visual repertoire. Rarely in surviving Roman art was an emperor depicted in anything more than a standardised scene of

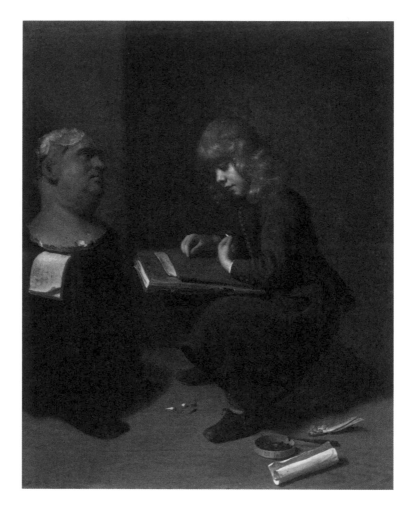

1.10 Michael Sweerts's painting of a *Boy Drawing before the Bust of a Roman Emperor* (c. 1661), just under fifty centimetres high. The Roman emperor concerned is Vitellius (Fig. 1.24), the emperor who had a lurid reputation for gluttony, immorality and sadism. Does the artist want us to feel uneasy at this innocent child being given such a monster for his drawing practice?

sacrifice, triumph, benefaction, procession or hunting; the narratives on the columns of Trajan and Marcus Aurelius, detailing the emperors' part in military campaigns, are some of the few exceptions. But modern artists gave a visual form to the stories of emperors they found in ancient literature. Some of the classics were: *Augustus Listening to Virgil recite the 'Aeneid'*; *The Assassination of Caligula*; or the always ghoulish *Nero Gazing at the Body of his Mother*, whose murder he had ordered (Figs 6.24; 7.12–13; 7.18–19).

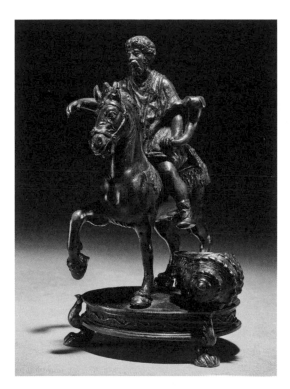

1.11 A sixteenth-century
bronze inkwell, copying the
figure of Marcus Aurelius
(emperor 161–80), that for
centuries stood in the piazza
on the Capitoline hill in Rome,
and is now in the Capitoline
Museums. The whole figure
is only just over twenty-three
centimetres high, and the ink
was held in the small shell-
shaped vessel at the horse's
feet.

Until the nineteenth century at least, these emperors were so important an element in a painter's stock-in-trade that technical treatises on art gave instructions on how they should best be represented (alongside biblical figures, saints, pagan gods and goddesses and assorted later monarchs), students perfected their drawing technique by copying plaster casts of famous imperial busts (Fig. 1.10) and subjects taken from the lives of the Caesars were set in art exams and competitions.[20] In 1847, the novice artists in Paris competing for the top bursary known as the 'Prix de Rome' (Rome Prize) were asked to demonstrate their talents with a painting of *The Death of the Emperor Vitellius*, tortured and dragged by a hook into the river Tiber. This ghastly lynching of a disreputable, short-term occupant of the imperial throne, in the civil war that followed the fall of Nero in 68 CE, may have resonated with the revolutionary European politics of the 1840s; but it was a controversial choice, deemed by some reviewers of the competition as a subject bad for the minds and talents of the young painters (Fig. 6.20).

It is not, however, only a question of painting and sculpture. Emperors have found a place almost everywhere, in every medium from silver to wax. They have been turned into inkwells and candlesticks (Fig. 1.11). They

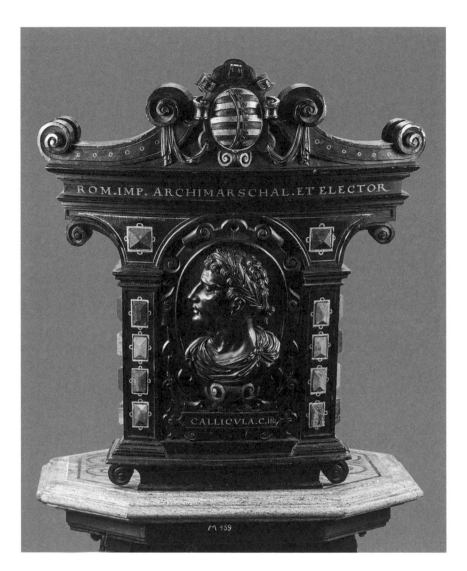

1.12 One of a set of imperial chairs made for the elector of Saxony, c. 1580, each carrying the portrait of a different emperor, making up the Twelve Caesars. Here Caligula is set against a luxurious background of gilding and semi-precious stones.

feature on tapestries, in pop-up decorations at Renaissance festivals and even on the backs of a notable set of sixteenth-century dining chairs (the question of which guest would be seated on Caligula or Nero must have added excitement to the *placement*) (Fig. 1.12).[21] A set of exquisite Twelve Caesar cameos, which hung around the neck of one Spanish officer serving in the Spanish Armada as he went down with his ship, the 'Girona', in 1588 (Fig. 1.13), is as different as you could imagine from the vast maiolica impe-

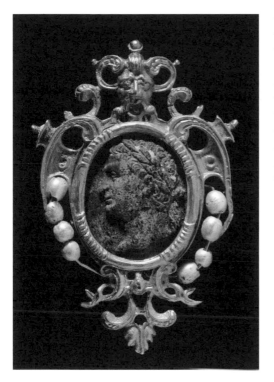

rial busts produced in the nineteenth century by an Italian firm of celebrity ceramicists (Fig. 1.14).[22] I suspect that no rulers in the history of the world have ever been presented more gaudily.

Nor is it a question only of elite patrons and their prestige possessions. Caesars have decorated the homes of the middle classes, on mass-produced prints and modest plaques, as well as the palaces of the super-elite. And they have been satiric and playful as well as impressively serious. William Hogarth chose Roman emperors to decorate the walls of his tavern in *The Rake's Progress* (appropriately enough, given the decadence depicted, it is only the face of Nero that is fully visible) (Fig. 1.15). Centuries before, a witty, or disgruntled, artist in fourteenth-century Verona left a marvellous imperial caricature in the plaster underneath a set of painted portraits of emperors that are among the earliest to survive from the modern world (Fig. 1.16).[23]

These imperial characters have also played a role in a far wider range of cultural, ideological and religious debates than we often give them credit for. The main reason that Nero appears in the stained-glass window at Poiters was that he was the emperor who supposedly, among his other persecutions, sent Saint Peter and Saint Paul to their deaths. And it is in

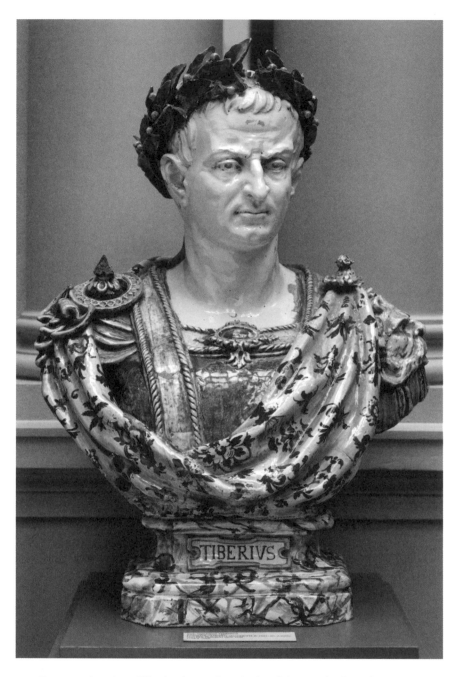

1.14 Emperors in colour. Tiberius (named on the base) is one of at least fourteen Roman rulers, produced in high-glazed earthenware by a firm of Italian ceramicists, Minghetti of Bologna, in the late nineteenth century. Overpowering display pieces, standing a metre tall, they are now split up across the world from the United Kingdom to Australia.

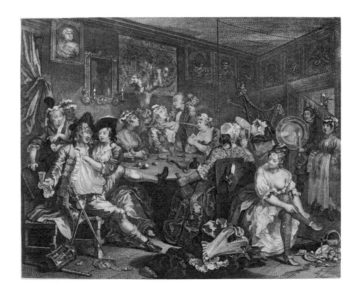

1.15  An engraving of William Hogarth's 1730s painting of the *Tavern Scene* or *Orgy*, in his *Rake's Progress*—a series of images document-ing the decline of one Thomas Rakewell (sprawling on the chair to the far left). Just visible, high on the wall behind are portraits of Roman emperors: only the depraved Nero, second from the right on the rear wall (between Augustus and Tiberius) appears undefaced, as an emblem of what is going on below.

1.16  This small sketch of an emperor with his distinctive 'Roman' nose, found in the plaster underneath paintings in the Palazzo degli Scaligeri in Verona of the 1360s, including portraits of Romans rulers and their wives (Fig. 3.7g). Whether by the lead artist Altichiero or one of his team, this is not so much a preparatory drawing as a satire on the serious theme of the decoration.

that role that he features prominently also on the huge bronze doors of St Peter's Basilica in Rome, made by the sculptor, architect and theorist Filarete, for Old St Peter's in the fifteenth century, and one of its few elements that was reincorporated into the New.[24] But if it was emperor Nero as Antichrist, who greeted, and still greets, visitors to one of the most holy places in all Christendom, there were also constructive attempts to reconcile the story of Jesus with that of the emperors. One of the most popular subjects in early modern painting—examples lurk unrecognised in almost every major Western art gallery—is the emperor Augustus's vision of the baby Jesus. This marvellous pious fiction had Augustus on the day of Jesus's birth consult a pagan prophetess on the question of whether anyone would

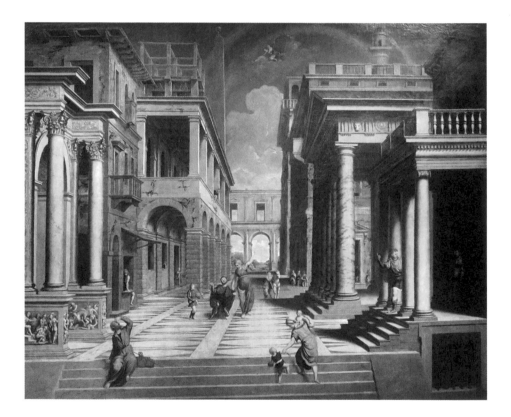

1.17 Paris Bordone's large painting (more than two metres across), *Apparition of the Sibyl to Caesar Augustus* (mid-sixteenth century). In the centre of a grand architectural scheme, the emperor kneels, while the prophetess ('the Sibyl') stands next to him; in the sky there is a vision of the Virgin Mary and the infant Jesus. It is a painting well-travelled among the European elite: once owned by Cardinal Mazarin, it was later the property of Sir Robert Walpole at Houghton Hall in England (below, p. 105), before being sold to Catherine the Great of Russia.

be born in the world more powerful than himself, and whether he should allow himself to be worshipped as a god. The miraculous sight of the Virgin and Child in the sky above Rome gave him his answer (Fig. 1.17).[25]

Even today emperors are being recreated and re-energised. Although most of the examples I have mentioned so far have been earlier than the twentieth century, the Caesars remain a recognisable idiom in modern culture. Ostentatious sets of imperial busts are still being made, and still mean something (in Federico Fellini's film *La dolce vita*, imperial heads, ancient and modern, are repeatedly used to link the decadence of contemporary Rome with its decadent past[26]). And emperors play a role in popular image-making too, even now. Modern political cartoons depicting their unfortunate target with a laurel wreath and lyre, against the backdrop of a burning city, are only one part of it. The commercial power of the Caesars still works in 'Emperor' pub-signs or beer-bottle labels; and there is plenty of knowing self-irony in such jokes as 'Nero' trademark matches or boxer shorts. Meanwhile souvenir-makers are still producing chocolate coins emblazoned with the heads of the Caesars, just as Romans pastry chefs produced their imperial biscuits. Emperors have remained good enough to eat (Fig. 1.18g).

## Ancient-and-Modern

This book is inevitably bifocal. It is concerned particularly with modern re-creations of the Roman emperors over the last six hundred years or so, but ancient images will always be in sight too—simply because a modern Julius Caesar, Augustus or Nero can never be entirely separated from its ancient predecessors. That is for several reasons.

For a start, there is an inextricable two-way influence between the old and the new. Unsurprisingly perhaps, modern images of emperors have almost always been produced in imitation of (or in response to) ancient Roman prototypes. That is true, of course, for many classicising themes in art. Every modern version of Jupiter or Venus, of guileless Naiad or of raunchy satyr is the product of some kind of conversation with the art of antiquity. But with these imperial rulers that conversation is especially intense. Modern conventions in the 'look' of many individual emperors—from the cool classical profile of Augustus to the shaggy beard of Hadrian—have often been derived from detailed study of surviving Roman art and literature. At the same time, however, these modern representations of imperial rulers have influenced how we see, and recognise, their ancient counterparts. Before they have ever looked at a single ancient portrait of Julius

Caesar, the vast majority of even the most scholarly archaeologists and art historians today have come across his face in the cartoons of *Astérix*, or in popular comedy films (*Carry on Cleo* was my own introduction) (Fig. 1.18h and i). Three centuries ago, it was probably Titian's paintings of the Caesars (or one of the many sets of prints based on them) that provided the same kind of popular mental benchmark for their appearance (Chapter 5). For better or worse, most modern viewers have some template of the most famous imperial figures in their minds before ever casting an eye directly on any Roman sculpture, cameo or coin. We see the ancient through the modern.[27]

But the connections between ancient and modern run even deeper than that, and they put a distinctive stamp on the whole subject. In marble sculpture in particular, it can prove impossible to decide whether an individual piece was made in ancient Rome, or anything up to two millennia later. More than two and a half centuries ago, the learned J. J. Winckelmann (who was the first to devise a reasonably plausible chronological scheme for ancient art) complained that it was very hard, especially in the case of 'heads' to 'tell the difference between the old and the new, the authentic and the restoration'. No amount of modern technical sophistication or scientific wizardry has made it any easier since.[28] That is why, in addition to the couple of hundred portraits of Augustus that are generally accepted as ancient, there are at least forty more which continue to shuffle backwards and forwards between the categories of 'ancient' and 'modern'; they are part of my tantalising hybrid category 'ancient-and-modern'.

One notorious sculpture in the Getty Museum is a striking example of that, still defying final, conclusive dating despite a special exhibition and an expert conference in 2006 having been devoted to that very question. This is a bust of the emperor Commodus (a keen amateur gladiator who was assassinated in 192 CE, and was more recently antihero of the film *Gladiator*, by Ridley Scott). After two hundred years or so in an English

1.18 [ FACING PAGE ]

(a)  The emperor Titus, as he appeared in Fellini's *La dolce vita* (1960)
(b)  Chris Riddell, cartoon of Gordon Brown (UK prime minister) as Nero (2009)
(c)  Cambridge pub sign (based on a statue by Nicolas Coustou, commissioned 1696)
(d)  Augustus beer, from Milton Brewery, Cambridge
(e)  Advertisement for Nero boxer shorts (1951)
(f)  Capitoline Museums matches: 'Nerone's [Nero's] matches'
(g)  Head of Augustus on chocolate coin
(h)  Kenneth Williams as Julius Caesar in *Carry on Cleo* (1964)
(i)  Caesar, from R. Goscinny and A. Uderzo, *Astérix* series

(a)

(b)

(c)

(d)

(e)

(f)

(g)

(h)

(i)

aristocratic collection, it was bought by the Getty in 1992, and at that point was considered to be a product of sixteenth-century Italy, imitating ancient portraits of the emperor. It has since been variously reclassified, both as a later, eighteenth-century piece and more radically as an original portrait of the second century CE, or in some uncertain limbo between the three (Fig. 1.19).[29]

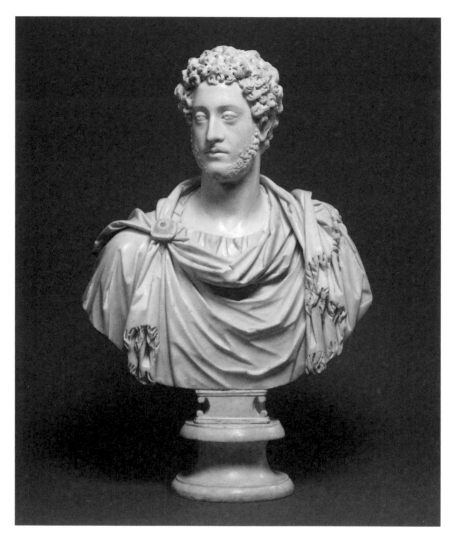

1.19 The 'Getty *Commodus*'. Whatever the horror stories told of Commodus, he is here represented, almost life-size, as an entirely conventional emperor of the late second century CE, dressed in a military outfit and with the beard characteristic of many second-century rulers (unlike their clean-shaven predecessors). But whether he is ancient, modern or a mixture of the two still remains uncertain.

There are almost no criteria that might beyond doubt clinch the date. The tools and techniques of sculptors remained more or less identical from the second century to the eighteenth, and they often produced more or less identical results (especially at this relatively compact scale, where there is less opportunity for give-away signs of date than in a full-length figure). The material does not help either, as the bust is made of marble from an Italian source that has been quarried through most periods of history since the late first century BCE. What is more, there is no record of how, when or from where the piece was brought to England. The arguments now rest on impressionistic hunch and microscopic evidence. Traces of mineral deposits in the cracks (indicating that it might have been buried) and signs that it had possibly been 'resurfaced' at some point (more likely if it is very old) are now taken to suggest that it probably goes back to the ancient Roman world. But this is no more than 'suggest'. Although current consensus has nudged him towards antiquity (and, as I write, he is proudly on display in the museum's Roman gallery), since being acquired by the Getty, Commodus has moved around the museum: sometimes on show alongside ancient, sometimes alongside modern works, according to the prevailing curatorial view of his date; and occasionally left out of sight altogether in the twilight of the storeroom.

Faking and forgery—that is, clearly fraudulent attempts to make a newly created piece appear ancient—add an extra dimension to such puzzles. The 'Getty *Commodus*', as it is usually known, is not a fake in that sense. Even supposing it were made in the sixteenth century, inspired by Roman antecedents, there is no indication that anyone was then trying to pass it off as ancient (if they were, it was an extremely unsuccessful attempt since, so far as we know, the possible second-century date has only recently been floated). But among those forty or so portraits of Augustus whose bona fide antiquity has been disputed, some were very likely sold under false pretences and really belong to the 'modern' category. The assumption usually is that they were produced mostly between the sixteenth and nineteenth centuries by shrewd operators in Italy, aiming at the pockets of wealthy collectors and gullible mi'lords (especially, but not exclusively, English) who were chasing after ancient portraits for their ancestral homes and private museums. These were the men who 'look with their ears'; or so one famous eighteenth-century restorer, sculptor and art dealer put it in his advice to potential buyers, referring to their woeful susceptibility to the salesman's patter.[30]

But it is still not so easy. Forgery is a much harder category to pin down than is often assumed—as one notable series of miniature imperial heads

vividly illustrates. These are found on replicas of Roman coins and medals produced in the sixteenth century by Giovanni da Cavino in Padua (Fig. 1.20). Many of them were once taken to be authentically antique, but in this case, unlike in that of so many marble busts, we can be sure that they are not: these 'Paduans', as they are sometimes called, are a different weight from the ancient prototypes, and made of a different metal alloy; they are more delicately worked; and—should there be any lingering doubt—some of the sixteenth-century dies and punches with which they were made still survive. Nevertheless, disagreement continues on the motives behind this. Was Giovanni da Cavino a forger, with fraudulent intent? Or was he producing elegant imitations involving no false pretences, to appeal per-haps to collectors who were unable to acquire the originals they wanted? Ultimately, it all depends on what terms they were represented or sold, and that might well have been different on different occasions. Whether sculp-ture or coin, cameo or medal, an honest 'replica' only becomes a dishonest 'fake' if, or when, it is knowingly claimed to be something it is not. One person's shabby counterfeit may well be another's valued facsimile.[31]

In other cases, the distinction between ancient and modern is further blurred, for different reasons. Despite their optimistic museum labels, most ancient marble sculptures rediscovered before the late nineteenth century are quite literally hybrids or 'works in progress'. To be sure, they have an authentic Roman origin, but they have been aggressively cleaned up, altered, adjusted and imaginatively restored long after they were first made. Certainly, little of the original surface could have survived the procedures recommended for 'cleaning' ancient marble in one early nineteenth-century artists' handbook—involving acid baths, chiselling and pumice.[32] Very few marble emperors, apart from recent archaeological finds (and even they are not immune), have not had some such 'work' done. The Getty *Commodus* may well be a relatively minor instance of this: a second-century CE piece, *re*surfaced and *re*polished to produce a new, smooth finish a millennium and a half later—only adding, of course, to the difficulties of assigning it any single date.

Other instances include those many austere ancient Roman imperial heads that in the sixteenth century and later were inserted into new, lav-ish supports, with flamboyant drapery, making an altogether more showy impression (the basic rule is that the more splendid and brightly coloured the bust under any Roman portrait-head is, the less likely it is to be entirely ancient). But sometimes more imaginative adjustments have gone on. A controversial marble bust of a young woman, now in the British Museum, has often been identified as Antonia, the mother of the emperor Claudius

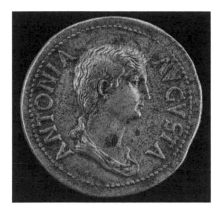
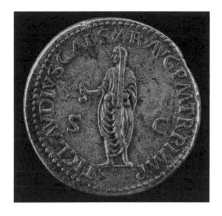

1.20 One of Giovanni da Cavino's sixteenth-century bronze 'Paduans', just over three centimetres in diameter. On one side a portrait of Antonia, the mother of the emperor Claudius; on the other, her son the emperor, dressed for religious ritual, with his name (Ti[berius] Claudius Caesar) and his imperial titles around the edge. 'S C', short for 'senatus consulto', marks the authority of the senate in minting Roman coins of this type.

(who also features in Fig. 1.20). One question has been: is it ancient or modern? It is probably both. For most likely a makeover in the eighteenth century has 'sexed up' an original first century CE sculpture by cutting it away to give the impression of much skimpier clothing and a plunging neckline (not how Romans usually portrayed imperial ladies, though appealing to a modern buyer).[33]

Critics and restorers themselves, from the sixteenth century on, debated the role of restoration in completing fragmentary ancient sculpture. How many modern additions and improvements were legitimate? How far was the restorer to be seen as an artist in his own right?[34] But, in some portraits, hybridity became an end in itself. In the Capitoline Museums at Rome (standing, as it has done for centuries, in a grand room on the first floor of the Palazzo dei Conservatori) is a full-length figure in marble, the body clad in armour of Roman imperial type, arm outstretched as if to address his legions; the head, by contrast, in the fashion of a sixteenth-century dynast, appears to have come from another age (Fig. 1.21). And indeed it has. This is a statue of the warlord Alessandro Farnese (*Il Gran Capitano* as he was known, 'The Great Captain', or even 'Big Boss'), erected in 1593, the year after his death. The body was formed out of an ancient Roman statue, said at the time to be of Julius Caesar, its head completely replaced with the distinctive features of *Il Gran Capitano*.

There may have been practical reasons for this. To our eyes now, the amalgam appears awkward (and very few visitors today stop to admire it).

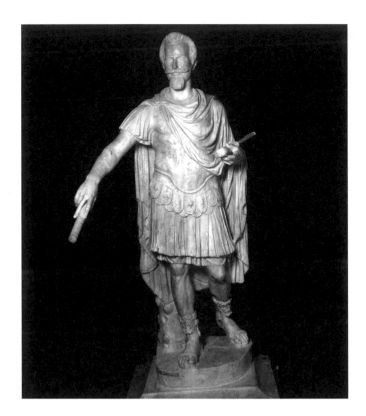

1.21 Both ancient *and* modern. The portrait head of Alessandro
Farnese by the sculptor Ippolito Buzzi (d. 1634) has been inserted
into the life-size body of an ancient statue believed to be that
of Julius Caesar. As if to underline the connections between this
sixteenth-century warlord and Roman antiquity, his portrait stood
(and still stands) in front of a painting of a famous military victory
from the myths of early Rome.

But it meant a very speedy and cheap commission, as the records of the
payment to the sculptor make clear. More to the point, though, it was also
a powerful visual way of parading a link between the modern hero and
the ancient past. The comparison of Alessandro Farnese with Caesar had
already been made in a eulogy at his funeral. Here that comparison was
monumentalised in marble.[35]

There were ancient Roman precedents for this practice. Caesar could
hardly have complained at his treatment by those who wanted (literally) to
'deface' and 'reface' his portrait to honour some sixteenth-century follower.
Centuries earlier, his own admirers had done much the same. By the end of
the first century CE, on a famous statue of Alexander the Great that stood
in the centre of Rome the head of Julius Caesar had been substituted for

the original, as if to put the Roman conqueror firmly in the tradition of his Greek predecessor: to place Caesar, if not in Alexander's shoes, then at least on his neck.[36] In both cases—Caesar and *Il Gran Capitano*—viewers were meant to keep the old *and* the new simultaneously in their sights: this was art ancient-*and*-modern.

## Imperial Connections: From Napoleon and His Mother to the Last Supper

There is, however, an even more complicated, more subtle and trickier tradition of introducing the imperial faces of ancient Rome into modern portraiture and into modern art more generally. This has sometimes rebounded on the artist or sitter concerned. But modern viewers can lose a lot of the rich layers of meaning if they fail to spot it. A particularly pointed (and notorious) example of this is Antonio Canova's portrait sculpture of Napoleon's mother, Letizia Bonaparte ('Madame Mère' as she was often known), commissioned by the lady herself in 1804.

Canova did not literally take his chisel to an ancient work of art. But he made much the same point as the sculptor who 're-faced' Julius Caesar to create 'The Big Boss', for he based his figure very closely on an ancient statue that now sits, as it has for two centuries, in the middle of the 'Room of the Emperors' in the Palazzo Nuovo of the Capitoline Museums in Rome; at the time this was confidently identified as 'Agrippina', a woman at the centre of the imperial family in the first century CE (Fig. 1.22).[37] Some contemporary critics missed the significance; it was a case, they judged, where the fine boundary between creative imitation and straightforward copying was too fine for comfort, and they accused Canova of plagiarism. Others saw that it raised bigger questions: who exactly was the 'Agrippina' depicted in the ancient statue, and so with whom was Madame Mère being linked, and with what message?

Part of the puzzle went back to the fact that there were *two* prominent Agrippinas in the imperial family of the first century, stereotyped in very different ways. One was the virtuous, if sometimes tediously uncompromising, granddaughter of the emperor Augustus and wife of the popular imperial prince Germanicus, who defended her husband's memory after his gruesome murder (masterminded, it was claimed, by the jealous emperor Tiberius); she was later exiled, tortured and in 33 CE starved herself, or was starved, to death. The other was her villainous daughter—Agrippina 'the Younger' to distinguish her from 'the Elder'—the wife of the emperor Claudius, whom she reputedly dispatched in 54 CE with a dish of poisoned

mushrooms, and the mother, incestuous lover, and eventually murder victim of the emperor Nero. (There is more on this pair in Chapter 7.)

Opinions were sharply divided, usually according to the political sympathies of the critic concerned, on whether it was the paragon or the villain who was the subject of the ancient statue and so the model for Madame Mère. But whichever way it went, the implications were bleak for Napoleon, her son. For what both Agrippinas, the villainous and the virtuous, had in common were their truly monstrous offsprings: the emperor Nero in the case of the Younger, the emperor Caligula in the case of the Elder. Not a few commentators implied that Canova's target had been Napoleon himself. It was a classic instance of the inseparability of the ancient and the modern (the whole point was not to plagiarise, but to *align* Madame Mère with a Roman model); and it was another case where such an alignment brought its own controversies and unwelcome political implications. It was the 'Andrew Jackson dilemma' writ large.[38]

In 1818 after the fall of Napoleon, the sixth Duke of Devonshire—an eager collector of contemporary sculpture and a particularly fervent admirer of Canova, with the money to indulge his passions—purchased the statue of Madame Mère in Paris. The subject herself was none too pleased about the sale ('<she> rather complained of my possessing her statue', the duke admitted—or boasted). But, whatever the bad feeling, it became one of the highlights of his collection, installed in his palace at Chatsworth, in northern England—where, so he wrote in his own guidebook to the property, he would pay nocturnal visits to the statue 'by lamplight'.[39]

It has been in Chatsworth ever since, admired as a masterpiece of Canova, and given extra celebrity from its Napoleonic links (the plinth on which it stands blazons the Latin words, in large capitals, 'Napoleonis Mater', 'Mother of Napoleon'). But whatever the duke may have made of the sculpture's antique precedents, for most visitors its connections with either Agrippina have long been forgotten, and with those connections a large part of the interest, peculiarity and *meaning* of the statue has been lost too. A controversial work of art that once exposed some of the awkward questions about imperial character, dynasty and power has settled into a much blander role, as an accomplished portrait combined with a Napoleonic souvenir.

There is a huge amount to gain by putting those classical connections *back*, both here and elsewhere. It is often, and rightly, said that much of the art produced before the late nineteenth century, in the West at least—I do not want to foist this preoccupation on the rest of the world—must necessarily remain opaque to those who do not have a reasonable knowledge of

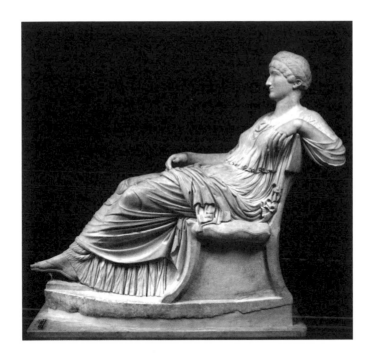

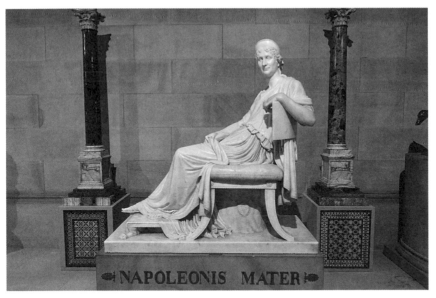

NAPOLEONIS MATER

1.22 Canova courted danger in modelling his portrait of Napoleon's mother, Madame Mère, so closely on the life-size statue of 'Agrippina' now in the Capitoline Museums in Rome. Was it the 'good Agrippina' or the monster of the same name? And what, if anything, did that say about the sitter or her son? The irony is that modern art historians are certain that the figure in Rome could not possibly have been a portrait of either Agrippina; on grounds of style and technique alone, it must belong a couple of centuries later (below, p. 137). But partly thanks to Canova, the mistaken identity lingers.

the Bible and of the classical myths recounted in Ovid's *Metamorphoses* (a Roman poem, in several volumes, which for centuries held nearly biblical status in artists' studios).[40] That is almost as true for knowledge of the most prominent Roman emperors, their vices and virtues, their power politics and the once well-known anecdotes told about them that were part of the cultural hinterland of artists, patrons and viewers in the past.

Of course, we should not exaggerate. There have always been plenty of people who did not know or care anything about the ancient classical world, or did not have the time, inclination, resources or cultural capital to engage with these ancient rulers and their stories, any more than with curiosities of Ovid. Even if Classics was never *quite* so exclusively the privilege of rich white males as is often claimed (the British tradition, for example, of working-class Classics is a rich one[41]), the classical heritage never is, or was, the be-all and end-all. The fact remains, though, that much of European art speaks to us in more interesting, complicated and surprising ways if we *do* engage with that heritage, emperors included.

Some of this comes down, as with the sarcophagus of Alexander Severus, to the nuts and bolts of identification and interpretation. As we shall discover, there are some very odd cases of mistaken identity to be uncovered, and (like the gaudy ceramics I touched on) once proud *sets* of imperial figures, now dispersed across the world and unrecognised, to be tracked down and reassembled. There is Latin, on tapestries and prints, that has been garbled, misunderstood or simply unread for an embarrassingly long time. But we shall also find more unexpected ways in which the story of Roman emperors adds meaning to works of art—even to some which, like the portrait of Madame Mère, appear at first sight to have little or nothing directly to do with Roman imperial history at all.

Another striking case of that is Paolo Veronese's controversial *Last Supper*, painted for a religious order in Venice in 1573 and tactically renamed *The Feast in the House of Levi*, after the Inquisition objected to the inclusion of some elements—such as jesters, drunkards and Germans—that were, at the very least, highly unorthodox for a Catholic *Last Supper* (Fig. 1.23). On the front plane of the canvas, Veronese gave considerable prominence to a portly steward or, as the painter himself called him, *un scalco* (a carver). Dressed in a bright striped tunic, the man stands apparently transfixed, as he gazes intently across at Jesus.[42] It can hardly be a coincidence that this carver's facial features are modelled on an ancient Roman portrait then on display in Venice, universally believed at the time to depict the emperor Vitellius, whose assassination was two and a half centuries later to be the subject set for the young French artists competing for the Prix de Rome.

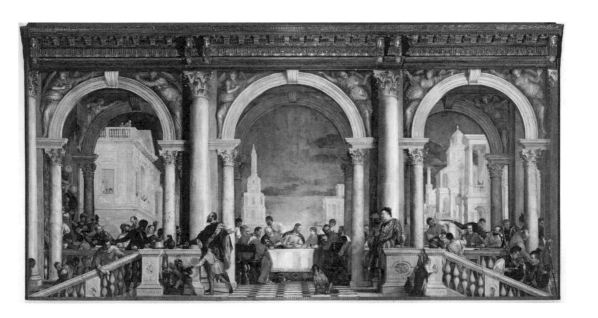

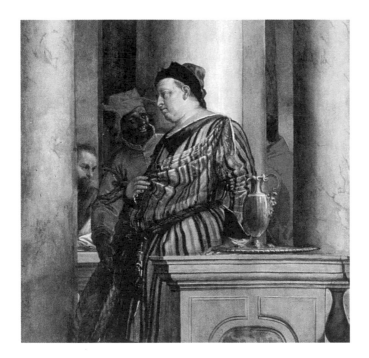

1.23 This vast painting, more than thirteen metres across, was made for the refectory of a Venetian friary. Though Jesus takes the centre place at table, the figure that catches the eye in the foreground is Veronese's 'carver', a look-alike Emperor Vitellius. The same Vitellius also lies behind the features of the man in green, sitting near the column at the top of the stairs on the left.

Known as the 'Grimani *Vitellius*' (after Cardinal Domenico Grimani, who bequeathed it to the city on his death in 1523), it was very popular with artists and draughtsmen, replicated hundreds of times over (Fig. 1.24). It is a plaster cast of this very sculpture that the boy in Fig. 1.10 is carefully drawing, and it also appears to be the basis for one of the smaller figures in the background of Veronese's *Last Supper*.[43] But those who knew something of the reputation of this walk-on part in imperial history could not have failed to spot some meaningful irony here, in addition to a convenient artistic model. For in this painting, a look-alike Vitellius, reputedly one of the most cruelly immoral of all Roman rulers, albeit on the throne for only a few months, has been shown enthralled by the sight of Jesus. But more than that, an emperor whose gluttony was said to have been a match for any of the notorious over-eaters of Roman history (the word 'Vitellian' until recently being a synonym for 'gastronomically lavish'), has been converted into a carver, or steward. The tables, in other words, have been turned from consumer to server.

Those who were better informed about Vitellius's family might even have spotted a further resonance with the Christian story. For it was none other than the father of this Vitellius—one Lucius Vitellius—who as Roman governor of Syria became the nemesis of Pontius Pilate, dismissing him from his post in Judaea in 36 CE, a few years after the events depicted in the painting.[44] It is as if this anachronistic imperial likeness (the emperor was actually still in his teens at the time of the Last Supper) was incorporated into the biblical scene to act as a wry internal commentary on Veronese's own work and pointing to further depths in its characters and narrative. It is a pity to miss them.

## Suetonius and His Twelve Caesars

Veronese and his contemporaries mostly knew their Vitellius, directly or indirectly, through the ancient *Life* of him that was written in the second century CE by Gaius Suetonius Tranquillus. It was here they would have found many of the lurid tales of his gluttony and immorality (a partiality to flamingo tongues and pheasant brains, for example, as well as to watching executions). Suetonius had experienced the imperial court from the inside, serving as librarian and general secretary to the emperor Hadrian, before falling from favour in a scandal that was said to have involved Hadrian's wife, Sabina. The *Life* of Vitellius was just one of a series of biographies of the first Twelve Caesars, in which the biographer charted the story of the first century and a half of one-man rule at Rome: starting with the

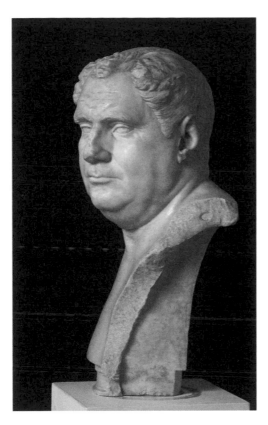

1.24 Although it has recently had relatively little celebrity, this strikingly jowly face, half a metre tall—assumed, on its rediscovery, to be an authentic portrait of the emperor Vitellius—was one of the most replicated ancient images in art between the sixteenth and nineteenth centuries. He has now been demoted to (another) 'unknown Roman', but there is hardly a major gallery in the West where he can't be found, lurking in disguise, in paintings, drawings and sculpture (below, pp. 218–26).

'dictatorship' and then assassination of Julius Caesar in 44 BCE, then the *Lives* of the five emperors of the first imperial dynasty (Augustus, Tiberius, Caligula, Claudius and Nero), followed by those of the three short-lived contenders for power in a year of civil war in 69 CE (Galba and Otho, as well as Vitellius), and ending with the three emperors of the second imperial dynasty of Vespasian and his sons, Titus and Domitian.[45]

These *Lives* of emperors were among the most popular history books of the European Renaissance. Early humanists owned them in multiple manuscript copies (Petrarch possessed at least three). A printed edition in Latin first appeared in 1470, another thirteen by 1500, and translations into the vernacular came thick and fast. According to one rough reckoning, some 150,000 printed copies, in Latin or translation, were produced across the continent between 1470 and 1700.[46] They were hugely influential on art and culture. It was, in fact, the popularity of this series of imperial biographies that gave the Twelve Caesars their canonical place in later history and launched the fashion for their re-creation in those canonical line-ups of modern busts and paintings. Ancient Roman sculptors had

often produced *groups* of portraits (rulers displayed alongside their intended successors or their legitimating ancestors, for example, or sets of famous philosophers), but so far as we know they never produced chronological 'runs' of their emperors, from one to twelve.[47] That was the Renaissance's tribute to Suetonius. And it was in his *Lives* that detailed physical descriptions of the individual rulers were found, and many of the anecdotes about them that provided inspiration for artists over the centuries: Claudius discovered cowering behind a curtain after the murder of Caligula; Nero 'fiddling while Rome burned'; the heroic suicide of Otho; and many more. Sceptical modern historians may judge such stories as the gossip of the palace corridors, or even outright fantasy, but—thanks to Suetonius and his readers—they have become inextricably part of our view of Roman emperors.

Some later emperors and their families have also captured the popular and artistic imagination. There have been many re-creations of the philosopher emperor Marcus Aurelius (whose often clichéd *Thoughts*, probably written in the 170s CE, are an improbable twenty-first-century self-help bestseller[48]), his wife Faustina[49] and his son Commodus, the amateur gladiator, as well as of Elagabalus whose grotesque dining habits were almost a match for those of Vitellius; even Alexander Severus and Julia Mamaea still, once in a while, have a small share of the limelight.[50] There is also plenty of material elsewhere in the literary tradition of pagan and Christian Rome, besides Suetonius's *Lives*, that has occasionally provided a stimulus for modern artists. This includes a set of highly inventive, whimsical biographies of later emperors, now going under the title of the *Augustan History*, which have given us a variety of extravagant anecdotes. The stories of Elagabalus's deadly rose petals are only the start. If we believe the *Augustan History*, the same emperor enjoyed pretentiously colour-coded meals (all blue, all black or whatever, depending on his mood) and invented the whoopee cushion (to be surreptitiously and embarrassingly deflated at dinner under his posh, pompous and, no doubt, anxious guests).[51]

We shall be taking a look, from time to time, at one or two of these characters. But there is, happily, no need for readers to hold in their heads all the twenty-six or so emperors (not twenty-four) who ruled between Julius Caesar and Alexander Severus, still less the next forty or so emperors who ruled Rome in the less than seventy years until the end of the third century CE; about many of these we know little, and even their exact number depends on how many usurpers and co-rulers you choose to count. It is Suetonius and his Twelve that lie at the heart of this book and at the heart of the modern visual and cultural template for Roman emperors.

# Imperial Perspectives

A classical eye on modern art opens up many different perspectives. Like any focus, it may sometimes obscure as well as illuminate. There will almost inevitably be some losses in gathering together, as I do, images of Roman emperors and thinking about them across the work of different artists, different media, different times and places. Particular chronological developments, various aspects of painterly or sculptural technique, important local and topical references or the role of imperial images within an artist's whole output may in this way be relegated to the background, their importance glossed over. Titian's *Caesars*, after all, have links with his biblical scenes and *Bacchanals*, as well as with images of emperors by other artists, ancient and modern. But there are definite gains too in daring to take this specifically classical view, and in focussing on emperors in particular.

For a start, it corrects a misleading imbalance in how we look at the story of ancient art in the European Renaissance and later. Of course, there has been much excellent specialist work on many of the ancient imperial images that I shall be exploring; but pride of place has almost always gone to the modern reception of one-off celebrity statues, such as the *Laocoon* and the *Apollo Belvedere*, rather than to the reception of these multiple replications of the faces of imperial power. It is not only weary museum- or gallery-visitors that tend to pass by emperors' heads without much of a second glance. Some of the most influential recent studies of the modern rediscovery and reappropriation of classical art have given them almost as scant attention, even though they occupy such a large part of the visual landscape and have exercised the imagination of artists (and the brains of scholars) for centuries.[52] It has proved all too easy, for example, to forget that the foot and the hand which are the centre of the most famous visual reflection in the eighteenth century on the nature of the artist's relationship with the past are the foot and hand of a Roman emperor—remnants in the Capitoline Museums of a colossal statue of the fourth-century Constantine (Fig. 1.25).[53] My aim is to give these emperors, whether faces or fragments, their part in the story again.

It is an international—and a highly mobile—part, which is not best explored within geographical boundaries or according to narrow political lines. Politics can be important, as we have seen. But those who counted themselves Republicans did not all share Andrew Jackson's principled implacable hostility to the material souvenirs of imperial power; and even if modern European autocrats in particular may have exploited the face of Roman emperors, they were not the only ones to do so. Across regimes

1.25 Among the most powerful, and puzzling, images to evoke the relation-ship between the modern artist and the classical past is Johann Heinrich Fuseli's small chalk drawing (less than half a metre tall), *The Artist's Despair before the Grandeur of Ancient Ruins* (1778–80). Does the artist despair because he cannot live up to the example of antiquity? Or because the art of the ancient world is so *very* ruined? The hand and the foot by which the artist sits come from a colossal ancient statue of Constantine (emperor 306–37).

of all kinds, republics, monarchies and petty fiefdoms, through war zones, looting and diplomatic negotiations, imperial images, ancient and mod-ern, have always been on the move: bought and sold, stolen, bartered and given away, they have been transported across the continent of Europe and beyond. A block of marble from Greece might be fashioned as an imperial head in Rome, before ending up, 1500 years later as a diplomatic gift or bribe, elegantly *re*fashioned, in a princely palace in modern Spain. One

exquisite set of twelve sixteenth-century silver emperors (that we shall meet again in Chapter 4) was probably made in the Low Countries, sold on to the Aldobrandini family in Italy, then somehow made its way back north to England and France, before being dispersed in the nineteenth century and ending up across half the globe, from Lisbon to Los Angeles.

No doubt these works of art were viewed and valued differently as they moved around (and that will be one of my concerns), but they certainly did not *belong* to any one place. Nor did many of the sculptured images belong to any one time either. The restorations, the imitations, the hybridity and the uncertain boundaries between modern and ancient undermine any straightforwardly chronological treatment. Part of their pleasure is that, as 'works in progress', they refuse to be pinned down to a single date. They are, to adopt a favourite term of some modern historians of the Renaissance, *anachronic*: they resist and transcend linear chronology.[54]

There are also far too many of them for a single book, which spans over two thousand years, from the anonymous artists who produced the ancient marble portraits of Julius Caesar to Salvador Dalí, Anselm Kiefer and Alison Wilding in the last half-century. Inevitably even some of my own favourite art and artists find only a walk-on part: Rubens has tended to lose out to Titian, Josiah Wedgwood to the tapestry makers of Flanders. Images in opera, theatre, television and film too have had to remain in the background. Early film was in large part constructed out of the representation of scenes from the Roman world, including its characterful rulers; but that is another story.[55] This is a book largely about non-moving images, concentrating on a selection of the most revealing and surprising emperors (and 'emperors') produced, or reproduced, since the fifteenth century. Its aim is to show just how eye-opening it can be to rediscover the visual language of Roman rulers, just how much fun to follow their travels across nations and continents, sometimes through a fog of misunderstanding, misidentification and mistranslation, and just how intriguing to recreate from scattered traces some of the most influential modern images of Roman emperors that we have already lost. But even the most ordinary looking imperial bust, one of those forgotten wallflowers in the gallery, sometimes has an eventful and important life history.

In the back of my mind will be some of the big questions about the presentation of modern political power, dynasty and monarchy that are often shelved—and that a classical perspective can sharpen. There have been important and subtle studies over the last few decades of how the image of a king is constructed, of the 'self-fashioning' of the elite, or of the use of ritual—and the invention of tradition—in creating a monarch or

underpinning monarchy.[56] But the idea that modern power should be cast in the image of imperial Roman power, or that Roman emperors provided a fitting backdrop for the European aristocracy centuries later, has often seemed self-evident, almost too banal to be investigated or unpicked.

I shall be showing that it is not self-evident at all, and asking directly what these modern images of emperors were *for*. What did they mean to those who commissioned, bought or looked at them? Why did so many people in the West choose to recreate a series of emperors most of whom had such a strong reputation (even if an unreliable one) for immorality, cruelty, excess and misrule? Only in the case of one of Suetonius's Twelve (that is, Vespasian) were there no rumours at all of death by assassination. Why then were they celebrated on the palace walls of modern dynasts? And why did they occasionally decorate the council chambers of republics? To put it another way, leaving aside Andrew Jackson's own particular scruples about 'Caesarism', why would anyone *want* to be laid to rest in a hand-me-down coffin claimed once to have held the remains of an assassinated Roman emperor?

But first, let's go back two thousand years to the imperial images from the ancient world itself that underlie so many of the later copies, versions, imitations and transformations. We cannot properly understand those modern representations unless we reflect a little more on how the Roman emperors who inspired them were portrayed in the ancient world itself—with all the puzzles, debates and controversies that brings. Here too there are some basic questions that often get passed over, and taking a modern perspective may indeed throw light back onto the ancient images them-selves. How, out of the many thousands of Roman portraits that survive, can we spot—or name—an emperor? If a Renaissance artist wanted to find an ancient model for his re-creation of an ancient ruler, where did he go? Except for the tiny images in coins, there is hardly a single surviving ancient imperial portrait that comes with a reliable name attached, so how did later sculptors and painters know which was which?

No such images have been more controversial, or instructive, than those of Julius Caesar, and none have exposed so clearly the disconcerting gap between an imperial face and an imperial name. They stand at the very beginning of the tradition of Roman imperial portraiture and also at the very heart of the modern engagement with the Twelve Caesars. So, it is from these that we start.

# II

# WHO'S WHO
# IN THE TWELVE
# CAESARS

## 'It's Caesar!'

In October 2007, French archaeologists exploring the bed of the river Rhône at Arles dragged a marble head out of the water (Fig. 2.1). It was apparently still dripping when the director of the team shouted, 'Putain, mais c'est César' ('Fuck, it's Caesar' probably captures his surprise better than any other, more polite, translation). Since then, this head has been the subject of dozens of newspaper articles and at least two television documentaries, it has been the star of an exhibition shown in Arles and at the Louvre, and in 2014 it even appeared on French postage stamps.[1]

Part of this attention has been sparked by one very special claim, that the head is not simply a portrait of Julius Caesar, but is one of the holy grails in the study of Roman portraiture: an image of Caesar sculpted *in his lifetime* by an artist who had studied him face to face. If so, it would be the only certain example to survive (though other candidates have over the years been proposed). The assumption is that the bust was originally set up in some prominent place in the Roman city of Arles, redeveloped by Caesar in 46 BCE as a settlement for his veteran soldiers; and that, after Caesar's assassination in 44, fearing that their Caesarian connections might prove (to say the least) awkward, the locals decided to dispose of this potentially hot property in the river, where it lay for over two thousand years.

Modern archaeologists and art historians are still divided on the identity and significance of the find. Sceptics emphasise how different overall the head from the Rhône appears to be from Caesar's portrait on contemporary

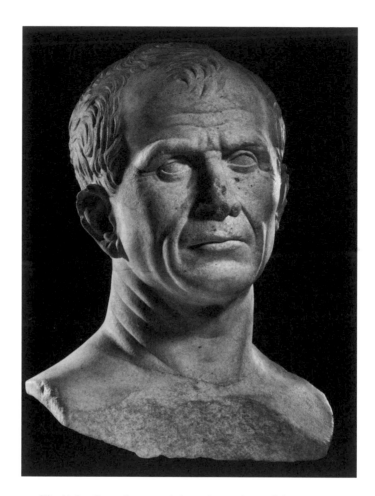

2.1 The 'Arles *Caesar*', a portrait bust dragged out of the river Rhône to a huge fanfare in 2007. Whether it is really an image of Julius Caesar himself is a matter of debate, but its supporters point to the prominent lines on the neck, one of Caesar's characteristic features.

coins—and different too from other, admittedly posthumous, portraits commonly identified as him. The supporters of the identification, by contrast, stress the specific points of similarity between this head and some individual features on the coin portraits, notably the lines in the neck and the prominent Adam's apple (Fig. 2.3). A few come close to claiming that the fact that it does *not* in general look much like the other Caesars could actually be confirmation that it is an authentic and unique image carved from life, and not a run-of-the-mill replica piece—an ingenious 'have it both ways' style of argument (it's Caesar whether it looks like him or not) that doesn't inspire confidence.[2]

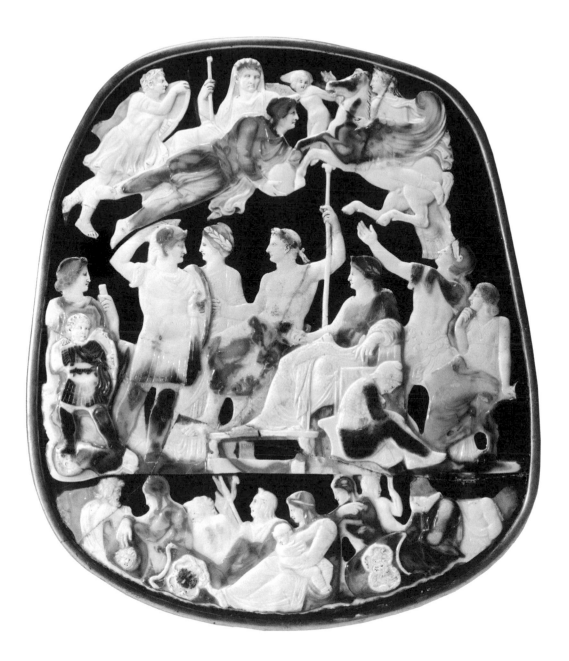

2.2 The *Great* [i.e., 'big'] *Cameo of France*, roughly thirty by twenty-five centimetres, captures one view of Roman hierarchy: the emperor Augustus, at the top, looks down from his afterlife in heaven; in the centre, the emperor Tiberius holds court, next to his mother Livia; at the bottom huddle the conquered barbarians. Made around 50 CE, and on display in France since the Middle Ages (hence its title), it is certainly not a biblical scene as once thought. But who exactly all the minor members of the imperial family are remains a puzzle.

2.3 This coin (a silver *denarius*) minted in 44 BCE shortly before Caesar's assassination has often been taken as the key to his appearance, with a prominent Adam's apple, wrinkly neck and a wreath possibly carefully placed to cover up a bald patch. Caesar's name and title run around the coin edge: 'Caesar Dict[ator] Quart[o]' (dictator for the fourth time). Behind his head is a symbol of one of his priesthoods.

Despite the scepticism (and I am one of the sceptics), it seems as if this is set to be the face of Julius Caesar for the twenty-first century—taking its place as the most recent in a series of favoured portraits of him that have held sway for a time in the popular and scholarly imagination, before being pushed aside by a rival contender. But, whatever the credentials of the piece, it opens up some big questions that will guide this chapter. What was the purpose, and the politics, of portraiture in the Roman world itself? How did its role change through the reign of Caesar and his successors? How (and how reliably) have ancient portraits of these rulers been identified, when almost none are named or carry any other identifying mark? Before we can start exploring modern re-creations of these imperial rulers, we need to consider how the original Roman versions of them have been pinned down, from the Caesar of the Rhône through the godlike serene images of the emperor Augustus to some strange outliers—such as the famous Grimani head of 'Vitellius' (Fig. 1.24) which, as we shall discover at the end of this chapter, was not only a favourite model for modern artists but has had a starring role in scientific debates, from the sixteenth century on, about the relationship of the shape of the skull to human character.

It turns out that we are not necessarily any better now at identifying emperors in ancient portraits than our predecessors were hundreds of years ago. True, a few very old errors, often going back to the Middle Ages, have

been overturned, some spurious emperors have been dethroned, and those masquerading under entirely different identities have been conclusively revealed as rulers of the Roman world. The idea that the famous bronze statue of the emperor Marcus Aurelius on horseback on the Capitoline hill in Rome actually represented a humble local strongman who had saved the city from an invading king has long been written off as a piece of garbled medieval folklore, or more generously as an ingenious reappropriation of the ancient past (Fig. 1.11).[3] And the traditional notion that one particularly splendid ancient Roman cameo depicted the biblical scene of the triumph of Joseph at the court of the pharaoh was demolished by a learned friend of Peter Paul Rubens, who around 1620 correctly pointed out that it was instead a family group of the emperor Tiberius, complete with Augustus looking down from heaven and some benighted barbarians underneath (Fig. 2.2). The old reading was a tremendous tribute to the Christian talent for finding a religious message in the most unlikely places, and it may well help to explain why the cameo was preserved. It was also flagrantly wrong.[4]

But such cases are rare. Historians in the twenty-first century are still spotting emperors by much the same methods as those in the fifteenth or sixteenth, we are still debating the pros and cons of many of the same objects and we can on occasion be more gullible than the shrewd scholars of the past. In the eighteenth century, J. J. Winckelmann reported that Cardinal Albani, famous collector and connoisseur, was doubtful that any genuine heads of Julius Caesar had survived. Whatever exactly he meant by 'genuine', I suspect that Albani would have had his doubts about the specimen from the Rhône.[5]

## Julius Caesar and His Statues

In Roman history, Julius Caesar stood on the boundary between the free Republic (that power-sharing regime so beloved of anti-monarchists from the Founding Fathers to the French revolutionaries) and the autocratic rule of the emperors. He marked the end of one political system and the beginning of another. Although its rights and wrongs have been debated ever since, his story in outline was simple. After a fairly conventional early career, winning election to a regular series of political, military and priestly offices, by the middle of the first century BCE, Caesar stood out above most of his political peers. He had been a massively successful conqueror even by Roman standards (so brutal that some of his own countrymen occasionally muttered about war crimes). And he had won enormous support from the ordinary people of Rome, thanks largely to a number of high-profile

popular measures, such as land distribution and free grain rations, which he had either initiated or supported. By 49 BCE, he was unwilling any longer to toe the line within conventional politics, and in a civil war against the traditionalists (or 'the uncompromising reactionaries', depending on your point of view), he fought his way to what was in effect one-man rule. Within a few years he was made 'dictator for life', turning an old Roman emergency-powers office of *dictator* into dictatorship in the modern sense. His assassination was carried out under the slogan of 'Liberty', the watchword of the old republican regime. But if his assassins really wanted to undo the autocratic turn at Rome, they failed. Within less than fifteen years, after another civil war, Caesar's great nephew Octavian (later to take the name 'Augustus') had established himself on the throne, and devised a form of autocracy that would last for the rest of Roman time.[6]

By starting his series of imperial biographies with Julius Caesar, Suetonius turned him into the first emperor of Rome. Few historians in recent years have followed this line. Although Caesar inevitably faces two ways, we now tend to see him more as the last chapter of the Republic, as the death blow to a political system that had been tottering for decades, unable to accommodate the ambition, wealth and power of a new generation of leaders (Caesar was not the only one moving in this direction). Being *dictator* was a long way from being emperor (or from being *princeps*, which is the closest Latin equivalent of that term). But Suetonius's alternative view does alert us to the ways in which Caesar left his stamp on the system of one-man rule that was to follow him.[7] Most obviously, he gave his personal name to all his successors. Every Roman emperor ever after took 'Caesar'— which up to then had been no more than what we would call an ordinary surname—as part of his official title. And that remained the case right down to the rulers of the Holy Roman Empire into the nineteenth century (whether as 'Caesar' or 'Kaiser') or to other look-alikes, such as the 'Czars'. When we talk about the Twelve *Caesars*, that is exactly what they were.

Julius Caesar also established a template for the future with an entirely new use of images. He was the first Roman to have his portrait systematically displayed on coinage. A few precedents for this had been set by the kings and queens who came after Alexander the Great in the Greek world, but in Rome itself only the imaginary portraits of long-dead heroes had ever featured on coin designs. It was Caesar who firmly set the tradition, lasting in many places until the present day, that the head of the living ruler belonged in the purses of his subjects.[8] He was also the first to use multiple statues of himself to parade his image to the public in Rome and much further afield.

A tradition of portraiture at Rome went back long before Caesar, of course. It is now often seen as a distinctively Roman genre of art, embedded in the rituals and practices of Rome's aristocracy and of Roman public life: images of ancestors were displayed at the funerals of the elite and were part of the furniture of their houses; statues of prominent individuals, bigwigs and benefactors, had for centuries stood in the public squares, temples and market places of the Roman world.[9] In fact, in the Western tradition at least, the now common convention of allowing a marble head to stand for the whole body—'a head the sculptor severs in one's lifetime' as Joseph Brodsky put it in his eerie poem on a bust of the emperor Tiberius—appears to have been a Roman innovation. In classical Greece, portraits had usually been full-length figures, and there were plenty of those in Rome too. But it was the Romans who made it seem (almost) natural that an image truncated at the neck or shoulders could stand for a *person* rather than a murder victim. In that sense, and others, our idea of the 'portrait head' goes back to Rome.[10]

Caesar was the first to go beyond this and to engineer the widespread replication of his image, hundreds of times over. Never before had portraits been used so concertedly to promote the visibility, omnipresence and power of a single person—in quantity and in strategic placing. One Roman historian, admittedly writing two hundred years later, reports a decree issued during his lifetime that there should be a statue of Caesar erected in every temple at Rome, and in every city of the Roman world; and Suetonius mentions that on particular occasions his image was carried in procession alongside those of the gods. Caesar's head being placed on the shoulders of the statue of Alexander was only one loaded use of portraits among many.[11]

How, or by whom, all these images were produced is a mystery. I very much doubt that Caesar patiently posed for battalions of sculptors; maybe none of the portraits were done from life in the strictest sense of the term. And some of the claims about their vast numbers may well have been wishful thinking or scaremongering, or else reflected plans never carried out in the short time that he held power. Nonetheless it seems certain that portraits that were intended to be, and were generally taken as, 'Julius Caesar' spread across the Roman landscape as those of no single individual had ever done before. At least eighteen pedestals have been discovered in what is now Greece and Turkey, with inscriptions to show that they originally held a statue of Caesar put up while he was still alive; three more are known in the towns of Italy, and Arles and the other towns of Gaul may well have had their fair share too.[12] And that tradition continued for centuries after his death. Across the Roman Empire, there were any number of attempts

(sometimes much later) to commemorate in 'portraits' the man who gave his name to the long succession of Roman rulers. Perhaps those images of Caesar as conquering hero and proud ancestor of the imperial regime did something to assuage the grim precedent of his assassination that must have haunted many of the rulers who came after him.

There is no reason at all why some of these statues should not have survived to the present day—whether those sculpted during his lifetime (the 'holy grails'), or the even more numerous later copies of them, or variations on the theme, that were created after his death. The tricky question is how we can recognise any such survival when we find it, and what would convince us that it was intended as a portrait of Caesar rather than of anyone else. Everything hangs on that.

Many of the obvious diagnostic clues that we might expect are now missing, or never existed. There are, to start with, no helpful labels. Not a single statue has ever been discovered still attached, or even adjacent, to a pedestal carrying his name (and if a bust has 'Julius Caesar' inscribed on its base, that is a strong indication that the bust—or the inscription—is modern). Nor do images of Roman rulers, unlike those of Christian saints, ever become associated with symbols that point to their identity. There was nothing like the keys of Saint Peter or the wheel of Saint Catherine for the Caesars. And their bodies never gave any hint of who they were. Whether the emperor concerned was thin or fat, tall or short, there was no reference to that in their full-length statues, which are more or less identical figures, clad in a toga, armour or heroic nudity. There are no portly Henry VIIIs, or hunched Richard IIIs. With Roman rulers everything comes down to the face.

From the moment antiquarians and artists half a millennium ago first started systematically to identify Roman portraits, to the moment the marble head was dragged out of the Rhône, all attempts in the modern world to pin down the face of Caesar have overwhelmingly relied on two key pieces of evidence. The first is Suetonius's colourful and intimate description of the dictator's appearance, complete with his ruses for disguising his baldness and his enthusiasm for depilation:

> He is said to have been tall in stature, fair-skinned, with slender limbs, a rather full face, and sharp dark eyes . . . . He was particularly fastidious over his body image, so that not only was he carefully trimmed and shaved, but also, according to some critics, he used to pluck his body hair, while seeing his baldness as a terrible disfigurement, since he found it exposed him to the jibes of abusers. So, he used to comb forward his thinning hair from the crown of his head, and out of all the honours decreed to him by the senate

and people, there was no other that he received and made use of more gladly than the right to wear a laurel wreath at all times.[13]

The second is the series of silver coins issued in early 44 BCE, showing him with that lined neck, Adam's apple, a strategically placed wreath and his name spelled out around the edge (Fig. 2.3). The truth is that there are other coins with heads—not of Caesar at all, but of characters from Roman myth and history—that show similar distinguishing marks on neck and throat, not to mention coins depicting Caesar on which he looks decidedly different.[14] But leaving such variants aside (as they are usually left, without an inconvenient second look), this memorable image has always claimed more authority than any other evidence as the baseline for identifying the bona fide face of Caesar.

To be fair, material of this kind puts us in a better position to identify Caesar and his successors than any other Roman characters ever; the faces of Cicero or the Scipios, or Virgil or Horace, are irretrievably lost to us in a way that the faces of the emperors are not entirely so; no Roman poets ended up on the coinage as British authors may, occasionally and controversially, end up on banknotes.[15] Even so, there is no sophisticated modern technique that can precisely pinpoint an image of Caesar. If you want to claim a particular sculpted head as his portrait, all you can do is what has always been done: that is, try to match the candidate up to the canonical coin portraits and to the physical details highlighted by Suetonius. It is a subjective process of 'compare and contrast', relying as much on the rhetoric of persuasion (can you convince yourself, as much as anyone else, that you are right?) as on objective criteria. And it is much more difficult than any quick summary makes it seem.

Even supposing that Suetonius, who was writing a century and a half after Caesar's death, actually knew what his subject had looked like, it is next to impossible to align any surviving image with Suetonius's description. That is partly because the details he highlights—the colour, the texture, even the thinning hair—do not convert easily into marble. (It may be reassuring to know that men have been 'combing over' to conceal their baldness for two thousand years, but how exactly would you expect a sculptor to represent the trick?) But it is also because Suetonius's Latin is in places ambiguous. The phrase that I have translated as 'a rather full face' (*ore paulo pleniore*) could equally well mean 'a disproportionately large mouth', which would send us on the hunt for a very different set of features.[16] In any case, neither translation comfortably fits the portraits on the coins, where Caesar seems if anything rather gaunt, and has a perfectly ordinary

sized mouth. And those coins present their own problems. As antiquarians already saw more than two hundred years ago, the process of comparison between a tiny two-dimensional head, not much more than a centimetre tall, and a life-size portrait in the round, is extremely tricky. Winckelmann (just before reporting Cardinal Albani's general scepticism on portraits of Caesar) admitted that he could not find any sculptures that he thought were a close enough match for the coins. But at least one fellow connoisseur at the time went further: he more or less implied that it was not simply a question of finding a satisfying resemblance, but more fundamentally of deciding what exactly would *count* as a resemblance between these two very different media.[17]

So how does this work out in practice? Intriguing as these dilemmas about method are, they hardly prepare us for the ferocity of the debates over rival sculptures of 'Caesar', for the hyperbole of the claims made in their favour or for the impact of the discussion far beyond the world of professional archaeologists, artists and collectors. (Benito Mussolini is only one infamous 'celebrity' with a stake in these controversies, and there are unexpected Bonapartist connections too.) The story of two pieces, in particular, that were in turn the favourite candidates for the authentic face of Caesar from the mid-nineteenth to the mid-twentieth century, illustrate the surprising twists and turns of scholarly fashion and the sometimes learned, sometimes implausible arguments mounted on different sides. They help us to think harder about how modern viewers over the centuries have learned to *see* Caesar.

## Pros and Cons

Apart from the coins, more than a hundred and fifty portraits have at one time or other been seriously claimed to be ancient Roman images of Julius Caesar (the number varying according to how stringently you take the word 'seriously'). They are mostly in marble, but there are some candidates on gems too, and in ceramic.[18] They are now found in collections across the Western world, from Sparta, Greece to Berkeley, California, and a few have emerged from improbable places. The head from the Rhône is not the only one to have been discovered in a river. Another specimen, whose current home is a museum outside Stockholm, was mysteriously dredged up in 1925 from three metres of mud in the bed of the Hudson, by 23rd Street in New York: it must somehow have been 'lost' overboard from a boat carrying a cargo from Europe (my inverted commas convey my puzzlement about the circumstances), rather than be stunning proof of all

those claims that the Romans really had reached America (Fig. 2.4a).[19] Out of this number, there are hardly any whose identification or authenticity has never been questioned. One such is a marble head found along with other recognisably imperial portraits in 2003 in excavations on the island of Pantelleria, between Sicily and North Africa, in what seems to have been a later dynastic group, including a retrospective 'portrait' of Caesar as its founding father (hence the greater than usual certainty about who it is); but in time this too may well find its challengers (Fig. 2.4b).[20] Almost every single other piece has been periodically under fire: either on the grounds that, while it may be ancient, it is certainly not Caesar, or because, while there is little doubt that it is intended to be Caesar, it is certainly not ancient, but a modern replica, version or fake.[21]

The conflicting claims can be baffling in their variety. The head from the Hudson, for example, has also been thought to be Augustus or his right-hand man Agrippa, alternatively Sulla (the notoriously murderous despot of the early first century BCE) or now more often just another 'unknown Roman'. Particularly hard to pin down has been the 'Green Caesar', once a prized possession of Frederick II of Prussia, now in Berlin, and named for the distinctive Egyptian green stone from which it is made. Where it was found is entirely unknown, but its Egyptian connections have proved hard to resist. Is it, as one writer has recently hoped on almost no evidence at all, the very statue that Cleopatra put up in honour of Caesar in Alexandria after his death? Is it perhaps no more than a portrait of 'one of Caesar's admirers from the Nile', aping the style of his hero? Or is it actually an eighteenth-century fake, but intended to pass for Caesar all along? Who knows?[22] (Fig. 2.4c)

Among all these Caesars, some have earned more fame than others, and at different periods. One early favourite was the 'true portrait' housed in the sixteenth century in the *palazzo* of the Casale family in Rome. According to a remarkable contemporary guidebook, written when its author, Ulisse Aldrovandi from Bologna, was detained in Rome under the Inquisition, this bust's owner kept it under lock and key, but would show it to visitors 'lovingly'. (*If* it is the same bust of Caesar still in the collection of the Casale descendants, it is now often reckoned that this prized possession was no antique at all, but only a century or so old at the time.)[23] (Fig. 2.4d)

In the 1930s, Mussolini brought to prominence a full-length Caesar that used to stand in the courtyard of the Palazzo dei Conservatori on the Capitoline hill in Rome. This had once been much admired by travellers to the city and was one of only two Caesars accepted as incontrovertibly 'Caesarian' by another of those hard-headed critics in the late eighteenth

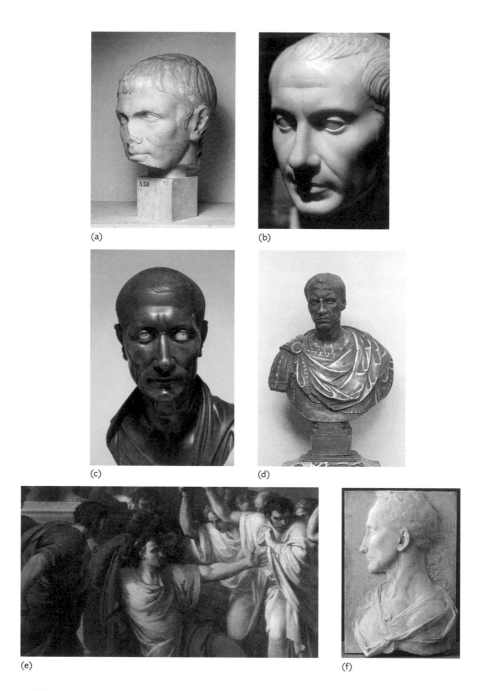

2.4

(a) The 'Caesar' from the Hudson River

(b) *Julius Caesar* (mid-first century CE) from Pantelleria

(c) The *Green Caesar*, assumed to originate in Egypt

(d) The *Julius Caesar* now in the Casali Collection in Rome

(e) Head of Caesar from Vicenzo Camuccini, *Death of Caesar* (1806)

(f) Head often identified as Caesar, by Desiderio da Settignano (c. 1460)

century. It later fell from favour under the usual whiff of suspicion that it might be a modern, seventeenth-century pastiche: in this case, needlessly (true, there has been a lot of 'work' done to the arms and legs, but a sketch of it dated to 1550 knocks on the head the idea that it was a seventeenth-century creation). In any case, no such doubts prevented Mussolini from making it his own trademark image of Caesar, and the symbol of his ambitions to follow in the footsteps of the Roman dictator.[24] 'Il Duce', as Mussolini was known, had the sculpture moved from its home in the Conservatori courtyard to give it pride of place in the Roman city council chamber in the next-door Palazzo Senatorio, where it still presides over discussions of planning regulations and parking fines. In a programme uncannily reminiscent of the replication of Caesar's statues two thousand years earlier, he also had copies of it made to stand both in Rimini in northern Italy, from where Caesar had launched his final bid for power in Rome, and next to his brand new highway in the centre of Rome (via dell'Impero, or 'Empire Street', as it was then known; later renamed, after the adjacent archaeological remains, via dei Fori Imperiali, or 'Street of the Imperial Fora') (Fig. 2.5).[25]

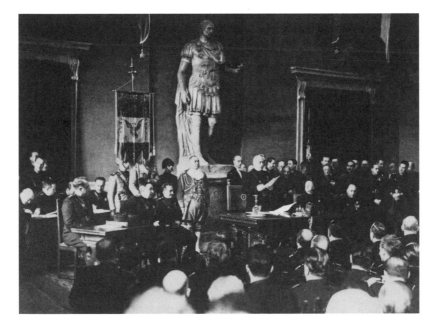

2.5 Benito Mussolini announces the abolition of the Italian Chamber of Deputies, in March 1936. Appropriately enough he spoke directly in front of the statue of Julius Caesar, which he had ordered to be moved to this council chamber: one dictator in front of another.

But the clearest insight into what the modern world has been searching for (and sometimes inventing) in images of Caesar, and into the strange narratives that can lie behind mute sculptures on museum shelves, comes in two marble heads that one after the other became the defining images of Caesar: one in the British Museum in London, the other in the Archaeological Museum in Turin. Almost any surviving sculpture of 'Caesar' has some similar, if lower-key, story attached (a succession of authentication, de-authentication, admiration and disdain); but this pair illustrate better than any others some of the most vivid disputes that 'Caesars' can provoke.

The first was bought by the British Museum in 1818, among a group of objects acquired from James Millingen, a British collector and dealer in Italian antiquities (Fig. 2.6).[26] Where, or how, it was discovered is not recorded, and it was not at first treated as anything special, being assumed cautiously to be an 'unknown head'. But about 1846, according to the Museum's handwritten catalogue, it was re-identified as a portrait of Julius Caesar.[27] Who did this, and on what grounds, is a mystery (presumably the similarity to coin portraits came into the argument somewhere). But for decades this image held sway as the Caesar of modernity's dreams. It illustrated biographies of the dictator, it appeared on any number of book jackets and it prompted what in hindsight seems embarrassingly extravagant prose.

In 1892, a particularly gushing encomium came from Sabine Baring-Gould, best-selling British author, Anglican clergyman and a man remembered more now as a hymn writer ('Onward Christian Soldiers' was his most famous anthem) than as a Roman historian. He conceded that the artist might have overlooked Caesar's baldness, and that he probably did not sculpt the portrait from life (a disappointment that lurks in the background of many of these discussions). But it was certainly 'done by a man who knew Julius Caesar well, who had seen him over and over again, and had been so deeply impressed by his personality that he has given us a better portrait of the man than if he had done it from life. . . . he caught and reproduced those peculiarities of his expression which Caesar's face had when in repose, the sweet, sad, patient smile, the reserve of power in the lips, and that far-off look into the heavens, as of one searching the unseen, and trusting in the Providence that reigned there.'[28] Soon after, Thomas Rice Holmes, another passionate Caesarian, followed a similar line at the start of his history of Caesar's conquest of Gaul: 'The bust represents, I venture to say, the strongest personality that has ever lived . . . . In the profile it is impossible to detect a flaw . . . . He has lived every day of his life, and he is beginning to weary of the strain, but every faculty retains its fullest vigour . . . . The man looks perfectly unscrupulous; or . . . he looks

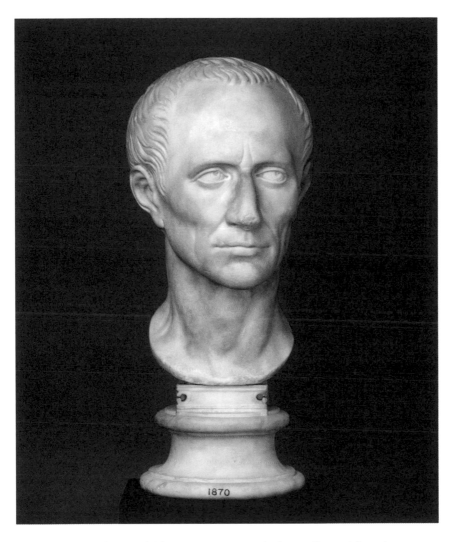

1870

2.6 Acquired by the British Museum in 1818 as an 'unknown Roman', from the mid-nineteenth to the early twentieth century, this life-size bust was the most famous, and most reproduced image of Caesar. It is now generally thought to be an eighteenth-century fake or pastiche.

as if no scruple could make him falter in pursuit of his aim.'[29] John Buchan too, classicist, diplomat and author of *The Thirty-Nine Steps*, writing in the 1930s called it 'the noblest presentment of the human countenance known to me' even if he struck a different chord from the others in admiring 'the fine, almost feminine, moulding of the lips and chin'. 'Caesar', he insisted, 'is the only great man of action, save Nelson, who has in his face something of a woman's delicacy.'[30]

It is now hard to take this kind of prose seriously. The special pleading ('it wasn't done from life, but it is even better than if it were') grates, and the hyperbole seems out of all proportion to the portrait itself, especially for those of us who are not so convinced of Caesar's unmitigated 'great-ness'. But it is, nevertheless, clear what lies behind it. The priority of these writers was to claim a face-to-face encounter with the human being cap-tured in the marble—even if, in practice, they were doing little more than finding an appropriate image onto which they could project their various assumptions about 'Caesar the man', from visionary power through a hint of unscrupulousness to an uncannily female side. There is also a hint, as Rice Holmes almost admits, that the passion is partly compensating for the lack of a really hard argument behind the identification of this head with Caesar. And that indeed was to become the problem. For what if the British Museum's bust was not really Caesar? Or was not even ancient Roman?

Doubts began to show very soon after 1846, when the statue was given the name of Caesar. A museum handbook published in 1861 took care to rebut a claim that this was not Caesar at all, but one of his contemporaries: 'There have not been wanting critics who have strenuously maintained that it is really a pourtrait <sic> of Cicero. We cannot, however, acquiesce in this view'.[31] But worse was to come. In 1899, the German art historian Adolf Furtwängler pronounced the head not ancient at all ('a modern work with fabricated corrosion') and, even though this had hardly been more than a passing swipe, the doubts had forever after to be acknowledged even by those who were keenest to dismiss them (along the lines of 'The antiq-uity of the British Museum head has been called into question, *but* . . .').[32] By the mid 1930s, at roughly the same time as Buchan was penning his encomium, this 'noblest presentment of the human countenance' was being moved from pride of place in the Roman galleries to a still prominent, but less chronologically specific location, at the entrance to the Museum's library. Its label left no room for doubt: 'Julius Caesar. Ideal portrait of the eighteenth century. Rome, bought 1818.' One regular visitor regretted this demotion, ruefully calling to mind Caesar's famous quip on divorcing his second wife in 62 BCE, while pointing also to the gullibility of those who bought fakes in Italy. There was a terrible warning in this famous head: 'he, who insisted that his wife must be above suspicion, now only serves to warn the unsuspicious Englishman against buying sham antiques abroad'.[33]

This Caesar has never been reinstated as a genuine ancient piece, and it has since passed from the care and control of the Museum's Greek and Roman Department to the British and Medieval Department and back again, as if no one could quite decide where the awkwardly illegitimate

specimen belonged (one thing is for certain: it is neither British nor medieval). It was only in 1961, however, that a detailed technical case was made against it: by Bernard Ashmole, who had been the Keeper of Greek and Roman Antiquities at the British Museum between 1939 and 1956. Ashmole emphasised the suspiciously brown colour of the whole piece. Had tobacco juice been applied to it, he wondered, as part of the forger's armoury for producing an 'antique' patina? But the real give-away was the pitted texture of the skin. Its supporters had put this down to the (ancient) head having been cleaned with acid (which was certainly part of the eighteenth-century repertoire of 'treatments'), though Furtwängler had already suggested it was 'fabricated corrosion'. Ashmole argued more precisely that the cause was physical battering—'distressing' is the technical term—carried out with the fraudulent intention to make it appear old. Indeed, he pointed out, you could see patches of smooth marble remaining, where the distressing had stopped a little short of the hairline. This appeared to be the conclusive proof. The sculpture is no longer on show at all, though it does occasionally emerge from its basement exile to star in exhibitions of notorious fakes.[34]

At almost exactly the same moment, however, there was another portrait waiting in the wings to take this Caesar's place. In the early years of the nineteenth century, Lucien Bonaparte—archaeologist, collector, sometime revolutionary and younger (partly estranged) brother of Napoleon—discovered a marble head in excavations near his house just south of Rome, on the site of the ancient town of Tusculum. It did not particularly stand out among the finds and, like the British Museum head, it was identified at first not as a Caesar but as a generic 'old man' or 'old philosopher'. After Bonaparte hit hard times both politically and economically, it ended up in the hands of new owners in a castle at Aglié outside Turin, where it remained anonymously for a hundred years or so.[35] It was only in 1940 (an auspicious moment for discovering Caesars in Italy, given Mussolini's enthusiasm) that an Italian archaeologist, Maurizio Borda, argued that it was in fact Julius Caesar (Fig. 2.7).

This was on the usual grounds of the similarities to the coin portraits of 44 BCE, but Borda went further. Not only did he conclude that the similarities were so close that the portrait must have been made during Caesar's lifetime, but he also felt able to use the sculpture to diagnose two deformations of the skull from which Caesar had obviously suffered. The slightly odd shape of the head was not caused by incompetence, or idiosyncrasy, on the part of the artist. It was an accurate reflection of two congenital cranial pathologies, *clinocefalia* (a slight depression at the top of the head) and *plagiocefalia* (a flattening on one side of the skull). This portrait has rivalled

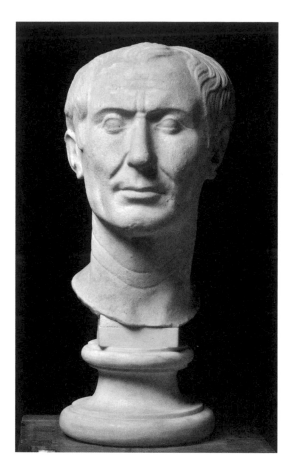

2.7 The favourite Julius Caesar of the mid-twentieth century. Excavated in the early nineteenth century at the site of Tusculum in Italy, it was at first identified as an anonymous 'old man', but re-identified in 1940 as the authentic, life-size, face of Caesar. Beyond the lines on the neck, here the shape of the skull has been taken to indicate a cranial deformity (from which Caesar may, or may not, have suffered).

the British Museum Caesar in the hyperbole it has prompted. 'The almost imperceptible movement of the slightly lifted head, and the momentary contraction of the forehead and the mouth, tell of a watchful and superior presence,' wrote one art historian only recently, praising its 'psychological realism'. 'In the look of the eyes, slightly converging, one has the impression of discerning a certain aristocratic reserve or irony.'[36] But, even more than its British Museum rival, the Tusculum head has been considered to be so close to life that it could support a clinical diagnosis: this is not just looking Caesar in the eye, it is taking his case notes.

Here too views have begun to change. The Caesar from Tusculum still has its enthusiasts, and in 2018 it was used—with much international media attention—to produce a full-scale, 'scientific' reconstruction of the authentic face of the dictator.[37] But even among its supporters, many no longer insist that it is a portrait taken from life (let alone the only such to have survived); still less that it is another of those holy grails of Roman portrait

2.8  Behind the ear of the British Museum *Caesar*, evidence of unfinished work—in a series of drill holes, made in the process of separating the ear from the head, but never intended to remain in the final, finished piece.

studies, an image made from the man's death mask.[38] They concede that it is much more likely a copy or version of an earlier sculpture in bronze that has been lost, and they group it together with four other ancient, though later, 'Caesars' (including the recent discovery at Pantelleria), in which there are arguably traces of similar oddities of the skull—as if they were all based on that same bronze original.[39] Far from the high-flown praise for its artistic quality with which Borda had greeted the head, there are also those who now rate it as a rather rough, or at least very badly corroded, piece of work ('a mediocre copy'). It may well be only a matter of time before it is relegated back to the status of 'unknown old man'. Its return to anonymity will certainly be eased, or hastened, by the fact that the Caesar from the Rhône is already there to take its place, and being greeted with all the same acclamations. Museum visitors confronting it for the first time (and using social media as eighteenth-century travellers used their journals) have reported themselves 'transfixed by the sheer presence emanating from it', unable to tear themselves away from the sight of the great man. This is not so very far from John Buchan and friends.[40]

But these certainties are always shifting and more surprises lie in store. There is even an outside chance that the British Museum Caesar may one day be rehabilitated as authentically ancient (even if not necessarily a Caesar, or not necessarily taken from life). For, almost unnoticed, behind both ears, on one side more clearly than the other, runs a line of drill holes (Fig. 2.8). These are signs of unfinished work. Following a pattern found

on genuinely ancient sculptures, the sculptor has started the delicate business of freeing the ear from the head (delicate, because it is very easy to break the ear off as you do it). He has speeded up the process by drilling these holes, but he has not done the final work with the chisel to make a clean gap. How is that to be explained? Possibly this is an unfinished fake (late eighteenth-century sculptors could well have been using the same techniques as their ancient forebears and it is not only genuine articles that might be left incomplete). Possibly it is a double bluff by some modern craftsman, hoping to add an aura of authenticity to the work, through that sense of a slight flaw. But those who sell fakes do not usually trade in imperfection. Whatever the other signs of modernity, those little holes may eventually re-open the question of exactly where on the spectrum between ancient and modern this sculpture lies. Whether it will ever re-emerge from its basement exile, who knows?[41]

## The 'Look' of Caesar

The story of the ancient face of Caesar can seem a frustrating series of about-turns, dead ends, identifications and re-identifications. For decades one particular portrait is treated as the most accurate and authentic image of the dictator; then, for reasons that are not obviously stronger than those that gave it the fame in the first place, it is sidelined as a fake, as not Caesar anyway or simply as a later second-rate hack copy of some original masterpiece, now lost to us entirely. It is as if, over the last couple of hundred years (and the pattern surely goes back earlier), every generation or so has homed in on its favourite Caesar, which holds sway for a while, offering the modern world that precious opportunity to look Caesar directly in the eye and to see through the marble image to the personality—even the clinical pathology—of the man behind it. In due course this is toppled by some new discovery, or rediscovery, and fades back into relative obscurity; while other members of the supporting cast, such as the 'Green Caesar' or Mussolini's version, slip in and out of the limelight. For those relegated, the distinction they retain (rather like Jesse Elliott's misidentified sarcophagi) is that they were *once thought to be* Caesar.

Yet despite these seemingly endless debates and disagreements, Julius Caesar is one of the most easily recognisable of all Roman rulers in the art of the modern world, in painting, sculpture and ceramics, cartoons and films, as well as in fakes and forgeries. Among any collection of Renaissance busts of the Twelve Caesars, he usually stands out as the slightly gaunt one with the aquiline features, though not necessarily the scraggy neck and

Adam's apple. That is how he is depicted too in almost every painting or drawing, from Mantegna's slightly sinister figure in his triumphal chariot (Fig. 6.7), through Camuccini's dying dictator (Fig. 2.4e) to the cartoon version of *Astérix*, complete with wreath and disconcertingly staring eyes (Fig. 1.18i). And it is exactly those features that have always made it tempting to imagine that Desiderio's delicate marble sculpture, one of the high points of fifteenth-century craftsmanship, was intended as an image of Caesar, despite—as in all its ancient predecessors—the complete absence of a name (Fig. 2.4f).[42] The 'look' of Caesar (and I choose my words carefully) is easy to spot.

That 'look' is, of course, a complicated, multi-layered and self-reinforcing stereotype, and one of the best examples of those entanglements between ancient and modern that I discussed in Chapter 1. Part of it certainly derives from the memorable heads on the coins of 44 BCE, part from full-sized sculptures believed to be ancient representations of Caesar (some of which were almost certainly not) and part from the words of Suetonius. But artists have also responded to the work of their modern peers and predecessors, who in the process of re-creating the image of Caesar—in painting, sculpture or even on the stage—helped to establish a touchstone by which his future representations would be judged.[43]

It is impossible to know how far this composite resembles the dictator's appearance in flesh and blood. Most people would, I think, claim some overlap between them; but however large or small the overlap was, that set of features successfully signals 'Caesar' to us. My guess is that they would roughly have signalled 'Caesar' to Roman viewers too; it would not have been difficult for many of them to work out who was standing in Mantegna's triumphal chariot, or ticking off the troublesome Gauls in the comic strip.

## The Forward Plan

The portraits of none of Julius Caesar's successors have attracted quite such lavish encomia and gushing hyperbole, or been so fiercely debated. But Augustus, Caligula, Nero and Vespasian have all recently starred in their own exhibitions, and over the last couple of hundred years there have been other 'mais c'est César' moments as images of later emperors came spectacularly to light; or so it was claimed. One of the most recent, and most unconvincing, examples is a headless, and partly body-less, seated marble figure, seized from 'tomb raiders' by the Italian police in 2011, and almost instantly hyped as the emperor Caligula—with plenty of juicy allusions to

his madness, debauchery and promiscuity thrown in.[44] Without a face to go on, unless a battered, more or less featureless, head discovered not far away actually belonged to the piece, the identification relied heavily on the statue's elaborate sandal, which was taken to be one of the military boots or *caligae* the emperor wore as a toddler and was the source of the nickname 'Caligula' by which he is now usually known. Few people chose to ask why on earth, in this once rather grand sculpture, there should have been a visual reference to the childish nickname ('Bootikins' gets the flavour) that the emperor, officially known as 'Gaius', is said to have loathed. Such is our desire to rediscover the famous, and infamous, emperors.

By and large these later rulers have been tracked down by the methods very like those used in the hunt for Caesar. The same subjective procedure of *compare and contrast*—with Suetonius's description or the tiny coin portraits—underlies most identifications and has long been so taken for granted that in the eighteenth century one trick of the *ciceroni*, or tour guides, was to carry round a pocketful of ancient coins to help their clients give a name to the statues they were looking at.[45] There are similar arguments with Caesar's successors too about how to distinguish an emperor made by a modern sculptor from one produced in the Roman world itself; and there are any number of hopeless examples of wishful thinking, changing identities and deeply disputed cases. A pair of statues found in a building off the Forum in Pompeii has kept archaeologists busy for decades, trying to decide (on no firm evidence at all) whether they are some lofty imperial couple or two ambitious local dignitaries aping the imperial style.[46]

That said, there are some significant differences between images of Caesar and those of later emperors. Their identification has not always proved *quite* so difficult. A few sculptures have actually been found with names attached, and others in contexts, such as the dynastic group at Pantelleria, that drastically narrow down the options of who is who;[47] and the far greater number and variety of surviving coin portraits offer a wider basis for comparison than anything before. There are also many more examples to work with overall. His successors often went far beyond Caesar in the mass dissemination of portraits. The guess that there were originally between twenty-five thousand and fifty thousand portraits of Augustus to be found across the Roman world may be too generous. But one reliable index of quantity comes from inscribed pedestals. Just over twenty survive that once held an image of Caesar; there are over two hundred that held an image of Augustus, at least a hundred and forty of them put up during his life (a long one, to be sure, but the underlying point remains).[48]

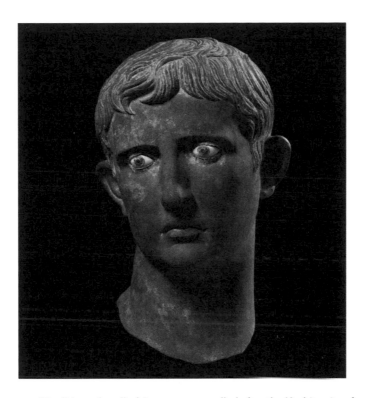

2.9 The 'Meroe head' of Augustus, so-called after the Kushite city of Meroe in modern Sudan where it was found. Complete with its original inlaid eyes, it almost certainly once belonged to an over-life-size bronze statue of the emperor, erected by the Romans in Egypt, raided by the Kushites and taken back as a trophy to Meroe. In the early twentieth century, it was excavated by British archaeologists and taken to the UK. The calm classical features of the portrait should not obscure the complicated stories of empire and violence that now lie behind it.

There are clear signs that, after Caesar, 'getting the imperial image out' became a highly centralised operation. Even when they are discovered hundreds or thousands of miles apart, some of the surviving imperial portraits are very closely similar to each other, right down to (or especially in) such tiny details as the precise arrangement of the locks of the hair (Figs 2.9 and 2.10b). For most modern art historians, the only way to explain the combination of such wide distribution and sometimes virtually identical portraits has been to imagine that models of the imperial face, probably in clay, wax or plaster, were sent out from the administration in Rome to the different parts of the empire, to be imitated by local artists and craftsmen, often in local stone. Some authorised prototype ensured that when Roman subjects,

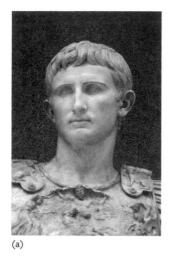

(a)

(b)

(c)

(d)

(e)

(f)

2.10
(a) The head of Augustus from his statue at the villa of Livia at Prima Porta near Rome
(b) Diagram of the hair locks on an imperial portrait (based on the Prima Porta head, 2.10a)
(c) Head usually identified as Tiberius, Augustus's successor
(d) Caligula depicted closely on the model of his predecessor Tiberius
(e) Head variously identified as Augustus, Caligula and two chosen heirs of Augustus, Gaius and Lucius Caesar, who died young
(f) Head variously identified as Augustus, Caligula, Gaius Caesar and Nero (and possibly re-cut to give it different identities)

wherever they were, looked up at the statues in their distant hometowns, they all saw the same emperor.

There is actually not a shred of evidence for these prototypes, no trace in the Roman record of those who might have designed, made or dispatched them and no clue to the identity of the artists who used them to produce the finished sculptures. And they cannot possibly account for the wide variety of independent images, empire wide, that were intended to represent the emperor. Not everything was 'top down', or 'centre out'. The moulds for imperial biscuits were surely not based directly on any template dispatched from Rome, nor were the splendid carvings of the emperor in the guise of an Egyptian pharaoh, nor all those rough-and-ready paintings that Fronto reported seeing (Fig. 2.11). Nonetheless, the logic that some such regulated process of copying lies behind some of the similarities in some sculptures is almost inescapable, and has obvious consequences for how imperial faces are recognised.

Over the last hundred years or so this has provided not so much a new method for identifying the portraits of emperors, but a new weapon in the traditional armoury of comparison. Many faces have been pinned

2.11 On the walls of the Egyptian temple at Dendur, built c. 15 BCE, Augustus several times appears in the guise of a pharaoh. Here, on the right, in an image that was once brightly painted, he offers wine to two Egyptian deities. In the cartouches (oval frames) next to his head he is named in hieroglyphs as 'Autokrator' (emperor) and 'Caesar'—making this a much firmer identification than almost any of his Greco-Roman style portraits.

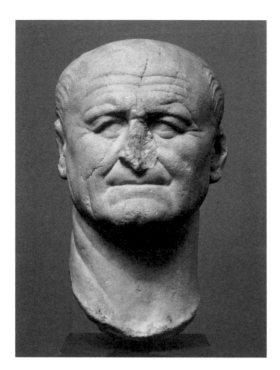

2.12 The down-to-earth style and decidedly middle-aged appearance of this head of Vespasian marks a—no doubt intentional—contrast with the youthful perfection of images of the previous, Julio-Claudian, dynasty.

down on the basis of tiny diagnostic details, which suggest that they derived from the same centrally produced model. At its most extreme, there can be something even more absurd about all this than the fuss over Caesar's neck and his Adam's apple: everything can rest on the tell-tale pincer formation of the curls above the statue's right eye, for example, and almost nothing on what the sculpture actually looks like overall. But it means that, while barely a single head of Julius Caesar has gone unchallenged, combining the 'absolutely certain' identifications with the 'very probable', there are now a total of around two hundred surviving portraits of Augustus (who leads the count), and even twenty for young Alexander Severus.[49]

This does not mean that all the Roman rulers following Caesar have an equally distinctive 'look' in ancient or modern art: far from it. Among Suetonius's Twelve, Nero—with his characteristic double chin and sometimes the beginnings of a stubbly beard—regularly stands out in line-ups of marble busts almost as clearly as Julius Caesar; likewise, it is not hard to spot the almost impossibly perfect and youthful Augustus or the recognisably middle-aged, down-to-earth Vespasian (Fig. 2.12). But for modern viewers there are some frustrating mismatches between the emperors who are most memorably described in literature—Caligula, for example—and their rather bland representations in marble. Leaving aside the details

of the hairstyle, some of Caesar's immediate successors (especially if you include the penumbra of heirs and princes) really do look confusingly indistinguishable. To understand this, we must turn to other innovations at this period and to the politics behind them: a brand-new style of portraiture introduced with Augustus and a radically new sense of the function of the portraits within the imperial dynasty. Carefully constructed similarity (as well as occasional difference) could be the whole point.

## Caesar Augustus and the Art of Dynasty

Julius Caesar's plans for the future, whatever they might have been, were assassinated with him. It was Augustus who established the permanent system, though sometimes fragile continuity, of one-man rule at Rome. Under the name of Octavian, this young man had had a notorious record of brutality and treachery in the fifteen years of civil war that Caesar's assassination had sparked. But in one of the most astonishing political transformations ever, after his victory over his rivals, he re-invented himself as a responsible statesman, coined a respectable new name ('Augustus' means not much more, or less, than 'revered one') and proceeded to rule as emperor for more than forty years. He nationalised the army under his own command, he ploughed enormous sums of money into redeveloping the city and supporting the people, and he cleverly managed to get most of the elite to acquiesce in his de facto control of the political process, while disposing of those who did not. Every emperor afterwards included not just the name 'Caesar' but 'Caesar Augustus' in his official titles: the assassinated dictator who stood at the origin of the Roman system of one-man rule was forever linked to the canny politician ('the tricky old reptile' as one of his much later successors called him) who devised the long-term plan.[50]

One major problem that the tricky old reptile never entirely solved, however, was the system of succession. It is clear enough that he intended his power to be hereditary, but he and his long-standing wife Livia had no children together, and a sequence of chosen heirs died at inconveniently early ages. Eventually Augustus was forced to fall back on Tiberius, Livia's son by her first husband, who in 14 CE became emperor (hence the title 'Julio-Claudian' now given to this first Roman dynasty, reflecting its mixed descent from the 'Julian' family of Augustus and the 'Claudian' family of Tiberius's father). Even when such practical difficulties were overcome, the principles of succession remained hazy. Roman law had no fixed rule of primogeniture; if you wanted to succeed to the throne, it certainly helped to be the eldest son of the ruling emperor, but it was not a guarantee. No

natural son succeeded his father in the first hundred years of imperial rule, until Titus followed Vespasian onto the throne in 79 CE. It is hardly a coincidence that Vespasian was also the only emperor of the first twelve who is said, indisputably, to have died of natural causes. All the other assassinations, forced suicides or just the rumours of poisoning (unfounded though they may have been) point to the moment of succession as a moment of uncertainty, anxiety and crisis.

The 'look' of the new brand of imperial portraits is inseparable from this new political structure and had very little to do with the personal traits of Augustus himself. The description in Suetonius is one of the give-aways on that; the portraits at least do not have the irregular teeth, hook nose and knitted eyebrows that the biographer picks out as the emperor's distinguishing features. Even more telling is the slightly icy perfection of the image, which was derived directly from statues of the classical age of fifth-century Greece, and the glaring fact that the portraits made through all forty-five years of the reign were close to identical, from his bronze head found in Sudan, the loot from a local raid on the Roman province of Egypt (Fig. 2.9) to his statue found on the site of Livia's villa outside Rome (Fig. 2.10a). It is almost *Dorian Gray* turned upside down: in Oscar Wilde's novel, the portrait ages while its subject remains youthful; in the case of Augustus, right up to his death in 14 CE in his late seventies he was still being depicted as a young man. To us, it may well seem rather blandly idealising, and we look in vain for any sign of that personal, dynamic relationship between sitter and subject sometimes taken, over-romantically perhaps, to be the touchstone of the greatest modern portraiture (in this case, the sculptors had probably never met their subject). But in the history of Roman self-display, where warts and wrinkles had previously been the common currency, this youthful, classicising image was shockingly innovative; a style unprecedented in Roman art was designed to embody the emperor's unprecedented new deal, and his break with the Roman past. Far from being routinised, uninspired, government-issue work, this image of Augustus was one of portraiture's most brilliantly original and successful creations ever. Intended to 'stand in' for him among the vast majority of the inhabitants of the Roman Empire who would never set eyes on him in person, it has 'stood in' for him ever since.[51]

Table 1 [FACING PAGE] Dynasties often trade on complexity; their multiple adoptions and remarriages are almost impossible to represent clearly on one page. This table is an intentionally simplified family tree of the Twelve Caesars, focussing on the main characters featured in the book.

# TABLE 1

## THE JULIO-CLAUDIAN DYNASTY

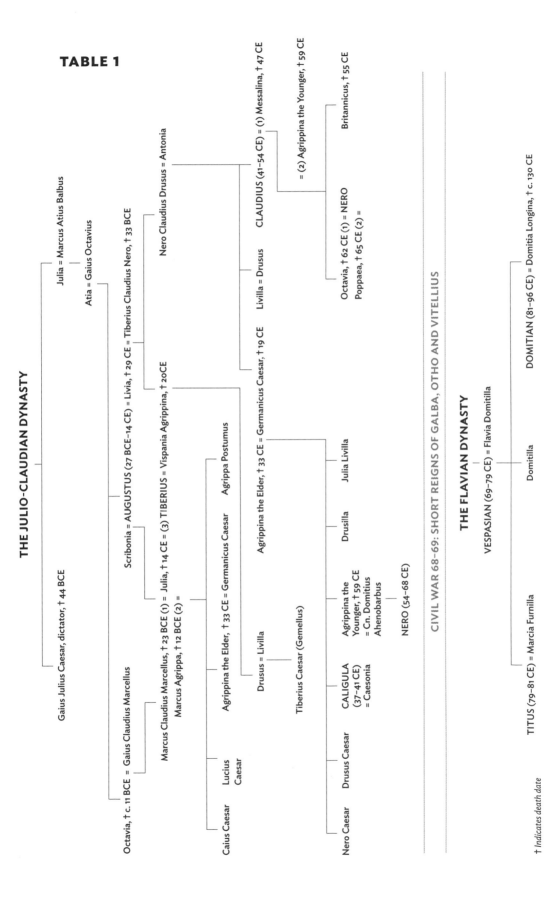

CIVIL WAR 68–69: SHORT REIGNS OF GALBA, OTHO AND VITELLIUS

## THE FLAVIAN DYNASTY

† Indicates death date

It also set the standard for the portraits of his successors over the next centuries. Whatever the glimpses of individuality we may catch in Claudius's slightly piggy eyes, Nero's jowly double chin, or later in Trajan's neat fringe, or Hadrian's bushy beard, the emperors' public portraits were about identity in the political, rather than the personal, sense. They were also about incorporating their subject into the genealogy of power and legitimating his place in the imperial succession. They provided a diagram of both the continuity and sometimes the ruptures in the *right to rule*. Through the tortuous family complexities of the Julio-Claudian dynasty (and later dynasties followed a similar pattern with a roster of bearded look-alikes in the second century CE), chosen successors were marked out by their sculptural similarity to the ruling emperor they were intended to replace—and by their similarity to the image of Augustus, back to whom the hereditary right to imperial power was traced.

It was not a series of absolutely identikit images: Tiberius can appear slightly more angular than Augustus (Fig. 2.10c), Caligula a little softer (Fig. 2.10d). But the general principle was that portraits were designed to make the emperor look the part, and for the first imperial dynasty looking the part meant looking like Augustus. Indeed, the biggest scholarly debates and disagreements around the identification of these Caesars have focussed not (as with the controversial pair in Pompeii) on whether a particular portrait is a member of the imperial family at all, but on which particular Julio-Claudian prince, princeling or short-term heir it is. Even the precise layout of the curls is not always up to producing a consistent answer. One delicate marble head in the British Museum, for example, has been identified as Augustus himself, as two of his short-lived heirs and as Caligula (Fig. 2.10e). An even more puzzling sculpture, in the Vatican, has been claimed for Augustus, Caligula, Nero and another of the would-be heirs (not to mention the possibility that it might be an Augustus later re-carved into a Nero, or even a Nero re-carved back into an Augustus) (Fig. 2.10f).[52] It is hard to resist the conclusion that a perverse amount of scholarly energy has sometimes been devoted to drawing a fine line between subjects who were always intended to look the same.

That commitment to similarity inevitably alternated with a commitment to difference. After the fall of Nero and a year of civil war between 68 and 69 CE, the new dynasty of emperors—the 'Flavians', after its founder Flavius Vespasianus—was installed, and portraiture changed with the politics. Vespasian, as he is now usually known, adopted a 'warts and all' style, in contrast to the idealising perfection of the Julio-Claudian 'look'. In general, the new emperor emphasised his down-to-earth approach to imperial

power, his no-nonsense family background in a decidedly unfashionable part of Italy and his hard experience as a soldier. It was he, for example, who according to Suetonius put a tax on urine, a vital ingredient in the Roman laundry industry (hence the name 'Vespasiennes' for the old street urinals in Paris); and he cannily—if apocryphally—remarked that 'money doesn't smell'. His portraits too were obviously intended to play to assumptions of what down-to-earth realism looks like (Fig. 2.12). But there is no reason to suppose that they were any less a political construction than those of Augustus. In an attempt to exploit old-fashioned Roman tradition, he was carefully marking the visual distance between himself and the excesses of his predecessor Nero and the specious classicism shared by Augustus and his heirs. And that is how he has survived, been recreated and embellished, for two thousand years in the artistic imagination.[53]

What constitutes a 'likeness' has always been one of the big questions of art history and theory, from Plato to Ai Weiwei. There is always a debate about what exactly is (or should be) represented in a portrait: a person's features, their character, their place in the world, their 'essence' or whatever.[54] But our realisation that imperial portraits from Augustus on were largely focussed on political rather than personal identity was not shared by modern artists, historians and antiquarians before the twentieth century. They were aware of how disconcertingly youthful and idealising some of these images seemed (a feature that was sometimes explained away by the 'vanity and the arrogance' of the imperial subjects[55]). But their usual assumption was that not far behind all these ancient heads, the physical contours of real rulers, real persons and real personalities lay.

So indelibly real did they seem that, from the late sixteenth century on, imperial portraits were regularly used as accurate scientific specimens of people from the past, in a way that went far beyond the detection of the deformities of Caesar's skull in the Tusculum head. There are some unexpected twists in this tale.

## The Skull of Vitellius

Galba, Otho and Vitellius are three emperors who have not so far played a part in this chapter. This now half-forgotten trio ruled for just a few months each, before being assassinated or forced to suicide, during the civil wars in 68–69 CE that separated the Julio-Claudian dynasty from the Flavian. Suetonius's picture of them is vivid, characterful but fairly one-dimensional: Galba, the elderly miser; Otho the libertine with a loyalty to Nero; Vitellius the glutton and sadist. Their ancient portraits have not recently claimed

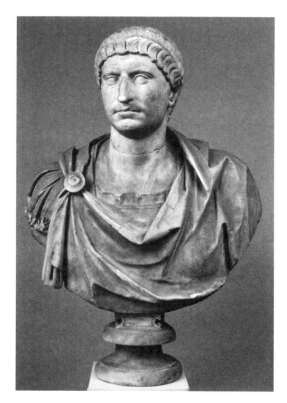

2.13 A portrait bust now in the 'Room of the Emperors' in the Capitoline Museums is identified as Otho, who ruled briefly in the civil wars of 69 CE, largely on the basis of what appears to be a wig (which Suetonius mentions that he wore). Otho was a friend and supporter of Nero, and—if he is correctly identified—a Neronian style may be reflected here, in contrast to Fig. 2.12.

the kind of attention from art historians that those of Caesar or Augustus have attracted. In fact, despite several references—particularly in military contexts—to images of one contender for power being destroyed and replaced by those of another, it seems improbable that any of them during their brief moments of power, in the middle of civil war, would have had the time or resources to devote to circulating full-scale busts in marble or bronze; and they are not very likely candidates for posthumous commemoration. But earlier generations of scholars and artists (and even a few in recent years), wanting to complete a full line-up of Twelve Caesars, have looked for plausible heads to fill the gap between Nero and Vespasian.[56]

The heads on coins and the descriptions in Suetonius again played the key part. Every Roman emperor, no matter how short his reign, issued coinage, because he needed 'his' cash to pay 'his' soldiers; and Suetonius picked out a useful detail or two here and there. Otho's wig to cover his baldness (a throwback to Julius Caesar), or the elderly Galba's hooked nose, were just about enough to recreate a plausible, if speciously convincing, 'look'—and even to point (wrongly or not) to an ancient bust or two to fit the bill (Fig. 2.13).[57] Vitellius was a special case—because of that distinctive

head, the Grimani *Vitellius* (Fig. 1.24), discovered supposedly in excavations in Rome in the early sixteenth century, and apparently such an exact match for some of the images of the emperor on coins that it was taken to be a unique image of him 'from the life'.

Perhaps the most recognisable and replicated of all imperial portraits, its fame went far beyond Veronese's *Last Supper* and images of drawing lessons. As we shall see, this Vitellius has a cameo role in Thomas Couture's vast reflection on Roman imperial vice and scarcely disguised allegory for contemporary French corruption, *The Romans of the Decadence* (Fig. 6.18); and it was the model for the corpulent, and rather wooden, emperor watching the gladiators in one of Jean-Léon Gérôme's spectacular reconstructions of the amphitheatre, *Ave Caesar!* (Hail Caesar!). One copy of a copy of it, still on display in Genoa, is part of an extraordinary nineteenth-century pastiche, being embraced by the 'Genius of Sculpture' itself, as if it stood for the highest achievement of the sculptor's art (Fig. 2.14).[58]

But, for many modern observers, there was more to this portrait than mere 'art'. It was frequently used as a key example in those early scientific disciplines which read human character from external appearance: physiognomics, a discipline going back to antiquity itself, which claimed to be able to deduce temperament from facial features, often comparing humans to animal types; and phrenology, especially fashionable in the early nineteenth century, which claimed much the same from the shape of the skull (and so the shape of the brain within).[59]

In one of the most famous and detailed modern textbooks on this subject, by the Neapolitan scholar Giambattista della Porta, first published in the late sixteenth century, Roman emperors feature in the illustrations of historical characters: they include a *Vitellius*, not unlike the Grimani, whose features, and the size of whose head, are compared to an owl to demonstrate his *ruditas* (uncouthness) (Fig. 2.15).[60] Phrenology was often a showier affair, with an established place on the popular lecture circuit in Victorian Britain. In one of his celebrity lectures in the 1840s, Benjamin Haydon—painter, art theorist, bankrupt and an enthusiast for reading skulls—featured a comparison between the head of Socrates, as it had been (imaginatively) re-created in ancient sculpture, and the head of the emperor Nero, predictably to the disadvantage of the latter.[61] At roughly the same time, David George Goyder, a phrenological ideologue and eccentric enthusiast for a number of other lost causes (he was a minister of the Swedenborgian Church and staunch advocate of Pestalozzian education) went one better. According to a newspaper report of one of his lectures in Manchester, after an attack

on the vested interests of establishment religion in their opposition to his new science (lining up Socrates and Galileo among others in its support), and an explanation of the basic system by which different parts of the brain were the seat of different talents and temperaments, the *pièce de resistance* involved a demonstration of his methods, complete with visual aids and, I imagine, all the razzmatazz he could muster. Among these was a 'head of Vitellius', whose skull, Goyder explained, was 'round and narrow, not high' indicating 'an irascible, quarrelsome, and violent disposition'.[62] He produced on stage a cast of the Grimani *Vitellius*.

It will by now come as no surprise that this famous image, despite its (chance) resemblance to some of his portraits on coins, had nothing to do with the emperor at all. After decades of recent debate along predictable lines (is the head even ancient?), the standard modern view has demoted

2.14 The early nineteenth-century sculpture celebrating the 'Genius of Sculpture', by Nicolò Traverso in the Palazzo Reale in Genoa. The delicate, youthful figure of 'Genius' embraces a modern version of the Grimani *Vitellius*—originally a marble bust, but that was removed for display elsewhere and replaced with the plaster cast currently on display. The 'Genius', in other words, now embraces a copy of a copy of the Grimani *Vitellius*.

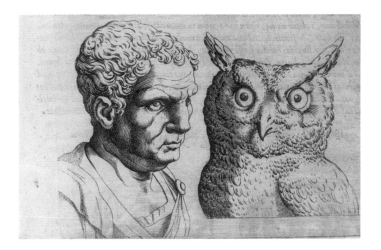

2.15 In Giambattista della Porta's sixteenth-century treatise on physiog-
nomics, the head of Vitellius is likened to that of an owl, pointing to his
uncouthness (the similarities constructively enhanced by the drawing).
Other emperors featured include Galba (his hooked nose compared to
an eagle's beak) and Caligula (for his distinctive sunken forehead).

it to 'unknown Roman' and, thanks to some tiny technical details in the
carving, has given it a date of the mid-second century CE, almost a hundred
years after Vitellius's assassination.[63] There is a combination of irony and
absurdity in this story. The idea that what was probably the single most
reproduced head of any emperor in modern art was an 'emperor' in quo-
tation marks all along can hardly fail to raise a wry, ironic smile. And the
picture of a nineteenth-century visionary (or, depending on your point of
view, crackpot) demonstrating the truth of a pseudo-science with the help
of a head of a misidentified pseudo-emperor is more than a little absurd.
But that absurdity is itself testament to the extraordinary power of the
face-to-face encounter with the rulers of ancient Rome that these portraits
seemed to offer.

It is a face-to-face encounter that, even more surprisingly for us, impe-
rial coins offered too, despite their tiny size. Between the fourteenth and
sixteenth centuries, especially, these miniature heads were far more than
aids to the identification of large-scale portraits, important as that has
always been. The next chapter will explore some of the earliest encounters
between the modern world and the image of the Roman emperors—treated
as almost living presences in miniature form, to be collected, displayed, car-
ried round in your pocket, copied onto paper and re-created on your walls.

# III

# COINS AND
# PORTRAITS,
# ANCIENT AND
# MODERN

## Putting Coins in the Picture

A Roman coin, featuring the head of the emperor Nero, shares the limelight in one of the most celebrated portraits painted by the fifteenth-century German artist Hans Memling. The sitter proudly displays to the viewer the bronze coin, on which—even at this small scale—it is possible to see clearly not only the emperor's face, but his name and official titles running around the edge ('Nero Claudius Caesar Augustus Germanicus . . .' as the heavily abbreviated Latin reads). Recent X-rays have shown that this coin—an almost exact copy of an authentic type minted in Gaul in 64 CE—was not part of the original design but one of several alterations and additions that Memling made in the course of his painting. Yet it was to become the most distinctive, and has been the most puzzling, element in the picture. Why did the painter decide to represent his subject clasping the head of one of the most notorious imperial villains? And why on a coin? (Fig. 3.1)

It would be easier to suggest a particular reason if we knew for sure the identity of the portrait's main subject. Recent views have favoured Bernardo Bembo, the Venetian scholar, collector and politician of the late fifteenth century, who in the 1470s spent time in Flanders, where Memling was then working, and whose personal emblem included a palm tree and laurel leaves (unusual elements visible in the landscape background and on the lower edge of the portrait). If so, then the coin might be a flattering reference to the quality of Bembo's own collection; for some Renaissance experts in ancient coinage insisted that, whatever the emperor's despicable charac-

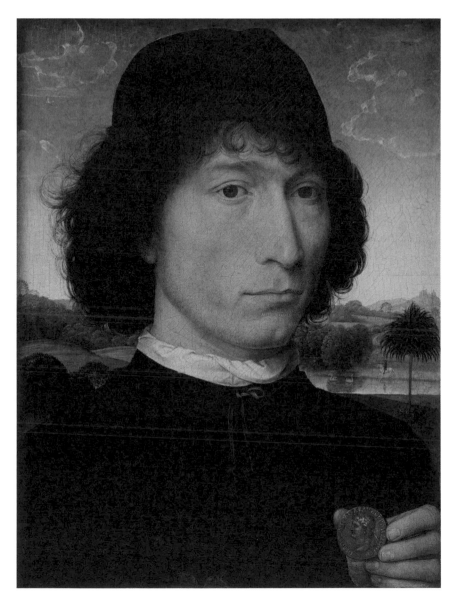

3.1 Hans Memling's *Portrait of a Man with a Roman Coin* (1471–74). Despite its tiny size (the whole painting is only about thirty centimetres tall), the coin at the bottom right attracts the viewer's attention. Why is the (anonymous) sitter holding it up to us? And what is the significance of it being a coin of the emperor Nero?

ter, Nero's coins were particularly fine works of art. But there have been plenty of other identifications and explanations too. One idea is that the coin makes a visual pun on the otherwise anonymous sitter's name: perhaps this was a hint that he was called 'Nerione', a not uncommon Italian name

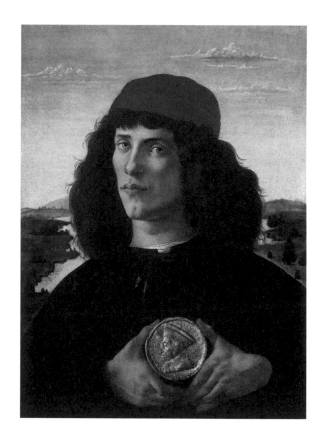

3.2 Sandro Botticelli's *Portrait of a Man with a Medal of Cosimo the Elder* (c. 1475) outdoes Memling's painting. It is twice the size (fifty-seven by forty-four centimetres), and the medal stands out even more forcefully, made of gilded gesso (plaster).

at the time. Or maybe a more subtle moral point was being made. It might have been a reminder, as one art historian has recently put it, 'that worldly fame and visual commemoration cannot always be associated with virtue'.[1]

Whatever the right answer, there is a powerful triangulation here, to which I shall return, between the coin, the modern face and the very idea of the portrait. It was a triangulation that clearly struck Sandro Botticelli. Within a couple of years, he had upstaged and perhaps slightly parodied Memling's composition. In his painting of another unknown sitter, *Portrait of a Man with a Medal of Cosimo the Elder*, Botticelli replaced the ancient coin of Nero with a commemorative medallion of the Florentine dynast Cosimo de' Medici, and has rendered it not in simple paint, but as a three-dimensional model in gilded gesso, inset into the painting (Fig. 3.2).[2]

Almost a hundred years later, in his portrait of Jacopo Strada, Titian likewise pointed to the importance of coins in defining the image both of his subject, and of the Roman past. Strada was a prominent dealer, antiquarian and collector, and one of those Renaissance men who seems to have got everywhere (Fig. 3.3). He was born in Mantua, lived much of his life in Vienna and became extraordinarily influential (and rich) as agent and advisor to the Pope as well as to a number of northern European businessmen and aristocrats, from the Fugger bankers in Augsburg to the Habsburg emperors. In the 1560s Strada was often in Venice scouting for art and antiquities on behalf of Albrecht V of Bavaria, who had employed him to plan and acquire an appropriate collection for his palace in Munich (the Residenz). It was during one of these stays that he commissioned Titian to paint his portrait: the fee was to be an expensive fur lining for a cloak, no doubt like the one shown in the painting, and a fairly unscrupulous 'leg-up' for Titian in finding rich buyers for pieces from his workshop. Or so one of Strada's jealous rivals alleged, while also suggesting that there was little to choose between painter and sitter when it came to commercial greed: 'two gluttons at the same dish' he wrote.

Strada's lascivious avarice has often been seen as a prominent aspect of the portrait. He proprietorially fondles an ancient sculpture of Venus, while also displaying it to the viewer as if to a potential purchaser; and the pile of Roman coins lying on the table gestures to the monetary side of his business in ancient art. But there is more to it than that. What Titian also underlines here is the primacy of Roman coinage (especially imperial coinage) in Strada's engagement with history. For, as well as the coins in front of him, which were of course collectibles rather than legal tender, he wears another hanging from the splendid gold chain around his neck and bearing what looks like an emperor's head, as if it were a personal emblem or talisman. The two books prominent on the top of the cupboard behind continue the same theme by hinting at Strada's scholarly writing. He was best known for his *Epitome thesauri antiquitatum* (Encyclopaedia of antiquities), first published in 1553, which offered brief biographies of 'Roman' rulers from Julius Caesar to the Holy Roman emperor Charles V (1500–58), illustrated throughout by portraits in the form of coin heads—some taken from his own collection.[3]

Another Venetian painter, Tintoretto, presented a similar idea even more flamboyantly, when he undertook the portrait of Strada's teenaged son Ottavio, which his father commissioned along with his own (the two paintings, almost exactly the same size, being presumably intended to form a pair) (Fig. 3.4). It is hard to imagine that Tintoretto did not have one eye

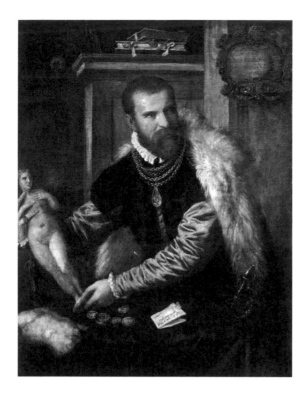

3.3 Jacopo Strada was one of the most significant European figures in the study of (and trade in) antiquities in the sixteenth century. Titian's large portrait of him, painted in the 1560s, underlines the importance of coinage in the cultural and scholarly world of the time: from the ancient coins scattered on the table to the specimen hanging around his neck. The title at the top right, identifying Strada, is a later addition.

on the portrait that Titian was simultaneously creating in the same town. For young Ottavio, in surely deliberate contrast to the picture of Jacopo, is shown turning away from a naked Venus towards a slightly implausible flying figure of 'Fortune', who is showering on his lap a *cornucopia* (horn of plenty) of ancient coins. This no doubt dramatised some of the moral choices facing the young man, and could certainly be read as a presage of future wealth. But it also contrasted the relative paucity of ancient marble sculpture as a means of access to the world of antiquity with the amazing abundance of ancient coinage. As one sixteenth-century scholar put it, in modern Rome ancient coins 'gush out in a never-ending stream'.[4]

Each of these paintings underlines the fact that there was far more to the coinage of imperial Rome than a useful aid in pinning down full-scale portraits of emperors in marble or bronze. For hundreds of years, coins and their heads played a bigger role in how emperors were imagined than any of those precise, or dodgy, comparisons of neck wrinkles and Adam's apples might suggest.[5] They were the only authentic ancient portraits easily available to anyone outside southern Europe. They turned up from the soil in their hundreds wherever the Romans had been, a tiny proportion of the millions of them which had once been minted in one of the world's

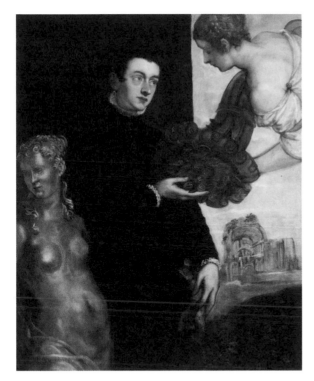

3.4 Tintoretto's portrait of Jacopo Strada's son Otta- vio made a pair with the portrait of his father: it was painted at the same time, and the two pieces are the same size (roughly 125 centimetres by one metre). Both prominently feature coins and the goddess Venus (but whereas the father lovingly fingers his Venus, the son turns away).

first truly mass-production industries (averaging, according to one brave attempt to calculate, some twenty-two million silver pieces a year from the central mint at Rome alone, not counting the bronze and gold, or the production of other mints). Even in Britain Shakespeare could expect his audience for *Love's Labours Lost* to know what 'the face of an old Roman coin' meant.[6]

But it is more than a question of familiarity. These tiny pieces of metal were often taken as the physical embodiment of the lessons that Rome's history and its rulers could offer. Petrarch, for example, in the mid-fourteenth century pointedly gave a selection of Roman coins to Charles IV, just before his coronation in Rome as Holy Roman emperor. They were, he suggested, a better lesson in princely behaviour than a copy of his own book *De viris illustribus* (*On Famous Men*) for which Charles had explicitly asked. Another scholar, Cyriac of Ancona, repeated the trick in the early fifteenth century by giving the new Holy Roman emperor a coin of Trajan—whose tempo- rary victories in the Near East in the second century CE offered an example for a crusade against the Ottoman Turks.[7] Coins also provided an important model for re-creating emperors on paper, in paint and in stone, as well as a template for modern portraiture more generally. The final part of this

chapter will unpick some of the connections that lead ultimately from those first images of Julius Caesar stamped on the coins of 44 BCE to the later tradition of Western secular portraiture almost down to our own day.

## Coin Portraits

Petrarch's gift to Charles IV did not bring the result he had hoped. He had singled out a head of Augustus (so realistic, he claimed, that it appeared to be 'almost breathing'[8]), which would set an example to the new emperor and encourage him to take active steps, as Augustus had done, to restore the fortunes of Italy and of the city of Rome itself. But Charles did nothing of the sort; instead, after his coronation in Rome, he went straight back to his preferred home in Bohemia (in what is now the Czech Republic). He also apparently sent to Petrarch, as a gift in return, a coin of Julius Caesar. If so, he may have missed the point; for Charles seems to have been treating these imperial heads, not—like Petrarch—as the embodiment of a moral and political lesson, but as artistic commodities and tokens of reciprocity and friendship.[9]

But whatever their misunderstanding or different priorities on this occasion, Petrarch and Charles shared the widespread sense of the value and importance of the images of emperors on Roman coins, that was not finally lost until the nineteenth century (when the study of 'numismatics', as it began to be called, became simultaneously professionalised and side-lined thanks to its new status as an academic discipline). From the mid-fourteenth century to the end of the sixteenth in particular, before the rediscovery of significant numbers of full-scale marble portraits, coins were generally thought to offer the most vivid, authentic and available vision of the rulers of the Roman world. It is true that there were long-running, and to us rather puzzling, debates about their original purpose: one of the biggest scholarly controversies of the Renaissance, only laid to rest in the late eighteenth century, centred on the question of whether most of these *medaglie* (as they were called in Italian) were 'coins' in the usual modern sense of the term—or whether they were not ancient small change at all, but rather commemorative medallions, struck in honour of those whose heads they featured. But there *was* universal agreement that, whatever their original function, they brought you closer than anything else could to the emperors in flesh and blood.[10]

We have long since lost the ability to respond to coins in this way, even as a rhetorical conceit, but Petrarch was not alone among early view-ers in referring to them as 'almost breathing'. Filarete, the creator of the

great bronze doors of St Peter's, also described the heads on coins as seeming 'completely alive'; it was through the art of coinage, he went on, 'that we recognise . . . Caesar, Octavian, Vespasian, Tiberius, Hadrian, Trajan, Domitian, Nero, Antoninus Pius and all the others. What a noble thing it is, for through it we know those who have died a thousand or two thousand or more years ago.'[11] Nor was Petrarch alone in focussing on their moral dimension. In the mid 1500s, Enea Vico—the antiquarian from Parma who wrote the first basic handbook on the study of ancient coins (as he strongly believed them to be), and died a scholar's death, collapsing while carrying a precious antiquity to one of the dukes of Ferrara—also convinced himself of their reforming power. 'I have seen some', he wrote, 'who were captured by such pleasure of looking at them, that they were deflected from their wicked habits and gave themselves . . . over to an honourable and noble life.'[12]

But equally important for many was the direct, unmediated access that coins offered to the classical world and its people, which gave them a historical reliability that outranked classical texts. As Vico again put it, they amounted to 'a history that keeps silent and displays the truth whereas words . . . say whatever they please'. Almost two hundred years later, the English politician, playwright and essayist Joseph Addison made the same point more plainly. He had one of the characters in his semi-satirical *Dialogues* on ancient coinage insist that a coin was 'much safer' as evidence than Suetonius, because its authority came directly from the emperor himself, without the distorting intermediary of a biased biographer.[13]

It is hardly surprising, then, that for centuries, from the Renaissance to the nineteenth century, imperial coins were the most popular collectibles across Europe, and not just among the super-elite. The combination of their portability, their relative plenty and so their relative affordability put them within reach of men and women of far more modest means. (Despite some occasional posturing about 'scarcity', it is reckoned that in the mid-fifteenth century an emperor's head on a silver coin probably sold for only about twice its metal value.[14]) The best evidence for the extent of this collecting is hidden away in the author's 'acknowledgements' at the end of an account of the life of Julius Caesar, and of the main players in the civil wars after his death, published in 1563 by Hubert Goltzius, a writer, painter and printer from Bruges.[15]

Goltzius devotes some fifty pages at the start of the book to the coins of his subjects (beginning with five pages full of almost identical miniature images of Caesar with that wrinkly neck and Adam's apple, drawn from slightly different specimens); and as if to clinch the point, the very last

page of the book carries an illustration of Fortune pouring a stream of coins from a cornucopia, a rather more sedate version of the flying figure in Tintoretto's portrait of the young Strada. In the eighteen-page section of 'acknowledgements' appended to the main text, he names and thanks the scholars and collectors whose holdings he studied in the course of his researches on the first of the Caesars and on other topics of Roman history. There are 978 of them in all, spread across Italy, France, Germany and the Low Countries, carefully laid out in the chronological order in which he consulted them during his travels around Europe in 1556 and between 1558 and 1560.

Of course, acknowledgements in books were tricky rhetorical exercises, produced—then no less than now—as much for show as for gratitude. Yet, even allowing for some exaggeration and some carefully calculated inclusions, these names point to the social, cultural and international diversity of the collectors. They include a handful of the top rank of the European governing class—from the pope to the king of France and the Medici in Florence—and a few celebrity artists, Vasari and Michelangelo notably among them. They span Catholics, Calvinists and Jews, whose names are carefully inscribed in Hebrew, as well as native locals and ex-pats: four 'Englishmen' based abroad, plus one 'Ioannes Thomas' (who looks temptingly like 'John Thomas', though could be German) and even more 'Spaniards'. The overwhelming majority are the now largely unknown local councillors, priests, lawyers and doctors in ordinary European towns.[16] Their collecting ambitions were presumably tailored to fit their pockets. Only the very richest would have come close to the Medici who had several thousand specimens altogether, not all Roman, in their late fifteenth-century coin collection, or even to the German princess in the early eighteenth century who boasted of her precious series of Roman rulers up to seventh-century CE Byzantium ('Now I have . . . a suit of emperors from Julius Caesar to Heraclius with no gaps', she wrote, which would have amounted to about 100 in all).[17] But they must all, at their different levels, have shared something of the pleasure of acquisition, classification, ordering, reordering and exchange that is part and parcel of collecting: from the thrill of the chase to the quiet satisfaction of completing the set.

It would, however, be quite wrong to imagine that coins were all locked away in cabinets, or hidden in boxes and purses, entirely for the private pleasures of their owners. Coins, more than anything else, stamped the faces of emperors onto the Renaissance cultural landscape. You would have seen them swinging around the necks of men like Jacopo Strada (the chain of cameo Caesars worn by the Armada victim (Fig. 1.13) was a showier and

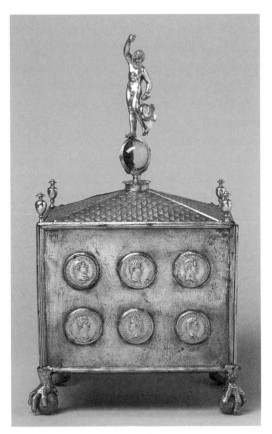

3.5 A small sixteenth-century German casket (just over twenty centimetres in length), decorated back and front with gilded replicas of coins of the Twelve Caesars; here the second Six, from Galba top right, to Domitian bottom left. On either end is a selection of characters from early Roman history and myth.

more expensive variant on the same fashion accessory). You would also have spotted them incorporated into *objets d'art* of many kinds in many different contexts, from libraries to churches.

Smart leather book-bindings featured imprints or 'plaquettes' of the coins of Caesar, Augustus and their successors. One precious casket, which belonged to the extravagant collection of art and bric-à-brac assembled in the sixteenth century by a junior branch of the Habsburg dynasty at Schloss Ambras near Innsbruck, was inset with gilded casts of twelve Roman coins, offering a line-up of Suetonius's emperors from Julius Caesar to Domitian (Fig. 3.5). Even that luxury item was upstaged by a roughly contemporary liturgical chalice from Transylvania, decorated with seventeen original coins of emperors and their wives, from Nero to the Byzantine Justinian (with what is probably a local first-century BCE coin to make up 18) (Fig. 3.6).[18]

There were all sorts of different messages in these displays. The imprints in the bindings may well have been intended to draw attention not so much to the contents of the book (it was not a question of a head

of Julius Caesar being stamped onto the cover of his biography), but to the processes of its production, and to the similarity between the ancient method of striking coins and the modern method of printing.[19] The coins on the casket from Schloss Ambras hinted no doubt at the precious contents within, as well as at the sense of order that came with a line-up of the Twelve Caesars. And if anyone should be tempted to assume that all this was 'just decoration', de-signified trinkets from a distant past or boasts of modern wealth, they should reflect on the experience of sipping communion wine out of a vessel that gave worshippers a close-up view of some of the greatest persecutors (as well as some of the most pious rulers) in the history of the church. These images, more often than not, were making a point; they were a big part of the Renaissance cultural currency.

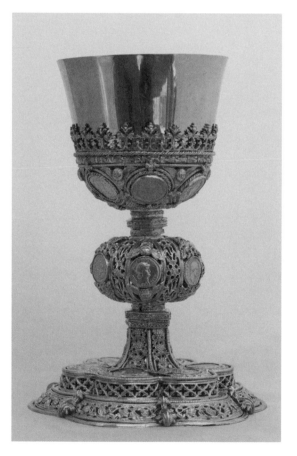

3.6 An early sixteenth-century chalice from Nitra in modern Slovakia, with eighteen coins—all but one Roman—set into the decoration. Details: one of several Neros incorporated into the design (above), and his successor Galba (below).

It is barely an exaggeration to say that at this period wealthy, educated Europeans (and probably even a few of Shakespeare's 'groundlings', to judge from his throwaway reference) would have recognised major coin types much as they later recognised celebrity ancient sculptures. It is only over the last three hundred years or so that Classical antiquity has become so overwhelmingly defined by marble. Before then, Julius Caesar's coin portrait and probably the Nero in Memling's painting would have had something of the fame that the *Apollo Belvedere*, the *Dying Gaul* or the *Laocoon* came later to enjoy.[20]

## Picturing Emperors

Images on coins, rather than in sculpture, were the models to which artists first turned when they wanted to create brand new imperial portraits to illustrate histories of Rome or the biographies of emperors.[21] Sometimes this involved ingenious adaptation. One manuscript of Suetonius's *Lives*, produced in Venice around 1350, includes some clever hybrid images, with distinctive heads and facial features drawn from coin portraits inserted into more generic imperial bodies (Fig. 3.7a and b).[22] Far more commonly, as in Strada's *Epitome*, the coins appeared *as coins*. The very earliest example of this is also the simplest. It is the work of the first decades of the fourteenth century, by a Veronese scholar, Giovanni de Matociis—or 'il Mansionario' (the sacristan), as he is more often known, from his position in the cathedral.

Il Mansionario has several claims to fame. For classicists even now his great achievement was to be the first reader since antiquity to realise that those Latin authors we call 'Pliny the Elder' and 'Pliny the Younger' were actually two different people—not, as was then thought, one and the same. But his compendium of imperial biographies, from Julius Caesar to Charlemagne (crowned Holy Roman emperor in 800 CE), was no less innovative. For he illustrated each of his 'lives' with a schematic diagram of a coin: a head in profile, surrounded by the emperor's titles inscribed within two plain circles. In some of these, both the portrait and the inscription are clearly based on authentic specimens, which the author—who was probably also the artist—had seen or may even have owned. (That is clear with the image of Maximinus 'the Thracian', Fig. 3.7c and d.) In others, where presumably he needed a portrait but had no coin, he adapted or simply invented something according to the same formula.[23] It was the start of an artistic trend that would continue for more than two hundred years.

Some later versions of this basic scheme were far more detailed, carefully drawn and flamboyant. In a manuscript copy of Suetonius's *Lives*,

3.7

(a) Galba from a mid-fourteenth-century manuscript of Suetonius's *Lives*

(b) Coin of Galba (bronze *sestertius* minted 68)

(c) Coin of Maximinus Thrax (silver *denarius* minted 236–238)

(d) Maximinus Thrax (emperor 235–38) from il Mansionario's compendium of imperial biographies

(e) Caracalla (emperor 198–217) from il Mansionario's compendium of imperial biographies

(f) Coin of Marcus Aurelius (emperor 161–80), (silver *denarius*, minted 176–77)

(g) Altichiero's Caracalla from the Palazzo degli Scaligeri in Verona (mid-fourteenth century)

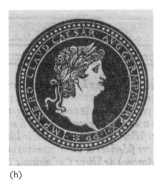

(h)  (i)  (j)

(k)  (l)

(m)

(n)

(h) Nero from Fulvio's early sixteenth-century *Illustrium imagines*
(i) Cato from Fulvio's early sixteenth-century *Illustrium imagines*
(j) Eve from Rouillé's mid-sixteenth-century *Promptuaire des medailles*
(k) Nero from the late fifteenth-century roundels, at La Certosa, Pavia
(l) Attila the Hun from the late fifteenth-century roundels at La Certosa, Pavia
(m) Julius Caesar from Horton Court, Gloucestershire, UK (about eighty centimetres in diameter)
(n) Vespasian from Raimondi's luxury early sixteenth-century series of the Twelve Caesars (each one seventeen by fifteen centimetres); see also Fig. 4.8

**3.8** The opening page of the life of Nero from a manuscript copy of Suetonius's *Lives* commissioned in the 1470s by Bernardo Bembo (plausibly the sitter in Memling's portrait, Fig. 3.1). The decoration is mostly drawn from coins: lower centre, the head of Nero with his name and titles; down the right-hand side, various reverse designs from the emperor's coinage (from the top: the goddess 'Rome'; military exercises; triumphal arch; celebration of the corn supply; Rome's port of Ostia). Around the initial letter 'E' is a scene of Nero 'fiddling while Rome burns'.

commissioned in the 1470s by Bernardo Bembo—the most plausible candidate to be the subject of Memling's portrait—almost every one of the individual biographies opens with a page of what can only be described as a 'numismatic extravaganza': down one side runs a 'column' constructed out of some of the reverse (or 'tail') designs of the emperor's coins; and at the foot of the page is the emperor's head, so precisely reproduced—with both its portrait and inscription—that it is still possible to pinpoint the coin type from which it was taken. In Nero's case, the coin is very similar indeed (though not absolutely identical) to the one so proudly displayed in Memling's painting. Assuming we have the identity of the sitter right, it is very tempting to speculate that there may be a link here between the manuscript, the portrait and a particular prized specimen in Bembo's own collection (Fig. 3.8).[24]

But, whatever the personal story, the important point is that between the fourteenth and sixteenth centuries coins were more than just the best evidence available for the appearance of the Roman emperors; they provided a lens through which those rulers were repeatedly re-imagined and recreated in modern art. To 'think *emperor*' usually meant to 'think *coins*', not 'marble bust'. That was true in almost every medium, from the relatively cheap to the hugely extravagant, from the mass-produced to the one-off. When Raphael's friend and antiquarian collaborator Andrea Fulvio compiled his very successful, and (as we shall see) much imitated, illustrated compendium of great lives (*Illustrium imagines* or *Images of the Great*) in the early sixteenth century, his emperors and empresses were depicted, at the start of each mini-biography in the book, as if they were coin portraits (Fig. 3.7h).[25] When, at about the same time, Marcantonio Raimondi engraved his luxury set of heads of the Twelve Caesars, they too were shown as they appeared on coins (Fig 3.7n), as were many of the earliest marble reliefs of emperors from Renaissance Florence.[26] On a grander scale, if you look up at the ceiling painted by Andrea Mantegna in the 'Camera picta' (the Painted Room, also known as the Camera degli Sposi, or Bridal Chamber) in the Ducal Palace at Mantua, you still see eight emperors in roundels, staring down at you—their heads admittedly almost full-on, rather than in profile, but their titles running around the edge of each circle, just as on a coin (Fig. 3.9).[27]

Thousands of prestige buildings across Europe, and some not so grand, built these distinctive coin-like profiles of emperors into their facades. Often just one or two carefully chosen Roman rulers were set on either side of a door or arch, but the great over-achievers in this respect were the monks (and their patrons) of La Certosa, the large Carthusian monastery

3.9 Looking up to Mantegna's ceiling of the so-called 'Camera picta' in the Ducal Palace in Mantua, painted around 1470. At the centre, there is a trompe l'oeil opening apparently to the blue sky outside, and around that the sequence of eight emperors (from Julius Caesar to Otho) looking down.

near Pavia in north Italy. The exterior of their church was plastered with sculpture of all kinds; but its lowest band of decoration, and what hits visitors at eye-level as they enter the building or walk along its frontage, consists in a continuous line of sixty-one portrait roundels. Made in the late fifteenth century, each almost half a metre across, the vast majority of them are distinctively coin-like, depicting a large number of Roman emperors, plus some assorted companions (including a few early kings of Rome, a handful of near Eastern characters and Alexander the Great as the solitary Greek, plus Attila the Hun, some figures from myth and a small bunch of abstractions, including 'Concord' and 'Speedy Assistance') (Fig. 3.7k and l). Whatever the logic of the design (which continues to baffle commentators), the roundels find a striking, if rather homespun, echo a thousand miles away at Horton Court in rural England. Four limestone medallions decorate the rear wall of a garden extension, euphemistically titled a 'loggia', built in the 1520s for an owner who had been in Rome representing Henry

VIII. Three of them—Julius Caesar, Nero and Attila the Hun—are part of the line-up at La Certosa and appear again in England in the characteristic idiom of magnified imperial coinage (Fig. 3.7m).[28]

Many other emperors-on-coins find a place in Renaissance painting, now often only half noticed. Even when they were making big points with the figure of Roman rulers, artists still commonly cast them in numismatic guise. When, for example, Vincenzo Foppa in the fifteenth century wanted to use the heads of Augustus and Tiberius to display and define the parameters of Jesus's life on earth (born under the former, died under the latter), he chose two images in the style of coin portraits to decorate the arch that stood over his, more than usually chilling, scene of the crucifixion (Fig. 3.10).[29] It takes a much more determined inspection to make out the faded head of Augustus in a roundel fixed to the wall lurking above the figure of Jesus in Titian's painting of *Christ and the Adulteress*—but there he is, once presumably standing out more clearly (Fig. 3.11). The interpretative possibilities here are intriguing. The emperor's profile obviously locates the scene in Roman times, but it may also be an oblique reference to the story of Augustus and the Sibyl: instead of a vision of Jesus appearing to the emperor, we have a vision of the emperor glimpsed in the background of the ministry of Jesus. It may not even be too fanciful to see a parallel (or contrast) between Jesus's famous reaction to the woman caught in adultery and brought to him for punishment ('Let he who is without sin cast the first stone') and the almost equally famous reactions of Augustus—whose legislative programme regularised the punishment for adultery (removing the threat of death), and who exiled his own daughter Julia for the crime. In line with the biblical story, which sets the law of Moses against that of Jesus, the presence of the Roman emperor in the painting nudges us to reflect more widely on competing moralities, different legal systems and the authority behind them. And all that hangs on a painted image of an imperial profile in the style of a coin.[30]

It would be naïve to imagine that all Renaissance artists had a stash of ancient small change piled next to their drawing boards (though, if Goltzius was correct, and not simply boasting of his contacts, Vasari and Michelangelo maybe did); and equally naïve to assume that they had a commitment to archaeological accuracy in our terms. Sometimes, as in Memling's painting or in some of il Mansionario's portraits, it *is* possible to identify the type of coin that provided the model. But very often artists copied from other drawings and from printed sources as much as they copied from the original pieces themselves; they invented and adapted coin portraits as much as they faithfully replicated them. The coin-*like* images at La Certosa

3.10 Vincenzo Foppa's *Crucifixion* (1456), just under seventy by forty centimetres, sets the scene within a classical arch. The identities of the unnamed emperors at the top of the painting have been debated, but they are best seen as Augustus (left) and Tiberius (right)—as if to embed the life of Jesus within the historical narrative of Rome.

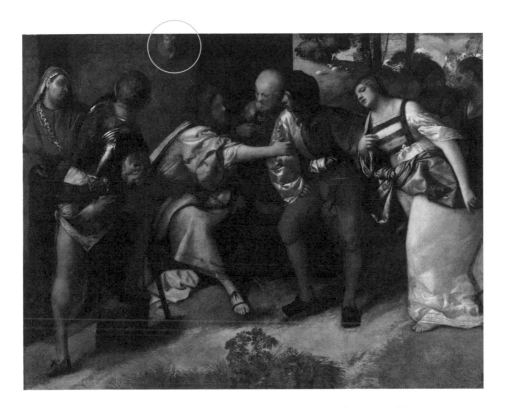

3.11 Titian's *Christ and the Adulteress* (c. 1510) illustrates the gospel story in which Jesus, (centre left) refuses to condone the stoning to death of a woman accused of adultery (far right)—although that was the punishment laid down under the Law of Moses. It is a large canvas, almost two metres wide, with a complicated history (it has been cut down from something even larger, with a whole figure—whose knee in blue and white is just visible behind the woman—removed from the right-hand side). Few people now notice the head of Augustus on the wall behind Jesus.

were precisely that, 'variations on the theme' of coinage rather than exact reproductions, and the artists and antiquarians were sometimes quite open about their procedures. One ambitious French compiler of biographies in the 1550s admitted that his artist had sometimes to work 'from fantasy' (*phantastiquement*), while stressing at the same time that these fantasies were 'imagined with the advice and counsel of the most learned of our friends': a nice attempt to combine learned scholarship and outright invention.[31]

It is true that there were quite a few of what we would call 'howlers' in these artists' work. Il Mansionario's eccentric portrait of the emperor Caracalla, for example, is almost certainly copied from a coin of the emperor Marcus Aurelius; he had misunderstood the tricky Latin of the name and imperial titles inscribed on the coin and misidentified the emperor

concerned (Fig. 3.7e and f). It was easy to do. Raimondi's splendid head of Vespasian is certainly based closely on a coin portrait. But again: wrong coin and so wrong emperor. He too had misread the name and titles running around the edge and had actually reproduced an image of Vespasian's son Titus (Fig. 3.7n).[32]

Plenty of modern scholarly sniffiness has been directed at such errors (even though we are not always any better in reading the Latin, or getting the right emperor, than our Renaissance predecessors[33]). 'The width and variety of the ignorance of the Certosa sculptors are wonderful to behold . . . they cannot keep it to themselves,' carped one recent study, which objected among other things to the mis-copied and mis-spelt Latin in the inscriptions surrounding the portraits.[34] A great deal of careful scholarly effort has also been devoted to disentangling the exact sources of these images, and to solving the puzzles of where precisely the artists found their coin models, and who copied what from whom. Some significant connections are revealed. Very close similarities, for example, show that il Mansionario's manuscript must have been used a few decades later (mistakes and all) as the main source for an elaborate series of coin-like emperors painted on a ceiling in a *palazzo* in Verona; that is the one where some artist had fun drawing an irreverent imperial caricature in the preparatory layer underneath the finished painting (Fig. 1.16). There is a clear trail from coins, to manuscript, to replication in paint, as the unorthodox 'Caracalla' shows.[35]

This is clever, and rather satisfying, detective work, but it sometimes misses the bigger point. Whether they were exact replicas, free adaptations, inventions, errors or copies of copies of copies, it was the *coin-like* form that was crucially important. Roman imperial coinage offered the most authentic images of those famous faces of the Roman past. More than that, the template of this coinage, and the numismatic idiom of portrait heads established in Rome by Julius Caesar, gave a stamp of authority to *any* portrait it framed. Though emperors were central, it was a style that could lend its authenticity to almost any figure from the past, male or female.

That is seen clearly in the fashionable Renaissance genre of the 'portrait book', which combined brief biographies of historical characters with a matching portrait. The first of these—Fulvio's, published in 1517—largely focussed on figures from Roman imperial history, but it stretched at the margins from the god Janus and Alexander the Great at the beginning to the tenth-century CE Holy Roman emperor Conrad at the end. Even those outlying images followed the same numismatic format, sometimes based on real specimens of coinage, sometimes imaginatively (or mistakenly) adapted. One of the most engaging mistakes is an image of the god

Bacchus, taken from a coin, passing for the portrait of the Roman Republican politician, and Julius Caesar's adversary, Cato the Younger (Fig. 3.7i).[36]

The same was true of the far more elaborate series of portraits in a book published in the 1550s by one of Fulvio's successors in France, Guillaume Rouillé. His *Promptuaire des medalles* (Handbook of coins) ambitiously included hundreds of biographies and portraits from Adam and Eve, through the Greeks and Romans, mortals and immortals, to the reigning king of France, Henry II. The drawings were less formulaic, more clearly characterised, than Fulvio's rather sketchy and look-alike series of profiles. But, in a way that now seems faintly ridiculous, they still pressed every subject into a numismatic frame. On the first page, for example, Eve is represented like a Roman empress, with an inscription around her head mimicking that on a Roman coin: '*Heva ux(or) Adam*' (Eve, wife of Adam) (Fig. 3.7j). Rouillé was the man who proudly pointed to his own combination of fantasy and learned scholarship; you can see why.[37]

A similar combination is found at La Certosa. Whatever the deficiencies in Latin shown by the sculptors or designers, they depicted most of the non-imperial subjects who rubbed shoulders with the emperors—from Romulus and Remus to Nebuchadnezzar—as versions of the Roman emperors themselves, albeit slightly exoticised ones. Who knows if they spotted the ironies that resulted? But it is hard now not to be struck by the fact that Attila the Hun, Rome's infamous enemy, was represented at both La Certosa and Horton Court according to an idiom originally devised to assert Roman autocratic power on coins (Fig. 3.7l).[38]

This centrality of imperial coinage in the Renaissance visual repertoire, and in its reconstruction of historical characters, is nowhere better or more surprisingly summed up than in a few lines of a once popular biography of Jesus, *La humanità di Christo* (The humanity of Christ), first published in 1535 by Pietro Aretino—satirist, theologian, pornographer and friend of Titian. The narrative of *La humanità* frequently refers to visual images, but in the episodes surrounding the trial and crucifixion of Jesus it does so in a very unexpected way indeed. When he tries to capture the appearance of some of the protagonists, Aretino compares them not simply to Roman emperors (though that alone points to the familiarity of emperors as visual types); he explicitly compares them to how those emperors were represented on their coins. Two of the Jewish priests involved in the trial, Annas and Caiaphas, are likened respectively to 'the head of Galba as you see it on *medaglie*' and to 'the coin portrait of Nero, with something of the menacing look of Caligula'. Whatever the awkward theological issues raised by such comparisons, they are as clear a demonstration as you could want of how

imperial coin portraits were embedded in a Renaissance 'way of seeing', and how they offered a standard against which to imagine the faces of the past.[39]

It was not the faces only of the past, but of the present too. For one of the most influential and radical inventions of early Renaissance art was the convention, which lasted into the nineteenth century, of representing living subjects—kings or local bigwigs, statesmen or soldiers, even writers or scientists—in the guise of Roman emperors. These are the statues, busts, paintings and medallions, whether toga-clad, breastplated or laurel-wreathed, which still fill museums and stately homes, parks and public squares by the thousand. They are relatively little discussed in general histories of portraiture, partly no doubt because their classical idiom is easily mistaken for a reactionary artistic form, stale antiquarianism or simply a trite attempt to cash in on the prestige of ancient Rome (their standard blanket description used in modern scholarship—*all'antica* (in ancient style)—though strictly correct is often also a polite dismissal).[40] Their very familiarity often obscures their ambivalence, political edginess and the debates about the nature of representation and the function of portraits that they prompt.

It is worth at this point taking a forward look and reconnecting with the richness, complexity and dangers of this tradition, as we see it from the seventeenth to the nineteenth century—before returning to its Renaissance origins in the work of medal makers and sculptors in the fourteenth and fifteenth centuries. It is hardly an exaggeration to say that Western secular portraiture of living subjects was born in dialogue with the style, faces and dress of the rulers of ancient Rome. This was, of course, as they appeared not only in stamped metal, but in marble sculpture too. Yet one of the main messages of Memling's famous painting of the man with his coin of Nero was to remind viewers that ancient imperial images, on coins in particular, were central to the presentation of the modern face. We shall see just how central.

## The Romans and Us

For many years, until they were removed in 2012 to the nearby museum, two large marble statues of King George I and King George II stood at the entry to the Cambridge University Library, by leading sculptors of their day—one by John Michael Rysbrack, the other by Joseph Wilton. 'The Georges', father and son, who between them ruled Britain from 1714 to 1760 and were major benefactors of the library, stood resplendent in the guise of Roman emperors clad in battle kit that was more ceremonial

than practical. Their faces were pure eighteenth-century, with (it was hard not to imagine) a slight Hanoverian sneer; but they were both depicted in a decorated breastplate, a leather skirt (the so-called 'feathers' or *pteruges*) over their thighs, close-fitting boots, and with a laurel wreath on their heads; George II also embraced a globe, an obvious symbol of imperial domination. Many of the students and staff who regularly walked past them did not notice their attire. Others put it down to a harmless quirk of eighteenth-century artistic fashion, to a faintly silly form of fancy dress, or to the mammoth conceit (or desperation) of two rather ordinary monarchs who fancied themselves as Roman emperors, and certainly did not rule the world. 'Thank goodness they're gone, the pompous puffed-up royals,' was how one library user greeted their removal (Fig. 3.12).[41]

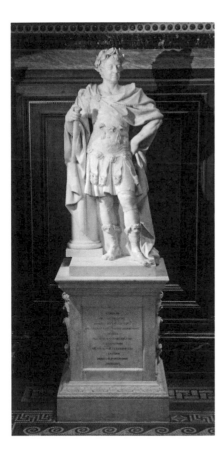 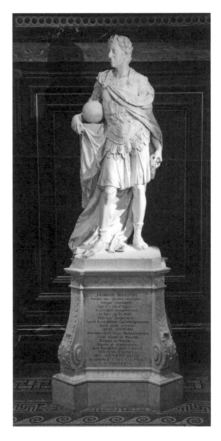

3.12 'The Georges' who once stood at the entrance the Cambridge University Library. By Michael Rysbrack (*King George I*, 1739, left) and Joseph Wilton (*King George II*, 1766, right), both of these life-size statues are dressed up in the military costume of Roman emperors, and crowned with laurel wreaths.

These Georges are just a couple of those vast numbers of portrait sculptures in early modern Europe, the British Empire, and later America which cast their subjects in Roman imperial guise, albeit in subtly different combinations of contemporary and ancient style.[42] In some cases, flowing modern wigs make an incongruous partner for Roman imperial armour. In some just the hint of a toga around the neck of a bust is enough to signal the Roman aspect of the image. Others are floridly 'antique'. Not far from the University Library, in the gardens of Pembroke College (demoted from its original central London location), sits an early nineteenth-century bronze statue of the prime minister William Pitt the Younger, by Richard Westmacott. He is draped in a full toga, carrying a scroll and seated on what looks suspiciously like a throne.[43]

The vast majority of these sculptures are generic images. The Georges are depicted in the standard idiom of 'Roman emperors', with no reference back to any particular ancient ruler or statue. Only occasionally in marble or bronze is there any sign of a direct comparison between the modern sitter and an individual ancient imperial figure. Canova's portrait of Madame Mère as 'Agrippina' is the clearest example of that, though Rysbrack did something similar when he 'merged' the features of one of his slightly less elevated aristocratic subjects with those of Julius Caesar.[44] In paintings, there are more often pointed cross-references. Sometimes that is for fun. It was not surprising, given their interests in the antiquities of Italy, that George Knapton in the eighteenth century should have painted some of the members of the London 'Society of Dilettanti' in Roman imperial outfits. But when he based his portrait of young Charles Sackville directly on Titian's version of Julius Caesar from his cycle of Caesars, it was a two-edged joke meant to appeal to the learned and occasionally tiresomely witty Dilettanti. For Sackville was a notorious 'rake', keen cricketer and opera-buff, who had dressed up as a Roman in a typically louche carnival parade while in Florence in the 1730s, an occasion referred to in the text beside his shoulder on the painting. The comparison of this pleasure seeker, or wastrel, with the commanding presence of the Roman dictator is presumably intended to be glaringly implausible, while at the same time it also hints at some of the more disreputable aspects of Caesar's own career. Determined conqueror he may have been, but his sex life was in the same league as Sackville's (Fig. 3.13, with Fig. 5.2a).[45]

Less of a joke, and more intriguing, is a portrait of Charles I by Anthony van Dyck, painted in the 1630s, a decade or so before the king's execution. It shows him long-haired with his characteristic beard, in a suit of modern armour, his crown and military helmet perched just behind

3.13 George Knapton's mid-eighteenth-century portrait of Charles Sackville, just under a metre high, is closely modelled on Titian's version of Julius Caesar (Fig. 5.2a). The Latin text at his shoulder refers to Sackville dressing up as a Roman consul at a carnival parade (or Roman 'Saturnalia') in Florence in 1738.

him—with nothing at first sight to link the painting to Roman rulers in any way. But the precise stance of the king, his grip on the baton, as well as the shiny angular appearance of the breastplate, were unmistakeably based on another emperor in Titian's series, of which Charles was by then the owner, after acquiring them among his great haul of paintings from Mantua (below, pp. 171–77). In this case, the model is Otho, the extravagant, effeminate libertine (as the Romans stereotyped him), whose main, perhaps only, virtue was to have faced inevitable defeat in civil war with a brave and dignified suicide. It is hard to imagine that this was originally intended as coded criticism of the king. Van Dyck, who was the leading creator of Charles's royal image and the restorer of some of Titian's series of emperors when

3.14 Seen here in an eighteenth-century copy, the pose of
van Dyck's portrait of King Charles I (almost a metre and a half
high) was based on Titian's version of the emperor Otho
(Fig. 5.2h)—known for his libertine lifestyle but a noble death.
The 'un-Roman' royal crown is relegated to the background.

they first arrived at the English court, would be a very unlikely sponsor of
subversion; and Charles himself seems to have been particularly keen on
the original painting of Otho, specially commissioning a print of it, alone
out of all Titian's *Caesars*. Yet any viewer who spotted the source—and
many surely did, since it was part of the best-known set of imperial images
at the time—would have been rewarded with thoughts of the uncomfort-
able similarities between Otho and the English king—particularly after
Charles's execution, the dignity of which stood in contrast to many other
aspects of his career. As Madame Mère later found, there was always liable
to be a reputational risk in looking too much like a particular member of
the Roman imperial family (Fig. 3.14 with Fig. 5.2h).[46]

There were, however, some awkward political issues underlying even those generic images of 'sitter as emperor'. It was all very well to imagine a monarch or dynast in imperial guise. But at his country house of Houghton Hall in Norfolk Sir Robert Walpole, prime minister under the Georges, had his own bust, swathed in its marble toga, surrounded by those of Roman emperors—as if to align himself with them. How could this not be another version of the 'Andrew Jackson problem'? How could a modern republican, anti-monarchist, radical, or even an elite Whig like Walpole, who supported only constitutional, parliamentary versions of one-man-rule, comfortably adopt for himself any image with such resonance of autocracy, or hint at such a clear parallel with the wielders of imperial power?[47]

This has always been a difficulty for those who looked back to—and wanted to ape—the glory days of Rome before the dictatorship of Caesar, in the free democratic Republic, with all its heroic tales of liberty, bravery and self-sacrifice. Glory days they might (or might not) have been; but how on earth did your portrait make it clear that you were being represented as a Roman democrat, not a Roman emperor? For, although a wealth of contemporary literature survives in genres as diverse as comic drama, hard-core philosophy and private letters, little *material* trace of the Republic has been preserved, whether in architecture or sculpture. The frustrating paradox is that almost all the physical remains from ancient Rome come from the 'decadence' of the Empire, from the 'city of marble' with which Augustus replaced, as he boasted, the old Republican 'city of brick'.[48]

If you want to reimagine the world, or the style, of the Republican heroes and their virtues, you more or less have to invent it—and *them*. From Cincinnatus, the Republican patriot who in the fifth century BCE saved Rome then selflessly laid down his power and returned to his farm, to Cicero, their faces and features have been entirely lost. Portraiture certainly had deep roots in Roman tradition, but of those few examples from the time before Julius Caesar that have survived, none, or hardly any, can reliably be named—except in quotation marks, and with an even heavier injection of wishful thinking than in the identification of emperors. Nor, until Caesar, were there contemporary heads on coins to match and compare. Roman prestige portraiture (I am not here talking about more humble images on grave stones) was overwhelmingly imperial. It did not all depict emperors themselves, or course, but almost always it adopted or adapted those imperial styles. It is hard to escape the awkward fact that to be represented as a Roman in the modern world is almost bound to carry with it whiffs of autocracy.

3.15 Horatio Greenough's vast statue of George Washington (1840) was an awkward combination of an imagined Roman hero and the Greek god Zeus (inspired by a colossal statue that once stood in Zeus's temple at Olympia). For several decades in the nineteenth century it seemed safer to house it outdoors near the Capitol. Here it is admired(?) by a group of African-American schoolchildren, around 1900. It is now in the National Museum of American History.

Some artists—like the seventeenth-century German silversmith who crafted a large silver-gilt dish now in the British royal collection—seem to have embraced (or ignored) the difficulties. In the centre he recreated one of the most glorious stories of Republican virtue (Mucius Scaevola at the very end of the sixth century BCE proving his bravery to the enemy by thrusting his right hand into burning flames); while all around the dish's rim, as witnesses to the scene, is an incongruous group of imperial autocrats in their miniature roundels—from Julius Caesar and Augustus, to a number of later rulers, most of whom, Galba included, were victims of civil war.[49] Others did try to escape the problem, if not always successfully. In America, Horatio Greenough's colossal portrait of George Washington evokes the Republican Cincinnatus in the act of returning his sword of office and so returning power to the people. But it was not just far too big and weighty for its surroundings (it nearly broke the floor of the rotunda of the Capitol when it was installed there in 1841); it also disastrously overplayed its hand in modelling the American republican hero on a classical Greek god (Fig. 3.15).[50]

3.16 In the 1760s, Joseph Wilton (the sculptor of the younger George, Fig. 3.12) attempted to give Thomas Hollis—British activist and supporter of the American revolution—anti-monarchical credentials within a Roman idiom. This is spelled out on the base of the portrait bust, where you can just make out that Wilton has carved the symbols (daggers and a 'cap of liberty') used on a famous coin issued by the assassins of Julius Caesar.

More often, portraits of radicals and modern republicans on both sides of the Atlantic opted for a particularly austere version of Roman style, without for example the ballooning drapery of a voluminous toga or the highly decorated armour. It was not so much that they were following a Roman Republican model as is often claimed (for there were hardly any Republican models to follow), they were creating a republican idiom by stripping the imperial portrait of any trace of luxury and excess.[51] Even that was not necessarily enough. In his bust of Thomas Hollis, a wealthy and well-connected eighteenth-century British radical (who followed his anti-monarchical principles in making benefactions to Harvard University), Wilton not only presented his subject reduced to bare flesh, but carved onto the base a pair of daggers and a 'cap of liberty' (the small hat worn by Roman slaves when they were freed by their masters). This was a reference to the design of a coin issued by the assassins of Julius Caesar in the aftermath of his murder, celebrating the freedom of the state that had been won by violence; and it was a clear signal of Hollis's politics. But for us it is also a clear signal that the idea of monarchical power was very deeply embedded

3.17 Two versions of a nineteenth-century royal birthday present, by the German artist Emil Wolff. Both life-size sculptures of Prince Albert in ancient dress, the later version on the right (of 1849) lengthens his 'skirt' in an attempt to give a more sober and serious impression.

in this Roman idiom—and that you had to take drastic steps to counter it successfully (Fig. 3.16).[52]

Queen Victoria and Prince Albert faced similar problems a hundred years later, as emerges from the story of a life-size marble sculpture of the prince that—with typical royal bravura or self-regard—he himself commissioned as a birthday present for his new wife. Representing Albert in imperial guise presented some difficulty, for the obvious reason that he was not the modern emperor, but merely the consort of a ruling queen. The solution of the sculptor, Emil Wolff, in consultation with the subject himself, was to democratise the imperial style with gestures to the iconography of the classical Athenian warrior: the armour that Albert wears is not very far from that of the Georges, but at his feet rests a recognisably Greek helmet, and he holds a Greek shield to match. It was hardly a success. When the first version arrived, Victoria politely said that it was 'very beautiful', but ominously added in her diary that 'we know not yet where to place it'. It ended up being placed well out of sight in a back corridor in their palace on the Isle of Wight—as, she explained, 'Albert <thought> the Greek armour, with bare legs and feet, looked too undressed to place in a

room'. Meanwhile a second version was commissioned, with sandals and a longer 'skirt' to cover a little more of the legs, and this was put on display in Buckingham Palace in 1849. It is a revealing story not only of how kings and queens can have just as embarrassing failures with their birthday gifts as any of us, but of how easily this Roman idiom could implode. Far from creating a figure of distinction, the ancient costume turned Albert into a man in slightly incongruous fancy dress—rather as some Cambridge library users later saw the Georges (Fig. 3.17).[53]

The anxieties of the royal couple also point to bigger questions about the nature of this ancient style, about what exactly was being represented in these modern imperial look-alikes, and about the conventions of viewing that underpin them. A painting by Benjamin West—*The Death of General Wolfe* (the British commander killed at the battle of Quebec against the French in 1759)—had brought these questions dramatically to the surface more than fifty years before, in the early 1770s (Fig. 3.18). West was an American who had studied classical art at first hand in Italy (where he

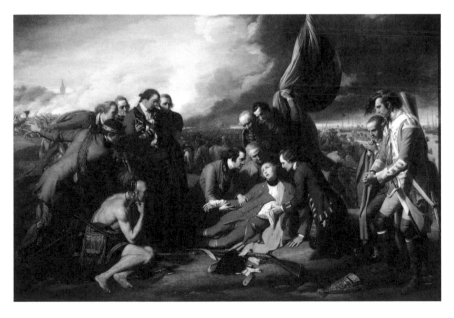

3.18 The battle of Quebec between the French and the British in Canada in 1759 resulted in a British victory, but in the death of James Wolfe, the British commander. Benjamin West's decision to depict his last moments in contemporary eighteenth-century rather than ancient Roman costume was much discussed, even though West was not the first to use a modern idiom for this scene. But the large canvas (more than two metres wide) is striking in other respects: from the Christ-like pose of the dying man to the prominent role of the First Nation Canadian in the composition.

perceptively, or notoriously, compared the famous statue of the *Apollo Belvedere* to a 'young Mohawk warrior'[54]), but worked for much of his life in England, serving as the second president of the Royal Academy after Sir Joshua Reynolds. His depiction of Wolfe became the focus of heated debate because, among other things, he had chosen to portray the general and his companions in contemporary eighteenth-century dress rather than in Roman-style armour or togas.

The painting itself has often been over mythologised as a revolutionary turning point. It was certainly not the first such image to use modern dress (George Romney and Edward Penny had already depicted Wolfe's death in the same contemporary idiom several years earlier[55]), and there were plenty of later paintings and sculpture that went on using an antique style. Not all the visitors and critics who discussed the painting in the 1770s even mentioned the costume anyway, which may have been the preoccupation of a fairly tight circle of art theorists and their patrons. William Pitt the Elder, for example, prime minister like his son, was more interested in complaining about 'too much dejection' on the face of Wolfe and the surrounding company. If it seems, to a modern audience at least, that he had entirely missed the point of the painting, he was probably in tune with the majority of viewers at the time, who were more interested in the emotion of the scene than in what the characters were wearing.[56]

Nonetheless, the debate about the clothing chosen is significant not only for its high-profile participants (which partly ensured the dispute's fame) but also for articulating so clearly some big issues of interpretation. West's own position is unsurprising. When challenged to defend his choice, he insisted that Canada, where Wolfe had died, was 'a region of the world unknown to the Greeks and Romans', which made it especially ridiculous to dress up his characters in ancient costume. 'I consider myself', he went on, 'as undertaking to tell this great event to the eye of the world; but if, instead of the facts of the transaction, I represent classical fictions, how shall I be understood by posterity!' It was posterity that was one of the concerns of his opponents. Joshua Reynolds not only objected to the lack of dignity in the contemporary dress, but also argued that it was only classical costume that could give such a heroic moment in history a timeless permanence; without it, in a few years, the events depicted would simply appear *out of date*.

Most of this information, including the direct quotations, comes from a highly tendentious source: a laudatory biography of West himself. It is meant to pave the way for West's eventual victory over his critics, which culminates, we are told, in Reynolds admitting his error: 'I retract my

objections . . . and I foresee that this picture will not only become one of the most popular, but occasion a revolution in art.' What is more, King George III, whom Reynolds had originally dissuaded from buying it, is supposed to have ended up regretting that he had failed to acquire such a masterpiece. But, tendentiously reported or not, these disagreements vividly capture some of the much deeper questions that underlie these different idioms of representation: questions about different ways of representing the present, about how the passing of time may upset the temporality of an image by turning present into past and about how the boundaries between past and present are defined by, and challenged in, art.[57]

This particular debate is fashioned very much in the style of elite eighteenth-century London, with its elegant repartee between rival painters, and a walk-on part for the king, and even at one point for the Archbishop of Canterbury too, predictably on Reynolds's side; it is almost unthinkable in any other context or at any other date. Even so, the basic logic of these memorable exchanges can help us pinpoint some of the issues that must have been on the agenda centuries earlier, as we return now to probe a little more carefully into the early traditions in the Italian Renaissance of representing modern living subjects—and dead emperors.

## The Renaissance and the Romans

It is often assumed that underneath the decision to represent modern worthies in Roman guise lay a strong alignment between classical and contemporary virtue—whatever the potential political mismatch and the inevitable hints of autocracy. That is, in part, true. In eighteenth-century Britain, more clearly than anywhere else, the investment of the elite in Latin literature and in its language of moral and philosophical debate certainly encouraged the idea that Roman portraits could act as a mirror of—or a template for—the gentleman. When Voltaire remarked in the 1730s that 'the members of the English Parliament are fond of comparing themselves to the old Romans', he was referring to what many modern scholars would call 'self-fashioning': the ancient Romans provided an important model by which these men (and I mean *men*) learned to behave and to see themselves. But there was more to it. For the portrayal of a living subject as an ancient Roman—and more specifically as an imperial Roman—went back much earlier, to the beginnings of the modern traditions of portraiture in the West.[58]

Among the many cultural shifts and subversions of the Italian Renaissance, there were two related revolutions in ways of seeing and ways of

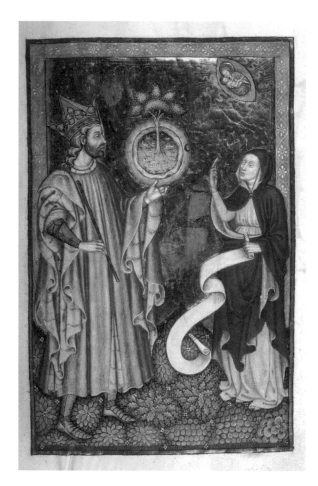

3.19 Full-page illustration of Augustus and the Sibyl, from a manuscript edition of Suetonius's *Lives*, produced in Milan in 1433. The subject is the same as that of Fig. 1.17, but in a strikingly medieval style and costume. The Sibyl on the right points to the Virgin and Child in heaven. The emperor apparently wears armour under his robe, and holds a staff in his right hand and a symbol of the universe in his left.

representing, to which we are in part still the heirs. The first was the radical change, which happened—at different rates in different media, contexts and places—between the fourteenth and sixteenth centuries, in how Roman emperors and other characters from the classical past were portrayed in art. As I have so far only hinted, in the Middle Ages these ancient rulers standardly appeared in the guise of their modern equivalents. In the stained glass at Poitiers, the emperor Nero wears a medieval crown, and the robes of a twelfth-century king to match (without the name 'Nero' written underneath, we would have trouble identifying him—even with the little devil on his back, and the nearby crucifixion of Saint Peter) (Fig. 1.6). And in one gloriously illustrated manuscript of Suetonius's *Lives* produced in 1433, each of the emperors appears in the regal costume of the fifteenth century, with just the occasional laurel wreath to gesture to his Roman identity: Tiberius, for example, is clad in an elaborate red and gold tunic

with stockings underneath, while Augustus in his encounter with the Sibyl—needless to say, not a story told by Suetonius, but here used as the emperor's identifying image—looks suspiciously like a fifteenth-century bishop (Fig. 3.19).[59]

The contrast is glaring with the depictions in ancient Roman style that we explored in other manuscripts earlier in this chapter. There was a considerable period of overlap between these two idioms (the ecclesiastically dressed Augustus is later than some of those illustrations of Suetonius based closely on ancient coins). Nonetheless, as time went on, Renaissance artists increasingly re-created—and Renaissance viewers expected—emperors who looked like Romans, not like their own contemporaries. By the end of the sixteenth century virtually no artists at all were dressing up their ancients in modern clothes. This change is often put down to a growing knowledge and understanding of the authentic remains of the classical past, both literary and visual. But, important as that antiquarian expertise was, it does not explain everything. The artists who worked in the earlier idiom knew perfectly well that Roman emperors wore togas not doublets and hose—just as Shakespeare knew that Romans did not wear breeches, as the actors in his *Julius Caesar* did, and Joshua Reynolds knew that General Wolfe had not died at the battle of Quebec kitted out in a Roman breastplate and military skirt.

Underneath these major changes in Renaissance art lie some of the issues that were made explicit a few hundred years later in the clash between Reynolds and Benjamin West. At stake were changing answers to questions of how the present and the past were to be envisaged, and how the similarities and differences between the ancient and modern worlds were to be expressed. It can hardly be a coincidence that, more or less simultaneously with the 'correct' representation of Roman emperors, a parallel revolution in the portraits of the living saw modern subjects for the first time represented in the guise of ancient Romans. To oversimplify somewhat (because, as we shall see, there were always exceptions and other idioms available), the European Renaissance—especially, in the first instance, in Italy—was a time when Roman emperors ceased to be portrayed as if they were modern rulers, and modern rulers started to be portrayed as if they were Roman emperors.[60]

The exact reasons for these changes are now irrecoverable, and many different factors and inheritances must have been involved, in what was part of a much bigger artistic revolution. Roman imperial heads themselves, whether in miniature metal or occasionally full-sized marble, were certainly one impetus behind the distinctive conventions of portraiture that

developed in this period; but I am not trying to suggest that they were the only driver. Specific earlier traditions also played a part, from personalised seal stones, busts containing relics of saints (so-called 'reliquary busts'), to the tiny lifelike figures of the donors and sponsors often incorporated into major religious paintings. And the growth of portraiture as a genre was no doubt linked to wider cultural and intellectual trends (the Renaissance 'discovery of the individual', as one popular over-generalisation would have it).[61] There are also any number of micro-differences across Europe, and in different media, even if the overall pattern is similar almost everywhere.

That said, images of the Caesars were hugely influential in the development of the visual language of modern portraiture, especially though not entirely of men, in which an idiom of the past was repeatedly adapted for the representation of the present. This was what Reynolds's shorthand would later present as 'timelessness'.

It can hardly be a coincidence that what is almost the earliest freestanding portrait bust of a living person to have survived from the modern era in the West is cast in Roman imperial style. This is the marble sculpture by Mino da Fiesole, produced around 1455, depicting Giovanni, the son of Cosimo de' Medici of Florence; it is reckoned to come a close second in date to the very earliest bust, a portrait, also by Mino, of Cosimo's other legitimate son, Piero, carved just a couple of years before, in 1453–54. What distinguishes the image of Giovanni from that of his brother is that he is dressed in elaborate antique armour, not out of character with the garb of the Cambridge Georges. It is impossible to know what exactly prompted the sculptor to adopt this particular idiom (Giovanni had a keen interest in classical antiquity, but so also did Piero). Whatever the reason, it is a powerful sign that the conflation of modern sitter and ancient emperor, however differently and intensely it might have been inflected later, was embedded at the very earliest stages of this artistic tradition (Fig. 3.20).[62]

Once again, however, it is coins and *medaglie* that defined this conflation most clearly, and even earlier. I am not referring only to those skilful replicas or clever fakes of ancient coinage made by the likes of Cavino, or the 'coin-like' images that defined the faces of the past, as at La Certosa. The living too had a stake in this. From as early as the 1390s, we find a rich and illustrious tradition of bronze portrait medallions of modern subjects (*medaglie*, or medals, in our sense), on a rather larger scale than 'real' coinage, as much as several centimetres in diameter. They regularly carried images of their sitters which mimicked the Roman emperor's head on coins (or, where a woman was the subject, that of his wives or daughters), often with an identifying inscription around the profile. And these were accom-

panied by a whole variety of reverse (or 'tail') designs, usually celebrating the virtue of the person concerned, and sometimes copying closely what was found on an ancient coin. Here the modern portrait had almost totally merged with the Roman (Fig. 3.21).

In museum cases today, these medals tend to be overlooked, just as arrays of ancient coinage are. Our modern preoccupation with portraits in paint or life-size marble has tended to deflect attention from small-scale plaques of bronze. But in the Renaissance, in northern Europe as much as in Italy, they had enormous political and social importance, being widely circulated to spread the image of their subject ('the currency of fame' as they have been called, even though they were never coinage in the monetary sense). Many were the work of leading and experimental artists, not the hackwork of mass production—even if replicability was part of their appeal.[63]

The connection they paraded between images of ancient emperors and images of the living, and so also between the past and the present, was part of their point. One of his learned correspondents actually wrote to Leonello d'Este, Marquis of Ferrara, who commissioned thousands of such medallions, congratulating him on having appeared on them 'after

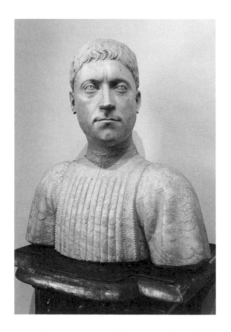 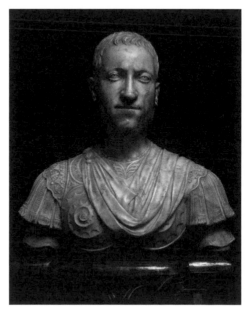

3.20 Two sons, two idioms: on the left Mino da Fiesole's portrait of Piero, son of Cosimo de' Medici (1453–54); on the right, a couple of years later, in classical style, his brother Giovanni; both are almost life-size.

COINS AND PORTRAITS, ANCIENT AND MODERN

3.21 The classical and the Renaissance merge. A bronze medallion by Pisanello (about ten centimetres in diameter) commemorating Leonello d'Este, Marquis of Ferrara, with his titles in very abbreviated Latin around the edge: 'GE R AR' identifies him as the son-in-law (GENER) of the king (REGIS) of Aragon. On the reverse, marking the marquis's marriage, a little lion ('Leonello') is being taught to sing by Cupid (under the signature of Pisanello).

the fashion of the ancient Roman emperors, with on one side your name inscribed next to the representation of your head'. Other commentators suggested more nuanced links between the Roman coins and the *medaglie* of the present day. Filarete, who produced some splendid examples of modern imperial medallions himself, referred to the practice of burying them in the foundations of new buildings (following what was believed to be the Roman custom of burying coins); and, in another nice twist on the conflicting temporalities of representation, he speculated on how future archaeologists would one day discover them, just as his own contemporaries found such things when they dug down into the ruins of ancient Rome. The fact is that wherever you look in the theory and practice of Renaissance portraiture, Roman emperors are not far away.[64]

That is one thing that Memling's portrait, with which we began this chapter, is insisting on. Of course, here as always, the combination of the modern subject with a particular emperor raises troubling questions—which do not go away however hard you might assert that it is all a clever pun, a moral message or merely a tribute to the artistic quality of Neronian coins. As with Charles I and Otho, or Madame Mère and Agrippina, so also with this anonymous sitter—Bembo or not—and Nero, suspicions are always raised if you know the stories of the emperor or empress concerned.

But in having the subject display the coin so prominently as the distinctive emblem of the portrait, Memling was making much bigger points about his own practice and about representational practice more generally. Roman imperial portraits underpinned the idea of modern portraiture. The faces of Roman emperors on coins served to validate the images of living sitters as well as the subjects of the past. Portraiture could be perceived not simply as a binary relationship between artist and subject, but as a triangulation between artist, subject and the image of the emperor—in coin.

But there were other ways in the Renaissance of configuring the idea of the Roman emperor. And one of those—which we have so far only touched on—was as a *set*, in particular as a set of the Twelve Caesars. Though, as we shall see in the next chapter, this was a much more contested set than we might imagine.

# IV

# THE TWELVE
# CAESARS,
# MORE OR LESS

## Silver Caesars

One of the great mysteries in the history of art is the set of twelve grand and exquisitely decorated silver-gilt dishes (or *tazze*, in Italian), each one with a miniature Roman emperor poised at its centre (Fig. 4.1). Now known as the 'Aldobrandini Tazze', after the Italian family who once owned them, they stand half a metre tall, from the foot of the bowl to the head of the emperor, and rank as some of the most impressive pieces of Renaissance silverware anywhere. But their backstory is frustratingly obscure. We do not know exactly when they were made (sometime in the later sixteenth century, but how much earlier than the first documentary record of them in 1599 is debated). We do not know where or by whom (there are some distinctively northern European features in the designs, but—in the absence of any assay marks—suggestions for their origin have ranged from Augsburg to Antwerp). We do not know who commissioned them. Their combined weight in silver, more than thirty-seven kilograms, certainly points to an original owner who was one of the period's super-rich—but not Cardinal Pietro Aldobrandini who, as contemporary documents show, did not acquire the full set until the early years of the seventeenth century, although it now takes his name. It is impossible even to be sure what they were for, how they were used or displayed. The idea that they were designed to decorate some lavish banqueting table is a very plausible guess, but no more than that.[1]

4.1 'Claudius' from the set of Aldobrandini Tazze made in the late sixteenth century, standing almost half a metre tall from top to base. The emperor, in Roman military dress, his name inscribed near his foot, is detachable and can be screwed into and out of the bowl—which carries intricate scenes from his life. This is the original stem and base (unlike six of the set, which were refitted with more elaborate supports in the nineteenth century).

What *is* certain is that—even if we cannot pin down the precise date of manufacture—their decoration adds up to the earliest systematic attempt to illustrate Suetonius's *Lives of the Twelve Caesars* to have survived. This is not like individual, exquisite manuscript illustration, which goes back earlier. Here, on the inner surface of each bowl, four scenes selected from the *Life* of each emperor were engraved in the silver, carefully arranged in the order in which they came in the text (the only exception being that if a triumphal procession was illustrated, celebrating some military victory won by the emperor during his reign, this consistently appeared as the

finale, even if that disrupted the chronology²). It is almost as if the silver emperors, screwed into the centre of the bowl, with the name of each—from Suetonius's Julius Caesar to his Domitian—inscribed at their feet, look down to survey their life story beneath them.

The imperial figures themselves appear relatively conventional, almost a little bland (although a look at their faces in profile makes it instantly clear that they were based on portraits on coins). But the narrative scenes on the bowls are highly distinctive, minutely crafted and packed with detail. They include some episodes that remain modern favourites, almost the emblems of the emperor concerned. Nero, for example, is pictured 'fiddling while Rome burns': that is, he is shown playing his lyre in a tower overlooking the city, while flames blaze all around him and the citizens are escaping with their prized possessions (Fig. 4.2a). But others point to different priorities among Renaissance artists and viewers, illustrating parts of Suetonius's narrative that modern readers tend to pass over. Several of those bizarre omens of future imperial power that few of us now take seriously here get star billing. The first scene on Galba's bowl shows an eagle snatching away the entrails from a sacrifice being conducted by the future emperor's grandfather: 'it meant', as Suetonius put it, 'that supreme power, even if late coming, was predicted for his family' (Fig. 4.2b).³ Overall, the view of the imperial regime that the scenes present is markedly positive, not to say triumphalist. Military victory, in particular, is celebrated. There are no fewer than nine scenes of triumphal processions or their equivalent (Fig. 4.2c), while, despite Suetonius's interest in the deaths of his subjects, there is only one death scene in silver. That is the brave suicide of Otho in 69 CE, who is pictured reclining on an elegant couch as he stabs himself in the chest (Fig. 4.2d).

Whoever made these dishes (and several artists must have been involved), the overall designer had certainly read Suetonius with care, and captured all kinds of tiny detail: from the birds that were said to have been scattered over Nero during his victory parade to the elephants with torches that were a feature of Julius Caesar's.⁴ But there were other sources too. Two scenes, featuring the port at Ostia (a project of the emperor Claudius) and the Circus Maximus (where Domitian presented lavish shows), are close copies of prints, reconstructing both monuments, by the sixteenth-century antiquarian Pirro Ligorio (Fig. 4.2e). It is almost certain that Roman coins—or, more likely, a printed compendium of coin designs or even an edition of Suetonius which used relevant coins as illustrations—lay behind Ligorio's reconstructions.⁵ These drew not on the heads, but on the images of the 'tails', which often featured some of the buildings of the city of Rome,

4.2 Scenes from the bowls of the Aldobrandini Tazze:

(a) Nero 'fiddling while Rome burns'

(b) Omens of Galba's rise to power

(c) The triumph of Julius Caesar, showing the elephants mentioned by Suetonius

(d) The suicide of Otho

(e) Claudius's harbour at the port of Ostia

(f) Nero playing his lyre in a theatre

as well as its costumes and rituals. A striking case of a similar borrowing is the image on the *tazza* of Nero which shows the emperor giving a musical recital on stage: the emperor's pose is taken wholesale from the 'tails' of one of his coins, which shows the god Apollo, or—as some believed—Nero

himself, playing his lyre (Fig. 4.2f).[6] Those miniature designs once again were providing a template for re-imagining the Roman world.

This lavish, learned and slightly self-congratulatory line-up in the Aldobrandini Tazze captures one aspect of the Twelve Caesars. We have already encountered a few stand-alone celebrity images of Roman emperors ancient and modern, and there are more to come. But Caesars—whether in marble, metal, paint or paper—are now more often presented to us in groups or as collections. Where we find one imperial figure, another is likely to be not far behind: brother, father, wife, successor or a whole dynasty. These precious silver Caesars sum up one vision of this plurality, carefully ordered and identified, two complete dynasties with the rival candidates of the civil war in between, a fixed and bounded set.

It will come as no surprise to discover that the Suetonian Twelve on this model have sometimes stood as visual symbols of the very principles of classification, representing the systematic ordering of knowledge itself. We shall take a careful look at some of that ordering, and find the Caesars underpinning, for example, that most rigorous of classificatory schemes, namely the library catalogue. But much of this chapter will focus on the other side of modern collections of Roman rulers, whether the canonical twelve or slightly more expansive versions: that is, on their disorder, their subversive variants, their losses, incompleteness, misidentifications, rearrangements and frustrations. We shall be looking at collections of emperors as 'works in progress', and at the Twelve Caesars as a paradigm that has always been pointedly resisted as much as it has been followed, a focus of debate and uncertainty as much as an artistic rulebook or straitjacket. That will turn out to be the case even for the Aldobrandini Tazze, in a very unexpected way.

## The Perfect Set?

As objects of art the Twelve Caesars were a Renaissance invention.[7] A modern tribute to Suetonius's *Lives*, from Julius Caesar to Domitian, and an attempt to visualise the heroes and antiheroes of that literary text in material form, they also represented a classicising variant on some of those other canonical groups of historical figures who were repeatedly re-imagined in early modern art—such as the Twelve Apostles or the Nine Worthies (who were made up of Julius Caesar, with Alexander the Great and the mythical Trojan hero Hector, alongside three Jewish and three Christian characters to match). They provided a template for modern monarchs too, who had their dynasties squeezed into runs of twelve to mirror the Sue-

tonian Twelve. This was never more extravagantly presented than in the 'Portico of the Emperors', part of the stage set designed by Rubens for the triumphal entrance into Antwerp of the Habsburg Prince Ferdinand in 1635: it showcased twelve larger than life-size, gilded statues of the Habsburg monarchs from Rudolf I to Ferdinand II, as the new Twelve Caesars.[8]

After tentative beginnings in the sculpture of the mid-fifteenth century, by the mid-sixteenth portrait groups of the Roman imperial dozen had become a distinctive feature of European (and later American) décor, from the grandest to the relatively modest, and in almost every conceivable medium.[9] From time to time, artists and patrons enjoyed incorporating original sculptures, restored and reworked to fit, in their line-ups of marble busts.[10] But the majority of these images were entirely modern works, albeit based directly or indirectly on ancient prototypes, and they were still being produced well into the twentieth century. They were also ubiquitous. Despite the occasional scholarly blind spot (one of the most thorough cataloguers of the Twelve Caesars recently went so far as to claim that there were no such sets—in stone at least—in England[11]), there was no country in the West that they did not invade, even if they came later to some than to others.

They certainly appealed to the taste of the very rich. There was hardly an aristocratic residence in Renaissance Rome without at least one complete set of busts of the Caesars. The Villa Borghese currently has two on show (Fig. 4.3). One is a seventeenth-century set in porphyry and alabaster giving its name to the 'Room of the Emperors', the other was carved in the late sixteenth century by Giovanni Battista Della Porta, whose family workshops were responsible for many of the imperial faces in Rome around that period (including two more groups of the Twelve in the Palazzo Farnese, one of which—in its own 'Room of the Emperors'—was accompanied by copies of Titian's painted series of the Caesars from Mantua).[12] They found their place, as collectibles or precious curiosities, in the cabinets and treasuries of statesmen, cardinals and kings. A neat row of twelve small plaques carrying imperial heads is shown fixed to the wall behind an array of works of art, stuffed birds, flowers, globes and assorted pets, in paintings of the private gallery of a leading Flemish politician in Brussels in the 1620s (Fig. 4.4).[13] And Rudolf II, Holy Roman emperor at the turn of the sixteenth and seventeenth centuries, rivalled the patron of the Aldobrandini Tazze in having two sets of the Twelve Caesars in silver (one apparently freestanding busts, the other relief plaques) in his castle outside Prague; in this case, though carefully itemised in an early seventeenth-century inventory, they have long since been lost, most likely recycled or melted down.[14] In the open air, they lined the carefully designed 'natural' *allées* and

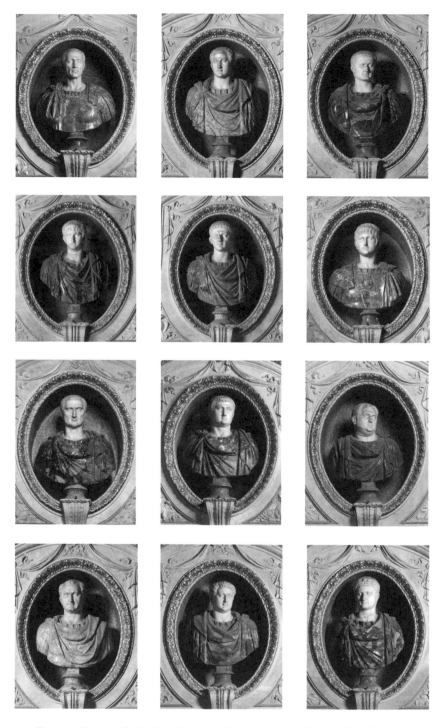

4.3 Giovanni Battista Della Porta's sixteenth-century set of busts of Twelve Caesars in the Villa Borghese in Rome, placed high on the walls of the grandest reception room: they make up the canonical set from Julius Caesar to Domitian.

4.4 Hieronymus Francken and Jan Brueghel the Elder commemorated the visit to a private collection in Brussels of the Habsburg governors of the Southern Netherlands (Archdukes Albert and Isabella) in the 1620s. The panel, over a metre wide, depicts the variety of the contents of this 'cabinet': sculpture, paintings, seashells, a stuffed bird—and a set of plaques of the Twelve Caesars on the back wall.

walkways in ornamental gardens. One useful reminder that more recent fortunes too have been ploughed into emperors is found at Anglesey Abbey, a large country house in the east of England. Here, in the early 1950s, Lord Fairhaven, whose wealth derived from a lucky combination of an American industrial inheritance and success in British horse breeding, constructed an 'Emperors' Walk'—with a collection of twelve eighteenth-century Caesars he had bought on the antiques market, strikingly set off against the trees.[15]

Such collections were not, however, merely the treasures of aristocrats or the aspirational; they extended into less elite homes and less elite media too. Any number of sets of Twelve Caesars in etchings and engraving were produced in the 1500s and 1600s, to end up in libraries or hanging on the

walls of more modest residences: emperors in close-up, head and shoulders, full-length, or on horseback, and often accompanied by brief biographies, or miniature scenes illustrating key moments in their lives. The introduction to a collection of prints of imperial heads, published in 1559 with accompanying text by Jacopo Strada, discusses the function of such images and justifies the production of yet another set. It stresses their use as wall display, singling out the decoration of 'dining rooms' (*triclinia* in the original Latin text), and explains the particularly large size of this edition: this was a gesture to visual frailty, and to ensure that even the elderly and those with poor sight should be able to appreciate the imperial faces.[16] Other emperors found their way into different media. In mid-sixteenth-century France, someone with a little more money to spare owned a tiny casket decorated with enamel roundels that had borrowed some of its distinctive imperial portraits from Marcantonio Raimondi's series of prints of emperors (Figs 3.7n; 4.8), completed by two almost absurdly chubby *putti* clutching skulls underneath the slogan 'Memento mori, dico' (Remember you must die, I say). 'These emperors are dead and gone, to serve now as mere decoration,' must have been part of the message (Fig. 4.5).[17]

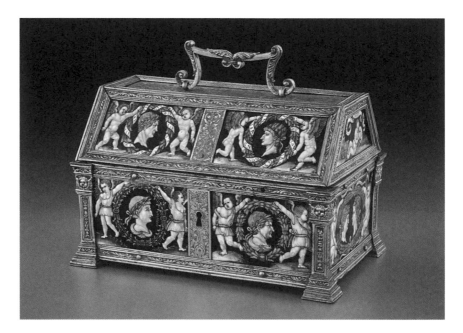

4.5 This tiny metal casket (only seventeen centimetres in length), made c. 1545, carries enamel images of the Caesars, some based on the engravings of Marcantonio Raimondi (with some later replacements). Eight single images fit into the long sides, with 'doubles' (two facing heads within one wreath) at either end to make up Twelve.

4.6 A nineteenth-century mass-produced bronze medallion of Caligula, ten centimetres across, with two holes for nailing it to a wall or furniture. Very likely it was originally part of a set of Twelve, whether to be acquired piecemeal or all together.

A bourgeois market was certainly one target in the eighteenth and nineteenth centuries for many series of small mass-produced imperial portrait plaques in metal or ceramic, sometimes featuring the canonical Twelve (Fig. 4.6). Josiah Wedgwood, one of the most successful English pottery manufacturers of the 1700s, was quite explicit about his aim of making available high culture to the '*Middling Class* of People'. His sets of small collectible roundels featuring the heads of Roman emperors, and their wives, alongside Greek heroes, various kings and queens and (with rather less popular appeal) popes no doubt did just that, as well as adding to the Wedgwood fortune.[18]

There was pleasure to be had, and money to be made, from sets of the Twelve Caesars. But it is important not to forget—as it can be easy to do when we see these faces lined up against museum and gallery walls— that there were disappointments and dissatisfactions too, failures as well as successes. One particularly unfortunate mid-eighteenth-century experiment in waxwork is, to our eyes at least, a strangely unattractive 'mistake' (Fig. 4.7).[19] But things could go wrong even in the most standard media and even for those with plenty of resources behind them. We can all sympathise with the man commissioning a set of Twelve Caesars to decorate an English country house in the 1670s, who discovered that the first consignment to arrive from Florence had the wrong features on the wrong emperors. Complaining of the sculptors, he wrote, 'I find fault with them that they have ignorantly planted beards upon those chinns which never wore any'; so, he lent them some of his own coins to help them get the appearance right.[20]

4.7 Four small wax relief panels of emperors (within the frame they are only fourteen centimetres high), from what is now a series of ten: Titus has probably been recently lost; Caligula may very likely never have been made (or it went missing very early). Here: Julius Caesar, Augustus, Tiberius and a quizzical Claudius.

One hallmark of these sets of Caesars, like the Aldobrandini Tazze, was the sense of *completion* they implied. That was signalled by the numbers, I to XII, often printed or inscribed next to the imperial faces on paper or plaques, and sometimes even on more prestige painting and sculpture. These made an obvious incentive, for those who had not acquired the complete set all at once, to fill the gaps (and, of course, it was from the principle of 'filling the gap', or of getting the buyers 'hooked', that much of Wedgwood's profit came). But the numbers were also about asserting a sense of *order*. That was partly in practical terms: they enabled anyone to line emperors up 'correctly' even if they could not quite remember whether Otho (VIII) came before or after Vitellius (IX); and, in the case of those imperial chairs (Fig. 1.12), no matter who drew the short straws of Caligula or Nero, they offered a diagram for the seating plan at dinner. There was, however, a bigger point. As one art historian has recently summed it up, numerical cycles of the Caesars 'seemed to symbolize the encyclopaedic knowledge of collectors'; they reflected 'a complete well-ordered knowledge of the past'.[21]

There is a hint of that in the painting of the Flemish collector's gallery (Fig. 4.4): the neat imperial line-up on the rear wall suggests a sense of system and order underlying what we might otherwise mistake for clutter and disorder. But it is taken to its logical extreme in the library of the English collector, antiquarian and politician Sir Robert Bruce Cotton, which he started in the late sixteenth century, and which became one of the most important and valuable collections of books and manuscripts in the country, as well as housing coins and curiosities. Here, bronze busts of the Twelve Caesars were placed on top of the ranks of the shelves in cupboards (or 'bookpresses') and provided the system of classification for the contents below. Even now, in the British Library—which was founded in the eighteenth century around the nucleus of the Cotton library, and where most of its contents that escaped a fire in 1731 have been preserved—anyone who wants to consult the only surviving manuscript of *Beowulf* must order it as 'Vitellius A xv' (originally the fifteenth item on the top shelf of the Vitellius press); for the *Lindisfarne Gospels*, the call number is 'Nero D iv'. There was no obvious connection in subject matter between the imperial character above and the texts below, but emperors and their images stood, and still stand, for the whole taxonomic system.[22] That is reflected too in other libraries across the world, and goes beyond the common practice, with roots in antiquity itself, of using ancient busts to provide appropriate décor for the bookish environment ('library busts' as they are still advertised in

upmarket sales catalogues). At roughly the same date as Cotton was establishing his own collection, the library at the Villa Medici in Rome was installed, also with imperial busts above the shelves.[23] There is perhaps a faint echo of that tradition in the marble busts of a selection of emperors that even now adorn some areas of New York Public Library: knowledge and libraries still operate under the sign of the Caesars.[24]

Yet the Cotton system also reveals the ragged edges of its own categories. Its main lines were certainly defined by the succession of Suetonius's emperors from Julius Caesar to Domitian, but two women with imperial connections were also part of the classificatory scheme: Cleopatra, the queen of Egypt, one-time partner of Julius Caesar and defeated enemy of Augustus; and the second-century CE Faustina, the reputedly virtuous wife of the emperor Antoninus Pius (but, as with the first-century Agrippinas, there was also a disreputable daughter of the same name, who was the wife of Marcus Aurelius and hard to tell apart from her mother). This pair is often treated as an addition to the main set. So they might have been. One recent attempt to reconstruct the physical layout of the Cotton library, long since destroyed, has the Cleopatra and Faustina section in a subsidiary alcove off the main series of presses, between Augustus and Tiberius.[25] It is possible that it was later proprietors or curators of the library who devised these extra sections, and not Cotton himself. But whoever was responsible, it underlines how flexible and *porous* the canonical category of the Twelve Caesars could be, and just how easy it was to disrupt the standard line-up—in this case with the dissonant characters of one later, virtuous imperial wife (if we have the correct Faustina), and one imperial mistress and victim. It is a flexibility that is found time and again, and it makes the Twelve Caesars a far more dynamic—and interesting—category than it might at first seem. What we call 'the Twelve Caesars' are often not quite that at all.

## Reinventions, Ragged Edges and Work in Progress

From the very moment that modern artists began to produce images of the Twelve Caesars they were already redefining, adapting and having fun with the category. It is impossible now to pinpoint exactly when and where the first attempt was made to capture Suetonius's emperors in stone, but there are clear references in Italian accounts and inventories as early as the mid-fifteenth century to sculptors producing, and being paid for, 'twelve heads', 'twelve marble heads of emperors' or even 'twelve marble heads taken from *medaglie* of XII emperors'; and a number of images which seem to fit the description still survive—for the most part marble relief panels,

some more or less matching in size and style, depicting coin-like profile portraits of imperial characters. All kinds of puzzles about these remain, and it has proved frustratingly difficult to link the people who might have commissioned the earliest sculptures (Giovanni de' Medici, the subject of the first modern imperial-style portrait (Fig. 3.20), has been one of the candidates), with the contemporary artists who produced them and with the images themselves. No complete set has been preserved. What is absolutely clear, however, is that these innovative line-ups of 'twelve emperors' were not always the same as the canonical Twelve. Within the elite culture of the mid-fifteenth century the phrase 'Twelve Caesars' undeniably pointed to the text of Suetonius and 'his' emperors, but the sculptors (or their patrons) made their own 'substitutions'. It is hard otherwise to explain the presence, amongst the surviving panels, of Agrippa, son-in-law and right-hand man of Augustus, and of Hadrian and Antoninus Pius, alongside Julius Caesar, Augustus, Nero, Galba and others–in place, it seems, of Caligula, Vitellius or Titus.[26]

Half a century or so later, the very first series of prints to commemorate the Twelve Caesars allows us to identify more precisely the kind of substitution that was going on. This was that impressive, influential and much replicated set originally produced by Marcantonio Raimondi in 1520—who, in designing it, as we have already seen (Fig. 3.7n), inadvertently confused the titles and coin image of Vespasian with that of his son Titus. A line-up of Twelve Caesars it certainly was. But, even allowing for such errors, it was not quite the Suetonian Twelve. In place of Caligula, inserted in the last slot, as '12' in the numbered sets, was the emperor Trajan (98–117 CE), with his names, titles and standard portrait type derived, like the others in the series (and correctly in this case), from coin heads. Or so Raimondi intended. Ironically, more than one major modern museum would have us imagine that his line-up was actually completed by the emperor Nerva, who ruled briefly between 96 and 98 CE: the uncharismatic, elderly successor of Domitian, and the adoptive father of Trajan. This is because their cataloguers have made exactly the same type of blunder in identifying this final emperor as Raimondi himself made in mixing up his Vespasian and Titus. As is very easy to do with these almost identical imperial names, they have confused the 'Nerva Traianus' on the print (that is, as we would call him, 'Trajan') with his predecessor, who was just plain 'Nerva'. These errors in identification, repeated, even by some of the best-qualified experts, across almost half a millennium, must count as another factor in the slipperiness of the category. They also offer a warning about scoffing too loudly at the mistakes of earlier generations: the full versions of emperors' names, in

all their deceptive similarity, have been tripping up the wary as well as the unwary for centuries (Fig. 4.8).[27]

Why these substitutions were made, we can only guess. The usual explanation is that there was a moral agenda underlying them, with the aim of inserting a 'good' emperor into the Twelve in place of a 'bad' one, in order to make the set a more convincing role model: hence Trajan, some-

4.8 Marcantonio Raimondi's early sixteenth-century engraving of Trajan (emperor 98–117) is now commonly misidentified as his predecessor and adoptive father Nerva (96–98) from the Latin titles around the edge. It is an understandable error. Trajan's title was (as here) 'Imp[erator] Caes[ar] Nerva Traianus Aug[ustus] Ger[manicus]' etc. But 'Nerva' is a reference back to Trajan's father, and does not point to the emperor Nerva himself (whose titles would have been 'Imp[erator] Caes[ar] Nerva Aug[ustus]' etc.).

times dubbed *optimus princeps* (the best emperor), ousted the reputedly monstrous Caligula. There is no doubt something in this, even if it does not entirely explain, for example, the apparent omission of Titus from those early marble profiles (though a 'golden boy' in the biographical tradition, he perhaps did not have sufficient popular recognition); nor does it explain why Raimondi rejected Caligula but apparently had no problems about including the equally appalling Domitian and Nero.

The bigger point, however, is that the canonical Twelve thrived on difference, as well as on standardisation. It is only over the last century or so, when the academic straitjacket had tightened, that the habit of ringing the changes has ceased. It was not only Titian who stopped short of Twelve, ending with Titus and omitting Domitian in the Caesars he painted for Mantua in the 1530s. To judge from an early inventory of the collection, the unfortunate waxwork experiment (Fig. 4.7) was originally a truncated set which left out Caligula.[28] Even more radical variations on the theme were possible. In 1594, the Fugger family of Antwerp erected a 'pop-up colonnade' (*porticus temporaria*) of the Twelve Caesars as part of the celebrations to welcome yet another of the junior Habsburgs (in this case Rudolf II's younger brother). It was on a more modest scale than Rubens's later ostentation in the 'Portico of the Emperors', but offered a more varied mix of characters. The design featured the four 'best' Roman emperors, in images five metres high: Augustus and Titus (included this time, as the conqueror of Jerusalem), plus Trajan and Antoninus Pius; but these were followed by four Byzantine emperors and, tactfully, four Habsburgs to make up the dozen.[29]

In short, like many such categories, which at first sight appear rigidly uniform, the 'Twelve Caesars' was one to be adapted, reconstructed, re-invented and modernised around the symbol of that canonical number. It was as much a *dialogue with*, as a precise attempt to *replicate*, the Suetonian Twelve. Those who looked with care would find not simply more of the same, but new questions always being raised about the category itself. Particular substitutions (a 'good' emperor for a 'bad') or curtailments (eleven rather than twelve) always promised, or threatened, to add new meaning to the set.

That flexibility, or sometimes disorder, was given an extra edge by the process of collecting itself. To be sure, some of those matching marble series of the Twelve Caesars in palaces and gardens were produced as a single commission or acquired as a one-off purchase. Indeed, almost all imperial sets, when we look at them now in museum cabinets and on gallery shelves, are liable in retrospect to appear frozen and finished, as if that is

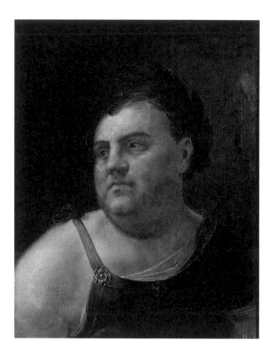

4.9 Hendrick Goltzius's *Vitellius* (roughly seventy by fifty centimetres) from the series commissioned in the early seventeenth century probably by Maurits, Prince of Orange. Goltzius died at the beginning of 1617, which would make this implausible, 'off-the-shoulder', emperor the first in the series. But the timings, the commission and even the artists are not well documented.

how they had always been intended. But collections—of Caesars as much as of anything else—were often works in progress. It was not only those without the financial resources, such as Wedgwood's more modest clients, who acquired their emperors piecemeal. The 'fun of the chase' has often been an important driver here. Many of even the richest collectors enjoyed the incremental pleasures of constructing the set, and of gradually filling the gaps (as well as creating new ones, if it looked as if the chase might end prematurely).

That is signalled in an intriguing way in Fulvio's *Illustrium imagines* (Fig. 3.7h and i), where occasionally a blank roundel takes the place of a portrait. In part, this is a pledge of authenticity ('in the absence of a reliable image of this person, I will merely indicate a blank'); but these empty spaces were also a reminder that there was always more to add to a collection (even in print), always a specimen that you did not have.[30] There were other ingenious ways of insisting on variety. One Netherlandish prince in the early seventeenth century, for example, commissioned a set of the Twelve Caesars—but each one from a different artist. The finished paintings arrived over a period of years between 1618 and 1625, depending on the speed of the painters. They ranged from a chillingly stern Julius Caesar by Rubens to an almost absurdly semi-clad Vitellius and an innocently dreamy Otho by rather lesser talents (Fig. 4.9).[31]

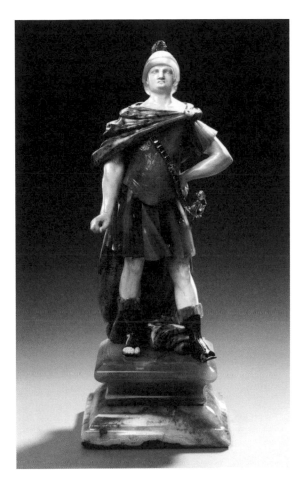

4.10 This diminutive eighteenth-century figure (about twenty-six centimetres high including the base), in precious and semi-precious stones, gold and enamel, represents the emperor Titus. Carved separately, the different parts (arms, faces, etc.) were then bound together with very strong glue!

It is clear that the aims of some collectors, even if they had begun modestly enough with a desire for just the first Twelve, were constantly extendable. The German princess who was so proud of her ancient coins had surely not started out with the ambition of acquiring a specimen for each ruler from Julius Caesar to Heraclius; her aims grew with her collection. Others found their ambitions thwarted or cut off in midstream. Archives from the early eighteenth century allow us to track the gradual acquisition by Augustus 'the Strong', elector of Saxony and king of Poland, of a miniature, and frankly rather gaudy, set of emperors in semi-precious stones: a tiny Domitian was the first he bought, followed by a matching Titus in the following year, and a Vespasian in early 1731 (so far working backwards through the Flavian dynasty); but a few months later a Julius Caesar was added (Fig. 4.10). And that is where this set stopped in its tracks. All kinds of factors may have been at work, from a capricious change of heart on the

part of the elector to one on the part of the artist. That said, the chances are that had Augustus 'the Strong' lived a few years beyond early 1733, we would now be looking at a set of the Twelve Caesars, not Four.[32] In other cases, collections developed and changed over time through accidental loss, theft, breakages and rearrangement. The missing Caligula among those unfortunate waxworks may have been just that: missing, lost somehow or removed before the early inventory was taken. Even the lavish Twelve Caesars in the grandest *salone* of the Villa Borghese in Rome were soon rearranged: the same Caesars, but disaggregated, repositioned and no longer in the 'correct' chronological, Suetonian order.[33]

This idea of a work in progress, with all its ragged edges and accidents, is nicely summed up in the history of one major collection on display in the gallery of Herrenhausen Castle in Hanover, now comprising eleven bronze portraits of emperors (the Suetonian Twelve, without Julius Caesar and

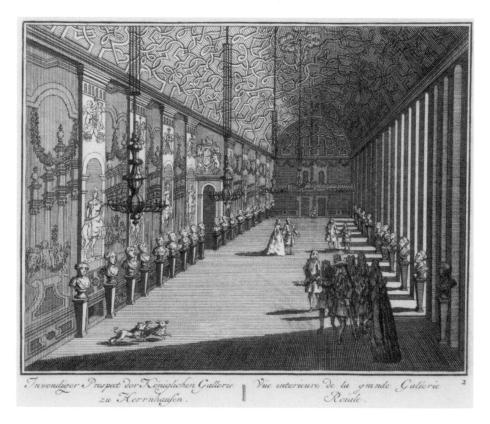

*Inwendiger Prospect der Königlichen Gallerie zu Herrnhausen.* | *Vue interieure de la grande Gallerie Roiale.*

4.11 An eighteenth-century view of the Gallery at Herrenhausen Castle in Hanover, by Joost van Sasse. Neither those who parade themselves fashionably, nor the dogs, pay much attention to the busts lining the walls.

Domitian, but including Septimius Severus), as well as a Republican 'Scipio' and an Egyptian king 'Ptolemy'. Acquired in 1715 by George I—elector of Hanover, as well as king of Great Britain and Ireland—from the property of Louis XIV at his death, they were not originally a single, homogeneous collection. To judge from the slightly different sizes and detailing, they had been put together from three separate early modern sets, only to be passed off as original Roman works that had been dragged out of the Tiber (J. J. Winckelmann, among others, soon poured even colder water on any such idea). In 1715, they had numbered twenty-six pieces, but these were taken back to France by Napoleon in 1803 and only fourteen ever returned, the others never surfacing since. The loss of Domitian, stolen in 1982, reduced the number again (Otho too had been stolen a few years earlier, but had luckily been found under a bush in the nearby gardens and reinstalled); and just to add an extra element to the confusion, after a cleaning programme in 1984, the heads of Galba and Vespasian were put back onto each other's (named) plinths, adding a layer of glaring mistaken 'identities'. At first glance, this is not far from being a set of the canonical Twelve, but on closer inspection it is a very long way off indeed (Fig. 4.11).[34]

## Emperors' New Clothes, from Rome to Oxford

A much more ambitious, and an even more complicated, collection of imperial heads still occupies one of the main rooms of the New Wing (the Palazzo Nuovo) of the Capitoline Museums in Rome. This is the 'Room of the Emperors', whose sixty-seven busts, from Julius Caesar to Honorius (393–423 CE), plus a selection of their wives, make it now the largest systematic collection of Roman emperors in marble anywhere in the world (Fig. 4.12). Standing on two rows of shelves, they are arranged around the room in precise chronological order, except for a couple of pieces which stand separately on pedestals and the seated figure in the centre: the so-called 'Agrippina', which was the model for Canova's Madame Mére, though she has more recently changed her identity. The distinctively later style of this statue is now thought to make it impossible that she was either of the first-century imperial ladies by the name of Agrippina; but whether she is really Helena, the mother of the emperor Constantine (306–37 CE), as she has come to be called, is a matter of debate (Fig. 1.22).

The whole range of imperial portrait types here, almost literally, rub shoulders—from some bona fide ancient pieces (rightly or wrongly identified as imperial characters), through heads that have been artfully 'restored' into an emperor or imperial lady, hybrids of all types (including some

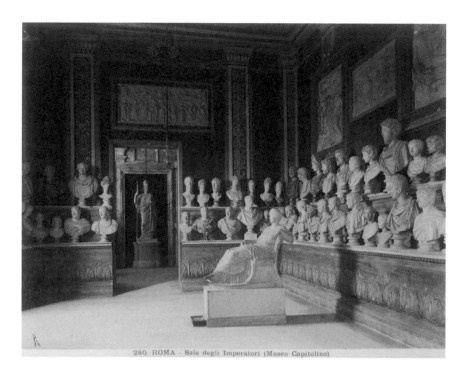

280. ROMA - Sala degli Imperatori (Museo Capitolino)

4.12 The 'Room of the Emperors' in the Capitoline Museums, as it was arranged in the 1890s, with the so-called 'Agrippina' centre-stage. The profusion of images tends to mask the differences in scale: see, for example, on the left of the door (upper shelf) the large Titus, next to the much smaller female head (conventionally identified as Titus's daughter Julia).

genuine ancient faces inserted into flamboyant modern multicoloured busts), to any number of modern 'versions', 'replicas' or 'fakes'.[35] It is as mixed—and as typical—a collection of Roman emperors as you now could imagine. When they were first installed, however, the belief (or hope) was that all these heads were authentically ancient.

That was in the 1730s, when the Palazzo Nuovo was being redesigned to become what was in effect the first public museum in Europe. The *palazzi* on the Capitoline hill (including the older wing that was the Palazzo dei Conservatori) had certainly long contained some famous antiquities and works of art, and there were any number of other papal or private collections, which allowed access to the favoured few. But one of the biggest operators in Rome of the period—Alessandro Gregorio Capponi—converted the more recent wing (the Palazzo Nuovo) into a new civic museum, which afforded 'open access to the curiosity of foreigners and dilettantes and greater ease to youths studying the liberal arts'. This involved evicting the

local Department of Agriculture, among other guilds and agencies, from the premises and extracting money from the pope, both to buy up much of Cardinal Albani's large collection of ancient statues as the nucleus of the new museum and to convert the building into a series of galleries.[36]

In this design, two rooms out of seven on the first floor—the main display area—were earmarked for the faces of men and women of classical antiquity. Adjoining the Room of the Emperors was (and still is) the 'Room of the Philosophers': a collection of almost a hundred marble 'portraits' of ancient thinkers and writers—'philosophers' very broadly defined—from Homer to Cicero, Pythagoras to Plato. In these rooms, Capponi went far beyond a collection of the Twelve Caesars that were, in whatever subtle variations, one of the standard fixtures in the neighbouring aristocratic residences, and far beyond any eclectic line-up of library busts of literary characters. In the case of the emperors, he was aiming for a systematic, total display of these imperial faces that was not unknown in collections of coins, but had never before been attempted on this scale in marble.

For two hundred years or so, the Room of the Emperors was taken to be a highlight of the museum. Early catalogues and guidebooks (unlike some of the more fainthearted modern versions) went through each head in turn, sometimes at enormous length. One compendium devoted over three hundred pages to the contents of the room, with an illustration of each sculpture, and a long description combining the archaeological details and assorted observations by Winckelmann with an historical pen-portrait of each of the men and women represented.[37] Visitors varied in their reactions, from those who delighted in tracing the stylistic development in portraiture or making comparisons with modern leaders (according to one American observer, Trajan shared his instant recognisability with 'our own Washington') to those who rightly spotted the blurring of the lines between sculpture and historical character (were you supposed to be reflecting on the history of art or on the history of imperial power?). Not all were as clued-up about Roman rulers and their family trees as they tried to pretend. At least one in their memoirs confidently misidentified the 'Agrippina' in the centre of the room as the *mother* of the prince Germanicus—when it did not take much knowledge of ancient history to know that she was either his wife (Agrippina the Elder) or his daughter (Agrippina the Younger), certainly not his mother.[38]

But whatever their reactions or expertise, it is clear that visitors on their tour of the museum did not usually skip the Room of the Emperors– unlike now, when it is regularly by-passed entirely or given a very hasty visit indeed. It must count as a nightmare come true for anyone with even

a slight distaste for rows of marble busts, especially when it is combined with the next-door Room of the Philosophers (adding up to a grand total of almost two hundred severed heads between them, on shelf after shelf). Its modern claim to fame rests much more on its place in the history of museum display: an early eighteenth-century installation frozen in time, almost an exhibit of itself. As one historian of classical archaeology has recently put it, the Room of the Emperors, at the heart of the Capitoline Museums, represents a museological 'time-capsule', as if it were unchanged over the centuries.[39]

Unchanged it definitely is not. Whatever illusion we might cherish of this immutable collection of imperial faces that have come down to us directly from the 1730s, the truth is that the Room of the Emperors has been in flux—its contents debated, discarded and rearranged—ever since the museum's foundation. At the very beginning, there were disagreements about what exactly its boundaries should be, as well as problems in ensuring the presence of a complete set. As Capponi's diaries of the time mention, a bust of Julius Caesar's main adversary, Pompey the Great, who was killed in Egypt in 48 BCE, was one of the first pieces to be installed, before being almost instantly removed—on expert advice and on the obvious grounds that whatever his ambitions might have been, Pompey was even less of an 'emperor' than Julius Caesar. Meanwhile Cardinal Albani did not always prove as cooperative in parting with his sculptures as Capponi hoped. The line-up of the Suetonian Twelve Caesars, a necessary nucleus of the Room, threatened to be left incomplete at the start when Albani tried to keep hold of his 'Claudius', until Capponi came up with more money.[40]

The contours of the collection have never actually been fixed. Over almost two hundred years, as old catalogues and guidebooks show, the number of portraits has gone up and down, and the selection of characters has constantly been adjusted. Currently sixty-seven when all are present (a few are commonly 'on leave', loaned out to temporary exhibitions), they make a slimmer and less cramped display than in the past. There were eighty-four on display in 1736, trimmed down to seventy-seven by 1750 (one of four duplicate Hadrians had been shed, as well as one of three Caracallas and two Lucius Veruses, plus a little further 'weeding'). The seventy-six listed in 1843 were up to eighty-three ten years later, to eighty-four in 1904, and back to eighty-three by 1912. A few of these differences may perhaps be put down to miscounting or omissions on the part of inattentive compilers, but there are some clear hints that changing criteria are at play, whether that is the principle, increasingly strongly applied, of one statue per person, or other questions of who belongs where or at what point the series

(a)                              (b)                              (c)

4.13 The centrepiece in the Room of the Emperors, on which the surrounding rulers gaze, has changed over the centuries. Before 'Agrippina' (Fig. 1.22), there were, in order, (a) the grossly over-life-size *Baby Hercules* (two metres); (b) a sculpture once identified as Hadrian's lover Antinoos (almost two metres); (c) the so-called *Capitoline Venus* (again just under two metres).

should end. Julian, who ruled from 361 to 363 CE (and will appear again in Chapter 6), was for many years the latest ruler on show, though at some point a different and very dubious portrait of 'Julian' was substituted for the original one, and in the early nineteenth century a head optimistically identified as the obscure Magnus Decentius (who ruled in the early 350s) usurped the final place, despite reigning before Julian. Decentius is still there (though now identified as Honorius, or alternatively as the slightly earlier Valens), though Julian has been transferred next door to the Room of the Philosophers, presumably on the basis of his surviving writing, which includes some decidedly flamboyant theology. Other portraits have fallen victim to modern scepticism and have either been removed entirely or else anonymised. The original 'Julius Caesar' is still in place, but now demoted to the rank of an 'unknown Roman', or *busto maschile*—so making an underwhelming start to the whole imperial series.[41]

It is, however, in the piece of freestanding sculpture, usually placed in the middle of the room—as if the object of the gaze of these assembled emperors and their families—that we find the most drastic changes over time. The 'Agrippina' has been the centrepiece of the display for more than two hundred years. But the first focal point, installed in the room even before the emperors themselves, was an outsized baby Hercules in

shiny dark green basalt that had been found on the site of a large set of third-century CE baths in Rome (the joke of this gross statue was presumably that it depicted a semi-divine toddler on a colossal scale, more than two metres tall).[42] This was upstaged in 1744, when a statue, found at the emperor Hadrian's Villa at Tivoli, and then believed to represent Antinoos, Hadrian's lover, was given the central position.[43] This soon gave way to the famous *Capitoline Venus*, which was lodged there in pride of place among the imperial characters immediately after its presentation to the museum in 1752. It was some time after this precious Venus had been taken to Paris by Napoleon in 1797 (to be returned to Rome only in 1816) that the 'Agrippina' was transferred to the Room of the Emperors (Fig. 4.13).[44]

These shifting arrangements have rarely been noticed and their implications never spelled out. It is one thing to have the emperors and empresses gazing at the staid figure of an 'Agrippina' or even at the vast version of baby Hercules. It was quite another to make it appear that the whole object of their attention was Hadrian's young boyfriend, scantily clad, or what was then one of the most famous nudes in Europe—the *Capitoline Venus*. It is an important reminder that line-ups of Caesars were not

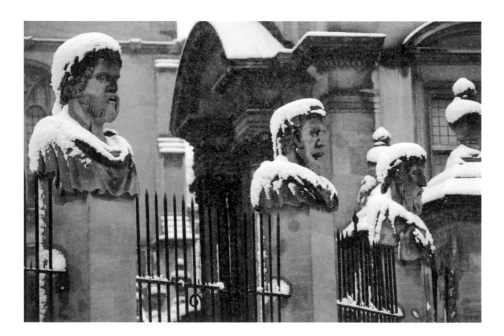

4.14 'They are crowned never but with crowns of snow,' as Max Beerbohm described them in the early twentieth century. The Oxford 'emperors' outside the Sheldonian Theatre, whose original versions go back to the seventeenth century, are—emperors or not—sometimes really crowned with snow.

CHAPTER IV

142

always as passive as we often assume. Not much was required to animate these figures, and to make them seem to engage actively with their setting.

The Caesars could even be imagined as exemplary participants in the human affairs going on around them, or occasionally be turned into wry, witty observers of contemporary life. So, for example, in the sixteenth-century theatre in the tiny Italian town of Sabbioneta, busts of Augustus and Trajan set into the wall of the upper gallery—along with a variety of pagan gods and goddesses, plus a figure of Alexander the Great—served partly to signal the ancient antecedents of this radically new, classicising experiment in theatre design. (The famous Renaissance slogan 'Roma quanta fuit ipsa ruina docet' (How great Rome was, its very ruins show) is still plastered across the outside of the building for those who did not get the point.) But the emperors, with their eyes directed firmly to the stage, also acted as model members of the audience, forever locked in apprecia-tion of the performance.[45]

Rather more light-hearted was the circle of eight emperors placed around the seventeenth-century fountain at Bolsover Castle, in northern England. A century before the similar arrangement with the *Capitoline Venus* in Rome, these imperial figures provided the background to—and were the voyeurs of—a naked figure of Venus, which was the fountain's centrepiece. Even more animated, and almost brought to life as characters in one of the funniest comic novellas of the early twentieth century, is the series of so-called 'Roman emperors', beloved of tourist guides, that still stand outside the Sheldonian Theatre in Oxford; un-classical in style though they are, they are the most famous open-air line-up of Caesars in Britain (Fig. 4.14).

The Sheldonian, designed by Christopher Wren in the 1660s, is the main centre of University ceremonial (not a theatre in the 'dramatic' sense). Of the original fourteen stone emperors that Wren placed around its main facade, one was removed during nearby building works within a few decades, and the others have long since eroded and been replaced, twice, by new versions: first in 1868, and then again in the early 1970s (though at least a couple of the seventeenth-century set can still be found recycled as ornaments in Oxford gardens).[46] The literary fame of these rather gruff Caesars comes from Max Beerbohm's novel *Zuleika Dobson*, first published in 1911, whose young and exotically named heroine arrives among the dreaming spires to stay with her grandfather, who is the head of the fic-tional, or semi-fictional, Judas College. Not only does Zuleika proceed to fall in love for the first time, but all the male undergraduates (and Oxford was then an almost entirely male university) proceed to fall in love with

her: literally *all* of them, and so badly in love that they end up killing themselves for her, every single one. At the end of the novel, the unworldly dons seem hardly to have noticed that the students are all dead (even though the dining hall is strangely empty); meanwhile on the very last page, Zuleika is found making inquiries about how best to get to Cambridge (where it is not hard to guess what will happen). It is a clever satire both on the dangers of women and on the madness of this masculine university world.[47]

Beerbohm re-imagines these emperors, with their prime vantage point in the city centre, as key observers of the tragi-comic events of the novel. From the very beginning, they are more aware than the flesh-and-blood characters of the trouble that lies in store. Although Zuleika barely gives them a glance as she makes her way to Judas College with her grandfather ('the inanimate had little charm for her'), the emperors themselves—as one old don notices—break out into a sweat as they watch her, 'great beads of perspiration glistening on their brows'. 'They at least', Beerbohm continues, 'foresaw the peril that was overhanging Oxford and they gave such warning as they could. Let that be remembered to their credit. Let that incline us to think more gently of them.' This prompts him to some more general musing on the morality and fate of these imperial autocrats. 'In their lives,' he goes on, 'we know they were infamous, some of them.' But in Oxford they have been given their punishment: 'exposed eternally and inexorably to heat and frost, to the four winds that lash them and the rains that wear them away, they are expiating, in effigy, the abominations of their pride and cruelty and lust. Who were lechers, they are without bodies; who were tyrants, they are crowned never but with crowns of snow; who made themselves even with the gods, they are by American visitors frequently mistaken for the Twelve Apostles. . . . To these emperors, for whom none weeps, time will give no surcease. Surely, it is a sign of some grace in them that they did not rejoice, this bright afternoon, in the evil that was to befall the city of their penance.'[48]

There is, however, an even bigger joke here. The truth is that there is nothing whatsoever to suggest that Christopher Wren, or his sculptor William Byrd, designed these figures to represent Caesars. They are now almost universally interpreted as such (*almost*: the sculptor who made the new 1970s version is reported as saying that 'they were nothing so elevated . . . they merely illustrated different kinds of beards'[49]). But, so far as I have been able to discover, Beerbohm was the first to refer to them in print as 'Roman emperors', even if the oral tradition may go back further. Their appearance suggests that they were more likely intended originally to represent a group of 'worthies' or figured boundary markers ('herms'),

with some very remote classical inspiration. They are, in other words, one of the most extreme cases of the porosity of the category of emperor, whether twelve or not, that you could find: here, as occasionally elsewhere, the ingenuity, wit and wishful thinking of later writers and viewers have succeeded in converting a series of quite other, innocuous figures into a line-up of Roman rulers, with all the cultural baggage that goes with them. Beerbohm's double bluff is that (even though the Apostles do not normally come in groups of thirteen or fourteen) the authorial voice of the novelist was no closer than the 'ignorant' speculation of those American visitors to the original intention of the sculptor.

## Silver Caesars Rearranged

No such big questions of identity hang over the Caesars of the Aldobran-dini Tazze. Each emperor carries his name in an original inscription near his feet, and they preside over scenes of their glorious deeds drawn directly from Suetonius's *Lives*. But even with this apparently canonical set, there is a lot more disruption and constructive re-identification than I have so far acknowledged. The Aldobrandini Tazze have long undermined their own status as the perfect set of Caesars. In some ways, they are as striking an example of the fluidity of the category as the 'emperors' of Oxford.

For a start, the set of twelve is no longer a set, but is dispersed in ones and twos across the world, in museums and private collections from London to Lisbon and Los Angeles. How exactly the separation happened remains a mystery, though the outlines of the story are clear enough.[50] Their origins look rather like another case of a work in progress (the earliest written reference to them is as a group of six only, on sale in 1599). But for two and a half centuries—from 1603, when they were documented in the collection of Cardinal Pietro Aldobrandini, until 1861, when they were all sold together at auction in London—they formed a complete collection of the Suetonian Twelve, passing between different owners, from Italy to England. Soon afterwards, they went their very different ways. A singleton was sold in Hamburg in 1882, the Rothschild family in Paris are recorded as owning seven, six and two in decreasing numbers between 1882 and 1912, and in 1893 at another London auction six of the *tazze* which had been in the possession of the dealer and collector Frederic Spitzer were sold in separate lots—and the disaggregation has continued, along with some dramatic interventions on some of the pieces. Spitzer, for example, had the six that he owned refitted with much more elaborate feet, presumably to enhance their value and selling appeal. But he did not go so far as whoever

decided to detach both the foot and the imperial figure from the bowl representing the life of Titus (the figures conveniently 'screw in' and 'screw out') and to re-invent it as a 'rosewater dish' by Benvenuto Cellini—as it was sold at auction in 1914.

Those kinds of alteration are, however, only one part of the fluidity of the imperial imagery on the *tazze*, as I first discovered in 2010 when I went to have a closer look at the one that had ended up (via the Spitzer sale) in the Victoria and Albert Museum. This was supposed to be the figure of Domitian with scenes from his life on the bowl: the emperor's wife travelling to meet him in Germany, his campaigns against the Germans, his triumphal procession celebrating his conquest of them and finally his receipt of their formal submission.[51] The figure itself, with the name inscribed, was exactly as advertised. But it was soon clear that there was something very wrong indeed with the scenes on the bowl. The clearest warning came with the depiction of the triumphal procession. For, unusually, the triumphal chariot in which the general travelled was empty, and he had apparently dismounted to kneel in front of another figure seated alongside the processional route. This had nothing to do with Suetonius's account of Domitian's victory parade, but exactly matches what he has to say about the triumph over the Germans celebrated by Tiberius, while Augustus was still on the throne: 'before he turned to drive up onto the Capitoline hill, he got down from the chariot and dropped to his knees in front of his father [Augustus] who was presiding over the ceremony'.[52] Roman readers would have taken this as a sign of Tiberius's deference; for me it was a clear hint that the bowl had been wrongly identified and was attached to the wrong emperor (Fig. 4.15a).

So it turned out. The scene identified as Domitian's wife riding to join him in Germany could not possibly be that. Nothing of the sort features in Suetonius's *Life*—and, anyway, why is the woman apparently on fire? It must instead be the story of Tiberius's lucky escape when as a baby, during the civil wars following Julius Caesar's assassination, he was on the run with his mother Livia, and a forest fire nearly engulfed their whole party (Fig. 4.15b). Likewise, what was dubbed the submission of the Germans to Domitian (puzzlingly accompanied by scenes of collapsing buildings) fits much better with Suetonius's reference to Tiberius's generosity to the cities of the eastern empire after a severe earthquake. And the battle between Romans and some distinctively clad sixteenth-century pike-men featured on the remaining scene could equally well depict Tiberius's campaigns in Germany as Domitian's. It took only a careful look, and a text of Suetonius, to see that the wrong emperor was on the wrong bowl.[53]

This obviously raised other questions. If the Domitian bowl really illustrated scenes from the *Life of Tiberius*, where did that leave the so-called 'Tiberius' bowl that was in Lisbon, wrongly attached, as had long been recognised, to the figure of Galba? This turned out to be the bowl of Caligula (thanks to some extraordinary wishful thinking, the scene of Caligula prancing on horseback across a bridge of boats, for example, had been interpreted as Tiberius going into retirement on the island of Capri) (Fig. 4.15c). To square the circle, the so-called 'Caligula' bowl in Minneapolis proved to be that of the elusive Domitian, who had also fallen victim to some over-optimistic misidentifications (the scene of the burning of the Capitol in Rome during the civil war of 68–69, complete with unmistakable flames, had rather desperately been read as the outbreak of popular disturbances on the death of Caligula's father Germanicus).[54] But that was only the start: as recent work on the *tazze* has shown, there have been any number of misreadings of the scenes, and—despite the clear labelling—emperors have migrated from bowl to bowl. The Domitian bowl in Minneapolis is actually topped by the figure of Augustus, while the Augustus bowl is combined with the figure of Nero, serving as the much-loved table decoration of a private collector in Los Angeles. And so on. Only two, Julius Caesar and Claudius, seem to have survived in their original state.

These recombinations have been going on for centuries; the fact that they are only possible when more than one of the *tazze* is in the same ownership pushes the mistakes back into the nineteenth century and most likely before. They are partly to be explained by the practical ease with which the pieces come apart. If all twelve emperors were unscrewed to be cleaned, it would take, at the very least, considerable efficiency to ensure they all returned to their correct bowls (after all, even the expert conservators in Hanover managed to return the marble busts of Galba and Vespasian to the wrong plinths). They are also partly to be explained by a maybe increasing unfamiliarity with the text of Suetonius. If the cleaning staff, understandably, did not spot that the scenes chased on bowls failed to match the emperors, then neither did the rich owners and collectors. But overall, whatever the precise reasons, the fluidity of these combinations is a wonderful example of how the canonical set of the Twelve Caesars is almost never quite as canonical as it seems, but almost always in flux, in the process of disaggregation and recombination. Behind those line-ups of marble busts are many unexpected histories such as this.

But there is an added level of pointed irony and thwarted intentions in the story of the imperial figure and bowl that I went to see in the Victoria and Albert Museum. When it first entered the museum in 1927, it actually

(a)

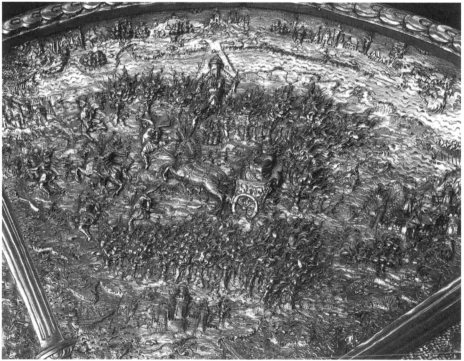

(b)

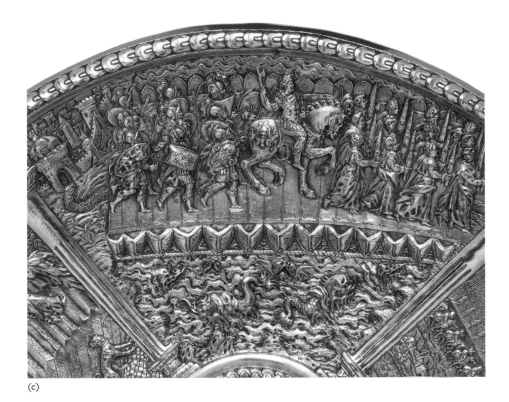

(c)

4.15

(a) [FACING PAGE] The bowl of Tiberius (previously identified as Domitian):
Tiberius stands down from his triumphal chariot to honour Augustus

(b) [FACING PAGE] The bowl of Tiberius (previously identified as Domitian):
Livia and the baby Tiberius escape through the flames in the Civil Wars

(c) The bowl of Caligula (previously identified as Tiberius):
Caligula on his bridge of boats across the Bay of Baiae

displayed the figure of Vitellius above what was then taken to be the Domitian bowl. The present combination is the result of an attempt in the 1950s to put some of the emperors back with their right bowls. Three museums, the Victoria and Albert, the Metropolitan Museum of Art and the Royal Ontario Museum, which each owned one of the *tazze*, arranged to swap their figures. The figure of Vitellius was sent to the Met to join the Vitellius bowl, Otho, who had stood on the Vitellius bowl, was sent by the Met to the Ontario Museum to be reunited with 'his' bowl', and Ontario's figure of Domitian came to London. It was a well-meaning example of international collaboration, and the Met and the Royal Ontario Museum each ended up with their *tazze* correctly composed. The only trouble was that—as the

London bowl did not actually belong to Domitian at all—the Victoria and Albert's *tazza* remained just as mongrel as ever.[55] There could be no better symbol of the perils of misidentification stretching back hundreds of years, and of the ways that the desire to order and systematise these sets of Twelve Caesars is so often transcended or thwarted. I very much doubt that Domitian will be leaving the Tiberius bowl any time soon. But who knows?

Those perils of misidentification will be one theme in the next chapter, which takes a careful look at another major work of sixteenth-century art: Titian's eleven *Caesars*, probably the most significant and influential set of modern Caesars of all, which travelled the length of Europe, only to be completely destroyed in a fire in Spain in the eighteenth century. Theirs is a fascinating story of reconstruction, with all the fun of getting down to the detail of just one set of Caesars. How can we recapture what these lost paintings looked like, and what was so special about them? Can we recreate their changing contexts—and meaning? Why did they become *the* Caesars for centuries in early modern Europe?

But it starts with an unexpected tale of survival.

# V

# THE MOST
# FAMOUS CAESARS
# OF THEM ALL

## Lucky Finds?

In 1857, so the story went, Abraham Darby IV loaned portraits of six of the Caesars painted by Titian himself to the Manchester Art Treasures Exhibition, a show that still ranks as the largest art exhibition ever held in Great Britain. Darby had made his money from the iron industry, in the wake of his more innovative great uncle, Abraham Darby III, who is famed for having constructed the first iron bridge in the world (across the river Severn near his works in central England). The younger Darby was looking for prestige in art as well as in iron, and was investing much of his fortune in building up a large collection of paintings. He had bought these particular masterpieces from another entrepreneur, John Watkins Brett: a telegraph engineer, art dealer and plausible chancer—who had almost managed in the 1830s to persuade the United States government to make his own collection the basis of the first American National Gallery. Brett was a canny salesman and seems to have given these six Caesars—Julius, Tiberius, Caligula, Claudius, Galba and Otho—some irresistibly glamorous connections as well as a first-rate artistic pedigree (Fig. 5.1). The Duke of Wellington had apparently noticed that Titian's Tiberius was the spitting image of Napoleon; while others spotted a definite resemblance between Wellington himself and the Galba.[1]

They were not, needless to say, Titian's original *Caesars* at all. Those paintings, eleven in total, from Julius Caesar to the emperor Titus, had been commissioned in the 1530s by Federico Gonzaga, first Duke of Mantua in Northern Italy (one of a dynasty that combined a relatively low

5.1 Believed by its mid-nineteenth-century owner, Abraham Darby IV, to be Titian's original painting of the emperor Tiberius ('TIBERIO' is still faintly visible in the upper left corner), this was put on display at the Manchester Art Treasures exhibition in 1857 (alongside the five other emperors from Darby's set). Some critics at the time were doubtful about the authenticity of many pieces in this show (partly snobbishly—refusing to believe that a northern industrial town could host first-rate art). But in this case they were correct. It is a later copy.

place in the pecking order of the European aristocracy with the possession of an extraordinary gallery of art); they had been acquired by Charles I of England, when the Gonzaga family hit hard times in the 1620s; and after Charles's execution in 1649 they were bought by Spanish agents, ending up in the royal collection in the Alcázar palace in Madrid. They are now known only through numerous series of copies of varying quality (Fig. 5.2)—because, hung high up on the wall, and for that reason hard to

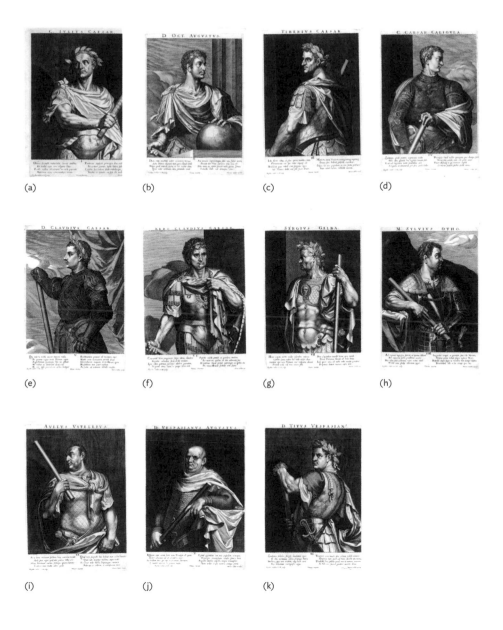

(a)  (b)  (c)  (d)

(e)  (f)  (g)  (h)

(i)  (j)  (k)

5.2  The most influential copies of Titian's *Eleven Caesars* were the prints made by Aegidius Sadeler in the early 1620s, on a reduced scale (these are roughly thirty-five centimetres in height; the originals were about three times larger). Here, from top left: (a) Julius Caesar; (b) Augustus; (c) Tiberius; (d) Caligula; (e) Claudius; (f) Nero; (g) Galba; (h) Otho; (i) Vitellius; (j) Vespasian; (k) Titus.

rescue, they were completely destroyed when the palace burned down in December 1734, along with hundreds of other paintings. Velasquez's *Las Meninas* was one of the lucky ones, saved by being torn from its frame and thrown out of a window.[2]

The more knowledgeable critics of the Manchester exhibition were well aware that Titian's *Caesars* had been lost in Spain more than a century earlier (despite the cock-and-bull claim that these six had actually found their way to America after the execution of Charles I[3]). Along with many other paintings on display in 1857, lent by their often gullible owners, Darby's prized possessions were dismissed in reviews as 'second-rate copies' not fit to 'take their place among works of Titian'.[4] This did not stop them being sold at Christie's as 'genuine' Titians, when Darby (who had over-reached himself in putting together his collection) was auctioning them off again in 1867; the prices fetched (each one went for under £5) suggests that the bidders had a better idea.[5]

Brett and Darby were not the only ones to profit from, or to be taken in by, the fantasy of Titian's original *Caesars*. A few decades earlier, in 1829, the British press was reporting 'an extraordinary instance of good fortune'. 'A man who keeps a petty broker's shop in an obscure situation in Maryle-bone', as the articles rather loftily opened, had bought up ten old paintings at a local auction for £5 12s; later inspected by 'lovers of vertu', they were adjudged to be ten of Titian's *Caesars* and valued at £2000. One writer went on to claim that the man had quickly sold his lucky find to 'a rich English nobleman, whose name I have unfortunately forgotten, for the exorbitant sum of eight thousand pounds'.[6] There is a definite whiff of an urban myth to this tale (note the convenient amnesia over the buyer's name). But, true or not, it is part of the extraordinary allure of this set of imperial images. More than a hundred years after they had gone up in flames, they were still providing good copy for popular newspapers. For centuries, these celebrity paintings—now more or less unrecognised, except by the most learned 'lovers of vertu'—represented the modern face of the ancient emperors.[7]

It has been impossible to keep a few glimpses of Titian's emperors out of this book so far, from the portrait of Charles I modelled on Titian's *Otho* (Fig. 3.14) to the disreputable Charles Sackville ironically pictured in the guise of Titian's *Julius Caesar* (Fig. 3.13). But there is an important story to be told of these paintings in their own right, and of their replicas that were found in thousands across Europe. Some of these were taken directly from the originals themselves, some were much more remotely connected to them; and they were produced in any number of different media, from paintings and prints on paper, to re-creations in three dimensional sculp-

5.3 Tea fit for a king, or queen. A copy of Titian's *Augustus*, drawn from Sadeler's prints (Fig. 5.2b), decorates a small French teacup, just nine centimetres tall, bought by the future King George IV, in 1800.

tures, cheap plaques or elaborate book bindings. To be sure, different versions of the Caesars, based on the work of other artists, also established a foothold in the popular imagination from the sixteenth century on,[8] but never with the impact of the faces that Titian created, nor in such ingenious (or improbable) adaptations—which went as far as a delicate French porcelain cup, decorated with a copy of a copy of a copy of the head of Titian's Augustus, out of which members of the British royal family may have sipped their tea in the early nineteenth century (Fig. 5.3).[9]

These Caesars raise in a new form some of the issues we have already explored. There are plenty of curious misidentifications lurking here and more intriguing twists and turns in their story, with all the proud owners, the scheming middlemen and hucksters who bought and sold them, and the near disasters they suffered along the way; long before the final blaze, van Dyck had been asked to step in to restore at least one of the emperors seriously damaged by a mercury leak on board ship during their journey from Mantua to London. And they reintroduce some of the characters that we have met before, including the dealer and antiquarian Jacopo Strada, who in the 1560s commissioned the drawings that have left us the most accurate

idea of the paintings' original installation in the Ducal Palace in Mantua. But they also open up some big questions of interpretation. In their travels from Italy to England to Spain, and in their replications that became almost ubiquitous in Europe, it is possible to pin down a whole variety of different readings of these imperial figures in their different settings. Sometimes they have been an important accessory of aristocratic bravura and a legitimation of dynastic power; sometimes they have been a prompt to reflect on the dangers, corruption and immorality of autocracy—as some hard-talking Latin verses attached to the most popular series of early printed copies of the paintings make very clear.

One of the morals of the story of Abraham Darby's *Caesars* is that Titian's original canvases, painted in Venice between late 1536 and late 1539, can never entirely be separated from the thousands of reproductions that were produced from the mid-sixteenth century on. It is not simply that it sometimes proved difficult to distinguish the original from a reproduction (or that it was sometimes tempting not to try too hard to do so). Even more to the point, since the fire of 1734, our main access to the originals has been through those reproductions, with all the scholarly arguments that are inevitably raised about which of them is the 'best' guide to what Titian painted, or how much 'better' the originals might have been. That said, this chapter starts by focussing on what we can reconstruct of Titian's *Caesars* themselves and their changing settings, relishing the story of what was once the most influential set of emperors in the modern world, its elusive details, curious puzzles and inconsistencies, before moving on to who copied them and why, to their wide diaspora and its implications.

## The 'Room of the Caesars'

In the sprawling palace of the Gonzaga, the room where the *Caesars* were originally on display now gives little hint of its once spectacular appearance (Fig. 5.4). In its current state, the relatively small first-floor 'Camerino dei Cesari'[10] (just under seven metres by five) is slightly gloomy, since later buildings have partly blocked the light to its single window, also removing what must once have been a great view. And it is only thanks to some energetic renovation in the 1920s (when parts of the ceiling fresco were uncovered and a set of copies of Titian's paintings were purchased and reinserted into their appropriate places) that there is anything more to see than some empty stucco niches, decorated with a few generic classical scenes.[11] It is hard to imagine that this was originally one of a series of splendid showcase rooms—the 'Appartamento di Troia', or Trojan Suite, as

it was known (after paintings in another room illustrating scenes from the Trojan War)—sponsored by Federico Gonzaga, the first Duke of Mantua, to celebrate his own success: he had kept sufficiently on the right side of the Holy Roman emperor, Charles V, to have his title upgraded from mere marquis to duke in 1530, and his tortuously negotiated marriage to an aristocratic heiress had brought in new territory and wealth to Mantua.[12] With his Titians in their elaborate setting, Federico presumably also intended his Camerino dei Cesari to echo—even upstage—some earlier imperial themes in the palace: not only its growing collection of ancient Roman sculpture, but also Andrea Mantegna's medallions of eight emperors' heads on the ceiling of the Camera picta, and even more famously, from the late fifteenth century, Mantegna's series of nine canvases of *The Triumphs of Caesar* (Figs 3.9; 6.6–7).[13]

As images of emperors, Titian's paintings were unnerving, radical and an instant visitor attraction—'more like real Caesars than paintings',

5.4 The 'Room of the Caesars' in the palace of the Gonzaga is now a very pale shadow of its sixteenth-century glory, even with copies of Titian's paintings inserted into the spaces the originals once occupied (here, from left, Galba, Otho, Vitellius, Vespasian and Titus). The decoration between the paintings is original (though the small sculptures from the niches have been lost), as is the mythological painting (with gods, goddesses and winds) on the ceiling.

according to one of his contemporaries.[14] It is hard now to appreciate how daring a choice Titian was as an artist for a line-up of Roman rulers (his home town of Venice, with no classical history of its own, was not the 'go-to' place for this kind of commission). But, even from the copies, we get a sense of how he animated these life-size, three-quarter figures, with their various stances, hinting at respect and animosity, friendship and stand-off, within a group that had often been portrayed as rather staid. Appropriately enough, in the original arrangement, Tiberius looked loyally towards Augustus, Galba firmly turned his back on his usurper Otho. Titian also pointed to a new configuration—even hybrid—of ancient and modern rulers. The emperors' features were recognisably drawn from coins and Roman sculpture and the overall appearance of their dress reflected a Roman style, but there were striking contemporary allusions. A close look at the painting of the emperor Claudius, for example, would have revealed that he was sporting an identifiable piece of sixteenth-century armour, which had been made in 1529 for Federico's nephew, another Italian princeling, Guidobaldo della Rovere (the actual breastplate is still preserved in the Bargello Museum in Florence).[15]

Nonetheless, for all their novelty and fame ('unbeatable' as one of the Carracci brothers, a family of sixteenth-century painters, wrote in the margin of their copy of Vasari's *Life of Titian*[16]), these painted Caesars were just one element in the overall design of a room that was much more than a backdrop for a series of celebrity portraits. To walk into this Camerino in the 1540s was to be faced with total immersion in Roman imperial iconography from floor to ceiling.[17]

The mastermind behind the overall design was Giulio Romano, the pupil of Raphael who was Federico's in-house painter and architect, and is now best known for his grand conception of the Gonzaga pleasure palace, the Palazzo Te, as well as being the only Renaissance artist mentioned by name in Shakespeare.[18] Thanks to surviving letters of the late 1530s, we can still trace the duke's (ultimately successful) attempts to get the finished imperial portraits out of Titian as quickly as possible—exploiting a mixture of threats, sweeteners, a tailor-made pension-plan and carefully judged intimacy ('*Messer Tiziano*, my dearest friend . . .').[19] Meanwhile Giulio Romano and his assistants were busy creating the most intricate imperial space since antiquity itself. Titian's eleven *Caesars*, when they were delivered, were to occupy the upper part of the walls; while the stuccoed niches in between some of them were to carry ancient or modern 'classical' sculptures. The vaulted ceiling depicted the ancient celestial realm, with gods, goddesses and winds. The lower register of the wall packed in images of yet more

emperors, their families and their narratives: paintings of emblematic 'stories' taken from Suetonius to go with each emperor; coin-like medallions commemorating the parents, wives and other relatives of the ruling Caesars; and a series of Roman figures on horseback, which sixteenth- and seventeenth-century observers usually assumed to be emperors too (though they may have been intended as soldiers or guards[20]). Completed at speed by 1540, for a few decades this room was one of the most celebrated in Europe, its installation known far wider than court society. By 1627, it had been dismantled.

With some of this decoration we are on reasonably firm ground. As well as the many copies of Titian's portraits, a few of the original paintings from the lower register, by Giulio Romano and his workshop, still survive. These too (or some of them) came to London, and were then sold off to different buyers after King Charles's execution. What had once formed the decoration of a single room in Mantua has ended up hundreds of miles apart, across Britain and further afield. At least two of the emblematic stories—an eagle landing on the shoulder of the future emperor Claudius as an omen of his rise to power and Nero 'fiddling' amid the flames (Fig. 5.5)—eventually came back into the royal collection and are now in Hampton Court Palace. The triumphal procession of Vespasian and Titus (a larger panel which seems to have served as the 'story' to go with both emperors) was bought by a local dealer and sold on to France, where it is now in the Louvre.[21] Several of the figures on horseback have also been lucky: two survive in Hampton Court, one in Christ Church, Oxford (Fig. 5.6), another three in Marseille, one in a private London Gallery and one is at Narford Hall in Norfolk (along with a similar panel showing a Victory with a horse, which must also have been part of the series).[22]

Fitting all this together, however, and filling the gaps to recapture the overall impression of the original design, has proved a tricky jigsaw puzzle. Some of the contemporary inventories (for example, the registers of the Gonzaga artworks around the time of the sale in 1627, and of the property of Charles I when it was disposed of in 1649–50) can offer a useful checklist.[23] But the most important keys to our understanding of the room go back ultimately to Jacopo Strada, whose work for Albrecht V of Bavaria in the 1560s—when Titian was painting his portrait—included planning his 'Kunstkammer', a gallery of art, curiosities and precious collectibles, in Munich. It seems that in one part of this vast treasure house Strada decided to feature some kind of re-creation, in painted copies, of the scheme of the Camerino: not just the images of the Caesars themselves, but also the narrative scenes. A German inventory of Albrecht's gallery was compiled

5.5 Two of Giulio Romano's 'stories' from underneath the emperors in the Camerino, each just over 120 centimetres tall. On the left, it is hard to decide which is the more startled: the eagle who has landed on the future emperor Claudius's shoulder, or Claudius himself. But it is almost certainly no coincidence that an eagle was part of the Gonzaga coat of arms. On the right [FACING PAGE], the classic scene of Nero at the fire of Rome engages with, and partly quotes, Michelangelo's painting in the Sistine Chapel of a couple of decades earlier: the figures fleeing the fire are based on the refugees in Michelangelo's *Flood*.

in 1598, including a systematic description of his Mantuan copies—and it is from this indirect and unexpected source that we have some of our most detailed information on the content, interpretation and occasionally misinterpretation of Giulio Romano's 'stories' that accompanied each emperor.[24]

But even more important are some of the documents that Strada assembled in preparing to reconstruct this 'mini-Mantua' in Munich. For he commissioned drawings of the Camerino dei Cesari, as well as other parts of the Gonzaga estate from a local artist, Ippolito Andreasi (an unfortunate soul, murdered by his wife's lover in 1608 and since then largely forgotten).[25] Some of these drawings survive in the Kunstmuseum at Düsseldorf,

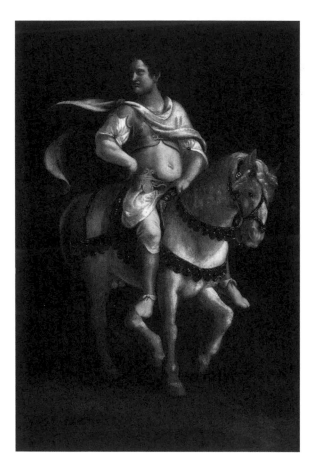

5.6 Figures on horseback, just under a metre tall, were set between the imperial 'stories' on the lower level of the walls in the Camerino. This one, now in Oxford, originally stood between the *Fire of Rome* and *Galba's Dream*. But whether they were meant to be seen as emperors or cavalry guards is anyone's guess.

including not only careful versions of Titian's individual emperors (among the earliest copies to survive), but more general views of the wall decorations of the Camerino, from which it is possible to reconstruct a more or less complete picture of three sides (Fig. 5.7).

Putting the Munich inventory together with Andreasi's copies has helped to track down preliminary versions of some of the lost paintings from the room and identify their subject matter. A strange drawing in the Louvre, for example—of a man falling backwards into the arms of three others—matches a description in the inventory and a scene sketched by Andreasi: it is the 'story' to accompany the portrait of the emperor Tiberius (who, according to Suetonius, once in modesty withdrew so quickly from a man attempting to embrace his knees that he fell over) (Fig. 5.8).[26] But, even on their own, Andreasi's drawings hint not only at the busy, almost overpowering, intensity of the original design, but also at some significant relationships between the different elements of the layout, and at the

5.7 A composite reconstruction of the west wall of the 'Room of the Caesars' using Andreasi's drawings of the mid-sixteenth century. On the upper level, portraits of Nero, Galba and Otho are flanked by niches containing statuettes. On the lower level, the stories associated with each emperor (the fire of Rome (Fig. 5.5), Galba's dream and Otho's suicide) are separated by horsemen (Fig. 5.6); above and below each of these are medallions illustrating members of the imperial family. The main entrance to the room, by the central door on this side, is disguised by having the story panel, of Galba's dream, attached to it.

importance of some features that have been almost entirely overlooked (or misread) by most modern critics.

This is clear from my composite of his drawings of the west wall of the room in Figure 5. 7, featuring the portraits of Nero, Galba and Otho, plus their associated images.[27] Hardly a space on the wall is left blank. On the upper level, Titian's emperors were flanked, in niches, by assorted free-standing statuettes. It is easy enough to spot a Hercules with his club on the far right; and the figure second from the left has been tracked down (on the basis of this drawing) to a Renaissance bronze, probably of an 'athlete', now in Vienna.[28] On the lower register, a relevant 'story' is placed below each emperor: Giulio Romano's *Fire of Rome* under Nero; a scene from Suetonius, of the goddess Fortune appearing to the emperor in a dream, under Galba; and his own brave suicide under Otho. Each of these is flanked by Giulio Romano's horsemen, with the recognisable appearance

5.8 Giulio Romano's preparatory drawing (just over fifty centimetres high) for the 'story' under Tiberius. The puzzling scene (which baffled commenters as far back as the sixteenth century) is explained by a passage in Suetonius's *Life* of the emperor giving examples of the emperor's modesty: a man, on the left, attempts to apologise to the emperor by clutching his knees (a standard ancient gesture of abasement), but Tiberius, here wearing a discreet coronet, draws back so quickly to avoid this that he almost falls over.

of the one now in Oxford (Fig. 5.6), seen here in its original place, second from the left.[29]

But there is another element in this design that has often been passed over without comment. Clearly visible in Andreasi's drawings, above and below each of the figures on horseback, are medallions, possibly originally in stucco, carrying—in the conventional style we have seen before—a portrait profile and the names and titles of the subject around the edge, in the fashion of a coin. Andreasi has sometimes been sketchy in copying these, and occasionally has omitted the heads entirely. But he has included enough to show that these medallions were closely based on the illustrations in Fulvio's *Illustrium imagines*, or were drawn from one of the later collections of illustrated biographies that re-used the same images.[30]

With the help of Fulvio, it is possible to work out who most of these characters were, and often the precise text that was reproduced around the edge. It is a careful and, for the most part, learned line-up. On either side of the *Fire of Rome* were shown Nero's two fathers: the emperor Claudius, his adoptive father on the left, and, on the right, Domitius Ahenobarbus, his natural father, the first husband of his mother Agrippina the Younger ('Domitius the father of the emperor Nero'). Of the matching medallions below, one is too sketchy to make out, and Andreasi has left the other blank (though Agrippina herself must be a likely candidate). On the right-hand side of the wall, alongside the painting of Otho's funeral pyre, on the upper

5.9 Beneath Titian's portrait of Augustus, Andreasi shows the accompanying story from Suetonius: when still a baby, he once disappeared from his cradle and was found at the top of a nearby building, gazing at the sun—an omen of future greatness. The medallions surrounding this show: on the upper level, his wife Livia and her first husband, Tiberius Nero (the father of the emperor Tiberius); on the lower, his daughter Julia and Livilla (the wife and murderer of Tiberius's son Drusus).

register were the fathers of Otho and Vitellius; and below, their mothers.[31]

Taken altogether, with similar portrait medallions on the other walls, these add up to a huge family gallery of emperors and their relations—though there were some apparently quirky choices. On the east wall, Andreasi has shown four medallions under Titian's portrait of Augustus: the first three, his wife Livia and daughter Julia, as well as Livia's first husband 'Tiberius Nero' (not to be confused with the emperor Nero or with Tiberius, Augustus's successor), were predictable enough. But completing the set is Livilla, 'the wife of Drusus, the son of (the emperor) Tiberius' as the caption reads. She was indeed Drusus's wife; she was also said to have been his murderer and the lover of Sejanus, the notorious prefect of the Praetorian Guard, who aimed at overthrowing Tiberius—and she ended up, according to one account, imprisoned by her mother and starved to death (Fig. 5.9).[32] Was this a case of artists in a hurry, picking out a face that would fit, without really knowing the story? Or is there a hint here of a darker side to their choice, a gloomier version of dynastic politics on display?

Whatever the answer—and that is something to which I shall return—these figures remind us of the imperial overload in this single room. Counting Titian's portraits and Giulio Romano's 'stories', along with the forty or so medallions, and taking the figures on horseback as emperors too, there was a grand total of not just the eleven Titians, but more than seventy emperors and their immediate relations in the Camerino dei Cesari.

## Loose Ends, Explanations and the Imperial Inheritance

The room was a major exercise in 'imperial extravaganza'. But there remain any number of loose ends that make its precise design, and purpose, tantalisingly hard to pin down. The study of the Camerino has been dogged for centuries by puzzles, inconsistencies, optimistic inferences and modern mistakes taken as 'facts'—that have themselves become part of the story of these *Caesars*.

One problem is that there are just too many pieces in the jigsaw puzzle, and apparently good 'evidence' for more paintings than could ever actually have fitted into the room. It is a fair assumption that Andreasi originally made drawings of each of the four walls, as well as of all eleven Caesars. But if so, his plan of the north wall, carrying the portraits of Vitellius, Vespasian and Titus, has been lost—making it now impossible to reconstruct the exact layout. There is no way of squeezing into its width of less than five metres (including a door, which may have carried a painting), all the images we think must have been there: that is, up to three 'stories' by Giulio Romano's workshop, amongst them the surviving *Triumph of Vespasian and Titus* (on its own not far short of two metres); plus two figures of horsemen to make up the total of twelve listed in some brief notes on the room which Strada made in 1568. Something has to go. But, without Andreasi's key, we have no clue as to what—or where.[33]

Another problem comes from the contemporary inventories themselves, which are sometimes more inconsistent than helpful, and sometimes plainly wrong. Their diligent, or disaffected, compilers were just as capable of making mistakes as those who screwed and unscrewed, studied or owned the Aldobrandini Tazze: the painting based directly on Suetonius, for example, of the eagle landing on Claudius's shoulder (Fig. 5.5) turns up in one list as a Julius Caesar, and in the Munich inventory—even more bizarrely—as a not particularly famous Roman aristocrat being offered the post as 'mayor' of Rome in 25 BCE.[34] And they could be notably divergent (or sloppy) over exact numbers. We have little more than ingenuity to fall back on if we want to reconcile the *twelve* figures of horsemen punctuating

the lower register of the room that were noted by Jacopo Strada in 1568 ('emperors', as he called them) with the *ten* recorded in the inventory made in 1627, or with the *eleven* in the lists made after they had been taken to England, when the property of Charles I was sold.[35]

What is clear is that the beguiling power of the number twelve has often been at work, as if—without the need for a careful count—Caesars could be assumed to come in round dozens. That may help to explain Strada's twelve horsemen. It has certainly skewed both Renaissance and later accounts of Titian's portraits themselves, which have been more often dubbed his 'Twelve' than his 'Eleven' emperors. Already by 1550, Georgio Vasari in his *Lives of the Most Excellent Painters* consistently referred to Titian's 'twelve portraits of the twelve Caesars'.[36] Four hundred years later, the art historian Frederick Hartt, determined to find the twelfth emperor, concocted an elaborate fantasy to show that Domitian had once been shown in the centre of the (lost) decoration of the ceiling.[37] There is no reason whatsoever to suppose that he had. But, from soon after Titian had finished his eleven, eyes were on the mysterious 'missing' Caesar.

The fact is that there are a large number of these 'twelfth Caesars' floating around. The painter Bernardino Campi, who copied the emperors in Mantua in 1561, certainly made one to complete the imperial dozen (below, pp. 179–80). But there were other rival Domitians intended to plug the gap. These include one attributed to Giulio Romano in the Mantuan inventory of 1627 (the attribution being an implausible guess or erroneous folk memory, in the eyes of most modern art historians), and two surviving examples closely following Titian's general format, by Domenico Fetti, a painter employed in Mantua in the early seventeenth century.[38] Even though there was no space to fit a Domitian into the Camerino itself, the 'incompleteness' of Titian's set seems to have become part of its allure, as later painters found the challenge of completing the master's work too good to resist. It is another version of the Caesars as a work in progress (Fig. 5.10).

So why *did* Titian stop at eleven? There is no firm evidence, only guesses and inferences, good and bad. It is hard to believe the regular modern explanation, that the room, especially with the window interrupting the east side, was just too small to fit twelve Caesars comfortably. If either Titian or Giulio Romano had wanted to include all twelve they surely could have found a way of doing so (making the paintings a little smaller can hardly have been beyond the wits of this pair). It may partly have been—as in other fluid sets of Renaissance Romans—in order to omit the monstrous Domitian (though again, if so, why Caligula, Nero or Vitellius were

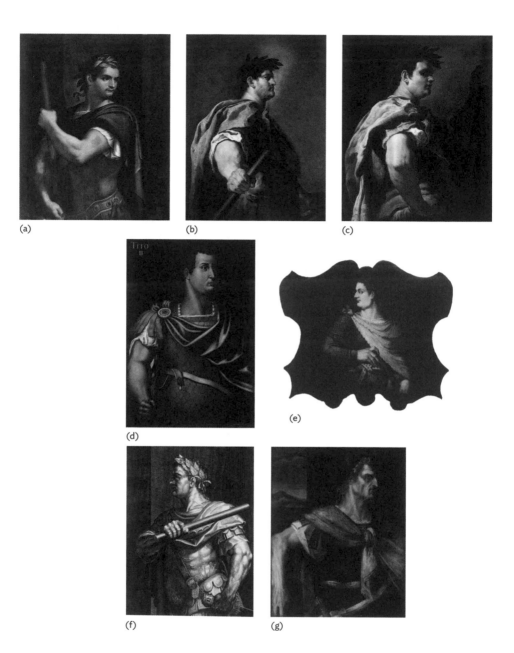

5.10 Titian's 'missing' *Domitian* was an opportunity for artists to fill the gap in their own way.

(a) Bernardino Campi's sixteenth-century version, made for the Marquis of Pescara

(b) and (c) Two different versions by Domenico Fetti (1589–1623)

(d) Domitian originally from a private collection in Mantua, though wrongly labelled 'Titus'

(e) The version from the royal palace in Munich, cut down to serve as an 'over-door' decoration

(f) Aegidius Sadeler's engraving, c. 1620

(g) The version from the set acquired by the Ducal Palace in Mantua in the 1920s, of which eleven now hang in the Camerino

given house room is hard to fathom). More likely a point about dynasty was being made.

One major theme of the room's decoration—as on the bowls of the Aldobrandini Tazze—was dynastic succession. Three of Giulio Romano's 'stories' focussed on signs of future power. Andreasi's drawings show, as well as the eagle on the shoulder of Claudius, a scene in which Julius Caesar is spurred to seek one-man rule for himself by contemplating a statue of Alexander the Great, and another in which a miracle involving the baby Augustus predicts his divinely ordained sovereignty (following Suetonius's account, the baby has disappeared from his cradle, to be discovered on top of a neighbouring building, gazing at the rising sun) (Fig. 5.9).[39] More than that, the portrait medallions, picturing imperial parents and children, address the continuity of power, in its transmission from one generation to the next. The absence of Domitian—as last in the line (rather than as monster)—leaves open the possibility that this series of rulers would continue. It is an image of imperial rule passed on, without end.[40]

It is a celebration, in other words, of the future of the Gonzaga—but also of their genealogy, symbolic and literal. Whatever more subversive readings I shall be tempted to detect in some of these images, the newly promoted Duke Federico was at one level trying to legitimate himself, and his family, by aligning them with the emperors of Rome. This was by then a well-established tactic. We have already noted public displays in which some of the Habsburg nobility were likened to their Roman equivalents, or even to the full Suetonian Twelve (below, pp. 122–23). On an even grander scale, the whole lineage of the modern Holy Roman emperors (whether from the Habsburg dynasty, as they were at this period, or others) was notionally traced back to the ancient world. One of their most powerful slogans was 'translatio imperii', evoking the idea of the direct 'transfer of power' from ancient Romans to Franks and on to later German rulers.[41]

This slogan appeared in all kinds of guises. It was extravagantly converted into bronze in the great sixteenth-century mausoleum of Emperor Maximilian I in Innsbruck, never finally completed. Here, it was originally planned that a grand total of thirty-four busts of Roman emperors, starting with Julius Caesar, should join a roster of Habsburg ancestors and related Christian saints—all leading up to Maximilian himself.[42] And it launched any number of tendentious literary and historical enterprises. One of the most ambitious of these was a project by Jacopo Strada himself. In 1557, he published, from early drafts of the manuscript, a 'bootleg' first edition of a vast historical compendium by a learned monk, Onofrio Panvinio, who had drawn up a comprehensive list of Roman office holders, consuls, victorious

generals and emperors; it stretched without a break over more than two thousand years, from Romulus, the mythical founder of the city of Rome, to Charles V, the Holy Roman emperor, who abdicated in 1556. It was an extraordinary achievement of scholarly diligence and ingenuity in the service of what now seems a decidedly implausible imperial ideology.[43]

Federico's Camerino was part of that tradition. Whether, as has recently been suggested, Titian hammered home the equivalence between the Gonzaga and the Caesars, by basing the portrait of Augustus on the features of Federico himself, is doubtful. Titian's Augustus does seem to have been significantly different from the standard Renaissance version, and perhaps has a faint resemblance to some portraits of the duke; but it matches even more closely some bearded coin-portraits of the young Roman emperor, to which Titian would almost certainly have had access.[44] Observant visitors would, however, have noticed the 'rhyme' between the eleven Caesars and the eleven sculpted heads (of henchmen, supporters, relations or ancestors of Charles V, to whom Federico owed his dukedom) in the 'Sala delle Teste' (Room of the heads) next door. It was a hint of equivalence between antiquity and modernity.[45]

Who those visitors were is a final point of uncertainty, and raises a question relevant to any set of emperors, whether in paint or paper, marble or wax. Who was looking at them and at whom were they aimed? The 'Trojan Suite' as a whole gives every appearance to us of being a sequence of prestige display rooms, intended to put Federico and his dynasty on show, designed to impress. But that does not sit entirely easily with the domestic paraphernalia listed there in an inventory of Gonzaga property made in 1540, soon after the Suite was completed. Like the adjacent rooms, the Camerino then housed several beds and mattresses, as well as a clavichord.[46] This does not, of course, mean that it was *not* intended to impress. The function of European rooms before the nineteenth century was much less fixed than we now take for granted, and there were many uses (from lavish celebration to sleeping and music-making) to which a Renaissance 'display room' might be put. But it does suggest a target audience that was more internal and domestic than we might at first imagine, with wider implications about how these images operated. To put it another way, the presentation of the Gonzaga as the inheritors of the prestige and power of the Roman Caesars might have been aimed not so much at outside visitors, but at the Gonzaga themselves. It is perhaps too easy for us to forget that those who needed convincing that a modern aristocrat or autocrat stood in the tradition of ancient imperial power included not only his subjects, courtiers and rivals—but also the very ordinary human being that was the aristocrat or autocrat himself.

# From Mantua to London and Madrid

One person who did not have much chance to enjoy, or to learn from, the Camerino was the man who had commissioned it. A surviving letter from early January 1540 gives evidence of payment for the crates in which Titian's final portraits were transported from Venice to Mantua;[47] by the end of June that year Duke Federico I was dead. The room did not survive in its glorious pristine state for long. Less than ninety years—and one regent and seven dukes—later, in 1628, most of its paintings, along with other Gonzaga masterpieces, were on the way to England, acquired for King Charles I. A rash of over-expenditure on further palace 'improvements', combined with the need to raise cash to face military threat (the extra, contested, territory won by Federico in the 1530s had eventually proved harder to hold onto than it was worth) more or less forced the Gonzaga to sell much of their art collection, the Titians and Giulio Romanos included. Often treated, even by modern scholars almost half a millennium later, as a 'tragedy', the sale might in fact have saved more than it lost. For in 1630, in what is rather blandly known as 'The War of Mantuan Succession', Austrian troops, campaigning in support of one of a number of rival claimants to the dukedom, sacked the city of Mantua, against a typical backdrop of looting, theft and destruction.[48]

There is another reason that makes 'tragedy' an overstatement, when applied to the paintings of the Camerino dei Cesari. For the room, in the form in which Giulio Romano had designed it, had been dismantled years earlier. The inventory of 1627 (made at the time of the sale of the collection) makes clear that its main elements—Titian's 'Eleven', the extra emperor attributed in this list to Giulio, the 'stories' and the horsemen—were no longer in their original location, but in the so-called 'Logion Serato' overlooking the garden, a new gallery or 'closed loggia', begun in the early seventeenth century by Federico's grandson (now known, after its eighteenth-century decoration, as the 'Galleria degli Specchi', or Gallery of mirrors). What is more, the inventory also makes clear that two of the 'stories'—the *Fire of Rome* and the *Eagle on the Shoulder of Claudius*—had already been re-used as over-door decorations in a completely different part of the palace (how the total of 'twelve' stories recorded in the Logion Serato are to be reconciled with these two outliers is another numerical problem).[49] Why, or exactly when, the Camerino had been dismembered in this way is a mystery. Perhaps it was simply a casualty of the decorative schemes and new enthusiasms of Federico's successors. But the irony is that this most celebrated of all imperial rooms, with an overwhelming influence

on later visions of the emperors, had a very short life—maybe already in pieces a few decades before Charles I acquired its principal elements.

To say that Charles 'acquired' the paintings is euphemistic shorthand for a combination of seedy negotiation, double-dealing, defaulted payments and sheer incompetence that ended with almost four hundred paintings and sculptures being sent to London from Mantua. The king in most cases did not know what he was getting (it was the result of selection by agents, not the fruits of a shopping list drawn up by His Majesty). The main negotiator of the deal, a Flemish broker by the name of Daniel Nys, has often been condemned as self-interested, unscrupulous and bordering on treacherous; fair characterisation or not, the unwillingness of the king's agents to part with hard cash meant that Nys ended up bankrupt. And it was the poor arrangement of the shipping and the sloppy storage that led to the mercury (packed right next to the paintings) spilling over them during a storm en route, leaving some blackened beyond recognition.[50]

In that complicated story, some important details of the fate of the pieces from the Camerino—what exactly came to England and in what condition it arrived—remain murky. A few tall tales have long circulated. One German visitor to Mantua in the early eighteenth century found on display there what he believed to be an original emperor by Titian (only 'eleven of them are gone') lodged next to a small collection of globes and a stuffed sea-ox; it was most likely a copy, or one of those spare Domitians. A century later, a note in a learned edition of Vasari's *Life of Giulio Romano* bizarrely claimed that the paintings from the Camerino had all been destroyed in the sack of the city in 1630, despite an otherwise unanimous chorus of references to them being taken to England.[51]

In general, discussion of the effects of the mercury and the remedies applied to the paintings was predictably guarded (it was claimed that a clever mixture of milk, spit and alcohol managed to undo a lot of the damage). But it was impossible to conceal what the 'quicksilver' had done to Titian's *Vitellius* (or *Otho*, as yet another early misidentification had it). According to an annotated inventory of the royal collection made in the late 1630s, this had been sent to Brussels for restoration, but must have come back in no fit state for prominent display, for—as the inventory records—it had been consigned to a passageway used for storage.[52] The original may well have been replaced by a new version, courtesy of the king's painter, Anthony van Dyck, who in 1632 was paid the substantial sum of £20 (the going rate for a half-length portrait) for the 'Emperour Vitellius', at the same time as he was paid £5 for 'mendinge the Picture of the Emperour Galbus'.[53] If so, there is no explicit reference to this in any later document. But 'spot the copy' (or

copies) or 'name the artist' became part of a guessing game around these emperors. One rare eyewitness description of King Charles's collection from a French visitor to the London court in 1639 referred to the eleven Titians and the twelfth, which 'Monsieur le Chavallier Vandheich' painted so brilliantly that it was as if he was 'bringing Titian back to life'. Was this, as seems likely, the *Vitellius*? If so, it had conveniently been forgotten that the Domitian had never been by Titian anyway.[54]

What is certain is that the paintings of the Camerino signified something different in their new homes, first in London and then in Madrid. The idea of a complete and complex ensemble of imperial images was gone for good (as it had started to disappear already in Mantua). Once they arrived in England, the paintings were split up not just between different rooms, but between different royal properties, whether hidden away, like the *Vitellius*, in a storage-passage at Whitehall, or on display at Greenwich, like the 'story' of the death of Otho.[55] The only group to reflect something of the original arrangement were seven of Titian's emperors (from Julius Caesar to Otho, omitting Caligula), which were hung next to seven of the Mantua horsemen, also identified as Caesars: 'A Halfe figure of Julius Caesar By Titian. A lesser of Julius Caesar on Horsebacke By Julio Romano', as the description of an inventory of 1640–41 went.[56] These were hung in what was called the 'gallery' at St James's Palace, which went up in flames in 1809 (this whole story is dogged by fire and destruction), making it hard to know where exactly the lost paintings were displayed in the lost gallery.

Most likely, to judge from the order in which they are listed, these seven pairs of imperial figures were arranged in two groups of three and four on the sidewalls of this long room, which at that date held fifty-five paintings in all. They seem to have flanked Guido Reni's vast depiction of Hercules on his funerary pyre, also from Mantua, which hung alone on the narrow end wall. Despite the prosaic description in the inventory ('Hercules lyeing on a Pile of Wood'), it was a scene of the most famous apotheosis of ancient mythology: the image of the mortal hero about to be transformed by the flames into one of the immortal gods. In a prime position in the gallery, this balanced van Dyck's even larger, three-and-a-half-metre tall, brand new canvas of the king on horseback under a triumphal arch, which closed the room at the far end—or rather *opened* it, with its impossibly gigantic architecture through which we glimpse further vistas (Fig. 5.11).[57]

In the court of Charles, Roman emperors—both Titian's versions and others—were used to make a point about modern monarchy. In several cases, the king's portrait was based on a Roman prototype. Van Dyck's triumphal image is, for example, indirectly at least, a descendant of the

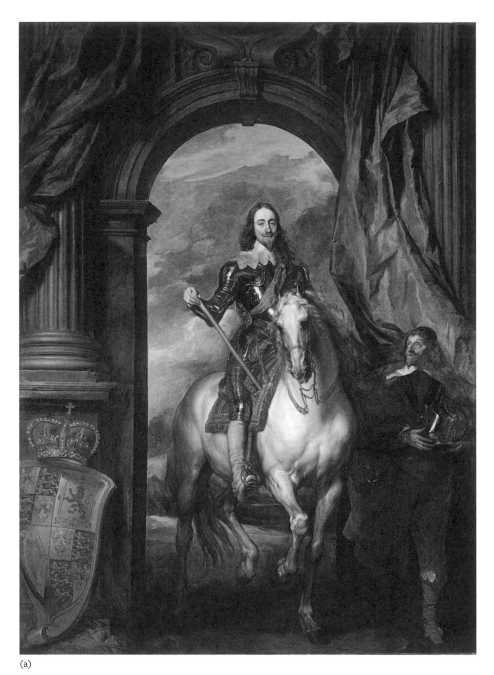

(a)

5.11 The gallery at St James's Palace, where the nucleus of Titian's emperors and some of the horsemen were hung, was dominated at either end by: (a) van Dyck's giant canvas of 1633, showing King Charles I on horseback—with echoes of the Roman equestrian statue of Marcus Aurelius (Fig. 1.11); and (b) [FACING PAGE] Guido Reni's 1617, frankly implausible, depiction of Hercules becoming a god, as he was consumed on his funeral pyre (a little smaller at two and a half metres tall).

(b)

famous ancient equestrian statue of Marcus Aurelius on the Capitoline hill at Rome;[58] and we have already seen that, whatever the awkward associations might have been, Titian's *Otho* lay behind van Dyck's half-length portrait of the king in armour. But the seven imperial pairs in the gallery contributed to the dialogue with the image of the living monarch, in a particularly loaded way.

The main axis of the gallery made an important and obvious religious point. At one end was the modern monarch, who famously proclaimed the 'divine right' of the human ruler. At the other end was the most renowned example of an ancient mortal hero, turned fully fledged god, at the very moment of his apotheosis. The Roman emperors helped to underline that equivalence. They were not, as some critics have imagined, 'an enfilade of "portraits"' acting as some kind of guard of honour leading up to van Dyck's figure of Charles (they were at the other end of the room).[59] Instead, clustered around Hercules, they were presented almost as if they were the mythical character's ancient historical analogues. For just as Hercules

crossed the line between human and divine, so many of these Roman emperors were thought to have crossed that same line 'in real life'. Three on display in the gallery, Julius Caesar, Augustus and Claudius, were all officially made 'gods' at their death, and in the case of every single one of them there was a blurred boundary, to say the least, between imperial and divine power.

The visitors to this area of the palace were highly select (again, as at Mantua, it was a semi-private space, where the king learned to *see himself* in Roman terms, as much as foisted that image on others). But any who knew their Roman history would very likely have got the point that the emperors provided the missing link between ancient mythical apotheosis and the complicated idea of 'human divinity' that underpinned some of Charles's theories of autocracy. They offered, in other words, not just a line-up of avatars of one-man rule, but also a lens through which to reflect on the powers and status of the monarch—helping to expose the connections between Hercules and the king, between divinity and the human ruler.[60]

Charles I enjoyed his Roman emperors, exploiting their lessons, longer than Federico in Mantua. Even so, it was for no more than a decade. After the start of the English Civil War in 1642, he barely cast eyes on any of the art collections in his London palaces again. Following his execution in 1649, most of the 'king's goods', that is, his art, jewels, royal insignia and household effects, were put up for sale, or assigned in settlement of his debts to his creditors—who usually recouped their money by selling the pieces on. It was fund-raising for the new, cash-strapped parliamentary regime dressed up as a gesture of republican iconoclasm and a blow against the trappings of royalty.[61] By now the original connections between the different elements from the Camerino were entirely lost, and most of the paintings went their separate ways, by sometimes tortuous routes. The eleven horsemen (or mounted emperors), for example, were made over in 1651 to Ralph Grynder, who had been the royal upholsterer and headed one of the syndicates of creditors. He split them up, to sell on to buyers who included a dealer who supplied Louis XIV of France (hence the trio now in Marseille). When Charles II regained his father's throne in 1660, after a short period of 'parliamentary' rule, just two of the original set were returned to the royal collection—whether thanks to the campaign of threats and strong-arm tactics from the apparatchiks of the new king, or as the result of a politically convenient act of generosity on the part of their new owners, we do not know.[62]

Only Titian's *Caesars* themselves were kept together. In fact, they were reassembled, now as a complete 'Twelve', from their different locations

across the royal properties—from backstairs to palatial picture gallery—and acquired as a set, along with many other prizes from the collection, for King Philip IV of Spain. The commercial dealings that led to this were almost as grubby as those that had surrounded the purchase of the so-called 'Mantua peeces' by Charles I just over twenty years earlier, and every means was used to beat down the cost. That involved keeping Philip's name, and any hint of lavish royal coffers, out of the dealings—and being (rightly or wrongly) a bit sniffy about the quality of some of the art on offer.[63]

The twelve *Caesars* were clearly a desirable catch, although not at the very top of the list. The first instinct of Alonso de Cárdenas, Philip's main agent, was to be wary of them, for the simple reason, as he claimed in a memorandum to one of the king's ministers, that six of the set were very damaged, and the *Vitellius* was by van Dyck anyway. By November 1651, for whatever reason, he put a more favourable spin on their condition (perhaps hoping that the purchase would put him ahead of rivals, who were also trying to ingratiate themselves with Philip by sending some of Charles I's art treasures his way). Writing to his contact at the Spanish court, Cárdenas now claimed to have been told that nine of the *Caesars* were well preserved, at least considering 'the age of the paintings'; and of the remaining three, only the *Nero* was damaged beyond repair. Nonetheless, he conceded, one was a replacement by van Dyck, and the set was 'not highly valued by everyone'. After some protracted negotiations, and some canny displays of lack of interest, he managed to acquire all twelve for £600 from a syndicate of Charles's creditors; it was half their official valuation. They were dispatched to Spain, with some of the allure of Titian still attached to them, but at the same time acknowledged to be in need of repair and a mongrel group (though perhaps not as mongrel as they really were, assuming that neither the replacement *Vitellius* nor the additional *Domitian* had any direct connection with Titian himself).[64]

What remedial treatment the paintings received on their arrival in Madrid, in 1652, we do not know. But they joined a royal collection which had already invested heavily in images of Roman rule. At his palace of the Buen Retiro (Nice Retreat—or even, almost, Second Home), just outside the centre of Madrid, for example, Philip displayed a notable series of paintings on Roman themes, including emperors in their defining roles: from addressing the troops and receiving religious honours, through imperial triumphal processions, to an emperor's funeral (Fig. 5.12).[65] His new acquisition of the *Twelve Caesars* were hung, in a similarly imperial context, in a picture gallery of another palace, the Real Alcázar (Royal fortress) in the city centre. This 'Galería del mediodía' (Southern gallery) was on the

5.12 The 'Nice Retreat' (Buen Retiro) of the Spanish royal family in Madrid paraded many images of Roman imperial power. Here Giovanni di Stefano Lanfranco's *Sacrifice for a Roman Emperor* of 1635—more than three and a half metres wide—focusses on the links between the ancient ruler and the pagan gods. The emperor in his golden cloak observes, as an elderly priest conducts a sacrifice to ensure his safety and success—and the unfortunate rams, which are to be the victims, are brought on.

first floor and part of the king's quarters—again as much a private space as a public one—where the paintings took their place among an array of notable portraits of Habsburgs and others. It was now *as portraits* that they were seen; their deracination (or liberation) from the complex dynastic ensemble at Mantua, a century earlier, was complete.

But anyone who looked out of the windows of the gallery—whose alternative name was, significantly, the 'Galería de los retratos' (Portrait gallery)—would have seen other illuminating connections. For, at least until 1674, when the garden was destroyed in the course of palace renovations, the gallery overlooked the Jardín de los emperadores (Garden of the emperors). Here, as yet more inventories make clear, there were two series of modern busts of the Twelve Caesars, from Julius Caesar to Domitian, leading up to a full-length portrait statue of Philip's great grandfather, Charles V (and the last Habsburg from the Spanish branch of the family to hold the office of Holy Roman emperor). In this case, the Caesars really did form a guard of honour for a modern monarch. And anyone looking up from those busts in the garden would have been able to glimpse, even if fleetingly, through the large windows of the adjacent gallery, the line-up of the most famous modern paintings of the emperors ever created: emperors in dialogue with emperors.[66]

Yet, for all their fame, it is hard not to suspect that the 'Titians' seemed by now a little past their prime. That was, very likely, the reason that they were hung so high up, near the ceiling of a display space that was two storeys in height. And that in turn explains why, in the devastating palace fire of 1734, they were impossible to reach in the rescue attempts and—despite those spurious later sightings—were completely destroyed.

## The Art of Replication

Yet, by the time of the fire, Titian's original paintings (in whatever way they had been completed to Twelve, restored, replaced or repainted) were only one part of the story. Soon after they were first on display at Mantua and long after they had been destroyed, thousands of copies of them were produced and these became some of the most familiar images across the continent of Europe, found not only in castles and palaces but in far more modest settings too, in every medium from paint and paper to enamel and bronze. The word 'copies' tends to underestimate their importance. For it was in this almost industrial process of replication that Titian's portraits—though not household images to us—became *the face* of the Roman emperors for generations, at least into the late nineteenth century. And 'face' is sometimes all they were. For although much of the original point of the Camerino dei Cesari had lain in the complex decorative scheme, with its narrative intersections, its imperial 'stories' and imperial horsemen, I have discovered only one later attempt to recreate anything of the flavour of the original ensemble. That was Jacopo Strada's 'mini-Mantua', featured in Albrecht V's Kunstkammer in Munich. Almost universally, the process of copying left the original context aside, and paraded a line-up of portraits—just as they appeared in the gallery of the Alcázar—ready to be fitted into new contexts of very different kinds.[67]

This process of replication started only twenty years after the paintings were installed in the Camerino, when the artist Bernardino Campi came to Mantua for a wedding celebration in 1561 with his patron, the Marquis of Pescara; while there, he copied the Titians, adding a Domitian of his own, so close to the style of the originals, it was said, that no one could tell the difference. One powerful modern myth (based on a determined misreading of a sixteenth-century biography of the painter) holds that Campi generously left the Domitian behind, as a gift to his hosts, to be housed as the missing piece in the room adjacent to the Camerino. What Campi actually did, according to the biographer, was present *all* his paintings to the marquis to take back home.[68] But he very likely saw lucrative opportunities

here. For a set of careful pen and ink drawings of each of Titian's emperors, signed by Campi and dated to July 1561, with brief biographical sketches, plus notes on their different costumes and colouring, has recently been rediscovered in an Italian archive—presumably intended to provide the basis for more copies, to be produced on demand.[69] And, sure enough, we find references to at least six further sets by Campi in the hands of European aristocrats at the time: one belonging to Ferdinand I of Austria, the Holy Roman emperor, three more the proud possessions of a trio of prominent members of the Spanish court, and a little later in the 1580s—on the principle, I suppose, that no Gonzaga palace should be without its Caesars—versions owned by two junior branches of the family, based at Sabbioneta and Guastalla.[70]

But Campi did not have a monopoly on these reproductions. Local artists were kept busy producing copies for the homes of the Mantuan nobility, and in the early 1570s one of them was commissioned to paint a set for another Spanish courtier, Antonio Pérez, as a gift from the current duke.[71] From further afield, there is evidence that Emperor Maximilian II asked to send a painter from Vienna to make his own copies; while in the early seventeenth century, the Farnese family had another set, displayed (behind busts of the Twelve Caesars) in their palace at Rome, attributed in a later inventory—rightly or wrongly—to one, or two, of the brothers Carracci.[72] Yet another was made for the Gonzaga of Mantua themselves, while the collection was waiting in Venice to be shipped to England; it appears that they were soon half regretting the sale of some of their favourite possessions (the Caesars almost certainly among them) and acquired some look-alikes as mementos.[73] Ironically, one set of copies eventually became redundant. When the originals arrived at the Alcázar in 1652, they trumped a replica set that was almost certainly already in the Spanish royal collection. That, at least, is the implication of a letter of 1585, discussing the sale of the artworks collected by Antonio Pérez. It claims that King Philip II (Philip IV's grandfather) was not in the race to buy Pérez's copies of the Caesars, because he had already acquired his own versions 'from Rome'.[74]

With all this information, it is frustrating to find how difficult it is to match up the copies documented in letters, inventories and biographies with the many sets that actually survive. Apart from Campi's signed drawings, there is only one that can be pinned down exactly. That first set of painted replicas, made by Campi for the Marquis of Pescara, must be those in the D'Avalos collection, now part of the holdings of the National Gallery at Naples (Pescara's family name was D'Avalos). Other genealogies

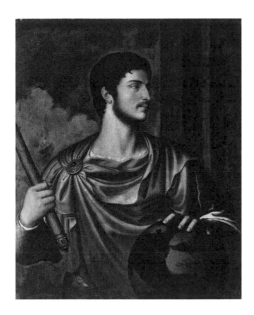
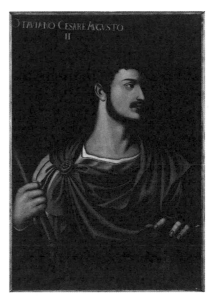

5.13 Replicating Titian's emperors was big business for painters, but it is hard now to distinguish which surviving copy was made when, by whom and for whom. On the left is one of the most certain: Bernardino Campi's *Augustus* painted for the Marquis of Pescara in 1561. On the right, *Augustus* originally from a local Mantuan collection.

can occasionally be reconstructed. For example, a little-known set in a private collection in the United Kingdom comes from an old Mantuan family, with close connections to the Gonzaga—and so is very likely to have been among the early copies made for the local elite (Fig. 5.13).[75]

For the rest, there are puzzles, loose ends and any number of tortuous, ingenious, inconclusive and sometimes implausible attempts to track the history of the different copies through the generations of European aristocracy. Take the surviving replicas in Munich, once the nucleus of the 'mini-Mantua' in Albrecht V's Kunstkammer, but later cut down, to serve as decoration over the doors of some grand rooms in the Munich Residenz, or royal palace. Could these be the ones made by Campi for Ferdinand I, which might then have passed down to his son-in-law Albrecht? Possibly. But if so, why is the Domitian in this set so completely different from the one Campi had produced for the Marquis of Pescara (Fig. 5.10e and a)? It is just conceivable that, despite the model template he had drawn, Campi was ringing the changes and exploiting the freedom that the absent Domitian gave him. Much more likely is that the set in Munich was not by him at all.[76] And what of the lost copies owned by Emperor Rudolf II in Prague? Were these the ones made for Antonio Pérez, and then put up for sale? Or

did he inherit, and take from Vienna to his new 'imperial' capital, the set commissioned in 1572 by his father, Maximilian II?[77]

Who knows? But whatever the origin of Rudolf's Caesars, they had a greater impact on European art over the next few centuries than Rudolf himself could ever have predicted. For they almost certainly provided the basis of the series of seventeenth-century engravings which gave 'Titian's' emperors their popular presence across Europe, far beyond the palatial residences of the aristocracy. In the early 1620's, during the reign of Emperor Ferdinand II (Rudolf's successor but one), Aegidius (or Gilles) Sadeler, one of a dynasty of Flemish printmakers who had become in-house engraver to the court at Prague, produced a printed series of the Caesars (Figs 5.2 and 5.10f). Compared with the earlier drawings by Andreasi and Campi (which are closely similar down to small details), these were in some respects a less accurate version of the originals. Maybe the versions from which he copied in Prague were already sketchier; maybe Sadeler was giving the 'Titians' a rather more contemporary and more northern-European gloss. But, accurate or not, they became for generations a staple of his firm's trade, and flowed by the hundreds, if not thousands, into the libraries of Europe and the drawing rooms of the bourgeoisie.[78] Some of the copies documented after this point *may* have still been taken from the originals themselves (it is not completely impossible, for example, that Lord Leicester's *Twelve Emperors* 'from after Titian' sighted at Penshurst Place in Kent in the 1720s were copied when the paintings were in London[79]). But it is clear, from the details of their designs, that most of the surviving versions, from the mid-seventeenth century on, were modelled on the prints. The face of the Roman emperors was now the face of *Sadeler's copies of copies* of Titian's portraits.

The truth is that most of the painted versions, based on Sadeler, are almost embarrassingly distant from anything that might be mistaken for a Titian. Abraham Darby's six were almost certainly a group of these 'second generation' versions (Fig. 5.1), as was the even clunkier set that once hung in Bolsover Castle—where imperial figures also surrounded the fountain, leering at a naked Venus.[80] It would have been very difficult indeed for anyone, unless blinded by optimism, to detect the hand of the master in these. But more important is how these distinctive Caesars made their way into very different contexts, in very different media. The image of what was in fact *Sadeler's* Augustus on the royal teacup (Fig. 5.3) was only one of many copies of his imperial portraits to find a home not on gallery walls, but on all kinds of more 'domestic' objects, from the exquisitely precious to the very ordinary. There were certainly some connoisseur items among them,

5.14 Sadeler's emperors got everywhere, and by unexpected routes. Here a late fifteenth-century edition of Suetonius has been re-bound around 1800, incorporating small (under four centimetres tall) enamel versions of Sadeler's engravings which were made c. 1690.

designed to impress despite (or, equally likely, because of) their small scale. One late eighteenth-century book collector, for example, commissioned a new binding for his prized 1470 edition of Suetonius's *Lives*, which re-used in the decoration a miniature set of enamels, produced in Augsburg a century or so earlier and based on Sadeler's prints (and similar enamels ended up on a pair of display 'shields' in the Munich Schatzkammer, or royal treasury) (Fig. 5.14).[81] But at the same time, the cheap mass-produced plaque I illustrated in the last chapter, designed to be nailed to the wall or onto the furniture of those with less pretension and money, features none other than Sadeler's *Caligula* (Fig. 4.6). There must have been thousands upon thousands more of such versions.

Sadeler's engravings were even turned into sculpture. Some of the modern images of emperors, in marble or metal, that still line palatial galleries and garden walks, turn out—if you look carefully—to be based on

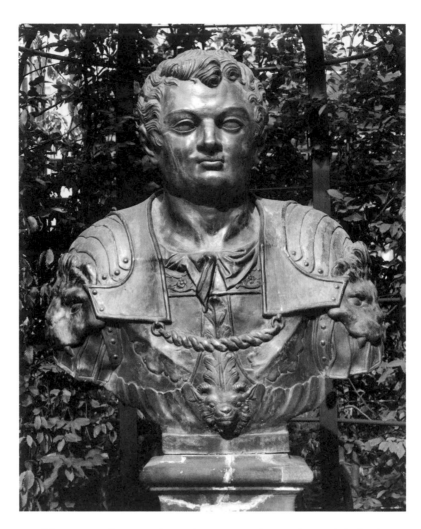

5.15 The contrast between the garden setting in Amsterdam and the lead emperor is striking. He is a same-size version (just under a metre tall) of Eggers's late seventeenth-century *Otho* from Berlin—and the link to Titian's *Otho* is conclusively given away by the clothing.

those famous engravings. In the garden of what was the royal residence of Charlottenburg, in Berlin, for example, stands a line-up of late seventeenth-century imperial busts, the work of the sculptor Bartholomeus Eggers (it was among these that Effi Briest, in Theodor Fontane's novel of the same name, used to stroll in the afternoons, wondering how to tell her Nero from her Titus[82]). At first glance they do not appear to be the spitting image of Sadeler's prints. That is partly because, in converting the two-dimensional, often profile, face of the prints into three dimensions, Eggers has lost some

of the character of the originals. But look at the dress and the armour, and in some cases (especially *Otho*, with the chain across his chest, and the recognisable folds at the neck) the match is very close. One art historian has recently dubbed these busts 'imaginative fantasies'. Maybe; but, if so, they are the imaginative fantasies of Titian mediated through Aegidius Sadeler (Fig. 5.15).[83]

It is now almost impossible to re-imagine the European world of the seventeenth to nineteenth centuries, in which the Roman emperors, as they were recreated by Titian and spread across the continent thanks to Sadeler, were *the* standard way of envisaging these ancient rulers; a world in which to close your eyes and think of, say, Otho was almost certainly to see *this* version of the emperor. Their influence has not entirely disappeared. You get a brief glimpse of Sadeler's engravings in Peter Greenaway's 1991 film *Prospero's Books*. Only a few years ago, a report in the *Daily Mail* of the discovery of that rather dubious Roman statue of Caligula (above, pp. 63–64) was illustrated with a coloured version of Sadeler's *Caligula*. And you can still buy tote bags, t-shirts, mobile-phone cases and duvet covers branded with his emperors.[84] But since the late nineteenth century, they have lost their instant familiarity. Almost no one now sees Roman emperors in this guise.

Why have they been eclipsed? Partly, I suspect, the growing cult of the 'original' (witness those excited 'discoveries' which started this chapter) made the loss of Titian's paintings themselves harder to overlook. But even more to the point, in the search for the authentic imperial faces of the past, Titian's radical combination of slightly florid Renaissance modernity and archaeological accuracy came to seem more awkward than innovative. A biography of Titian published in the 1870s already catches the changing mood. Its authors concede that the original paintings might have been far superior to the copies, but they still have little time for the emperors' 'forced and unnatural attitudes', the 'grotesque' theatricality and 'affected bombast'.[85] It is a far cry from one of the Carracci brothers calling them 'unbeatable'.

## The Writing on the Wall

There is, however, one important element in Sadeler's engravings almost entirely ignored by modern art historians. Beneath each imperial figure run several lines of Latin verses, summing up the achievements and character of the emperor above: a reference to 'two columns of Latin inscription' is typical of the attention usually paid to them. Who wrote these words is a mystery, and in some places the language of the poetry is so clumsy that it

is almost impossible to translate into reasonable sense (hence perhaps the lack of a translation even when, occasionally, modern scholars *do* reprint the Latin). But, as the full versions in the Appendix below make clear, for the most part these poems represent fierce attacks on the career and the morality of the ruler concerned. How is this to be read?

Even within the conceptual world of the European aristocracy, images of the Caesars played various roles. We have already seen them acting as legitimating ancestors for modern dynasties. They might also act as 'examples' to shape the conduct of the modern ruler. Sometimes this was as a positive model to follow. One seventeenth-century Spanish theorist proposed carefully restricting the images within the palace walls: 'There should be no statue or piece of painting allowed', as an early English translation ran, 'but such as may create in the Prince a glorious Emulation.'[86] But more often such *exempla*, both textual and visual, provided not only honourable models to emulate, but also warnings of what kind of behaviour was to be avoided. Or, to follow the slightly quirky emphasis of one sixteenth-century student of coins: you can learn from observing crocodiles, hippopotamuses, rhinoceroses and other monstrous *animals*—so too from observing monstrous *emperors*.[87]

That presumably was part of the point of Giulio Romano's imperial 'stories' designed for the Camerino dei Cesari. They intermingled examples of good and bad conduct (Otho's noble suicide versus Nero 'fiddling while Rome burned'), asking the viewer to make the contrasts and draw the implied lessons.[88] But the verses in Sadeler's engravings went much further than that.

Of the Twelve Caesars, only Vespasian was unequivocally praised ('Look now at the image of a good Caesar'). All the others were the subjects of more or less intense criticism. Some were obvious targets. Tiberius founded his rule on 'savage rites and more than hateful emotions', Nero 'made a pile of evil' and 'tried to destroy his native land by fire and his mother by the sword', and Domitian 'clouded the name of Caesar and stained its shrine'. But those who might have been expected to prompt a more favourable response were also partly damned. The verses under Julius Caesar accuse him of incest with his mother ('deadly too because of the crime of violating his mother'). Augustus is, admittedly, credited with ending wars in the Empire, but the first part of his career at least is written off as 'achieving nothing worthy of glory'. Even Titus, who comes second only to Vespasian in virtue is rather darkly credited with being 'clever enough to take <his> pleasures secretly'.

These scurrilous, awkward verses, pouring scorn on almost all their imperial subjects, are the only detailed responses we have to the content, rather than the style, of Titian's *Caesars*, and it is very hard to know exactly how to take them. The whole set of prints was dedicated by Sadeler to Emperor Ferdinand II. Was the emperor surprised, shocked or wrily amused by what he read under each of the images? What point was Sadeler (or his clumsy versifier) trying to make? How did the message go down among the thousands of others who owned, admired or recopied these classic images? Or were they as little read then as they are now?

There is no way of telling. But they push us to think harder about the darker, more subversive or controversial sides of images of the Caesars—starting with another royal palace (Hampton Court in England), another set of precious lost originals, more cases of mistaken identity and—first of all—one of the most overblown and least loved depictions of Roman emperors in the modern world.

# VI

# SATIRE, SUBVERSION AND ASSASSINATION

## The Caesars on the Stairs

For those who have little taste for 'extreme baroque', the decoration of the 'King's Staircase' at Hampton Court Palace, just outside London, is hard to take ('florid' is one of the politer adjectives applied to it).[1] Finished in the early years of the eighteenth century, these paintings were part of a radical makeover of the palace, started by King William and Queen Mary very soon after they seized the throne from Mary's father in 1688. They were the work of Antonio Verrio, an Italian artist, astute businessman and survivor, who managed to win major commissions from all the rulers of England between Charles II and Queen Anne, across revolutions in dynasty, politics and religion. His task here was to cover, in appropriately grand style, the ceremonial stairway, designed by Christopher Wren, that led up to the state-rooms of the King's Apartments on the first floor, hence 'King's Staircase' (Fig. 6.1).[2]

It is hard now, as you walk up the steps, to get much sense of the decoration's theme, beyond its apparently colossal overstatement. All you catch, at first sight, is an assortment of ancient gods and goddesses sprawling over the ceiling, Hercules with his club improbably balanced on a cloud, an unusually languorous, scantily clad collection of Muses (also on a cloud, topped by a rather self-satisfied Apollo) and below, what looks like a slightly bemused emperor Nero crowned with laurel and strumming a guitar (Fig. 6.2b). It was not until the 1930s, after generations of bafflement recorded in the guidebooks to Hampton Court, that one art his-

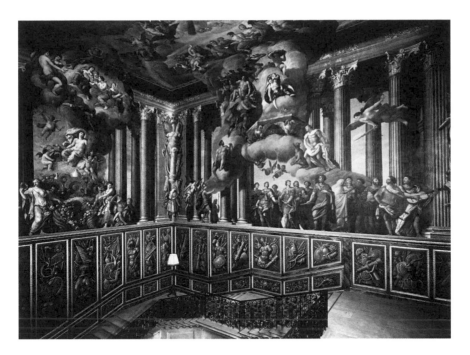

6.1 Antonio Verrio's early eighteenth-century baroque spectacle on the 'King's Staircase' at Hampton Court Palace makes much more sense when you know the story on which it is based: the emperor Julian's *The Caesars* (mid-fourth century CE), satirising his predecessors. On the main wall, a group of Roman emperors stands on the ground, with Alexander the Great coming to join from the left, all hoping to be admitted to a heavenly dinner party; their empty table is ready on a cloud above their heads, while the gods themselves are visible on the ceiling; also balanced on clouds in mid-air are Hercules and Romulus (the host) with his wolf. At the top of the left-hand wall, the god Apollo plays his lyre, reclining above the Muses.

torian spotted what originally lay behind all this. Verrio had produced a version in paint of a curious satire on the Roman emperors, written by one of their number: the fourth-century emperor Julian, now best known for his attempt at a pagan revival in the face of ascendant Christianity (hence his nickname 'the Apostate'). *The Caesars* is one of a number of his surviving works, all written in Greek—from mystical pagan theology to a book archly entitled 'The Beard Hater' (*Misopogon*), combining an ironic defence of his own appearance (beard included) with an attack on some of his ungrateful subjects.[3]

A simple joke drives *The Caesars*. It is Roman party time and Romulus, Rome's founder (who has since become a god), has decided to invite the past emperors to a literally divine banquet. The top tables have been

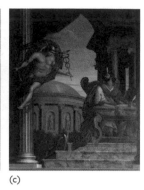

(a)　　　　　　　　　　　　　(b)　　　　　　　　　　　　　(c)

6.2 Four Roman rulers from the 'King's Staircase': (a) a rather haughty Julius Caesar turns his back on Augustus, who is being pestered by the philosopher Zeno; (b) Nero strumming his guitar; (c) on an adjacent wall, the fourth-century emperor Julian is writing at his desk, the god Mercury/Hermes hovering behind to inspire him.

arranged for the Olympian deities in strict order of seniority, from Zeus and his father Kronos down to the minor gods. A lower table has been prepared for the emperors, who file in one by one, a large selection of all four hundred years of them, from Julius Caesar down to Julian's immediate predecessors. They are not appealing guests for the divine company. Watch out for Caesar, Zeus is warned, he is after your kingdom. Nero is written off as a wannabe Apollo. Hadrian can do nothing but look for his lost boyfriend. And so on. The vast majority of these would-be revellers are disinvited from the party immediately, before the gods hold a more formal—and occasionally hilarious—vetting procedure to judge the relative worth of those left: Julius Caesar, Augustus, Trajan, Marcus Aurelius, Constantine and Alexander the Great, whom Hercules has squeezed into the competition at the last minute. At the end of this, after a secret ballot, Marcus Aurelius is declared the winner; though it is not clear that any of the emperors actually get to sup with the gods.[4]

This is the key to the painting. Julian is shown on a side wall near the top of the stairs, with the god Hermes or Mercury (whom he claims inspired his satire) looking over his shoulder (Fig. 6.2c).[5] On the upper levels, among the fluffy clouds, are the proper Olympian gods, and just underneath is an empty table apparently waiting for the emperors to take their place. But for the time being, immediately below Romulus and his wolf, a selection of them are kept waiting in the human world, while Alexander is coming to join the party from the left, closely followed by a 'Winged Victory'. Not all the emperors are identifiable. But in addition to

Nero with his guitar, the prominent character at the centre of the imperial group, in the red top, makes a fairly convincing Julius Caesar, and just to the right of him is Augustus (his companion, draped in white, must be the philosopher Zeno, who—in Julian's skit—was assigned to Augustus by the gods, to give him some wisdom) (Fig. 6.2a).

There is a close fit between text and image. But the big question is: what on earth was the point? Why did Verrio decorate (or daub) the walls of a royal palace with a visual version of a satire that cast almost every Roman emperor as somewhere on the spectrum between villain and idiot? It has been tempting to find a coded religious and political message here. Some modern interpretations have seen King William himself in the figure of Alexander, portrayed as if the equal of all the Roman emperors put together. Or, more specifically, they have detected an assertion of William's Protestantism again the Catholicism of his predecessor James II, represented here by these Roman rulers (is the slightly sinister figure of Zeno a covert attack on clerics?). Another view more subtly suggests we see the painting as an 'interactive essay' on William's qualities as ruler, casting him in very different roles, not just as the triumphant Alexander, but as Julian himself (his tolerant paganism equated with Protestantism) and even as the Apollo on his cloud, more glorious than self-satisfied, bringing back an era of culture.[6]

None of this is impossible. It is certainly true that Julian was better known and more widely read around 1700 than he has been since (although, even then, he was hardly a recognisable figure outside a small circle of the cultural elite). But there are serious difficulties with these coded meanings. Whether or not his tolerance was admired, the public parade of Julian, a proselytising pagan, as a symbol for the Protestant faith would have been decidedly tricky—not to mention the inconvenient fact that Alexander was not actually the winner in the gods' competition to find the best emperor; that was Marcus Aurelius.

Even more important, the attempts to unravel the hidden messages of the painting pass over what we see plainly on its surface. The surprising thing here is not what secrets may be dug out of it, but that in one of the most ceremonial areas in this royal palace we are presented with an array of Roman emperors as laughable failures (Marcus Aurelius apart). This is a very long way indeed from those powerful symbols of imperial power that we so often assume such line-ups to be. Why?

We are never likely to discover the intentions of Verrio, or of William III, or even the reactions of all those, from servants to ambassadors, who went up and down the stairs before the centuries of general bafflement

set in. But these strikingly disconcerting paintings prompt us to look more quizzically at some of the other imperial images in this palace—and then to look forward a hundred years or so into the nineteenth century, and its very different world of exhibitions, salons, galleries, competitions and public debate. Here too the complexity and the *edge* of some images of emperors (too easily written off, rather blandly, as 'Victorians in togas' or routine exercises in stale classicism) have often been overlooked.

But first to other Caesars in Hampton Court, and especially to Julius Caesar himself.

## Mantegna's Caesar

Julius Caesar has always been more intensely argued over than any other Roman ruler. Writers, activists and citizens have for centuries debated which side they were on: Caesar's or his assassins'? Shakespeare's *Julius Caesar* is only one, brilliantly ambivalent, meditation on this question. In the early fourteenth century, Dante imagined the assassins Brutus and Cassius in the very lowest of circle of hell, their feet stuffed into the mouths of Satan himself, only slightly better off than Judas Iscariot who is chewed up head-first. A century or so later, two learned Italian humanists conducted a notable exchange of pamphlets on the relative merits of Caesar and Scipio, the Roman Republican hero who had saved Rome by getting the better of Hannibal (for one, Poggio Bracciolini, Caesar was a tyrant who had destroyed liberty; for the other, Guarino Veronese, he had actually rescued liberty from the corruption into which it had fallen[7]). When Andrew Jackson was accused of 'Caesarism' in the early nineteenth century he may (or may not) have known that it was a charge levelled at any number of Western leaders before him. As one recent writer aptly put it, for more than a millennium Caesar's career has given 'flesh and blood to the abstract categories of political thought'.[8]

Some of the divisions have obvious roots in modern politics (Poggio's connections with the Florentine Republic underpinned some of his distaste for Caesar). But it was never a simple split between monarchs and monarchists lining up in the dictator's favour, and republicans against. There was plenty in Caesar to admire, whichever side you were on, from the literary style of his own writing that was imitated, willingly or not, by generations of schoolboys, to his daring, high-risk, but stunningly successful military 'genius'. In the medieval line-up of the 'Nine Worthies' he was grouped with two other warriors, Alexander the Great and the Trojan hero Hector, and he found a place, alongside Alexander once again, on one of the most

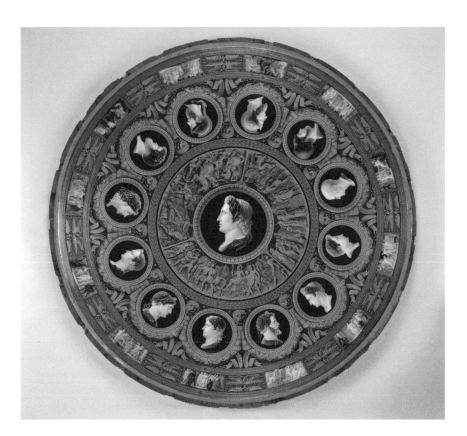

6.3 The porcelain top (roughly a metre in diameter) of the 'Table of the Great Commanders', with Alexander the Great as its centrepiece. It features a series of Roman emperors, in addition to Julius Caesar, grouped together in the lower part of this image: from right to left, Augustus, Septimius Severus (bearded), the fourth-century Constantine (with jewelled headband), Trajan, then Caesar himself (in detail). The scene beneath Caesar shows him turning away from the severed head of his rival Pompey the Great when it was presented to him. The table was commissioned by Napoleon in 1806, later given to the British king George IV and is now in Buckingham Palace.

expensive and brazen pieces of furniture commissioned by Napoleon, the 'Table of the Great Commanders' (its showy porcelain top decorated with scenes of triumph, slaughter and the heads of the twelve 'greatest' generals from the classical world) (Fig. 6.3).[9] Few until very recently have followed some of Caesar's enemies in ancient Rome itself, in wondering if his military

6.4 John Deare's relief sculpture, dated 1796, shows Caesar fighting from a boat, while from the right a Briton leads the attack on the Romans. The original inscription underneath the panel indicates that this would not be a Roman victory: HOC [V]NVM AD PRISTI[N]AM FORTVNAM CAESARI DE[F]VIT ('Caesar lacked this one thing to complete his traditional success', a quotation from his own account of the invasion of Britain). Significantly perhaps, Deare was a supporter of the American Revolution, and this sculpture, over a metre and a half wide, was made to fit over a fireplace in the English house of John Penn, grandson of William Penn of Pennsylvania.

success were more genocide than genius, and few artists have shared the alternative perspective of the eighteenth-century sculptor, John Deare. He depicted what appears at first sight to be Caesar in heroic combat against the enemy Britons, but in the inscription attached he reminded viewers that this would end up as a military failure on Caesar's part (Fig. 6.4).[10]

But going beyond the books and the battlefield, his other exemplary virtues for centuries provided a fruitful repertoire for painters and designers across Europe, even if the stories lying behind them have long ceased to be recognisable to most of us. Caesar's 'clemency' (*clementia*) was always a favourite theme, particularly as it was displayed after his victory in the civil wars that launched his one-man rule in Rome. The leader of his enemies in that conflict was Pompey the Great (Gnaeus Pompeius Magnus, in Latin), a once ambitious, self-aggrandising conqueror turned conservative traditionalist, who was defeated by Caesar in battle on the plain of Pharsalus in northern Greece in 49 BCE, and soon after came to a very nasty end, treacherously decapitated while trying to take refuge in Egypt. Caesar's behaviour in the aftermath of Pompey's death offered lessons for leaders ancient and modern, of all political colours.

The ceiling of one of the rooms in Federico Gonzaga's Palazzo Te shows Caesar being presented with the dead Pompey's 'filing cabinets' but ordering their contents to be burned: a magnanimous pledge that there would be no witch-hunts based on compromising information found in them (Fig. 6.5).[11] And any number of artists tried their hand at capturing the scene of Caesar's distress and disgust at being presented by Pompey's murderers with his severed head (which serves as Caesar's pictorial emblem, next to his portrait, on the 'Table of the Great Commanders') (Fig. 6.3). Again, this was supposed to be a mark of his humanity and decency, even if more cynical critics have suspected that these were crocodile tears rather than the genuine article.[12]

Yet—whatever his virtues—Caesar's assassination always looms large, and he could never provide a straightforward model for any modern dictator or dynast. The man who (to follow Poggio) brought ruin to the system of republican rule also brought ruin upon himself, becoming a symbol of the danger, even the death sentence, hanging over a monarch. It is very hard to look at any image of Julius Caesar, however ostensibly celebratory, without the knowledge of 'what happened next' creeping into the picture.

That sense of foreboding certainly informs Andrea Mantegna's series of nine paintings depicting Caesar's extravagant triumphal procession in

6.5 A classic example of Julius Caesar's magnanimity: seated at the centre of the scene, he orders the correspondence of his defeated rival, Pompey, to be destroyed—so that any information it contained could not be used against others. This is the main panel in the ceiling of the 'Chamber of the Emperors' in the Palazzo Te, the Gonzaga pleasure palace on the outskirts of Mantua, designed by Giulio Romano in the 1520s.

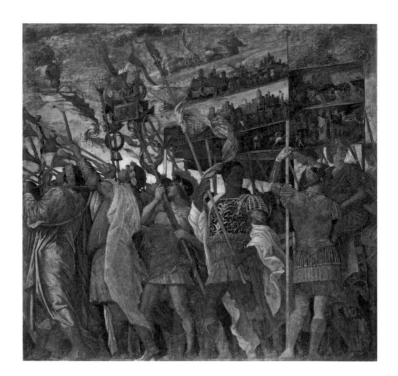

6.6  The first two scenes [HERE AND FACING PAGE] from Andrea Mantegna's *Triumphs of Caesar*, of the late fifteenth century. Large canvases, almost three metres high, they draw on ancient descriptions of these sometimes flamboyant Roman victory parades: with their booty, paintings illustrating the campaigns and slogans on placards. Here the single black participant, painted out by Roger Fry, has been restored to his rightful place.

46 BCE, held to honour his military victories all over the Roman world. Originally painted for the Gonzaga in the late fifteenth century (possibly commissioned by Duke Federico's father), they were another part of the haul of art acquired by Charles I in the 1620s.[13] They have been on display at Hampton Court almost continuously ever since. There have been swings of fashion in the appreciation of Mantegna and disappointment in the paintings' dilapidated condition and botched restorations—none more botched than that started by the artist Roger Fry in the early twentieth century, which notoriously removed the face of the single black soldier in the procession to make it match the white faces of all the others (Fig. 6.6).[14] But overall these *Triumphs* have been as much admired as Verrio's *Caesars* have been despised. It is partly that admiration—for such a brilliantly vivid re-creation of Roman spectacle—that has obscured the uncomfortable ambivalence of the theme depicted.

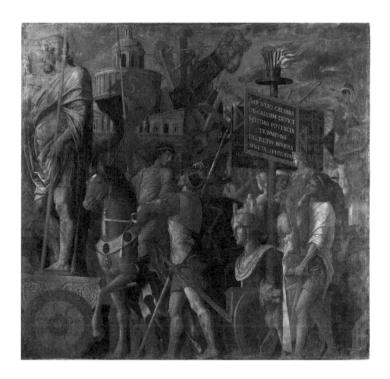

Most of the canvases in the series concentrate on the many participants in the procession itself, its jostling soldiers, captives and curious spectators, as well as the booty and precious artworks that were being trundled through the streets of Rome. But if these appear to be a self-confident assertion of dynastic military success, the final canvas changes the tone. Here Caesar himself sits on his triumphal chariot, a gaunt pensive figure, who seems already to have some inkling of what fate has in store less than two years hence (Fig. 6.7).[15] The prominent figure behind him heightens that unease. For this 'Winged Victory' takes the place of the slave whose job it was in the real procession to whisper repeatedly in the general's ear, 'Remember you are (only) a man'—in case, as happened with Caesar it was often said, success should encourage him to forget his merely human status.[16] And a closer look reveals even deeper anxieties elsewhere. A placard carried by a soldier in the second canvas (Fig. 6.6) spells out the honours voted to Caesar for his conquest of Gaul, but it finishes with three ominous words: 'invidia spreta superataq(ue)' (literally 'with envy scorned and overcome').[17] The truth was, of course, quite the reverse. Anyone familiar with even the bare outline of Caesar's career would know that one of the reasons for his assassination was that he had *not* overcome the envy of some of his fellow citizens.

There is an ambivalence here that sits uneasily, at the very least, with the pretensions to dynastic power or one-man rule of either the Gonzaga or the English monarchy. Perhaps it was because he understood this (rather than because he was a fan of Mantegna's brush-strokes) that Oliver Cromwell, the leader of the short-lived parliamentary, or republican, government, withdrew the *Triumphs* from the sale of the rest of the 'king's goods' after the execution of Charles I, and kept the series for the state. (What better warning lesson was there for any would-be monarch?) But another set of works of art that once had pride of place in Hampton Court,

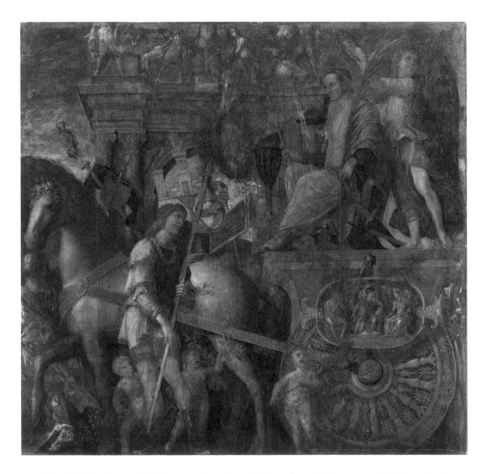

6.7 The final scene in Mantegna's series of *Triumphs*, with Caesar on his triumphal chariot, raises awkward questions (as the ceremony often did for the Romans themselves). Did the glory of it all go too far? Was this an example of pride coming before a fall? Would the victorious general heed the message whispered repeatedly in his ear that he was 'only a man'? In Caesar's case, assassination followed within eighteen months.

also on the theme of Julius Caesar and also later reserved for Cromwell, raises these ambivalences even more sharply: a group of precious tapestries commissioned by King Henry VIII, the palace's most famous proprietor. The originals have long been destroyed, lost and almost entirely forgotten, and (as with Titian's *Caesars*) only clever detective work can reconstruct them from many later versions and adaptations. But they comprised one of Tudor England's most important and expensive masterpieces—and one whose precise classical theme and difficult message has been misinterpreted for centuries. If we take the trouble to dig below the surface (and it *is* some trouble), an intriguing story emerges.

## Woven Caesars at Hampton Court

Henry acquired these ten vast Flemish tapestries, featuring episodes in the life of Julius Caesar, in the mid 1540s. Woven in wool, silk and gilt thread, each one was around four and a half metres in height—and, hung side by side, they would have stretched for a width of almost eighty metres. When the royal collection was valued a hundred years later, this set was priced at £5022, making it the second most expensive item out of all 'the king's goods'. That was more than four times the cash value assigned to Titian's eleven *Caesars* (and more than eight times what those paintings actually raised), and it was exceeded only by another set of tapestries almost certainly also commissioned by Henry: this was ten, even larger, scenes illustrating the biblical story of Abraham, assessed at £8260.[18]

It is hard now to recapture the importance of tapestries in Renaissance decoration, both in terms of price and prestige, and in terms of their number (inventories suggest that there were more than 2500 across Henry VIII's residences, even if that figure is inflated by some that were serving as mundane bed coverings rather than display pieces). Those we now see usually hang rather drearily, along the corridors of stately homes and galleries, in drab browns and greens, giving little hint of their original status and sparkle. Their bright colours have faded from long exposure to the light, and the glitter of the metal threads has been oxidised into oblivion. By the nineteenth century, many of these earlier masterpieces, which had often been more coveted than paintings by the richest European aristocrats—featuring themes from Roman imperial triumphs and the story of Hercules to the Garden of Eden and the Massacre of the Innocents— looked so dull and undistinguished that they were simply thrown away.[19]

That is almost certainly what happened to Henry's tapestries of Caesar. They were noticed and admired by visitors to Hampton Court at the end

of the sixteenth century (one praised the images as being 'woven into the tapestry to the very life'). After being withdrawn from the sale of 'goods' after the execution of King Charles, rather than sold at what would likely have been a huge profit, they were later returned to the royal collection. Up until the 1720s, there are various references to them being repaired, relined and some moved around to different palaces, until a last fleeting glimpse of them is caught in 1819 (when, or so optimists believe, a water-colour of *Queen Caroline's Drawing Room* at Kensington Palace shows one serving almost as wallpaper, behind the framed paintings on the wall).[20] At some point after that—unless they are lurking, abandoned and unnoticed, in some royal attic—they must have been discarded on the nineteenth-century equivalent of a skip.

It is, nevertheless, possible to reconstruct the general appearance of Henry's series. For even more than painting, tapestry was a medium of replication. The original paper designs for the weaving—or copies of them, or copies of copies—were regularly re-used or sold on, sometimes a century or more later, to produce new versions of roughly the same scenes. You would *expect* a major series like this to have its descendants—re-weavings or slightly adjusted iterations—in the collections of other members of the super-rich of Renaissance Europe. And so, if you look hard enough, it does.

No complete set of tapestries descended from Henry's originals survives.[21] But some clever sleuthing has made convincing connections between a number of scattered documents, which appear to refer to later versions of this Caesar series, and individual tapestries that remain on pub-lic display, or have come to light fleetingly when sold at auction across Europe and the United States (these objects are still collectors' items on the art market, though at prices far lower in real terms than those they once commanded). The arguments remain tentative in places. But overall, thanks largely to the later generations of these tapestries that once hung on the walls of Pope Julius III, two members of the Farnese family and Queen Christina of Sweden, we can get a fairly clear impression of the line-up of Henry's set. The lucky find of what appear to be a couple of small prelimi-nary sketches for one of the scenes has even helped to identify the designer behind the series as the early sixteenth-century Netherlandish artist Pieter Coecke van Aelst.[22]

Eye-witness descriptions of Henry's tapestries mention the precise subjects of only two scenes in his original group: the murder of Julius Cae-sar himself in 44 BCE; and the murder four years earlier of his enemy, Pompey.[23] The scene of Caesar's death is almost certainly reflected in a tapestry still on show in the Vatican. This is clearly dated 1549, and is one

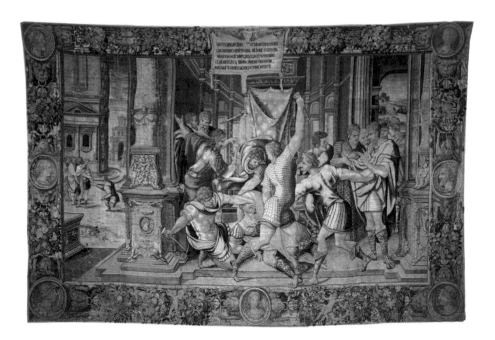

6.8 Caesar's assassination on a huge tapestry (seven metres across) in the Vatican, dated 1549 and almost certainly produced by the same workshop as Henry VIII's set. Caesar himself is submerged in the central group of assassins; we see him on the left in the background being warned of the plot by Artemidorus—but taking no notice.

of a set of ten acquired, according to documentary records, by Julius III in the early 1550s, made in Brussels very shortly after Henry's commission—though a little less lavishly (this set had no metal thread: 'without gold' as one inventory makes explicit) (Fig. 6.8).[24]

It features a terrible melée, in the middle of which Caesar is being dispatched by the daggers of the conspirators; while in the background, on a much smaller scale, the philosopher Artemidorus is vainly attempting to pass the victim a note warning him of what is about to happen (an incident recounted by several ancient writers, but which would become even more famous by being re-staged in William Shakespeare's play).[25] At the top, a lengthy caption woven into the fabric offers what art historians have called a 'moralising' reading of the scene (finishing with the words 'the man who used to fill the whole world with the blood of citizens, ended up filling the senate house with his own blood'). Moralising it may be. But it is also a quotation, slightly abbreviated and now universally unrecognised, from the description of Caesar's death by the second-century CE Roman historian Florus, chosen to act as a key to what is depicted below.[26] It is only one of

many classical allusions in these tapestries that have been forgotten, mis-read or mistranslated.

This *Assassination* is the closest we get to the original pieces owned by Henry VIII: made in the same decade, almost certainly from the same design and by the same weavers.[27] But, thanks to an intriguing and some-times tortuous trail, the other Roman scenes that once, so expensively, dec-orated the walls of Hampton Court can mostly be pinned down. It is worth getting a flavour of the twists and turns of this trail by following up just one part of it—starting from a sixteenth-century tapestry that appeared at auction in 1935 and has since gone underground again (Fig. 6.9).

This shows a group of men in Roman dress apparently trying to break down a closed door with a ram, their feet and brute force. It might not otherwise catch our eye, but the woven caption makes it part of the story of Julius Caesar: 'Abripit absconsos thesauros Caesar et auro / vi potitur qua-mvis magne Metelle negas' (Caesar carries off the hidden treasure and takes possession of the gold by force, although you forbid it, great Metellus). For those viewers in the know, it depicts the moment at the beginning of his

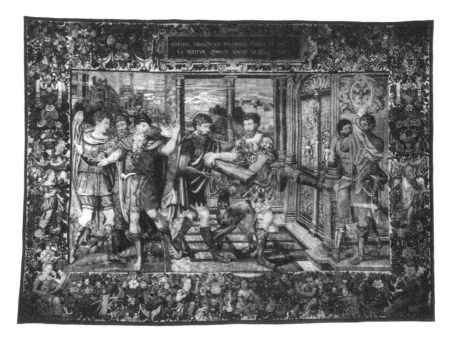

6.9 A descendant of Henry VIII's Caesarian tapestries appeared on the art market in the 1930s; its current whereabouts are unknown. The scene, however, is clearly identifiable. Caesar has returned to Rome in the middle of the civil war against Pompey and—on the hunt for cash—breaks down the doors of the treasury.

war against Pompey when Caesar enters Rome and forcibly gets his hands on the cash locked away in the Roman state treasury, despite the opposition of Metellus, one of Pompey's loyalists.[28] But more than that, a chain of evidence makes it close to certain that this tapestry is a descendant of one of Henry's.

The first hint comes in an inventory of the tapestries taken by Queen Christina to Rome when she abdicated in 1654, among them a set featuring Julius Caesar. This included a *Murder of Caesar* and *Murder of Pompey*, matching the two themes documented at Hampton Court, and making it overwhelmingly likely that Christina's set was related to Henry's. Significantly, it also included a piece described as *Caesar Breaking into the Treasury*. That connection is strengthened by another inventory, which lists ten tapestries on similar Caesarian subjects (presumably another set of 'relations' of Henry's) owned by Alexander Farnese, the Duke of Parma, in 1570. Each of these is referred to in shorthand by the first word of its woven caption—one being *Abripit*, the exact word which occurs first here ('Abripit absconsos . . .').[29] Just to clinch it, there is a visual link too. For in 1714, to celebrate the marriage of a Farnese princess to Philip V of Spain, the whole facade of Parma Cathedral was draped with their family's two sets of tapestries on the theme of Caesar (Alexander's mother had also acquired a set, as early as 1550). In a detailed contemporary print of the cathedral decked out for the occasion, you can see on the ground floor, hanging prominently (though reversed) on the right-hand side of the main door, precisely this design (Fig. 6.10).[30]

In this way—thanks to a combination of archival learning and lucky survivals—investigative art historians have gradually been able to piece together the appearance of the original set at Hampton Court. One of the latest additions is a splendid tapestry of *Caesar Crossing the River Rubicon* (the act which marked Caesar's invasion of Italy and so the beginning of civil war). This turned up in an auction in New York City in 2000,[31] and—as I write—is awaiting a buyer in a carpet showroom there (Fig. 6.11). Its subject and caption, 'Iacta alea est . . .' (The die has been thrown), can also be matched up with the inventories of Queen Christina and of Alexander Farnese, and a similar design can again be spotted on the cathedral facade, this time at the top right-hand corner.[32] The same goes for a more sinister image now known from three tapestries in Italy and Portugal. It shows a group of men consulting a prophet or a magician, surrounded in some of the creepier versions by an assortment of snakes and bats, against a witch's cauldron. The captions on each are different, but one reads 'Spurinna haruspex Cesaris necem predicit' (Spurinna the soothsayer predicts

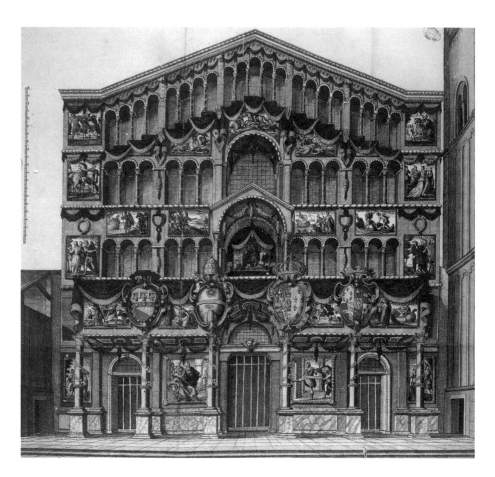

6.10 A contemporary print shows Parma Cathedral in Italy decorated to celebrate a Farnese wedding in 1714—with several 'Caesar tapestries' on display. On the right of the main door, for example, Caesar breaks into the treasury (Fig. 6.9); on the top right, Caesar crosses the Rubicon (Fig. 6. 11); in the centre of the facade on the right, the decapitation of Caesar's rival, Pompey (known from a surviving tapestry at Powis Castle).

the death of Caesar)—making this another of the warnings that Caesar received shortly before his assassination, here the dire prediction that he should (in Shakespeare's words) 'beware the Ides of March' (Fig. 6.12).[33]

    There are, predictably, all kinds of loose ends in these reconstructions. If we add everything together, we end up with more scenes than the ten that comprised Henry's and the other main sets. Were some added later, or substitutions made? There are uncertainties too about the dates and order of the later weavings, some probably as late as the second half of the seventeenth century. It largely comes down to making deductions from the

style of the borders (though some of these have been removed or replaced) and from the different forms of the caption (as a rough rule, the shorter the later). Whether some of the individual examples that have passed through the salerooms once belonged to the sets owned by Queen Christina or the Farnese family is another mystery.[34] But overall, the reconstruction of one of the most sumptuous works of art in Henry VIII's collection has been a triumph of scholarly detective work.

Except for one thing. No modern art historians (and, indeed, few of those who in the sixteenth and seventeenth centuries re-used the original designs) have correctly identified the ancient source from which van Aelst took his inspiration.[35] The result is that they have drastically misinterpreted some of the scenes depicted, and have completely missed some of the awkward implications of these Roman imperial images.

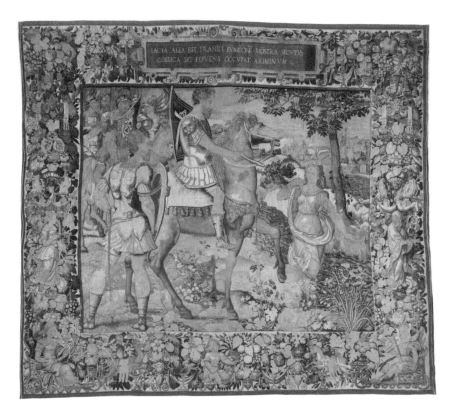

6.11 Caesar approaches the river Rubicon, where the female figure (of 'Rome') confronts him. The caption on the tapestry (almost five metres across) identifies the scene. 'Iacta alea est' it starts, 'the die (or dice) has been thrown', meaning that things are now all up in the air. It goes on to say, '... he crosses the Rubicon, following the signs in the heavens (and) so, impetuous, he seizes (the town of) Rimini'.

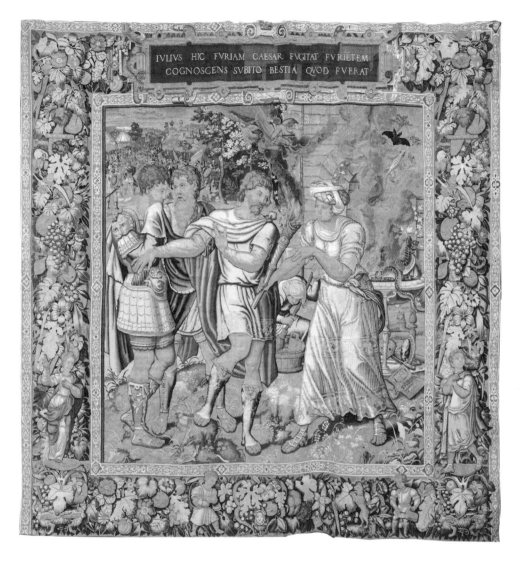

IVLIVS HIC FVRIAM CAESAR FVGITAT FVRIÉTEM
COGNOSCENS SVBITO BESTIA QVOD FVERAT

6.12 The scene on this sixteenth-century tapestry (roughly four metres square) has usually been identified as Julius Caesar consulting the soothsayer Spurinna; and the caption reads 'Julius Caesar here flees the furious fury'. But the cauldron, the eerie bats and the sex of the 'soothsayer' suggest a different reading (see pp. 207–8).

# Lucan on Tapestry

Henry's tapestries did not simply depict key events in Caesar's career, as has usually been assumed. And they were not, as a group, based on Suetonius's *Life* or on any other ancient works of history. Instead, almost every scene in the series for which we have direct evidence is clearly inspired by the first-century CE poet Marcus Annaeus Lucanus, now usually known as 'Lucan'. He was a victim of the emperor Nero, forced to suicide in 65 CE, after his involvement in a failed coup, and his one surviving poem, the epic *Pharsalia*, takes as its theme the civil war between Caesar and Pompey (its title referring to the final battle of Pharsalus). This is a bleak dissection of civil conflict, almost an experimental anti-epic, from which no character emerges as a true hero. How far it represents an unequivocal attack on one-man rule has long been debated, but Lucan's Caesar (like his Pompey) is certainly deeply flawed, his military skill, drive and ambition put to horribly destructive ends.[36]

Far from the highlights of Julius Caesar's career, Henry's tapestries were a visual depiction of civil war, seen through the eyes of a dissident ancient poet who was a casualty of the imperial regime—as a second look at them makes absolutely clear.[37]

What first alerted me to Lucan as the inspiration behind the tapestries were the scenes supposed to depict the soothsayer Spurinna predicting the death of Caesar. This was, to be sure, a well-known incident in Caesar's life story, unequivocally identified by the caption woven above one of the surviving versions; the captions on the others are more garbled.[38] But it could not possibly have been designed as that—for the simple reason that Spurinna was a *man*,[39] and a venerable soothsayer or diviner (*haruspex* in Latin) at that. The main figure here is definitely female, and—complete with snakes, bats and cauldron—every inch a witch. She can only be one of the most famous and lurid characters of Lucan's *Pharsalia*: Erictho, the terrifying necromancer from Thessaly in northern Greece (in the tapestries she is even wearing a trademark Thessalian-style hat), who preys on corpses and conjures the powers of the underworld.[40] What is depicted here is the moment in the poem when Pompey's son comes to consult her about the outcome of his father's war against Caesar—and she orchestrates, with the help of a temporarily revivified corpse, a prophecy of Pompey's imminent defeat.

In labelling this as 'Spurinna', modern scholars have been misled not only by their own unfamiliarity with Lucan's *Pharsalia* (and with Spurinna's gender), but also by the confident misidentification on one of the tapestries

themselves. A big mystery of tapestry production is who was responsible for these captions, with what degree of care or learning they operated and how the texts were transmitted, or adapted, over different generations of weaving. Why they got it wrong in this case is unclear (whether unfamiliarity with the original source, or a more constructive attempt actively to reinterpret the scene). But one thing *is* clear: van Aelst, who originally designed the scene, must have had Lucan's Erictho in mind.

From there, much of the rest falls into place. Another equally classic, and now equally unrecognised, moment in the *Pharsalia* is reflected in three descendant tapestries (one at Powis Castle in Wales, where it still hangs not far from the line-up of imperial busts; the others popping up in salerooms) (Fig 6.13). Two of their captions refer to this scene of battle as Caesar 'killing a giant', the other as Caesar 'leading an attack'.[41] The problem is that, among all his different exploits, there is no reference whatsoever in the history or legend of Julius Caesar to any fight with a giant, though he may on occasion have led an attack (as the sculptor John Deare imagined). But there is an easy solution. For here—although no modern art historian seems to have noticed—the smaller fighter (the 'Caesar' against 'the giant') is standing on top of a large pile of dead bodies. If you know the *Pharsalia*, this is an obvious pointer to van Aelst's intended subject: the bravery of one of Caesar's soldiers, Cassius Scaeva, during the siege of Pompey's camp at Dyrrachium (near modern Durres in Albania) before the final battle of Pharsalus. In order to prevent Pompey's troops breaking out, Scaeva threw down from Caesar's siege wall the corpses of his own fallen comrades and fought the enemy from the top of this grisly pile ('he did not know how great a crime bravery is in a civil war', observed Lucan darkly). In the end, shot in the eye by a crack archer from the Pompeian side (the 'gigantic' figure shown here), he pulled the arrow out and continued to fight. It is this scene of disconcerting 'heroism' that is shown here, nothing to do with giants, or with the more generic 'Caesar leading an attack', at all.[42]

The only tapestry in the series that can have nothing to do with the *Pharsalia* is that of Caesar's assassination (the poem is unfinished and breaks off before that point, even supposing the story was ever intended to get that far). Everything else that is identifiable—even if sometimes mentioned by other ancient writers also—can be traced directly back to Lucan's narrative. The *Breaking into the Treasury* was one of his famous set pieces, so too the *Crossing of the Rubicon* (the female figure at the water's edge is one of Lucan's distinctive details not found elsewhere), and the *Murder of Pompey*, treacherously decapitated as he landed in Egypt, a lurid version of which also survives at Powis Castle.[43]

Just occasionally, muddled as they often are, the woven captions have kept alive the links to the *Pharsalia*. One set of tapestries, for example, depicts Pompey taking sad leave of his wife Cornelia, before going off to join battle with Caesar, a rare moment of tenderness in an otherwise brutal poem. Most modern critics, and early modern caption writers, have misinterpreted this as Caesar saying goodbye to *his* wife, but one woven

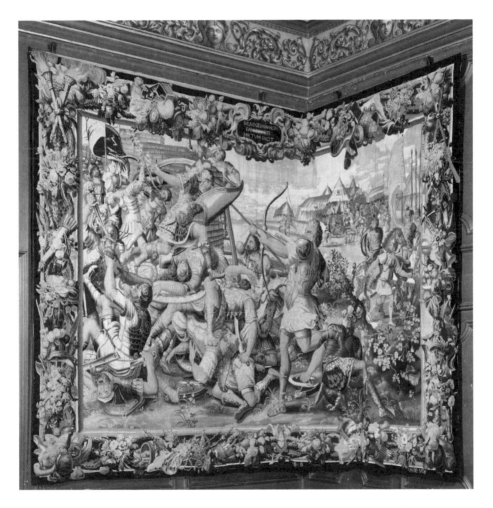

6.13 The caption on this seventeenth-century descendant (over four metres wide) of one of Henry VIII's tapestries at Powis Castle describes the scene as 'Caesar making an attack'. But the details of the image itself—a soldier fighting on top of a pile of dead bodies, a marksman taking aim at him—make it clear that the original designer had a notable story from Lucan's *Pharsalia* in mind. It shows Caesar's soldier Cassius Scaeva fighting off the opposition from the top of a grisly pile of corpses, and being shot in the eye by one of Pompey's troops.

caption correctly identifies it: 'Pompey the Great makes for his camp; Cornelia sadly sails to the island of Lesbos . . .' (and in another version of the scene, where the caption misidentifies the main figure as Caesar, in the image itself the logo of Pompey's side, 'SPQR'—'the Senate and People of Rome'—remains visible on the standards behind the general).[44] In yet another case, even a direct quotation from Lucan has been missed. Above a woven scene showing the battle of Pharsalus itself, the caption begins 'Proelia . . . *plusqua<m> civilia*' (Wars . . . *worse than civil*). This is a famous phrase taken directly from the first line of the *Pharsalia*, introducing the theme of war at its most immoral. Whoever composed this caption was pointing to the original inspiration of the tapestry cycle.[45]

What combination of ignorance, misunderstanding and determined reinterpretation turned a cycle of tapestries that recreated the story of Lucan's *Pharsalia* into the 'key events in Caesar's career' is impossible to know. It was a process, as the captions on the tapestries and the entries in the inventories make clear, that went back far beyond the endeavours of modern art historians to, at least, the later sixteenth century. But there can be no doubt that when the staff of Henry VIII unpacked the cases that arrived from Brussels, containing one of the most expensive works of art the king ever purchased, what they saw was a series of depictions of the dark epic conflict that had heralded one-man rule in Rome, and paved the way for a dictatorship that ended with Caesar's assassination. Was there a lesson in this?

## Negative Reactions

It would be simplistic to imagine that the scenes on Henry's tapestries were taken to be a straightforward attack on monarchical rule. I am certainly not suggesting—amusing as the thought is—that there were red faces all round as the staff wondered how to explain the unexpected message of the new purchase to His Majesty. We know nothing about the commissioning process, or about the input of Henry himself. But there is no reason to suppose that he or his advisers did not get what they were expecting, or had even asked for.

Throughout the Middle Ages and Renaissance, Lucan's poem had been popular at least among the European elite (albeit not on the scale of Ovid or Virgil), and we find several different, and to us sometimes unfamiliar, approaches to it. Not until the second half of the seventeenth century did the now standard political readings begin to dominate. One thirteenth-century adaptation of the poem into vernacular French, Jean du Thuin's

*Hystore de Jules César*, turned Caesar into a chivalrous knightly hero and his relationship with Cleopatra (a major theme in the last, unfinished book of the *Pharsalia*) into a triumph of courtly romance. This may, indirectly, have set the scene for dozens of later operas (most famously Handel's *Giulio Cesare in Egitto*) but it required radical alterations to Lucan's version to construct an almost entirely new story. Less surprising are the many readers who saw the poem as a dire warning not of tyranny but of the dangers of civil war—a welcome lesson in Tudor England, for certain.[46]

That said, even if many interpretations were in play, the unsettling version of one-man rule embedded in these images is not easily explained away. It is hard to imagine, as some have, that—whatever their source—they were meant as a practical lesson for Henry's young son Edward, or as some kind of reassurance for the king himself (dressing up, for example, his hugely profitable dissolution of the monasteries as if it were the equivalent of Caesar breaking into the treasury).[47] The contrast with the scenes drawn from Suetonius on the Aldobrandini Tazze, made just a few decades later, underlines the point. Instead of omens pledging the successful transmission of imperial power, this series of tapestries offers the prediction of defeat made by a witch who dabbles in corpses. If the only view of imperial death on the *tazze* was the brave suicide of Otho, here van Aelst has focussed on the bloody murder of each of the protagonists. Whichever side you are on, the end is bad.

The combination, and repetition, of such negative images reinforces the unease. Imagine someone wandering around Hampton Court in the early years of the eighteenth century, whether resident or visitor, staff or monarch. In theory at least (depending on who was allowed where, of course) they have would have been able to see some of the tapestries still in place, and within a stone's throw not only the 'King's Staircase' with its emperors posing as failed dinner guests but also Mantegna's subtle warnings of overweening power. Whatever conclusions they drew, it is another warning for us against seeing modern images of Roman emperors as uniformly and—for those in power—reassuringly positive. Of course, many, as we have already seen, were just that. Yet, in Hampton Court, that most monarchical of modern settings, the images on the walls were doing something more complicated: they were prompting a dialogue between a negative, or ambivalent, presentation of Roman imperial power and the power of the modern king; they were raising questions about how far it was possible to see modern monarchy reflected in the ancient; and they maybe even provided a lens through which the modern monarch could face up to monarchy's discontents.

# Imperial Vices and Imperial History

Inside and outside royal palaces, and for a wider audience, images of the power of Roman emperors have always gone hand in hand with the portrayal of their personal vices—and with the hint of the systemic corruption of the imperial regime of which those vices were a symbol. That idea was written indelibly into the history of Christianity, with persecution of the Christians by Nero and other pagan rulers being a staple of image-making from the twelfth-century stained glass at Poitiers (Fig. 1.6), up to the pious paintings and lurid films of more recent decades. But it extends in different directions, much further than religion.

Aegidius Sadeler was not the only commercial printmaker to suggest an alternative view of the virtues of the Caesars, in the poems that lurked beneath the images. The imperial portraits designed by another Flemish artist, Jan van der Straet (usually known as Stradanus), and reproduced in large numbers by more than one engraver in the late sixteenth and early seventeenth centuries, offered a similarly hostile vision of the emperors (Fig. 6.14). In these prints too, the accompanying Latin verses saw the worst in almost every emperor concerned, and not only the usual villains. It is not surprising that Nero is said to have been a ruler who would have been better off sticking to his lyre and keeping out of politics (wielding the *plectrum* not the *sceptrum*, as the poem quips). But Augustus is also denounced for blurring the lines between himself and the gods, an error revealed when (as one colourful but improbable variant on his death story went) he was murdered by his wife Livia: 'when you <Augustus> dare to compare yourself to god, Livia is said by mixing poison to have reminded you of your mortal lot'. Only Vespasian and Titus escape unscathed, and that is partly—and uncomfortably for us—because they destroyed the Temple in Jerusalem.[48]

On these prints, however, the hostility is not only inscribed in the verses. Behind each of their portraits there are scenes from the life of the Caesar; and in some versions—where the emperor on horseback is depicted as if he were an equestrian statue—yet more scenes are engraved on the pedestal. The emphasis in these is overwhelmingly on death, destruction, imperial sadism and excess. In the background to the figure of Augustus, for example, matching the claims made in the poem, is the notorious 'Banquet of the Twelve Gods', at which—sporting a fancy dress that his enemies deemed close to sacrilege—he is supposed to have impersonated the god Apollo; and on the front of his pedestal is what must be Livia offering her husband a deadly poisoned fig. On the front of Domitian's there is the unmistakable figure of the young emperor skewering flies with his pen.[49]

(a)                                                    (b)

6.14 Two of Jan van der Straet's emperors, in a late sixteenth-century engraving by
Adriaen Collaert: (a) Augustus; in the background the notorious banquet at which he
dressed up as the god Apollo; on the pedestal, the naval battle of Actium (at which he
defeated the forces of Antony and Cleopatra) and Livia feeding him a poisoned fig;
(b) Domitian; in the background on the right, his assassination; on the front of the
pedestal, he skewers flies; the verses accuse him of being 'the foulest blot on his
family' and of 'killing the innocent for no reason'.

That same image of juvenile cruelty is captured in some curious
sketches made by Rubens, in the early years of the seventeenth century.
Rubens is well known for his antiquarian interests and for his imperial
portraits, from the single *Julius Caesar* that he contributed to a 'multi-artist'
series of the Twelve to possibly two other line-ups of different imperial
groups, which now survive partly as originals, and partly reconstructed
from copies.[50] These portraits range from austere portrayals, in the case of
Caesar, to something more fleshy, more human and slightly irreverent. But
none are nearly as irreverent as the sketches of emperors that cover two
sides of a single sheet of paper now in Berlin.[51]

These sketches may partly have been informal working drawings for
some bigger project. Next to Julius Caesar, for example, identified by the
phrase *veni, vidi, vici* (I came, I saw, I conquered), Rubens has written *sine
fulmine* (without thunderbolt), as if still in the process of deciding what

attributes to give him. But some of them seem also to have taken on a life of their own as humorous caricatures. On the other side of the paper (Fig. 6.15) an almost laughably thuggish Vespasian is identified by what was once, according to Suetonius, his common nickname, *mulio* (mule-driver), while young Domitian is stabbing flies (*ne musca*, wrote Rubens, following the quip reported by Suetonius that 'not even a fly' is keeping him company).[52] Whatever the ultimate purpose of these drawings, they remind us—like that fourteenth-century caricature under the plaster in Verona (Fig. 1.16)—that even those who produced some of the most serious and sober images of imperial power might simultaneously carry in their heads an alternative, more down-to-earth or comical, vision of the Roman emperors.

But it was a couple of hundred years later that artists started to explore even more systematically, more subtly, more quizzically and more pointedly these failings of Roman emperors and of the political and social system they symbolised. And it is from this period that we have much richer access to some of the less than reverential reactions to images of imperial power, however reverentially those images might (or might not) have been

6.15 Rubens's imperial caricatures, drawn on a piece of paper (roughly twenty by forty centimetres), c. 1598–1600. Vespasian is shown twice on the left-hand side (once, above, with reference to his buildings; below with the phrase 'consul nicknamed mule-driver'). Titus faces him, with a reference to his victory over the Jews (and apparently a note to the artist himself to 'check if the emperor carries a military staff on Trajan's column'). On the right are two versions of Domitian, one aiming at a fly, with the phrase 'ne musca'—'not even a fly (is keeping him company)'.

intended. This was in the context of a very different world of art and its institutions. Paintings were not only produced, and survived, in far greater numbers and stylistic variety than ever before (by the 1850s, thousands of new works were displayed each year in Paris alone, making any kind of generalisation treacherous); but it was also a world of galleries, public exhibitions, academies, new forms of teaching, a wider range of patrons and buyers, a cacophony of ideological disputes and a new chorus of art criticism, commentary and journalism—which opens up to us a whole range of contemporary discussions, impossible to explore before.

At first sight, the canvases of the late eighteenth and nineteenth centuries are second only to rows of marble busts as the popular image of 'Romans in the modern world'. They recreate scenes drawn from Roman history or myth (side by side with those drawn from ancient Greece, modern nationalist myths and what are now little-known by-ways of the Bible), often on a colossal scale, and supposedly for edifying purposes. *Exemplum virtutis* (an example of admirable conduct) was one of the catchphrases often prompted by these 'history paintings' as they were usually called—an artistic genre that may be numbing for modern gallery visitors but for decades stood at the very top of the hierarchy set by European academies of art (above such 'secondary' genres as landscape, or smaller paintings on other themes).[53] But at the time they provoked a far more mixed reaction than is often imagined.

It is always dangerous to assume, in the absence of other evidence, that images of power in previous centuries went down as planned (all those vast images of ancient Egyptian pharaohs may have been as much spat upon as worshipped). We have already had a fleeting glimpse, in the satiric verses on prints, for example, of just how two-edged 'examples of admirable conduct' on the part of a Roman emperor had long been. But from the mid-eighteenth century on, column after column of printed commentary provides plenty of vivid evidence for drastically divergent reactions to Roman emperors, and to Roman culture more generally.

The English satirist William Makepeace Thackeray was surely not the only one to have his doubts about the model offered by the glorious Roman heroes recreated, for example, in the paintings of Jacques-Louis David. Was the first Brutus (the legendary ancestor of Julius Caesar's assassin), who had his two sons put to death for political treachery, really a good example to follow in modern family life? Where did the boundary lie between strictness and sadism?[54] Nor was Théophile Gautier alone in feeling a few qualms, as well as admiration, in the face of the lavish evocation of the *Age of Augustus* by Jean-Léon Gérôme, commissioned by Napoleon III, and

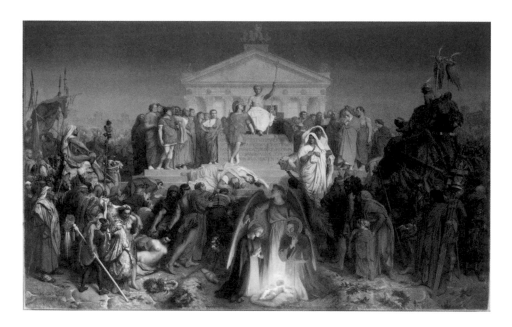

6.16 Jean-Léon Gérôme's *The Age of Augustus, The Birth of Christ* (1852–54), a colossal painting, ten metres across, incorporates many precise historical references, as well as aligning the Nativity with reign of Augustus. To the right of the emperor's throne stand artists and writers. The bodies of Antony and Cleopatra lie on the steps, with Julius Caesar's corpse just visible to the right—though largely concealed by his killers, Brutus and Cassius, dressed in white togas. The different peoples under Rome's sway throng on either side, from a naked captive being dragged in by her hair on the left, to Parthians on the right returning the military standards that they had once captured from a Roman army.

put on show in 1855 at the Universal Exhibition in Paris (Fig 6.16). The emperor stands centre-stage, defeating his enemies (Antony and Cleopatra lie dead on the steps) and bringing peace to the barbarian nations who are lined up in homage; but in a new spin on the old medieval story that carefully aligned the birth of Jesus with the Augustan age, a classic nativity scene sits prominently beneath the imperial dais. What concerned Gautier here was not (as had worried others) the awkward mixture of classical and gothic styles, but the fact that many of those doing homage to the emperor were from nations that would eventually bring the Empire down. Was this painting as much a presage of Rome's downfall as a celebration of Augustan greatness?[55]

In a different vein, the artists were sometimes judged to be simply not up to the task of capturing imperial virtue. In the 1760s, three paintings were commissioned from three different artists for one of the country prop-

6.17 Carle van Loo's painting of 1765, three metres square, showing Augustus shutting the gates of the temple of the god Janus in Rome—an act which traditionally marked those (rare) moments when the whole of the Roman world was at peace. It later provided an appropriate backdrop for the signing of the peace treaty between Napoleon and the British in 1802.

erties of Louis XV, depicting noble deeds of the king's ancient predecessors: Augustus shutting the Temple of Janus, to symbolise peace throughout the Roman world (Fig. 6.17); Trajan taking the trouble to listen to a poor woman asking for his help; and Marcus Aurelius distributing bread during a famine. The philosopher and critic Denis Diderot—while he admired the emperors concerned—had little time for the quality of their depiction. 'Your Augustus is pitiful,' he imagines saying to the painter. 'Could you not have found an apprentice in your studio who would have dared to tell you that he was wooden, common and short . . . *that*, an emperor!'; and of the scene of Trajan, he quips that 'the horse is the only notable character'. The king himself it seems had other objections. He was not bothered by such questions of artistic quality. He promptly threw the paintings out of what was in effect a very grand hunting lodge: he wanted scantily clad nymphs on its walls, not edifying examples of monarchical virtue. Ironically, two of

the three paintings (*Augustus* and *Marcus Aurelius*) came to be appropriately recycled. In 1802, Napoleon's staff came across them when they were looking for suitable decoration for the room in Amiens where 'the first consul' (his official title) was to sign the peace treaty with the British—and they have remained in the town ever since.[56]

But the images I turn to now are not those in which we detect cracks in the display of Roman virtue, but those where artists have faced head-on the transgressions of imperial rulers, the corruption of empire and the fragility and violence of dynastic succession: first, a group of paintings produced or exhibited in Paris all in the same year, featuring one of the most notorious villains out of the Twelve Caesars; second, a much more diverse set of images that in depicting the murder of imperial rulers, from Julius Caesar to Nero, raises important and uncomfortable questions about the nature of the imperial system itself.

# Vitellius 1847

1847 was the emperor Vitellius's greatest year in art since his short and unsavoury reign during the civil wars of 69 CE. He had long been one of the most recognisable of all Roman rulers, thanks to 'his' bust in the Grimani collection in Venice (which was not him at all, but most likely a portrait of some unknown Roman of the second century CE) (Fig. 1.24). His image had starred in popular demonstrations of physiognomics, and—in only faint disguise—had crept into a range of famous paintings. But in 1847, in Paris at least, the year before the revolution that deposed King Louis Philippe and his 'July Monarchy', with riots and protests already breaking out, Vitellius was everywhere in the art world.

His most famous appearance was as a cameo in the most sensational painting among the two thousand or more new works of art on show at the annual Paris 'Salon': Thomas Couture's huge canvas *Les Romains de la Decadence* (*The Romans of the Decadence*—or *The Orgy* as it was aptly known for short) (Fig. 6.18). It had been hyped in an enthusiastic advertising campaign for a couple of years before it was ever seen in public, and the finished product did not disappoint. Over sixty years later, an article in an American art magazine was calling for a reproduction of it to be on display in every school in the United States; for it was 'the greatest sermon in paint ever rendered'. (American school children have had a lucky escape, one can't help thinking.)[57]

It was the kind of sermon that inspires, not by edifying example, but by an extravagant image of immorality; a mixture of shock and—no doubt—

titillation. The canvas is filled with sprawling Roman banqueters in various states of undress, at the end of an all-night party (the sun seems to be just rising). Surrounding them are statues of men from the city's glorious past, with a few austere observers on the margins, definitely not joining in the 'fun'. It was a demonstration of Rome's moral decline, with a few twists and tricky questions. In particular, what are we to make of the heroically nude marble figure who dominates the scene, based on a statue in the Louvre, traditionally identified as 'Germanicus'—and, in contrast to the lascivious semi-nakedness of the party-goers below, reminds us that there are honourable and less honourable ways of going without one's clothes? Germanicus, the husband of Agrippina the Elder, had been a popular and successful prince in the great traditions of Rome, once seen as a potential heir to the imperial throne. But he was also father to the monstrous emperor Caligula, and allegedly in 19 CE the victim of poisoning on the orders of his uncle, the emperor Tiberius. Here he serves as a hint that—whatever the exact date of the 'decadence' portrayed—the signs of corruption were inescapably present at almost the very beginning of imperial rule.[58]

There was a wider, contemporary message too. Despite the politics of the moment, commentators at the time did not interpret the painting as a narrow attack on the institution of monarchy; but it *was* widely seen as a criticism of disparities of wealth and of the careless immorality of the contemporary French elite and bourgeoisie.[59] A clever set of cartoons in the satirical magazine *Les Guêpes* (Wasps), picturing the reactions of different Salon visitors, made this point sharply. In one, a thief decries the fact that the bourgeoisie in the painting has finished all the food. Another turns the social disequilibrium on its head: a man labelled as a 'utilitarian' points out that Couture's canvas itself could have provided enough material to clothe a poor family.[60]

But, towards the left of the pile of banqueters, the slumbering figure with the distinctive features of Vitellius—so comatose that he does not even notice the naked odalisque just a few inches from his nose—gives an extra edge to this. Although he is often overlooked now, he was widely recognised by critics in 1847, who referred vaguely to his 'Vitellian' excesses. 'Glory to Vitellius Caesar alone' hailed one poet in an ironic response to the painting.[61] But what exactly is he doing in this scene?

In part, he may be another clue to the date of the 'decadence'. Was the emperor to be understood as the host of this orgy? And so, was Rome's moral decline already well under way by 69 CE? In part, he may be an allusive tribute to Veronese, whom Couture often claimed as his inspiration.[62] In his *Last Supper*, Veronese had given the well-fed steward the face of

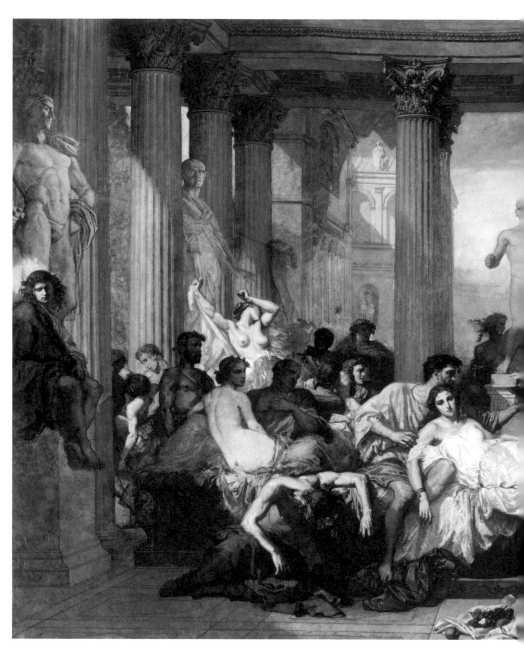

6.18 Roman vice is displayed on an appropriately grand scale, across Thomas Couture's canvas of *The Romans of the Decadence*, almost eight metres wide. The sun is just rising, but this Roman orgy is still going strong; one of the few party-goers already slumbering is a figure towards the left of the main group, whose features—widely recognised by critics when it was first shown in 1847—were based on those of the Grimani *Vitellius* (Fig. 1.24).

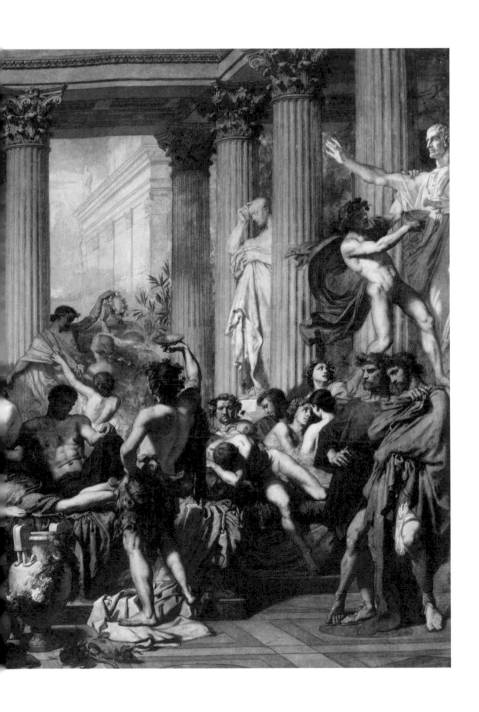

the Grimani *Vitellius* (Fig. 1.23); here the artist is nodding to that by conscripting the same face for one of his own characters. But there are other implications too. Anyone who knew the story of Vitellius, and of his very nasty end (dragged through the streets of Rome, tortured, beaten to death, impaled on a hook and thrown into the Tiber, as the new Flavian dynasty came to power), would see in this figure a strong hint that this scene of debauchery—and whatever modern lifestyle it evoked—was doomed. For those who spotted it, the face of the emperor was a visual guarantee that punishment was inevitable. As in Veronese's painting, the features of the Roman emperor offer almost an internal commentary on the scene, and a key to how we should read it.

But this was not the only Vitellius to confront visitors to the Salon of 1847. Among a range of painters offering classical themes, from ancient mythology to the saints and martyrs of the early church, one artist put Roman emperors centre-stage. That was the now little-known Georges Rouget, best remembered, if at all, as Jacques-Louis David's favourite assistant. He exhibited two paintings, exactly the same size, intended as a contrasting pair: the one, a rather cosy image of the future emperor Titus, learning the art of good government from his father Vespasian; the other a striking study entitled *Vitellius, Roman Emperor, and Christians Released to the Wild Beasts* (Fig. 6.19). The emperor, who is based on a (slightly slimmed down) version of the 'Grimani', sits gazing ahead, apparently lost in his own thoughts, with his back to the arena where we can faintly make out victims facing the lions. At his shoulder, a martyr in chains holds a crucifix, while a young woman looks up at him intently from below.[63]

Some critics had fun reflecting that, in contrast to Couture with his decadent crowd, Rouget managed to conjure up Roman vice with only three figures. But they remained vague on the dynamics of the scene. Do we see an emperor unflinchingly set against mercy, despite entreaties? Or, more likely, are we to imagine that the painter is showing us the disturbing figments of the emperor's imagination (the young woman may be his troubled conscience)? If so, then this prefigures some images, which (as we will see in the next chapter) focus on the awkwardness of power *for the powerful*, and on the human dilemmas and anxieties that may afflict even the cruellest tyrant.[64] But it is a very far cry from the other controversial role that Vitellius took in the art of this particular year.

During the summer of 1847, ten of France's most ambitious young artists spent several months painting the gory scene of Vitellius's murder. They were the talented (and lucky) ones who had got through to the final round of the competition for the Prix de Rome, which gave the winner

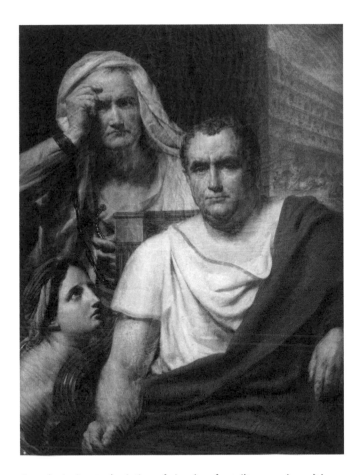

6.19 An intimate depiction of vice (or of a guilty conscience) in Georges Rouget's *Vitellius, Roman Emperor, and Christians Released to the Wild Beasts*, little more than a metre tall; it was first shown in 1847. Vitellius himself actually had nothing to do with the persecution of Christians, and the Colosseum, glimpsed in the background, was not built until after his reign. But the work offers an unsettling image of imperial cruelty in contrast to the 'good' emperor Titus, whom Rouget portrayed in a matching painting.

not only celebrity, but also a generous bursary for long-term residence in Rome. It was a simple process, though often laced with controversy. Every year, each of the short-listed candidates was asked to produce a painting on a theme set by a committee of the Académie des Beaux-Arts (Academy of Fine Arts), which then judged between them.[65] In May 1847, the committee described the scene they wanted the contestants to represent: Vitellius dragged out of his hiding place in Rome, his hands tied behind his back, his head forced up at sword point so that his assassins 'could abuse it more

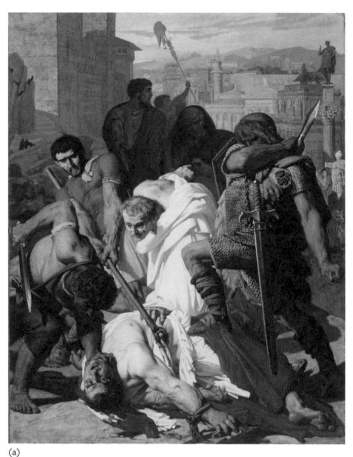

(a)

6.20 The assassination of Vitellius was the subject set for the 'Prix de Rome' in painting in 1847: (a) the first prize winner was Jules-Eugène Lenepveu, with a small but gory scene, just over thirty centimetres tall, set against an a-historical panorama of the city (Trajan's column was erected more than fifty years after Vitellius's death); (b) [FACING PAGE] the second prize went to Paul-Jacques-Aimé Baudry with a no less brutal image on a slightly larger scale (it is almost one and a half metres wide).

easily'. In late September, the winner and runner up were announced: in first place, Jules-Eugène Lenepveu; in second, Paul-Jacques-Aimé Baudry (Fig. 6.20). Theirs were both grisly renderings, in which the emperor's face was not simply exposed, but was almost tugged off by the angry mob.[66]

The critics dissected the judges' verdict. Lenepveu had slightly over-done the emotion, was one view; Baudry's version was so 'wild', according to painter-turned-critic Etienne-Jean Delécluze, that it might have been

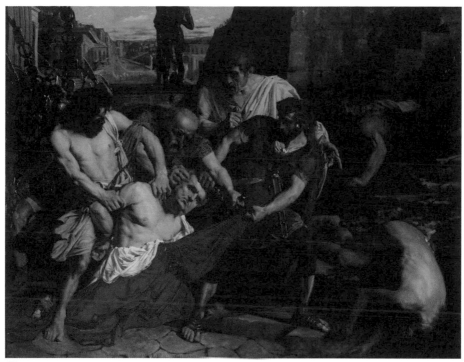

(b)

done by a native Gaul at the time of Vitellius; others criticised aspects of the colouring and perspective, or suggested different candidates for the prize. But there was also unease about the subject itself. There had been plenty of mythical deaths and some bloody themes before (the biblical story of Judith decapitating Holophernes, for example, or Cato, the Republican ideologue and enemy of Julius Caesar, disembowelling himself). But this was the first and only imperial assassination in the history of the prize. It was not a subject, according to Delécluze again, which lent itself to fine treatment. 'What kind of satisfaction can one derive from the representation, however well it is done, of a foul monster like the emperor Vitellius dragged to death, his throat slowly slit by soldiers and Roman citizens who have taken justice into their own hands?'[67]

How do we account for this focus on Vitellius as the emperor of the moment, and the conjunction of his excess, his guilty conscience and his murder? Again, it would be naïve to imagine a *direct* connection between these Vitellian themes and contemporary dissatisfaction with Louis Philippe and the July Monarchy. The overwhelming majority of criticism in newspapers and magazines concentrated on technical artistic details, or at most on broad social parallels—certainly not on the Roman emperor as

a coded analogue for the king. Besides, in a gesture to fair play, the final selection of theme for the Prix de Rome competition was made by lot out of a shortlist of three (in 1847, two much blander subjects were also in the frame).[68] Nonetheless, it would be equally naïve to deny indirect links at least. Delécluze's comments about the people taking 'justice into their own hands' surely reflect underlying contemporary politics, especially as they appeared in a journal that was a strong supporter of the monarchy. And it is hard not to wonder whether the ten young artists locked away in their studios during the summer, working on their paintings of the lynching of a Roman emperor, saw no connection at all with the revolutionary uprising brewing outside. In one case, we know that they did. In a letter written the following year, Baudry (the second prize winner) complained of the anodyne theme set in the competition of 1848, shortly after the fall of the king in February: it was 'Saint Peter in the house of Mary'. How could it be, he asked, that under the monarchy they had set 'the agony of a tyrant', but came up with nothing comparable under the new republic?[69] He, at least, had noticed.

## Assassination

Assassination always attracted artists, and the murder of Julius Caesar was a popular theme from the Middle Ages on, with different political spins. But assassination was about more than bloody violence or covert poisoning, palace plots or popular uprising. In a history of the Twelve Caesars, of whom only one (Vespasian) died without any allegations at all of foul play, it was also an integral part of imperial succession and even the imperial system itself. Many Renaissance paintings turned a blind eye to this, preferring to show succession more positively in terms of favourable omens for the future (better to have the emperor Claudius marked out for greatness by an eagle landing on his shoulder, than—as Suetonius among others gleefully recounted—discovered ignominiously cowering behind a curtain after the murder of his predecessor). Artists in the nineteenth century, on the other hand, whether prompted by contemporary politics or not, regularly used imaginative re-creations of scenes of assassination to interrogate the imperial system itself, reflecting on the vulnerability of the ruler, and on where power really lay. How emperors died proved to be a telling diagnostic of the regime as a whole.

One of the most influential of these paintings, widely reproduced in prints, and even used as the basis of stage sets for performances of Shakespeare's *Julius Caesar*, was Gérôme's *Death of Caesar* of 1859 (Fig. 6.21). The

impression it makes is about as far as you could imagine from the same artist's *Age of Augustus* (Fig. 6.16). The dictator lies in the senate house where he fell, ironically at the foot of Pompey's statue. But this is now the moment after the deed itself, and the next steps are already being taken, the political readjustments already being made, in a world now *without* Caesar: some senators are simply taking flight; one large gentleman is biding his time; the assassins, daggers raised, are now in control (even if, as it turns out, only briefly). There is a very loaded contrast here with earlier representations of this most symbolic of all assassinations. In most cases (as in the tapestry in the Vatican, Fig. 6.8), Caesar is the focus of attention at the moment of his death; while he yet has breath, the victim is still star of the show. Here Gérôme is reminding us of just how fleeting autocratic power is. Caesar has been reduced to a blood-stained bundle, barely noticeable at bottom left.[70]

Other painters chose other moments of murder to make other points. Jean-Paul Laurens, for example, a painter renowned for his opposition to the corruptions of monarchy, pictured the scene of the death of Tiberius in 37 CE—following the ancient rumour that the old man had been finished off by his successor Caligula or his henchman, Macro (even dying peacefully in his bed was not enough to dispel suspicions that an emperor had actually been suffocated there) (Fig. 6.22). Here a rather burly assassin, almost certainly meant to be Macro, needs only the pressure of his knee, and a touch of the hand on the throat, to dispatch the frail Tiberius. It is an emblem of the domestic setting of imperial power (the fate of the Roman world is settled *in a bedroom*), and it turns on its head one reassuring narrative of succession: here it is not Tiberius who *hands on* the throne to Caligula; Caligula *steals* it from Tiberius.[71]

Narratives are also challenged in re-creations of the next imperial succession, just four years later. Caligula was killed, along with his wife and baby daughter, in a plot led by a couple of disaffected members of the imperial ('Praetorian') guard, with a personal grudge. This is the moment when, in the absence of any more plausible candidate to take his place, they are said to have dragged the middle-aged, slightly doddery and decidedly implausible Claudius from his hiding place and hailed him *imperator*.[72] It was a scene that Lawrence Alma-Tadema, a Dutch painter long based in London, painted three times between 1867 and 1880.

Alma-Tadema has a controversial place in the history of nineteenth-century art. He is best known for his elegant, often languid re-creations of Roman domestic life, in carefully observed settings, as close to authentic as the archaeology of the day would allow (from women in the baths to assignations on sunny marble terraces or customers in ancient artists'

showrooms). For some modern critics, he was putting a new kind of history into history painting, with a more democratic interest focussing on more ordinary 'historical' lives. For others, he was flogging a worn-out classicism, which was looking increasingly time-expired in the face of radical modernism (though the fact is that he was one of the best-selling painters of his day). Others again have seen his work as the commercial banalisation of classical themes for *nouveaux riches* clients. Just after Alma-Tadema's death, Roger Fry, in the midst of his own bungled endeavours on Mantegna's *Triumphs* at Hampton Court, wrote scathingly and snobbishly of his appeal to the 'half-educated members of the lower middle class': his paintings made it look as if he thought the Roman world was constructed out of 'highly-scented soap'.[73]

Alma-Tadema did not produce many paintings that featured Roman emperors, but they were far more sophisticated than Fry's silly generalisation suggests, and would have demanded rather more than 'half-education'.[74] The spectacular painting of the *Roses of Heliogabalus* (Elagabalus), for example, commemorates not merely an imperial practical joke that backfires by smothering his guests; it also vividly points to a paradox lying at the heart of Roman imperial culture—that (in the ancient imagination at least) even the kindness and generosity of emperors could be lethal (Fig. 6.23).

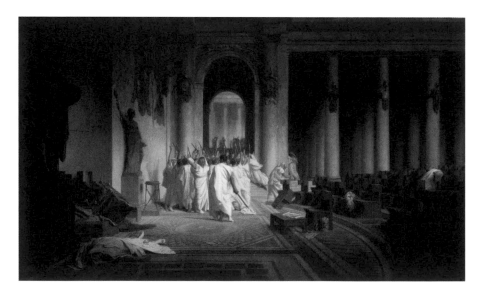

6.21 Jean-Léon Gérôme's 1859 painting of the *Death of Caesar* is a chilling image of power change. The dead Caesar, fallen in front of the statue of his rival Pompey, is only a tiny part of the one-and-a-half-metre wide canvas. What matters now is the sequel, and what the assassins (in their huddle in the centre) will choose to do.

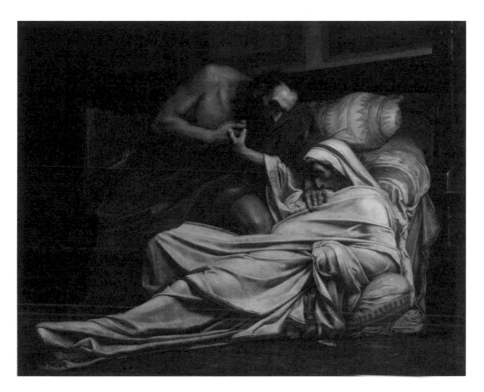

6.22 In his *Death of Tiberius* of 1864, Jean-Paul Laurens magnified the scene of the emperor's death in his bed into a large format 'history painting' (almost two and a half metres across). For an emperor, death in bed was no guarantee that it was not murder.

But Alma-Tadema's treatment of the accession of Claudius raises further complexities.

It is the second of his three versions, first exhibited in 1871, and entitled *A Roman Emperor, AD 41*, that is the most challenging (even though the artist seems to have been dissatisfied enough—or perhaps pleased enough—to return to it on a smaller scale a few years later) (Fig. 6.24). The moment depicted is clear. Caligula and his family lie murdered in the centre; some members of the Praetorian Guard (as well as a couple of women identified by critics at the time as 'prostitutes') crowd in from the left; while on the right another member of the guard bows before the newly proclaimed emperor Claudius who has hardly emerged from behind his curtain. But there are all kinds of telling detail. The new emperor wears some lovely, upmarket red shoes (it was his shoes peeking out, according to Suetonius, that gave away his hiding place). But he doesn't have the power to match. It is the soldiers who call the shots; the new emperor must do what they say; power is not really where it seems.[75]

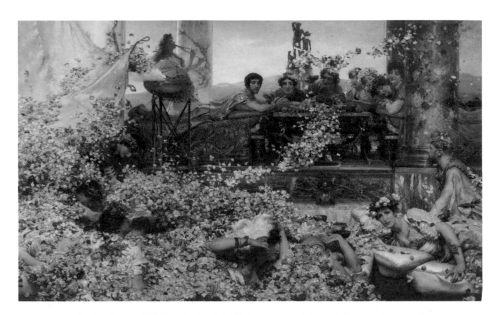

6.23 In the *Roses of Heliogabalus* (1888), Lawrence Alma-Tadema captures the paradoxes of imperial power. The large canvas, more than two metres across, focuses on the 'generosity' of Elagabalus (emperor 218–22) in showering his guests with rose petals; but, according to the story, the petals smother and kill them.

So, is *A Roman Emperor* suggesting that 41 CE was a turning point in the history of the empire, with the victory of violence over legal order? Maybe. In which case, the distinctive marble statue of Augustus—daubed, rather like the statue of Pompey, in Gérôme's assassination scene, with the victim's bloody handprints—represents the once noble history of the imperial regime (before Augustus's death, some twenty-five years earlier, in 14). But there are hints that it is more complicated than that, and that the statue of Augustus here points to the violence and lawlessness that was *always* at the heart of the imperial regime. That is certainly suggested by the painting just visible at the back of the room, labelled on its lower border 'Actium'. This was the battle that brought Augustus to sole power in 31 BCE. But it was a battle in a civil war, against fellow Roman Mark Antony. Surely the message—not unlike that conveyed by the statue of Germanicus in Couture's *Decadence*—is that the Roman imperial system was founded on violence and disorder from the very beginning. To put it more crisply, (Roman) monarchy was built on illegality.

Unlike Roger Fry, John Ruskin, the most famous art guru of the later nineteenth century, recognised, even if he disliked, the political edge in Alma-Tadema's work.[76] Maybe in this case some of the potential buyers

did too. The painting remained unsold for ten years, until it was bought by the American collector William T. Walters—and is now in the Walters Art Museum in Baltimore.

## The End of Nero

If there is one painting, however, that represents more cleverly and succinctly than any other the capacity of nineteenth-century artists to probe critically the nature and foundation of the imperial system, it is the work of one whose home territory was Moscow and St Petersburg, not Paris or London or the Netherlands. But Vasily Smirnov travelled widely in the rest of Europe in the 1880s, exhibiting at the Paris Salon, before his death in 1890, aged only thirty-two. His most famous painting is a depiction of Nero on a grand scale, not the feckless strummer of Verrio's murals, or the 'fiddler while Rome burned', but *The Death of Nero* (Fig. 6.25).[77]

Smirnov closely followed Suetonius's vivid description of the last hours of the emperor in 68 CE, when the armies and the city decisively turned against him.[78] He was abandoned in the palace, his calls to once obedient servants went unheard—until eventually he made for an out-of-town villa where (unable to do the deed himself) he was ignominiously helped to

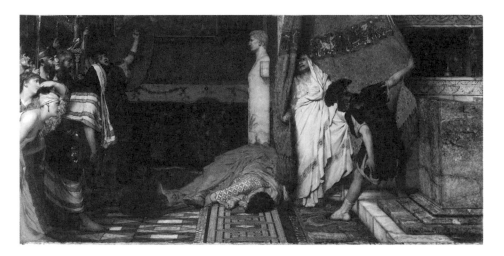

6.24 Alma-Tadema's painting of the death of Caligula and the accession of Claudius (*A Roman Emperor, AD 41*), first exhibited in 1871. Almost two metres across, it shows the dead body of Caligula in the centre, while Claudius (who is to be his unwitting successor) is discovered behind a curtain. The portrait of Augustus in the background raises questions about the imperial system as a whole. Was this a departure from what Augustus planned? Or was this kind of murder embedded in imperial history from the beginning?

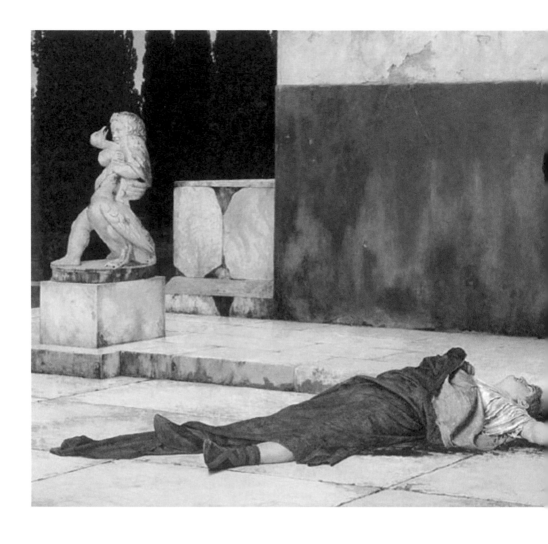

6.25 What happens when power ebbs away? Vasily Smirnov 's huge painting of 1887, four metres wide, focuses on the abandonment of the dead emperor Nero, now tended by just three women—his power of command, and all his men, gone.

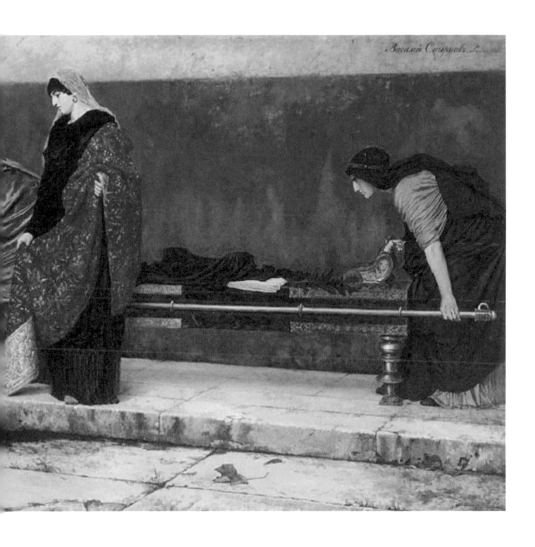

suicide by a slave and carried off for burial by a few loyal women. That is exactly what they are doing in this painting: taking the corpse to the family tomb.

But there is a famous statue in the corner, the only work of art in the room, and instantly recognisable as the statue we now know as *The Boy and the Goose*—many versions of which are found all over the Greco-Roman world. It is a much-debated object (Fig. 6.26). Is it pure kitsch, or an elegant genre piece? Is it myth, or is it real-life? And most of all, what is the intention of the child: is this innocent fun or is he trying to kill the bird? In this painting, it is no doubt partly intended as the leftover decoration in a faded imperial property (according to the polymath Pliny, there was a version of

6.26 The sculpture in the corner of Smirnov's painting (Fig. 6.25) is a famous—and puzzling—ancient group of a small boy and a goose. A version of this statue was owned by Nero, but is the marble toddler (playing with/ strangling/torturing the goose) a symbol of Nero himself?

it in Nero's most lavish palace, the 'Golden House'[79]). But it is surely doing more than that. It shifts the interpretative dilemma of the sculpture to the figure of the emperor himself. How culpable was Nero? How far were *his* excesses innocent fun or juvenile sadism? The bottom line was: were all tyrants children (or all children tyrants)? The statue crystallises the dilemmas of the picture—and of imperial power—as a whole.

There is, however, a twist. Who bought this painting? Unlike Alma-Tadema's *Emperor* it did not remain unsold for a decade. The Russian tsar Alexander III almost instantly snapped it up.[80] It might seem at first sight an odd choice for a monarch. But perhaps he, like Henry VIII, enjoyed this prompt to reflect on the complexities and difficulties of one-man rule.

# VII

# CAESAR'S WIFE...ABOVE SUSPICION?

## Agrippina and the Ashes

In 1886, a year before he painted his first version of the undignified accession to the throne of the emperor Claudius, Alma-Tadema recreated another scene from the history of imperial Rome, also exposing the cruelty and corruption of Roman autocracy (Fig. 7.1). At first glance, you might take this to be one of his slightly dreamy re-creations of Roman domestic life. There are no soldiers in this painting, no men even—just a solitary lady reclining on a couch, gazing pensively at what might possibly be her jewel box.

A closer look shows that it is nothing of the sort. The lady is reclining in what can only be a large tomb: there are epitaphs fixed to the wall; clearly legible behind her is the abbreviation 'DM', short for 'Dis Manibus' (to the spirits of the departed)—a standard phrase on Roman memorials; and the stairway on the left hints that the scene is set underground; what might have been a jewel box is more likely a small funerary urn that she has taken down from the niche in the wall. The title of the painting identifies it precisely: *Agrippina Visiting the Ashes of Germanicus*. Alma-Tadema has, in other words, imagined a scene in the life of one of the Roman imperial family's tragic heroines: Agrippina the Elder (as she is now called, to distinguish her from her daughter, 'the Younger').[1]

The story of her devotion to the memory of her husband Germanicus— whose statue surveyed the 'decadence' of Couture's painting—was a favourite in ancient Rome.[2] Writers lingered not only on the ghastly death of

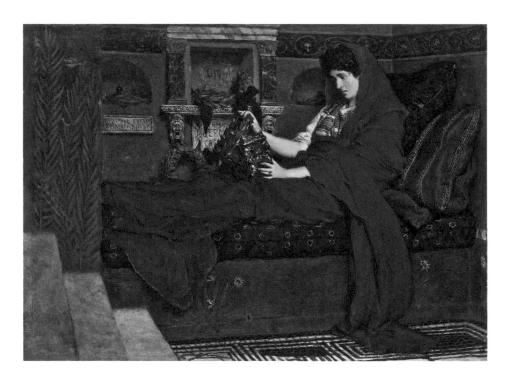

7.1 Agrippina, visiting the family tomb, cradles the box containing the ashes of her husband Germanicus, which she has taken down from the niche beside her. Alma-Tadema's painting of 1886 captures an atmosphere of brooding domesticity at an intimate scale (it is less than forty by twenty-five centimetres).

the dashing young man himself in Syria in 19 CE, widely believed to have been ordered by his uncle, the jealous emperor Tiberius; but also on the unswerving loyalty of Agrippina, who—as one of the very few direct natural descendants of the emperor Augustus—had an even better royal pedigree than her husband. She is supposed to have carried his ashes back to Rome, over almost two thousand miles, to a rapturous reception from the public (whose grief at Germanicus's death has been compared to the modern out-pouring of popular emotion at the death of Princess Diana[3]). Here Alma-Tadema pictures Agrippina alone on what must be a later visit to the family tomb; she has come to hold once more the ashes that had become her trademark or talisman. The name of 'Germanicus' can just be made out on the memorial plaque on the wall.

Worse, however, was to come. In the standard story at least (the truth is another matter), Agrippina did not retreat into judicious, inconspicu-ous retirement. Instead, she stood up to Tiberius and to his apparatchiks in a series of displays of admirable principle, family loyalty or pointless

stubbornness (depending on your point of view). Eventually, in 31 CE she was exiled to a tiny island off the coast of Italy, where she starved herself (or was starved) to death. It was only in the reign of her son Caligula—one of those imperial monsters devoted to their mothers—that her ashes were brought back to Rome. The large memorial stone in which these were then placed still survives, though with a twist in the tale. It was rediscovered and recycled for use as a grain measure in the Middle Ages, and only restored as an ancient monument in the seventeenth century and placed in the Capitoline Museums in Rome, where it still stands. (The Roman burghers in 1635 could not resist inscribing a tasteless joke on its new pedestal: there was a certain irony, they suggested, in constructing a measure for grain/sustenance (*frumentum*) out of the memorial of a woman who died by *refusing frumentum*.)[4]

Agrippina's story and Alma-Tadema's attempt to recapture the sorrowing widow in the tomb (not to mention the bluff 'humour' of the seventeenth-century Romans) raise some bigger questions about the role of women in the imperial family, and about their images ancient and modern. So far in this book, representations of the wives, mothers, daughters and sisters of the Roman emperor, have played only a minor part. There always have been, it is true, considerably fewer of them than of the emperors themselves, or of their brothers and sons. But some have gained celebrity status. A Roman bust of Faustina, the wife of the second-century emperor Antoninus Pius, for example, was the object of a famous early sixteenth-century tug-of-love between Andrea Mantegna and Isabella d'Este, who eventually managed to buy it from the cash-strapped painter for a knock-down price (though if this was the rather dreary bust *Faustina* still in the Ducal Palace at Mantua, it is hard to see what the fuss was all about (Fig. 7.2)).[5] And *Agrippina Visiting the Ashes of Germanicus* is just one of many paintings where modern artists have used the figures of women to expose the corruption of the imperial court.

This chapter will explore the history of women in the imperial hierarchy, as part of the complex genealogy of the ruling house. There are some famous and not so famous names, from Augustus's wife Livia (whose villainies gained new notoriety thanks to the actor Siân Phillips, who played her in the BBC/HBO series *I, Claudius* in the 1970s), to Messalina (Claudius's third wife, rumoured in ancient Rome to have taken on a part-time job in a brothel) or Octavia (the virtuous first wife of Nero, whose fate was to watch her nearest and dearest drop down dead in front of her). But what did they really do? How important were they? And how were they depicted in visual images, ancient or modern? We have seen that the beginning of one-man

rule went hand in hand with revolutionary changes in the representation of the new political leaders (emperors, princes and male heirs): was that the same for the women of the family? What do we gain by taking a female focus? We shall end by taking a closer look at Agrippina the Elder and the Younger: one an implacable martyr; the other, the wife of Claudius and mother of Nero who eventually becomes a gruesomely dissected corpse. And we shall be bringing yet another Agrippina to light in a famous, and controversial, painting by Rubens, which is my very last case of mistaken identity.

## Women and Power?

There was no such thing as a 'Roman empress'. It is almost impossible to avoid the term entirely (more than a few 'empresses' will, I confess, creep into the pages that follow). And various honours granted to the most important women at court, including the title 'Augusta', the female equivalent of 'Augustus', suggests some public prominence. Livia herself was the first of these: she was formally known as 'Julia Augusta' after her husband's death (almost as confusingly, at the time, I imagine, as it is now), and she was earlier hyped in one 'absurdly hyperbolic' poem as 'Romana princeps' (which is not far short of 'queen').[6] Nevertheless, poetic over-statement aside, there was no official position of imperial consort, and certainly no possibility of a woman occupying the throne herself. When we talk of the women of the imperial family we are referring to a motley, shifting crew of emperors' wives, mothers, daughters, sisters, cousins and lovers, with varying degrees of influence and importance, but no formal position in the hierarchy.

That said, Roman writers treated these female members of the imperial family as much more powerful in practice than elite women had been in the earlier period of the Republic. How true that was is hard to determine. I strongly suspect that Livia, or any of the others, would have been amazed to learn of the influence attributed to them by writers ancient and modern, or the inconvenient rivals they are said to have liquidated (rumour, of course, flourished in a world where a deadly case of peritonitis was indistinguishable from a deadly case of poisoning). But true or not, that *perception* of female power goes back directly to the structure of one-man rule.

First, in any court culture like imperial Rome, influence is seen to lie with those close to the man at the top. It is the power of proximity, and it belongs to those who have the ear of the emperor, whether because they chat at dinner, shave his beard or (better still) share his bed. Up to a point,

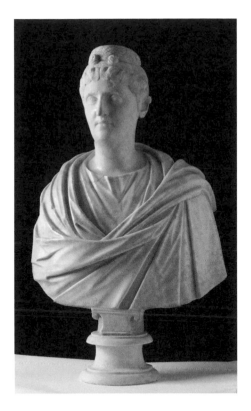

7.2 This Roman bust, just under life-size, may (or may not) be the portrait of Faustina, wife of Antoninus Pius (emperor 138–61), over which Isabella d'Este and Mantegna fought in the early sixteenth century. Whether she is correctly identified or not, the hairstyle is one of the stylistic features that date the portrait to the mid-second century.

of course, there *is* power in proximity, and this is what drives the old cliché about women being 'the power behind the throne'. But more than that, women are a wonderfully convenient explanatory device for the mysteries, inconsistencies and vagaries of the emperor's decision-making; hence the exaggeration of their influence. The advent of autocracy meant that power moved away from the open discussion of the Republican forum or senate house, to the hidden corridors and secret cabals of the imperial palace. No one outside the palace walls really knew how—or by whom—decisions were made inside.[7] Blaming the influence of wife, mother, daughter or lover was a convenient catch-all explanation ('he did it to please Livia', or Messalina, or Julia Mamaea, or whoever). Modern media sometimes resort to the same device when trying to explain the inner workings of the White House, 10 Downing Street or the British royal family (think Ivanka Trump, Cherie Blair or Meghan Markle).

But in Rome this was also linked to the centrality of women in the strategies of dynastic succession. To put it at its simplest, their crucial role in producing legitimate heirs underlies the two dramatically different female types that dominate ancient writing and imagination. On the one

# TABLE 2

## THE JULIO-CLAUDIAN DYNASTY: THE MAIN FEMALE CHARACTERS

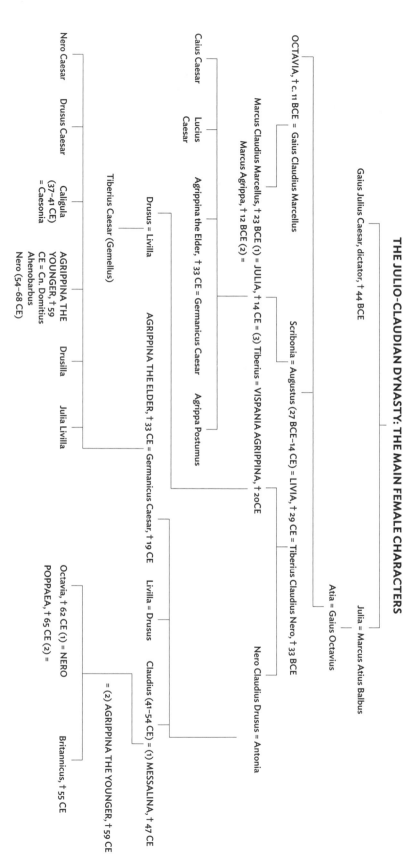

† Indicates death date

hand, were those who acted correctly within the dynasty, bore children loyally and facilitated the transmission of power. On the other, and much more prominent in the modern imagination, were the likes of Messalina or Livia, with their deadly skills at poisoning (the traditional female crime: secret, stealthy and domestic, a fatally perverted form of cookery). Their behaviour threatened to disrupt orderly succession, whether through adultery or incest—or through a dangerous partiality for their own offspring within the pattern of succession, and the single-minded elimination of any rivals.

What this means is that the accusation of gross sexual immorality often thrown at the women of the imperial family *may* reflect what they got up to, but not necessarily (most people at the time had no more reliable information on Messalina's sex life than we do). It certainly *does* reflect one of the ideological pressure points in the Roman imperial dynasty, as in many similar patriarchal structures: namely, how to regulate the sexuality of those whose purpose it was to bear legitimate heirs, and the anxiety on the emperor's part (in an era in which you could never know for sure) that 'his' children might not really be 'his'. It was a pressure point given extra charge by the fact that no natural son *did* actually succeed his father, for more than a hundred years of Roman imperial rule. Vespasian was not only the first emperor universally agreed to have died a natural death, in 79 CE; he was also the first emperor to have his natural son succeed him.[8]

These anxieties underlie the famous quotation, now almost a proverb, which I have adapted for the title of this chapter, 'Caesar's wife must be above suspicion'.[9] The origin of this lies in an incident early in Julius Caesar's career, when he was still an ambitious young politician, a couple of decades away from being *dictator* at Rome. His then wife Pompeia was conducting a special religious ritual, rigidly restricted to women only, when a man was reported to have infiltrated the gathering. The rumours were that it was a lover's prank, and that the man in question was having an affair with Pompeia. Caesar claimed that he himself did not suspect her, but he divorced her nonetheless, because Caesar's wife must be '*above* suspicion'.[10] Similar anxieties also underlie, in a more ambivalent way, the competing stories about the death of Augustus. One lurid version we have already seen was that Livia finished him off, by smearing poison on the emperor's favourite figs as they grew on the trees ('by the way, don't touch the figs', as the television Livia memorably warned her son Tiberius). The other, recounted by Suetonius, insisted just a little too hard perhaps, and almost parodically, on the conjugal devotion of the imperial couple: he dies while kissing his wife and simultaneously managing to say, 'Live mindful of our marriage Livia, farewell . . .'.[11]

What really happened on the deathbed of Augustus is entirely lost to us (and there is no particular reason to believe either of these colourful tales). But the contradictory accounts of the scene in Roman writers point straight at the dilemmas about imperial death, succession and the potentially disruptive role of women within the structures of power. In some ways the representations of 'empresses' in official Roman art is in dialogue with those anxieties.

## Sculptures, Great and Small

There are plenty of women from the imperial family in our galleries of Roman portrait statues, and plenty of evidence for more that we have lost (recorded, for example, on statue pedestals now minus their statues). But it is even harder than with their husbands, brothers and sons to pin down exactly who is who. These images are no less revolutionary than their male counterparts, indeed probably more so. The new politics of empire dramatically influenced the *style* of the portraits of men at the top. Autocracy and dynasty put women on display in the repertoire of public sculpture for the very first time, initially as part of the diagram of imperial power, and then more widely. Before the early years of one-man rule there was no established tradition in Rome itself of honouring real-life, mortal women with public statues (it was different with goddesses and in other parts of the wider Roman world).[12] But identifying who was who, with any certainty, proves to be extremely hard.

The basic difficulty, as with the men, is that only a handful of these portraits come complete with a name; and there is no scientific method for establishing their identity. But that is only the start. Important as the statues of women were in spreading the image of the ruling family across the empire, there were always fewer of them than of the men. Certainly, fewer survive: some ninety portraits of Livia, for example, even on a generous count, versus the two hundred or so of Augustus. There is, in other words, less material to compare and contrast.

What is more, there are even fewer external criteria to provide any kind of benchmark. In identifying the men, matching up the portraits with the heads on coins or with the descriptions of the emperor's features in Suetonius has proved treacherous (a miniature image is hard to align with a full-sized sculpture, a colourful description in Suetonius hard to square against white marble). But it is at least *something*—and in the case of the women we can hardly attempt even that. The heads of imperial women do appear on Roman coins, but much less frequently than the emperors them-

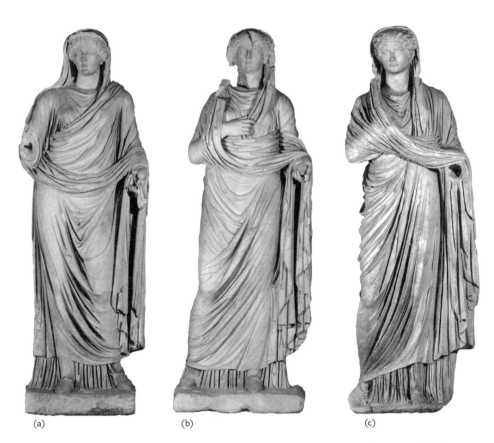

(a)                                    (b)                                    (c)

7.3 Three imperial women from a group of thirteen surviving imperial statues, slightly over life-size, that once stood in one of the public buildings of the small Roman town of Velleia in north Italy. There is some evidence, in the words inscribed on the surviving plinths, of how these statues are to be identified, but almost more important is how similar they look: (a) Livia; (b) Agrippina the Elder; (c) Agrippina the Younger.

selves,[13] and Suetonius does not systematically describe the appearance of the wives and daughters as he does of the men in power. Context and find-spot can help, particularly in the case of groups of imperial portraits. The representation of Livia, for example, a few steps behind Augustus, on the sculptured frieze of the famous 'Altar of Peace' in Rome, raises few doubts.[14] But even in some of these groups, the women's almost identical bland classical features can still prompt endless debates about who exactly they were intended to be. A trio of imperial ladies on public display at the town of Velleia in north Italy illustrates that point perfectly. We can be fairly certain, partly on the basis of inscribed plinths found on the same site, that we are dealing with a Livia and two Agrippinas, Elder and Younger; but to the average viewer (and I am not sure the specialist can really do any better) they might as well be identical triplets (Fig. 7.3).[15]

For the most part, the women's hairstyles give the surest guide, at least to the date of the sculpture, and so also to the possible pool of candidates. There is much less of the, sometimes spurious, precision in the exact layout of the locks of hair, which has played so large a role in identifying their male counterparts.[16] It is more a question of the overall character of the coiffure, which changes over time, from the modestly flat hairdos of the early first century CE to the elaborate piles seventy years later, under the Flavian dynasty and later (Fig 7.2). But here another problem enters. The fact is that (unless some imperial context gives a clear steer) it can be impossible to know whether a particular portrait is one of the emperor's female relatives, some rich private individual with the same fashionable hairstyle or someone consciously aping the appearance of the 'empresses'.[17]

Similarity is the hallmark of the 'empresses'. With the male members of the imperial dynasties, there was always a representational trade-off between similarity and difference. The look-alike Julio-Claudian princes were look-alike precisely in order to appear as indistinguishable as possible from the Augustus they were being marked out to succeed. Yet reigning emperors also needed recognisability, or in some cases—such as Vespasian—they needed to assert a strong form of difference from their predecessor. Hence, tenuous though 'the look' may sometimes be, there were, and continue to be, standard expectations of the appearance of a Julius Caesar, an Augustus or a Nero. Not so with the female members of the dynasty. Whatever the sharply drawn, colourful and conflicting stereotypes of the different characters in ancient literature, the official art of the Roman Empire (and any *unofficial* version of these women is lost to us) seems almost to have insisted on their bland homogeneity, even—hairdos apart—interchangeability.

This was not a *failure* of ancient sculpture or sculptors to distinguish between one woman and the other. Whoever the artists of the finished pieces were, the chances are that they never saw these women face to face anyway (no more than they would have seen the emperors and princes), but that they were working from some kind of model sent out from Rome. Once again, who—if anyone—controlled the process is a mystery. It would be implausible, given what else we know about how things were done in the imperial palace, to imagine that the emperor and his advisers sat down and took the decision that all the women of the family should henceforth be depicted alike (or, as sometimes seems to happen, especially in the later empire, that the women's features should be made to match their husbands'[18]). Yet, however it was achieved, the similarity was the point. It acted as an antidote to the potentially disrupting effects of the demands, desires

7.4 A miniature portrait of a woman, on an ancient cameo, just under seven centimetres tall (the frame is an addition of the seventeenth century). It was most likely made for, and depicts, a member of the ruling house, but there is debate about exactly who she is, and who the children are. Messalina with her son and daughter, Britannicus and Octavia, are very strong candidates.

and disloyalties of the individual women in the political hierarchy that were such a prominent part of the Roman literary imagination. These repetitive images asserted their role not as individual agents, but instead as generic symbols of imperial virtues and dynastic continuity. That was backed up by other aspects of their portraits.

One of those aspects is encapsulated in a miniature image on a Roman cameo, which ended up (complete with a new seventeenth-century frame) in the collection of the French kings, having once been owned by Rubens, who produced a drawing of it (Fig. 7.4). The preciousness and cost hint at a very close connection between cameos such as this and the ancient imperial

court, whether they were palace décor or diplomatic presentation pieces (these are quintessentially *royal* objects). But the exquisite appearance and the extraordinary skill needed to create portraits of this type—involving an intricate process of cutting away the precious stone to reveal different colours for different parts of the design, on a tiny scale—can cloak some of the oddities and complexities of meaning.

For a start, we find the same old problems about the identity of the artists and the models they used (most are unknown) and the identity of the subjects (most are debated). Here the woman has been variously identified as Messalina, Agrippina the Younger, Caesonia the wife of Caligula and Drusilla his sister. It is, however, the logic of the design that counts most, whoever it was originally intended to be. For behind the woman, a *cornucopia* (horn of plenty) not only brims with fruit (a common symbol of richness and fecundity in ancient art) but out of the top, slightly incongruously, peeps a young child—probably a boy, though later re-cutting makes it hard to be absolutely certain, even with the help of Rubens's, perhaps not wholly accurate, drawing. Another figure, traditionally seen as a girl, nestles at the woman's other shoulder.[19]

Assuming the child in the cornucopia is male, this is an assertion of fecundity not in the sense of fruits of the field, but in the sense of producing an heir to the throne. It might seem unsurprising to herald the 'empress' as mother, and there are many other Roman examples, great and small, that parade exactly that role. But there is very likely more to it in this case. Let's suppose that the woman *is* Messalina (which remains a standard view, though the identity of the mother partly depends on what sex we decide the children are, or whether the lower one is a child at all). If so, then this image is not only about as far from the satire of 'empress-as-prostitute' as you could imagine, but is almost an attempt to foreclose on any such idea, emphasising instead the image of the imperial woman as guarantor of male succession: no more and no less.

It is only with the benefit of hindsight that we realise that this particular succession would not turn out as well as it promises. For, if Messalina *is* the mother, then the little boy himself, emerging from the cornucopia as the hope of the dynasty, must be Britannicus, the emperor Claudius's son, who conveniently dropped down dead at dinner in his early teens, so ensuring that he could offer no threat to his stepbrother Nero's place on the throne. The Roman historian Tacitus implied that you might have thought that the death was from natural causes, except for the awkward fact that the funeral pyre had been prepared in advance.[20]

The presentation of 'empresses' in the guise of goddesses was another way of inoculating the visual realm against the supposed dangers of female power, agency and transgression. There were all kinds of overlaps in the Roman imagination between the power of the gods and the power of emperors; and, in one of the most puzzling elements of ancient religion for a modern audience (referenced in Charles I's gallery of paintings and parodied on that staircase at Hampton Court), some emperors, as well as some of their female relatives, were officially recognised as *divine*, with temples, priests and worship, after their death.[21] But during their lifetime, the male members of the family were more often represented in iconic human roles (as general, orator and so on). It was much commoner for 'empresses' to be given the appearance of goddesses—or, more accurately, their statues regularly combined the facial features associated with imperial women, and the clothing, attributes and stance of goddesses.

So, for example, a full-scale statue often identified, rightly or wrongly, as Messalina, again with the baby Britannicus (Fig. 7.5), actually apes the

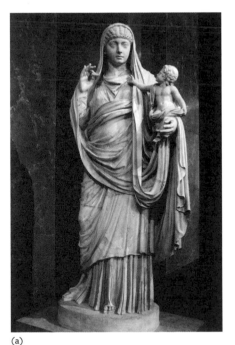

(a)    (b)

7.5 There was a fuzzy boundary between images of goddesses and images of the women of the imperial family. Here (a) a full-sized statue of (probably) Messalina with a child draws on (b) a famous classical Greek statue of the goddess 'Peace' holding her child 'Wealth' (seen in a later Roman version).

pose of a famous fourth-century Greek sculpture of the goddess Peace (Eirene) holding her child Wealth (Ploutos)—partly exploiting the same conceit as in the cameo, by substituting human prosperity, in the shape of a child, for material prosperity in the shape of cash or crops.[22] Even more striking is one of the sculpted marble panels from the most important assemblage of Roman sculpture unearthed in the twentieth century. Hun-

7.6 On a first-century monument celebrating the Roman imperial family in the ancient city of Aphrodisias in modern Turkey, one of many sculptural panels (more than a metre and a half tall, but placed so high up that details would have been hard to make out from the ground) depicts Agrippina the Younger—or is it the goddess Ceres?—crowning the emperor Nero.

dreds of miles away from Rome, in the small town of Aphrodisias in what is now Turkey, these panels—dozens of them—once decorated a building, put up by a group of local bigwigs in the first century CE, in honour of the Roman emperor and his power. They celebrated a variety of successes and dynastic moments in the history of the Julio-Claudian family, and one is generally agreed to depict Agrippina the Younger crowning her son Nero as emperor (Fig. 7.6).[23] Her face and hairstyle fit reasonably well with other so-called Agrippinas. But her pose, dress and that cornucopia again clearly blended with familiar ancient representations of the goddess Ceres, the goddess who—among other things—protected crops, harvests and productivity more generally.

Many modern observers have taken this blending of mortal woman and immortal goddess for granted, with a disappointing lack of puzzlement. Museum labels and photo captions tend to read laconically, 'Agrippina *as* Ceres', or 'Livia *in the guise of* Vesta' or whatever, without facing the question of what that 'as' or 'in the guise of' really means. Are we meaning these empresses were dressed up as goddesses, adopting a convenient artistic template for the public display of a woman? Or is it that they were imagined as super-human figures, whether in a subtle metaphor of female power or in a strong and literal assertion of the empress's divinity? Or is it the other way around? Was the audience meant to see 'Ceres *as* Agrippina', 'Vesta, the goddess of the hearth, *in the guise of* Livia'?[24] These are questions of sculptural identity with a new spin: not, 'Is it Agrippina the Elder or the Younger', but 'Is it Agrippina or the goddess Ceres'?

There is no single right answer here. One observer's clever visual metaphor may always be another's plodding equivalence between empress and goddess. But this convention was another means of dulling the individuality of these women in the imperial family, and mitigating the risk of their prominence. The sculptural vignette of the coronation of Nero shows how this works. Whether or not you believed the lurid rumours of Agrippina engineering Nero's path to the throne (including the famous poisoned mushroom trick to dispose of her then husband Claudius), it would be unthinkable in Roman terms to imagine a mortal woman publicly honoured for securing the imperial succession of her son. The figure of Ceres, by overlaying Agrippina, effectively conceals any hint of mortal agency in the dynamics of succession, transferring it to the level of the divine (even if a few cynics might still have shaken their heads). To put that more generally, blending the figures of empress and goddess was both a gesture of honour to the imperial woman concerned, and at the same time a strategy for effacing her individuality and worldly power.

# Mothers, Matriarchs, Victims and Whores

These two very different images of imperial women—the carefully contrived lack of individuality in official visual arts on the one hand, and the colourful, sometimes counter-cultural literary tradition on the other—have left their mark on modern representations.[25] For a start, it has proved next to impossible ever to create a convincing line-up of Twelve 'Empresses' to match the Twelve Caesars. It is true that a number of female relatives sit alongside the emperors in the Room of the Emperors in the Capitoline Museums, and in the overall design of the Camerino dei Cesari at Mantua some of the dynastic gaps between the generations were filled with small roundels of the emperors' wives and mothers. But there is no Suetonius to define anything like an orthodox set of imperial women; even if you restrict the focus to the wives only, there are many more empresses than emperors (almost every emperor married several times); and, apart from those changing fashions in hairstyles, there is no ancient 'look' to distinguish one from another. The familiar modern groups of the Twelve Caesars, whatever their fuzzy edges, substitutions and misidentifications, are usually exactly that: *Caesars only.*

Occasionally an adventurous modern artist did attempt a series of empresses to parallel the men, whether out of a sense of symmetry, completeness or maybe a desire to introduce an erotic touch to the otherwise austere imperial landscape. But it was less easy than it must have seemed. The problems become clear in the most famous and influential such series to have survived, from the hand of the engraver Aegidius Sadeler in the early seventeenth century. For Sadeler did not stop with his twelve emperors, and their—part bitter, part cheeky—accompanying verses. He also produced twelve matching imperial women to make a complete set of twenty-four, in couples (Fig. 7.7).

Sadeler's source of inspiration for this has long been a puzzle. There is no original artist named on the prints of the women (unlike the acknowledgement to Titian as '*inventor*' on those of the men—including, wrongly, Domitian). So did Sadeler devise them himself, in order to get both sexes in? Or, if he copied them, where were, or are, the originals? There have been all kinds of suggestions. But finds in the archives at Mantua and elsewhere make it now virtually certain that these figures ultimately go back to a set of *imperatrici* (empresses) painted in the 1580s by a local artist, Theodore Ghisi, to complement Titian's *Caesars*—and installed in their own room, the 'Camera delle Imperatrici', somewhere in the palace.[26] How this was laid out, even where exactly it was, and what happened to the paintings (or to

(a)

(b)

(c)

(d)

(e)

(f)

(g)

(h)

(i)

(j)

(k)

(l)

7.7 In the early seventeenth century, Aegidius Sadeler produced prints of twelve 'empresses' to match his emperors. Much less familiar as household names, they are in order of their twelve imperial husbands: (a) Pompeia; (b) Livia; (c) Vipsania Agrippina; (d) Caesonia; (e) Aelia Paetina; (f) Messalina; (g) Lepida; (h) Albia Terentia; (i) Petronia; (j) Domitilla; (k) Martia; (l) Domitia Longina.

the versions of them, which might have been Sadeler's immediate source) is largely a matter of guesswork. There is certainly no sign that they were ever part of the negotiations that brought the other 'Mantua peeces' to England. All we now know of them comes from the prints.

In some ways, they were a close match with the emperors. The women were shown as the same distinctive three-quarter-length figures, and in Sadeler's versions they too have verses beneath, albeit slightly less hostile in general than those attached to the Caesars themselves (some of the most renowned imperial 'villainesses' got off lightly, more tragic mothers than whores).[27] They were also replicated, in several series of frankly undistinguished oil paintings that have turned up all over Europe, and more appealingly in other media too. Their faces were included among the tiny enamels on that elaborate binding of Suetonius's *Twelve Caesars* (Fig. 5.14); and the image of Sadeler's Augustus on the royal teacup was matched by his Livia in the centre of the saucer (modestly concealed, or firmly obliterated, when the cup was in its place) (Fig. 7.8). But there were some telling differences too.

All but one of these women in their flouncy frocks look more or less identical, with none of the individuality—either in features or dress—of the corresponding emperors; it would be very hard to tell, say, *Petronia* (wife of Vitellius), from *Martia Fulvia* (wife of Titus), just on appearance. The verses sometimes only add to the confusion. In one case the writer was hopelessly muddled about who the woman depicted was, apparently imagining (wrongly) that Pompeia, Julius Caesar's second wife who was supposed to be 'above suspicion', was the daughter of Caesar's enemy Pompey.[28] The fact that there was usually more than one wife to choose from and other marital complications (to put it euphemistically) only added to the problems. These complications lie behind the one and only distinctive character in the line-up. For the emperor Otho had had just one wife, early in his life, Poppaea, who later married Nero. Presumably in order to avoid the difficulties that this might cause in his set, the artist chose to omit Poppaea altogether, to depict a later wife of Nero (a different, but related, Messalina), and in the case of Otho to substitute his *mother* for a wife. Her standout appearance is simply down to the fact that she is represented as much older than the others.

It is almost as if the project to construct a series of twelve 'empresses' ended up exposing the fact that it was impossible to do so on the same terms as the men. It foundered on the routine similarity between them, on simple confusions about who was who, and on the lack of any distinctive ancient 'look', for the later artists to discover, follow or adapt. And the

7.8 The saucer to go with the royal teacup decorated with Sadeler's *Augustus* (Fig. 5.3), featured his image of Augustus's wife Livia (though, in a wry comment about female invisibility maybe, you would not see her when the cup was resting on the saucer).

Sadeler prints (or the paintings lying behind them) were not the only case of this. Similar dilemmas, in even starker form, are found a century earlier in Fulvio's compendium *Illustrium imagines*, with its series of numismatic-style portraits accompanying a brief biography of each of his famous Romans, both men and women. In one entry, that of Cossutia (who may have been married to Julius Caesar in his youth, so nudging Pompeia to third place), her life history is covered in a single sentence, but there is no image. In two others—'Plaudilla', probably the wife of the third-century emperor Caracalla, and 'Antonia', possibly the emperor Augustus's niece—there is an image, but no biography. Whether or not this is an advertisement of scholarly probity on the part of Fulvio, a guarantee that he would not fill any gaps for which he did not have proper evidence or a tease about completing the collection (above, p. 134), it can hardly be a coincidence that all these gaps concern women. It is indeed instructive that in a slightly later, bootleg version of Fulvio's book, a portrait of 'Cossutia' has been found to take the place of the blank. But it has nothing to do with Cossutia at all; it is actually a rather effeminised portrait of the emperor Claudius that has simply been borrowed, knowingly or ignorantly, for the purpose. A man here quite literally stands in for a woman.[29]

It was impossible for these modern artists to re-create a systematic authentic line-up of the Twelve Caesars in female form. But, beyond the gaps, uncertainties and identikits (and perhaps partly liberated by them), as far back as the Middle Ages, Western artists have enjoyed re-imagining the colourful tales of these women's power and powerlessness. Like Alma-Tadema in his painting of Agrippina and the ashes, they have used and embellished ancient anecdotes, satire and gossip about them to expose the corruption of empire and the tragedies of its innocent victims. They have produced some brilliant, if chilling, re-creations of the dynamics of Roman autocracy, through a female lens, although with more than the occasional hint of misogyny. Their empresses appear in different guises, from sexual predators to blameless heroines.

Aubrey Beardsley's versions of Messalina-as-prostitute are memorable late nineteenth-century attempts to re-imagine imperial vice. In one of these, the empress steps out into the night, her black cloak merging with the darkness, our attention turned onto her vampish feathered hat, brazen pink skirt and naked breasts (echoing one Roman satirist who picked out her 'gilded nipples' (Fig. 7.9)[30]). It is a disconcerting and slightly puzzling image. Is Messalina setting out for a night at the brothel, that grim look—which is shared with her menacing companion—hinting at their single-minded determination for sex? Or is she returning home to the palace of the cuckolded Claudius, frustrated that she has still not had enough? Either way, it is a picture of a dangerous sexual omnivore in the highest places, simultaneously exposing to ridicule the pathetically insatiable woman and, by implication, the inadequate and humiliated husband.[31]

In this art-nouveau style, which brings its own peculiar engagement with 'decadence', Beardsley was playing with a long tradition of such rampant Messalinas. She was a particular favourite of British eighteenth-century caricaturists, James Gillray and others, for whom she conveniently symbolised the grotesqueness of unchecked female sexual desire. To be honest, you sometimes have to look hard for her. In one of Gillray's nasty satirical prints, pillorying Lady Strathmore for adultery with the servants, drunkenness, child-neglect and desertion of her husband (there was, need-less to say, another side to the story), a picture of Messalina is pinned to the wall in the background.[32] But she plays an even more telling cameo role in a mocking cartoon of an even better-known adulteress: Lady Emma Hamilton, who is depicted in her nightdress, 'comically' obese, watching in despair through the bedroom window as Lord Nelson's fleet sails for France, while her elderly husband sleeps oblivious in the bed behind her (Fig. 7.10).[33] On the floor is a careful selection from Sir William Hamilton's

7.9 Aubrey Beardsley's drawing of 1895 of Messalina and her companion (or servant or slave) on a night out. Less than thirty centimetres tall, the image fades the companion into the night while drawing all attention to the skirt—and breasts—of the empress.

7.10 In James Gillray's cartoon of 1801 pillorying Emma Hamilton (the lover of Lord Nelson), she is pictured watching Nelson's fleet depart. The head of Messalina from her husband's collection of antiquities is on the floor, between a phallus and a Venus. The title adds to the (uncomfortable) joke: 'Dido, in Despair!' evokes the story of the queen of Carthage who, in the founding myth of Rome, killed herself when she was abandoned by the 'hero' Aeneas, who sailed away to his destiny.

precious collection of antiquities—including the head of a so-called Messalina, positioned between a broken phallus (equipped with feet and tail) and a naked Venus, into whose crotch she apparently tries to peer. Again, there are tricky questions here about what exactly we are laughing at (who is the biggest fool: Emma Hamilton, her husband or Nelson her lover?). For those who knew the story of Messalina, her image (like that of Vitellius in Couture's *Decadence*) offers reassurance that the licentious disorder she represents will come to an end. And that is what we witness, in a scene depicted with brutal clarity by an artist who made ancient celebrity deaths something of a speciality: she was shortly finished off by her husband's henchmen, in his pleasure gardens—as one ancient writer put it, like a piece of 'garden rubbish' (Fig. 7.11).[34]

'For those who knew the story' is of course crucial. Some of the tales lying behind these images may now be as unrecognised by most of us as the more arcane byways of the Old Testament (and they may never have been part of people's ordinary everyday repertoire). But it takes only a little

decoding to see how artists were using, and cleverly adapting, them to offer sharp reflections on the role of women in the hierarchy of power—and to open a window onto the corruption at the domestic heart of the empire. Carefully comparing different versions reveals how tiny changes of context, focus or personnel prompt significantly different reflections.

One of the most surprisingly influential stories in the repertoire brings the Roman poet Virgil face to face with Augustus and the emperor's sister, Octavia. Taken from a rather uninspired biography of the poet, written in the fourth century CE long after his death, and on who-knows-what factual basis, it tells how Virgil went to the palace to read out selections from his epic poem the *Aeneid*, to give the emperor a sneak preview. But the recitation was suddenly interrupted. When he came to the part of his poem that mentioned Octavia's son Marcellus, who had recently died, the mother was so overcome that she fainted and could hardly be revived[35]. It was an extremely popular theme for painters in the eighteenth and nineteenth centuries, partly because it hinged on the power of creative art to

7.11 Georges Antoine Rochegrosse flaunts the *Death of Messalina* on this large canvas (almost two metres across) painted in 1916. Messalina herself, in the scarlet dress, is grabbed by a soldier, while on the left her mother (who had tried to persuade her daughter honourably to take her own life) cannot bear to look.

7.12 In Angelica Kauffman's painting of *Virgil Reading the 'Aeneid' to Augustus and Octavia* (1788), the women are the stars of the occasion. They are highlighted at the centre of the canvas (a metre and a half across); the two servants take Octavia (who has collapsed in distress at the mention of her dead son) in hand; the emperor and the poet are pushed aside.

overwhelm its audience: the challenge was to capture in painting the impact of poetry. That is exactly what Angelica Kauffman (one of the few female artists I am able to put in the spotlight) shows in a nicely down-to-earth version of the incident painted in 1788, *Virgil Reading the 'Aeneid' to Augustus and Octavia* (Fig. 7.12). Here Octavia has passed out, Virgil is looking understandably unnerved at the effect he has had, Augustus seems shocked but uncertain what to do, while two capable woman servants—one of whom is shooting an accusing 'look what you've done' glance at the poet—take care of the casualty.[36]

Other artists, however, gave this a far more sinister spin—notably Jean-Auguste-Dominique Ingres, who over more than fifty years produced at least a hundred drawings of this scene, as well as three paintings. But he included an important addition to the cast of characters.[37] For Roman rumour alleged that Livia had been implicated in Marcellus's death, fearing

the young man was a rival to her own son Tiberius in the competition to be made Augustus's heir. In each of his paintings, starting in the early 1810s (Fig. 7.13), instead of Kauffman's sensible servants, Ingres has introduced the elegant, mature and alarmingly steely figure of Livia, who is not mentioned in the ancient account of the incident. Her attitude betrays her guilt. She gestures only perfunctorily to Octavia's plight, and in two of the versions she turns her gaze away into the distance, as if she had no emotional engagement with the events at all, or at least had more important things on her mind. In the final painting, completed in 1864 by colouring an earlier engraving, the group is dominated by a statue of Marcellus himself, and two elderly courtiers (also present in an earlier version) mutter to each other in a corner in a knowing huddle, while on the other side, half cut off by the edge of the canvas, a servant lifts up her hands in horror—as any innocent viewer, who read the scene correctly, might have done.

Ingres here cleverly plays off different versions of the stereotypes of imperial women: the innocent victim versus the deadly power behind the throne. But he does more than that. He points to a different version of the corruption of autocracy, which goes far beyond, or much deeper than, the crude debauchery of Couture's *Decadence*. In Ingres's re-creation of what at first glance might seem like an ordinary domestic scene (not far from 'Victorians in togas'), there is a profoundly uncomfortable version of vice. This is a Roman imperial court in which the normal rules of humanity no longer apply: one in which the murderer coldly cradles the widow of her victim, and only the servant girl seems upset.

## The Agrippinas

It is, however, in the visual re-creation of the Agrippinas, mother and daughter, that we find the most compelling and disturbing reflections on the Roman court and the imperial family. They were key figures in the transmission of imperial power, from the beginning of the first dynasty to its end. Agrippina the Elder, the natural granddaughter of Augustus by his second wife Scribonia, was the only one of his grandchildren not to be either dead or in exile when Augustus himself died in 14 CE. The Younger, her daughter, was the last wife of the emperor Claudius and the mother of the last Julio-Claudian emperor, Nero. As Madame Mère found to her cost, they have been perilously easy for modern viewers (and ancient viewers too, I would guess) to confuse. One Agrippina can seem much like another, the long-suffering widow of Germanicus always in danger of being mistaken for her scheming and murderous daughter.[38]

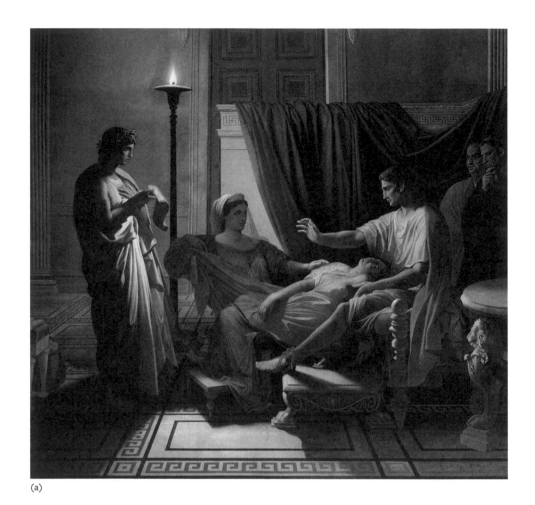

(a)

7.13 Jean-Auguste-Dominique Ingres returned to the scene of Virgil reading his poem to the imperial family many times from the early nineteenth century to 1864, in different formats and at different scales; but the presence of Livia, who was said to have played a part in the death of Octavia's son Marcellus, adds a sinister twist. Of these three: (a) the largest version, c. 1812, about three metres by three, in which Augustus cradles his sister, while Livia looks on; (b) [FACING PAGE] a later version from 1819, cut down to about a metre and a half square from a larger painting, to focus only on the three protagonists; (c) [FACING PAGE] a much smaller version (roughly sixty by fifty centimetres), painted in 1864 over an earlier engraving, which brings a statue of Marcellus himself into the centre—while the servant on the far left starts back in response to the scene.

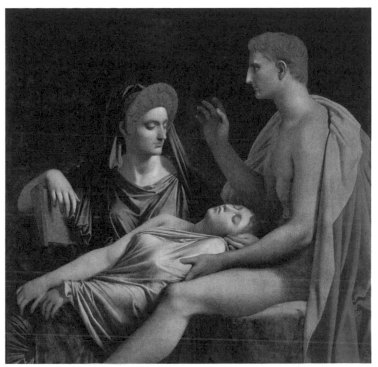

(b)

(c)

Alma-Tadema was only one of many artists to immortalise the Elder. Since the eighteenth century, their prime theme has been her loyal journey home from Syria with her husband's ashes. This meant statues of her, veiled, carrying the urn, dotted around the parks and galleries of Europe (though, as was recognised already in the eighteenth century, there was a tendency to see an Agrippina in *every* statue of a Roman woman[39]); and it meant narrative paintings with all kinds of different nuances. Benjamin West, for example, in the 1760s, just a few years before his *Death of Wolfe*, focussed on her landing in Italy—making it a highly ritualised, heroic moment, almost literally spotlighting the noble heroine holding the urn to her breast as if it were her child (Fig. 7.14).[40] Half a century later, J.M.W. Turner re-created the same scene, but he made Agrippina and her children a diminutive group scarcely visible on the bank of the Tiber, completely overshadowed by the vast monuments of ancient Rome. This was originally designed as one of a pair with a painting of the modern ruins of the city—more than hinting that the tragedy of Agrippina was the beginning of Rome's fall.[41]

7.14 Benjamin West's monumental depiction (two and a half metres wide) of *Agrippina Landing at Brundisium with the Ashes of Germanicus* (1768). Agrippina with the remains of her husband, and with her children and attendants, has just arrived at the port of Brundisium in Italy. Pale but brightly lit, this group is the centre of attention, and people have flocked to see, admire and grieve with them.

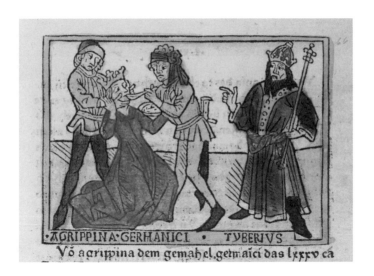

7.15 This late fifteenth-century woodcut from a German printed edition of Boccaccio's *On Famous Women* depicts in medieval guise the punishment and torture of Agrippina. The emperor Tiberius directs proceedings on the right; the terrified Agrippina on the left is force-fed by two of his henchmen.

Other parts of her story have been captured too. In the seventeenth century, she was depicted by Nicholas Poussin grieving by the deathbed of Germanicus, with young Caligula, a threat as much as a hope for the future, by her side[42]—a subject later set for the young French artists competing in 1762 for the sculptural branch of the Prix de Rome to render into marble.[43] There are even a series of uncomfortably matter-of-fact medieval images (not so far from the 'humour' of those seventeeth-century Romans who composed the inscription on the pedestal for her tombstone), which show the unfortunate woman in exile, being force-fed by Tiberius's apparatchiks to prevent her martyrdom, all in contemporary medieval guise (Fig. 7.15).

But in general, whatever accusations of stubbornness there might have been against her, over the last three hundred years or so Agrippina the Elder has proved to be an easy fit with a variety of political positions. For moralists, or anti-monarchical radicals, who often valued wifely loyalty as much as they detested tyranny, she was the perfect combination. She had her uses among royalty too, however. West's painting of Agrippina landing at Brundisium established his reputation in England. This was partly because it could be conveniently exploited in favour of George III's widowed mother Augusta, who—almost foreshadowing the later dilemmas of

Madame Mère—had been satirised as an Agrippina the Younger for her supposed controlling influence over her son.[44] West's painting played its part in retuning the image of the Dowager Augusta as the fiercely loyal widow, Agrippina the *Elder*.

For one of the problems with the younger Agrippina in the standard Roman historical narrative (accurate or not) was precisely that she was supposed to have wielded far too much power over her son Nero. It was not simply that, after her marriage to Claudius, she managed to fast-track him to the throne in 54 CE, aged sixteen, by-passing the unfortunate Britannicus, Claudius's natural son by Messalina. The story was that at the beginning of Nero's reign, she really was a major political force in the palace, underpinned by the incestuous relationship into which she had enticed the boy (pictured rather decorously in Fig. 7.16, in an otherwise raunchy eighteenth-century collection of the sexual exploits of the Twelve Caesars turned into soft porn). But it was not long before her son had had enough of her, and by the late 50s—so the story went—he had decided that the only way to free himself from Agrippina was by murder. The villain then turned victim.

Nero's first attempt was an almost comical failure. He had a collapsible boat built, which self-destructed as planned when Agrippina was out to sea—but the plot was foiled, because it turned out that his mother could swim. So he fell back on more conventional means and sent in a hit squad. Roman writers dwelt on some of the most lurid, personal and very likely fantastical details of the killing. One claims that, in her last words, Agrippina told her assassins to strike her womb. Suetonius tells how Nero (a drink

7.16 One of the most notorious books of erotica of the late eighteenth century was by the 'Baron d'Hancarville' (as he liked to call himself), which focussed on the sex lives of the Twelve Caesars, and more especially their wives: *Monumens de la vie privée des XII Césars* (almost *Evidence for the Private Life of the Twelve Caesars*). In comparison with the others, this scene of Nero and Agrippina is rather delicately chaste.

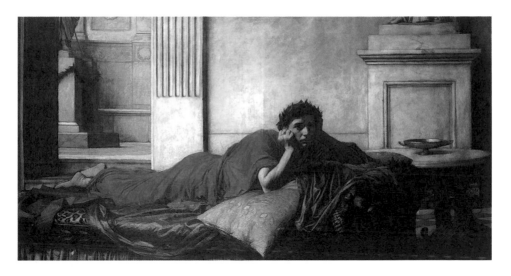

7.17 In this painting of 1878, more than one and a half metres across, John William Waterhouse focusses on *The Remorse of Nero after the Murder of His Mother*. The image of the young emperor is uncannily close to that of a moody modern teenager.

in hand) inspected his mother's naked body after her death, praising some parts of it, criticising others.[45]

Modern images of Agrippina the Younger have been dominated by the story of her murder, from the moment when Nero takes a quick break during a grand dinner to order her assassination, to John William Waterhouse's reflection on the aftermath of the crime (an attempt to penetrate the psychopathology of the young sadist, which picks up Suetonius's claims that the emperor was plagued by guilt at what he had done) (Fig. 7.17).[46] But it is the relationship of the emperor to his mother's naked corpse that was the most popular subject. A series of unsettling voyeuristic images from the end of the seventeenth century on re-enact Nero's inspection of the body: sometimes a clinical appraisal of her remains appears to be taking place; sometimes the emperor can barely bring himself to look at what he has done; sometimes he gets uncomfortably close to the woman who had been both his mother and lover. Whether it is the leopard skin rug on which the dead Agrippina sprawls in one painting or the almost pin-up breasts and languid poses of many, it is impossible to ignore the eroticism that combines with the violence here (Fig. 7.18).

But the 'appeal' of Agrippina's body goes back to the Middle Ages, centuries earlier, when repeated images in manuscript illuminations and in woodcuts portray Nero not simply inspecting the body, but supervising (or in at least one case actually carrying out) its dissection. In a variety of

7.18 Arturo Montero y Calvo's huge canvas of 1887, five metres across, displays *Nero before the Corpse of His Mother*. The emperor on the left gazes on the semi-naked body of Agrippina, while holding her hand. His advisers on the right scrutinise her with (for us) uncomfortable curiosity.

gruesome scenes—the coloured ones are the worst—the woman's abdomen is being slit open, to reveal the organs within. It is not always clear that the victim is dead, raising the question of whether this is an autopsy or vivisection (Fig. 7.19).

Although a number of elements in these pictures may go back to ancient accounts of the aftermath of the murder (Suetonius's glass of wine, for example, appears in some images), the dissection and its details are not a Roman story. All these images are illustrations of a hugely popular medi-

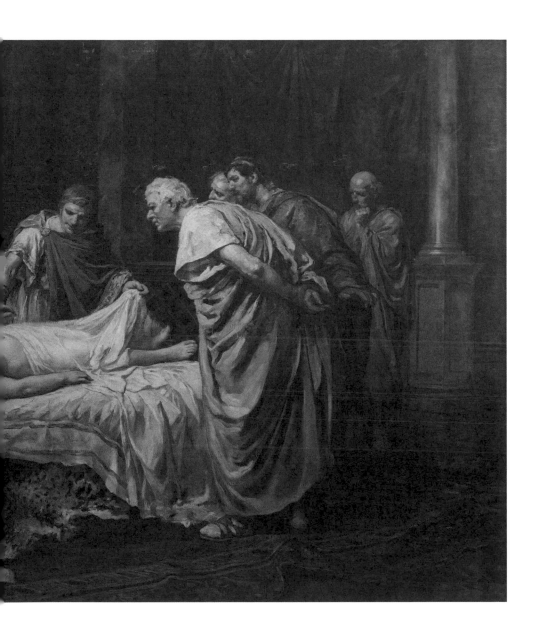

eval elaboration, which told how Nero had his mother cut open so that he could find her womb. It is found in, among other places, the thirteenth-century *Roman de la Rose*, the 'Monk's Tale' in Chaucer's *Canterbury Tales* a century or so later ('he hir wombe slitte, to biholde / Wher he conceived was'), and in that early fifteenth-century mystery play and box-office hit, *Le mistère de la vengeance de la mort et passion Jesuchrist*, in short, the *Revenge of Jesus Christ*). Popular in various manuscript and printed versions, in different European languages, this dramatised the punishment of the Jews

7.19 A tiny image in a late fifteenth-century manuscript of the *Roman de la Rose* shows Nero clothed in red medieval dress watching the dissection of his mother (her ankles tied together) and the exposure of her womb: almost a scene of butchery.

for the crucifixion of Jesus culminating in the destruction of the Temple in Jerusalem by Vespasian and Titus, but with various subsidiary narratives leading up to it. The dissection of Agrippina is one of those. Whether this was actually performed on stage, or merely narrated, is not entirely certain. But one French printed version implies a performance, and gives the stage directions. Agrippina appears to be still alive, so she is 'to be tied to a bench, her belly facing up'. Thankfully, it goes on to say that 'a prop (*fainte*) is needed in order to open her up'. It was to be a clever piece of theatricals, not live surgery.[47]

This story has sometimes been seen as a flagrant case of the medieval enthusiasm for violence and extreme spectacle, the writers, artists and theatrical managers of the time taking the opportunity to add extra blood and guts to what was already a bloody incident. And the later images have also been related to contemporary debates about scientific dissection (how transgressive or justifiable was it? How was it to be represented?). But even more significant is the connection of the story with the issues of women's role in imperial succession and the transmission of power. For the nub of it does preserve a connection with the ancient account that explained how Agrippina exposed her belly and asked her murderers to strike her womb. As Chaucer underlined (and it is a detail repeated in the other versions), Nero wants to find his mother's organs of reproduction. That hints, of course, at the incestuous relationship between the two. But more than that, the story displays, makes explicit and 'dissects', both literally and metaphorically, the woman's role in making and conceiving emperors.

That interpretation is supported by what happens next in some versions of the story, including the thirteenth-century collection of saints' 'Lives' known as the *Golden Legend*. Here, in the 'Life of Saint Peter', Nero insists that the doctors who have been dissecting his mother make *him* pregnant. As they know that this is impossible, they give him a potion in which a tiny frog is concealed, which grows in Nero's stomach, eventually causing him such pain that he has to give birth to it by vomiting—though he is then desolated to find that all he has produced is a messy, bloody frog. The doctors blame him (he had not, after all, gone the full nine months), while the frog is kept safe but locked away, until at the fall of the emperor the poor creature is burned alive.[48]

Where this story came from is unknown. It may, or may not, be indirectly related to one ancient account of Nero taking the theatrical role of a woman in childbirth, and to another ancient story that he would be reincarnated as a frog.[49] Its message, however, is clear: not only are men incapable of producing children without women, but emperors on their own are incapable of transmitting the power they wield. What looks like a lurid medieval fantasy, with its dissection, phantom pregnancies and frogs, in the cruel aftermath of matricide, in fact points directly at the big issues surrounding the role of women in the Roman imperial and dynastic succession; it re-presents in a surprising form some of the key debates and anxieties embedded in the images of 'empresses' ancient and modern.

## Agrippina the Third

Those medieval images of Agrippina sliced open could hardly be more different in style from an elegant and much-admired painting by Rubens that now hangs in the National Gallery of Art in Washington, DC, painted in the early seventeenth century, only a hundred years or so after those last dissections. Taking us back to Agrippina the Elder, who launched this chapter, this double portrait is now entitled *Germanicus and Agrippina*. It depicts the determined and devoted young couple, side by side, in profile—Agrippina in the front plane, partly concealing her husband. Another version of the same characters, by the same artist, is in the Ackland Art Museum in Chapel Hill, but here, though the arrangement is basically the same, it is reversed, with the man in front of the woman (Fig. 7.20). Art historians have argued about the relative quality of the two pieces (some preferring the Washington version, some the Chapel Hill), about the reasons for the different prominence of the man and the woman and about the micro-history of the panels (one suggestion is, on the basis of the construction of the

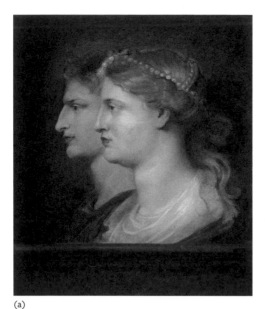

(a)  (b)

7.20 Two early seventeenth-century versions of a double imperial portrait by Rubens (both over half a metre tall), now usually identified as Germanicus and his wife Agrippina the Elder: (a) the version now in the National Gallery in Washington, DC; (b) a similar version, though reversing the figures, now in the Ackland Art Museum, Chapel Hill, North Carolina. But the earlier identification of these figures as the emperor Tiberius and his first wife, another Agrippina, was not necessarily wrong.

wood backing, that 'Germanicus' was an afterthought in the Washington painting, originally intended as a portrait of 'Agrippina' alone). Yet, however those issues are resolved, there are even more intriguing questions of identity that have a major impact on our interpretation of the scene, and introduce another unexpected layer into the 'Agrippinas problem'.[50]

This double-profile form is a classic example of Rubens's use of antique models; for ancient gems and coins, which the artist is known to have studied closely, regularly arranged heads in this way. One particular source of his inspiration, though clearly not the exact model, is often assumed to be the so-called 'Gonzaga Cameo' (Fig. 7.21), an ancient gem much admired by Rubens when he was working in Mantua between 1600 and 1608, and variously identified over its modern history, as depicting Augustus and Livia, Alexander the Great and his mother Olympias, Germanicus and Agrippina the Elder, Nero and Agrippina the Younger, Ptolemy II of Egypt and his wife Arsinoe and almost any other famous ancient couple you could think of.[51] There have even been some ambitious, though ultimately inconclusive,

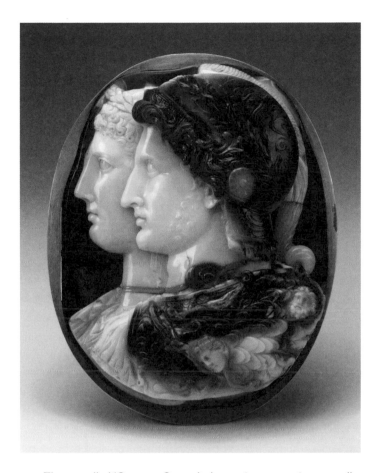

7.21  The so-called 'Gonzaga Cameo', almost sixteen centimetres tall, may date back to the third century BCE (but that depends on who you think the figures represented are, and it could be from several centuries later). Its layout, with two adjacent profiles, found in other ancient cameos, lies behind Rubens's design in Fig. 7.20.

attempts to pin down particular features of Rubens's 'Germanicus' to portraits then identified as the prince on ancient coins and gems that the artist knew, or might have known.[52] But, although the overall design of these paintings clearly does reflect a characteristic ancient form, it is far from clear that Rubens intended his characters to be Germanicus and Agrippina.

In a way reminiscent of the shifting identities of so many Roman portraits themselves, different names have been applied over their history to the couples in each of these paintings. According to a 1791 sale catalogue compiled in Paris, the Ackland version was then believed to be a portrait of the eighth-century Byzantine emperor Constantine VI, and his mother and

# TABLE 3

## THE 'AGRIPPINAS'

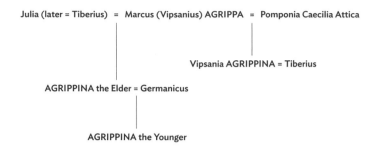

Julia (later = Tiberius)  =  Marcus (Vipsanius) AGRIPPA  =  Pomponia Caecilia Attica

Vipsania AGRIPPINA = Tiberius

AGRIPPINA the Elder = Germanicus

AGRIPPINA the Younger

co-regent Irene; for most of its time in Chapel Hill, since 1959, it has been rather guardedly entitled *Roman Imperial Couple*.[53] The Washington version was bought in the early 1960s from a collection in Vienna where it had been since 1710, known as *Tiberius and Agrippina*.[54] But in Washington doubts were raised almost immediately, and by the end of the 1990s it had been officially renamed *Germanicus and Agrippina*; recently the Ackland Museum has followed suit, and their *Roman Imperial Couple* is also now *Germanicus and Agrippina*. Why?

Apart from the usually treacherous attempts to match up the physiognomy of the male figure to other so-called Germanicuses (the 'Agrippina' has never been a major part of this game), one powerful impetus behind the change of identity is that, if you know a little of their story, *Tiberius and Agrippina* sounds such an unlikely pairing. Why, we cannot help but think, would Rubens have put the implacable Agrippina in a pair with her bitterest enemy Tiberius, who either killed her or forced her to suicide? It makes no sense at all.

At this point, I have to introduce a new character. For there were not just two Agrippinas, but three. As the family tree shows (Table 3), Agrippina the Elder was the daughter of Augustus's daughter Julia and her second husband Marcus Vipsanius Agrippa, her full name being Vipsania Agrippina. But Agrippa had been married before, and there was a daughter of that marriage, who was also known as Vipsania Agrippina. We now call *this* Vipsania Agrippina just 'Vipsania', but that is largely to avoid the confusion of having too many Agrippinas around. In antiquity, and right up until at least the eighteenth century, she was usually referred to, like the others, as Agrippina. There were always three of them.

This third Agrippina was the first wife of the future emperor Tiberius. She is pictured as that (under the name 'Agrippina') in Sadeler's line-up of

empresses (Fig. 7.7c). The catalogue of the Vienna collection refers to her explicitly as the wife of Tiberius—and the expert curators in Washington, DC who ushered in the new identification were well aware that Tiberius had been married to an 'Agrippina'. But, in the modern view of Roman history, it has always been hard to see them as a plausible imperial pairing (not to mention the unexpectedly idealising representation of 'Tiberius' in these paintings).[55] That apparent incongruity meant that the emperor and his first wife, Vipsania Agrippina, were simply cast aside, and a new identity found. We are never likely to know for certain what Rubens had in mind, but there is no strong reason to suppose that the traditional title is wrong, and some reasons to think it was right.

For it does offer a particularly rich reading of the painting. Tiberius may have had a generally bad reputation in ancient and modern literature (if only as a morose hypocrite, who was Augustus's last choice as heir, despite being Livia's natural son), but according to Suetonius there was one woman to whom he was devoted, in true love. That was Vipsania Agrippina. But he was forced by his stepfather Augustus to divorce her, so that he could marry, for entirely dynastic reasons, Julia, Augustus's own daughter (it only added to the marital intricacies that Julia had been the wife of Marcus Vipsanius Agrippa, the father of Vipsania Agrippina). Tiberius was utterly opposed to the idea (and in the standard story, with its predictable dash of misogyny, Julia turned out to be a bundle of trouble), but he had no choice in the matter—and he never got over it. According to Suetonius, after this divorce, when Tiberius was still almost in mourning for Vipsania Agrippina, on one occasion he spotted her in the Roman street, and he followed her weeping. His minders ever after took great care that he should never catch a glimpse of her again.[56]

Maybe we have a hint of that in this image of two people staring in parallel, not looking at each other but held in the same canvas. Indeed, it is hard to think of a better way of capturing the relationship between Tiberius and *his* Agrippina. Rubens has, in other words, breathed life into what was almost a visual cliché of ancient cameo design, by blowing these figures up to almost life size and giving a new story, and a new significance, to the visual form.

We have learned again what a difference a name can make—even if in this case it is the same name.

# AFTERWORD

## Looking Back

In December 1802, a young Irishwoman, Catherine Wilmot, was staying in Florence on a long journey through Europe. After a visit to the Uffizi, she wrote home to her brother to share its highlights. To be honest, the gallery was not at that time quite the treasure house of artistic masterpieces that it is today. A large number of its prized works had been sent south to Palermo in an attempt to keep them (not entirely successfully, as it turned out) from the clutches of Napoleon, who wanted them for his new Museum of the Louvre.[1] Even so, it is striking—but not I hope, by now, surprising—that top of Wilmot's list came the line-up of busts of Roman emperors stretching into the third century CE, the usual mixture of ancient originals, modern versions, pastiches and hybrids. 'What would have pleas'd you most of anything', she wrote, 'was an arrangement of Roman Emperors from Julius Caesar to Gallienus.' For the busts of their partners, however, she had nothing but disdain, briskly dismissing the 'frightful empresses smirking opposite to them'.[2]

As we have seen, for hundreds of years after the European Renaissance, images of Roman emperors—on museum shelves and far beyond—roused intense passions. Recaptured in marble and bronze, in paint and on paper, turned into waxwork, silver and tapestry, displayed on the backs of chairs, on porcelain teacups or stained-glass windows, emperors *mattered*. In the dialogue between present and past, imperial faces and imperial life-stories were alternately—even simultaneously—paraded as the legitimators of modern dynastic power, questioned as dubious role models or deplored as emblems of corruption. Not unlike the contested images in our modern

'sculpture wars', they provided a focus for debates on power and its discontents (and they are a useful reminder that the function of commemorative portraits is not simply celebration). But more than that, they became a template for representing kings, aristocrats and anyone rich enough to be the subject of a painting or sculpture. In fact, the whole genre of European portraiture has roots in those tiny heads of Roman emperors on coins, as well as in their busts or full-sized statues. It is no mere quirk of fashion that, at least up to the nineteenth century, so many statues of aristocrats, politicians, philosophers, soldiers and writers were kitted out in togas or Roman battle dress.

There has always been an edginess to modern images of Roman emperors, sometimes lurking just below what might now seem a blandly conservative surface. One of my favourite examples of this—worth saving to enjoy as a finale—is the bust of the *Young Octavian* (the future emperor Augustus), by the African-American sculptor Edmonia Lewis, closely based on a sculpture of the same subject in the Vatican collection (Fig. 8.1). Lewis had an extraordinary career, thwarted by racism at home, but eventually finding some success as a professional artist in Rome, before moving to London where she died in 1907. To all appearances though, this work—whatever its technical skill—is indeed bland, unchallenging, almost sentimental. Or so it seems until we realise that at the same time as she was creating her *Octavian*, Lewis was also working on her now much more famous statue *The Death of Cleopatra*, first shown at the Centennial Exhibition in Philadelphia in 1876 (Fig. 8.2). The interpretation of this *Cleopatra* has been intensely debated. Was this a celebration of an African queen? Or was Lewis intentionally separating her image of Cleopatra from that of an African-American woman? Was she hinting here perhaps at the figure of the slave-owning 'Old Pharaoh' of African-American songs and sermons? Whatever the answers, this representation of the queen was radically new. Many artists before had focussed on the moment just before her death in 30 BCE when she resolved to kill herself rather than be paraded as a piece of booty in the triumph of her brutal Roman conqueror. Hardly any had ever depicted, as Lewis did, Cleopatra's death agony itself—a shocking sight for the statue's first viewers. But who was that brutal Roman conqueror? It was none other than the real 'young Octavian'. The fact that these two pieces must have been taking shape, side by side, in her studio at the very same time decisively subverts the superficial blandness of the imperial bust; it undermines its apparent cloying innocence.[3]

But there is a twist in this story, which picks up another of the important themes of this book. When Lewis produced her version of the imperial

statue in the 1870s, no one doubted that the Vatican bust was an unusually youthful image of the emperor Augustus, still going under the name of Octavian, which he used until 27 BCE; it had been discovered, so it was regularly claimed, in excavations at the site of the port of Rome at Ostia in the early nineteenth century. Now it is known as *Young Octavian* only for old time's sake. For no one any longer believes that it represents him at all, with the usual names from among his would-be heirs and successors being canvassed instead. Predictably too there has been a series of suggestions that it is not even an ancient piece anyway, but a modern version or forgery—the connection with Ostia wishful thinking or outright fabrication. One of the most intriguing reconstructions holds that it was actually produced in the studio of Antonio Canova, the faint resemblance to the emperor Napoleon being far from coincidental. Although the most up-to-date studies have tended to favour an ancient date (and recent archival work has also tended to support the Ostian find-spot), there is a wonderful anachronic irony in imagining Lewis's *Young Octavian* being based on an early nineteenth-century bust, informed as much by the image of Napoleon as by that of any ancient Roman imperial character.[4]

Whatever the right answer, these *Young Octavians*, both ancient and modern, underline just how fluid and shifting images of the Caesars are, Twelve or not. They are sometimes presented as a rigidly fixed category, founded in the dynastic certainties of Rome, and even—as in the classificatory scheme of Sir Robert Cotton's library—acting as a symbol of the definitive organisation of knowledge itself. But that fixity is rarely quite what it seems. The history of images of the Caesars, right back to antiquity, is one of constructively changing identities, hapless or wilful misidentifications: of Caligulas recarved into Claudiuses, of Vespasian mixed up with his son Titus, of the face of Vitellius standing in for that of a portly 'carver' at the Last Supper, or—in the case of the Aldobrandini Tazze—of the figure of Domitian screwed into the wrong dish, to preside over scenes from the life of Tiberius. The category is so porous that even in Cotton's library, Faustina and Cleopatra can be inserted into the 'orthodox' line-up of the Caesars, Titian can pointedly stop his own series at number eleven, and outside the Sheldonian Theatre in Oxford, thirteen or fourteen anonymous stone figures have become probably the most famous set of 'Roman emperors' in the United Kingdom. Of course, there are many occasions when spotting the right emperor is important. (I hope I have shown that if we overlook the comatose 'Vitellius' in a heap of decadent Roman revellers, we may well miss the point of the whole painting.) But it should come as a relief to most of us that we are probably no worse at matching up the

correct imperial names with the correct imperial faces than people in general have ever been. In fact, part of the dynamic fun of the images of the Caesars, part of the reason for their visual longevity, is that they are so hard to pin down. They are not a breed of iconographic fossils.

## Emperors Now

No one now makes a beeline for the busts of Roman emperors when they enter the Uffizi, or any other museum. And—although we continue to debate how to represent figures from the past (what difference does it make if Shakespeare's *Julius Caesar* is played in togas, doublet and hose or the uniforms of some modern dictatorship?)—to clothe a contemporary portrait statue in a Roman outfit would come across as more than slightly ludicrous.[5] The costume of ancient Rome no longer seems, as it did to Joshua Reynolds, a marker of timelessness, but more a marker of fancy dress; it belongs not to the world of commemorative sculpture, but to the world of the toga-party (Fig. 8.3).

Images of Roman emperors are certainly still all around us, in advertisements, newspapers and cartoons. But some would say that these have been reduced to banal shorthands, their range narrowed to a few familiar clichés. Nero and his 'fiddle' is by far the commonest and most instantly recognisable; but it is now less a meditation on power, more an off-the-peg symbol, deployed to criticise any politician whose mind seems not to be on the real problems of the moment (Fig. 1.18b). Such clichés are not so far away from that journalists' parlour game which fills vacant column inches with speculation about which Roman emperor a particular US president, or UK prime minister, most resembles. My own answer, when queries along those lines now come to me, is usually 'Elagabalus', if only to unseat the enquirer with an emperor they haven't heard of—and, as a bonus, to be able to direct them to Alma-Tadema's great painting (Fig. 6.23).

It is all more complicated, however, than the final descent of a once challenging iconography into the realm of visual cliché. I would not claim that images of Roman emperors are more crucial elements in the art of the West now than they were two or three centuries ago. They are not. But if we look a little harder, we find that contemporary painting and sculpture are much more engaged with those ancient rulers than we assume. Salvador Dalí may be an extreme case, with his repeated images of the emperor Trajan, a fellow Spaniard whom he claimed as his ancestor—as well as fantasising that there was a prefiguration of the double helix of modern genetics in Trajan's column.[6] Other artists, though, have repeatedly returned to

imperial heads as if to the originary site of Western portraiture, whether Julia Mamaea, the mother of Alexander Severus (from whom we started), or a one-eyed Augustus, chillingly rendered in chocolate (preserved with a combination of marble and acrylic) by Turkish artist Genco Gülan (Fig. 8.4a, b, and c). The Grimani *Vitellius* also continues to cast its shadow, nowhere more memorably than in the brilliantly overblown bust in gilt bronze by Medardo Rosso from the turn of the nineteenth and twentieth centuries, reducing the emperor to a large blob of fat (or, as the museum catalogue more politely puts it, 'the facial features are characteristic of his fluid technique of modelling'[7]). By contrast, Jim Dine's version some hundred years later has turned the marble statue into what appears to be a plausible flesh and blood human being (Fig. 8.4d and e). Andy Warhol very likely had an investment in this *Vitellius* too. So far as I know, he never used its distinctive face in his own work, but it almost certainly had an appeal for him. That is to say, when I was in Washington, DC in 2011, preparing the lectures that are the basis of this book, I wandered into an antique shop

(a)                                                (b)

8.1 Edmonia Lewis's under life-size version (just over forty centimetres high) of the young Octavian (a), completed in 1873, is based on a Roman portrait sculpture in the Vatican (b), which in the nineteenth century was one of the most popular and widely reproduced images of the emperor.

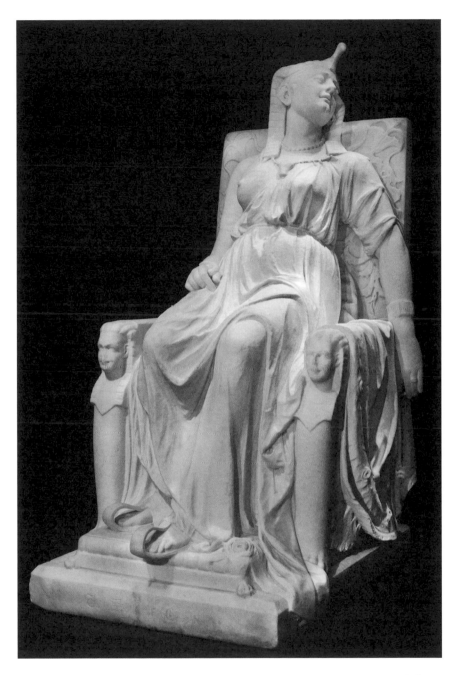

8.2 This more than life-size statue of Cleopatra by Edmonia Lewis (even seated, the queen is over one and a half metres tall) was startling to its first viewers, for showing the dying body of the queen (rather than the moments immediately before her death). The sculpture itself has a curious and sad history. It was 'lost' for a century after its first exhibition in Philadelphia in 1876, and resurfaced in a scrapyard in the 1980s (having spent part of the intervening period marking a horse's grave).

8.3  President Franklin D. Roosevelt celebrated his fifty-second birthday in January 1934 with a toga-party in the White House. Whether or not he was troubled by the qualms of Andrew Jackson (p. 6), it is often claimed that this Roman theme was a wry joke by his staff and friends on the allegations that FDR was becoming a dictator.

in Georgetown—and was surprised to be confronted with an exuberant, perhaps somewhat vulgar, large mahogany version of the Grimani *Vitellius*, looking as if it probably dated to the eighteenth century. I was examining it with what must have seemed like the attention of a potential buyer, when a member of staff approached to tell me that it had once been the property of Warhol. Assuming that was true (and not merely a canny sales ploy), we can only wonder whether the artist was aware how central the face of the Grimani *Vitellius* had been since the sixteenth century in the culture of visual *replication*—which was, after all, his own trademark.

But what of the use of images of emperors and their imperial stories in bigger debates about autocracy and corruption, or in facing more fundamental questions about the nature of representation itself? Artists are still making powerful interventions here. In an apparently playful collage, British sculptor Alison Wilding, for example, juxtaposes the almost ironically appropriate name of 'Romulus Augustus' (the teenager said to be the very last emperor to rule over the Western Roman Empire in the later fifth century CE), with that of 'Saturnia Pavonia', the 'emperor *moth*' (Fig. 8.5). But the key is that she made the geometrical image out of sliced up prints

(a)

(b)

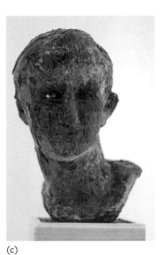
(c)

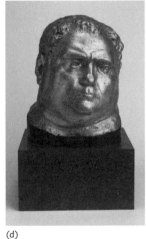
(d)

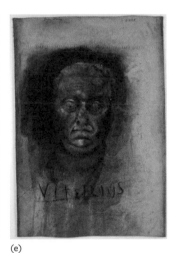
(e)

8.4 Modern imperial heads up to the twenty-first century:
(a) *Julia Mamaea*, a print, about thirty-five by thirty centimetres, by James Welling (2018)
(b) *Julia Mamaea*, a painting, about seventy-five by fifty-five centimetres, by Barbara Friedman (2012)
(c) *Chocolate emperor* (Augustus), in chocolate, plaster, marble and acrylic, sixty centimetres high, by Genco Gülan (2014)
(d) *Emperor Vitellius* in gilt bronze, just under life-size (thirty-four centimetres) by Medardo Rosso (1895)
(e) *Head of Vitellius* in charcoal, water colour and acrylic, just over a metre high, by Jim Dine (1996)

of the moth and of a *coin* of Romulus Augustus. If, in other words, the representation of Roman imperial power was first reconstructed in the Renaissance through coins—here Wilding captures its final destruction in the same form. Forty years earlier, in *Nero Paints*, Anselm Kiefer had taken destruction very differently, using the idea of Nero—as emperor and artist—to reflect on Nazi devastation in eastern Europe. In the 1970s and 1980s, Kiefer often engaged with Germany's (in)ability to face its Nazi past. In this painting, a palette hovers over a devastated landscape, the brushes spurting flames as if themselves the agents of destruction (Fig. 8.6). It

8.5 Alison Wilding's 2017 collage, roughly thirty-seven centimetres square, not only plays on the idea of the 'emperor moth' (*Saturnia pavonia*) but also looks back to the Renaissance tradition of coin images: the collage is partly made out of sliced-up prints of a coin of Romulus Augustus (emperor 475–76).

8.6 On this large canvas of 1974, roughly two metres by three, Anselm Kiefer shows an artist's palette set against a bleak and burning landscape; entitled *Nero Paints*, it raises questions, through its reference to the artist emperor, about the relationship between art, power and destruction.

raises questions not only about the relationship between art and autocracy (Nero's dying words were 'What an artist the world is losing'), and about the role of any artist as both cause and witness of atrocity (do all artists 'fiddle while Rome burns'?), but also about our obligation, uncomfortable as it may be, to understand the artist/autocrat. As Kiefer famously stated, 'I do not identify with Nero or Hitler, but I have to re-enact what they did just a little bit, in order to understand the madness.'[8]

But it is in the moving image over the last century or so that we have found the most intense, and most watched, debates about Roman autocracy and its relationship to our own ethics and politics. The main story of this book has drawn to a close around the time that cinema was becoming a leading medium of art and argument. Any sequel would have to focus on film, which at its very beginning was shaped by images of ancient Rome, its excesses, its moral conflicts, its political and religious controversies.[9] It is here that we now find the wide engagement with these ancient dynasts, tyrants or benevolent rulers that I have traced, not only through the most

(a)

8.7 Gérôme's paintings of the emperor in the amphitheatre captured the spectacle of imperial power. In *Pollice Verso* (literally 'Turned Thumb' or 'Thumbs Down'), a canvas one and a half metres across, painted in 1872 (a), the emperor sits passively in his box on the left, while the audience to the right makes it clear that the victorious gladiator should kill his defeated rival. Ridley Scott's filmic version of the amphitheatre (b) [FACING PAGE] was directly inspired by this painting (in Scott's words, 'That image spoke to me of the Roman Empire in all its glory and wickedness.').

elite works of art, but also through the cheaper versions of imperial images in mass-produced plaques or widely disseminated prints.

The direct descendants of the stained-glass window at Poitiers showing the emperor Nero presiding over the persecution of Christians are those mid-twentieth century films—*The Robe* or *Quo Vadis*, for example—that pit the temporal power of the Roman autocrat against the spiritual power of Christian morality. The BBC television adaption in the 1970s of Robert Graves's *I, Claudius* focussed on the ideas of domestic corruption (plus decadence) that had long before been explored in the paintings of Couture and Alma-Tadema, or in the prints of Beardsley. In 2000, Ridley Scott's box-office hit *Gladiator* presented the political dilemmas of one-man rule that would have been familiar to the designers of Henry VIII's tapestries, or

(b)

even to whoever composed the lumpy, sarcastic verses underneath Sadeler's prints of Titian's emperors. In this case there was a direct artistic influence too. For Scott's re-creation of the scenes in the imperial amphitheatre were based closely on Gérôme's great canvases of the emperor presiding over the gladiatorial shows from his private box. (Fig. 8.7). I can't help thinking that Gérôme would have warmed to the idea of the moving image.[10]

But that is another story, for another book.

• • •

I have only one last loose end to tie up. And that is: what happened to the so-called coffin of Alexander Severus from which I started, brought back from Beirut by Commodore Jesse D. Elliott? Let me reassure readers that its partner, the coffin of 'Julia Mamaea', remains safe in the cloisters at Bryn Mawr College. The story is not quite so simple with that of Alexander Severus himself. This is safe and well cared for too. But it now finds itself in some very odd company indeed, having been removed from the Mall by the mid 1980s—where it was looking increasingly out of place—to a Smithsonian storage depot in Suitland, Maryland. There it now resides, usually wrapped up in plastic sheeting, and lodged (for reasons I haven't quite figured) in the transportation department. It still has its label attached commemorating Andrew Jackson's refusal to be buried in it, but it is now surrounded by vintage pony-traps, old traffic signs and time-expired racing cars (Fig. 8.8). Part of me finds something slightly appealing about the

8.8 The strange last resting place for the coffin in which Andrew Jackson would not be buried. Here temporarily freed from its plastic sheeting, it stands in the transportation section of a Smithsonian storage depot in Maryland.

postmodern juxtaposition of ancient sarcophagus and the left-over detritus of modern technology and commerce that its original occupant, emperor or not, could never have known. At the same time, part of me finds it a little sad. For all my talk about the continuing importance of the Roman imperial legacy, you could hardly find a better example of its fall from grandeur to banality or oblivion.

There is no way that Elliott's absurd ambitions for this sarcophagus, and its pair, will ever be achieved. No American president will be laid to rest in it. But Elliott had some more modest aims too. He felt, as he put it, 'an interest in introducing among us these ancient relics, and am confident that they will be appreciated by the antiquarians and learned of our country'.[11] Personally, I find myself hoping that his confidence might be borne out, and that one day this coffin might be released from its plastic sheeting, and there might be a couple of square metres for it on the Mall again. In some ways it is a very ordinary Roman coffin indeed. But its story of pride, of contest, of controversy, of politics and, of course, of glorious (or shameless) misidentification captures many of the themes of my *Twelve Caesars*.

# Acknowledgements

This book has been ten years, on and off, in the making. Over that time, I have been helped and supported by many friends, colleagues and generous institutions. My ideas took shape at the Center for Advanced Study in the Visual Arts in Washington, DC, which hosted me (and provided a stunning office) while I was giving the A. W. Mellon Lectures in the Fine Arts in 2011. My thanks to everyone there, especially Elizabeth Cropper, Peter Lukehart and Therese O'Malley, as well as Sarah Betzer and Laura Weigert (who introduced me to the magic of tapestry). Also in DC, I learned a lot from, and had fun with, Howard Adams, Charles Dempsey, Judy Hallett, Carol Mattusch and Alex Nagel (then of the Smithsonian).

The research for the project was begun, and a decade later—by a neat symmetry—finished, at the American Academy in Rome, which has on several occasions given me a precious chance to get on with my work in the best of all locations, with a well-stocked library, excellent food and expert company. As the dedication to the book gratefully acknowledges, my thanks go to all at the AAR, especially, on my most recent stay, to Lynne Lancaster and John Ochsendorf, and to Kathleen Christian, for sharing her 'Caesarian' knowledge. So also to friends and colleagues at Yale University. I gave the Rostovtzeff Lecture there in 2016 on some of the themes of this book, and benefitted hugely from a seminar afterwards, with Stephen Campbell, Michael Koortbojian, Noel Lenski, Patricia Rubin and (remotely) Paula Findlen. Later I spent a wonderfully productive month at Yale as guest of the Classics Department and of the Yale Center for British Art. I am especially grateful to Emily Greenwood and Matthew Hargraves, and to all those art historians and Renaissance scholars who then (and throughout this project) have welcomed a classical interloper into their midst.

The book would have taken even longer to complete if it had not been for two years research leave, made possible by a Senior Research Fellowship, funded by the Leverhulme Trust. I cannot thank this intellectually fearless organisation enough.

Many others have helped in different ways. I am especially grateful to Malcolm Baker, Frances Coulter, Frank Dabell, Philip Hardie, Simon Jervis, Thorsten Opper, Richard Ovenden, Michael Reeve, Giovanni Sartori (for help with Sabbioneta), Tim Schroder, Julia Siemon, Alexandra Streikova (for help in Slovakia), Luke Syson, Carrie Vout, Jay Weissberg,

Alison Wilding, David Wille and Bill Zachs; and for help in tracking down an image of a chocolate Roman coin in the middle of a pandemic, to Andrew Brown, Debs Cardwell, Amanda Craven and Eleanor Payne. As he has done before, Peter Stothard read and improved the whole manuscript; Debbie Whittaker caught many errors with her eagle eyes and tracked down information I had written off as untraceable; Robin Cormack and the rest of the family joined me on any number of emperor hunts, and shared their own expertise, photographic and otherwise. (Not for the first time did I reflect on the pleasures and advantages of being married to a professional art historian!)

Finally, I owe great debts to those who gently guided the finished book into the world: Michelle Komie, Kenny Guay, Terri O'Prey, Jodi Price, Kathryn Stevens, Susannah Stone (who found some very elusive images), Francis Eave, David Luljak and the anonymous reviewers of the manuscript.

I could not have done this without any of you.

# Appendix

# The Verses underneath Sadeler's Series of Emperors and Empresses

The Latin of these verses (in which I have retained the original spelling) is generally inelegant, and at times worse—verging on the untranslatable. My translations do not disguise that inelegance, using a fairly literal rendering, though sometimes correcting what I believe to be errors in the grammar or punctuation. I have noted some of the passages of Suetonius (and elsewhere) which are directly echoed in the verses.

### C(aius) Julius Caesar

> Omine discincti metuendus Caesar amictus,
>     Et mediū zona non religante latus:
> Feralis scelere et vitiatae in nocte parentis,
>     Maternum visus commaculasse torum.
> Tantorum impleuit praesagia dira malorum
>     Et certam somnum iussit habere fidem.
> Legibus hic Vrbem dedit, ordinibusque solutam
>     Iunctus et infandis cui fuit ille modis.

## Caius Julius Caesar

Caesar, to be feared because of the omen of his ungirt cloak, and with his belt not fastening across his middle: deadly too because of the crime of violating his mother in the night, dreaming that he had polluted his maternal bed. He fulfilled the dire prophecies of such great calamities, and he proved dreams <literally 'sleep'> to be reliable. He gifted the broken-down city with laws and order, the city to which he was also joined in unspeakable ways.

(Clothing: *Julius Caesar* 45; Incest: *Julius Caesar* 7)

## D(ivus) Oct(avianus) Augustus

Dum rata mactati nitor remanere, tuorque
    Acta Patris, dignum tum gero laude nihil;
Nilque quod emineat, supra ac nos euehat istam,
    Quae mihi bellorum laus socianda venit.
Ad famam imperiumque sibi iam Julius armis
    Strauit iter: Trita currere vile via est.
Ista noua, ac maior fuerit mihi gloria, Janum
    Extinctis bellis sub domuisse sera.

## The deified Octavian Augustus

While I strive that the enactments of my murdered father be validated and
I safeguard them, I achieve then nothing worthy of glory, and nothing that
stands out or elevates us above that military glory which is to be attached
to me. Julius laid a road to fame and power for himself by force of arms. It
is worthless to run on the well-trodden path. For me it will have been the
new and greater glory to have tamed Janus by locking him up, once wars
had been extinguished.

(Closing the gates of the Temple of Janus: *Augustus* 22)

## Tiberius Caesar

Iste feros ritus, et plus quam immitia corda
    Firmamenta sui qui ratus imperij est
Dedidicit quas vitali cum sanguine leges
    Vel Natura dedit, vel sibi fecit Amor.
Matrem, atque Vxorem, natosq, nurinq, nepotesq
    Omnes fax habuit pabula saeuitiae.
Odisse hic sese populum, ac sua facta probare
    Nam voluit, laetum reddidit interitu.

## Tiberius Caesar

He who considered that savage rites and more than hateful emotions were
the foundations of his power, unlearned the laws which with life-giving
blood either nature gave or love made for itself. His flame (incitement)
made his mother and wife, his children, daughter-in-law and grandchil-
dren, one and all, the fodder for his cruelty. Because he wanted the people
to hate him, but to respect his deeds, he made them happy at his death.

(Treatment of his relations: *Tiberius* 51–54;
'Let them hate me': *Tiberius* 59)

## C(aius) Caesar Caligula

Laetitiam picto poteris cognoscere vultu
    Vrbi olim quanta hoc regnum ineunte fuit.
Venit ad imperium multo fumantibus aris
    Sanguine, et innumerâ per fora caede boûm.
Principio haud melior quisquam, quo denique peior
    Nemo fuit, cecidit cum sibi gentis amor.
Vnam Romani te, qui truncare cupisti
    Ceruicem populi, factio caedit ouans.

## Caius Caesar Caligula

You will be able to recognise on the painted face joy, as much as the city once had when he entered his reign. He came to power with altars steaming with much blood and the countless killing of oxen through the fora. In the beginning no one was better than he than whom later no one was worse, when the love of the people for him collapsed. You who wanted to chop the single neck of the Roman people, an exultant conspiracy slaughters.

(Sacrifices on accession: *Caligula* 14; wishing the
Roman people had 'a single neck': *Caligula* 30)

## D(ivus) Claudius Caesar

Qui miséra tristís nescit imperi mala,
    Et quanta regno insit dolorum copia,
    Angustiarum quantaque hinc vis effluat:
    Me videat, ac dominatui dicat vale.
    Me sors tulit praecelsum ad hoc fastigiū
    Existimantem poenam ad insontem rapi
    Mortis metu trementem, et inde desijt
    Discordiarum nunquam, et insidiarum agens
    Me factiosus tum pauor ciuilium:
    Ac scelus ad extremum abstulit venefici.

## The deified Claudius Caesar

Anyone who does not know the terrible woes of sad power and what a huge quantity of ills there is in ruling, and what overwhelming difficulties flow from this, let him look at me and say goodbye to domination. Chance bore me aloft to this pinnacle of power, as I thought that though innocent I was being carried off to punishment, quaking in fear of death, and from then there was never any lack of factional fear of discord and civil plotting pursuing me. And finally the crime of poisoning got rid of me.

(Thinking he was being carried off to punishment:
*Claudius* 10; his fear of plotting: *Claudius* 36)

## Nero Claudius Caesar

Caesareā Nero progeniem stirps vltima claudens
    Nequitiæ cumulum fecit, et ille modum.
Igne solum patrium, ferroque abolere parentem,
    Et genus omne suum, se quoque nixus erat.
Segnitie euicta potuit se perdere tandem,
    Et matrem, quibus et vita adimenda fuit:
At patriam haud potuit, matremque ex ignibus eius
    Hic nouus Æneas sustulit ante suam.

## Nero Claudius Caesar

Nero, the final progeny ending the line of Caesars, made a pile of evil
and he put an end to it. He strove to destroy his native land by fire, and
his mother by the sword, and his whole stock, and himself too. Once he
had overcome his sloth, he was able eventually to destroy himself and his
mother, both of whose life had to be taken away. But he could not destroy
his native land, and this new Aeneas rescued it before his own mother from
its flames.

(Comparison with Aeneas: *Nero* 39; his sloth: *Nero* 49)

## Sergius Galba

Hunc capiti nostro vidit splendere nitorem
    Septima Luna, eadem hoc vidit abisse decus.
Stantem ope nam Fortuna suâ indignata columnā
    Proruit: exitij sed mea caussa fuit.
Nam Capitolina inuidit Venus ipsa monile
    Parui Fortunae Tusculi ab vrbe Deae.
Inde queri visa est noctis mihi moesta p(er) umbrā
    Ereptura datum munere cassa dato.

## Sergius Galba

The seventh month saw this splendour shining on our head, the same
month saw this glory gone. For having been offended Fortuna knocked
down the standing column with her own resources; but the cause of the
downfall was mine. For Capitoline Venus herself envied for her necklace
the goddess Fortuna from the town of tiny Tusculum. From there sadly
she <Fortuna> appeared to me through the shade of the night to complain,
about to seize the gift, deprived of the reward given.

(The seventh month: *Galba* 23; Fortuna and the necklace,
*Galba* 18—this is also the theme of the 'story' accompanying
Galba's portrait in the Camerino at Mantua: above, p. 163)

## M(arcus) Sylvius Otho

Ad regnum ingressus fuit hic vt apertus Othoni
    Per miseram facta proditione necem:
Hic idem fuit extremus regni exitus. Auli
    Vi sibi cum gladijs adueniente super.
Suspector magni et quoniam fuit iste Neronis,
    Nomine quem voluit saepe referre Nero,
Rettulit atque fuga: ac manibus tum denique mortem
    Persimilem sibi et hic coscijt ipse suis.

## Marcus Sylvius <u>Otho</u>

As this approach to royal rule for Otho was open, through terrible murder
after treason had been committed, so too was this final end of his royal rule,
when the force of Aulus came on top of him with swords. And since he was
an admirer of great Nero, whom he often wanted to replicate in his name,
as Nero, he replicated him also in his flight; and by violence he achieved
finally a similar death for himself and for his followers.

(Use of the name Nero: *Otho* 7; suicide of himself and his followers:
*Otho* 11–12)

## Aullus Vitellius

Si te tam miserum factura haec sarcina tandē,
    Aule, fuit regni; quid tibi pulsus Otho est?
Mens hominum euentus, sortisque ignara latentis
    Exitiosa boni tincta colore petit.
Quid tam suspecti hoc habuit tum culmē honoris?
    Quid non at potius turbinis, atque mali?
Te carcer tulit infelix, laqueusque reuinxit,
    Factusque es cribrum, et carnificina miser.

## Aullus <u>Vitellius</u>

If this burden of ruling was in the end, Aulus, likely to make you so wretch-
ed, why was Otho expelled by you? The mind of men, unaware of the
outcome and of the fate that lies hidden, seeks destruction painted in the
colour of good. What then did this peak of so suspect an honour have? Or
rather what did it not have of disturbance and evil? The unlucky prison
held you, the noose bound you, and you became a sieve and a wretched
victim of butchery.

(Murder: *Vitellius* 17)

## D(ivus) Vespasianus Augustus

Effigiem iam cerne boni nunc Principis: est quam
    Laetior obscuro sol vt ab imbre nitet.
In medium tres, qui inter te, et venere Neronem,
    E medio miseris hi periere modis:
Te fatū quoniam iam tunc poscebat, erasque
    Principis exemplum sancte future boni.
Augebis laudes, augebis inique triumphos
    Ante voles ò qui vertere cumque pium.

## The deified Vespasian Augustus

Look now at the image of a good emperor. He is all the more welcome as the sun that shines after the gloomy rain. The three who came between you and Nero, in the middle, perished in dreadful ways. Since fate then demanded you, you were indeed the model of a good emperor, a god to be. O whoever you are, you unfair person, who shall want to outdo the pious ruler, you will increase his renown, you will increase his triumphs.

## D(ivus) Titus Vespasian(us)

Laudatae soboles stirpis laudatior ipse,
    O Tite, virtutum clara propago Patris.
Delitiae, quo tum viuebas, atq amor, aeui
    Vne voluntates surripuisse sagax.
Vsurpet sine laude qius <sic> o tam nobile nomen?
    Tempora iam quod ad haec obsolet ista minus.
Perdidit, heu, subito quod non te numen amicum.
    Si Tibi res fuerat perdere acerba diem.

## The deified Titus Vespasian

You who were the even more renowned scion of a renowned line, O Titus, the famous offspring of the virtues of your father. The delight and love of the age in which you lived, you alone were clever enough to take your pleasures secretly. Who will take over so noble a name without honour, because right up to these times it does not fade. Alas, it was an unfriendly spirit that suddenly destroyed you, since it had been a terrible thing for you to lose a day.

(Titus counting a day 'lost' if he had not helped anyone: *Titus* 8)

## Flavius Domitianus

Debueras regimen non tu fecisse bienni
    O fortuna Titi; ast esse perenne magis
Flauius hunc si post facturus stemma pudendū
    Caesareum vitijs criminibusque fuit.
Caesaris hic quantum nituit fraterq, paterque
    Nomen inobscurat, commaculatque tholum.
Admisit sors hoc, quod conspiratio mendum
    Insectans odijs firma abolere parat.

## Flavius Domitian

O fortune of Titus, you ought not to have made your reign for just two years. It would have better to last forever, if afterwards Flavius was going to make the Caesarian line shameful with his vices and crimes. As much as his brother and father shone brightly, he clouds the name of Caesar and stains its shrine. Fortune admitted this blot, which a powerful conspiracy prepares to obliterate, pursuing him with hatred.

## Pompeia Iulii Caes(aris) Vxor

Illa ego sum Patris, sum Coniugis obses amoris
    Nata, marita eadem sumque furoris obex.
Sed quid nostra virum seu iam retinere parentem
    Vincla valent, regni ius ubi quisque petit?
Qualis amicitiam patris te Caesar adegit
    Velle amor et nexu sanguinis esse ratam?
Vt non omne ferus fas non abrumpere posses;
    Et quae prima loco, prima malisque forem.

## Pompeia, the wife of Julius Caesar

I am the one born to be the pledge of the love of my father and my husband, and as a wife I was also a brake on madness. But how are my chains strong enough to hold a husband or a father, when each one is seeking the right to rule? What kind of love impelled you, Caesar, to want the friendship of my father and for it to be ratified by a connection in blood? So that in your cruelty you could not entirely break faith; and I who was first in rank was first in misery too.

(The writer appears to have confused Caesar's wife Pompeia with a daughter of Pompey the Great, or with Julia, Caesar's daughter and Pompeys's wife.)

## Livia Drusilla D(ivi) Oct(aviani) Augusti Vxor

Imperium placidis aurigabatur habenis
    Pax, fera cum quaeuis natio colla daret.
Livia cum charo transmisi laeta marito
    Tempora, et Augustis inuidiosa dehinc.
O felix vna ante alias, duplicique beata
    Sorte viri: bona quod secla tulere bonum.
Post vitam finis capit hunc tranquilla quietam.
    Inter nostra cadens oscula demoritur.

## Livia Drusilla, the wife of the deified Octavian Augustus

Peace was steering the empire with gentle reins, when every fierce tribe was giving its neck in submission. I Livia, with my dear husband, bequeathed happy times, the envy of the Augusti (emperors) afterwards. O I alone, lucky before other women, blessed with the double good fortune of my husband: the good which good ages have brought. After a quiet life a tranquil end takes him. He dies falling away among our kisses.

(Kisses at the emperor's death: *Augustus* 99; 'O felix una ante alias' is a quotation from Virgil, *Aeneid* 3, 321—referring to Polyxena, the Trojan princess, sacrificed on the tomb of Achilles)

## Agrippina Tiberii Vxor

Altius ad viuum nostri persedit Amoris
    In Tiberi charos intima plaga sinus.
Iulia nec quamuis tetigit furtiua cubile
    Coniugis illa méi, tota potita viro est.
Agrippina animum Tibéri, mentemque tenebat
    Atque oculos tenuit post aliquando suos.
Iulia non tenuit, rapuit quae gaudia nobis:
    Nam Patris exilium lege, virique tulit.

## Agrippina, the wife of Tiberius

Deep down to the quick, a profound affliction for love of me lodged into the dear breast of Tiberius. Although that stealthy woman touched the bed of my husband, Julia did not entirely gain possession of the man. Agrippina continued to hold the mind and the heart of Tiberius, and long after she sometimes held his eyes. Julia who snatched our joys from us did not hold them, but by the ruling of her father and husband she suffered exile.

(The eyes: *Tiberius* 7, and see above, p. 273)

## Caesonia Caesar(is) Caligulae Vxor

Haec quae Caesareo videnda coetu
    Augustas nitet inter, aureoque
    Ornatu muliebriter renidens
    Nil distat reliquis; recondit audax
    Vultum foemina casside, ac sub armis
    Vires abdidit illa delicatas.
    Haec protectaque parmula rotunda
    Ibat iuxta equitans comes marito;
    Castrensis caligae vnde nuncupato
    Imprimis ea Caesari probata est.

## Caesonia, the wife of Caesar Caligula

She who is to be seen in her marriage to Caesar shines among the Augustae (empresses), and gleaming as a woman with golden adornment is no different from the rest; the audacious woman clads her face in a helmet, and she conceals her delicate strength underneath weapons. And she, protected with a small round shield, used to go out riding next to him, as companion to her husband; and so she was especially approved by the Caesar called after the army boot.

(Military dress and joint riding: *Caligula* 25)

## Aelia P(a)etina Claudii Vxor

Hanc ego cur sedem vxores sortita tot inter
    Quae numeror de bis Aelia quarta tribus?
Claudius immodice tot quando vxorius arsit
    Nonadamans omnis, dissimilisque fuit.
Culpa quidem nostrum leuis, ac non improba nexū
    Abscidit: ast alias dat scelus esse reas.
Tandem hunc, quae natum cupit Agrippina videre
    Iam dominum, insidijs perdere dicta suis.

## Aelia P(a)etina, the wife of Claudius

Why did I win this place among so many wives, Aelia who am numbered fourth out of six? When Claudius burned immoderately and devotedly for so many wives, he was not completely hard as stone, and was unlike it. A trivial fault and not wicked broke our union. But crime makes other women guilty. In the end Agrippina who desired to see her son now as emperor is said to have destroyed him with her plots.

(Six wives, including two betrothals: *Claudius* 26)

## Statilia Messallina Claudii Neron(is) Vxor

Amplexus Claudi ad dulces Octavia primum
    Spreta, ac iussa mori mi patefecit iter.
Deinde Sabina, grauis pulsu quae calcis obiuit
    Tam magni nuptam Principis esse dedit.
Cuius quanta fuit non formidasse furorem
    Laus mihi, materiam nec tribuisse malo:
Pellice tam doleo Agrippina facta noverca;
    Mi socrus, ac mater Coniugis illa mei est.

## Statilia Messallina, the wife of Claudius Nero

Octavia, the daughter of Claudius, scorned and ordered to die first laid the
way open for me to his sweet embraces. Next Sabina, who died from the
force of a rough heel, allowed me to be the bride of so great an emperor. As
much praise as there was for me not to have feared his fury and not provid-
ed material for evil, equally I regret having been made a stepmother, with
Agrippina as his mistress. She is my mother-in-law, and she is the mother
of my husband.

(Death of Sabina 'by the heel': *Nero* 35. The family relations
evoked at the end of the verses are unfathomable; the writer may have
confused the Messalina who was the wife of Nero with the Messalina
who was the wife of Claudius; and/or may have confused the Latin
*noverca* and *nurus*—'stepmother' and 'daughter-in-law'.)

## Lepida Sergii Galbae Vxor

Heu, quae tam rigidi potuit vis effera fati
    E Sergi charo me rapuisse sinu?
Quem nunquam vinclo excussa Agrippina iugali
    Peruicit cineri destituisse fidem:
Et tamen illa suas artes tentauerat omnes,
    Nec minus et vim collegerat iste suam.
Inieci desiderium quod amata marito
    Ipsa mei, vita caelibe gessit agens.

## Lepida, the wife of Sergius Galba

Alas, what savage force of an unbending fate could have snatched me from
the loving embrace of Sergius? It was he whom Agrippina, released from
the bond of marriage, never prevailed upon to have abandoned his loyalty
to the dead: and although she had brought all her wiles to bear, no less had
he mustered all his resolve. Because I myself, loved as I was, inspired desire
for me in my husband, he went on living according to a bachelor's life.

(Early death of Lepida and Galba's refusal of Agrippina: *Galba* 5)

## Albia Terentia Othonis Mater

Vxoris sedem impleui moestissima mater
  Tam nato tristis, quam dulci laeta marito.
  Huius spectaui testes probitatis honores
  Mansurum decus erecti sibi marmoris; atq hunc
  Prosper laudatis tandem tulit exitus actis.
  Coniugis ille expers (sed spem dilecta fouebat
  Messallina) parum felici claruit ausu
  Dum petit imperium caussam sibi mortis acerbae.

## Albia Terentia, the mother of Otho

Wretched mother, I have filled the place of a wife, as sad for my son, as I am joyful for my dear husband. I watched the honours that were the witnesses of his uprightness, the lasting glory of a statue erected to him; and eventually a favourable death carried him off, his deeds praised. Without a wife (but the beloved Messallina encouraged his hope) he became famous for an unlucky attempt while he sought the throne, the cause of his tragic death.

(Otho's hope of Messalina: *Otho* 10)

## Petronia Vitellii Prima Vxor

Vxor sanguinci non illaetabilis Auli
  Coniugis exitium nil miserata doles.
Nec deiecta doles aduersam coniuge sortem;
  Sors quia nam misero laeta carere viro est.
Vulnerum, et indignae tum post ludibria mortis
  Cumque viro amissi nominis, ac decoris:
Fundo hausit faecem istius Fundana doloris.
  Imperij, ac gaudi pocula prima bibis.

## Petronia, the first wife of Vitellius

Cheerful wife of the bloodthirsty Aulus, though you pity the death of your husband, you do not lament. Nor, deprived of your husband, do you lament an adverse fate. For it is a happy fate to be without a dreadful husband. After the insults of the wounds, and of a shameful death, of a name and honour lost along with a husband, it was Fundana who drew the dregs of that grief from the very bottom. You drink the first drafts of power and joy.

## Flavia Domicilla Vespasiani Vxor

Vidissem nostri meliora reducere quondam
    Tempora Caesareum quae diadema viri;
Et praematuro celerem quae tempore frugem
    Cepissem nati de probitate Titi:
Heu rapidum morior. Mihi ducere longa negatū
    In gaudis tecum fila marite tuis.
Caesareas inter quam tu mirare maritas
    Priuato viuens sum sociata viro.

# Flavia Domicilla, the wife of Vespasian

I who would love to have seen the Caesarian crown of my husband one day
bringing back better times; and would love to have caught the rapid fruit
that came prematurely from the good character of my son Titus: alas I die
quickly. It has been denied to me to draw out, my husband, long threads
with you in your happiness. I whom you admire among the wives of the
Caesars, when I was alive I was the partner of a private citizen.

## Martia Fulvia Titi Vespesian(i) Vxor

Tam bone si cunctis coniux mi diceris esse
    Inuide cur quæso mihi es; quid rogo parce mihi es?
Ipsa quoque heu demens quae sum diuortia passa
    Debueram nodum velle manere tori
Quando vsus natam tuleramus pignora nostri;
    Coniugij ac dulce hoc munus vtrique fuit.
Non me fronte vides dulci gratante marito;
    Nec peramata vides coniugis ora Tito.

# Martia Fulvia, the wife of Titus Vespasian

If my husband you are said to be so good to all, why I beg are you hostile
to me; for what reason I ask are you mean to me? I myself, alas, who sadly
suffered divorce, must have wanted the marriage knot to remain, when we
bore a daughter as the pledge of our union; and this reward of the marriage
was pleasing to both of us. You do not see me with a sweet expression and a
joyful husband; nor do you see a wife's face beloved of Titus.

(Daughter born and divorce: *Titus* 4)

## Domitia Longina Domitiani Vxor

Vxor inhumani saevique auuersa mariti
    Moribus, esse proba, ac non nisi iusta potes.
Non te rupta fides spretae aut commercia taedae
    Participem damnent caedis inesse viri.
Tantam si mundo posses subducere pestem
    Laus, quae nunc aliqua est, tunc tua tota foret
Grande tyrannorum quisquis de morte meretur.
    Vita tyrannorum non habet illa fidem.

## Domitia Longina, the wife of Domitian

Wife of an inhuman and savage husband, different in character, you can
be upright and nothing if not just. Broken faith or a spurned marriage
would not condemn you for joining in your husband's murder. If you could
remove so great a blight from the world, glory—of which you now have
some—would then be entirely yours, whoever deserves great reward from
the death of tyrants. The life of tyrants has no loyalty.

(Divorce and remarriage: *Domitian* 3; her involvement
in conspiracy against Domitian: *Domitian* 14)

# Notes

## Chapter I
### The Emperor on the Mall:
### An Introduction

1 Many details of the acquisition (includ-
ing the exact dates and how, and from
whom the objects were acquired) remain,
at best, vague. Stevenson, 'An Ancient
Sarcophagus'; Warren, 'More Odd
Byways', 255–61; Washburn, 'A Roman
Sarcophagus'. Elliott's controversial
career is defended in Elliott, *Address*
(where he gives a few details on the
sarcophagi, 'Appendix', 58–59). A modern
archaeological analysis: Ward-Perkins,
'Four Roman Garland Sarcophagi'.

2 Modern accounts of the reign: Ando,
*Imperial Rome*, 68–75; Kulikowski,
*Triumph of Empire*, 108–11; Rowan,
*Under Divine Auspices*, 219–41 (focussing
on coins). Charles I: Peacock, 'Image of
Charles I', esp. 62–69. An overview of his
portraits: Wood, *Roman Portrait Sculpture*,
56–58, 124–25. Different motives for the
assassination: Herodian, *Roman History*
6, 9; *Augustan History, Alexander Severus*
59–68; Zonaras, 12, 15.

3 Lafrery, *Effigies viginti quatuor*; for
Lafrery (or Lafreri) as publisher, see
Parshall, 'Antonio Lafreri's *Speculum*',
esp. 3–8. Alexander does not easily
shake off the number 24; he appears,
for example, in that ranking in Tytler's
nineteenth-century *Elements of General
History*, 612.

4 The brutality of Maximinus: Herodian,
*Roman History* 6, 8 and 7-,1; *Augustan
History, The Two Maximini* 1–26; Aurelius
Victor, *On the Emperors* (*De Caesaribus*)
25 (illiteracy). Kulikowski, *Triumph of
Empire* 111–12 succinctly sees through
some of the ancient hype on these rulers.

5 *Augustan History, Alexander Severus* 63.

6 Harwood, 'Some Account of the
Sarcophagus,' 385; looking back almost
thirty years to his early service under
Elliott, the author—by then a rear-
admiral—systematically unpicks the case

for the connection of the sarcophagi with
the imperial couple (though the Latin
of the 'Julia Mamaea' inscription defeats
him).

7 There has been controversy over all
aspects of this story: whether the tomb
complex outside Rome had anything to
do with Alexander Severus, whether the
Capitoline sarcophagus was that of the
emperor and his mother and whether the
Portland Vase was found there. Sceptical
discussions: Stuart Jones, 'British School
at Rome' and de Grummond (ed.),
*Encyclopaedia*, 919–22. Less sceptically,
with full documentation on the finds:
Painter and Whitehouse, 'Discovery'.
By the mid-1840s, reputable guidebooks
were already warning their readers off
any connection of the sarcophagus with
Alexander and his mother: 'this idea is
rejected by the modern authorities' was
the firm line taken by Murray's *Handbook
for Travellers* in 1843. The complex his-
tory of the Portland Vase itself: https://
www.britishmuseum.org/research
/collection_online/collection
_object_details.aspx?objectId
=466190&partId=1.

8 Jackson's letter: Stevenson, 'An Ancient
Sarcophagus'; Warren, 'More Odd
Byways', 255–61. Accusations of
'Caesarism' levelled at Jackson and
others: Malamud, *Ancient Rome*, 18–29,
Cole, 'Republicanism, Caesarism'; Wyke,
*Caesar in the USA*, 167–202.

9 The installation of the 1960s infor-
mation panel: Washburn, 'A Roman
Sarcophagus'.

10 Stewart, 'Woodcuts as Wallpaper', 76–77
(discussing a late sixteenth-century bed
decorated with this imperial paper).
The interior design company Timney
Fowler (http://www.timneyfowler.com
/wallpapers/roman-heads/) supply
modern versions.

11 The title of this section is borrowed from
Keith Hopkins, *A World Full of Gods:
Pagans, Jews and Christians in the Roman
World* (London, 1999).

12 Alföldi, 'Tonmodel und Relief-
medaillons'; Boon, 'A Roman
Pastrycook's Mould'. Gualandi and
Pinelli, 'Un trionfo' contest the idea that
these objects are moulds of this type,
but propose no more plausible use.

13 The range and function of this

portraiture: Fejfer, *Roman Portraits*, 372–429; Stewart, *Social History*, 77–142. Private images of emperors were more common than is sometimes imagined; for their possible religious importance, see Fishwick, *Imperial Cult*, 532–40.

14 Complete catalogues: Boschung, *Bildnisse des Augustus*, 107–94; Bartman, *Portraits of Livia*, 146–87. Estimated totals (largely based on how many were likely to have been produced each year): Pfanner, 'Über das Herstellen von Porträts', 178–79. A full catalogue of surviving portraits of Alexander and Julia Mamaea: Wegner, 'Macrinus bis Balbinus', 177–99, 200–217. See further below, pp. 64–73.

15 Augustus, *Autobiography* (*Res Gestae*) 24: 'Silver statues of myself on foot, on horseback and in chariots stood in the city to the number of about eighty. These I took down myself.' Romans sometimes regarded statues in precious metals as dangerously extravagant, but the claim to have turned an honour to himself into an honour for a god was typical of Augustus's self-advertising modesty.

16 Walker and Bierbrier, *Ancient Faces* is a good introduction to these.

17 The painting of Septimius Severus and his family: Mathews and Muller, *Dawn of Christian Art*, 74–83. The text of the inventory, with discussion, is published in *POxy.* 12, 1449, and some key lines are accurately translated in Rowlandson, *Women and Society*, no. 44; it is also discussed in *Dawn of Christian Art*, 80–83, which argues that the surviving image of Septimius with Caracalla and Julia Domna is one of those listed in the inventory (though the idea that the papyrus points to four thousand panel paintings of the emperor Caracalla is based on combination of fantasy and inaccurate translation). The remarks of Marcus Aurelius's tutor: Fronto, *Correspondence* (*Ad Marcum Caesarem*) 4, 12, 4. The Latin text is uncertain in detail, but the broad lines are clear (though some suggest that he is 'kissing' rather than 'laughing at' the portraits). Other lost painted portraits: Bartman, *Portraits of Livia*, 12, with Epigraphic Catalogue 45 and 52. The second-century CE epitaph of a man described as 'painter of emperors and of all the better people' (*CIL* 11, 7126, reproduced

in Fejfer, *Roman Portraits*, 420) may conceivably indicate a portrait artist with a speciality in imperial and upper class subjects; but it more likely indicates a painter *employed by* the imperial house and 'better people'.

18 Poitiers glass: Granboulan, 'Longing for the Heavens', 41–42 (for Nero in particular, see below, n. 24). The Lothar Cross and the problems surrounding such re-use (Was the cameo recognised as the emperor? Was it creatively reinterpreted and Christianised?): Wibiral, 'Augustus patrem figurat'; Kinney, 'Ancient Gems' (113–14 on the cross); and more generally Settis, 'Collecting Ancient Sculpture'. A later parallel, a sixteenth-century cross from the cathedral at Minden in Germany, incorporating an ancient cameo of Nero, raises similar questions: was it unrecognised, or was it a gesture of Christian triumphalism? (Fiedrowicz, 'Christenverfolgung', 250–51).

19 The Caesars at Versailles: Maral, 'Vraies et fausses antiques', 104–7 (and 110–11, for an even more lavish pair of imperial busts with bronze heads and gilded drapery); Michel, *Mazarin*, 315–18 (on those acquired from Cardinal Mazarin's collection); Malgouyres (ed.), *Porphyre*, 130–35. The emperor series at Powis: Knox, 'Long Gallery at Powis' (with the eighteenth-century comments in Andrews, *Torrington Diaries*, 293). The Bolsover fountain: Worsley, 'The "Artisan Mannerist" Style'.

20 One influential treatise is Lomazzo, *Trattato dell'arte*, 629–31 (the instructions given on how emperors should be depicted are heavily, but not wholly, dependent on their descriptions in the biographies of Suetonius and of the *Augustan History*).

21 Pop-up decorations: below, pp. 122–23, 133. The sixteenth-century German chairs: *Splendor of Dresden* no. 95 (illustrating the Julius Caesar chair); Marx, 'Wandering Objects', 206–7. Tapestries: below, pp. 199–210.

22 The Spanish officer's necklace: Sténuit, *Treasures of the Armada*, 206–7, 256, 265 (on the discovery, though misidentifying the figures depicted as Byzantine); Flanagan, *Ireland's Armada Legacy*, 185, 198; National Museum of Ulster online

(https://www.nmni.com/collections /history/world-cultures/armada -shipwrecks). Minghetti's work: Barberini and Conti, *Ceramiche artistiche Minghetti* (for the display of four of his emperors at the Milan international exhibition in 1881, see *Guida del visitatore*, 157). This set of Caesars is now scattered over the world, including: a Tiberius, Caligula and Domitian in the Victoria and Albert Museum, London; a Julius Caesar and Nero in the National Museum of Ireland, Dublin; and I have found nine others in Geneva, Lisbon, Bologna and private collections or commercial galleries or auction sales. In addition to the total located (fourteen), the fact that there is a Julius Caesar both in Dublin and a commercial gallery in Australia, as well as a duplicate Titus, indicates that we are dealing with more than a single line-up of twelve.

23 Dessen, 'Eighteenth-Century Imitation' puts Hogarth's Nero in the context of other contemporary allusions to the emperor. The caricature: Napione, 'Tornare a Julius von Schlosser', 185 (for the Verona series in general, see below, pp. 98, 314n35).

24 Medieval French traditions on Nero and Peter and Paul (including the glass at Poitiers): Henderson, 'The Damnation of Nero and Related Themes'; Thomas, *The Acts of Peter*, 51–54; Cropp, 'Nero, Emperor and Tyrant', 30–33. Nero on the doors of St Peter's: Glass, 'Filarete's Renovation', connecting the iconography also with the use of the basilica for the coronation of the Holy Roman emperor (with further details in Nilgen, 'Der Streit über den Ort der Kreuzigung Petri').

25 The essence of the story, featuring the Delphic oracle rather than the Sibyl, goes back at least as far as the early sixth century (John Malalas, *Chronicle* 10, 5), and is found in many different versions: Cutler, 'Octavian and the Sibyl'; White, 'The Vision of Augustus'; Raybould, *The Sibyl Series* 37–38; Boeye and Pandey, 'Augustus as Visionary'. Other, now even less well known, confections attempt to align imperial and Christian history: the myth, for example, of the fourth-century CE Faustina (wife of the emperor Maxentius) visiting Saint Catherine of

Alexandria in prison was captured by many artists, including Tintoretto (in the Patriarchal Palace, Venice), and Mattia Preti (now in the Dayton Art Institute, Dayton, Ohio).

26 Statues of emperors in Fellini (signalling the equivalence of the vices of ancient and modern Rome): Costello, *Fellini's Road*, 61; De Santi, *La dolce vita*, 157–63; Leuschner, 'Roman Virtue', 18. The identification of some of the (modern) imperial busts featured in *La dolce vita*: Buccino, 'Le antichità', 55.

27 This feedback loop between modern representations and our understanding of the ancient evidence itself: Hekster, 'Emperors and Empire'.

28 Winckelmann, *Anmerkungen* 9 ('das neue vom alten, und das wahre von den Zusätzen zu unterschieden'); see Gesche, 'Problem der Antikenergänzungen', 445–46.

29 The description, as sixteenth-century, on its accession to the Getty: 'Acquisitions/1992', 147; Miner and Daehner, 'Emperor in the Arena' (with further discussion, arguing for a date in the 180s). The exhibition in 2008–9 is documented online (with details of surface analysis) at http://www.getty.edu /art/exhibitions/commodus/index.html.

30 Cavaceppi, *Raccolta*, vol. 2, 129; the phrase 'chi le osserva con le orecchie' is borrowed from Baglione *Le vite*, 139, who had used it to refer to the clients of his rival Caravaggio. The English gullibility was the prompt for many sharp remarks from the English themselves: the antiquities market in Rome is 'so long exhausted of every valuable relic that it has become necessary to institute a manufactory for the fabrication of such rubbish as half the English nation come in search of every year,' observed E. D. Clarke in 1792 (Otter, *Life and Remains*, 100). But it always depended on the point of view of the writer. The basic rule was that other people were foolish dupes, the writer himself a learned connoisseur. Bignamini and Hornsby, *Digging and Dealing* is a thorough introduction to the art market in early modern Rome.

31 The blurry line between a fake, a copy and an original: Sartwell, 'Aesthetics of the Spurious' (postulating twenty-one stages between authenticity and

inauthenticity!); Elkins, 'From Original to Copy'; Wood, *Forgery, Replica, Fiction*; Mounier and Nativel, *Copier et contrefaire*. The Paduans: Burnett in Jones (ed.), *Fake?*, 136–39; Scher (ed.), *Currency of Fame*, 182–83; Burnett, 'Coin Faking in the Renaissance'; Syson and Thornton, *Objects of Virtue*, 122–25

32 Carradori, *Elementary Instructions*, 40.

33 The history of its reworking: Walker, in Jones (ed.), *Fake?*, 32–33, and 'Clytie: A False Woman?' (the nymph Clytie is the sculpture's rival identification).

34 Cavaceppi, *Raccolta*, vol. 2, 123–30, with discussion of Cavaceppi's theories of art in Meyer and Piva (eds), *L'arte di ben restaurare*, 26–53.

35 Full documentation: Bodart, 'Cérémonies et monuments'. The fact that the man who delivered the eulogy and in whose garden the statue of Caesar stood was named Cesarini cannot have been a coincidence (on the Cesarini collection, see Christian, *Empire without End*, 295–99); in fact, the name itself may lie behind the (optimistic) identification of the original statue as Julius Caesar. The career of *Il Gran Capitano*: Lattuada, *Alessandro Farnese*. An overview of his memorials (including the statue): Schraven, *Festive Funerals*, 226–28. Other such hybrid sculptures (including at least one in the same room as *Il Gran Capitano*): Leuschner, 'Roman Virtue', 6–7.

36 Statius, *Occasional Verses* (*Silvae*) 1, 1, 84–87 is the single piece of evidence for this; but there are other examples of similar practice (for example, the face of the emperor Augustus superimposed on the face of Alexander on two paintings: Pliny, *Natural History* 35, 93–94).

37 Haskell and Penny, *Taste and the Antique*, 133–34.

38 To judge from a letter he wrote in 1806 to Quatremère de Quincy, Canova believed (or found it prudent to claim) that the original sculpture represented the Elder Agrippina; see Quatremère de Quincy, *Canova et ses ouvrages*, 143, where he also, perhaps over-energetically and even before he had finished it, rejects the accusations of plagiarism (it is worth noting that very few of his other works bear any such close resemblance to an ancient original). The controversy around the work, the possible role of Madame Mère herself in selecting 'Agrippina' as a model, and Canova's political intentions: Johns, 'Subversion through Historical Association', and *Antonio Canova and the Politics of Patronage*, 112–15; Draper in Draper and Scherf (eds), *Playing with Fire* 106–8 (minimising Canova's subversive intentions).

39 Cavendish, *Handbook of Chatsworth*, 34 (night-time visits); 95 (Madame Mère's complaints). The formation of the Chatsworth collection, including this piece: Yarrington, '"Under Italian skies"'. The text of a later letter from the duke in which he described Madame Mère scolding 'long and loud about the statue which she says <the French authorities> had no right to sell nor I to buy': Devonshire, *Treasures*, 80 (also reprinting some passages from the rare *Handbook of Chatsworth*); Clifford et al., *Three Graces*, 93.

40 Barolsky, *Ovid and the Metamorphoses of Modern Art* is one recent study to underline this point.

41 Hall and Stead, *People's History of Classics*.

42 Salomon, *Veronese*, 17–22; Fehl, 'Veronese and the Inquisition' (including the text of Veronese's interrogation by the Inquisition in which he described the figure as 'un scalco, ilqual ho finto ch(e)l sia uenuto p(er) suo diporto a ueder, come uanno le cose della tola' (a carver whom I imagined to have come to amuse himself, to see how the table service was going).

43 The history of the Grimani *Vitellius* and more versions of it in modern art are discussed below, pp. 75–76, 218–26.

44 Josephus, *Jewish Antiquities* 18, 89.

45 Suetonius's life and writing: Wallace-Hadrill, *Suetonius*; Power and Gibson, *Suetonius the Biographer*.

46 Suetonius's popularity in the Renaissance, including with Petrarch: Conte, *Latin Literature*, 550. The medieval manuscripts: Reeve, 'Suetonius'. The number of printed editions: Burke, 'Survey of the Popularity of Ancient Historians'.

47 Imperial family sculptures: Rose, *Dynastic Commemoration*. Other themed line-ups of different subjects in different media: Hekster, *Emperors and Ancestors* (for example, pp. 221–24, for the

third-century CE emperor Decius displaying a series of 'good' predecessors on his coins); Mattusch, *The Villa dei Papyri*.

48 I justify a little more fully this caustic view of the emperor's *Thoughts* (or *Meditations*) in 'Was He Quite Ordinary?'.

49 As with the Agrippinas, there are a confusing number of imperial ladies by the name Faustina. This one is known as 'the Younger', to distinguish her from 'the Elder', the wife of the emperor Antoninus Pius. They are quite separate from the wife of Maxentius (above, n. 25).

50 Modern images of Julia Mamaea: see below, Fig. 8.4a and b.

51 A brief review of the problems of the *Augustan History* (including who wrote it, when and why): Conte, *Latin Literature*, 650–52. The career of Elagabalus: Ando, *Imperial Rome*, 66–68; Kulikowski, *Triumph of Empire*, 104–8.

52 For example, in Haskell and Penny, *Taste and the Antique*, out of a catalogue of ninety-five pieces, there are just four imperial portraits (Caracalla, Commodus and two versions of Marcus Aurelius), as well as one imperial lady ('Agrippina'), one prince (Germanicus) and three sculptures believed to depict Hadrian's boyfriend Antinoos. In Barkan, *Unearthing the Past*, out of 199 images, only six are remotely 'imperial' (including drawings of the legs of Marcus Aurelius's horse). Compare Aldrovandi's 'Delle statue antiche' (see below, p. 53), which lists literally hundreds of imperial busts he saw on display in sixteenth-century Rome.

53 On the 'fragmentariness' of this image, see Nochlin, *Body in Pieces*, 7–8; the classical referent is explained in Edwards, *Writing Rome*, 15.

54 *Anachronicity* is the leitmotiv of, for example, Wood, *Forgery, Replica, Fiction*.

55 See below, pp. 283–85.

56 Among many notable studies of the construction of kingly, dynastic or elite power: Cannadine, 'Context, Performance and Meaning of Ritual'; Cannadine and Price, *Rituals of Royalty* (largely focussed on traditional societies); Burke, *Fabrication*; Duindam, *Dynasties* (including discussion of ceremonial alongside more narrowly political concerns). 'Self-fashioning' is a term I have commandeered from Stephen Greenblatt (*Renaissance Self-Fashioning* and elsewhere).

## Chapter II
## Who's Who in the Twelve Caesars

1 The discovery and identification: Long, 'Le regard de César' in the exhibition catalogue, Long and Picard (eds), *César*. The reaction of Luc Long to the appearance of the head is reported, for example, at http://www.ledauphine.com/vaucluse /2010/08/16/cesar-le-rhone-pour -memoire-20-ans-de-fouilles-dans -le-fleuve.One documentary, 'Le buste de Jules César' was made by Eclectic Production in 2009, another, tied to the exhibition, 'César, le Rhône pour mémoire', was made by the French Tv-Sud in 2010.

2 Critics include: Paul Zanker (for example, http://www.sueddeutsche .de/wissen/caesars-bueste-der-echte -war-energischer-distanzierter -ironischer-1.207937); Koortbojian, *Divinization of Caesar*, 108–9 (arguing that portrait busts set, like this one, on pillars or 'herms' were exclusively associated with private rather than public monuments). Johansen, 'Les portraits de César' comes close to 'having it both ways', both stressing overlaps with some other Caesarian portraits, and insisting that we must be 'open' to new variations in his portraiture (p. 81).

3 Kinney, 'The Horse, the King'; Stewart, 'Equestrian Statue of Marcus Aurelius'.

4 The identification of individual imperial figures on the cameo is still contested: Vollenweider and Avisseau-Broustet, *Camées et intailles*, 217–20; Giuliani and Schmidt, *Ein Geschenk für den Kaisar*; and briefly, Beard and Henderson, *Classical Art*, 195–97. Rubens, on this and other gems: de Grummond, *Rubens and Antique Coins*; more recently and briefly, Pointon, 'The Importance of Gems'.

5 Winckelmann, *Geschichte*, Part 2, 383; translated by Mallgrave, *History*, 329 ('the most experienced connoisseur of antiquities, the most august Cardinal Alessandro Albani, doubts that any genuine heads of Caesar have survived').

6 The career of Julius Caesar: Beard, *SPQR*, 278–96; and, in greater detail, Griffin (ed.), *Companion to Julius Caesar*. 'War crimes': Pliny, *Natural History* 7, 92; Plutarch, *Cato the Younger* 51. The history of the 'dictatorship' (and the precedent of the earlier first-century Sulla): Lintott, *Constitution of the Roman Republic*, 109–13; Keaveney, *Sulla*.

7 The question of who counted as the 'first emperor': Hekster, *Emperors and Ancestors*, 162–77. The implications of the title *princeps*, Wallace-Hadrill, 'Civilis princeps'.

8 The Greek precedents: Thonemann, *Hellenistic World*, esp. 145–68 (they are often more tentative than they seem at first sight: the head of a living ruler being hard to distinguish from the image of the dead Alexander, the head of Alexander from that of the mythical Heracles). Outside Rome (and *outside* is the key), a couple of cities in the eastern Mediterranean seem to have blazoned the head of Caesar's rival Pompey on their coinage, already in the 50s BCE (Jenkins, 'Recent Acquisitions', 32; Crawford, 'Hamlet without the Prince', 216). It is a sign of where the wind was blowing.

9 The social role of Roman portraits: Stewart, *Social History*, 77–107. Funerary and commemorative practice: Flower, *Ancestor Masks*.

10 Brodsky's poem: *Collected Poems*, 282–85; first appearing in English in the *New York Review of Books* 25 June 1987 (recalling an encounter between the poet and a bust of the emperor and reflecting partly on the history of autocracy, ancient and modern, partly on the ambivalent ways in which marble heads mediate between past and present—themes developed in Brodsky's essay prompted by the bronze statue of Marcus Aurelius on the Capitoline, 'Homage to Marcus Aurelius'). Portrait *heads* as distinctively Roman: Beard and Henderson, *Classical Art*, 207 (in the course of more general reflections on portraiture, 205–38). A Roman allusion to marble heads as 'decapitation' and a presage of murder: Pliny, *Natural History* 37, 15–16.

11 Dio, *Roman History* 44, 4; Suetonius, *Julius Caesar* 76. Modern overviews of Caesarian portraits and an analysis of

key pieces: Zanker, 'Irritating Statues'; Koortbojian, *Divinization of Caesar*, 94–128. A minutely detailed discussion: Cadario, 'Le statue di Cesare'.

12 Pedestals in Greece and Turkey: Raubitschek, 'Epigraphical Notes'. In Italy: Munk Højte, *Roman Imperial Statue Bases*, 97.

13 Suetonius, *Julius Caesar* 45.

14 An imaginary portrait of the mythical Roman king Ancus Marcius, minted in 56 BCE, showing 'Caesarian' features: *RRC* 425/1. A very different image of Caesar on coins, minted in the eastern Mediterranean in 47/6: *RPC* 1, 2026.

15 The vast majority of (and probably *all*) ancient 'portraits' of classical cultural figures, Greek and Roman, are conventional 'type' images, which bear no relationship to the actual appearance of their 'subjects'; usefully discussed by Sheila Dillon, *Ancient Greek Portrait Sculpture*, 2–12.

16 Wider issues in the attempts to compare Suetonius's descriptions and imperial sculptures in general: Trimble, 'Corpore enormi'.

17 Winckelmann, *Geschichte*, Part 2, 383; translated by Mallgrave, *History*, 329. E. Q. Visconti, in his catalogue of part of the collection in the Vatican (*Museo Pio-Clementino*, 178), commenting on a bust believed to be of Julius Caesar, wrote, 'The uncertainty of his image on coins, not well delineated on the bronze because of lack of artistic quality, nor sufficiently distinct simply because of their small size on the silver and gold issues, has given a field day to those ready with their names <literally 'baptisers', *battezzatori*> to recognise Caesar in many heads and busts that do not resemble him at all except in a few general characteristics of his appearance.'

18 Gems are notoriously difficult to date, and the majority of those representing Caesar are now thought to be modern. One of the more plausibly ancient candidates: Vollenweider, 'Gemmenbildnisse Cäsars', 81–82, plate 12: 1, 2 and 4; Johansen, 'Antichi ritratti', 12 (both with other examples). A rather scrappy fragment of ancient pottery from the Greek island of Delos, with a moulded head taken to be Caesar: Siebert, 'Un portrait de Jules César'.

19 The discovery was reported in the *New*

*York Times* 13 January 1925. A more
sceptical discussion: Andrén, 'Greek and
Roman Marbles', 108, no. 31.

20 Schäfer, 'Drei Porträts', 20–23. The
impact of the discovery (running the
head from the Rhône a close second):
Wyke, *Caesar*, 1.

21 Different scholars come up with very
different totals of surviving Caesarian
portraits, depending not only on the
material available to them and new finds,
but on the rigour of their criteria. One
hundred and fifty is the grand and gener-
ous total in all media. In 1882, Bernoulli
(in *Römische Ikonographie*, the first
systematic attempt at a comprehensive
catalogue) claimed sixty portrait heads.
The number has gone up and down ever
since. In 1903, Frank Scott's enthusiastic
and self-confessedly amateur catalogue in
*Portraitures* reached eighty-four (though
he included a number about which he
had serious doubts, and others he knew
about only at second hand). The most
recent and sober cataloguer has trimmed
the number closer to twenty: Johansen
'Antichi ritratti' and 'Portraits in Marble'
(later, in 'Portraits de César', cautiously
accepting the Arles 'Caesar' into the
club).

22 The different suggestions for the
Hudson River Caesar: Andrén, 'Greek
and Roman Marbles', 108, no. 31. The
archaeology of the 'Green Caesar': Spier,
'Julius Caesar', with further bibliography.
Some of its different identifications:
Kleiner, *Cleopatra and Rome*, 130–31
(Cleopatra's statue, developing sug-
gestions of Fishwick, in 'The Temple
of Caesar', though Kleiner herself is
more cautious in *Roman Sculpture*, 45);
Zanker, 'Irritating Statues', 307 ('one of
his admirers from the Nile'); Johansen,
'Antichi ritratti', 49–50 (a modern piece).

23 Aldrovandi, 'Delle statue antiche', 200,
describing it as in the possession of
Marco Casale, an inheritance from his
father. The background to Aldrovandi's
gazeteer: Gallo, 'Ulisse Aldrovandi'.
Different views on the Caesar currently
in the Casali collection: Johansen,
'Antichi ritratti', 45 (Renaissance);
Santolini Giordani, *Antichità Casali*, 111–
12 (largely Roman). My hunch (and it
can be no more) is that the display of the
statue reported by Aldrovandi is as much

reflection of its special, celebrity status
as a practical fear of theft (as Furlotti,
*Antiquities in Motion*, 190 suggests).

24 The history of the sculpture: Stuart
Jones (ed.), *Catalogue of the Ancient
Sculptures . . . Palazzo dei Conservatori*,
1–2 and Albertoni, 'Le statue di
Giulio Cesare' (both agreeing that its
nucleus is ancient, probably second
century CE); Johansen, 'Portraits in
Marble', 28 (reviewing suggestions of
a seventeenth-century date); Visconti,
*Museo Pio-Clementino*, 179 (taking it
as one of only two certain Caesars he
knows). The clinching sixteenth-century
sketch, by Giovannantonio Dosio:
Hülsen, *Skizzenbuch*, 32 (although Dosio
actually entitled his sketch 'Octavian',
Julius Caesar's successor). The sculpture
also seems to match the description
of a statue of Caesar in Aldrovandi's
sixteenth-century guide ('Delle statue
antiche', 180).

25 Caesar as Mussolini's trademark:
Laurence, 'Tourism, Town Planning and
*romanitas*' (on the Rimini statue, 190–
92); Nelis, 'Constructing Fascist Identity'
(with full bibliography); Dunnett, 'The
Rhetoric of Romanità'.

26 Le Bars-Tosi, 'James Millingen'.

27 The sculpture's museum history and
changing identification can be tracked in
the manuscript catalogue and in succes-
sive museum guides: *Synopsis of Contents
1845*, 92 ('an unknown head. Purchased
in 1818'); *Synopsis of Contents 1846*, 92
('a Bust of Julius Caesar. Purchased in
1818'). Scott, *Portraitures*, 164–65 reports
(wrongly: he has misread his source) that
it was once in the Ludovisi collection in
Rome.

28 Baring-Gould, *Tragedy of the Caesars*, vol.
1, 114–15.

29 Rice Holmes, *Caesar's Conquest*, xxvi. To
be fair to Rice Holmes, his prefatory
essay on 'The Busts of Julius Caesar'
(xxii–xxvii) starts with full admission that
identification of any of these busts is per-
ilous, he gently criticises Baring-Gould
for reading his 'ideal <of Caesar> in, or
rather into, his favourite busts' and he
reviews other top candidates (many now
almost entirely forgotten) for the most
authentic image of Caesar to survive. But
in the end, he just can't resist the bust in
the British Museum.

30  Buchan, *Julius Caesar*, 11.
31  Combe et al, *Description of the Collection of Ancient Marbles*, 39–41 (quotation p. 39); it is possible that the slightly guarded phrase 'Head supposed to represent Julius Caesar', in the *Synopsis of Contents* 1855, 88 already reflects a degree of hesitation about the identification.
32  Furtwängler, *Neuere Fälschungen*, 14 ('eine modern Arbeit mit künstlich imitierter Korrosion')
33  Chambers, *Man's Unconquerable Mind*, 27 (from a lecture delivered on 27 May 1936). He explained that he had used to enjoy taking a break from his work in the Library and visiting the line of Roman emperor portraits 'till I finished opposite the bust of Julius Caesar. There, I said to myself, are the features of the foremost man of all this world . . . . And I returned refreshed to my work.' On the phrase 'Caesar's wife must be above suspicion', see further below, p. 241.
34  Ashmole, *Forgeries*, 4–8; Jones, *Fake?*, 144 commemorates its starring role in a 'fakes' exhibition in 1990; it had featured in a British Museum exhibition 'Forgeries and Deceptive Copies' already in 1961. Thorsten Opper has pointed out to me the similarity between this piece and the *Julius Caesar* in the Farnese collection which was restored by the sculptor Carlo Albacini in the late eighteenth century—suggesting that Albacini might have been the creator of the British Museum portrait, drawing on his close familiarity with the Farnese *Caesar* (now in Naples). If so, those who first catalogued it in the British Museum as an 'unknown head' failed to spot the resemblance.
35  The history of Bonaparte's Tusculan collection: Liverani, 'La collezione di antichità' (including its dispersal, partly to the royal house of Savoy who were proprietors of the Castello d'Aglié). The excavations at Tusculum: Pasqualini, 'Gli scavi di Luciano Bonaparte'. Canina writing his *Descrizione* around 1840 identifies the head only as an anonymous old man (p. 150).
36  Borda, 'Il ritratto tuscolano'. 'Psychological realism' etc.: Zanker, 'Irritating Statues', 303 (an uncharacteristically gushing moment in an otherwise sober essay).

37  A rather rough and shaggy reconstruction of Caesar's face, a collaboration between archaeologist Tom Buijtendorp and physical anthropologist Maja d'Hollosy, and largely based on the Tusculum head, was put on show at the National Antiquities Museum in Leiden: https://www.rmo.nl/en/news-press/news/a-new-look-at-julius-caesar/; *Daily Mail* 25 June 2018 ('Julius Caesar had a "crazy bulge" on his head after it was squashed during childbirth, new 3D reconstruction reveals'). Further 'scientific' attention to the Tusculum head: Sparavigna 'The Profiles'; Carotta, 'Il Cesare incognito' (using the head to back up his eccentric belief that Julius Caesar was Jesus Christ!).
38  This Caesar as his *only* portrait from life to survive: Simon, 'Cäsarporträt', 134; Kleiner, *Roman Sculpture*, 45; and (slightly hedging his bets) Pollini, *From Republic to Empire*, 52. Discussion of the death mask: Long, 'Le regard de César', 73. A wax image of Caesar, used to provoke the crowd at his funeral, *is* recorded, by a historian writing in the second century CE (Appian, *Civil War* 2, 147), but I very much doubt that Caesar's body was in any fit state for a death mask in the strict sense of the term to be made.
39  This is a common tactic in studies of Roman portraiture, which tends to group the sculptures of 'Caesar' that *do* survive by 'type' and classify them according to some imagined prototype, hopefully taken from the life, which *does not*. This method underlies Johansen, 'Antichi ritratti' and, to a lesser extent, Zanker, 'Irritating Statues'.
40  A 'mediocre copy': Long, 'Le regard de César', 67. Ecstatic reactions to the Arles Caesar on social media were reported on *Télérama* 13 March 2010: http://www.telerama.fr/art/ne-ratez-pas-le-buste,53355.php (no longer live); Twitter enthusiasm remains ('toucher la tête de César a été un plaisir indéfinissable', 24 April 2020).
41  Ashmole, *Forgeries*, 5 notes the drill holes but largely ignores them. Colleagues at the Yale Center for British Art suggested that the holes could have 'originally' been filled and concealed with plaster (which is true, but I think makes little difference to the basic argument).

42 The identification of this 'Caesar': Caglioti, 'Desiderio da Settignano: Profiles', esp. 87–90; Vaccari, 'Desiderio's Reliefs', 188–91. A brief overview of its context: Caglioti, 'Fifteenth-Century Reliefs', 70–71. See below, pp. 130–31.

43 The role of modern 'portraits', no longer taken as ancient images of Caesar, in establishing the conventional Caesarian iconography: Pieper, 'The Artist's Contribution'.

44 Exhibition catalogues include: Coarelli (ed.), *Divus Vespasianus*; Sapelli Ragni (ed), *Anzio e Nerone*; Tomei and Rea (eds), *Nerone*; La Rocca et al. (eds), *Augusto*; Coarelli and Ghini (eds), *Caligola* (343–46 for the new 'Caligula'); *Nero: Kaiser, Künstler und Tyrann*. Enthusiastic and sometimes lurid reports of the 'Caligula': *The Guardian* 17 January 2011; *Daily Mail* 19 January 2011 ('the debauched tyrant'), *The Daily Telegraph* 12 July 2011 ('a crazed and power-hungry sex maniac'). The 'official' Italian account: Ghini et al. (eds), *Sulle tracce di Caligola*.

45 Addison, *Dialogues* 1, 22

46 The different identities proposed since 1822: Stefani, 'Le statue del *Macellum*' (concluding they are Julia, the daughter of the emperor Titus, and Britannicus, the son of Claudius); more briefly Döhl and Zanker, 'La scultura', 194 (the local founders of the building); Small, 'Shrine of the Imperial Family', 118–21; 126–30 (Agrippina the Younger and Britannicus).

47 The inscribed names (Claudius and Nero) on an important series of imperial images from Aphrodisias in modern Turkey: Smith, 'Imperial Reliefs', esp. 115–20). Even without an explicit label, no one would contest that the repeating figure of the emperor on Trajan's column was Trajan himself.

48 Munk Højte, *Roman Imperial Statue Bases*, 229–63.

49 The details of these hairstyles have been bitterly debated, and the language of debate is sometimes as rebarbative as the hyperbole of the reactions to statues of Caesar. A balanced but critical discussion of the method: Smith, 'Typology and Diversity' (responding to Boschung, *Bildnisse des Augustus*). A challenge to the preconceptions of the method: Vout, 'Antinous, Archaeology and History' (followed by a slightly grumpy response

in Fittschen, 'Portraits of Roman Emperors'); Burnett, 'The Augustan Revolution', esp. 29–30.

50 Beard, *SPQR*, 337–85; Edmondson, *Augustus*. The 'tricky old reptile' was a quip of the fourth-century emperor Julian (*Caesars* 309).

51 The importance of images of (and in the age of) Augustus: Zanker, *Power of Images* (a classic account); Beard and Henderson, *Classical Art*, 214–25; Hölscher, *Visual Power*, 176–83. The role of emperors' portraits more generally in 'standing in' for the emperor: Ando, *Imperial Ideology*, 206–73.

52 The different identifications of these pieces: Pollini, *Gaius and Lucius Caesar*, 100, 101; see also pp. 8–17 for the details of the hair locks, and identifying criteria more generally. The habit of 'reworking' imperial heads to change their identity: Varner, *Mutilation and Transformation*.

53 The career and political image of Vespasian: Levick, *Vespasian* (the tax on urine: Suetonius, *Vespasian* 23). The portraits and the ideology driving them: Coarelli (ed.), *Divus Vespasianus* (esp. Zanker, 'Da Vespasiano a Domiziano'; and pp. 402–3 discussing my Fig. 2.12).

54 Introduction to these questions: Brilliant, *Portraiture*, Woodall, *Portraiture*, West, *Portraiture*.

55 *Mementoes*, 34.

56 The role of images during this civil war: Tacitus, *Histories* 1, 36; 1, 55; 2, 55; 3, 7 (referring to images of Galba in 'towns', rather than just military contexts). The portraits of Galba: Fabbricotti, *Galba*. The so-called 'Year of the Four Emperors' in general: Morgan, *69 AD*.

57 Suetonius, *Otho*, 12; *Galba*, 21.

58 The incredible diffusion of versions of this statue in painting and sculpture: Bailey, 'Metamorphoses of the Grimani "Vitellius"' and 'Metamorphoses . . . : Addenda and Corrigenda'; Zadoks-Josephus Jitta, 'Creative Misunderstanding'; Fittschen, *Bildnisgalerie*, 186–234 and 'Sul ruolo del ritratto', 404–5, 409; *D'après l'antique*, 298–311; Principi, 'Filippo Parodi's *Vitellius*' (esp. pp. 59–61, documenting the many modern sculptural versions in Genoa alone); Giannattasio, 'Una testa' (on the 'Genius of Sculpture'); *Gérôme*, 126–29 and Beeny, 'Blood

Spectacle', 42–45 (on *Ave Caesar!*); with further examples below, pp. 218–26. The history of the Grimani collection: Perry, 'Cardinal Domenico Grimani's Legacy'; Rossi, *Domus Grimani*.

59 Physiognomics: Porter, *Windows of the Soul* (the early modern history); Barton, *Power and Knowledge*, 95–131 (in the classical world). Phrenology: Poskett, *Materials of the Mind*.

60 Della Porta, *De humana physiognomonia* II, 29. Rubens was influenced by Della Porta's work in his portrayal of emperors and others: McGrath, '"Not Even a Fly"', 699; Meganck, 'Rubens on the Human Figure', 57–59; Jonckheere, *Portraits*, 35–37.

61 Haydon, *Lectures on Painting*, 64–65

62 *Manchester Times and Gazette* 13 February 1841. Goyder's autobiography, *Battle for Life*, 296–334, gives the text of his standard lecture, though Caracalla is substituted for Vitellius.

63 Various different views on the date: Bailey, 'Metamorphoses of the Grimani "Vitellius"', 105–7, with further discussion in D'Amico, *Sullo Pseudo-Vitellio*.

# Chapter III
## Coins and Portraits, Ancient and Modern

1 The identification of the sitter and interpretation of the Roman coin: Lobelle-Caluwé, 'Portrait d'un homme' (the first to propose Bembo); Borchert (ed.), *Memling's Portraits* 160; Campbell et al., *Renaissance Faces* 102–5 (quotation on 'worldly fame' p. 105), Lane, *Hans Memling*, 205–7, 213–14, Christiansen and Weppelmann (eds), *Renaissance Portrait*, 330–32; Nalezyty, *Pietro Bembo*, 33–37. Vico, *Discorsi* 1, 53 writes of the coins of Nero (along with those of Caligula and Claudius) as 'surpassing the others in beauty'; see also Cunnally, *Images of the Illustrious*, 160.

2 Lightbown, *Botticelli* 38; Pons, 'Portrait of a Man'. The direct response to Memling's portrait: Nuttall, 'Memling', 78–80.

3 Jansen's recent study, *Jacopo Strada*, is now the central reference point for all aspects of Strada's career, with full bibliography (taking a positive view of

the Titian portrait, pp. 1–8; 868–73). Earlier discussions of Titian and Strada: Freedman, 'Titian's *Jacopo da Strada*'; Jaffé (ed.), *Titian*, 168–69; Vout, *Classical Art*, 107–8 (pointing to the erotic overtones of collector and sculpture). The 'two gluttons' phrase ('doi giotti a un tagliero') is from the correspondence of Niccolò Stop<p>io, cited and discussed by Jansen, *Jacopo Strada*, 605; 871–72 (the original documents are in Munich, Hauptstaatsarchiv, *Libri Antiquitatum* 4852, fols 153–54).

4 Further details: *Jacopo Tintoretto*, 136–37; Bull et al., 'Les portraits' (comparing the two portraits, arguing convincingly against the idea that Ottavio's portrait was the work of Tintoretto's daughter, and including the X-ray evidence for changes in both compositions in the process of the work). The gushing of the coins ('perenni vena scaturiunt') is the phrase of Gerolamo Bologni (in the critical edition by D'Alessi, *Hieronymi Bononii*, 8). More generally on the ubiquity of coinage: Cunnally, *Images of the Illustrious*, 3–11. Note, however, that a similar figure of (blind) Fortune pouring coins from a cornucopia—in Cesare Ripa's much translated, and roughly contemporary, emblem book—is a symbol of female 'prodigality' (*Iconologia*, 163), hinting at a possible counter-narrative.

5 Haskell, *History and Its Images*, 13–79 (whose ideas inevitably lie behind this chapter, even though my emphasis is very different). In what follows I reference Haskell only to draw attention to discussions of particular relevance to my subjects.

6 Shakespeare, *Love's Labours Lost*, Act 5, scene 2, line 607 (and, as Raffaella Sero has pointed out to me, the reference to Julius Caesar as 'the hook-nosed fellow of Rome' in *2 Henry IV*, Act 4, scene 2, line 40, could allude to a coin image). Overview of the estimates of total coin production: Noreña, *Imperial Ideals*, 193.

7 Petrarch and Charles IV: Petrarch *Letters* 19, 3. Cyriac: Scalamonti, *Vita*, 66–67; Glass, 'Filarete and the Invention', 34–35. Further examples: Brown, 'Portraiture at the Courts of Italy', 26. A later gift, implying a link between Roman emperors and moral lessons, was made to Desiderio Erasmus in 1522 by

one of his correspondents: 'four gold
coins of *virtuous* (*bonorum*) emperors',
mentioned in *Correspondence of Erasmus*,
no. 1272 (my italics); first published in
Erasmus's *De puritate*, 97–98.

8 Petrarch, *Letters* 19, 3.

9 The complicated interactions, and gift-
giving, between Petrarch and Charles IV:
Ascoli, *Local Habitation*, 132–34, 144–45;
Gaylard, *Hollow Men*, 5–6. Petrarch's
importance in numismatics: Williams,
*Pietro Bembo*, 279–80. The Caesar that
Charles gave in return: Petrarch, *Letters*
19, 13 (almost certainly a coin, but the
Latin (*effigiem*) *is* a little vague). To be
more generous to Charles, he may have
been nodding to Petrarch's use, in some
of his writing, of Julius Caesar as another
model for modern rulers (Wyke, *Caesar*,
132–33; Dandelet, *Renaissance of Empire*,
20–26).

10 The most active proponent of the
'medallion thesis' was Sebastiano Erizzo
(in his *Discorso*, 1–112). Notable partisans
on the other, correct, side include Enea
Vico (in his *Discorsi* 1, 28–34; confusingly,
28, 29 and 32 are wrongly paginated
as 36, 37 and 40 in the first edition);
Antonio Agustín (in his *Dialogos* 1,
1–25). Modern discussions: Fontana, 'La
Controversia' (taking the debate up to
the eighteenth century); more briefly,
Cunnally, *Images of the Illustrious*, 136–38.

11 Filarete, *Treatise* 1, 316 (original manu-
script: Lib. XXIV, *Magl*, fol. 185r).

12 Vico, *Discorsi* 1, 52. Death of Vico:
Bodon, *Enea Vico*, 45.

13 Vico, *Discorsi* 1, 48; Addison, *Dialogues* 1,
21.

14 Claimed 'scarcity': Weiss, *Renaissance
Discovery*, 171. Price: Cunnally, *Images of
the Illustrious*, 37–39.

15 Goltzius, *C. Iulius Caesar*. His life and
writing: Haskell, *History and Its Images*,
16–19; Cunnally, *Images of the Illustrious*,
190–95. In his dedicatory letter to
his earlier *Vivae . . . imagines* (fol. 3r),
Goltzius closely echoes the words of Vico
on the historical importance of coins,
versus literary accounts.

16 The list of acknowledgements, and the
popularity of coin collecting: Cunnally,
*Images of the Illustrious*, 41–46; Callatay,
'La controverse', 269–72. Both raise
questions about the accuracy of the
names (some suspicious anomalies are

investigated in detail by Dekesel, 'Hubert
Goltzius'). Callatay also notes that the
ideology of historical veracity does not
always fit easily with the fact that some
specimens were 'fakes', and in the case
of Goltzius, and others, some drawings
and descriptions have at least been
'improved'.

17 The princess's boast: Kroll, *Letters from
Liselotte*, 133; original German, Künzel,
*Die Briefe der Liselotte*, 291 (she goes on
to claim to have a total of 410 coins in
her collection). Though the primary data
are inconsistent, the collection owned by
Lorenzo de' Medici (1449–92) certainly
numbered well over two thousand (the
evidence: Fusco and Corti, *Lorenzo de'
Medici*, 83–92).

18 Plaquettes: Hobson, *Humanists and
Bookbinders*, 140–42. The casket: Haag
(ed.), *All'Antica*, 238 (followed on p.
239 by a gilded bowl inset with original
Roman coins). For the chalice: *Tesori
gotici*, no. 29. (Many thanks to Frank
Dabell and Jay Weissberg for introducing
me to this extraordinary piece.)

19 Viljoen, 'Paper Value', 211–13.

20 Cunnally, 'Of Mauss and (Renaissance)
Men', esp. 30–32, who rightly stresses
that the Renaissance view of ancient art
was 'nummocentric' ('coin-centred') in
contrast to our modern 'marmorcentric'
('marble-centred') view.

21 An overview of Renaissance repre-
sentations and adaptations of Roman
coins, and further examples: Fittschen,
'Sul ruolo del ritratto antico', 388–94;
Haskell, *History and Its Images*, esp. 26–
36; Bacci, 'Ritratti di imperatori'.

22 Fermo, Biblioteca comunale, MS 81.
Discussion with further references:
Brown, *Venice and Antiquity*, 66–68;
Schmitt, 'Zur Wiederbelebung'.

23 There are three manuscripts of this
work: one in the Vatican (Biblioteca
Apostolica Vaticana, Chig. I VII 259),
an autograph copy, but lacking the
beginning (starting only with the reign
of Septimius Severus); one in Verona
(Biblioteca comunale, Cod CCIV) with
far fewer finished illustrations; and one
much more fragmentary version in Rome
(Biblioteca Vallicelliana, Cod. D 13).
A brief discussion: Weiss, *Renaissance
Discovery*, 22–24. Detailed study of
the links with coinage: Schmitt, 'Zur

Wiederbelebung'; Capoduro, 'Effigi di imperatori'; Bodon, *Veneranda Antiquitas*, 203–17 (showing that the series started from Julius Caesar, not Augustus as usually thought).

24 Paris, BNF, MS lat. 5814. Discussion: Alexander (ed.), *Painted Page*, 157–8. The almost overwhelming arguments for seeing Bernardo Bembo as its commissioner: Nalezyty, *Pietro Bembo*, 53.

25 Fulvio, *Illustrium imagines*. Brief introduction: Weiss, *Renaissance Discovery*, 178–79; Haskell, *History and Its Images*, 28–30; and see further below, pp. 164, 253.

26 Raimondi's prints: Viljoen, 'Paper Value' (his Twelve are not exactly the Suetonian set, Trajan substituting for Caligula; see below, pp. 131–33). The Florentine reliefs: Caglioti, 'Fifteenth-Century Reliefs'; Bacci, 'Ritratti di imperatori', 30–47.

27 The emperors within the overall scheme of the Camera picta: Christiansen, *Genius of Andrea Mantegna*, 27–38; Campbell, *Andrea Mantegna*, 203–11 and see below, p. 169, with n40.

28 Different perspectives on the Certosa portraits: Burnett and Schofield, 'Medallions'; Morscheck, 'The Certosa Medallions'. The Horton medallions: https://heritagerecords .nationaltrust.org.uk/HBSMR /MonRecord.aspx?uid=MNA165052; Harcourt and Harcourt, 'Loggia Roundels'. The fourth in the set depicts Hannibal. The Caesar, Nero and Attila are all connected iconographically, as well as in name, with roundels at La Certosa (Burnett and Schofield, 'Medallions', nos 17, 33 and 18); in the case of the image of Attila, in both places the design and its Latin inscription go back to earlier medallions in metal (Brown, *Venice and Antiquity*, 146; Bacci, 'Catalogo', 180–83).

29 Brown, 'Corroborative Detail', 91; Panazza, 'Profili all'antica', 224–25 (though Brown believes the unnamed emperors to be Julius Caesar and Augustus, and Panazza believes them to be Claudius and Tiberius, they seem to me consistent with the more appropriate pairing of Augustus and Tiberius). Compare Titian's painting of *The Crown of Thorns* (now in the Louvre), where a bust, clearly labelled 'Tiberius', the

emperor at the time of the crucifixion, presides over the scene.

30 Brown, 'Corroborative Detail'.

31 Rouillé, *Promptuaire* 1, A4v. The fragile boundary between truth, fake and fantasy, in this case and more widely: Perkinson, 'From an "*Art de Memoire*"', esp.700–707. See further below, p. 99.

32 The confusion of Caracalla and Marcus Aurelius: Capoduro, 'Effigi di imperatori', 292–95 and 308–9. The full names of Vespasian and Titus, imperial father and son, were almost identical; hence Raimondi's understandable error.

33 See below, pp. 131–32.

34 Burnett and Schofield, 'Medallions', 6.

35 The links between il Mansionario and these paintings: Capoduro, 'Effigi di imperatori'; Napione, 'I sottarchi'. The whole scheme: Richards, *Altichiero*, 35–75.

36 This image of the god featured on a coin minted under Cato's authority (*RRC* 462/2) or—an even closer match—on one minted by an older relative of the same name (*RRC* 343/2 a and b). Fulvio, or his draughtsman, must have taken one of these coin images, with 'Cato' written around them, as a portrait of the man himself.

37 Cunnally, *Images of the Illustrious*, 96–102; Haskell, *History and Its Images*, 30–32.

38 For the source of this image, see above, n. 28.

39 Aretino, *Humanità*, 466–67. The influence of this book on Titian: Waddington, 'Aretino, Titian'. (This has provided an ingenious explanation for the fact that the bust in Titian's *Crown of Thorns* (n. 29 above) seems to resemble images of Nero, despite being clearly labelled as Tiberius: Casini, 'Cristo e i manigoldi', 113).

40 The term *all'antica* was first used in English in the early seventeenth century (*Oxford English Dictionary*). Introductory discussions which take this idiom seriously: Ayres, *Classical Culture*, 63–75; Syson and Thornton, *Objects of Virtue*, 78–134; Baker, *Marble Index*, esp. 34–35, 77–87, 92–105.

41 The commissioning of the statues (in thanks for royal donations to the University): Willis, *Architectural History*, 55–57, 59–60. The scathing put-down can be found in the comments (18

January 2012) to a blog I wrote on the subject: www.the-tls.co.uk/king-georges -leave-the-university-library/ (no longer live).

42 In what follows, I take a necessarily broad overview of this tradition. Detailed dissection of small but significant differences in, especially, marble sculpture, with a keen eye for slight chronological and functional shifts: Craske, *Silent Rhetoric* and Baker, *Marble Index* (who wryly observes that one can read Wilton's 'George' as a slight parody of Rysbrack's: p. 106).

43 The statue of Pitt originally stood in a cenotaph to the prime minister in the National Debt Redemption Office: Darley, *John Soane*, 253–54. Its history and transfer to Pembroke: Ward-Jackson, *Public Sculpture*, 60–61.

44 Baker, *Marble Index*, 79; '"A Sort of Corporate Company"', 26–28. 'Merged' is the term chosen by Baker, who notes that the sitter, Daniel Finch, had paintings of scenes from the life of Caesar in his country house at Burley-on-the-Hill in Rutland.

45 See Redford, *Dilettanti*, 19–29, with 'Seria Ludo', an earlier version of the same discussion. The explanatory text on the painting (appearing on this one alone in the set) makes it clear that we are to imagine Sackville is shown as he appeared at the carnival ('Saturnalia') in Florence, 'sub persona consulis Romani ab exercitu redeuntis', (impersonating [literally, 'under the mask of'] a Roman consul returning from his army). There are hints of Titian's emperors in some other portraits in Knapton's series (especially that of William Denny, which looks back to Titian's Claudius).

46 See Wood, 'Van Dyck's "Cabinet de Titien"', 680; Griffiths, *The Print in Stuart Britain*, 84–86; the painting is discussed in Wheelock et al., *Anthony van Dyck*, 294–95 (without reference to the source). The imperial imagery of Charles I in general: Peacock, 'Image of Charles I'.

47 The original layout and the collection: Angelicoussis, 'Walpole's Roman Legion'. Among the six 'emperors' and two imperial ladies (some certainly wrongly identified), the two most notable ancient busts are Commodus and

Septimius Severus: https://collection. beta.fitz.ms/id /object/209386 and https://collection .beta.fitz.ms/id/object/209387. The present architectural context: Cholmondeley and Moore, *Houghton Hall*, 78–83.

48 Suetonius, *Augustus* 29.

49 RCIN 51661: https://www.rct.uk /collection/51661/dish. The emperors depicted are Caesar, Augustus, Galba, Philippus, Hostilian, Probus, Maximian and Licinius. The best-known ancient version of the Scaevola story: Livy, *History* 2, 12–13. The iconography of the central scene and the design of the imperial heads was taken by the artist (Elias Jäger) from illustrations in Gottfried, *Historische Chronica*.

50 The statue is based on the fifth-century BCE statue of the god Zeus in his temple at Olympia; despite the stress on republican 'liberty' on the inscription on the statue, it could not efface the awkward point that Washington was here portrayed as divine. Of much written on this reviled statue: Wills, 'Washington's Citizen Virtue' and *Cincinnatus*, 55–84; Clark, 'An Icon Preserved'; Savage, *Monument Wars*, 49–52. Washington's own doubts about 'a servile adherence to the garb of antiquity': Fitzpatrick, *Writings*, 504 (a letter to Thomas Jefferson); McNairn, *Behold the Hero*, 135.

51 Baker (*Marble Index*, 92–95) recognises the problems of representing a Republican image in modern marble, but in my view underestimates them. 'The British ruling elite's self-identification with the political ideals of Republican Rome' (p. 92) was certainly underpinned by important literary texts of the first century BCE, notably the works of Cicero; but that could not be extensively matched in surviving works of art. Elsewhere ('Attending to the Veristic Sculptural Portrait'), Baker takes a careful look at the 'warts and all' style of ancient portraiture—which modern scholarship tends to associate with the Republican rather than imperial period—and considers how it was adopted in eighteenth-century image-making. But this style is infinitely less common than the imperial version, and Baker finds (p. 57) it often used

for those sitters who had particular antiquarian interests (i.e., it appears to have had a cultural rather than a political significance).

52 Hollis's use of the cap and daggers elsewhere to proclaim his commitment to liberty: Hanford, '"Ut spargam"', 171 (on radical book covers); Ayres (ed.), *Harvard Divided*, 154–55. The original Roman coin (*RRC* 508.3) was adopted in numerous modern campaigns against tyranny (see Burns et al., *Valerio Belli Vicentino*, 369; Bresler, *Between Ancient and* All'Antica, 151).

53 Marsden (ed.), *Victoria and Albert*, 70–71.

54 Quoted by Prown, 'Benjamin West', 31.

55 McNairn, *Behold the Hero*, 91–108; Paley, 'George Romney's *Death of General Wolfe*'. Romney's painting (1763) is now lost, Penny's (also 1763) is in the Ashmolean Museum, Oxford, with a smaller version at Petworth House ('painfully feeble' according to Schama, *Dead Certainties*, 28). Roman versus modern dress had already been an issue in Rysbrack's different early eighteenth-century marble portrayals of the architect James Gibbs: Baker, *Marble Index*, 92–94.

56 The context of West's painting, and the different reactions (from Pitt to Reynolds): Schama, *Dead Certainties*, 1–39; McNairn, *Behold the Hero*, 125–43 (Pitt, p. 127); Miller, *Three Deaths*, 40–43 (Pitt, p. 42).

57 Galt, *Life, Studies and Works*, 45–51.

58 Voltaire, *Letters*, 51; this is the main theme of Ayres, *Classical Culture*.

59 Princeton University, MS Kane 44. Further discussion: Ferguson, 'Iconography'; Stirnemann, 'Inquiries'.

60 There were all kinds of variations on this theme. One of the most intriguing is that of the 'Roman Academy' of humanists, with Pomponio Leto at its head, who took their admiration and imitation of ancient culture to the extent of dressing up as Romans and celebrating pagan Roman festivals: Beer, 'The Roman Academy'.

61 Useful up-to-date reviews of the development of Renaissance portraiture: Syson, 'Witnessing Faces'; Rubin, 'Understanding Renaissance Portraiture'.

62 The portraits of Giovanni and Piero: Syson, 'Witnessing Faces', 13–15, and pp. 166–68 in the same exhibition catalogue

(Christiansen and Weppelmann (eds), *Renaissance Portrait*); and *Eredità del Magnifico*, 44–46. The context of the artist's overall output: Caglioti, 'Mino da Fiesole'.

63 Introduction to the Renaissance medal: Scher (ed.), *Currency of Fame* (with stunning illustrations); more briefly, and focussed on Italy, Syson and Thornton, *Objects of Virtue*, 111–22. Major catalogues include Attwood, *Italian Medals*; Pollard, *Renaissance Medals*.

64 The letter to Leonello d'Este was written in 1446 by the humanist Flavio Biondo (Nogara, *Scritti inediti*, 159–60); brief commentary by Syson and Thornton, *Objects of Virtue*, 113–14. Filarete's reflections: *Treatise* 1, 45 (original manuscript: Lib. IV, *Magl.*, fol. 25v), with discussion of the practice more widely by Hub, 'Founding an Ideal City', 32–39.

# Chapter IV
## The Twelve Caesars, More or Less

1 The best discussion of these *tazze* (with full reference to earlier studies) is the collection of essays in Siemon (ed.), *Silver Caesars*. The gilding is not original, but was added in the nineteenth century (Alcorn and Schroder, 'The Nineteenth- and Twentieth-Century History', 154).

2 Triumphal celebrations as central to Roman political power and prestige, imitated by Renaissance dynasts and artists: Beard, *Roman Triumph*. The consistency in the placing of triumphal scenes in the final position in each series is a clear sign of the systematic design behind the *tazze* (Beard, 'Suetonius, the Silver Caesars', 41–42).

3 Suetonius, *Galba* 4.

4 Suetonius, *Nero* 25; *Julius Caesar* 37.

5 Siemon, 'Renaissance Intellectual Culture', 46–50. The clearest versions of the relevant prints by Ligorio are included in the album of de' Musi, *Speculum Romanae Magnificentiae*.

6 *BMCRE* 1, 245, no. 236.

7 An excellent recent discussion of the 'Twelve Caesars': Christian, 'Caesars, Twelve', with further bibliography. Important earlier studies, on which I draw: Ladendorf, *Antikenstudium*; Stupperich 'Die zwölf Caesaren';

Wegner, 'Bildnisreihen'; Fittschen, *Bildnisgalerie*, 65–85

8 Martin, *The Decorations*, 100–131. One inspiration for the design was Jan Casper Gevartius, who had been composing a modern version of Suetonius for the Habsburgs (p. 107), and produced an illustrated record of the occasion. More recent discussion: Knaap and Putnam (eds), *Art, Music, and Spectacle*.

9 The earliest sculptural prototypes in the fifteenth century: below, pp. 130–31.

10 Cardinal Grimani seems to have been assembling such a line-up of emperors (though not the Suetonian Twelve) from what he believed to be ancient specimens, of which his famous 'Vitellius' was a part: Perry, 'Cardinal Domenico Grimani's Legacy', 234–38.

11 Fittschen, *Bildnisgalerie*, 64 ('Aus England sind mir Zwölf-Kaiser-Serien bisher nicht bekannt worden', and he goes on to wonder if the lack was a consequence of the English hatred of absolutism). In fact, there are (or were) many sets: for example, at Theobalds in Hertfordshire, where in the sixteenth and early seventeenth century the decoration included both paintings and two sets of busts of the Twelve Caesars (Groos (ed.), *Diary of Baron Waldstein*, 81–87; Hentzner, *Travels in England*, 38; Cole, 'Theobalds, Hertfordshire', esp. 102–3; Williams, 'Collecting and Religion', 171–72); at Goodnestone Park in Kent, with its 'colossal busts of the twelve Caesars' in the garden (Neale, *Views of the Seats*, sv Goodnestone, Kent); and Anglesey Abbey in Cambridgeshire (below, p. 125). Bolsover Castle is another good example (above, p. 14), but with only eight Caesars; so too the set acquired for Euston Hall (below, p. 127). Further imperial line-ups are dug out by Catherine Daunt in her doctoral thesis, *Portrait Sets*, 40–41, 47–49. The prominence of the Caesars in Renaissance England: Hopkins, *Cultural Uses*, 1–2.

12 The seventeenth-century set in the Villa Borghese, originally in the Palazzo Borghese in central Rome, moved to the Villa in the 1830s: Moreno and Stefani, *Borghese Gallery*, 129. The Della Porta busts, acquired by the Borghese family in 1609: Ioele, *Prima di Bernini*, 16–23, 194–95 (trying also to disentangle the different sets of Caesars made in the Della Porta workshop); Moreno and Stefani, *Borghese Gallery*, 59. The imperial busts in the Farnese palace: Jestaz, *L'Inventaire*, vol. 3, 185; Riebesell, 'Guglielmo della Porta'; the Carracci copies of Titian's emperors, paired with imperial busts: Jestaz, *L'Inventaire*, vol. 3, 132; Robertson, 'Artistic Patronage', 369–70. A further selection of Italian examples: Desmas and Freddolini, 'Sculptures in the Palace', 271–72.

13 https://art.thewalters.org/detail /14623/the-archdukes-albert-and -isabella-visiting-a-collectors -cabinet/. My thanks to Julia Siemon for directing me to this painting.

14 Bauer and Haupt, 'Das Kunstkammerinventar ', nos 1745, 1763.

15 https://historicengland.org.uk /listing/the-list/list-entry/1127092.

16 Strada, *Imperatorum Romanorum*, introduction by the publisher, Andreas Gesner (recommending it for 'those who on account of their age or poor eyesight are put off by smaller images'). This edition (which had pirated Strada's text) extends beyond the Twelve Caesars to include 118 rulers, from Julius Caesar to Charles V.

17 Wardropper, *Limoges Enamels*, 38–39. Restorations have changed the line-up on the casket; there are, for example, now three images of Vitellius, reduplicated in the nineteenth century.

18 'Middling Class': letter to Thomas Bentley, 23 August 1772 (Wedgwood Museum Archive, E 25– 18392, available online at http://www .wedgwoodmuseum.org.uk/archives /search-the-archive-collections -online/archive/to-mr-bentley-mrs -wedgwood-worse-dr-darwin-sent -for-transcript-page-1-of-5). Wedgwood's commercial methods: McKendrick, 'Josiah Wedgwood', esp. 427–30; 'Josiah Wedgwood and the Commercialization of the Potteries'. The plaques themselves: Reilly and Savage, *Wedgwood: The Portrait Medallions*.

19 Lessmann and König-Lein, *Wachsarbeiten*, 76–88. An antidote to my, perhaps unfairly negative, view of the art of waxworks: Panzanelli (ed.), *Ephemeral Bodies*.

20 This was Sir John Finch commissioning

Caesars for his patron, the Earl of
Arlington: Jacobsen, *Luxury and Power*,
125, drawing on National Archive
documents, State Papers 98/10, FO 40;
98/11, FO 173 (1669 and 1670). Jacobsen
also quotes the diarist John Evelyn's
unfavourable reaction to the busts—not
unfair, to judge from the surviving pair
from the set, on display at the Ancient
House Museum, Thetford. (My thanks
to Oliver Bone, of Thetford and King's
Lynn Museums, for providing details of
their colourful local history, including a
period outside the town's theatre, wel-
coming the audience.)

21 Christian, 'Caesars, Twelve', 155, 156.
22 Sharpe, *Sir Robert Cotton*, 48–83; Tite,
*Manuscript Library*; Kuhns, *Cotton's
Library*.
23 Paul, *The Borghese Collections*, 24.
24 The twenty-four busts are nineteenth-
century works by Leone Clerici (twelve
Greeks, plus twelve Romans, of whom
seven are emperors, good and bad):
*Handbook*, 16–17. (My thanks to Deirdre
E. Donohue and Vincenzo Rutigliano of
the NYPL for finding this information
for me.)
25 Tite, *Manuscript Library*, 92, fig. 33.
26 Middeldorf, 'Die zwölf Caesaren';
Caglioti, 'Fifteenth-Century Reliefs'
(correcting some of Middeldorf's
conclusions and citing the relevant
fifteenth-century documents); more
briefly, Fittschen, *Bildnisgalerie*, 65.
Although not in a coin-like format, it
has often been assumed that Desiderio's
*Julius Caesar* (Fig. 2.4f) was originally
one of a series of twelve, though the
evidence is shaky.
27 Errors at, for example, the Metropolitan
Museum, New York and the
Rijksmuseum, Amsterdam: http://www
.metmuseum.org/art/collection/search
/345691; https://www.rijksmuseum
.nl/nl/collectie/RP-P-OB-76.860.
28 Lessman and König-Lein, *Wachsarbeiten*,
76.
29 Boch, *Descriptio publicae gratulationis*,
124–28, available online at http://www.
bl.uk/treasures/festivalbooks
/BookDetails.aspx?strFest=0137;
Mulryne et al. (eds), *Europa Triumphans*,
492–571, esp. 564–66.
30 Fulvio's 'gaps': see further below, p. 253.
31 Oldenbourg, 'Die niederländischen

Imperatorenbilder'; Jonckheere,
*Portraits*, 115–18. Vitellius is by Hendrick
Goltzius, no relation of Hubert; Otho's
artist is unknown (Gerard van Honthorst
and Abraham Bloemaert have been
suggested).
32 Koeppe (ed.), *Art of the Royal Court*, 260–
61.
33 The plan of this arrangement, which
goes back to the late eighteenth century:
*I Borghese e l'antico*, 204–5.
34 Fittschen, *Bildnisgalerie*, esp. 17–39. It
was a similar principle of 'work in prog-
ress' by which the Limoges Casket ended
up with three images of Vitellius among
its Twelve Caesars (Fig. 4.5, with n. 17
above).
35 The date and authenticity of individual
pieces: Stuart Jones (ed.), *Catalogue of
Ancient Sculptures . . . Museo Capitolino*,
186–214; Fittschen and Zanker, *Katalog
der römischen Porträts* (more up-to-
date, but the portraits of the room are
scattered through the whole catalogue,
rather than treated in a single chapter).
36 The origin and early history of the
museum: Arata, 'La nascita'; Benedetti,
*Il Palazzo Nuovo*; Parisi Presicce 'Nascita
e fortuna'; Minor, *Culture of Architecture*,
190–215; Paul, 'Capitoline Museum';
Collins, 'A Nation of Statues', 189–98;
The role of Capponi is documented in
his diary: Franceschini and Vernesi (eds),
*Statue di Campidoglio*. The definition of
the museum's purpose is written into the
contract for the purchase of sculptures
for it in 1733, quoted in Paul, 'Capitoline
Museum', 24.
37 Bottari and Foggini, *Museo Capitolino*
(originally published in 1748; my
description is based on the edition of
1820).
38 The comparison between Trajan and
Washington: Griffin (ed.), *Remains*, 353.
The blurry line between art and power:
*Mementoes*, 34. Agrippina misidentified:
Wilson, *Journal*, 33.
39 Marlowe, *Shaky Ground*, 15: 'a time
capsule of a different era's construction
of the past'.
40 The disputes: Franceschini and Vernesi
(eds), *Statue di Campidoglio*, 40–41
(Claudius); 50 (Pompey).
41 The changing composition of the room
up to the early twentieth century can be
tracked through: Gaddi, *Roma nobilitata*,

194–96; Locatelli, *Museo Capitolino* 45–53; Murray's *Handbook for Travellers* (1843), 433; Murray's *Handbook for Travellers* (1853), 200; Murray's *Handbook of Rome*, 51; Stuart Jones (ed.), *Catalogue of Ancient Sculptures . . . Museo Capitolino*, 186–214 (with full details of the portraits on the shelves around 1910). My own observations in the museum confirm the idea of on-going flux. In 2017, the information panels intended to help the visitor work out who is who, giving a key to each head, proved a treacherous guide. In a few crucial places, the key did not match the current arrangement: where, for example, Livia was supposed to be, there was a head of Augustus.

42 In 1736, Gaddi, *Roma nobilitata*, 194 described its position as 'in sight of the door' (nell'prospetto dell'ingresso), so probably central; in 1750, Locatelli, *Museo Capitolino*, 46 placed it 'between the two widows' (fra le due finestre); Stuart Jones, *Catalogue of Ancient Sculptures . . . Museo Capitolino*, 276 notes that it remained in the Room of the Emperors until 1817.

43 This figure is now identified as an anonymous athlete, or a young man, resting his foot on a rock: Stuart Jones (ed.), *Catalogue of Ancient Sculptures . . . Museo Capitolino*, 288. It is described as being 'in the centre of the room' (nel mezzo della stanza) by Locatelli, *Museo Capitolino*, 47. The changing identification of these statues causes much confusion. Minor, *Culture of Architecture*, 202, 206–8 mistakes the Antinoos in the Room of the Emperors for the now far more famous Capitoline Antinoos, and misinterprets a 1780 drawing accordingly (p. 206). But, to add to the confusion, it seems that the Capitoline Antinoos had briefly been housed in the Room of the Emperors, before being moved by Capponi to the Great Hall (see Gaddi, *Roma nobilitata*, 194; Franceschini and Vernesi (eds), *Statue di Campidoglio*, 124).

44 The Venus: Haskell and Penny, *Taste and the Antique*, 318–20. The Venus replacing 'Antinoos', and followed by 'Agrippina': Stuart Jones (ed.), *Catalogue of Ancient Sculptures . . . Museo Capitolino*, 288, 215.

45 The theatre: Borys, *Vincenzo Scamozzi*, 160–67. The cultural context

of Sabbioneta and its theatre: Besutti, 'Musiche e scene', and below, p. 180.

46 The story of these emperors, and the current locations of those remaining from earlier series, is being investigated by an Oxford research group: https://www.geog.ox.ac.uk/research/landscape/projects/heritageheads/index.html.

47 Beerbohm, *Zuleika Dobson*; in Roberts's parody, *Zuleika in Cambridge*, she in fact finds Cambridge more resistant to her charms.

48 Beerbohm, *Zuleika Dobson*, 9–10.

49 *The Times* 19 February 2019 (letter from Will Wyatt, quoting the sculptor Michael Black—who was fond of a joke).

50 Siemon (ed.), *Silver Caesars*: esp. Siemon, 'Tracing the Origin'; Salomon, 'The Dodici Tazzoni'; Alcorn and Schroder, 'The Nineteenth- and Twentieth-Century History'.

51 The misidentifications in greater detail: Beard, 'Suetonius, the Silver Caesars'. The scenes had been confidently identified as Domitianic since at least the late nineteenth century: Darcel (ed.), *Collection Spitzer*, 24 (though a scratched 'VESPASIANUS' on the base suggests that at some point others had other ideas).

52 Suetonius, *Tiberius* 20.

53 Suetonius, *Tiberius* 6, 48 and 9.

54 Suetonius, *Caligula* 19; *Domitian* 1.

55 McFadden, 'An Aldobrandini Tazza': 'A cooperative action of the part of three museums . . . has restored the figures to their proper bowls' (p. 51); http://collections.vam.ac.uk/item/O91721/the-aldobrandini-tazza-tazza-unknown/.

## Chapter V
### The Most Famous Caesars of Them All

1 In working on this chapter I have been very grateful for exchanges and discussion with Frances Coulter, who is preparing a longer study on Titian's Caesars and has generously shared her great expertise. The Darby collection and Brett: Cottrell, 'Art Treasures', with references to Wellington, pp. 633 and 640. Cottrell draws on Brett's notes in the Private Catalogue of the Darby Collection, of which there is a copy in

the Ironbridge Gorge Museum Archive (E 1980. 1202); under the heading 'Titian The Caesars', Brett hypes the quality of the six paintings ('These Noble Pictures are . . . as works of Art unsurpassed'). My thanks to Georgina Grant of the Ironbridge Gorge Museum for providing me with a copy of the relevant sections of the Private Catalogue. How these relate to the six Caesars that Brett is supposed to have sold to the late king of Holland, *The Daily News* 2 April 1864, 2, is unclear to me! But confusion is endemic around these paintings: Wethey, *Paintings of Titian*, 239, following Crowe and Cavalcaselle, *Titian*, 423 identify the owner as Abraham Hume, not Abraham Darby.

2   Fundamental recent discussions of these paintings: Wethey, *Paintings of Titian*, 235–40; in much greater detail, Zeitz, *Tizian*, 59–103. The Alcázar fire: Stewart, *Madrid*, 81–82 (a brief but chilling account: 'only a handful of palace servants dying in the blaze'), with Bottineau, 'L'Alcázar', 150 (citing the even briefer eye-witness account of the French painter Jean Ranc, in whose palace studio the blaze began).

3   *The Literary Gazette*, 20 March 1841, 187–88; with Brett in the Private Catalogue, n. 1 above.

4   *National Review*, 'The Manchester Exhibition', 5 (July 1857) 197–222, quotation p. 202 (George Richmond, writing anonymously).

5   Christies sale, 8 June 1867, lots 127–32, under the heading, 'The following pictures were exhibited at Manchester in 1857'. One of the set, *Tiberius*, bought for four guineas by James Carnegie in 1867, was sold again at Christie's in 2014 as 'after Tiziano Vecellio': https://www .christies.com/lotfinder/Lot/after-tiziano -vecellio-called-titian-portrait-of -5851119-details.aspx.

6   *Morning Post* 6 November 1829, 3; *North Wales Chronicle* 12 November 1829, 2; *Caledonian Mercury* 14 November 1829, 2, and elsewhere. The £8000: Northcote, *Titian*, 171.

7   There were other fantasies of their survival outside the United Kingdom. One erroneous early twentieth-century idea held that versions in Munich (likewise copies) were in fact

the originals: Wielandt, 'Die verschollenen Imperatoren-Bilder' (proposing the idea), dismissed by Wethey, *Paintings of Titian*, 238, and others.

8   The closest rival is probably Antonio Tempesta's *Twelve Caesars on Horseback* (1596), which were not only very popular as prints but were copied into different media (Peacock, *Stage Designs*, 281–82, noting their inspiration behind some of Inigo Jones's theatrical costumes; four copies in paint at Anglesey Abbey in eastern England, http://www .nationaltrustcollections.org.uk /object/515497—/515500). Tempesta's career: Leuschner, *Antonio Tempesta*.

9   de Bellaigue, *French Porcelain*, no. 361.

10   It goes by many modern titles, including also 'Gabinetto dei Cesari' and 'Sala dei Cesari'.

11   The renovation: Cottafavi, 'Cronaca', 622–23. The copies: L'Occaso, *Museo di Palazzo Ducale*, 231–33.

12   Useful introductions to the development of the Ducal Palace at Mantua, to the 'Trojan Suite', and to the patronage of Federico (among a vast bibliography): Chambers and Martineau (eds), *Splendours*; Furlotti and Rebecchini, *Art of Mantua*. In the notes that follow I am necessarily highly selective in picking out important discussions and useful starting places on particular Mantuan themes.

13   The Gonzaga collections of antiquities: Brown and Ventura, 'Le raccolte'; Rausa, '"Li disegni"'. For an ancient statue of 'Faustina', which was the subject of a tug-of-love battle between Isabella d'Este and Mantegna, see below, p. 237.

14   Dolce, *Dialogo*, 59: 'i veri Cesari e non pitture' (also saying that huge numbers of people went to Mantua, just to see them).

15   Zeitz, *Tizian*, 78–79.

16   'Molto belle, e belle in modo <or di sorte> che non si puo far più nè tanto' (Very fine, and fine in a way that can neither be bettered nor equalled); quoted by Zeitz, *Tizian*, 101, with the context in Perini (ed.), *Gli scritti*, 162. The history of these annotations, and the question of which of the Carracci was the author: Dempsey, 'Carracci *Postille*'; Loh, *Still Lives*, 28–29, 239 n. 64 (reaching different conclusions).

17   The layout of the room: Koering, 'Le

Prince et ses modèles' and *Le Prince*, 282–95, in addition to Zeitz, *Tizian*, 65–100. Frances Coulter's excellent digital reconstructions can be found at https://ucdarthistoryma.wordpress.com/2016/11/24/journey-of-a-thesis-titians-roman-emperors-for-the-gabinetto-dei-cesari-mantua/ with Coulter, 'Supporting Titian's Emperors' (an analysis of the overall design); and paper versions, including a useful plan, in Berzaghi, 'Nota per il gabinetto', esp. 255–58. Shearman, *Early Italian Pictures*, 124–26 is still a useful summary in English.

18  The career of Giulio Romano: Hartt, *Giulio Romano*, with the essays in the exhibition catalogue *Giulio Romano*. Shakespeare: *Winter's Tale*, Act 5, scene 2, line 96.

19  'Messer Tiziano, mio amico carissimo', from Federico to Titian, 26 March 1537. The letters are collected and discussed in Bodart, *Tiziano*, 149–56, with documents nos. 253–304; Zeitz, *Tizian*, 61–65, with documents nos. 252–306.

20  Recent arguments for the identification of horsemen as emperors: Berzaghi, 'Nota per il gabinetto', 246–47; Coulter, 'Supporting Titian's Emperors'.

21  The Hampton Court panels: Shearman, *Early Italian Pictures*, nos 117 and 118; Whitaker and Clayton, *Art of Italy*, no. 39 (who draw attention among other things to signs of hasty execution). Another scene at Hampton Court of the sacrifice of a goat (with a related preliminary drawing in the National Gallery in Washington, DC, 1973.47.1) seems to be related to the Camerino, but (see below, p. 166 and n33) it is hard to know where exactly it might have fitted: Shearman, *Early Italian Pictures*, no. 119. The Louvre painting: Hartt, *Giulio Romano*, 174–75.

22  The pair at Hampton Court: Shearman, *Early Italian Pictures*, nos 120 and 121; Whitaker and Clayton, *Art of Italy*, no. 39. The trio at Marseille: *Peintures Italiennes*, no. 73. Lapenta and Morselli (eds), *Collezioni Gonzaga*, 189–92 discuss and illustrate all except the horseman and Victory at Narford Hall, whose current owners have confirmed their location. My thanks to Alfred Cohen of the Trafalgar Gallery, London, for providing full detail of the Gallery's horseman.

23  The Gonzaga inventory: Luzio, *Galleria dei Gonzaga*, 89–136; Morselli (ed.), *Collezioni Gonzaga*, 237–508 (with illustrations and further commentary in Lapenta and Morselli (eds), *Collezioni Gonzaga*). The inventory of the property of Charles I: Millar (ed.), *Abraham van der Doort's Catalogue* and *Inventories and Valuations*. (Both of the inventories of Charles I, with useful commentary, can be accessed online at https://lostcollection.rct.uk/).

24  The inventory, compiled by Johann-Baptist Fickler, diligent tutor of one of Albrecht's successors: Diemer (ed.), *Das Inventar*; with Hartt, *Giulio Romano*, 170–76; Diemer et al. (eds), *Münchner Kunstkammer*, vol. 2, nos 2600, 2610, 2618, 2626, 2632, 2639, 2646, 2653, 2660, 2667, 2678, 2683. The idea of a 'mini-Mantua': Diemer and Diemer, 'Mantua in Bayern?'; Jansen, *Jacopo Strada*, 611–13. The role of the Kunstkammer: Pilaski Kaliardos, *Munich Kunstkammer*.

25  The disputed attribution of these drawings: Verheyen, 'Jacopo Strada's Mantuan Drawings' (considering them the work of Strada himself); Busch, *Studien*, 204–5, 342 n. 90 (the first to identify them as Andreasi's). The career of Andreasi: Harprath, 'Ippolito Andreasi'. Jansen, *Jacopo Strada*, esp.701–8 makes clear that Strada's interest in the art and architecture of the Gonzaga extended much further than the Camerino.

26  Suetonius, *Tiberius* 27. The British Museum holds a preliminary sketch of another 'story', accompanying the portrait of Caligula (Inv. 1959,1214.1): Koering *Le Prince*, 287–88 and Berzaghi, 'Nota per il gabinetto', 245–46 (offering different views of which passage of Suetonius lies behind it).

27  It is an indication of the confusion surrounding the decoration of this room that in most accounts the orientation is given wrongly (what is, in fact, the west wall is dubbed the north, and so on). I am using the correct, rather than conventional, directions—following Koering and Coulter.

28  The statuette from Vienna: *Giulio Romano*, 403. It is hard to detect a theme here. On the opposite (east) wall, however, the statuettes of the Trojan hero

Paris, with Venus, Minerva and Juno add up to a *Judgement of Paris*: Koering, *Le Prince*, 285–86.

29 Of the other horsemen, the figure on the far left matches the one in the Trafalgar Gallery, London; the figure on the far right matches one of those at Hampton Court.

30 The usual view is that the illustrations in Fulvio's book were the work of the artist Ugo da Carpi, and they were much copied later: Servolini, 'Ugo da Carpi'.

31 The full line-up on the west wall is as follows. Upper level, left to right: (1) 'Ti(berius) Claudius Caesar Aug(ustus) P(ontifex) M(aximus) P(ater) P(atriae)' (Tiberius Claudius Caesar Augustus Chief Priest father of his country), i.e., the emperor Claudius (those scholars who have referred to this medallion have usually misread 'AUG PM' as the meaningless 'AUDEM', and the entry in Morselli (ed.), *Gonzaga. . . . Le raccolte*, 173 wrongly assumes that the wording identifies the horseman not the figure in the medallion); (2) 'Domitius Neronis Imp(eratoris) Pater' (Domitius the father of the Emperor Nero); (3) 'L(ucius) Silvius Otho Vthonis Imper(atoris) Pater' (Lucius Silvius Otho the father of the emperor Otho) replicating the error 'V' for 'O' in the original source; (4) 'L(ucius) Vitellius Vitellii Imp(eratoris) Pater' (Lucius Vitellius the father of the emperor Vitellius). Lower level, left to right: (1) not clearly decipherable, though 'uxor' (wife) is legible; the closest match is 'Livia Medullina', betrothed to Claudius but died on her wedding day; (2) blank; (3) 'Albia Terentia Othonis Imp(eratoris) Mater' (Albia Terentia the mother of the emperor Otho); (4) 'Sextilia A(uli) Vitellii Imp(eratoris) Mater' (Sextilia the mother of the emperor Aulus Vitellius).

32 The full line-up under Augustus is as follows. Upper level, left to right: (1) 'Livia Drusilla Augusti Uxor' (Livia Drusilla, the wife of Augustus); (2) 'Tiberius Nero Tiberii Imper(atoris) Pater' (Tiberius Nero, the father of the emperor Tiberius). Lower level, left to right: (1) '. . . Scribonia F Agripp<a>e Ux(or)', originally 'Iulia Augus(ti) ex Scribonia F(ilia) Agripp<a>e Ux(or)' (Julia the daughter of Augustus by Scribonia,

the wife of Agrippa), misread by Zeitz, *Tizian*, 98 and Koering, *Le Prince* 286; (2) 'Livilla Drusi Tiberii F(ilii) Uxor' (Livilla, the wife of Drusus, the son of Tiberius). The death of Drusus: Tacitus, *Annals* 4, 3–8. The grim end of Livilla: Dio, *Roman History* 58, 11, 7.

33 The *Triumph* scene is 1.7 m wide; the horsemen c. 0.5 m each; and the sacrifice of a goat, thought to be another of the 'stories' (above, n. 21), 0.66 m. If we add to these the (lost) 'story' accompanying Vitellius, and the borders between each painting, the total width required is over five metres. At this point we can do no more than speculate. The fact that Vitellius's parents are in medallions on the adjacent wall might suggest that, despite Strada's notes (below, n. 35) and the implications of the Munich inventory, there was no horseman under Vitellius, or that there was no 'story' to accompany Vitellius. Or possibly the surviving painting of the sacrifice of a goat from Hampton Court, often linked to the life of Domitian (Hartt, *Giulio Romano*, 175) did not belong in the room at all (where there was no portrait of Domitian). The best recent review of these puzzles, and various solutions: Berzaghi, 'Nota per il gabinetto'.

34 Claudius identified as Caesar: Millar (ed.), *Abraham van der Doort's Catalogue*, 43, and *Inventories and Valuations*, 328. The story of the 'mayor' is drawn from Tacitus, *Annals* 6, 11, 3. The inventories show that at least by 1598 the 'wrong' 'stories' had been paired with the 'wrong' emperors.

35 Strada's notes: Munich, Hauptstaatsarchiv, *Libri Antiquitatum*, 4852, fol. 167; published in Verheyen, 'Jacopo Strada's Mantuan Drawings', 64: '*Dodici* imperadori, sopradetti, a cavallo' (*Twelve* emperors aforementioned, on horseback) (my italics), cited by Verheyen as *Libri Antiquitatum*, vol. 2). The 1627 inventory: Luzio, *Galleria dei Gonzaga*, 92; Morselli (ed.), *Collezioni Gonzaga*, 269: '*Dieci* altri quadri dipintovi un Imperator per quadro a cavallo' (*Ten* other panels, depicting one emperor per panel on horseback) (my italics). The *eleven* in the inventory of Charles I's property: Millar (ed.), *Inventories and Valuations*, 270. (A single 'mounted

emperor' mentioned elsewhere in the Gonzaga inventories, though not attributed to Giulio Romano (Luzio, *Galleria dei Gonzaga*, 97; Morselli (ed.), *Collezioni Gonzaga*, 278) may or may not help partly to resolve the discrepancy. Quite how the figure of the Victory is to be computed here is only a further complication.

36 Vasari, *Vite*, 834 ('the twelve portraits of the emperors which Titian painted'). Strada (see n. 35) also refers to 'twelve' emperors. The inventories differ: Millar (ed.), *Inventories and Valuations*, 270 records 'twelve' (though one manuscript copy emends this to 'eleven': British Library, Harley MS 4898, f 502); the 1627 inventory made in Mantua correctly notes 'eleven' (Luzio, *Galleria dei Gonzaga*, 89; Morselli (ed.), *Collezioni Gonzaga*, 268); the correspondence connected with the sale to the agents of Charles I is inconsistent between 'twelve' and 'eleven plus one' (Luzio, *Galleria dei Gonzaga*, 139).

37 Hartt, *Giulio Romano*, 170, 176–77.

38 'Giulio Romano's' Domitian: Luzio, *Galleria dei Gonzaga*, 90; Morselli (ed.), *Collezioni Gonzaga*, 268 ('another similar painting with the figure of an emperor, by the hand of Giulio Romano'). Fetti's Domitian: Morselli in Safarik (ed.), *Domenico Fetti*, 260, 264–65. Every series of copies included a Domitian, whether new inventions or copies of copies; see Fig. 5.10.

39 Julius Caesar (Suetonius, *Julius Caesar* 7): Diemer et al. (eds), *Münchner Kunstkammer*, vol. 2, no. 2632; Hartt, *Giulio Romano*, 170, 174 (misidentifying the scene). Augustus (Suetonius, *Augustus* 94): Hartt, *Giulio Romano*,171–72; Diemer et al. (eds.), *Münchner Kunstkammer*, vol 2, no. 2610; with a preliminary sketch half in Windsor Royal Library, half in the Albertina, Vienna: Chambers and Martineau (eds), *Splendours*, 191.

40 In this I follow Koering, *Le Prince*, 285. Arasse, *Décors*, 249–50 n. 163 makes a similar point on the eight emperors of Mantegna in the Camera picta.

41 Pocock, *Barbarism*, 127–50.

42 Silver, *Marketing Maximilian*, esp. chaps. 2 and 3; Wood, *Forgery, Replica, Fiction*, 306–22.

43 Panvinio, *Fasti*. The 'bootleg': McCuaig, *Carlo Sigonio*, 30–33; and, more favourable to Strada (the notion of 'pirating' being more fluid then than now; see above, Chap. 4, n. 16): Bauer, *Invention of Papal History*, 52–53; Jansen, *Jacopo Strada*, 196–99. Other attempts to link ancient Roman to modern history include Fulvio's *Illustrium imagines*, which started with Janus and finished with the Holy Roman emperor Conrad, who died in 918 CE, and Konrad Peutinger's project to publish a compendium of emperors, from Julius Caesar to Maximilian himself (Silver, *Marketing Maximilian*, 77–78; Jecmen and Spira, *Imperial Augsburg*, 49–51).

44 Federico as the model for Augustus: Zeitz, *Tizian*, 94–100. But see, for example, *RRC* 494, 529, showing a bearded Octavian, matching the (copies of) Titian's Augustus.

45 Koering, *Le Prince*, 273–82 (noting the rhyme); more briefly, Hartt, *Giulio Romano*, 178–79.

46 Ferrari (ed.), *Collezioni Gonzaga* (the Camerino: p. 189).

47 Bodart, *Tiziano*, document 304; Zeitz, *Tizian*, document 306.

48 The circumstances and context of the acquisition: Luzio, *Galleria dei Gonzaga*; Brotton, *Sale*, 107–44; Anderson, *Flemish Merchant*.

49 The history of the 'Logion Serato': Furlotti and Rebecchini, *Art of Mantua*, 236–40 (it is wrongly believed by Shearman, *Early Italian Pictures*, 125 to be a new name for the Camerino). The dispersal of the paintings around the Ducal Palace: Luzio, *Galleria dei Gonzaga*, 89–90, 92, 97, 115; Morselli (ed.), *Collezioni Gonzaga*, 268–69, 278, 295.

50 Anderson, *Flemish Merchant* attempts to draw a more nuanced picture of Nys. The damage by mercury: Wilson, *Nicholas Lanier*, 130–31.

51 The eighteenth-century 'remnant': Keysler, *Travels*, 116–17. The bizarre claim about the destruction of the paintings: Richter (ed.), *Lives*, 47 ('Mrs Jonathan Foster' being responsible for the notes). It is possible that some of Giulio Romano's 'stories' did not end up in England, as not all can be traced in the inventories of Charles I's collection.

52 The remedies: R. Symonds, British Library, Egerton MS 1636, fol. 30, quoted by Wilson, *Nicholas Lanier*, 131. The damaged painting: Millar (ed.), *Abraham van der Doort's Catalogue*, 174 (it is listed, in a series of damaged Mantuan paintings, as 'utterlie spoyled by quicksilver').

53 The original document (The National Archive, Kew, Surrey, LC 5/132 f. 306) is online at: http://jordaensvandyck.org/archive/warrant-to-pay-van-dyck-280-for-royal-portraits-15-july-1632/.

54 Puget de la Serre, *Histoire* (no page numbers); the relevant passage is quoted by Wilks, 'Paying Special Attention', 158–59. Again, the documentation does not quite add up. Puget de la Serre implies that the emperors were all together in a single location, but that is clearly contradicted by the other evidence, including the roughly contemporary inventories.

55 Otho: Millar (ed.), *Abraham van der Doort's Catalogue*, 194; *Inventories and Valuations*, 66.

56 Millar (ed.), *Abraham van der Doort's Catalogue*, 226–27 (an inventory published here as an appendix, but not by the hand of van der Doort himself).

57 Hercules and Charles: Millar (ed.), *Abraham van der Doort's Catalogue*, 226, 227.

58 The direct sources for this image: Raatschen, 'Van Dyck's *Charles I*'; Howarth, *Images of Rule*. 141–45.

59 The precise reconstruction of the gallery involves conjecture. But Wilks, 'Paying Special Attention' confirms beyond serious doubt the basic articulation of the gallery and the position of Titian's emperors, contra Howarth, *Images of Rule*, 141, who imagines the 'enfilade' leading up to the portrait of Charles.

60 The links between Charles's claims of divine sanction and the role of Hercules in this gallery and elsewhere: Hennen, 'Karl zu Pferde', 47, 83; Wilks, 'Paying Special Attention', 159–60.

61 The disposal of the 'king's goods': Brotton, *Sale*, 210–312; Haskell, *King's Pictures*, 137–69.

62 The sale, and subsequent fate, of the horsemen: Shearman, *Early Italian Pictures*, 123–24 (with similar information on Giulio Romano's 'stories', some of which returned to the royal collection,

although in the case of the *Otho* panel subsequently lost again, pp 125–26). The 'restoration campaign' in general: Brotton, *Sale*, 313–51; Haskell, *King's Pictures*, 171–93.

63 The complex negotiations: Brown and Elliott (eds.), *Sale of the Century*, with some key documents translated and discussed by Brotton and McGrath, 'Spanish Acquisition'.

64 The first more negative assessment: Brown and Elliott (eds.), *Sale of the Century*, 285–86 (reprinting a memorandum of 8 August 1651 in Archivo de la Casa de Alba, Caja 182–195: 'The Twelve emperors by the hand of Titian . . . six of which are in very bad condition. And the one of the emperor Vitellius entirely lost . .' The changed view is reflected in a letter of 24 November 1651 from the same archive (Caja 182–176), translated in Brotton and McGrath, 'Spanish Acquisition', 13 (with the original Spanish in Brown and Elliott (eds), *Sale of the Century*, 282).

65 The history of the palace: Brown and Elliott, *Palace for a King* (with discussion of the paintings commissioned for it, pp. 105–40); Barghahn, *Philip IV and the 'Golden House'*, 151–401 (reconstructing in detail the hang of the paintings). Little of the Buen Retiro survives; some remaining rooms are part of the Prado museum complex.

66 The layout of the gallery: Bottineau, 'L'Alcázar', publishing the inventory of 1686 (esp. 150–51, for the 'Titians'); Orso, *Philip IV*, 144–53; Vázquez-Manassero, 'Twelve Caesars' Representations', esp. 656–58.

67 There is no complete or accurate list of copies, but there is a useful register of many, with essential documentation in Wethey, *Paintings of Titian*, 237–40; Zimmer, 'Aus den Sammlungen', 12–16; 26–27. For 'faces' literally, see the set of twelve late sixteenth-century copies of emperors from the collection of Schloss Ambras in Austria which cuts down Titian's three-quarter figures to 'face-only': Haag (ed.), *All'Antica*, 214–17.

68 Lamo, *Discorso*, 77 ('offerendo *tutti* i dodici ritratti al Marchese'—my italics), who also remarks on the style. The work of Campi and his extended family: *I Campi*.

69 Coulter, 'Drawing Titian's "Caesars"'
(having been seen a century and a half
earlier, and partially published in Morbio,
'Notizie'). They obviously relate in some
way—though exactly how is unclear—to
a very similar, but clearly 'squared' (for
copying), set of six drawings of Titian's
*Julius Caesar, Claudius, Nero, Galba, Otho*
and *Vitellius*; these remained unsold at
auction at Gros & Delettrez, Paris, 18
May 2009, lots 29 A–C (attributed to the
workshop of Giulio Romano).

70 Ferdinand and the Spanish collections:
Lamo, *Discorso*, 78. The (lost) paintings
for the junior branches of the Gonzaga
family: Sartori, 'La copia'. Some of the
documentation is collected in Ronchini,
'Bernardino Campi', esp. 71–72—though
it raises some of the usual problems
(why, for example, did Ferrante II of
Guastalla direct Campi to the *Emperors*
at Sabbioneta as his model, if Campi
had actually painted those, and had his
own templates anyway?). The heads of a
surviving series of emperors painted by
Campi and his workshop in the Palazzo
Giardino at Sabbioneta certainly reflect
the facial features of members of Titian's
series, though on very different bodies
and sometimes attaching the 'wrong'
heads to the 'wrong' emperors (Sartori,
'La copia', 21–24).

71 The several copies in Mantua:
Rebecchini, *Private Collectors*, publish-
ing local inventories and wills in which
paintings of 'Twelve Caesars' are listed,
sometimes explicitly attributed to Titian
(see App. 4, I, 139; 4, II, 34; 6, II; 6, III,
11; 6, V, 1; 6, V, 210; 6, VI, 1). The evi-
dence for the set commissioned for Pérez
by Duke Guglielmo: Luzio, *Galleria dei
Gonzaga*, 89.

72 The set commissioned by Maximilian
II: Zimmer, *Aus den Sammlungen*, 20,
43–47. The Farnese inventory, see
Jestaz, *L'Inventaire*, vol. 3, 132. A possible
sixteenth-century source of these paint-
ings: Robertson, 'Artistic Patronage', 370.

73 This is attested in a letter from Daniel
Nys on 2 October 1627 (published in
Luzio, *Galleria dei Gonzaga*, 147), with
Anderson, *Flemish Merchant*, 130–31.
Nys reports that the duke 'wants to
send a painter to copy the paintings of
the gallery' (voel mandare un pittore a
posta per copiare li quadri della galleria),

but insists that there are good artists in
Venice whom he can get to do the job.

74 The text of the letter: Voltelini,
'Urkunden und Regesten', no. 9433
('porque ya tiene otros duplicados,
que le embiaron de Roma'). Further
background on the collection: Delaforce,
'Collection of Antonio Pérez', esp. 752.

75 Those in the d'Avalos collection: *I
Campi*, 160 and *I tesori*, 50–53. Those
in the private collection have a docu-
mented history in Mantua, and have
been in the UK since the late 1970s. The
relationship between the set of copies by
'il Padovanino' recorded in a 1712 inven-
tory of the Ducal Palace at Mantua and
the copies made for the Gonzaga, while
the paintings were awaiting shipment in
Venice, is anyone's guess: Eidelberg and
Rowlands, 'The Dispersal', 214, 267 n.
53. The replicas that now stand in the
place of the originals in the Camerino
are quite separate, acquired in 1924 (see
above, n. 11).

76 The history of the Munich set is
predictably unfathomable. Strada is
known to have had painted copies of
the main elements of the Camerino
made at Mantua (as well as Andreasi's
sketches); but he must have been aware
that there was already a set of emper-
ors in Munich, since out of the whole
line-up of emperors he ordered only a
Domitian (he presumably assumed that
the Munich set was only Titian's original
Eleven—wrongly it seems, since Fickler's
Inventory (above, n. 24) registers *two*
Domitians in the Munich collection).
The documentation on this and the
complex inferences involved: Verheyen,
'Jacopo Strada's Mantuan Drawings', 64
(with n. 35 above); Diemer et al. (eds),
*Münchner Kunstkammer*, vol. 2, nos 2682,
3212; Zimmer, 'Aus den Sammlungen',
12–14.

77 There are impossible conundra here too.
As Zimmer, 'Aus den Sammlungen', 19–
20 observes, the relevant letter (above, n.
74) makes it seem unlikely that Rudolf
was seriously in the market for Pérez's
Caesars; but why were they even being
considered if he had already inherited a
set on the death of his father in 1576?

78 Sadeler's career: Limouze, 'Aegidius
Sadeler, Imperial Printmaker'; *Aegidius
Sadeler (c. 1570–1629)*. These were by

far the most popular printed versions of Titian's emperors, but there were many others: for example, those of Balthasar Moncornet in the early–mid-seventeenth century; of Georg Augustus Wolfgang in the late seventeenth century; of Thomas Bakewell and Louis-Jacques Cathelin in the eighteenth. Some of these were copies of Sadeler, but some were taken independently from other painted copies of the Titians. Sadeler's *Domitian*, for example, was not based on Campi's (another clear indication that Rudolf II did not own a Campi set; see Fig. 5.10). Wolfgang does base one of his figures on Campi's *Domitian*, but—in another case of mistaken identity—turns it into a *Tiberius*. (See British Museum, Inv. 1950,0211.189.)

79 Vertue, *Vertue's Note Book*, 52.The fact that in England Titian's series were housed separately makes the idea that they were copied as a set unlikely.

80 Worsley, 'The "Artisan Mannerist" Style', 91–92 sees a connection between these Caesars and the family's interest in Italy; but, directly dependant on Sadeler, they imply no knowledge of the originals or Italy (Illustrations: https://www.artuk .org/visit/venues/english-heritage -bolsover-castle-3510).

81 Details of the book: https://www .sothebys.com/en/auctions/ecatalogue /2011/music-and-continental-books -manuscripts-l11402/lot.11.html. I am very grateful to Bill Zachs for sharing this with me and for his information that the binding was commissioned by Robert Thornton (1759–1826), and that it is similar in style to the work of Roger Payne or Henry Walther. The shields: *Schatzkammer*, 282.

82 Fontane, *Effi Briest*, 166.

83 Halsema-Kubes, 'Bartholomeus Eggers' keizers'. They were originally designed for another royal palace at Oranienburg, and the same models were used again for the four lead busts now in the Rijksmuseum, Amsterdam (Fig. 5.15); 'imaginative fantasies' (phastasievollen . . . Dekor): Fittschen, *Bildnisgalerie*, 54–55.

84 *Daily Mail*: above, Chap. 2, n. 44. The modern memorabilia are available from https://fineartamerica.com.

85 Crowe and Cavalcaselle, *Titian*, 424.

86 The quotation: Saavedro Fajardo, *Idea de un príncipe*, 14 ('No a de aver . . . Estatua, ni Pintura, que no cie en el pecho del Principe gloriosa emulacion'), translated as *The royal politician*, 15–16. These theories, in relation to the images of ancient emperors among the Spanish monarchy: Vázquez-Manassero, 'Twelve Caesars' Representations', 658.

87 Agustìn, *Dialogos*, 18–19 (particularly interested in the appearance of Nero, as the persecutor of Peter and Paul).

88 Koering, *Le Prince*, 155–60 (noting how one of Giulio Romano's 'stories' in the Camerino, showing Julius Caesar being inspired by the statue of Alexander the Great, acts out the whole principle of 'exemplarity'); Bodart, *Tiziano* 158; Maurer, *Gender, Space and Experience*, 93–97 (on the wider Mantuan, and gender, context). 'Examples' more generally: Lyons, *Exemplum*.

# Chapter VI
## Satire, Subversion and Assassination

1 The nineteenth-century verdict, 'florid': *Visitor's Hand-Book*, 46. Worse ('gaudy colour, bad drawing and senseless composition'): Dutton Cook, *Art in England*, 22, quoting also the famous quip of Horace Walpole, that it looked as if the artist 'had spoiled it out of principle'.

2 A sympathetic account of Verrio and his work: Brett, 'Antonio Verrio (c. 1636–1707)'; Johns, '"Those Wilder Sorts of Painting"'. His work at Hampton Court in particular: Dolman, 'Antonio Verrio and the Royal Image'.

3 The breakthrough article: Wind, 'Julian the Apostate'; with Dolman, 'Antonio Verrio and the Royal Image', 22–24. The emperor himself: Bowersock, *Julian*.

4 Bowersock, 'Emperor Julian on his Predecessors'; Relihan, 'Late Arrivals', 114–16.

5 The identification: Wind, 'Julian the Apostate', 127–28.

6 A detailed religious/political interpretation: Wind, 'Julian the Apostate', 129–32. 'Interactive essay': Dolman, 'Antonio Verrio and the Royal Image', 24.

7 The punishment of Brutus and Cassius: Dante, *Inferno* 34, 55–67. McLaughlin, 'Empire, Eloquence' is a useful overview

of Renaissance disagreements on Caesar. The debate between Poggio and Guarino, with the texts: Canfora (ed.), *Controversia*; an English translation of an extract of Poggio's contribution, and the whole of Guarino, with further discussion, can be found in Mortimer, *Medieval and Early Modern Portrayals*, 318–75.

8 Wyke, *Caesar*, 155.

9 de Bellaigue, *French Porcelain*, no. 305. The other emperors depicted are Augustus, Trajan, Septimius Severus, Constantine (plus Republicans, Scipio and Pompey; Greeks, Themistocles, Miltiades, Pericles and Alexander; Roman enemies, Hannibal and Mithradates).

10 Ancient criticisms of Caesar: above, Chap. 2, n. 6. Deare's sculpture: Macsotay, 'Struggle'.

11 The painting has recently been discussed briefly by Mauer, *Gender, Space and Experience*, 113–15. The ancient anecdote is told by, for example, Pliny, *Natural History* 7, 94; Dio, *Roman History* 41, 63, 5; and for this general theme in ancient literature, see Howley, 'Book-Burning', 221–22.

12 Plutarch, *Pompey* 80 refers to Caesar's horror at the head (though it is his signet ring that prompts tears); Lucan, *Pharsalia* 9, 1055–56 is more cynical. Caesar being shown Pompey's head is represented (with different degrees of distaste) in paintings, prints and on maiolica, by, among others, Louis-Jean François Lagrenée, Antonio Pellegrini, Sebastiano Ricci and Giovanni Battista Tiepolo.

13 Martindale, 'Triumphs' (still the standard work); Campbell, 'Mantegna's Triumph' and *Andrea Mantegna*, 254–72 (sharing my own sense of the darker side of these paintings); Tosetti Grandi, *Trionfi*; Furlotti and Rebecchini, '"Rare and Unique"'.

14 Martindale, 'Triumphs', 117–18.

15 The face of Caesar is heavily restored, but closely based on a copy in Vienna: Martindale, 'Triumphs', 157.

16 A cautious analysis of this tradition of the slave: Beard, *Roman Triumph*, 85–92.

17 The theme of *invidia* in the painter's work: Campbell, 'Mantegna's Triumph', 96 (also illustrating the design of Mantegna's personal seal: a plausible head of Caesar). Vickers, 'Intended Setting' sees the point of the Latin phrase, but his conclusions are fanciful.

18 The key study of these tapestries: Campbell, 'New Light', with Karafel, 'Story'. Discussion of both the Caesar and the Abraham sets: Campbell, *Henry VIII*, 277–97. The relevant inventory entries: Starkey (ed.), *Inventory*, no. 11967 (with full dimensions); Millar (ed.), *Inventories and Valuations*, 158.

19 The history, importance and changing fortunes of tapestry: Campbell (ed.), *Tapestry in the Renaissance*, 3–11; Belozerskaya, *Luxury Arts*, 89–133.

20 The history of sightings: Campbell, 'New Light', 2–3. 'woven . . . to the very life': Groos (ed.), *Diary of Baron Waldstein*, 149. The watercolour, by Charles Wild, is in the Royal Collection (RCIN 922151).

21 I say 'Henry's *originals*' following the general assumption that he was the first commissioner; there is certainly no hint of any sets earlier than his.

22 Karafel in Cleland (ed.), *Grand Design*, nos 61 and 62 (though the precise subject of the scene is misidentified here; see below, pp. 209–10).

23 Caesar's murder: Williams (ed.), *Thomas Platter's Travels*, 202; Pompey's: Groos (ed.), *Diary of Baron Waldstein*, 149.

24 Campbell, 'New Light', 37 (quoting the relevant documents, from the Archivio di Stato in Rome). Recent discussion of the image on this tapestry: Astington, *Stage and Picture*, 31–33.

25 Suetonius, *Julius Caesar* 81 (without the name); Plutarch, *Julius Caesar* 65 (adapted by Shakespeare, *Julius Caesar*, Act 2, scene 3; Act 3, scene 1).

26 Campbell, 'New Light', 35 and Raes, *De Brusselse Julius Caesar wandtapijtreeksen*, 12, describe it as 'moralising'. The full caption on the tapestry reads: 'Datus libellus Cesari conjurationem continens / Quo non lecto venit in curia ibi in curuli sedentem / Senatus invasit tribusq et viginti vulneribus / Conodit sic ille qu terrarum orbem civili sanguine / Inpleverat tandem ipse saguine <sic> suo curiam implevit' (A pamphlet was given to Caesar containing details of the conspiracy. He did not read it but came into the senate house; there sitting on his official chair the senate attacked him and <killed> him with twenty-three blows.

Thus, the man who used to fill the whole world with the blood of his fellow-citizens, ended up filling the senate house with his own blood). This is closely based on Florus, *Epitome* 2, 13, 94–95: 'libellus etiam Caesari datus. . . . Venit in curiam. . . . Ibi in curuli sedentem cum senatus invasit, tribusque et viginti volneribus . . . . Sic ille, qui terrarum orbem civili sanguine impleverat, tandem ipse sanguine suo curiam implevit'.

27  The technical arguments underpinning the connection between the Vatican piece and Henry's set: Campbell, 'New Light', 5–6, 10–12. There are two later pieces adapting the same design: one, location unknown, auctioned at Drouot, Paris, 2 December 1988, lot 158; the other now in the French Musée National de la Renaissance, inv D2014.1.1.

28  Plutarch, *Julius Caesar* 35; Lucan, *Pharsalia* 3, 154–56, 165–68.

29  My intentionally simplified account skates over some of the side-stories, complexities and further likely descendants. Christina took her tapestries (inherited from her great uncle, Erik XIV, who died in 1577) to Rome when she abdicated in 1654, and after her death they were acquired by Don Livio Odescalchi, who made the inventory (a copy of which I consulted in the Hertziana Library in Rome). The inventory of Alexander Farnese: Bertini, 'La Collection Farnèse', 134–35. For those who would like to track down other versions: a similar scene (with borders and caption removed and misidentified as a biblical story) was sold at Christie's New York, 11 January 1994, lot 216); another is noted in Barbier de Montault, 'Inventaire', a list of tapestries in Rome (without further specification of place) compiled in the late nineteenth century, pp. 261–62—but this example (which has not come to light) has a shorter caption: 'Aurum putat Caesar' (Caesar thinks of the gold); see also Raes *De Brusselse Julius Caesar wandtapijtreeksen*, 86–87.

30  Forti Grazzini, 'Catalogo', 124–26; Karafel, 'Story', 256–58. The set owned by Margaret of Parma, Alexander's mother: Bertini, 'La Collection Farnèse', 128.

31  Sotheby's New York, 17 October 2000, lot 117.

32  The tapestry became part of a popular fake news story that it may have been one of Henry VIII's original set (see, e.g., *The Times* 26 December 2016); there can be no doubt, partly on the basis of the design of the borders, that it is one of the later weavings.

33  Suetonius, *Julius Caesar* 81; Plutarch, *Julius Caesar* 63; Shakespeare, *Julius Caesar*, Act 1, scene 2. The current location of the tapestry with the caption naming Spurinna is unknown; it is illustrated, from a sale catalogue, in Campbell, 'New Light', Fig. 18.

34  These technicalities of tapestry production: Campbell, 'New Light'. The repertoire of documented scenes include: Caesar crossing the Rubicon; Caesar breaking into the treasury; Caesar marching to Brundisium; Caesar on horseback with prisoner; the sacrifice of a bull; Spurinna foretelling the future (but see below, pp. 207–8); the departure of Pompey's wife at the start of the war (but see below, pp. 209–10); 'Caesar fighting a giant' (but see below, p. 208); the battle of Pharsalus; Pompey and his wife on board ship; the assassination of Pompey; the assassination of Caesar.

35  Helen Wyld, who studied, for the National Trust, the seventeenth-century descendants of this series at Powis Castle has come closest to realising that the standard identifications cannot be correct. http://www.nationaltrustcollections .org.uk/object/1181080.1.

36  The only other *cycle* of images based on Lucan—that I know of—is a mid-sixteenth-century series at Chateau Ancy-le-Franc , but it focusses entirely on the battle of Pharsalus itself (Usher, *Epic Arts*, 60–73). Individual scenes and characters from the *Pharsalia*, however, especially Erictho (see below, pp. 207–8) feature in other paintings.

37  Waldstein may have half realised this when he described Henry VIII's set as 'the story of Julius Caesar *and Pompey*' (my italics): Groos (ed.), *Diary of Baron Waldstein*, 149.

38  One reads, 'Queritur ex saga quidnam de Caesare fi / ad. Medium marti bella cavere monet' (It is inquired from the witch what would happen about Caesar. She warns to beware battle in the midst of war' (?)); the other 'Julius hic furiam

Caesar fugitat furientem / cognoscens subito bestia quod fuerat' (Julius Caesar here flees the furious fury, realising suddenly what the beast was (?)).

39 The final 'a' of the name may be part of the source of the modern confusion: it is often but *not always* associated with the female gender.

40 Lucan, *Pharsalia*, 6, 413–830.

41 This design clearly featured in Alexander Farnese's set of tapestries: the first three words of two of the variant captions—'*Julius hic Caesar* gigantem interficit amplum' (Here *Julius Caesar* kills a huge giant) are used to identify one of the Farnese pieces (Bertini, 'La Collection Farnèse', 135). The title *The War in Germany* in an inventory of Pope Julius's set may perhaps refer to this design too.

42 Lucan, *Pharsalia* 6, 140–262 (quotation, line 148); Suetonius *Julius Caesar* 68 refers to this, *without* the distinctive, lurid detail.

43 Lucan, *Pharsalia* 3, 114–68; 1, 183–227; 8, 536–691.

44 The tapestry with the 'correct' caption was sold at auction, Drouot Richelieu, Paris, 18 October 1993; present location unknown (illustrated by Campbell, 'New Light', Fig. 9). Campbell is so convinced that this must show Caesar and his wife that he tries to force this caption ('Castra petit Magnus maerens Cornelia Lesbum . . .') into that frame, claiming that both Pompey and Caesar had a wife called Cornelia (though Caesar's Cornelia was long dead by the time of the civil war), and that both Caesar and Pompey might be called 'Great' or 'Magnus' (even though it was Pompey's standard title). The logo 'SPQR' is visible on a version at Powis Castle. Wyld's discussion of this (http://www.nationaltrustcollections.org.uk/object/1181080.4) gets it broadly right.

45 The tapestry is in the collection of Lisbon Cathedral (illustrated by Campbell, 'New Light', Fig. 6). The caption on the 'Spurinna' scene, referring to the 'witch' (n. 38), may also reflect a correct identification of the scene as Erictho.

46 Medieval interpretations: Spiegel, *Romancing the Past*, 152–202; Menegaldo, 'César' (making it clear that 'the medieval reading' was not simply favourable to

Caesar). Renaissance and later political interpretations: Hardie, 'Lucan in the English Renaissance'; Paleit, *War, Liberty, and Caesar*.

47 Campbell, *Henry VIII*, 278–80.

48 Van der Straet's career: Baroni and Sellink (eds), *Stradanus*. The Latin of the verses is little better than that under Sadeler's *Caesars* (on Augustus: 'cum . . . teque audes conferre Deo, te Livia sortis / dicitur humanae misto admonuisse veneno').

49 This Banquet: Suetonius, *Augustus* 70. The poisoned figs: Dio, *Roman History* 54, 30. Domitian's games with flies: Suetonius, *Domitian* 3. There are enough striking similarities between some of these scenes in the prints and those on the Aldobrandini Tazze to suggest that they may have been one source for the designer of the latter (Siemon, 'Renaissance Intellectual Culture', 70–74). If so, it shows how almost identical visual elements can be used to construct an image with an entirely different ideological spin.

50 These imperial series: Jaffé, 'Rubens's Roman Emperors'; Jonckheere, *Portraits*, 84–115.

51 McGrath, 'Not Even a Fly'; Jonckheere, *Portraits*, 125–27. A close second in irreverence is Parmigianino's drawing of Nero (as the god Apollo, from a Roman coin), with a vast penis (Ekserdjian, *Parmigianino*, 20).

52 Suetonius, *Vespasian* 4; *Domitian* 3.

53 This orthodox hierarchy of genres was first established in the later seventeenth century by the art theorist André Felibien. The idea of *exemplum virtutis* in this context, and the complicated and contested history of 'history painting': Green and Seddon (eds), *History Painting Reassessed*; Bann, 'Questions of Genre' (and below, n. 73).

54 Thackeray, *Paris Sketch Book*, 56–84 ('On the French School of Painting').

55 The full title is *Siècle d'Auguste: Naissance de N.-S. Jésus-Christ* (The age of Augustus: birth of Our Lord Jesus Christ). The painting in the context of other works by Gérôme: House, 'History without Values'; *Gérôme* 70–73 (discussing a smaller preliminary painting now in the Getty Museum). The qualms: Gautier, *Beaux-arts*, 217–29. There

was a long artistic and literary history to making a link between the age of Augustus and the birth of Jesus. But part of Gérôme's inspiration for the theme came from the more recent work of the seventeenth-century theologian Jacques-Bénigne Bossuet: Miller, 'Gérôme', 109–11; *Gérôme*, 70, 72.

56 The story and reception of these paintings: Seznec, 'Diderot' and Rickert, *Herrscherbild*, 129–32. Diderot's comments: Diderot, *Oeuvres complètes*, 239 ('Cela, un empereur!') and 265. A fourth painting, of the emperor Titus, was commissioned but never produced.

57 The painting is still much discussed, if not admired: Weir, *Decadence*, 35–37 (a useful introduction); Fried, 'Thomas Couture'; Boime, *Thomas Couture*, 131–88 (a full account of the painting's history). The comparison with a sermon and school recommendation: Ruckstull, 'Great Ethical Work of Art', 534, 535.

58 A hint sometimes denied by reading this figure (whose 'true' or intended identity is, as usual, unknown) simply as the disapproving figure of the Republican 'Brutus'; as, for example, in *Le Constitutionnel* 23 March 1847, 1.

59 There is still debate about Couture's own political views and the precise contemporary message of the painting. Compare, for example, Boime, *Thomas Couture*, 183–87 and Fried, *Manet's Modernism*, 112–23. The impact spread outside France (see *The Daily News* 6 April 1847, 3: 'a powerful protest against the material tendencies of the day').

60 *Les Guêpes* 22 (March 1847), 22–23; Mainardi, *Art and Politics*, 80 notes Louis Napoleon's attack on the painting in 1855 for representing the French people as 'Romans of the Decadence'.

61 The poem, by George Olivier: *Journal des Artistes*, 1847, 201 ('Gloire au seul Vitellius César').

62 Appropriately enough, at the Salon, which was held at the Louvre, the *Romans of the Decadence* hung temporarily in the place of another painting by Veronese, the *Wedding Feast at Cana* (Gautier, *Salon*, 9); links with Veronese were drawn in his salon review by Thoré, *Salons*, 415, by *Le Constitutionnel*, 23 March 1847, 1, by *L'Artiste*, Nov./Dec. 1846–Jan./Feb. 1847, 240 ('nous avons

enfin notre Paul Véronèse'), and others.

63 Pougetoux, *Georges Rouget*, 27–28, 123 (in the wider context of the artist's work); *Rome, Romains*, 38–39. His *Vitellius* was also satirised in *Les Guêpes* 22 (March 1847), 26 (turning the emperor into a jolly cartoon character).

64 Contemporary comments: 'S . . ', *Iconoclaste*, 6–7 ('Trois têtes, et c'est fait'); Jean-Pierre Thénot in *Écho de la littéra-ture et des beaux-arts* 1848, 130.

65 Brief introductions to the prize: Boime, 'Prix de Rome' and Grunchec, *Grand Prix de Rome*, 23–28. A fuller account: Grunchec, *Grand Prix de Peinture*, 55–121.

66 Grunchec, *Grand Prix de Peinture*, 254–56 provides documentation of the year's competition and illustrations of the submissions.

67 Delécluze wrote in the *Journal des débats* 23 September 1847, 3. Other critics' dissections: *Journal des Artistes* 1847, 105–7; *Le Constitutionnel* 29 September 1847, 3 (Théophile Thoré).

68 The 'unsuccessful' subjects were a biblical story and an incident from the life of the Greek playwright Sophocles (Grunchec, *Grand Prix de Peinture*, 255).

69 Bonnet et al, *Devenir peintre*, 90.

70 Çakmak, 'Salon of 1859' (focussing also on a lost painting by Gérôme dominated by the shrouded body of the dead Dictator); Lübbren, 'Crime, Time'; *Gérôme*, 122–25. The stage sets: Ripley, *Julius Caesar*, 123–25, 185.

71 *Rome, Romains*, 74–75; *Jean-Paul Laurens*, 78–79 (in the context of the painter's wider career). Different versions of the ancient rumours: Tacitus, *Annals* 6, 50; Suetonius, *Caligula* 12.

72 Josephus, *Jewish Antiquities* 19, 162–66; Suetonius, *Claudius* 10; Dio, *Roman History* 60, 1.

73 Good introductions to his career: Prettejohn et al. (eds), *Sir Lawrence Alma-Tadema*; Barrow, *Lawrence Alma-Tadema*. Fry's fulminations: *The Nation* 18 January 1913, 666–67 (reprinted in Reed (ed.), *Roger Fry Reader*, 147–49). Some of the complexities of Alma-Tadema's place in the history of 'history painting': Prettejohn, 'Recreating Rome'.

74 In contrast to Fry's judgement, one of the themes of Zimmern, *Alma Tadema* is the *difficulty* of some of his painting.

75 This and the other versions: Prettejohn et al. (eds), *Sir Lawrence Alma-Tadema*, 27, 29, 164–66; Barrow, *Lawrence Alma-Tadema*, 37, 61–63. 'Chronicle' in the *Journal of the Royal Institute of British Architects* 1906 compares the character of the Praetorian Guard in each of the three paintings. An even more chilling version of the scene is Jean-Paul Raphaël Sinibaldi's *Claudius Named Emperor*, discussed in *Rome, Romains*, 76–77.

76 For example, Ruskin, 'Notes' (calling the painter a 'modern Republican', while deploring the triviality of the subject matter).

77 Postnikova, 'Historismus'; Marcos, 'Vom Monster', 366.

78 Suetonius, *Nero* 47–50.

79 Pliny, *Natural History* 34, 84 (my thanks to Federica Rossi for reminding me of this).

80 Mamontova, 'Vasily Sergeevich Smirnov', 245.

### Chapter VII
### Caesar's Wife . . .
### Above Suspicion?

1 Barrow, *Lawrence Alma-Tadema*, 34 (though the painting has not been prominent in studies of Alma-Tadema).

2 Tacitus, *Annals* 2, 53–83; Suetonius, *Caligula* 1–7. Agrippina's career: Shotter, 'Agrippina the Elder'.

3 Griffin and Griffin, 'Show us you care'.

4 The events leading up to the death of Agrippina: Tacitus *Annals* 4, 52–54; 6, 25–26; Suetonius, *Tiberius* 53. The recovery of the ashes by Caligula: Suetonius, *Caligula* 15; *CIL* 6, 886 (the tombstone). The conversion to corn measure: Esch, 'On the Reuse', 22–24.

5 Different views on the identification: Lyttleton in Chambers and Martineau (eds), *Splendours*, 170; Brown in *Giulio Romano*, 314. The tug of love: Christiansen, *Genius of Andrea Mantegna*, 6.

6 'Romana princeps' (the female equivalent of 'princeps'): *Consolatio ad Liviam* 356; discussed by Purcell, 'Livia' ('absurd hyperbole', p. 78). Livia's career, Barrett, *Livia* (pp. 307–8 for her name).

7 This point is made by Dio, *Roman History* 53, 19.

8 A wider discussion of these issues: Duindam, *Dynasties*, 87–155.

9 Plutarch, *Julius Caesar* 10.

10 Tatum, *Patrician Tribune*, 62–86.

11 The poisoned figs: Fig. 6.14a (the line about the figs in *I, Claudius* was the invention of the scriptwriter, and had nothing to do with the original by Robert Graves). The loving deathbed scene: Suetonius, *Augustus* 99.

12 The beginning of this tradition (and its sparse Republican precedents, notably the famous statue *Cornelia, Mother of the Gracchi*): Flory, 'Livia'. Useful reviews of (imperial and elite) female portraits: Wood, *Imperial Women*; Fejfer, *Roman Portraits*, 331–69; Hekster, *Emperors and Ancestors*, 111–59. Female portraiture in the Greek East: Dillon, *Female Portrait Statue*.

13 Coin images of Livia: Harvey, *Julia Augusta*, with some wider discussion of women on imperial coinage.

14 Bartman, *Portraits of Livia*, 88–90 (a book which reviews all known or presumed portraits of her). Even on such a well-contextualised monument as the Altar of Peace, there remain uncertainties on the identification of several female characters of the imperial family: Rose, *Dynastic Commemoration*, 103–4.

15 The whole group of seventeen imperial statues of different phases: Rose, *Dynastic Commemoration*, 121–26.

16 A systematic attempt at such minute analysis: Winkes, *Livia, Octavia, Iulia*.

17 Fejfer, *Roman Portraits*, 339–40; 351–57.

18 Wood, 'Subject and Artist'; Smith, 'Roman Portraits', 214–15.

19 The cameo and the different identifications: Wood, 'Messalina', 230–31; Ginsburg, *Representing Agrippina*, 136–38, both following studies that see the central figure as Agrippina and the 'child' to the left (who may or may not originally have also been in a cornucopia) as the Goddess 'Roma'; Boschung 'Bildnistypen', 72. The Rubens connection: Meulen, *Rubens Copies*, 139, 191, 197 and 199; McGrath, 'Rubens's Infant-Cornucopia', 317.

20 Tacitus, *Annals* 13, 16–17.

21 Beard, North and Price, *Religions of Rome* 206–10; and 348–63; above, pp. 175–76.

22 Wood, 'Messalina', esp. 219–30 (also reviewing alternative identifications);

Smith, *Polis and Personification*, 110–12 (for the Greek model).

23 Smith, 'Imperial Reliefs', 127–32, for this panel; *Marble Reliefs*, 74–78, for this panel—where he identifies the divine figure as the goddess 'Good Fortune', but with the same general implications. Ceres: Ginsburg, *Representing Agrippina*, 131–32.

24 Despite important work on the gendered ideology of these statues and their divine attributes (for example, Davies, 'Portrait Statues'), the problems of the equivalence of empress and divinity are often obscured by a focus on typology (in the case of both imperial and non-imperial women): 'Ceres-type', 'Pudicitia-type', and so on. This typology in action: Davies, 'Honorific vs Funerary'; Fejfer, 'Statues of Roman Women'.

25 The title of this section is borrowed and adapted from Sarah B. Pomeroy, *Goddesses, Whores, Wives and Slaves* (New York, 1975).

26 Zimmer, 'Aus den Sammlungen', esp. 8–10 and 19 (on the Mantuan originals, suggesting that, in the absence of any later evidence, they were probably destroyed in the Sack of Mantua in 1630 or had been sent away earlier), 21–22 (on whether Sadeler's prints were made from the originals which perhaps ended up in Prague, or on copies commissioned by Rudolf II), 29–30 (on the sources and influence of the empresses). There can be no doubt that the old orthodoxy (Wethey, *Paintings of Titian*, 236–37), that they were an invention of Sadeler, is incorrect. Some of the key archival documents on the 'empresses': Venturini. *Le collezioni Gonzaga*, 46–50 (with documents 303, 306, 307, 310, 314).

27 Full text in Appendix.

28 There may be even more layers of confusion here. When the verse starts (in the words of Pompeia), 'I am the one born to be the pledge of the love of my father and my husband', it looks as if the writer has in mind the figure of Caesar's daughter Julia, who was married to Pompey, and seems to have been an important factor—until her death—in keeping the peace between the two men.

29 The role of the gaps in Fulvio: Kellen, 'Exemplary Metals', 285–87; Orgel, *Spectacular Performances*, 173–79

(illustrating the role of an image of Claudius as a 'place-filler' for Cossutia in the 1524 Lyons edition of the book).

30 Juvenal, *Satires* 6, 122–23 ('papillis . . . auratis').

31 Warren, *Art Nouveau*, 133 (though imagining Messalina is the sole target of the 'sexual wit'). As well as *Messalina and Her Companion*, the title is also recorded as *Messalina Returning Home*, but it is not clear what Beardsley intended.

32 The print is entitled 'The Injured Count . . . S' (c. 1786); Clark, *Scandal*, 68–69.

33 Redford, *Dilettanti*, 135–36.

34 The phrase 'garden rubbish' is adapted from Tacitus *Annals* 11, 32 ('purgamenta hortorum'). The artist and 'historico-sadist', Georges-Antoine Rochegrosse (1859–1938) also painted more or less gruesome scenes of the deaths of the emperor Vitellius, Julius Caesar, the mythical Andromache, the Syrian king Sardanapalus and others (recently discussed by Sérié, 'Theatricality', 167–72).

35 Aelius Donatus, *Life of Virgil* 32, which may be based on Suetonius's lost *Life* of the poet.

36 Roworth, 'Angelica Kauffman's Place'; Horejsi, *Novel Cleopatras*, 154–55 (in the context of fictional representations of Octavia). Kauffman's husband, Antonio Zucchi, also painted a version of the scene, now in Nostell Priory, Yorkshire, UK.

37 Condon et al. (eds), *Ingres*, 52–59, 160–66; Siegfried, *Ingres* 56–64 (in part reworking her 'Ingres' Reading', 666–72). The latest, 1864, version: Cohn, 'Introduction', 28–30; https://www.christies.com/features/Deconstructed-Ingres-Virgil-reading-from-the-Aeneid-9121-1.aspx.

38 The career of the Elder: above, n. 2. The Younger: Barrett, *Agrippina* (a 'straight' biography); Ginsburg, *Representing Agrippina* (focussing on the loaded, ideological representations of her).

39 'It is a very convenient custom, to give the name of Agrippina to every statue of a Roman female whose character or title cannot be ascertained.': *Critical Review* 27 (1799), 558.

40 Prown, 'Benjamin West', 38–41; Smith, *Nation Made Real*, 143–45. From a different critical perspective: Nemerov,

'Ashes of Germanicus'. It is the subject of an excellent online lecture by John Walsh for Yale University Art Gallery, https://www.youtube.com/watch?v =qAr5YJyawSA. West's smaller version of the scene in Philadelphia: Staley, 'Landing of Agrippina'.

41 Liversidge, 'Representing Rome', 83–86; https://www.tate.org.uk/art /artworks/turner-ancient-rome -agrippina-landing-with-the-ashes -of-germanicus-n00523.

42 Harris, *Seventeenth-Century Art*, 274–75; Pierre Rosenberg in *Nicolas Poussin*, 156–59; Dempsey, 'Nicolas Poussin'.

43 The winner was Louis-Simon Boizot: Rosenblum, *Transformations*, 31–32 (reflecting on the influence of Poussin's version).

44 Hicks, 'Roman Matron', 45–47.

45 Tacitus, *Annals* 14, 1–12 (with the instructions to strike her womb); Suetonius, *Nero* 34; Dio, *Roman History* 61, 11–14.

46 Prettejohn, 'Recreating Rome', 60–61.

47 *Roman de la Rose*, 6164–76, discussed in detail by Raimondi, 'Lectio Boethiana', 71–77; 'Monks Tale', 3669–84. The complex tradition, and many different written and visual forms, of the *Revenge*: Weigert, *French Visual Culture*, 161–88 (citing the stage directions, p. 251 n. 30). Nero's role in the French Middle Ages more generally: Cropp, 'Nero, Emperor and Tyrant'.

48 Jacobus de Voragine, *Golden Legend*, 347–48

49 Nero's performance as Canace: Suetonius, *Nero* 21. His reincarnation, Plutarch, *On God's Slowness to Punish* 567 E–F. Discussion: Frazer, 'Nero'; Champlin, *Nero*, 25–26, 277.

50 The technical details of the Washington panel (including arguments for the later inclusion of Germanicus): Wheelock, *Flemish Paintings*, 160. Some of the arguments about quality: Wagenberg-Ter Hoeven, 'Matter of Mistaken Identity', 116.

51 Just to add to the complexity, doubts have been raised as to whether what is now called the Gonzaga Cameo is really the one owned by the Gonzaga and admired by Rubens: de Grummond, 'Real Gonzaga Cameo'. The different identifications proposed:

Zwierlein-Diehl, *Antike Gemmen*, 62–65.

52 In the 'compare and contrast' tradition, de Grummond's thesis (*Rubens and Antique Coins*, 205–26) tries to link other cameos and gems identified as 'Germanicus' to this image—with all the usual dangers.

53 The catalogue of the sale of the Lebrun Collection in 1791: de Grummond, *Rubens and Antique Coins*, 206.

54 Wheelock, *Flemish Paintings*, 160 and 165 n. 3.

55 Wheelock, *Flemish Paintings*, 162 is a good example of the squirming: Rubens, he argues, would not have given Tiberius such an idealising look, and it was 'improbable' that he would have paired Tiberius with his first wife. Similarly: Wagenberg-Ter Hoeven, 'Matter of Mistaken Identity'.

56 Suetonius, *Tiberius* 7.

## Chapter VIII
## Afterword

1 Pasquinelli, *La galleria*.

2 Sadleir (ed.), *Irish Peer*, 126–27, an account based entirely on Wilmot's letters home. On the empresses, she continues that their relation to the emperors is 'like tête à têtes in a magazine', referring to a gossipy (or scurrilous) column in *Town and Country Magazine* in the late eighteenth century, featuring an imaginary dialogue between a man and a woman (Mitchell, 'The Tête-à-Têtes').

3 Lewis's career: Bearden and Henderson, *African-American Artists*, 54–77; Buick, *Child of the Fire* (pp 186–207 on this and other Cleopatras). 'The Death of Cleopatra': Woods, 'An African Queen'; Nelson, *Color of Stone*, 159–78; Gold, 'The Death of Cleopatra'. The *Young Octavian* has attracted little comment; but see https://americanart.si.edu/ artwork/young-octavian-14633. The rediscovery of Lewis's grave: https:// hyperallergic.com/434881/edmonia -lewis-grave/.

4 Reviews of the disputed identifications and date: Pollini, *Portraiture*, 45–53, 96; Lorenz, 'Die römische Porträtforschung'. The attribution to Canova: Mingazzini, 'Datazione del ritratto'. The Ostian provenance: Bignamini, 'I marmi Fagan', 369–70.

5 One example is the 1994 statue by
Khalil Bendib of the assassinated
Palestinian-American Alex Odeh,
at Santa Ana, California. It is not
immediately clear whether Odeh is
wearing an Arab robe or Roman toga,
but in my own correspondence with
Bendib he wrote of it as a toga.

6 Dalí's fascination with Trajan: King,
'*Ten Recipes*'; https://www.wnyc.org
/story/salvador-dali-four-conversations/.

7 https://collections.vam.ac.uk/item
/O92994/the-emperor-vitellius
-sculpture-rosso-medardo/. Later
versions of the online text strangely
replace 'fluid' with 'lucid'.

8 Rosenthal, *Anselm Kiefer*, 60 (quotation,
p. 17, from an interview, June 1980,
in *Art: Das Kunstmagazin*); Saltzman,
*Anselm Kiefer*, 63–64.

9 Wyke, *Projecting the Past* (still the
classic study); Joshel et al. (eds), *Imperial
Projections*.

10 Landau (ed.), *Gladiator* (on Gérôme,
pp. 22–26, 49); Winkler (ed.), *Gladiator*.

11 Elliott, *Address*, Appendix 59.

# Bibliography

All the ancient texts referred to in this book are available in the original Greek and Latin, with English translations, in the Loeb Classical Library (Cambridge, MA), except Aurelius Victor, *On the Emperors* (*De Caesaribus*), which is available in Franz Pichlmayr and Roland Gründel, *Sexti Aurelii Victoris Liber de Caesaribus* (Leipzig, 1961), English translation by Harry W. Bird (Translated Texts for Historians 17, Liverpool, 1994). The Loeb text of Donatus, *Life of Virgil* is published with Suetonius, *Lives of the Poets*. Many of these works are available online in the original language and in translation. Two particularly useful websites are: www.perseus .tufts.edu and http://penelope.uchicago.edu /Thayer/E/Roman/home.html.

Of the early medieval texts: Chaucer, 'Monk's Tale' is cited from the edition of Walter W. Skeat (ed.), *The Complete Works of Geoffrey Chaucer* (second edition, Oxford, 1900), vol. 4; *Roman de la Rose*, from Félix Lecoy (ed.), *Le Roman de la Rose par Guillaume de Lorris et Jean de Meun*, 3 vols (Paris, 1965–70), English translation by Frances Horgan, *The Romance of the Rose* (Oxford, 1999); Dante, *Inferno* (*Hell*), from Georgio Petrocchi (ed.), *Dante Alighieri, La Commedia secondo l'antica vulgata* (Milan, 1966–67), English translation by Robin Kirkpatrick (London, 2006–7); John Malalas, *Chronicle*, from Johannes Thurn (ed.), *Ioannis Malalae Chronographia* (Berlin and New York, 2000), English translation by Elizabeth Jeffreys et al., *The Chronicle of John Malalas* (Melbourne, 1986). Important parts of Zonaras's *History*, written in the twelfth century but drawing heavily on earlier writers, are available in English translation by Thomas M. Banchich and Eugene N. Lane (Abingdon and New York, 2009).

Collections of ancient documents, inscriptions and coins cited:

*BMCRE*: Harold B. Mattingly and R.A.G. Carson (eds), *Coins of the Roman Empire in the British Museum* (London, 1923–62)

*CIL*: *Corpus Inscriptionum Latinarum* (Berlin, from 1863). Online: https://cil.bbaw.de/ and https://arachne.uni-koeln.de /drupal/?q=en/node/291

*POxy*: *The Oxyrhynchus Papyri* (London, from 1898). Online: http://www.papyrology.ox.ac .uk/POxy/ees/ees.html

*RPC*: *Roman Provincial Coinage* (London and Paris, from 1992) Online: https://rpc.ashmus .ox.ac.uk/

*RRC*: Michael H. Crawford (ed.), *Roman Republican Coinage* (Cambridge, 1974). Online: http://numismatics.org/crro/

Digital versions of many of the newspapers and magazines cited are available at https:// www.gale.com/primary-sources/historical -newspapers (subscription service) and https://gallica.bnf.fr (for French publications). *Oxford English Dictionary* is available online at https://www.oed.com/ (subscription service).

'Acquisitions/1992', *J. Paul Getty Museum Journal* 21 (1993), 101–63

Addison, Joseph. *Dialogues upon the Usefulness of Ancient Medals* (London, 1726; reprinted New York, 1976)

Agustín, Antonio. *Dialogos de medallas, inscriciones y otras antiguedades* (Tarragona, 1587)

Albertoni, Margherita. 'Le statue di Giulio Cesare e del Navarca', *Bullettino della Commissione Archeologica Comunale di Roma* 95.1 (1993), 175–83

Alcorn, Ellenor and Timothy Schroder. 'The Nineteenth- and Twentieth-Century History of the Tazze', in Siemon (ed.), *Silver Caesars*, 148–57

Aldrovandi, Ulisse. 'Delle statue antiche, che per tutta Roma in diversi luoghi, e case si veggono', in Lucio Mauro, *Le antichità de la città di Roma* (Venice, 1556), 115–316

Alexander, Jonathan J. G. (ed.). *The Painted Page: Italian Renaissance Book Illumination, 1450–1550* (Exhib. Cat., London, 1994)

Alföldi, Andreas. 'Tonmodel und Reliefmedaillons aus den Donauländern', *Laureae Aquincenses memoriae Valentini Kuzsinszky dicatae I, Dissert. Pannon.* 10 (1938), 312–41

Allan, Scott and Mary Morton (eds.). *Reconsidering Gérôme* (Los Angeles, 2010)

Anderson, Christina M. *The Flemish Merchant of Venice: Daniel Nijs and the Sale of the Gonzaga Art Collection* (New Haven and London, 2015)

Ando, Clifford. *Imperial Ideology and Provincial Loyalty in the Roman Empire* (Berkeley and Los Angeles, 2000)

Ando, Clifford. *Imperial Rome, AD 193–284* (Edinburgh, 2012)

Andrén, Arvid. 'Greek and Roman Marbles in the Carl Milles Collection', *Opuscula Romana* 23 (1965), 75–117

Andrews, C. Bruyn (ed.). *The Torrington Diaries: containing the Tours through England and Wales of the Hon. John Byng (later Fifth Viscount Torrington) between the years 1781 and 1794*, vol. 3 (London, 1936)

Angelicoussis, Elizabeth. 'Walpole's Roman Legion: Antique Sculpture at Houghton Hall', *Apollo*, February 2009, 24–31

Arasse, Daniel. *Décors italiens de la Renaissance* (Paris, 2009)

Arata, Francesco Paolo. 'La nascita del Museo Capitolino', in Maria Elisa Tittoni (ed.), *Il Palazzo dei Conservatori e il Palazzo Nuovo in Campidoglio: Momenti di storia urbana a Roma* (Pisa, 1996), 75–81

Aretino, Pietro. *La humanità di Christo* (Venice, 1535), 3 vols, cited from Giulio Ferroni (ed.), *Pietro Aretino* (Rome, 2002)

Ascoli, Albert R. *A Local Habitation and a Name: Imagining Histories in the Italian Renaissance* (New York, 2011)

Ashmole, Bernard. *Forgeries of Ancient Sculpture, Creation and Detection* (The First J. L. Myres Memorial Lecture) (Oxford, 1961)

Astington, John, H. *Stage and Picture in the English Renaissance: The Mirror up to Nature* (Cambridge, 2017)

Attwood, Philip. *Italian Medals c. 1530–1600*, 2 vols (London, 2003)

Ayres, Linda (ed.). *Harvard Divided* (Exhib. Cat., Cambridge, MA, 1976)

Ayres, Philip. *Classical Culture and the Idea of Rome in the Eighteenth Century* (Cambridge, 1997)

Bacci, Francesca Maria. 'Ritratti di imperatori nella scultura italiana del Quattrocento', in Nesi (ed.), *Ritratti di Imperatori*, 21–97

Bacci, Francesca Maria. 'Catalogo', in Nesi (ed.), *Ritratti di Imperatori*, 158–89

Baglione, Giovanni. *Le vite de' pittori, scultori et architetti* (Rome, 1642)

Bailey, Stephen. 'Metamorphoses of the Grimani "Vitellius"', *The J. Paul Getty Museum Journal* 5 (1977), 105–22

Bailey, Stephen. 'Metamorphoses of the Grimani "Vitellius": Addenda and Corrigenda', *The J. Paul Getty Museum Journal* 8 (1980), 207–8

Baker, Malcolm. '"A Sort of Corporate Company": Approaching the Portrait Bust in Its Setting', in Penelope Curtis et al., *Return to Life: A New Look at the Portrait Bust* (Exhib. Cat., Leeds, 2000), 20–35

Baker, Malcolm. *The Marble Index: Roubiliac and Sculptural Portaiture in Eighteenth-Century Britain* (New Haven and London, 2014)

Baker, Malcolm. 'Attending to the Veristic Sculptural Portrait in the Eighteenth Century', in Baker and Andrew Hemingway (eds), *Art as Worldmaking: Critical Essays on Realism and Naturalism* (Manchester, 2018), 53–69

Bann, Stephen. 'Questions of Genre in Early Nineteenth-Century French Painting', *New Literary History* 34 (2003), 501–11

Barberini, Nicoletta and Matilde Conti. *Ceramiche artistiche Minghetti: Bologna* (Bologna, 1994)

Barbier de Montault, Xavier. 'Inventaire descriptif des tapisseries de haute-lisse conservées à Rome', *Mémoires de l'Académie des Sciences, Lettres et Arts d' Arras*, second series, 10 (1878), 175–284

Barghahn, Barbara von. *Philip IV and the 'Golden House' of the Buen Retiro: In the Tradition of Caesar*, vol. 1 (New York and London, 1986)

Baring-Gould, S. *The Tragedy of the Caesars: A Study of the Character of the Caesars of the Julian and Claudian Houses*, 2 vols (London, 1892)

Barkan, Leonard. *Unearthing the Past: Archaeology and Aesthetics in the Making of Renaissance Culture* (New Haven and London, 1999)

Barolsky, Paul. *Ovid and the Metamorphoses of Modern Art from Botticelli to Picasso* (New Haven and London, 2014)

Baroni, Alessandra and Manfred Sellink. *Stradanus, 1523–1605: Court Artist of the Medici* (Turnhout, 2012)

Barrett, Anthony. *Agrippina: Sex, Power and Politics in the Early Empire* (New Haven and London, 1996)

Barrett, Anthony. *Livia: First Lady of Imperial Rome* (New Haven and London, 2002)

Barrow, Rosemary. *Lawrence Alma-Tadema* (London and New York, 2001)

Bartman, Elizabeth. *Portraits of Livia: Imaging the Imperial Woman in Augustan Rome* (Cambridge, 1998)

Barton, Tamsyn. *Power and Knowledge: Astrology, Physiognomics, and Medicine under the Roman Empire* (Ann Arbor, 1994)

Bauer, Rotraud and Herbert Haupt. 'Das Kunstkammerinventar Kaiser Rudolfs II. 1607–1611', *Jahrbuch der Kunsthistorischen Sammlungen in Wien* 72, (1976)

Bauer, Stefan. *The Invention of Papal History: Onofrio Panvinio between Renaissance and Catholic Reform* (Oxford, 2019)

Beard, Mary. *The Roman Triumph* (Cambridge, MA, 2007)

Beard, Mary. 'Was He Quite Ordinary?', *London Review of Books*, 23 July 2009, 8–9

Beard, Mary. *SPQR: A History of Ancient Rome* (London, 2015)

Beard, Mary. 'Suetonius, the Silver Caesars, and Mistaken Identities', in Siemon (ed.), *Silver Caesars*, 32–45

Beard, Mary and John Henderson, *Classical Art: From Greece to Rome* (Oxford, 2001)

Beard, Mary, John North and Simon Price. *Religions of Rome*, vol. 1 (Cambridge, 1998)

Bearden, Romare and Harry Henderson. *A History of Afrrican-American Artists, from 1792 to the Present* (New York, 1993)

Beeny, Emily. 'Blood Spectacle: Gérôme in the Arena', in Allan and Morton (eds), *Reconsidering Gérôme*, 40–53

Beer, Susanna de. 'The Roman "Academy" of Pomponio Leto: From an Informal Humanist Network to the Institution of a Literary Society', in Arjaan van Dixhoorn and Susie Speakman Sutch, *The Reach of the Republic of Letters: Literary and Learned Societies in Late Medieval and Early Modern Europe* (Leiden and Boston, MA, 2008), 181–218

Beerbohm, Max. *Zuleika Dobson, or, An Oxford Love Story* (Oxford, 1911), cited from Penguin edition (Harmondsworth, 1952)

Belozerskaya, Marina. *Luxury Arts of the Renaissance* (Los Angeles, 2005)

Benedetti, Simona. *Il Palazzo Nuovo nella Piazza del Campidoglio dalla sua edificazione alla trasformazione in museo* (Rome, 2001)

Bernoulli, Johann J. *Römische Ikonographie*, vol. 1: *Die Bildnisse berühmter Römer* (Stuttgart, 1882)

Bertini, Giuseppe. 'La Collection Farnèse d'après les archives", in *La Tapisserie au XVIIe siècle et les collections européennes* (Actes du colloque international de Chambourd) (Paris 1999), 127–40

Berzaghi, Renato. 'Nota per il gabinetto dei Cesari', in Francesca Mattei (ed.), *Federico II Gonzaga e le arti* (Rome, 2016), 243–58

Besutti, Paola. 'Musiche e scene ducali ai tempi di Vespasiano Gonzaga: Le feste, Pallavicino, il teatro', in Giancarlo Malacarne et al. (eds), *Vespasiano Gonzaga. nonsolosabbioneta terza: Atti della giornata di studio 16 maggio 2016* (Sabbioneta, 2016), 137–51

Bignamini, Ilaria. 'I marmi Fagan in Vaticano: La vendita del 1804 e altre acquisizioni', *Bollettino dei monumenti, musei e gallerie pontificie* 16 (1996), 331–94

Bignamini, Ilaria and Clare Hornsby. *Digging and Dealing in Eighteenth-Century Rome*, 2 vols (New Haven and London, 2010)

Boch, Johann. *Descriptio publicae gratulationis, spectaculorum et ludorum, in aduentu sereniss. Principis Ernesti Archiducis Austriae, . . . an. 1594* (Antwerp, 1595)

Bodart, Diane H. *Tiziano e Federico II Gonzaga: Storia di un rapporto di committenza* (Rome, 1998)

Bodart, Didier G. J. 'Cérémonies et monuments romains à la mémoire d'Alexandre Farnèse, duc de Parme et de Plaisance', *Bulletin de l'Institut historique belge de Rome* 37 (1966), 121–36

Bodon, Giulio. *Enea Vico fra memoria e miraggio della classicità* (Rome 1997)

Bodon, Giulio. *Veneranda Antiquitas: Studi sull'eredità dell'antico nella Rinascenza veneta* (Bern etc., 2005)

Boeye, Kerry and Nandini B. Pandey. 'Augustus as Visionary: The Legend of the Augustan Altar in S. Maria in Aracoeli, Rome', in Penelope J. Goodman (ed.), *Afterlives of Augustus, AD 14–2014* (Cambridge, 2018), 152–77

Boime, Albert. *Thomas Couture and the Eclectic Vision* (New Haven and London, 1980)

Boime, Albert. 'The Prix de Rome: Images of Authority and Threshold of Official Success', *Art Journal* 44 (1984), 281–89

Bonnet, Alain et al. *Devenir peintre au XIX^e*

siècle: Baudry, Bouguereau, Lenepveu (Exhib. Cat., Lyon, 2007)

Boon, George C. 'A Roman Pastrycook's Mould from Silchester', *The Antiquaries Journal*, 38 (1958), 237–40

Borchert, Till-Holger (ed.). *Memling's Portraits* (Exhib. Cat., Madrid, 2005)

Borda, Maurizio. 'Il ritratto Tuscolano di Giulio Cesare', *Atti della Pontificia accademia romana di archeologia. Rendiconti* 20 (1943–44), 347–82

Bormand, Marc et al. (eds). *Desiderio da Settignano: Sculptor of Renaissance Florence* (Exhib. Cat., Washington, DC, 2007)

Borys, Ann Marie. *Vincenzo Scamozzi and the Chorography of Early Modern Architecture* (Farnham, 2014)

Boschung, Dietrich. *Die Bildnisse des Augustus* (Das römische Herrscherbild, Part 1, vol. 2) (Berlin, 1993)

Boschung, Dietrich. 'Die Bildnistypen der iulisch-claudischen Kaiserfamilie: Ein kritischer Forschungsbericht', *Journal of Roman Archaeology* 6 (1993), 39–79

Bottari, Giovanni Gaetano and Nicolao Foggini. *Il Museo Capitolino*, vol. 2 (Milan, 1820; first edition 1748)

Bottineau, Yves. 'L'Alcázar de Madrid et l'inventaire de 1686: Aspects de la cour d'Espagne au XVII$^e$ siècle (suite, 3$^e$ article)', *Bulletin Hispanique* 60 (1958), 145–79

Bowersock, Glen W. *Julian the Apostate* (Cambridge, MA, 1978)

Bowersock, Glen W. 'The Emperor Julian on his Predecessors', *Yale Classical Studies* 27 (1982), 159–72

Bresler, Ross M. R. *Between Ancient and All'Antica: The Imitation of Roman Coins in the Renaissance* (PhD dissertation, Boston University, 2002)

Brett, Cécile. 'Antonio Verrio (c. 1636–1707): His Career and Surviving Work', *British Art Journal* 10 (2009/10), 4–17

Brilliant, Richard. *Portraiture* (London, 1991)

Brilliant Richard and Dale Kinney (eds.). *Reuse Value: Spolia and Appropriation in Art and Architecture from Constantine to Sherrie Levine* (Farnham, 2011)

Brodsky, Joseph. 'Homage to Marcus Aurelius', in *On Grief and Reason: Essays* (New York, 1995)

Brodsky, Joseph. *Collected Poems in English* (New York, 2000)

Brotton, Jerry. *The Sale of the Late King's Goods: Charles I and his Art Collection* (Basingstoke and Oxford, 2006)

Brotton, Jerry and David McGrath. 'The Spanish Acquisition of King Charles I's Art Collection: The Letters of Alonso de Cárdenas, 1649–51', *Journal of the History of Collections* 20 (2008), 1–16

Brown, Beverly Louise. 'Corroborative Detail: Titian's "Christ and the Adulteress"', *Artibus et Historiae* 28 (2007), 73–105

Brown, Beverly Louise. 'Portraiture at the Courts of Italy', in Christiansen and Weppelmann (eds), *Renaissance Portrait*, 26–47

Brown, Clifford M. and Leandro Ventura. 'Le raccolte di antichità dei duchi di Mantova e dei rami cadetti di Guastalla e Sabbioneta', in Morselli (ed.), *Gonzaga: . . . L'esercizio del collezionismo*, 53–65

Brown, Jonathan and John H. Elliott. *A Palace for a King: The Buen Retiro and the Court of Philip IV* (New Haven and London, 1980)

Brown, Jonathan and John Elliott (eds). *The Sale of the Century: Artistic Relations between Spain and Great Britain, 1604–1655* (Exhib. Cat., New Haven and London, 2002)

Brown, Patricia Fortini. *Venice and Antiquity: The Venetian Sense of the Past* (New Haven and London, 1996)

Buccino, Laura. 'Le antichità del marchese Vincenzo Giustiniani nel Palazzo di Bassano Romano', *Bollettino d'arte* 96 (2006), 35–76

Buchan, John. *Julius Caesar* (London, 1932)

Buick, Kirsten Pai. *Child of the Fire: Mary Edmonia Lewis and the Problem of Art History's Black and Indian Subject* (Durham, NC and London, 2010)

Bull, Duncan et al. 'Les portraits de Jacopo et Ottavio Strada par Titien et Tintoret', in Vincent Delieuvin and Jean Habert (eds), *Titien, Tintoret, Véronèse: Rivalités à Venise* (Exhib. Cat., Paris, 2009), 200–213

Burke, Peter. 'A Survey of the Popularity of Ancient Historians, 1450–1700', *History and Theory* 5 (1966), 135–52

Burke, Peter. *The Fabrication of Louis XIV* (New Haven and London, 1994)

Burnett, Andrew. 'Coin Faking in the Renaissance', in Jones (ed.), *Why Fakes Matter*, 15–22

Burnett, Andrew. 'The Augustan Revolution

Seen from the Mints of the Provinces',
*Journal of Roman Studies* 101 (2011), 1–30

Burnett, Andrew and Richard Schofield.
'The Medallions of the *basamento* of the
Certosa di Pavia: Sources and Influence',
*Arte lombarda* 120 (1997), 5–28

Burns, Howard et al. *Valerio Belli Vicentino:
1468c.–1546* (Vicenza, 2000)

Busch, Renate von. *Studien zu deutschen
Antikensammlungen des 16. Jahrhunderts*
(Dissertation, Tübingen, 1973)

Cadario, Matteo. 'Le statue di Cesare a
Roma tra il 46 e il 44 a.C', *Annali della
Facoltà di lettere e filosofia dell'Università
degli Studi di Milano* 59 (2006), 25–70

Caglioti, Francesco. 'Mino da Fiesole, Mino
del Reame, Mino da Montemignaio: Un
caso chiarito di sdoppiamento d'identità
artistica', *Bollettino d'arte* 67 (1991), 19–86

Caglioti, 'Francesco. 'Desiderio da Settig-
nano: Profiles of Heroes and Heroines
of the Ancient World', in Bormand et al.
(eds), *Desiderio da Settignano*, 87–101

Caglioti, Francesco. 'Fifteenth-Century
Reliefs of Ancient Emperors and
Empresses in Florence: Production and
Collecting', in Penny and Schmidt (eds),
*Collecting Sculpture*, 67–109

Çakmak, Gülru. 'The Salon of 1859 and
Caesar: The Limits of Painting', in Allan
and Morton (eds), *Reconsidering Gérôme*,
65–80

Callatay, François de. 'La controverse
"imitateurs/faussaires" ou les riches
fantaisies monétaires de la Renaissance',
in Mounier and Nativel (eds), *Copier et
contrefaire*, 269–92

Campbell, Lorne et al. *Renaissance Faces: Van
Eyck to Titian* (Exhib. Cat., London, 2008)

Campbell, Stephen J. 'Mantegna's Triumph:
The Cultural Politics of Imitation
"all'antica" at the Court of Mantua,
1490–1530', in Campbell (ed.), *Artists at
Court: Image-Making and Identity, 1300–
1550* (Boston, MA, 2004), 91–105

Campbell, Stephen J. *Andrea Mantegna:
Humanist Aesthetics, Faith, and the Force of
Images* (London and Turnhout, 2020)

Campbell, Thomas [P.]. 'New Light on a Set
of *History of Julius Caesar* Tapestries in
Henry VIII's Collection', *Studies in the
Decorative Arts* 5 (1998), 2–39

Campbell, Thomas P. (ed.). *Tapestry in the
Renaissance: Art and Magnificence* (Exhib.
Cat., New York, 2002)

Campbell, Thomas P. *Henry VIII and the Art*

*of Majesty: Tapestries at the Tudor Court*
(New Haven and London, 2007)

Canfora, Davide (ed.). *La controversia di
Poggio Bracciolini e Guarino Veronese su
Cesare e Scipione* (Florence, 2001)

Canina, Luigi. *Descrizione dell'antico Tusculo*
(Rome, 1841)

Cannadine, David. 'The Context, Perfor-
mance and Meaning of Ritual: The
British Monarchy and the "Invention
of Tradition" c. 1820–1977', in Eric
Hobsbawm and Terence Ranger (eds),
*The Invention of Tradition* (Cambridge,
1983), 101–64

Cannadine, David and Simon Price. *Rituals
of Royalty: Power and Ceremonial in
Traditional Societies* (Cambridge, 1993)

Capoduro, Luisa. 'Effigi di imperatori
romani nel manoscritto Chig. J VII 259
della Biblioteca Vaticana: Origini e
diffusione di un'iconografia', *Storia
dell'arte* 79 (1993), 286–325

Carotta, Francesco. 'Il Cesare incognito:
Sulla postura del ritratto tusculano di
Giulio Cesare', *Numismatica e antichità
classiche* 45 (2016), 129–79

Carradori, Francesco. *Elementary Instructions
for Students of Sculpture*, trans. Matti
Kalevi Auvinen (Los Angeles, 2002);
original Italian edition: *Istruzione
elementare per gli studiosi della scultura*
(Florence, 1802)

Casini, Tommaso. 'Cristo e i manigoldi
nell'*Incoronazione di spine* di Tiziano',
*Venezia Cinquecento* 3 (1993), 97–118

Cavaceppi, Bartolomeo. *Raccolta d'antiche
statue*, 3 vols (Rome, 1768–72), cited from
the edition of Meyer and Piva (eds), *L'arte
di ben restaurare*

Cavendish, William G. S. (Sixth Duke of
Devonshire). *Handbook of Chatsworth and
Hardwick* (London, 1845)

Chambers, David and Jane Martineau (eds).
*Splendours of the Gonzaga* (Exhib. Cat.,
London, 1981)

Chambers, R. W. *Man's Unconquerable Mind:
Studies of English Writers, from Bede to
A. E. Housman and W. P. Ker* (reprinted
London, 1964; first edition 1939)

Champlin, Edward. *Nero* (Cambridge, MA,
2003)

*Charles I: King and Collector* (Exhib. Cat.,
London, 2018)

Cholmondeley, David and Andrew Moore.
*Houghton Hall: Portrait of an English
Country House* (New York, 2014)

Christian, Kathleen Wren. 'Caesars, Twelve', in Anthony Grafton et al. (eds), *Harvard Encyclopedia of the Classical Tradition* (Cambridge, MA, 2010), 155–56

Christian, Kathleen Wren. *Empire without End: Antiquities Collections in Renaissance Rome, c. 1350–1527* (New Haven and London, 2010)

Christiansen, Keith. *The Genius of Andrea Mantegna* (New Haven and London, 2009)

Christiansen, Keith and Stefan Weppelmann (eds). *The Renaissance Portrait: From Donatello to Bellini* (Exhib. Cat., New York, 2011)

'Chronicle', *Journal of the Royal Institute of British Architects*, 1906, 444–45

Clark, Anna. *Scandal: The Sexual Politics of the British Constitution* (Princeton, 2003)

Clark, H. Nichols B. 'An Icon Preserved: Continuity in the Sculptural Images of Washington', in Barbara J. Mitnick et al., *George Washington: American Symbol* (New York, 1999), 39–53

Cleland, Elizabeth (ed.). *Grand Design: Pieter Coecke van Aelst and Renaissance Tapestry* (Exhib. Cat., New York, 2014)

Clifford, Timothy et al. *The Three Graces. Antonio Canova* (Exhib. Cat., Edinburgh, 1995)

Coarelli, Filippo (ed.). *Divus Vespasianus: Il bimillenario dei Flavi* (Exhib. Cat., Rome, 2009)

Coarelli, Filippo and Giuseppina Ghini (eds.). *Caligola: La trasgressione al potere* (Exhib. Cat., Rome, 2013)

Cohn, Marjorie B. 'Introduction', in Condon et al. (eds), *Ingres*, 10–33

Cole, Emily. 'Theobalds, Hertfordshire: The Plan and Interiors of an Elizabethan Country House', *Architectural History* 60 (2017), 71–116

Cole, Nicholas. 'Republicanism, Caesarism, and Political Change', in Griffin (ed.), *Companion to Julius Caesar*, 418–30

Collins, Jeffrey. 'A Nation of Statues: Museums and Identity in Eighteenth-Century Rome', in Denise Amy Baxter and Meredith Martin (eds), *Architectural Space in Eighteenth-Century Europe: Constructing Identities and Interiors* (London and New York, 2010), 187–214

Combe, Taylor, et al. *A Description of the Collection of Ancient Marbles in the British Museum*, Part 11 (London, 1861)

Condon, Patricia et al. (eds.). *Ingres. In Pursuit of Perfection: The Art of J.-A.-D. Ingres* (Louisville, 1983)

Conte, Gian Biagio. *Latin Literature: A History*, trans. Joseph B. Solodow (Baltimore and London, 1994)

Costello, Donald P. *Fellini's Road* (Notre Dame, 1983)

Cottafavi, Clinio. 'Cronaca delle Belle Arti', *Bollettino d'arte* June 1928, 616–23

Cottrell, Philip. 'Art Treasures of the United Kingdom and the United States: The George Scharf Papers', *Art Bulletin* 94 (2012), 618–40

Coulter, Frances. 'Drawing Titian's "Caesars": A Rediscovered Album by Bernardino Campi', *Burlington Magazine* 161 (2019), 562–71

Coulter, Frances. 'Supporting Titian's Emperors: Giulio Romano's Narrative Framework in the *Gabinetto dei Cesari*' (forthcoming)

Craske, Matthew. *The Silent Rhetoric of the Body* (New Haven and London, 2007)

Crawford, Michael H. 'Hamlet without the Prince', *Journal of Roman Studies* 66 (1976), 214–17

Cropp, Glynnis M. 'Nero, Emperor and Tyrant, in the Medieval French Tradition', *Florilegium* 24 (2007), 21–36

Crowe, Joseph Archer and Giovanni Battista Cavalcaselle. *Titian: His Life and Times*, vol. 1 (London, 1877)

Cunnally, John. *Images of the Illustrious: The Numismatic Presence in the Renaissance* (Princeton, 1999)

Cunnally, John. 'Of Mauss and (Renaissance) Men: Numismatics, Prestation and the Genesis of Visual Literacy', in Alan M. Stahl (ed.), *The Rebirth of Antiquity: Numismatics, Archaeology and Classical Studies in the Culture of the Renaissance* (Princeton, 2009), 27–47

Cutler, Anthony. 'Octavian and the Sibyl in Christian Hands', *Vergilius* 11 (1965), 22–32

D'Alessi, Fabio (ed.). *Hieronymi Bononii tarvisini antiquarii libri duo* (Venice, 1995)

D'Amico, Daniela. *Sullo Pseudo-Vitellio* (Tesi di laurea, Università Ca' Foscari, Venice, 2012/13)

Dandelet, Thomas James. *The Renaissance of Empire in Early Modern Europe* (Cambridge, 2014)

D'après l'antique (Exhib. Cat., Paris, 2000)

Darcel, Alfred (ed.). *La Collection Spitzer: Antiquité, Moyen Age, Renaissance*, vol. 3 (Paris, 1891)

Darley, Gillian. *John Soane: An Accidental Romantic* (New Haven and London, 1999)

Daunt, Catherine. *Portrait Sets in Tudor and Jacobean England* (DPhil dissertation, University of Sussex, 2015)

Davies, Glenys. 'Portrait Statues as Models for Gender Roles in Roman Society', *Memoirs of the American Academy at Rome*, supplementary vol. 7: *Role Models in the Roman World. Identity and Assimilation* (2008), 207–20

Davies, Glenys. 'Honorific vs Funerary Statues of Women: Essentially the Same or Fundamentally Different?', in Emily Hemelrijk and Greg Woolf (eds), *Women and the Roman City in the Latin West* (*Mnemosyne* supplement 360, Leiden, 2013), 171–99

de Bellaigue, Geoffrey. *French Porcelain in the Collection of Her Majesty the Queen*, 3 vols (London, 2009)

de Grummond, Nancy Thomson. *Rubens and Antique Coins and Gems* (PhD dissertation, University of North Carolina, Chapel Hill, 1968)

de Grummond, Nancy Thomson. 'The Real Gonzaga Cameo', *American Journal of Archaeology* 78 (1974), 427–29

de Grummond, Nancy Thomson (ed.). *Encyclopaedia of the History of Classical Archaeology* (London and New York, 1996)

Dekesel, Christian. 'Hubert Goltzius in Douai (5.11.1560–14.11.1560)', *Revue belge de numismatique* 127 (1981), 117–25

Delaforce, Angela. 'The Collection of Antonio Pérez, Secretary of State to Philip II', *Burlington Magazine* 124 (1982), 742–53

Della Porta, Giambattista. *De humana physiognomonia, libri IIII* (Vico Equense, 1586)

Dempsey, Charles. 'The Carracci *Postille* to Vasari's *Lives*', *Art Bulletin* 68 (1986), 72–76

Dempsey, Charles. 'Nicolas Poussin between Italy and France: Poussin's *Death of Germanicus* and the Invention of the Tableau', in Max Seidel (ed.), *L'Europa e l'arte italiana: Per cento anni dalla fondazione del Kunsthistorisches Institut in Florenz* (Venice, 2000), 321–35

de' Musi, Giulio. *Speculum Romanae Magnificentiae* (Venice, 1554)

De Santi, Pier Marco. *La Dolce Vita: Scandalo a Roma, Palma d'oro a Cannes* (Pisa, 2004)

Desmas, Anne-Lise and Francesco Freddolini. 'Sculpture in the Palace: Narratives of Comparison, Legacy and Unity', in Gail Feigenbaum (ed.), *Display of Art in the Roman Palace, 1550–1750* (Los Angeles, 2014), 267–82

Dessen, Cynthia S. 'An Eighteenth-Century Imitation of Persius, *Satire* 1', *Texas Studies in Literature and Language* 20 (1978), 433–56

Devonshire, Duchess of. *Treasures of Chatsworth: A Private View* (London, 1991)

Diderot, Denis. *Oeuvres complètes*, vol. 10 (ed. J. Assézat) (Paris, 1876)

Diemer, Dorothea et al. (eds). *Die Münchner Kunstkammer*, 3 vols (Munich, 2008)

Diemer, Dorothea and Peter Diemer. 'Mantua in Bayern? Eine Planungsepisode der Münchner Kunstkammer', in Diemer et al. (eds), *Münchner Kunsthammer*, vol. 3, 321–29

Diemer, Peter (ed.). *Das Inventar der Münchner herzoglichen Kunstkammer von 1598* (Munich, 2004)

Dillon, Sheila. *Ancient Greek Portrait Sculpture: Contexts, Subjects and Styles* (Cambridge, 2006)

Dillon, Sheila. *The Female Portrait Statue in the Greek World* (Cambridge, 2010)

Döhl, H. and Paul Zanker. 'La scultura', in F. Zevi (ed.), *Pompei 79* (Naples, 1979), 177–210

Dolce, Lodovico. *Dialogo della pittura* (Venice, 1557)

Dolman, Brett. 'Antonio Verrio and the Royal Image at Hampton Court', *British Art Journal* 10 (2009/10), 18–28

Draper, James David and Guilhem Scherf (eds). *Playing with Fire: European Terracotta Models, 1740–1840* (Exhib. Cat., New York 2003)

Duindam, Jeroen. *Dynasties: A Global History of Power, 1300–1800* (Cambridge, 2016)

Dunnett, Jane. 'The Rhetoric of Romanità: Representations of Caesar in Fascist Theatre', in Wyke, *Julius Caesar*, 244–65

Dutton Cook, Edward. *Art in England: Notes and Studies* (London, 1869)

Edmondson, Jonathan (ed.). *Augustus* (Edinburgh, 2009)

Edwards, Catharine. *Writing Rome: Textual Approaches to the City* (Cambridge, 1996)

Eidelberg, Martin and Eliot W. Rowlands. 'The Dispersal of the Last Duke of Mantua's Paintings', *Gazette des Beaux-Arts* 123 (1994), 207–87

Ekserdjian, David. *Parmigianino* (New Haven and London, 2006)

Elkins, James. 'From Original to Copy and Back Again', *British Journal of Aesthetics* 33 (1993), 113–20

Elliott, Jesse D. *Address of Com. Jesse D. Elliott, U.S.N., Delivered in Washington County, Maryland, to His Early Companions at Their Request, on November 24, 1843* (Philadelphia, 1844)

Erasmus, Desiderio. *De puritate tabernaculi sive ecclesiae christianae* (Basel, 1536)

Erasmus, Desiderio. *The Correspondence of Erasmus, 1252–1355* (Collected Works of Erasmus 9), trans. R.A.B. Mynors (Toronto, 1989)

*Eredità del Magnifico* (Exhib. Cat., Florence, 1992)

Erizzo, Sebastiano. *Discorso sopra le medaglie antiche* (Venice, 1559)

Esch, Arnold. 'On the Reuse of Antiquity: The Perspectives of the Archaeologist and of the Historian', in Brilliant and Kinney (eds), *Reuse Value*, 13–31

Fabbricotti, E. *Galba* (Rome, 1976)

Fehl, Philipp. 'Veronese and the Inquisition: A Study of the Subject Matter of the So-called "Feast in the House of Levi"', *Gazette des Beaux-Arts* 103 (1961), 325–54

Fejfer, Jane. *Roman Portraits in Context* (Berlin, 2008)

Fejfer, Jane. 'Statues of Roman Women and Cultural Transmission: Understanding the So-called Ceres Statue as a Roman Portrait Carrier', in Jane Fejfer, Mette Moltesen and Annette Rathje (eds), *Tradition: Transmission of Culture in the Ancient World* (*Acta Hyperborea* 14, Copenhagen, 2015), 85–116

Ferguson, J. Wilson. 'The Iconography of the Kane Suetonius', *The Princeton University Library Chronicle* 19 (1957), 34–45

Ferrari, Daniela (ed.). *Le collezioni Gonzaga: L'inventario dei beni del 1540–1542* (Milan, 2003)

Fiedrowicz, Michael. 'Die Christenverfolgung nach dem Brand Roms in Jahr 64', in *Nero: Kaiser, Künstler und Tyrann*, 250–56

Filarete (Antonio di Piero Averlino). *Filarete's Treatise on Architecture*, vol. 1, trans. John R. Spencer (New Haven, 1965), with facsimile of manuscript *Codex Magliabechiano*, c. 1465, in vol. 2.

Fishwick, Duncan, 'The Temple of Caesar at Alexandria', *American Journal of Ancient History* 9 (1984) 131–34.

Fishwick, Duncan. *The Imperial Cult in the Latin West: Studies in the Ruler Cult of the Western Provinces of the Roman Empire*, Part 2, 1 (Leiden, 1991)

Fittschen, Klaus. *Die Bildnisgalerie in Herrenhausen bei Hannover: Zur Rezeptions- und Sammlungsgeschichte antiker Porträts* (*Abhandlungen der Akademie der Wissenschaften zu Göttingen. Philologisch-Historische Klasse*, third series, vol. 275) (Göttingen, 2006)

Fittschen, K. 'Sul ruolo del ritratto antico nell'arte italiana', in Salvatore Settis (ed.), *Memoria dell'antico nell'arte italiana*, vol. 2 (Turin, 1985), 383–412

Fittschen, K. 'The Portraits of Roman Emperors and their Families: Controversial Positions and Unsolved Problems', in Björn C. Ewald and Carlos F. Noreña (eds.). *The Emperor and Rome: Space, Representation, and Ritual* (Cambridge, 2010), 221–46

Fittschen, K and P. Zanker. *Katalog der römischen Porträts in den Capitolinischen Museen und den anderen kommunalen Sammlungen der Stadt Rom. 1. Kaiser- und Prinzenbildnisse* (Mainz, 1985)

Fitzpatrick, John C. *The Writings of George Washington, 1745–1799*, vol. 28: *December 5 1784–August 30 1785* (Washington, 1938)

Flanagan, Laurence. *Ireland's Armada Legacy* (Dublin and Gloucester, 1988)

Flory, Marleen B. 'Livia and the History of Public Honorific Statues for Women in Rome', *Transactions of the American Philological Association* 123 (1993), 287–308

Flower, Harriet. *Ancestor Masks and Aristocratic Power in Roman Culture* (Oxford, 1996)

Fontana, Federica Missere, 'La controversia "monete o medaglie": Nuovi documenti su Enea Vico e Sebastiano Erizzo', *Atti dell'Istituto veneto di scienze, lettere ed arti* 153 (1994–95), 61–103

Fontane, Theodor. *Effi Briest* (Oxford, 2015) (first published as a serial in German, 1894–95)

Forti Grazzini, Nello. 'Catalogo', in Giuseppe Bertini and Forti Grazzini (eds), *Gli arazzi dei Farnese e dei Borbone: Le collezioni dei secoli XVI–XVIII* (Exhib. Cat., Colorno, 1998), 93–216

Franceschini, Michele and Valerio Vernesi (eds.). *Statue di Campidoglio: Diario di Alessandro Gregorio Capponi (1733–1746)* (Rome, 2005)

Frazer, R. M. 'Nero, the Singing Animal', *Arethusa* 4 (1971), 215–19

Freedman, Luba. 'Titian's *Jacopo da Strada*: A Portrait of an "antiquario"', *Renaissance Studies* 13 (1999), 15–39

Fried, Michael. 'Thomas Couture and the Theatricalization of Action in 19th-Century French Painting', *Art Forum* 8 (1970) (no pg. nos)

Fried, Michael. *Manet's Modernism, or, The Face of Painting in the 1860s* (Chicago, 1996)

Fulvio, Andrea. *Illustrium imagines* (Rome, 1517)

Furlotti, Barbara. *Antiquities in Motion: From Excavation Sites to Renaissance Collections* (Los Angeles, 2019)

Furlotti, Barbara and Guido Rebecchini. *The Art of Mantua: Power and Patronage in the Renaissance* (Los Angeles, 2008)

Furlotti, Barbara and Guido Rebecchini. '"Rare and Unique in this World": Mantegna's Triumph and the Gonzaga Collection', in *Charles I*, 54–59

Furtwängler, Adolf. *Neuere Fälschungen von Antiken* (Berlin, 1899)

Fusco, Laurie and Gino Corti. *Lorenzo de' Medici: Collector and Antiquarian* (Cambridge, 2006)

Gaddi, Giambattista. *Roma nobilitata* (Rome, 1736)

Gallo, Daniela. 'Ulisse Aldrovandi: Le statue di Roma e i marmi romani', *Mélanges de l'Ecole française de Rome: Italie et Méditerranée* 104 (1992), 479–90

Galt, John. *The Life, Studies and Works of Benjamin West, Esq.* (London, 1820)

Gautier, Théophile. *Salon de 1847* (Paris, 1847)

Gautier, Théophile. *Les Beaux-arts en Europe, 1855* (Paris, 1855)

Gaylard, Susan. *Hollow Men: Writing, Objects and Public Image in Renaissance Italy* (New York, 2013)

*Gérôme* (Exhib. Cat., Paris, 2010)

Gesche, Inga. 'Bemerkungen zum Problem der Antikenergänzungen und seiner Bedeutung bei J. J. Winckelmann', in Herbert Beck and Peter C. Bol (eds), *Forschungen zur Villa Albani* (Berlin, 1982), 439–60

Ghini, Giuseppina et al. (eds.). *Sulle tracce di Caligola: Storie di grandi recuperi della Guardia di Finanza al lago di Nemi* (Rome, 2014)

Giannattasio, Bianca Maria. 'Una testa di Vitellio in Genova', *Xenia* 12 (1985), 63–70

Ginsburg, Judith. *Representing Agrippina: Constructions of Female Power in the Early Roman Empire* (Oxford, 2006)

Giuliani, Luca and Gerhard Schmidt. *Ein Geschenk für den Kaiser. Das Geheimnis des Grossen Kameo* (Munich, 2010)

*Giulio Romano* (Exhib. Cat., Milan, 1989)

Glass, Robert. 'Filarete's Renovation of the Porta Argentea at Old Saint Peter's', in Rosamond McKitterick et al. (eds), *Old Saint Peter's, Rome* (Cambridge, 2013), 348–70

Glass, Robert. 'Filarete and the Invention of the Renaissance Medal', *The Medal* 66 (2015), 26–37

Gold, Susanna W. 'The Death of Cleopatra/The Birth of Freedom: Edmonia Lewis at the New World's Fair', *Biography* 35 (2012), 318–41

Goltzius, Hubert. *Vivae omnium fere imperatorum imagines* (Antwerp, 1557)

Goltzius, Hubert. *C. Iulius Caesar* (Bruges, 1563)

Gottfried, Johann Ludwig. *Historische Chronica oder Beschreibung der fürnehmsten Geschichten* (Frankfurt, c. 1620)

Goyder, David George. *My Battle for Life: The Autobiography of a Phrenologist* (London, 1857)

Granboulan, Anne. 'Longing for the Heavens: Romanesque Stained Glass in the Plantagenet Domain', in Elizabeth Carson Pastan and Brigitte Kurmann-Schwarz (eds), *Investigations in Medieval Stained Glass: Materials, Methods, and Expressions* (Leiden and Boston, MA, 2019), 36–48

Green, David and Peter Seddon (eds). *History Painting Reassessed: The Representation of History in Contemporary Art* (Manchester, 2000)

Greenblatt, Stephen. *Renaissance Self-Fashioning: From More to Shakespeare* (revised edition, Chicago, 2012)

Griffin, Francis (ed.). *Remains of the Rev. Edmund D. Griffin*, vol. 1 (New York, 1831)

Griffin, Jasper and Miriam Griffin. 'Show us you care, Ma'am', *New York Review of Books*, 9 October 1997, 29

Griffin, Miriam (ed.). *A Companion to Julius Caesar* (Chichester and Malden, MA, 2009)

Griffiths, Antony. *The Print in Stuart Britain: 1603–1689* (London, 1998)

Groos, G. W. (ed.). *The Diary of Baron Waldstein: A Traveller in Elizabethan England* (London, 1981)

Grunchec, Philippe. *Le Grand Prix de Peinture: Les concours des Prix de Rome de 1797 à 1863* (Paris, 1983)

Grunchec, Philippe. *The Grand Prix de Rome: Paintings from the École des Beaux-Arts 1797–1863* (Exhib. Cat., Washington, DC, 1984)

Gualandi, Maria Letizia and A. Pinelli. 'Un trionfo per due. La matrice di Olbia: un *unicum* iconographico "fuori contesto"', in Maria Monica Donato and Massimo Ferretti (eds), *'Conosco un ottimo storico dell'arte . . .'. Per Enrico Castelnuovo: Scritti di allievi e amici pisani* (Pisa, 2012), 11–20

*Guida del visitatore alla esposizione industriale italiana del 1881 in Milano* (Milan, 1881)

Haag, Sabine (ed.). *All'Antica: Götter und Helden auf Schloss Ambras* (Exhib. Cat., Vienna, 2011)

Hall, Edith and Henry Stead. *A People's History of Classics: Class and Greco-Roman Antiquity in Britain 1689–1939* (Abingdon and New York, 2020)

Halsema-Kubes, W. 'Bartholomeus Eggers' keizers- en keizerinnenbusten voor keurvorst Friedrich Wilhelm van Brandenburg', *Bulletin van het Rijksmuseum* 36 (1988) 44–53 (with English summary, 73–74)

*Handbook to the New York Public Library: Astor, Lenox and Tilden Foundations* (New York, 1900)

Hanford, James Holly. '"Ut Spargam": Thomas Hollis Books at Princeton', *The Princeton University Library Chronicle* 20 (1959), 165–74

Harcourt, Jane and Tony Harcourt. 'The Loggia Roundels', in *The Development of Horton Court: An Architectural Survey*, (National Trust Report, 2009), Appendix 9, 87–90

Hardie, Philip. 'Lucan in the English Renaissance', in Paolo Asso (ed.), *Brill's Companion to Lucan* (Leiden, 2011), 491–506

Harprath, Richard. 'Ippolito Andreasi as a Draughtsman', *Master Drawings* 22 (1984), 3–28; 89–114

Harris, Ann Sutherland. *Seventeenth-Century Art and Architecture* (London, 2005)

Hartt, Frederick. *Giulio Romano*, 2 vols (New Haven, 1958)

Harvey, Tracene. *Julia Augusta: Images of Rome's First Empress on Coins of the Roman Empire* (Abingdon and New York, 2020)

Harwood, A. A. 'Some Account of the Sarcophagus in the National Museum now in charge of the Smithsonian Institution', *Annual Report of the Board of Regents of the Smithsonian Institution*, 1870, 384–85

Haskell, Francis. *History and Its Images: Art and the Interpretation of the Past* (New Haven and London, 1993)

Haskell, Francis. *The King's Pictures* (New Haven and London, 2013)

Haskell, Francis and Nicholas Penny. *Taste and the Antique* (New Haven and London, 1981)

Haydon, Benjamin Robert. *Lectures on Painting and Design* (London, 1844)

Hekster, Olivier. 'Emperors and Empire, Marcus Aurelius and Commodus', in Aloys Winterling (ed.), *Zwischen Strukturgeschichte und Biographie* (Munich, 2011), 317–28

Hekster, Olivier. *Emperors and Ancestors: Roman Rulers and the Constraints of Tradition* (Oxford, 2015)

Henderson, George. 'The Damnation of Nero and Related Themes', in A. Borg and A. Martindale (eds), *The Vanishing Past: Studies of Medieval Art, Liturgy and Metrology presented to Christopher Hohler* (Oxford, 1981), 39–51

Hennen, Insa Christiane. *'Karl zu Pferde': Ikonologische Studien zu Anton van Dycks Reiterporträts Karls I. von England* (Frankfurt am Main, 1995)

Hentzner, Paul. *Paul Hentzner's Travels in England, during the reign of Queen Elizabeth, translated by Horace, late Earl of Orford* (London, 1797)

Hicks, Philip. 'The Roman Matron in Britain: Female Political Influence and Republican Response, 1750–1800', *Journal of Modern History* 77 (2005), 35–69

Hobson, Anthony. *Humanists and Bookbinders: The Origins and Diffusion of Humanistic Bookbinding, 1459–1559* (Cambridge, 1989)

Hölscher, Tonio. *Visual Power in Ancient Greece and Rome: Between Art and Social Reality* (Berkeley and Los Angeles, 2018)

Hopkins, Lisa. *The Cultural Uses of the Caesars*

on the English Renaissance Stage (Farnham, 2008)

Horejsi, Nicole. *Novel Cleoptras: Romance Historiography and the Dido Tradition in English Fiction, 1688–1785* (Toronto, 2019)

House, John. 'History without Values? Gérôme's History Paintings', *Journal of the Warburg and Courtauld Institutes* 71 (2008), 261–76

Howarth, David. *Images of Rule: Art and Politics in the English Renaissance, 1485–1649* (Basingstoke, 1997)

Howley, Joseph A. 'Book-Burning and the Uses of Writing in Ancient Rome: Destructive Practice between Literature and Document', *Journal of Roman Studies* 107 (2017), 213–36

Hub, Berthold. 'Founding an Ideal City in Filarete's *Libro architettonico*', in Maarten Delbeke and Minou Schraven (eds), *Foundation, Dedication and Consecration in Early Modern Europe* (Leiden, 2012), 17–57

Hülsen, Christian. *Das Skizzenbuch des Giovannantonio Dosio* (Berlin, 1933)

*I Borghese e l'antico* (Exhib. Cat., Milan, 2011)

*I Campi e la cultura artistica cremonese del Cinquecento* (Exhib. Cat., Milan, 1985)

*I tesori dei d'Avalos: Committenza e collezionismo di una grande famiglia napoletana* (Exhib. Cat., Naples, 1994)

Ioele, Giovanna. *Prima di Bernini: Giovanni Battista Della Porta, scultore (1542–1597)* (Rome, 2016)

Jacobus de Voragine. *The Golden Legend: Readings on the Saints*, trans. William Granger Ryan, with introduction by Eamon Duffy (revised edition, Princeton and Oxford, 2012), based on Latin text of Theodor Graesse (Leipzig, 1845)

*Jacopo Tintoretto* (Exhib. Cat., Venice, 1994)

Jaffé, David (ed.). *Titian* (Exhib. Cat., London, 2003)

Jaffé, Michael. 'Rubens's Roman Emperors', *Burlington Magazine* 113 (1971), 297–98; 300–301; 303

Jansen, Dirk Jacob. *Jacopo Strada and Cultural Patronage at the Imperial Court*, 2 vols (Leiden and Boston, MA, 2019)

*Jean-Paul Laurens 1838–1921: Peintre d'histoire* (Exhib. Cat., Paris, 1997)

Jecmen, Gregory and Freyda Spira. *Imperial Augsburg: Renaissance Prints and Drawings, 1475–1540* (Exhib. Cat., Washington, DC, 2012)

Jenkins, Gilbert Kenneth. 'Recent Acquisitions of Greek Coins by the British Museum', *Numismatic Chronicle* 19 (1959), 23–45

Jestaz, Bertrand. *L'Inventaire du palais et des propriétés Farnèse à Rome en 1644* (Rome, 1994)

Johansen, Flemming S. 'Antichi ritratti di Gaio Giulio Cesare nella scultura', *Analecta Romana Instituti Danici* 4 (1967), 7–68

Johansen, Flemming S. 'The Portraits in Marble of Gaius Julius Caesar: A Review', *Ancient Portraits in the J. Paul Getty Museum*, vol. 1 (Occasional Papers on Antiquities 4) (Malibu, 1987), 17–40

Johansen, Flemming S. 'Les portraits de César', in Long and Picard (eds), *César* 78–83

Johns, Christopher M. S. 'Subversion through Historical Association: Canova's *Madame Mère* and the Politics of Napoleonic Portraiture', *Word & Image* 13 (1997), 43–57

Johns, Christopher M. S. *Antonio Canova and the Politics of Patronage in Revolutionary and Napoleonic Europe* (Berkeley etc., 1998)

Johns, Richard. '"Those Wilder Sorts of Painting": The Painted Interior in the Age of Antonio Verrio', in Dana Arnold and David Peters Corbett (eds), *A Companion to British Art: 1600 to the Present* (Chichester and Malden, MA, 2013), 77–104

Jonckheere, Koenraad. *Portraits after Existing Prototypes* (Corpus Rubenianum Ludwig Burchard 19) (London, 2016)

Jones, Mark (ed.). *Fake? The Art of Deception* (Exhib. Cat., London, 1990)

Jones, Mark (ed.). *Why Fakes Matter: Essays on Problems of Authenticity* (London, 1992)

Joshel, Sandra et al. (eds). *Imperial Projections: Ancient Rome in Popular Culture* (Baltimore and London, 2001)

Karafel, Lorraine. 'The Story of Julius Caesar', in Cleland (ed.), *Grand Design*, 254–61

Keaveney, Arthur. *Sulla: The Last Republican* (second edition, Abingdon, 2005)

Kellen, Sean. 'Exemplary Metals: Classical Numismatics and the Commerce of Humanism', *Word & Image* 18 (2002), 282–94

Keysler, John George. *Travels through Germany, Hungary, Bohemia, Switzerland, Italy and Lorrain*, vol. 4 (London,

1758; originally published in German by Johann Georg Keysler, 1741)

King, Elliott. '*Ten Recipes for Immortality*: A Study in Dalínian Science and Paranoiac Fictions', in Gavin Parkinson (ed.), *Surrealism, Science Fiction and Comics* (Liverpool, 2015), 213–32

Kinney, Dale. 'The Horse, the King and the Cuckoo: Medieval Narrations of the Statue of Marcus Aurelius', *Word & Image* 18 (2002), 372–98

Kinney, Dale. 'Ancient Gems in the Middle Ages: Riches and Ready-Mades', in Brilliant and Kinney (eds), *Reuse Value* 97–120

Kleiner, Diana E. E. *Roman Sculpture* (New Haven, 1992)

Kleiner, Diana E. E. *Cleopatra and Rome* (Cambridge, MA, 2005)

Knaap, Anna C. and Michael C. J. Putnam (eds.). *Art, Music, and Spectacle in the Age of Rubens: The Pompa Introitus Ferdinandi* (Turnhout, 2013)

Knox, Tim. 'The Long Gallery at Powis Castle', *Country Life* 203 (2009), 86–89

Koeppe, Wolfram (ed.). *Art of the Royal Court: Treasures in Pietre Dure from the Palaces of Europe* (Exhib. Cat., New Haven and London, 2008)

Koering, Jérémie. 'Le Prince et ses modèles: Le Gabinetto dei Cesari au palais ducal de Mantoue', in Philippe Morel (ed.). *Le Miroir et l'espace du prince dans l'art italien de la Renaissance* (Tours, 2012), 165–94

Koering, Jérémie. *Le Prince en representation: Histoire des décors du palais ducal de Mantoue au XVI^e siècle* (Arles, 2013)

Koortbojian, Michael. *The Divinization of Caesar and Augustus: Precedents, Consequences, Implications* (Cambridge and New York, 2013)

Kroll, Maria (trans. and ed.). *Letters from Liselotte: Elisabeth Charlotte, Princess Palatine and Duchess of Orléans, 'Madame', 1652–1722* (London, 1970)

Kuhns, Matt. *Cotton's Library: The Many Perils of Preserving History* (Lakewood, 2014)

Kulikowski, Michael. *The Triumph of Empire: The Roman World from Hadrian to Constantine* (Cambridge, MA, 2016), published in the UK as *Imperial Triumph* (London, 2016)

Künzel, Carl (ed.). *Die Briefe der Liselotte von der Pfalz, Herzogin von Orleans* (reprinted Hamburg, 2013, from original edition, 1914)

Ladendorf, Heinz. *Antikenstudium und Antikenkopie* (Berlin, 1953)

Lafrery, Antonio. *Effigies viginti quatuor Romanorum imperatorum* (Rome, c. 1570)

Lamo, Alessandro. *Discorso . . . intorno alla scoltura e pittura . . . dall'Eccell. & Nobile M. Bernardino Campo* (Cremona, 1581)

Landau, Diana (ed.). *Gladiator: The Making of the Ridley Scott Epic* (New York, 2000)

Lane, Barbara. *Hans Memling: Master Painter in Fifteenth-Century Bruges* (Turnhout, 2009)

Lapenta, Stefania and Raffaella Morselli (eds). *Le collezioni Gonzaga: La quadreria nell'elenco dei beni del 1626–1627* (Milan, 2006)

La Rocca, Eugenio et al. (eds.). *Augusto* (Exhib. Cat., Rome, 2013)

Lattuada, Riccardo (ed.), *Alessandro Farnese: A Miniature Portrait of the Great General* (Milan, 2016).

Laurence, Ray. 'Tourism, Town Planning and *romanitas*: Rimini's Roman Heritage', in Michael Biddiss and Maria Wyke (eds), *The Uses and Abuses of Antiquity* (Bern, 1999), 187–205

Le Bars-Tosi, Florence. 'James Millingen (1774–1845), le "Nestor de l'archéologie moderne"', in Manuel Royo et al. (eds), *Du voyage savant aux territoires de l'archéologie: Voyageurs, amateurs et savants à l'origine de l'archéologie moderne* (Paris, 2011), 171–86

Lessmann Johanna, and Susanne König-Lein. *Wachsarbeiten des 16. bis 20. Jahrhunderts* (Braunschweig, 2002)

Leuschner, Eckhard. *Antonio Tempesta: Ein Bahnbrecher des römischen Barock und seine europäische Wirkung* (Petersberg, 2005)

Leuschner, Eckhard. 'Roman Virtue, Dynastic Succession and the Re-Use of Images: Constructing Authority in Sixteenth- and Seventeenth-Century Portraiture', *Studia Rudolphina* 6 (2006), 5–25

Levick, Barbara. *Vespasian* (London and New York, 1999)

Lightbown, Ronald. *Sandro Botticelli*, vol. 1: *Life and Work* (London, 1978)

Limouze, Dorothy. 'Aegidius Sadeler, Imperial Printmaker', *Philadelphia Museum of Art Bulletin* 85 (1989), 1; 3–24

Limouze, Dorothy. *Aegidius Sadeler (c. 1570–1629): Drawings, Prints and Art Theory* (PhD dissertation, Princeton University, 1990)

Lintott, Andrew. *The Constitution of the Roman Republic* (Oxford, 1999)

Liverani, Paolo. 'La collezione di antichità classiche e gli scavi di Tusculum e Musignano', in Marina Natoli (ed.), *Luciano Bonaparte: Le sue collezioni d'arte, le sue residenze a Roma, nel Lazio, in Italia (1804–1840)* (Rome, 1995), 49–79

Liversidge, Michael. 'Representing Rome', in Liversidge and Edwards (eds), *Imagining Rome*, 70–124

Liversidge, Michael and Catharine Edwards (eds.). *Imagining Rome: British Artists and Rome in the Nineteenth Century* (Exhib. Cat., Bristol, 1996)

Lobelle-Caluwé, Hilde. 'Portrait d'un homme avec une monnaie', in Maximilian P. J. Martens (ed.), *Bruges et la Renaissance: De Memling à Pourbus. Notices* (Exhib. Cat., Bruges, 1998), 17

Locatelli, Giampetro. *Museo Capitolino, osia descrizione delle statue . . .* (Rome, 1750)

L'Occaso, Stefano. *Museo di Palazzo Ducale di Mantova. Catalogo generale delle collezioni inventariate: Dipinti fino al XIX secolo* (Mantua, 2011)

Loh, Maria H. *Still Lives: Death, Desire, and the Portrait of the Old Master* (Princeton, 2015)

Lomazzo, Giovanni Paolo. *Trattato dell'arte della pittura, scoltura et architettura* (Milan, 1584)

Long, Luc. 'Le regard de César: Le Rhône restitue un portrait du fondateur de la colonie d'Arles', in Long and Picard (eds), *César*, 58–77

Long, Luc and Pascale Picard (eds.). *César. Le Rhône pour mémoire: Vingt ans de fouilles dans le fleuve à Arles* (Exhib. Cat., Arles, 2009)

Lorenz, Katharina. 'Die römische Porträtforschung und der Fall des sogennanten Ottaviano Giovinetto im Vatikan: Die Authentizitätsdiskussion als Spiegel des Methodenwandels', in Sascha Kansteiner (ed.), *Pseudoantike Skulptur 1: Fallstudien zu antiken Skulpturen und ihren Imitationen* (Berlin and Boston, MA, 2016), 73–90

Lübbren, Nina. 'Crime, Time, and the Death of Caesar', in Allan and Morton (eds), *Reconsidering Gérôme*, 81–91

Luzio, Alessandro. *La galleria dei Gonzaga, venduta all'Inghilterra nel 1627–28* (Milan, 1913)

Lyons, John D. *Exemplum: The Rhetoric of Example in Early Modern France and Italy* (Princeton, 1990)

McCuaig, William. *Carlo Sigonio: The Changing World of the Late Renaissance* (Princeton, 2014)

McFadden, David. 'An Aldobrandini Tazza: A Preliminary Study', *Minneapolis Institute of Arts Bulletin* 63 (1976–77), 43–56

McGrath, Elizabeth. 'Rubens's Infant-Cornucopia', *Journal of the Warburg and Courtauld Institutes* 40 (1977), 315–18

McGrath, Elizabeth. ' "Not Even a Fly": Rubens and the Mad Emperors', *Burlington Magazine* 133 (1991), 699–703

McKendrick, Neil. 'Josiah Wedgwood: An Eighteenth-Century Entrepreneur in Salesmanship and Marketing Techniques', *Economic History Review*, n.s., 12 (1960), 408–43

McKendrick, Neil. 'Josiah Wedgwood and the Commercialization of the Potteries', in McKendrick et al., *The Birth of Consumer Society: The Commercialization of Eighteenth-Century England* (London, 1982), 100–145

McLaughlin, Martin. 'Empire, Eloquence, and Military Genius: Renaissance Italy', in Griffin (ed.), *Companion to Julius Caesar*, 335–55

McNairn, Alan. *Behold the Hero: General Wolfe and the Arts in the Eighteenth Century* (Montreal, 1997)

Macsotay, Tomas. 'Struggle and the Memorial Relief: John Deare's Caesar Invading Britain', in Macsotay (ed.), *Rome, Travel and the Sculpture Capital, c. 1770–1825* (Abingdon and New York, 2017), 197–224

Mainardi, Patricia. *Art and Politics of the Second Empire: The Universal Expositions of 1855 and 1867* (New Haven and London, 1987)

Malamud, Margaret. *Ancient Rome and Modern America* (Malden, MA and Oxford, 2009)

Malgouyres, Philippe (ed.). *Porphyre: La Pierre Poupre des Ptolémées aux Bonaparte* (Exhib. Cat., Paris, 2003)

Mamontova, N. N. 'Vasily Sergeevich Smirnov, Pensioner of the Academy of Arts', in *Russian Art of Modern Times. Research and Materials. Vol. 10: Imperial Academy of Arts. Cases and People* (Moscow, 2006), 238–48 (in Russian)

Maral, Alexandre. 'Vraies et fausses antiques', in Alexandre Maral and Nicolas

Milovanovic (eds), *Versailles et l'Antique* (Exhib. Cat., Paris, 2012), 104–11

Marcos, Dieter. 'Vom Monster zur Marke: Neros Karriere in der Kunst', in *Nero: Kaiser, Künstler und Tyrann*, 355–68

Marsden, Jonathan (ed.). *Victoria and Albert: Art and Love* (Exhib. Cat., London, 2010)

Marlowe, Elizabeth. *Shaky Ground: Context, Connoisseurship and the History of Roman Art* (London, 2013)

Martin, John Rupert. *The Decorations for the Pompa Introitus Ferdinandi* (Corpus Rubenianum Ludwig Burchard 16) (London, 1972)

Martindale, Andrew. *The 'Triumphs of Caesar' by Andrea Mantegna, in the Collection of Her Majesty the Queen at Hampton Court* (London, 1979)

Marx, Barbara. 'Wandering Objects, Migrating Artists: The Appropriation of Italian Renaissance Art by German Courts in the Sixteenth Century', in Herman Roodenburg (ed.), *Forging European Identities, 1400–1700* (Cultural Exchange in Early Modern Europe 4) (Cambridge, 2007), 178–226

Mathews, Thomas F. and Norman E. Muller. *The Dawn of Christian Art in Panel Paintings and Icons* (Los Angeles, 2016)

Mattusch, Carol C. *The Villa dei Papyri at Herculaneum: Life and Afterlife of a Sculpture Collection* (Los Angeles, 2005).

Maurer, Maria F. *Gender, Space and Experience at the Renaissance Court: Performance and Practice at the Palazzo Tè* (Amsterdam, 2019)

Meganck, Tine. 'Rubens on the Human Figure: Theory, Practice and Metaphysics', in Arnout Balis and Joost van der Auwera (eds), *Rubens, a Genius at Work: The Works of Peter Paul Rubens in the Royal Museums of Fine Arts of Belgium Reconsidered* (Exhib. Cat., Brussels, 2007), 52–64

*Mementoes, Historical and Classical, of a Tour through Part of France. Switzerland, and Italy, in the Years 1821 and 1822*, vol. 2 (London, 1824)

Menegaldo, Silvère. 'César "d'ire enflamaz et espris" (v. 1696) dans le Roman de Jules César de Jean de Thuin', *Cahiers de recherches médiévales* 13 (2006), 59–76

Meulen, Marjon van der. *Rubens Copies after the Antique*, vol. 1 (Corpus Rubenianum Ludwig Burchard 23) (London, 1994)

Meyer, Susanne Adina and Chiara Piva (eds.). *L'arte di ben restaurare: La 'Raccolta*

*d'antiche statue' (1768–1772) di Bartolomeo Cavaceppi* (Florence, 2011)

Michel, Patrick. *Mazarin, prince des collectionneurs: Les collections et l'ameublement du Cardinal Mazarin (1602–1661). Histoire et analyse* (Notes et Documents des Musées de France 34) (Paris, 1999)

Middeldorf, Ulrich. 'Die zwölf Caesaren von Desiderio da Settignano', *Mitteilungen des Kunsthistorischen Institutes in Florenz* 23 (1979), 297–312

Millar, Oliver (ed.). *Abraham van der Doort's Catalogue of the Collections of Charles I* (Walpole Society, vol. 37, 1958–60)

Millar, Oliver (ed.). *The Inventories and Valuations of the King's Goods, 1649–1651* (Walpole Society, vol. 43, 1970–72)

Miller, Peter Benson. 'Gérôme and Ethnographic Realism at the Salon of 1857', in Allan and Morton (eds), *Reconsidering Gérôme*, 106–18

Miller, Stephen. *Three Deaths and Enlightenment Thought: Hume, Johnson, Marat* (Lewisburg and London, 2001)

Miner, Carolyn and Jens Daehner. 'The Emperor in the Arena', *Apollo*, February 2010, 36–41

Mingazzini, Paolino. 'La datazione del ritratto di Augusto Giovinetto al Vaticano', *Bullettino della Commissione archeologica comunale di Roma* 73 (1949–50), 255–59

Minor, Heather Hyde. *The Culture of Architecture in Enlightenment Rome* (University Park, PA, 2010)

Mitchell, Eleanor Drake. 'The Tête-à-Têtes in the "Town and Country Magazine" (1769–1793)', *Interpretations* 9 (1977), 12–21

Morbio, Carlo. 'Notizie intorno a Bernardino Campi ed a Gaudenzio Ferraro', *Il Saggiatore: Giornale romano di storia, belle arti e letteratura* 2 (1845), 314–19

Moreno, Paolo and Chiara Stefani. *The Borghese Gallery* (Milan, 2000)

Morgan, Gwyn. *69 AD: The Year of Four Emperors* (Oxford, 2005)

Morscheck, Charles R. 'The Certosa Medallions in Perspective', *Arte lombarda* 123 (1998), 5–10

Morselli, Raffaella (ed.). *Le collezioni Gonzaga: L'elenco dei beni del 1626–1627* (Milan, 2000)

Morselli, Raffaella (ed.). *Gonzaga. La Celeste Galeria: L'esercizio del collezionismo* (Milan, 2002)

Morselli, Raffaella (ed.). *Gonzaga. La Celeste Galeria: Le raccolte* (Exhib. Cat., Milan, 2002)

Mortimer, Nigel. *Medieval and Early Modern Portrayals of Julius Caesar* (Oxford, 2020)

Mounier, Pascale and Colette Nativel (eds.). *Copier et contrefaire à la Renaissance: Faux et usage de faux* (Paris, 2014)

Mulryne, J. R. et al. (eds.). *Europa Triumphans: Court and Civic Festivals in Early Modern Europe* (Farnham, 2004)

Munk Højte, Jakob. *Roman Imperial Statue Bases: From Augustus to Commodus* (Acta Jutlandica 80: 2) (Aarhus, 2005)

Murray, John (publisher). *Handbook for Travellers in Central Italy: Including the Papal States, Rome, and the Cities of Etruria* (London, 1843)

Murray, John (publisher). *Handbook for Travellers in Central Italy: Part II, Rome and its Environs* (London, 1853)

Murray, John (publisher). *Handbook of Rome and the Campagna* (London 1904)

Nalezyty, Susan. *Pietro Bembo and the Intellectual Pleasures of a Renaissance Writer and Art Collector* (New Haven and London, 2017)

Napione, Ettore. 'I sottarchi di Altichiero e la numismatica: Il ruolo delle imperatrici', *Arte veneta: Rivista di storia dell'arte* 69 (2012), 23–39

Napione, Ettore. 'Tornare a Julius von Schlosser: I palazzi scaligeri, la "sala grande dipinta" e il primo umanesimo', in Serena Romano and Denise Zaru (eds), *Arte di corte in Italia del nord: Programmi, modelli, artisti (1330–1402 ca.)* (Rome, 2013), 171–94

Neale, John Preston. *Views of the Seats of Noblemen and Gentlemen, in England, Wales, Scotland, and Ireland*, second series 2, vol. 2 (London, 1825)

Nelis, Jan. 'Constructing Fascist Identity: Benito Mussolini and the Myth of *romanità*', *Classical World* 100 (2007), 391–415

Nelson, Charmaine A. *The Color of Stone: Sculpting the Black Female Subject in Nineteenth-Century America* (Minneapolis, 2007)

Nemerov, Alexander. 'The Ashes of Germanicus and the Skin of Painting: Sublimation and Money in Benjamin West's *Agrippina*', *The Yale Journal of Criticism* 11 (Summer 1998), 11–27

*Nero: Kaiser, Künstler und Tyrann* (Exhib. Cat., Schriftenreihe des Rheinischen Landesmuseums Trier 40, 2016)

Nesi, Antonella (ed.). *Ritratti di Imperatori e profili all'antica: Scultura del Quattrocento nel Museo Stefano Bardini* (Florence, 2012)

*Nicolas Poussin, 1594–1665* (Exhib. Cat., Paris and London, 1994)

Nilgen, Ursula. 'Der Streit über den Ort der Kreuzigung Petri: Filarete und die zeitgenössische Kontroverse', in Hannes Hubach et al. (eds), *Reibungspunkte: Ordnung und Umbruch in Architektur und Kunst* (Petersberg, 2008), 199–208

Nochlin, Linda. *The Body in Pieces: The Fragment as a Metaphor of Modernity* (London, 1994)

Nogara, Bartolemeo (ed.). *Scritti inediti e rari di Biondo Flavio* (Vatican City, 1927)

Norcña, Carlos F. *Imperial Ideals in the Roman West: Representation, Circulation, Power* (Cambridge, 2011)

Northcote, James. *The Life of Titian: With Anecdotes of the Distinguished Persons of his Time*, vol. 2 (London, 1830)

Nuttall, Paula. 'Memling and the European Renaissance Portrait', in Borchert (ed.), *Memling's Portraits*, 69–91

Oldenbourg, Rudolf. 'Die niederländischen Imperatorenbilder im Königlichen Schlosse zu Berlin', *Jahrbuch der Königlich Preussischen Kunstsammlungen* 38 (1917), 203–12

Orgel, Stephen. *Spectacular Performances: Essays on Theatre, Imagery, Books and Selves in Early Modern England* (Manchester, 2011)

Orso, Steven N. *Philip IV and the Decoration of the Alcázar of Madrid* (Princeton, 1986)

Otter, William. *The Life and Remains of Edward Daniel Clarke* (London, 1824)

Painter, Kenneth and David Whitehouse. 'The Discovery of the Vase', *Journal of Glass Studies* 32, *The Portland Vase* (1990), 85–102

Paleit, Edward. *War, Liberty, and Caesar: Responses to Lucan's* Bellum Ciuile, *ca. 1580–1650* (Oxford, 2013)

Paley, Morton D. 'George Romney's *Death of General Wolfe*', *Journal for the Study of Romanticisms* 6 (2017), 51–62

Panazza, Pierfabio. 'Profili all'antica: da Foppa alle architetture bresciane del primo rinascimento', *Commentari dell' Ateneo di Brescia* 2016 (2018), 211–85

Panvinio, Onofrio. *Fasti et triumphi Rom(ani)*

*a Romulo rege usque ad Carolum V Caes(arem) Aug(ustum)* (Venice, 1557)

Panzanelli, Roberta (ed.). *Ephemeral Bodies: Wax Sculpture and the Human Figure* (Los Angeles, 2008)

Parisi Presicce, Claudio. 'Nascita e fortuna del Museo Capitolino', in Carolina Brook and Valter Curzi (eds), *Roma e l'Antico: Realtà e visione nel '700* (Exhib. Cat., Rome, 2010), 91–98

Parshall, Peter. 'Antonio Lafreri's *Speculum Romanae Magnificentiae*', *Print Quarterly* 23 (2006), 3–28

Pasqualini, Anna. 'Gli scavi di Luciano Bonaparte alla Rufinella e la scoperta dell'antica Tusculum', *Xenia Antiqua* 1 (1992), 161–86

Pasquinelli, Chiara. *La galleria in esilio: Il trasferimento delle opere d'arte da Firenze a Palermo a cura del Cavalier Tommaso Puccini (1800–1803)* (Pisa, 2008)

Paul, Carole. *The Borghese Collections and the Display of Art in the Age of the Grand Tour* (Aldershot, 2008)

Paul, Carole. 'Capitoline Museum, Rome: Civic Identity and Personal Cultivation', in Paul (ed.), *The First Modern Museums of Art: The Birth of an Institution in 18$^{th}$- and Early 19$^{th}$-Century Europe* (Los Angeles, 2012), 21–45

Peacock, John. *The Stage Designs of Inigo Jones: The European Context* (Cambridge, 1995)

Peacock, John. 'The Image of Charles I as a Roman Emperor', in Ian Atherton and Julie Sanders (eds), *The 1630s: Interdisciplinary Essays on Culture and Politics in the Caroline Era* (Manchester, 2006), 50–73

*Peintures italiennes du Musée des Beaux-Arts de Marseille* (Exhib. Cat., Marseille, 1984)

Penny, Nicholas and Eike D. Schmidt (eds.). *Collecting Sculpture in Early Modern Europe* (Studies in the History of Art 70) (New Haven and London, 2008)

Perini, Giovanna (ed.). *Gli scritti dei Carracci: Ludovico, Annibale, Agostino, Antonio, Giovanni Antonio* (Bologna, 1990)

Perkinson, Stephen. 'From an "*Art de Memoire*" to the Art of Portraiture: Printed Effigy Books of the Sixteenth Century', *Sixteenth Century Journal* 33 (2002), 687–723

Perry, Marilyn. 'Cardinal Domenico Grimani's Legacy of Ancient Art to Venice', *Journal of the Warburg and Courtauld Institutes* 41 (1978), 215–44

Petrarch, Francesco. *Letters on Familiar Matters*, trans. Aldo S. Bernardo (reprinted New York, 2005; from original 3 vols, New York and Baltimore, 1975–85)

Pfanner, Michael. 'Über das Herstellen von Porträts: Ein Beitrag zu Rationalisierungsmassnahmen und Produktionsmechanismen von Massenware im späten Hellenismus und in der Römischen Kaiserzeit', *Jahrbuch des Deutschen Archäologischen Instituts* 104 (1989), 157–257

Pieper, Susanne. 'The Artist's Contribution to the Rediscovery of the Caesar Iconography', in Jane Fejfer et al. (eds), *The Rediscovery of Antiquity: The Role of the Artist* (Acta Hyperborea 10) (Copenhagen, 2003), 123–45

Pilaski Kaliardos, Katharina. *The Munich Kunstkammer: Art, Nature and the Representation of Knowledge in Courtly Contexts* (Tübingen, 2013)

Pocock, John G. A. *Barbarism and Religion*, vol. 3: *The First Decline and Fall* (Cambridge, 2003)

Pointon, Marcia. 'The Importance of Gems in the Work of Peter Paul Rubens, 1577–1640', in Ben J. L. van den Bercken and Vivian C. P. Baan (eds), *Engraved Gems: From Antiquity to the Present* (Papers on Archaeology of the Leiden Museum of Antiquities 14) (Leiden, 2017), 99–111

Pollard, John Graham. *Renaissance Medals*, vol. 1: *Italy*; vol. 2: *France, Germany, The Netherlands and England* (Oxford, 2007)

Pollini, John. *The Portraiture of Gaius and Lucius Caesar* (New York, 1987)

Pollini, John. *From Republic to Empire: Rhetoric, Religion, and Power in the Visual Culture of Ancient Rome* (Norman, 2012)

Pons, Nicoletta. 'Portrait of a Man with the Medal of Cosimo the Elder, c. 1475', in Daniel Arasse et al. (eds), *Botticelli: From Lorenzo the Magnificent to Savonarola* (Exhib. Cat., Paris, 2003), 102–5

Porter, Martin. *Windows of the Soul: Physiognomy in European Culture, 1470–1780* (Oxford, 2005)

Poskett, James. *Materials of the Mind: Phrenology, Race and the Global History of Science, 1815–1920* (Chicago, 2019)

Postnikova, Olga. 'Historismus in Russland', in Hermann Fillitz (ed.), *Der Traum vom Glück: Die Kunst des Historismus in Europa* (Vienna, 1996), 103–11

Pougetoux, Alain. *Georges Rouget*

(1783–1869): Élève de Louis David (Exhib. Cat., Paris, 1995)

Power, Tristan and Roy K. Gibson (eds.). *Suetonius the Biographer: Studies in Roman Lives* (Oxford, 2014)

Prettejohn, Elizabeth, 'Recreating Rome in Victorian Painting: From History to Genre', in Liversidge and Edwards (eds), *Imagining Rome*, 54–69

Prettejohn, Elizabeth et al. (eds.). *Sir Lawrence Alma-Tadema* (Exhib. Cat., Amsterdam, 1996)

Principi, Lorenzo. 'Filippo Parodi's *Vitellius*: Style, Iconography and Date', in Davide Gambino and Principi (eds), *Filippo Parodi 1630–1702, Genoa's Bernini: A Bust of Vitellius* (Exhib. Cat., Genoa, 2016), 31–68

Prown, Jules David. 'Benjamin West and the Use of Antiquity', *American Art* 10 (1996), 28–49

Puget de la Serre, Jean. *Histoire de l'Entrée de la Reyne-Mère . . . dans la Grande-Bretaigne* (London, 1639)

Purcell, Nicholas. 'Livia and the Womanhood of Rome', *Proceedings of the Cambridge Philological Society* 32 (1986), 78–105

Quatremère de Quincy, Antoine C. *Canova et ses ouvrages, ou, Mémoires historiques sur la vie et les travaux de ce célèbre artiste* (second edition, Paris, 1836)

Raatschen, Gudrun. 'Van Dyck's *Charles I on Horseback with M. de St Antoine*', in Hans Vlieghe (ed.), *Van Dyck 1599–1999: Conjectures and Refutations* (Turnhout, 2001), 139–50

Raes, Daphné Cassandra. *De Brusselse Julius Caesar wandtapijtreeksen (ca. 1550–1700): Een stilistiche en iconografische studie* (MA dissertation, Leuven, 2016)

Raimondi, Gianmario. 'Lectio Boethiana: L'"example" di Nerone e Seneca nel *Roman de la Rose*', *Romania* 120 (2002), 63–98

Raubitschek, Antony E. 'Epigraphical Notes on Julius Caesar', *Journal of Roman Studies* 44 (1954), 65–75

Rausa, Federico. '"Li disegni delle statue et busti sono rotolate drento le stampe": L'arredo di sculture antiche delle residenze dei Gonzaga nei disegni seicenteschi della Royal Library a Windsor Castle', in Morselli (ed.), *Gonzaga. . . . L'esercizio del collezionismo*, 67–91

Raybould, Robin. *The Sibyl Series of the Fifteenth Century* (Leiden and Boston, MA, 2016)

Rebecchini, Guido. *Private Collectors in Mantua, 1500–1630* (Rome, 2002)

Redford, Bruce. '"Seria Ludo": George Knapton's Portraits of the Society of Dilettanti', *British Art Journal* 3 (2001), 56–68

Redford, Bruce. *Dilettanti: The Antic and the Antique in Eighteenth-Century England* (Los Angeles, 2008)

Reed, Christopher (ed.). *A Roger Fry Reader* (Chicago, 1996)

Reeve, Michael D. 'Suetonius', in Leighton D. Reynolds and Nigel G. Wilson (eds), *Texts and Transmission: A Survey of the Latin Classics* (Oxford, 1983), 399–406

Reilly, Robin and George Savage. *Wedgwood: The Portrait Medallions* (London, 1973)

Relihan, Joel. 'Late Arrivals: Julian and Boethius', in Kirk Freudenburg (ed.), *The Cambridge Companion to Roman Satire* (Cambridge, 2005), 109–22

Rice Holmes, Thomas. *Caesar's Conquest of Gaul: An Historical Narrative* (second, amended, edition, London, 1903; first edition, 1899)

Richards, John. *Altichiero: An Artist and His Patrons in the Italian Trecento* (Cambridge, 2000)

Richter, Jean Paul (ed.). *Lives of the Most Eminent Painters, Sculptors, and Architects: translated from the Italian of Giorgio Vasari*, vol. 4 (London, 1859)

Rickert, Yvonne. *Herrscherbild im Widerstreit: Die Place Louis XV in Paris: Ein Königsplatz im Zeitalter der Aufklärung* (Hildersheim etc., 2018)

Riebesell, Christina. 'Guglielmo della Porta', in Francesco Buranelli (ed.), *Palazzo Farnèse: Dalle collezioni rinascimentali ad Ambasciata di Francia* (Exhib. Cat., Rome, 2010), 255–61

Ripa, Cesare. *Iconologia* (revised edition, Siena, 1613; first edition without illustrations, Rome, 1593)

Ripley, John. *Julius Caesar on Stage in England and America, 1599–1973* (Cambridge, 1980)

Roberts, Sydney Castle. *Zuleika in Cambridge* (Cambridge, 1941)

Robertson, Clare. 'The Artistic Patronage of Cardinal Odoardo Farnese', in *Les Carrache et les décors profanes* (Rome 1988), 359–72

Rome, Romains et romanité dans la peinture historique des XVIII<sup>e</sup> et XIX<sup>e</sup> siècles (Exhib. Cat., Narbonne, 2002)

Ronchini, Amadio. 'Bernardino Campi in Guastalla', *Atti e memorie delle RR Deputazioni di storia patria per le provincie dell'Emilia* 3 (1878) 67–91

Rose, C. Brian. *Dynastic Commemoration and Imperial Portraiture in the Julio-Claudian Period* (Cambridge, 1997)

Rosenblum, Robert. *Transformations in Late Eighteenth Century Art* (second edition, Princeton, 1969)

Rosenthal, Mark. *Anselm Kiefer* (Chicago and Philadelphia, 1987)

Rossi, Toto Bergamo. *Domus Grimani: The Collection of Classical Sculptures Reassembled in Its Original Setting after 400 Years* (Exhib. Cat., Venice, 2019)

Rouillé, Guillaume. *Promptuaire des Medalles des plus renommées personnes qui ont esté depuis le commencement du monde* (Lyon, 1553; cited from second edition, Lyon, 1577)

Rowan, Clare. *Under Divine Auspices: Divine Ideology and the Visualisation of Imperial Power in the Severan Period* (Cambridge, 2012)

Rowlandson, Jane (ed.). *Women and Society in Greek and Roman Egypt: A Sourcebook* (Cambridge, 2009)

Roworth, Wendy Wassyng. 'Angelica Kauffman's Place in Rome', in Paula Findlen, Roworth and Catherine M. Sama (eds), *Italy's Eighteenth Century: Gender and Culture in the Age of the Grand Tour* (Stanford, 2009), 151–72

Rubin, Patricia Lee. 'Understanding Renaissance Portraiture', in Christiansen and Weppelmann (eds), *Renaissance Portrait*, 2–25

Ruckstall, Frederick Wellington (writing as Petronius Arbiter). 'A Great Ethical Work of Art: *The Romans of the Decadence*', *Art World* 2 (1917), 533–35

Ruskin, John. 'Notes on Some of the Principal Pictures Exhibited in the Rooms of the Royal Academy: 1875', in Edward Tyas Cook and Alexander Wedderburn (eds), *The Works of John Ruskin*, vol. 14 (London, 1904), 271–73

'S . . .' [Charles Bruno]. *Iconoclaste: Souvenir du Salon de 1847* (Paris, 1847)

Saavedro Fajardo, Diego de. *Idea de un príncipe político christiano* (Munich, 1640),

trans. J. Astry as *The royal politician represented in one hundred emblems* (London, 1700)

Sadleir, Thomas U. (ed.). *An Irish Peer on the Continent (1801–1803): Being a Narrative of the Tour of Stephen, 2<sup>nd</sup> Earl Mount Cashell, through France, Italy etc., as related by Catherine Wilmot* (London, 1920)

Safarik, Eduard A. (ed.). *Domenico Fetti: 1588/9–1623* (Exhib. Cat., Mantua, 1996)

Salomon, Xavier F. *Veronese* (Exhib. Cat., London, 2014)

Salomon, Xavier F. 'The *Dodici Tazzoni Grandi* in the Aldobrandini Collection', in Siemon (ed.), *Silver Caesars*, 140–47

Saltzman, Lisa. *Anselm Kiefer and Art after Auschwitz* (Cambridge, 1999)

Santolini Giordani, Rita. *Antichità Casali: La collezione di Villa Casali a Roma* (Studi Miscellanei 27) (Rome 1989)

Sapelli Ragni, Marina (ed.). *Anzio e Nerone: Tesori dal British Museum e dai Musei Capitolini* (Exhib. Cat., Anzio, 2009)

Sartori, Giovanni. 'La copia dei Cesari di Tiziano per Sabbioneta', in Gianluca Bocchi and Sartori (eds), *La Sala degli Imperatori di Palazzo Ducale a Sabbioneta* (Sabbioneta, 2015), 15–28

Sartwell, Crispin. 'Aesthetics of the Spurious', *British Journal of Aesthetics* 28 (1988), 360–62

Savage, Kirk. *Monument Wars: Washington, D.C., the National Mall, and the Transformation of the Memorial Landscape* (Berkeley etc., 2009)

Scalamonti, Francesco. *Vita viri clarissimi et famosissimi Kyriaci Anconitani*, ed. and trans. Charles Mitchell and Edward W. Bodnar (Philadelphia, 1996; original manuscript 1464)

Schäfer, Thomas. 'Drei Porträts aus Pantelleria: Caesar, Antonia Minor und Titus', in Rainer-Maria Weiss, Schäfer and Massimo Osanna (eds), *Caesar ist in der Stadt: Die neu entdeckten Marmorbildnisse aus Pantelleria* (Exhib. Cat., Hamburg, 2004), 18–38

Schama, Simon. *Dead Certainties (Unwarranted Speculations)* (London, 1991)

*Schatzkammer der Residenz München* (third edition, Munich, 1970)

Scher, Stephen K. (ed.). *The Currency of Fame: Portrait Medals of the Renaissance* (Exhib. Cat., New York and Washington, DC, 1994)

Schmitt, Annegrit. 'Zur Wiederbelebung der Antike im Trecento. Petrarcas Rom-Idee in ihrer Wirkung auf die Paduaner Malerei: Die methodische Einbeziehung des römischen Münzbildnisses in die Ikonographie "Berühmter Männer"', *Mitteilungen des Kunsthistorischen Institutes in Florenz* 18 (1974), 167–218

Schraven, Minou. *Festive Funerals in Early Modern Italy: The Art and Culture of Conspicuous Commemoration* (Farnham, 2014)

Scott, Frank J. *Portraitures of Julius Caesar* (New York, 1903)

Sérié, Pierre. 'Theatricality versus Anti-Theatricality: Narrative Techniques in French History Painting (1850–1900)', in Peter Cooke and Nina Lübbren (eds), *Painting and Narrative in France, from Poussin to Gaugin* (Abingdon and New York, 2016), 160–75

Scrvolini, Luigi. 'Ugo da Carpi· Illustratore del libro', *Gutenberg-Jahrbuch* (1950), 196–202

Settis, Salvatore. 'Collecting Ancient Sculpture: The Beginnings', in Penny and Schmidt (eds), *Collecting Sculpture*, 13–31

Seznec, Jean. 'Diderot and "The Justice of Trajan"', *Journal of the Warburg and Courtauld Institutes* 20 (1957), 106–11

Shakespeare, William. *2 Henry IV; Julius Caesar; Love's Labours Lost; The Winter's Tale*, cited from Stanley Wells and Gary Taylor (eds), *The Oxford Shakespeare: The Complete Works* (Oxford, 1988)

Sharpe, Kevin. *Sir Robert Cotton, 1586–1631: History and Politics in Early Modern England* (Oxford, 1979)

Shearman, John. *The Early Italian Pictures (The Pictures in the Collection of Her Majesty the Queen)* (Cambridge, 1983)

Shotter, David C. A. 'Agrippina the Elder: A Woman in a Man's World', *Historia: Zeitschrift für Alte Geschichte* 49 (2000), 341–57

Siebert. Gérard. 'Un portrait de Jules César sur une coupe à médaillon de Délos', *Bulletin de correspondance hellénique* 104 (1980), 189–96

Siegfried, Susan L. 'Ingres' Reading: The Undoing of Narrative', *Art History* 23 (2000), 654–80

Siegfried, Susan L. *Ingres: Painting Reimagined* (New Haven and London, 2009)

Siemon, Julia. 'Renaissance Intellectual Culture, Antiquarianism, and Visual Sources', in Siemon (ed.), *Silver Caesars*, 46–77

Siemon, Julia. 'Tracing the Origin of the Aldobrandini Tazze', in Siemon (ed.), *Silver Caesars*, 78–105

Siemon, Julia (ed.). *The Silver Caesars: A Renaissance Mystery* (New Haven and London, 2017)

Silver, Larry. *Marketing Maximilian: The Visual Ideology of a Holy Roman Emperor* (Princeton, 2008)

Simon, Erika. 'Das Caesarporträt im Castello di Aglie', *Archäologischer Anzeiger* 67 (1952), 123–38

Small, Alastair. 'The Shrine of the Imperial Family in the Macellum at Pompeii', in Small (ed.), *Subject and Ruler: The Cult of the Ruling Power in Classical Antiquity (Journal of Roman Archaeology* supplement 17) (Ann Arbor, 1996), 115–36

Smith, Amy C. *Polis and Personification in Classical Athenian Art* (Leiden, 2011)

Smith, Anthony D. *The Nation Made Real: Art and National Identity in Western Europe, 1600–1850* (Oxford, 2013)

Smith, R.R.R. 'Roman Portraits: Honours, Empresses and Late Emperors', *Journal of Roman Studies* 75 (1985), 209–21

Smith, R.R.R. 'The Imperial Reliefs from the Sebasteion at Aphrodisias', *Journal of Roman Studies* 77 (1987), 88–138

Smith, R.R.R. "Typology and Diversity in the Portraits of Augustus', *Journal of Roman Archaeology* 9 (1996), 30–47

Smith, R.R.R. *The Marble Reliefs from the Julio-Claudian Sebasteion (Aphrodisias 6)* (Darmstadt and Mainz, 2013)

Sparvigna, Amelia Carolina. 'The Profiles of Caesar's Heads Given by Tusculum and Pantelleria Marbles', Zenodo. DOI: 10/5281/zenodo.1314696 (18 July 2018)

Spiegel, Gabrielle M. *Romancing the Past: The Rise of Vernacular Prose Historiography in Thirteenth-Century France* (Berkeley etc., 1993)

Spier, Jeffery. 'Julius Caesar', in Spier, Timothy Potts and Sara E. Cole (eds), *Beyond the Nile: Egypt and the Classical World* (Exhib. Cat., Los Angeles, 2018), 198–99

*Splendor of Dresden: Five Centuries of Art Collecting* (Exhib. Cat., New York, 1978)

Staley, Allen. 'The Landing of Agrippina at Brundisium with the Ashes of Germanicus', *Philadelphia Museum of Art Bulletin* 61 (1965–66), 10–19

Starkey, David (ed.). *The Inventory of King*

*Henry VIII*, vol. 1: *The Transcript*
(London, 1998)

Stefani, Grete. 'Le statue del *Macellum*
di Pompei', *Ostraka* 15 (2006), 195–230

Sténuit, Robert. *Treasures of the Armada*
(London, 1972)

Stevenson, Mrs Cornelius. 'An Ancient
Sarcophagus', *Bulletin of the Pennsylvania
Museum* 12 (1914), 1–5

Stewart, Alison. 'Woodcuts as Wallpa-
per: Sebald Beham and Large Prints
from Nuremberg', in Larry Silver and
Elizabeth Wyckoff (eds), *Grand Scale:
Monumental Prints in the Age of Dürer and
Titian* (Exhib. Cat., New Haven, 2008),
73–84

Stewart, Jules. *Madrid: The History* (London
and New York, 2012)

Stewart, Peter. *The Social History of Roman
Art* (Cambridge, 2008)

Stewart, Peter. 'The Equestrian Statue of
Marcus Aurelius', in Marcel Van Ackeren
(ed.), *A Companion to Marcus Aurelius*
(Chichester and Malden, MA, 2012),
264–77

Stirnemann, Patricia. 'Inquiries Prompted
by the Kane Suetonius (Kane MS 44)',
in Colum Hourihane (ed.), *Manuscripta
Illuminata: Approaches to Understanding
Medieval and Renaissance Manuscripts*
(Princeton, 2014), 145–60

Strada, Jacopo. *Imperatorum Romanorum
omnium orientalium et occidentalium
verissimae imagines ex antiquis numismatis
quam fidelissime delineatae* (Zurich, 1559)

Stuart Jones, Henry. 'The British School
at Rome', *The Athenaeum*, no. 4244 (27
February 1909), 265

Stuart Jones, Henry (ed.). *A Catalogue of the
Ancient Sculptures Preserved in the Munici-
pal Collections of Rome: The Sculptures of the
Museo Capitolino* (Oxford, 1912)

Stuart Jones, Henry (ed.). *A Catalogue of
the Ancient Sculptures Preserved in the
Municipal Collections of Rome: The
Sculptures of the Palazzo dei Conservatori*
(Oxford, 1926)

Stupperich, Reinhard. 'Die zwölf
Caesaren Suetons: Zur Verwendung von
Kaiserporträt-Galerien in der Neuzeit',
in Stupperich (ed.), *Lebendige Anike.
Rezeptionen der Antike in Politik, Kunst
und Wissenschaft der Neuzeit* (Mannheim,
1995), 39–58

*Synopsis of the Contents of the British Museum*
(48th edition, London, 1845)

*Synopsis of the Contents of the British Museum*
(49th edition, London, 1846)

*Synopsis of the Contents of the British Museum*
(62nd edition, London, 1855)

Syson, Luke. 'Witnessing Faces, Remember-
ing Souls', in Campbell et al., *Renaissance
Faces*, 14–31

Syson, Luke and Dora Thornton. *Objects of
Virtue: Art in Renaissance Italy* (London
and Los Angeles, 2001)

Tatum, W. Jeffrey. *The Patrician Tribune:
Publius Clodius Pulcher* (Chapel Hill,
1999)

*Tesori gotici dalla Slovacchia: L'arte del Tardo
Medioevo in Slovacchia* (Exhib. Cat., Rome,
2016)

Thackeray, William Makepeace. *The Paris
Sketch Book* (London, 1870; first pub-
lished 1840)

Thomas, Christine M. *The Acts of Peter, Gospel
Literature and the Ancient Novel: Rewriting
the Past* (Oxford, 2003)

Thonemann, Peter. *The Hellenistic World:
Using Coins as Sources* (Cambridge, 2015)

Thoré, Théophile. *Salons de T. Thoré 1844,
1845, 1846, 1847, 1848* (second edition,
Paris, 1870)

Tite, Colin G. C. *The Manuscript Library of
Sir Robert Cotton* (Panizzi Lectures 1993)
(London, 1994)

Tomei, Maria Antoinetta and Rossella Rea
(eds.). *Nerone* (Exhib. Cat., Rome, 2011)

Tosetti Grandi, Paola. *I trionfi di Cesare di
Andrea Mantegna: Fonti umanistiche e
cultura antiquaria alla corte dei Gonzaga*
(Mantua, 2008)

Trimble, Jennifer. 'Corpore enormi: The
Rhetoric of Physical Appearance in
Suetonius and Imperial Portrait Stat-
uary', in Jaś Elsner and Michel Meyer
(eds), *Art and Rhetoric in Roman Culture*
(Cambridge, 2014), 115–54

Tytler, Alexander Fraser. *Elements of General
History, Ancient and Modern* (revised
edition, London, 1846)

Usher, Phillip John. *Epic Arts in Renaissance
France* (Oxford, 2014)

Vaccari, Maria Grazia. 'Desiderio's Reliefs',
in Bormand et al. (eds), *Desiderio da
Settignano*, 176–95

Varner, Eric R. *Mutilation and Transformation:
Damnatio Memoriae and Roman Imperial
Portraiture* (Leiden and Boston, MA,
2004)

Vasari, Giorgio. *Le vite de' più eccellenti
pittori, scultori ed architetti* (first published

Florence 1550, revised 1568; cited from Luciano Bellosi and Aldo Rossi (eds), Turin, 1986)

Vázquez-Manassero, Margarita-Ana. 'Twelve Caesars' Representations from Titian to the End of 17th Century: Military Triumph Images of the Spanish Monarchy', in S. V. Maltseva et al. (eds), *Actual Problems of Theory and History of Art*, vol. 5 (St Petersburg, 2015), 655–63

Venturini, Elena. *Le collezioni Gonzaga: Il carteggio tra la corte Cesarea e Mantova (1559–1636)* (Milan, 2002)

Verheyen, Egon. 'Jacopo Strada's Mantuan Drawings of 1567–1568', *Art Bulletin* 49 (1967), 62–70

Vertue, George. *Vertue's Note Book, A.g. (British Museum Add. MS 23,070)* (Walpole Society, vol. 20, Vertue Note Books, vol. 2, 1931–32)

Vickers, Michael. 'The Intended Setting of Mantegna's "Triumph of Cæsar", "Battle of the Sea Gods" and "Bacchanals"' *Burlington Magazine* 120 (1978), 360 + 365–71

Vico, Enea. *Discorsi sopra le medaglie de gli antichi* (Venice, 1555)

Viljoen, Madeleine. 'Paper Value: Marcantonio Raimondi's "Medaglie Contraffatte"', *Memoirs of the American Academy in Rome* 48 (2003), 203–26

Visconti, Ennio Quirino. *Il Museo Pio-Clementino*, vol. 6, (Milan, 1821; first edition, Rome, 1792)

*The Visitor's Hand-Book to Richmond, Kew Gardens, and Hampton Court; . . .* (London, 1848)

Vollenweider, Marie-Louise. 'Die Gemmenbildnisse Cäsars', *Antike Kunst* 3 (1960), 81–88

Vollenweider, Marie-Louise and Mathilde Avisseau-Brouset. *Camées et intailles*, vol. 2: *Les Portraits romains du Cabinet de médailles* (Paris, 2003)

Voltaire, *Letters Concerning the English Nation* (London, 1733)

Voltelini, Hans von. 'Urkunden und Regesten aus dem k. u. k. Haus-, Hof- und Staats-Archiv in Wien', *Jahrbuch der Kunsthistorischen Sammlungen des Allerhöchsten Kaiserhauses* 13 (1892), 26–174

Vout, Caroline. 'Antinous, Archaeology and History', *Journal of Roman Studies* 95 (2005), 80–96

Vout, Caroline. *Classical Art: A Life History from Antiquity to the Present* (Princeton, 2018)

Waddington, Raymond B. 'Aretino, Titian, and *La Humanità di Cristo*', in Abigail Brundin and Matthew Treherne, *Forms of Faith in Sixteenth-Century Italy* (Aldershot, 2009) 171–98

Wagenberg-Ter Hoeven, Anke A. van. 'A Matter of Mistaken Identity: In Search of a New Title for Rubens's "Tiberius and Agrippina"', *Artibus et Historiae* 26 (2005), 113–27

Walker, Susan. 'Clytie: A False Woman?', in Jones (ed.), *Why Fakes Matter*, 32–40

Walker, Susan, and Morris Bierbrier. *Ancient Faces: Mummy Portraits from Roman Egypt* (London, 1997)

Wallace-Hadrill, Andrew. 'Civilis princeps: Between Citizen and King', *Journal of Roman Studies* 72 (1982), 32–48

Wallace-Hadrill, Andrew. *Suetonius: The Scholar and His Caesars* (London, 1983; reissued pb, 1998)

Ward-Jackson, Philip. *Public Sculpture of Historic Westminster*, vol. 1 (Liverpool, 2011)

Ward-Perkins, John B. 'Four Roman Garland Sarcophagi in America', *Archaeology* 11 (1958), 98–104

Wardropper, Ian (with Julia Day). *Limoges Enamels at the Frick Collection* (New York, 2015)

Warren, Charles. 'More Odd Byways in American History', *Proceedings of the Massachusetts Historical Society*, third series, 69 (1947–50), 252–61

Warren, Richard. *Art Nouveau and the Classical Tradition* (London, 2017)

Washburn, Wilcomb E. 'A Roman Sarcophagus in a Museum of American History', *Curator* 7 (1964), 296–99

Wegner, Max. 'Macrinus bis Balbinus', in Heinz B Wiggers and Wegner, *Das römische Herrscherbild*, Part 3, vol. 1 (Berlin, 1971), 131–249

Wegner, Max. 'Bildnisreihen der Zwölf Caesaren Suetons', in Hans-Joachim Drexhage and Julia Sünskes (eds), *Migratio et commutatio: Studien zur alten Geschichte und deren Nachleben* (St Katharinen, 1989), 280–85

Weigert, Laura. *French Visual Culture and the Making of Medieval Theater* (Cambridge, 2015)

Weir, David. *Decadence: A Very Short Introduction* (Oxford, 2018)

Weiss, Roberto. *The Renaissance Discovery of Classical Antiquity* (Oxford, 1969)

West, Shearer. *Portraiture* (Oxford, 2004)

Wethey, Harold E. *The Paintings of Titian: Complete Edition*, vol. 3: *The Mythological and Historical Portraits* (London, 1975)

Wheelock, Arthur K. et al. *Anthony van Dyck* (Exhib. Cat., Washington, DC, 1990)

Wheelock, Arthur K. *Flemish Paintings of the Seventeenth Century* (Collections of the National Gallery of Art, Systematic Catalogue) (Washington, DC, 2005)

Whitaker, Lucy and Martin Clayton. *The Art of Italy in the Royal Collection: Renaissance and Baroque* (London, 2007)

White, Cynthia. 'The Vision of Augustus: Pilgrims' Guide or Papal Pulpit?', *Classica et Mediaevalia* 55 (2005), 247–77

Wibiral, Norbert. 'Augustus patrem figurat: Zu den Betrachtungsweisen des Zentralsteines am Lotharkreuz im Domschatz zu Aachen' *Aachener Kunstblätter* 60 (1994), 105–30

Wielandt, Manuel. 'Die verschollenen Imperatoren-Bilder Tizians in der Königlichen Residenz zu München', *Zeitschrift für bildende Kunst* 19 (1908), 101–8

Wilks, Timothy. '"Paying Special Attention to the Adorning of a Most Beautiful Gallery": The Pictures in St James's Palace, 1609–49', *The Court Historian* 10 (2005), 149–72

Williams, Clare (ed.). *Thomas Platter's Travels in England, 1599* (London, 1937)

Williams, Gareth D. *Pietro Bembo on Etna: The Ascent of a Venetian Humanist* (Oxford, 2017)

Williams, Richard L. 'Collecting and Religion in Late Sixteenth-Century England', in Edward Chaney (ed.), *The Evolution of English Collecting: The Reception of Italian Art in the Tudor and Stuart Period* (New Haven and London, 2003), 159–200

Willis, Robert (ed. John Willis Clark). *The Architectural History of the University of Cambridge and of the Colleges of Cambridge and of Eton*, vol. 3 (Cambridge, 1886)

Wills, Garry. 'Washington's Citizen Virtue: Greenough and Houdon', *Critical Inquiry* 10 (1984), 420–41

Wills, Garry. *Cincinnatus: George Washington and the Enlightenment* (Garden City, 1984)

Wilson, James. *A Journal of Two Successive Tours upon the Continent in the Years 1816, 1817 and 1818*, vol. 2 (London, 1820)

Wilson, Michael I. *Nicholas Lanier: Master of the King's Musick* (Farnham, 1994)

Winckelmann, Johann Joachim. *Geschichte der Kunst des Alterthums* (Dresden, 1764); trans. H. F. Mallgrave as *History of the Art of Antiquity* (Los Angeles, 2006)

Winckelmann, Johann Joachim. *Anmerkungen über die Geschichte der Kunst des Alterthums* (Dresden, 1767; cited from the edition, with commentary, by Adolf. H. Borbein and Max Kunze, Mainz, 2008)

Wind, Edgar. 'Julian the Apostate at Hampton Court', *Journal of the Warburg and Courtauld Institutes* 3 (1939–40), 127–37

Winkes, Rolf. *Livia, Octavia, Iulia: Porträts und Darstellungen* (Providence and Louvain-la-Neuve, 1995)

Winkler, Martin M. (ed.). *Gladiator: Film and History* (Malden, MA and Oxford, 2004)

Wood, Christopher S. *Forgery, Replica, Fiction: Temporalities of German Renaissance Art* (Chicago, 2008)

Wood, Jeremy. 'Van Dyck's "Cabinet de Titien": The Contents and Dispersal of His Collection', *Burlington Magazine* 132 (1990), 680–95

Wood, Susan E. 'Subject and Artist: Studies in Roman Portraiture of the Third Century', *American Journal of Archaeology* 85 (1981), 59–68

Wood, Susan E. *Roman Portrait Sculpture 217–260 AD: The Transformation of an Artistic Tradition* (Leiden, 1986)

Wood, Susan E. 'Messalina Wife of Claudius: Propaganda Successes and Failures of his Reign' *Journal of Roman Archaeology* 5 (1992), 219–234

Wood, Susan E. *Imperial Women: A Study in Public Images, 40 BC—AD 68* (revised edition, Leiden etc., 2001)

Woodall, Joanna (ed.). *Portraiture: Facing the Subject* (Manchester, 1997)

Woods, Naurice Frank. 'An African Queen at the Philadelphia Centennial Exposition 1876: Edmonia Lewis's "The Death of Cleopatra"', *Meridians* 9 (2009), 62–82

Worsley, Lucy. 'The "Artisan Mannerist" Style in British Sculpture: A Bawdy Fountain at Bolsover Castle', *Renaissance Studies* 19 (2005), 83–109

Wyke, Maria. *Projecting the Past: Ancient Rome, Cinema and History* (New York and London, 1997)

Wyke, Maria (ed.). *Julius Caesar in Western Culture* (Malden, MA and Oxford, 2006)

Wyke, Maria. *Caesar: A Life in Western Culture* (London, 2007)

Wyke, Maria. *Caesar in the USA* (Berkeley and Los Angeles, 2012)

Yarrington, Alison. '"Under Italian skies", the 6th Duke of Devonshire, Canova and the Formation of the Sculpture Gallery at Chatsworth House', *Journal of Anglo-Italian Studies* 10 (2009), 41–62

Zadoks-Josephus Jitta, Annie Nicolette. 'A Creative Misunderstanding', *Netherlands Yearbook for History of Art* 23 (1972), 3–12

Zanker, Paul. *The Power of Images in the Age of Augustus* (Ann Arbor, 1988)

Zanker, Paul. 'Da Vespasiano a Domiziano: Immagini di sovrani e moda', in Coarelli (ed.), *Divus Vespasianus*, 62–67

Zanker, Paul. 'The Irritating Statues and Contradictory Portraits of Julius Caesar', in Griffin (ed.), *Companion to Julius Caesar*, 288–314

Zeitz, Lisa. *Tizian, Teurer Freund: Tizian und Federico Gonzaga, Kunstpatronage in Mantua im 16. Jahrhundert* (Petersberg, 2000)

Zimmer, Jürgen. 'Aus den Sammlungen Rudolfs II: "Die Zwölff Heidnischen Kayser sambt Iren Weibern" mit einem Exkurs: Giovanni de Monte', *Studia Rudolphina* 10 (2010), 7–47

Zimmern, Helen. *Sir Lawrence Alma Tadema R.A.* (London, 1902)

Zwierlein-Diehl, Erika. *Antike Gemmen und ihr Nachleben* (Berlin and New York, 2007)

# Illustrations

*Astérix* series. ASTERIX®- OBELIX®-IDEFIX® / © 2021 LES EDITIONS ALBERT RENE / GOSCINNY – UDERZO

**1.19** Bust of the emperor Commodus, ? 180–85 CE, marble, height 69.9 cm, John Paul Getty Museum, inv. 92.SA.48

**1.20** Giovanni da Cavino, *Antonia*, 36 BCE–c. 38 CE, *Daughter of Mark Antony and Octavia* (obverse) and *Claudius Caesar* (reverse), bronze, diameter 3.18 cm, Samuel H. Kress Collection, National Gallery of Art, Washington, DC, inv. 1957.14.995.a–b. Courtesy National Gallery of Art, Washington

**1.21** Statue of Alessandro Farnese, first century CE/head sixteenth century, marble, height 172 cm excl. head, Musei Capitolini, Rome, Palazzo dei Conservatori, 'Hall of the Captains', inv. Scu 1190. Archivio Fotografico dei Musei Capitolini, photo: Antonio Idini © Roma, Sovrintendenza Capitolina ai Beni Culturali

**1.22a** Statue of Helena (so called 'Agrippina'), c. 320–25 CE, marble, height 123 cm, Capitoline Museums, Rome, Palazzo Nuovo, 'Room of the Emperors', inv. Scu 496. Archivio Fotografico dei Musei Capitolini, photo: Barbara Malter © Roma, Sovrintendenza Capitolina ai Beni Culturali

**1.22b** Antonio Canova, *Madame Mère*, 1804–7, marble, height 145 cm, Sculpture Gallery, Chatsworth House, Derbyshire, UK. Wikimedia

**1.23** Paolo Veronese, *The Feast in the House of Levi*, 1573, oil on canvas, 1309 × 560 cm, Gallerie dell'Accademia, Venice, inv. 203. Bridgeman Images

**1.24** Male bust, so-called 'Grimani *Vitellius*', first half of second century CE, marble, height 48 cm, Museo Archeologico Nazionale di Venezia, Venice, inv. 20

**1.25** Henry Fuseli, *The Artist's Despair before the Grandeur of Ancient Ruins*, 1778–80, red chalk and sepia wash on paper, 35 × 42 cm, Kunsthaus, Zurich, inv. Z.1940/0144. Bridgeman Images

**2.1** The 'Arles *Caesar*', mid-first century BCE, Dokimeion (Phrygia) marble, height 39.5 cm, Musée Départemental Arles Antique, inv. RHO.2007.05.1939. © Rémi Bénali

**2.2** The *Great Cameo of France* (*Grand Camée de France*), 50–54 CE, sardonyx, 31 × 26.5 cm, Bibliothèque Nationale de France, Paris, Cabinet des Médailles, inv. Camée.264

**2.3** Coin (*denarius*) with wreathed head of Caesar (obverse), Rome, 44 BCE, silver, ANS Roman Collection, inv. 1944.100.3628. © American Numismatic Society

**2.4a** Hudson River *Caesar*, marble, height 23 cm, Carl Milles Collection, Millesgården Museum, Stockholm, inv. A 38. Photo: Per Myrehed, 2019. © Millesgården Museum

**2.4b** Pantelleria *Caesar*, mid-first century CE, Greek marble, height 42 cm, Dipartimento dei Beni Culturali e dell'Identità Siciliana, inv. IG 7509

**2.4c** The *Green Caesar*, Roman Egyptian, ? first century CE, from Wadi Hammamat (eastern desert of Egypt), greywacke, height 41 cm, Staatliche Museen zu Berlin, Altes Museum, Antikensammlung, inv. Sk 342. Photo: Johannes Laurentius

**2.4d** The Casali *Caesar*, first century BCE or later, marble, height 77 cm, Palazzo Casali, Rome. Photo: Deutsches Archäologisches Institut, Rome, D-DAI-ROM-70.2015

**2.4e** Vincenzo Camuccini, *The Death of Caesar* (detail), 1804–5, oil on canvas, 112 × 195 cm, Galleria Nazionale d'Arte Moderna e Contemporanea, Rome, inv. 10159. © Adam Eastland / agefotostock.com

**2.4f** Desiderio da Settignano, profile of a man with a laurel crown, often identified as Julius Caesar, c. 1460, marble, 43 × 29 × 10 cm, Musée du Louvre, Paris, inv. RF 572. Photo: René-Gabriel Ojéda © RMN-Grand Palais / Art Resource, NY

**2.5** Benito Mussolini announcing the abolition of the Chamber of Deputies and formation of the Assembly of Corporations in Rome, 25 March 1936. Photo by Keystone-France / Gamma-Keystone via Getty Images

**2.6** Head of Julius Caesar, Rome, probably c. 1800, marble, height 35 cm, British Museum, inv. 1818,0110.3. © The Trustees of the British Museum

**2.7** Bust of Julius Caesar found at Tusculum, ? c. 45 BCE, Luna marble, height 33 cm, Museo di Antichità, Castello di Aglié, Turin, inv. 2098. © MiBACT–Musei Reali di Torino

**2.8** Detail of Bust of Julius Caesar at the British Museum, **2.6**. Photo: Mary Beard

**2.9** The 'Meroe Head'/head of Augustus (findspot Meroe, Nubia, now in Sudan), 27–25 BCE, plaster, glass, calcite and bronze, height 46.2 cm, British Museum, inv. 1911,0901.1. © The Trustees of the British Museum

**2.10a** Detail of statue of Augustus, Rome (found in the ruins of the villa of Livia, Augustus's wife, at Prima Porta on the via Flaminia), early first century CE, marble, height 208 cm, Musei Vaticani, Vatican City, Museo

Chiaramonti, Braccio Nuovo, inv. 2290. Adam Eastland / Alamy Stock Photo

**2.10b** Diagram of hair lock scheme, from Dietrich Boschung, *Die Bildnisse des Augustus* (Berlin, 1993), Part 1, vol. 2, Fig. 83. Photo: Robin Cormack

**2.10c** Head from a statue of Tiberius Caesar, c. 4–14 CE, set on a modern bust, marble, total height 48.3 cm, British Museum, inv. 1812,0615.2. © The Trustees of the British Museum

**2.10d** Portrait bust of the emperor Caligula (Gaius), 37–41 CE, marble, height 50.8 cm, Metropolitan Museum, New York, inv. 14.37. Rogers Fund, 1914

**2.10e** Portrait head, marble, height 35.6 cm, British Museum, inv. 1870,0705.1. © The Trustees of the British Museum

**2.10f** Portrait head variously identified, ? of young Nero (reworked from a head of Gaius Caesar or of Octavian) on a modern bust, late first century BCE–early first century CE, white marble, height 52 cm, Musei Vaticani, Vatican City, Museo Pio-Clementino, Sala dei Busti, inv. 591. Photo © Governatorato SCV–Direzione dei Musei e dei Beni Culturali. All rights reserved

**2.11** Detail from the Temple of Dendur, Egypt, completed by 10 BCE, Aeolian sandstone, total length 24.6 m. Metropolitan Museum of Art, New York, inv. 68.154

**2.12** Head of the emperor Vespasian, c. 70 CE, marble, height 40 cm, Ny Carlsberg Glyptotek, Copenhagen, inv. 2585. Photo: Ny Carlsberg Glyptotek, Copenhagen

**2.13** Bust (believed to be) of the emperor Otho, later first century CE, marble, height 81 cm, Musei Capitolini, Rome, Palazzo Nuovo, 'Room of the Emperors', inv. Scu 430. Archivio Fotografico dei Musei Capitolini, photo Barbara Malter, © Roma, Sovrintendenza Capitolina ai Beni Culturali

**2.14** Nicolò Traverso, *The Genius of Sculpture*, early nineteenth century, marble and plaster, height 140 cm, Palazzo Reale, Genoa, Galleria degli Specchi. Photo: Chiara Scabini. With the permission of the Ministero per i Beni e le Attività Culturali e per il Turismo, Palazzo Reale di Genova

**2.15** Giambattista della Porta, illustration from *De humana physiognomonia, libri IIII*, (Vico Equense, 1586). Wellcome Trust, London

**3.1** Hans Memling, *Portrait of a Man with a Roman Coin* [possibly Bernardo Bembo], 1470s, oil on oak panel, 31 × 23.2 cm, Collection

KMSKA (Royal Museum of Fine Arts)—Flemish Community (CC0), Antwerp, inv. 5. Photo: Dominique Provost

**3.2** Sandro Botticelli, *Portrait of a Man with a Medal of Cosimo the Elder*, 1474–75, tempera on wood, 57.5 × 44 cm, Galleria degli Uffizi, Florence, inv. 1890.1488. © Fine Art Images / agefotostock.com

**3.3** Titian, *Portrait of Jacopo Strada*, 1567–68, oil on canvas, 125 × 95 cm, Kunsthistorisches Museum, Vienna, inv. GG 81. © DEA / G. Nimatallah / agefotostock.com

**3.4** Jacopo Tintoretto, *Portrait of Ottavio Strada*, 1567, oil on canvas, 128 × 101 cm, Rijksmuseum, Amsterdam, inv. SK-A-3902. Purchased with the support of the J. W. Edwin Vom Rath Fonds/Rijksmuseum Fonds

**3.5** Casket, German (Nuremberg?), later sixteenth century, silver and gold plated, 40 × 23 × 15.8 cm, Kunsthistorisches Museum, Vienna, inv. KK 1178 (on display at Schloss Ambras, Innsbruck, Kunstkammer)

**3.6** Chalice of Udalric de Buda (canon of Alba Julia), early sixteenth century, gold coated silver and gold coins, height 21 cm, Diocesan Museum of Nitra. With kind permission of the Roman Catholic Diocese of Nitra, Slovak Republic

**3.7a** The emperor Galba, from a mid-fourteenth-century manuscript, Fermo, Biblioteca Comunale, MS 81, fol. 40v (illustrated in Annegrit Schmidt, 'Zur Wiederbelebung der Antike im Trecento', *Mitteilungen des Kunsthistorischen Institutes in Florenz* 18 (1974), plate 61). Photo: Kunsthistorisches Institut in Florenz–Max-Planck-Institut

**3.7b** Coin (*sestertius*) with bust of the emperor Galba, laureate, draped (obverse), Rome, 68 CE, copper alloy, British Museum, inv. R.10162. © The Trustees of the British Museum

**3.7c** Coin (*denarius*) with bust of Maximinus Thrax, laureate, draped, cuirassed (obverse), Rome, 236–38 CE, silver, ANS Roman Collection, inv. 1935.117.73. © American Numismatic Society

**3.7d** Head of Maximinus Thrax from Giovanni de Matociis (d. 1337), *Historia imperialis* (begun around 1310), Biblioteca Apostolica Vaticana, Vatican City, MS Chig.I.VII.259, fol. 11r. © Biblioteca Apostolica Vaticana

**3.7e** Head of Caracalla from Giovanni de Matociis, *Historia imperialis* [see 3.7c above], Biblioteca Apostolica Vaticana, Vatican City, MS Chig. I.VII.259, fol. 4r. © Biblioteca Apostolica Vaticana

**3.7f** Coin (*denarius*) with bust of Marcus

Aurelius, laureate (obverse), Rome, 176–77[?], silver, British Museum, inv. 1995,0406.3. © The Trustees of the British Museum

**3.7g** Altichiero da Zevio, *Bust of Marco Antonio Bassiano* [= the emperor 'Caracalla'] *e decorazioni*, fourteenth century, wall painting (fresco; removed in 1967 from Palazzo dei Scaligeri, Verona), Museo degli Affreschi 'G. B. Cavalcaselle', Verona, inv. 36358–1B3856

**3.7h** Image of Nero from Andrea Fulvio, *Illustrium imagines* (Rome, 1517), Bibliothèque Nationale de France, RES-J-3269-fol. XLVIIr

**3.7i** Image of Cato, from Fulvio, *Illustrium imagines* (Rome, 1517), Bibliothèque Nationale de France, RES-J-3269 fol. XLVIIr

**3.7j** Portrait of Eve, from Guillaume Rouillé, *Promptuaire des medalles des plus renommees personnes qui ont esté depuis le commencement du monde* (Lyon, 1577; 2 vols), vol. 1, p. 5, 'Adam and Eve', Bibliothèque Nationale de France, J-4730

**3.7k** Roundel of Nero on the facade of La Certosa, Pavia, Italy, late fifteenth century. Fototeca Gilardi

**3.7l** Roundel of Attila the Hun, on facade of La Certosa, Pavia, Italy, late fifteenth century. Fototeca Gilardi

**3.7m** Roundel of Julius Caesar in loggia at Horton Court, Gloucestershire, UK, early sixteenth century. National Trust Images

**3.7n** Marcantonio Raimondi, 'Vespasian' from the Twelve Caesars series, c. 1500–1534 (plate 91 taken from vol. 3 of the later sixteenth-century album *Speculum romanae magnificentiae*), engraving, 17 × 15 cm (sheet), The Metropolitan Museum of Art, New York, inv. 41.72(3.91). Rogers Fund, transferred from the Library

**3.8** 'Nero' (opening page) from a manuscript copy of Suetonius's *Lives* (*C. Suetonii Tranquilli duodecim Caesares*) commissioned by Bernardo Bembo, c. 1474, illumination on parchment, Bibliothèque Nationale de France, MS lat. 5814, fol. 109r

**3.9** Ceiling of the 'Camera picta' in the Ducal Palace at Mantua, painted c. 1470. With permission of the Ministero per i Beni e le Attività Culturali e per il Turismo, Palazzo Ducale di Mantova

**3.10** Vincenzo Foppa, *Crucifixion*, 1456, tempera on wood, 68.5 × 38.8 cm, Accademia Carrara, Bergamo, inv. 58AC00040. The Picture Art Collection / Alamy Stock Photo

**3.11** Titian, *Christ and the Woman Taken in Adultery*, c. 1510, oil on canvas, 139.3 × 181.7 cm,. Culture and Sport, Glasgow, Kelvingrove

Art Gallery and Museum, inv. 181. © Fine Art Images / agefotostock.com

**3.12** Michael Rysbrack, *George 1*, 1739, marble, height 187 cm (left) and Joseph Wilton, *George II*, 1766, marble, height 187 cm (right). © The Fitzwilliam Museum, Cambridge. Reproduced with the kind permission of the University of Cambridge

**3.13** George Knapton, *Charles Sackville, 2nd Duke of Dorset*, 1741, oil on canvas, 91.4 × 71.1 cm. Reproduced by kind permission of the Society of Dilettanti, London

**3.14** Follower of Sir Anthony van Dyck, *Portrait of King Charles I*, eighteenth century, oil on canvas, 137 × 109.4 cm, private collection. © The National Trust

**3.15** African American school children facing the Horatio Greenough statue of George Washington at the US Capitol, Washington, DC, 1899. Photo: The Library of Congress, Washington, DC

**3.16** Joseph Wilton, *Thomas Hollis*, c. 1762, marble, height 66 cm, National Portrait Gallery, London, inv. 6946. Photo: © Stefano Baldini / Bridgeman Images

**3.17** Emil Wolff, *Prince Albert*, 1844 (left), marble, height 188.3 cm, Osborne House and *Prince Albert*, 1846–49 (right), marble, height 191.1 cm, Buckingham Palace, Royal Collection Trust, inv. RCIN 42028 and inv. RCIN 2070 respectively. © Her Majesty Queen Elizabeth II 2021

**3.18** Benjamin West, *The Death of General Wolfe*, 1770, oil on canvas, 151 × 213 cm, National Gallery of Canada, inv 8007. Wikimedia

**3.19** 'Master of the Vitae Imperatorum', image of Augustus and the Sibyl, from manuscript edition of Suetonius's *Lives of Caesars* (*De vita Caesarum*, Milan, 1433), illumination on parchment, Princeton University Library, MS Kane 44, fol. 27r

**3.20** Mino da Fiesole, busts of Piero de' Medici, c. 1453, marble, height 54 cm (left; Masterpics / Alamy Stock Photo) and Giovanni de' Medici, c. 1455, marble, height 52 cm (right; Bridgeman Images), Museo Nazionale del Bargello, Florence, inv. 75 and 117

**3.21** Pisanello (Antonio Pisano), *Leonello d'Este, 1407–1450, Marquis of Ferrara* (obverse) and *Lion Being Taught by Cupid to Sing* (reverse), 1441–44, bronze, diameter 10.1 cm, National Gallery of Art, Washington, DC, Samuel H. Kress Collection, inv. 1957.14.602.a/b. Courtesy National Gallery of Art, Washington

**4.1** Claudius Tazza (Aldobrandini Tazze), late sixteenth century, gilded silver, height 40.6,

diameter 38.1 cm, private collection, on loan to The Metropolitan Museum of Art, New York, inv. L1999.62.1. Image © The Metropolitan Museum of Art, New York / Art Resource NY

**4.2a** Scene from Tazza with Tiberius figure and dish with scenes from the life of Nero (Aldobrandini Tazze: for details see 4.1 above), private collection, on loan to The Metropolitan Museum of Art, New York, inv. L1999.62.2. Image © The Metropolitan Museum of Art, New York/ Art Resource NY

**4.2b** Scene from the Galba Tazza (Aldobrandini Tazze: for details see 4.1 above), Bruno Schroder Collection

**4.2c** Scene from the Julius Caesar Tazza (Aldobrandini Tazze: for details see 4.1 above), Museo Lázaro Galdiano, Madrid, inv. 01453. © Museo Lázaro Galdiano, Madrid

**4.2d** Scene from the Otho Tazza (Aldobrandini Tazze: for details see 4.1 above), Royal Ontario Museum, Toronto. From the collection of Viscount and Viscountess Lee of Fareham, given in trust by the Massey Foundation. Courtesy of the Royal Ontario Museum, © ROM

**4.2e** Scene from the Claudius Tazza (Aldobrandini Tazze: for details see 4.1 above), The Metropolitan Museum of Art, New York, inv. L1999.62.1. Image © The Metropolitan Museum of Art, New York / Art Resource NY

**4.2f** Detail of scene from Tazza with Tiberius figure and dish with scenes from the life of Nero (Aldobrandini Tazze: for details see 4.1 above), private collection, on loan to The Metropolitan Museum of Art, New York, inv. L1999.62.2. Image © The Metropolitan Museum of Art, New York / Art Resource NY

**4.3** Giovanni Battista Della Porta, busts of the Twelve Caesars in the entrance hall (Salone d'ingresso) of the Villa Borghese, Galleria Borghese, Rome. Photo: Luciano Romano

**4.4** Hieronymus Francken II and Jan Brueghel the Elder, *The Archdukes Albert and Isabella Visiting the Collection of Pierre Roose*, c. 1621–23, oil on panel, 94 × 123.2 cm, Walters Art Museum, Baltimore, inv. 37.2010

**4.5** Imperial casket, attributed to Colin Nouailher, French, c. 1545, enamel on copper with gilt-metal frame, 10.6 × 17.1 × 11.3 cm, The Frick Collection, inv. 1916.4.15. Henry Clay Frick Bequest

**4.6** Portrait medallion of Caligula, nineteenth century, bronze, diameter 10 cm, private collection. Photo: Robin Cormack

**4.7** Christian Benjamin Rauschner, four imperi-al heads (Julius Caesar, Augustus, Tiberius, Claudius), mid-eighteenth century, wax, height c. 14 cm (panel). Herzog Anton Ulrich-Museum Braunschweig, Kunstmuseum des Landes Niedersachsen, inv. Wac 63, 64, 65, 66. Photo: Museum

**4.8** Marcantonio Raimondi, 'Trajan' (misidentified as Nerva), engraving from The Twelve Caesars series (plate 94 taken from vol. 3 of *Speculum romanae magnificentiae*; details as at 3.7 above), The Metropolitan Museum of Art, New York, inv. 41.72(3.94). Rogers Fund, transferred from the Library

**4.9** Hendrick Goltzius, *Vitellius*, early seventeenth century, oil on canvas, 68.1 × 52.2 cm. Stiftung Preußische Schlösser und Gärten Berlin-Brandenburg, inv. GK I 980. Photo: Stiftung Preußische Schlösser und Gärten Berlin-Brandenburg

**4.10** Johann Bernhard Schwarzenburger, *Titus*, shortly before 1730, hardstones, gold, black enamel and precious stones, height 26.6 cm (with pedestal), Grünes Gewölbe, Staatliche Kunstsammlungen Dresden, inv. V151. Photo: Jürgen Karpinski

**4.11** Joost van Sasse (from a drawing by Johann Jacob Müller), *Interior View of the Great Royal Gallery at Herrenhausen* (Hanover), c. 1725, copperplate engraving, c. 19.5 × 15 cm (image). The Picture Art Collection / Alamy Stock Photo

**4.12** Photograph showing view of the 'Room of Emperors' in the Capitoline Museums, Rome, 1890s. Granger Historical Picture Archive

**4.13a** Statue of Baby Hercules, third century CE, basalt, height 207 cm, Musei Capitolini, Rome, Palazzo Nuovo, inv. Scu 1016. Colaimages / Alamy Stock Photo

**4.13b** Statue of a young man with his foot resting on a rock, 117–38 CE, marble, height 184.5 cm, Musei Capitolini, Rome, Palazzo Nuovo, inv. Scu 639. Archivio Fotografico dei Musei Capitolini, photo: Stefano Castellani, © Roma Sovrintendenza Capitolina ai Beni Culturali

**4.13c** The 'Capitoline Venus', second century CE, marble, height 193 cm, Musei Capitolini, Rome, inv. Scu 409. Archivio Fotografico dei Musei Capitolini, photo: Araldo De Luca, © Roma, Sovrintendenza Capitolina ai Beni Culturali

**4.14** Photograph of snow on the emperors' heads outside the Sheldonian Theatre, Oxford. Ian Fraser / Alamy Stock Photo

**4.15a** and **4.15b** Scenes from the Tiberius Tazza (previously identified as that of Domitian; Aldobrandini Tazze: for details see

4.1 above): *The Triumph of Tiberius under Augus-*
*tus* (4.15a) and *The Escape of Tiberius and Livia*
(4.15b), Victoria and Albert Museum, London,
inv. M.247-1956. © Victoria and Albert
Museum, London
**4.15c** Scene from the Caligula Tazza
(previously identified as that of Tibertius;
Aldobrandini Tazze: for details see 4.1 above),
*Caligula on His Bridge of Boats*, Casa-Museu
Medeiros e Almeida Museum, Lisbon, inv. FMA
1183. Courtesy of the Medeiros e Almeida
Museum
**5.1** After Titian, *Tiberius*, copy once owned
by Abraham Darby IV, by 1857, oil on canvas,
130.2 × 97.2 cm, private collection. Photo
courtesy of Christie's London
**5.2a–k** Aegidius Sadeler (after Titian), prints of
Titian's *Eleven Caesars*, 1620s, line engravings,
approx. 35 × 24 cm (sheets), British Museum,
inv. 1878,0713.2644–54. © The Trustees of the
British Museum. All rights reserved
**5.3** Porcelain cup showing Augustus, French,
acquired (with matched saucer showing Augus-
tus's wife Livia Drusilla: see 7.8 below) 1800,
hard paste porcelain, tortoiseshell ground
and gilded decoration, height 8.8 cm, Royal
Collection Trust, inv. RCIN 5675. © Her
Majesty Queen Elizabeth II 2021
**5.4** The 'Camerino dei Cesari' at the Ducal Pal-
ace at Mantua as it is now. With permission of
the Ministero per i Beni e le Attività Culturali e
per il Turismo, Palazzo Ducale di Mantova
**5.5a** Workshop of Giulio Romano, *The Omen*
*of Claudius's Imperial Powers* c. 1536–39, oil on
panel, 121.4 × 93.5 cm, Hampton Court Palace,
Royal Collection Trust, inv. RCIN 402806.
© Her Majesty Queen Elizabeth II 2021
**5.5b** Workshop of Giulio Romano, *Nero Playing*
*while Rome Burns*, c. 1536–39, oil on panel,
121.5 × 106.7 cm, Hampton Court Palace Royal
Collection Trust, inv. RCIN 402576. © Her
Majesty Queen Elizabeth II 2021
**5.6** Giulio Romano, *A Roman Emperor*[?] *on*
*Horseback*, oil on panel, 86 × 55.5 cm, Christ
Church Picture Gallery, Oxford,
inv. JBS 132
**5.7** Composite reconstruction of the west wall
of the Camerino dei Cesari, from drawings of
Ippolito Andreasi, c. 1570, pen, brown ink and
grey wash over black chalk, Museum Kunstpa-
last, Düsseldorf. Upper level: portraits of Nero
(20.5 × 15.9 cm), Galba (20.5 × 15.8 cm) and
Otho (20.5 × 16 cm) (inv. F.P. 10910, 10911,
10931); niche figures (c. 23.5 × 8.5 cm) (inv. F.P.
10885, 10886, 10881, 10883). Lower level: with
'stories' (the fire of Rome, Galba's dream and

Otho's suicide) and horsemen (35.8 × 97.9 cm)
(inv. F.P. 10940). Images © Kunstpalast-Horst
Kollberg-ARTOTHEK
**5.8** Giulio Romano. *The Modesty of Tiberius*, c.
1536–37, pen brown ink and brown wash over
black chalk, 51 × 42 cm, Musée du Louvre,
Paris, inv. 3548-recto. Photo: Thierry Le Mage
© RMN-Grand Palais / Art Resource, NY
**5.9** Ippolito Andreasi, c. 1570, *Lower Right*
*Half of the North* [*sic*; in fact *East*] *Wall* of the
Camerino dei Cesari, pen, brown ink and grey
wash over black chalk, 31.8 × 47.7 cm, Museum
Kunstpalast, Düsseldorf, inv. F.P. 10878. Image
© Kunstpalast-Horst Kolberg-ARTOTHEK
**5.10a** Bernardino Campi, *The Emperor*
*Domitian*, after 1561, oil on canvas, 138 ×
110 cm, Museo e Real Bosco di Capodimonte,
Naples, inv. Q1152. With permission of the
Ministero per i Beni e le Attività Culturali e
per il Turismo, Museo e Real Bosco di
Capodimonte–Fototeca della Direzione
Regionale Campania
**5.10b** Domenico Fetti, *The Emperor Domitian*,
c. 1616–17, oil on canvas, 151 ×112 cm, Musée
du Louvre, Paris, inv. 279. © Photo Josse /
Bridgeman Images
**5.10c** Domenico Fetti, *The Emperor Domitian*,
1614–22, oil on canvas,133 × 102 cm, Schloss
Weissenstein, Pommersfelden, Bavaria, inv. 177.
Photo: Robin Cormack
**5.10d** Unknown artist, *Domitian* (wrongly
labelled *Titus*), before 1628, oil on
canvas, 126 × 88 cm, private collection
**5.10e** E003354 Supraporte 'Imperatorenbil-
dnis' (Domitianus), Umkr. Tizian. Residenz
München, Reiche Zimmer, Antichambre
(R.55), inv. ResMü. Gw 0156. © Bayerische
Schlösserverwaltung, Schaller, Munich
**5.10f** Aegidius Sadeler, *The Emperor Domitian*,
line engraving, approx. 35 × 24 cm, British
Museum, inv. 1878,0713.2655. © The Trustees
of the British Museum. All rights reserved
**5.10g** *Domitian* from the set acquired by the
Ducal Palace in Mantua in the 1920s. With per-
mission of the Ministero per i Beni e le Attività
Culturali e per il Turismo, Palazzo Ducale di
Mantova
**5.11a** Anthony van Dyck, *Charles I with M. de*
*St Antoine*, 1633, oil on canvas, 370 × 270 cm,
Windsor Castle, Royal Collection Trust, inv.
RCIN 405322. © Her Majesty Queen Elizabeth
II 2021
**5.11b** Guido Reni, *Hercules on the Funeral Pyre*,
1617, oil on canvas, 260 × 192 cm, Musée du
Louvre, Paris, France, inv. 538. Photo: Franck
Raux © RMN-Grand Palais / Art Resource

5.12 Giovanni di Stefano Lanfranco, *Sacrifice for a Roman Emperor*, c. 1635, oil on canvas, 181 × 362 cm, Museo Nacional del Prado, Madrid, inv. P000236. Photo © Museo Nacional del Prado

5.13a Bernardino Campi after Titian, *The Emperor Augustus*, 1561, oil on canvas, 138 × 110 cm. Museo e Real Bosco di Capodimonte, Naples, inv. Q1158. With permission of the Ministero per i Beni e le Attività Culturali e per il Turismo–Fototeca della Direzione Regionale Campania

5.13b Unknown artist, *Ottaviano Cesare Augusto*, before 1628, oil on canvas, 126 × 88 cm, private collection, Mantua

5.14 Edition of Suetonius's *Twelve Caesars*, printed in Rome, 1470; the binding c. 1800, with Augsburg enamels c. 1690 after Sadeler's Twelve Caesars inset into the inside front cover. Collection of William Zachs, Edinburgh. Photo courtesy of Sotheby's London

5.15 Bartholomeus Eggers, *Marcus Salvius Otho*, late seventeenth century, lead, height 89 cm, Rijksmuseum, Amsterdam, inv. BK-B-68-C. Peter Horree / Alamy Stock Photo

6.1 'The King's Staircase', Hampton Palace, featuring the mural by Antonio Verrio, with a scheme based on Julian the Apostate's satire *The Caesars*, written in mid fourth century. Historic Royal Palaces. © Historic Royal Palaces

6.2a Detail of the 'King's Staircase', Hampton Court Palace, showing Julius Caesar, Augustus (and Zeno). Historic Royal Palaces. © Historic Royal Palaces

6.2b Detail of the 'King's Staircase', Hampton Court Palace, showing Nero. Historic Royal Palaces. © Historic Royal Palaces

6.2c 'The King's Staircase', Hampton Court Palace: south elevation, showing Hermes and Julian the Apostate (seated). Historic Royal Palaces. © Historic Royal Palaces

6.3 The 'Table of the Great Commanders of Antiquity' (full table top, and detail of Caesar), French (Sèvres porcelain factory), 1806–12, hard-paste porcelain, gilt bronze mounts, internal wooden frame, diameter 104 cm, Buckingham Palace, Royal Collection Trust, inv. RCIN 2634. © Her Majesty Queen Elizabeth II 2021

6.4 John Deare, *Julius Caesar Invading Britain*, 1796, marble, 87.5 × 164 cm, Victoria and Albert Museum, London, inv. A.10:1-2011. © Victoria and Albert Museum, London

6.5 Ceiling decoration, 1530–31, of the 'Chamber of the Emperors' at the Palazzo Tè, Mantua. © Mauro Flamini / agefotostock.com

6.6 Andrea Mantegna, *The Triumphs of Caesar*, c. 1484–92: 1. *The Picture-Bearers* (left); 2. *The Bearers of Standards and Siege Equipment* (right), tempera on canvas, c. 270 × 281 cm, Hampton Court Palace, Royal Collection Trust, inv. RCIN 403958 and 403959. © Her Majesty Queen Elizabeth II 2021

6.7 Andrea Mantegna, *The Triumphs of Caesar*, c. 1484–92: 9. *Caesar on His Chariot*, tempera on canvas, 270.4 × 280.7 cm, Hampton Court Palace, Royal Collection Trust, inv. RCIN 403966. © Her Majesty Queen Elizabeth II 2021

6.8 *The Assassination of Caesar* (tapestry), Brussels, 1549, wool and silk, 495 × 710 cm, Musei Vaticani, Vatican City, Galleria degli Arazzi, inv. 43788. Photo © Governatorato SCV–Direzione dei Musei e dei Beni Culturali. All rights reserved

6.9 Tapestry captioned '*Abripit absconsos thesaurus Caesar …*', Brussels, c. 1560–70, wool and silk, 430 × 585 cm, present location unknown (auctioned by Graupe, Berlin, 26–27 April 1935, lot 685)

6.10 Ilario Mercanti ('lo Spolverini') (artist), Francesco Domenica Maria Francia (engraver), *Facade of Parma Cathedral Richly Decorated on the Occasion of the Marriage of Elisabetta Farnese, Queen of Spain* (16 September 1714) watercoloured engraving, c. 1717, 43.7 × 50.2 cm, Biblioteca Palatina, Parma, inv. S* II 18434

6.11 Tapestry captioned '*Iacta alea est transit Rubicone …*', Brussels, sixteenth century, wool and silk, 420 × 457 cm, in New York Persian Gallery (saleroom), inv. 27065

6.12 Tapestry captioned '*Iulius hic furiam Caesar fugitat furietem …*', Brussels, c. 1560–70, wool and silk, 415 × 407 cm, Palácio Nacional de Sintra/National Palace of Sintra, Sintra, Portugal. Image © Parques de Sintra-Monte da Lua, S.A. / EMIGUS

6.13 Tapestry captioned '*Iulius Caesar impetum facit*', Brussels, c. 1655–70, wool and silk, 335.5 × 467 cm, Blue Drawing Room, Powis Castle, Powys, Wales, inv. NT 1181080.1. © National Trust Images / John Hammond

6.14a Adriaen Collaert (engraver) after Jan van der Straet (Stradanus), *Augustus*, c. Netherlandish, 1587–89, engraving, 32.3 × 21.7 cm (sheet), The Metropolitan Museum of Art, New York, inv. 49.95.1002(2), The Elisha Whittlesey Collection. The Elisha Whittlesey Fund, 1949

**6.14b** Adriaen Collaert (engraver) after Jan van der Straet (Stradanus), *Domitian*, c. 1587–89, engraving, 32.4 × 21.6 cm (sheet), The Metropolitan Museum of Art, New York, inv. 49.95.1002(12). The Elisha Whittelsey Collection, The Elisha Whittelsey Fund, 1949

**6.15** Peter Paul Rubens, sketch of Roman emperors, early seventeenth century CE, pen and brown ink, on paper, 23.6 × 41.9 cm, Kupferstichkabinett, Staatliche Museen zu Berlin, Germany, inv. KdZ 5783 (verso). Photo: Dietmar Katz © bpk Bildagentur / Staatliche Museen zu Berlin / Dietmar Katz / Art Resource, NY

**6.16** Jean-Léon Gérôme, *The Age of Augustus: The Birth of Jesus Christ,* (c. 1852–54; exhibited 1855), oil on canvas, 620 × 1015 cm, Collection du Musée d'Orsay, Paris, dépôt au Musée de Picardie, Amiens, inv. RF 1983 92. Photo: Marc Jeanneteau / Musée de Picardie

**6.17:** Carle (or Charles-André) Van Loo, *Augustus Closing the Gates of the Temple of Janus,* (exhibited) 1765, oil on canvas, 300 × 301 cm, Collection du Musée de Picardie, Amiens, inv. M.P.2004.17.29. Photo: Marc Jeanneteau / Musée de Picardie

**6.18** Thomas Couture, *The Romans of the Decadence*, 1847, oil on canvas, 472 × 772 cm, Musée d'Orsay, Paris, inv 3451. Wikimedia

**6.19** Georges Rouget, *Vitellius, Roman Emperor, and Christians Thrown to the Wild Beasts*, exhibited 1847, oil on canvas, 116 × 90 cm, Musée du Berry, Bourges, inv. 949.I.2. Photo: Robin Cormack

**6.20a** Jules-Eugène Lenepveu *The Death of Vitellius*, 1847, oil on canvas, 32.5 × 24 cm, Musée d'Orsay, Paris, inv. RF MO P 2015 27. © Beaux-Arts de Paris, Dist. RMN-Grand Palais / Art Resource, NY

**6.20b** Paul Baudry *The Death of Vitellius*, 1847, oil on canvas, 114 × 146 cm, Musée Municipal de La Roche-sur-Yon, inv. 857.1.1. © Musée de La Roche-sur-Yon / Jacques Boulissière

**6.21** Jean-Léon Gérôme, *The Death of Caesar*, 1859–67, oil on canvas, 85.5 × 145.5 cm, The Walters Art Museum, Baltimore, inv. 37.884

**6.22** Jean-Paul Laurens, *The Death of Tiberius*, 1864, oil on canvas, 176.5 × 222 cm, Musée Paul-Dupuy, Toulouse, inv. 49 3 23. Photo: M. Daniel Molinier

**6.23** Sir Lawrence Alma-Tadema, *The Roses of Heliogabalus*, 1888, oil on canvas, 133.5 × 214.5 cm, Pérez Simón Collection, Mexico. Active-Museum / Alamy Stock Photo

**6.24** Sir Lawrence Alma-Tadema, *A Roman Emperor: AD 41*, 1871, oil on canvas, 86 × 174.3 cm, The Walters Art Museum, Baltimore, inv. 37.165

**6.25** Vasiliy Smirnov, *The Death of Nero*, 1887–88, oil on canvas, 177.5 × 400 cm, The Russian Museum, St Petersburg, inv. Ж-5592. The Picture Art Collection / Alamy Stock Photo

**6.26** *Boy with Goose*, first–second century CE (copy of Greek original of ? second century BCE), height 92.7 cm, Musée du Louvre, Paris, inv. Ma 40 (MR 168). Wikimedia

**7.1** Sir Lawrence Alma-Tadema, *Agrippina Visiting the Ashes of Germanicus*, 1866, oil on panel, 23.3 × 37.5 cm, private collection. Artepics / Alamy Stock Photo

**7.2** Bust identified as Faustina, Roman, c. 125–59 CE, Greek marble, height 76 cm, Palazzo Ducale, Mantua, inv. 6749. With permission of the Ministero per i Beni e le Attività Culturali e per il Turismo, Palazzo Ducale di Mantova

**7.3a–c** Statues from Velleia, Emilia Romagna (Roman Veleia), 37–41 CE: Livia (7.3a), marble, height 224.5 cm; Agrippina the Elder (7.3b), marble, height 209 cm; Agrippina the Younger (7.3c), marble, height 203 cm, Museo Nazionale Archeologico di Parma, Parma, inv. 828, 829 and 830 respectively. With permission of the Ministero per i Beni e le Attività Culturali e per il Turismo, Complesso Monumentale della Pilotta

**7.4** Cameo bust often identified as Messalina, laureate, with her children Britannicus and Octavia, Roman, mid-first century CE, sardonyx, seventeenth-century enamelled gold frame, 6.7 × 5.3 cm, Paris, Bibliothèque Nationale de France, Paris, Cabinet des Medailles, inv. Camée.277

**7.5a** Statue of Messalina with Britannicus, Roman, c. 50 CE (heavily restored in the eighteenth century), marble, height 195 cm, Musée du Louvre, Paris, inv. Ma 1224 (MR 280). © Peter Horree / agefotostock.com

**7.5b** Kephisodotos's *Eirene and Ploutos*, c. 375–360 BCE, later Roman copy, marble, 201 cm, Munich Glypothek, inv. 219. Munich Glypothek /Art Resource, NY

**7.6** Bas-relief of Agrippina the Younger and Nero, from the Sebasteion at Aphrodisias, Roman, mid-first century CE, marble, 172 × 142.5 cm, Archaeological Museum, Aphrodisias, Caria, Turkey, inv. 82-250. © Funkystock / agefotostock.com

**7.7a–l** Aegidius Sadeler, prints of twelve empresses from the series 'The Emperors and Empresses of Rome' published by Thomas Bakewell, (London 'Next the Horn Tavern in Fleet-street', active c. 1730[?]),

line engravings, approx. 35 × 24 cm, British Museum, inv. 1878,0713.2656–67. © The Trustees of the British Museum. All rights reserved

**7.8** Porcelain saucer showing Livia Drusilla, French, acquired (with matched cup showing Augustus: see **5.3** above) 1800, hard paste porcelain, tortoiseshell ground and gilded decoration, diameter 13.5 cm, Royal Collection Trust, inv. RCIN 5675. © Her Majesty Queen Elizabeth II 2021

**7.9** Aubrey Beardsley, *Messalina and Her Companion*, 1895, graphite, ink and watercolour on paper, 27.9 × 17.8 cm, Tate, London, inv. N04423. Digital Image: Tate Images

**7.10** James Gillray, *Dido, in Despair!*, 1801, hand-coloured etching, 25.2 × 36 cm, pic. ID 161499. Courtesy of the Warden and Scholars of New College, Oxford / Bridgeman Images

**7.11** Georges Antoine Rochegrosse, *The Death of Messalina*, 1916, oil on canvas, 125.8 × 180 cm, private collection. The History Collection / Alamy Stock Photo

**7.12** Angelica Kauffman, *Virgil Reading the 'Aeneid' to Augustus and Octavia*, 1788, oil on canvas, 123 × 159 cm, The State Hermitage Museum, St Petersburg, inv. ГЭ-4177. Photo: Vladimir Terebenin © The State Hermitage Museum

**7.13a** Jean-Auguste-Dominique Ingres, *Virgil Reading Sixth Book of the 'Aeneid' to Augustus, Octavia and Livia*, c. 1812, oil on canvas, 304 × 303 cm, Musée des Augustins, Toulouse, inv. RO 124. Album / Alamy Stock Photo

**7.13b** Jean-Auguste-Dominique Ingres, *Augustus Listening to the Reading of the 'Aeneid'*, c. 1819, oil on canvas,138 × 142 cm, Musées Royaux des Beaux-Arts de Belgique, Brussels, inv. 1836. Bridgeman Images

**7.13c** Jean-Auguste-Dominique Ingres, *Virgil Reading from the 'Aeneid'* [*to Augustus, Octavia and Livia*], 1864, oil on paper on panel, 61 × 49.8 cm, private collection. Photo courtesy of Christie's New York

**7.14** Benjamin West, *Agrippina Landing at Brundisium with the Ashes of Germanicus*, 1768, oil on canvas, 168 × 240 cm, Yale University Art Gallery, inv. 1947.16. Yale University Art Gallery. Gift of Louis M. Rabinowitz. Photo: Yale University Art Gallery

**7.15** *Agrippina the Elder and Tiberius*, from an incunable German translation by Heinrich Steinhöwel of Boccaccio's *De mulieribus claris*, c. 1474 (printed at Ulm by Johannes Zainer), hand-coloured woodcut illustration, 8 × 11 cm, Penn Libraries, Kislak Center for Special Collections, Rare Books, and Manuscripts, call number Inc B-720 (leaf [n]7r, f. cxvij)

**7.16** *Nero and Agrippina*, from 'Baron d'Hancarville' [Pierre-François Hugues], *Monumens de la vie privée des XII Césars*, Bibliothèque Nationale de France, Paris, RESERVE 4-H-9392, view 212

**7.17** William Waterhouse, *The Remorse of Nero after the Murder of His Mother*, 1878, oil on canvas, 94 × 168 cm, private collection. Painters / Alamy Stock Photo

**7.18** Arturo Montero y Calvo, *Nero before the Corpse of His Mother*, 1887, oil on canvas, 331 × 500 cm, Museo del Prado, Madrid, inv. P006371. Wikimedia

**7.19** *Nero and Agrippina*, illustrating *Roman de la Rose*, Netherlandish, 1490–1500, detail of illuminated manuscript on parchment, 39.5 × 29 cm, copying (text only) of edition printed in Lyon, c. 1487, British Library, London, Harley MS 4425, fol. 59r. © British Library Board. All Rights Reserved / Bridgeman Image

**7.20a** Peter Paul Rubens, *Germanicus and Agrippina*, c. 1614, oil on panel, 66.4 × 57 cm, National Gallery of Art, Washington, DC, inv. 1963.8.1. Andrew W. Mellon Fund. Courtesy National Gallery of Art, Washington

**7.20b** Peter Paul Rubens, *Germanicus and Agrippina*, c. 1615, oil transferred to masonite panel, 70.3 × 57.5 cm, Ackland Art Museum, Chapel Hill, NC, inv. 59.8.3. Ackland Fund

**7.21** 'The Gonzaga Cameo' (portraits variously identified), third century BCE or later (setting: later work), sardonyx, silver and copper, 15.7 × 11.8 cm, The State Hermitage Museum, St Petersburg, inv. ГР-12678. Photo: Vladimir Terebenin © The State Hermitage Museum

**8.1a** Edmonia Lewis, *Young Octavian*, c. 1873, marble, height 42.5 cm,. Smithsonian American Art Museum, Washington, DC, inv. 1983.95.180. Gift of Mr. and Mrs. Norman Robbins

**8.1b** Head of 'Young Octavian', first century BCE/CE (on modern bust), white marble, height 52 cm, Musei Vaticani, Vatican City, Museo Pio-Clementino, Galleria dei Busti, inv. 714. Photo © Governatorato SCV– Direzione dei Musei e dei Beni Culturali. All rights reserved

**8.2** Edmonia Lewis, *The Death of Cleopatra*, 1876, marble, 160 × 79.4 × 116.8 cm, Smithsonian American Art Museum, Washington, DC, inv. 1994.17. Gift of the Historical Society of Forest Park, Illinois

**8.3** President Franklin D. Roosevelt's toga-party birthday celebration, Washington, DC, 1934. © Franklin D. Roosevelt Presidential Library and Museum

**8.4a** James Welling, *Julia Mamaea*, 2018, gelatin dichromate print with aniline dye and India ink, 35.6 × 27.9 cm. © James Welling
**8.4b** Barbara Friedman, *Julia Mamaea Mother of the Future Emperor Alexander Severus*, 2012, oil on linen, 76.2 × 55.8 cm. © Barbara Friedman
**8.4c** Genco Gülan, *Chocolate Emperor*, 2014, chocolate, plaster, marble and acrylic, height 60 cm, EKA Foundation Collection. © Estate Genco Gülan
**8.4d** Medardo Rosso, *The Emperor Vitellius*, c. 1895, gilt bronze, height 34 cm. Victoria and Albert Museum, London, inv. 210-1896. © Victoria and Albert Museum, London
**8.4e** Jim Dine, *Head of Vitellius*, 2000, shellac, charcoal and paint on felt, 115.3 × 77.8 cm, Fine Arts Museums of San Francisco, inv. 2013.75.14. © 2021 Jim Dine / Artists Rights Society (ARS), New York
**8.5** Alison Wilding, *Romulus Augustus*, 2017, inks and collage on paper, 37 × 37 cm, private collection. Photo: Robin Cormack © Alison Wilding 2017
**8.6** Anselm Kiefer, *Nero Paints*, 1974, oil on canvas, 221.5 × 300.6 cm, Staatsgalerie Moderner Kunst, Munich, WAF PF 51. Photo: Atelier Anselm Kiefer © Anselm Kiefer
**8.7a** Jean-Léon Gérôme, *Pollice Verso*, 1872, oil on canvas, 149.2 × 96.5 cm, Phoenix Art Museum, Phoenix, AZ, inv. 1968.52. Museum purchase
**8.7b** Still from Ridley Scott (dir.), *Gladiator* (2000). United Archives GmbH / Alamy Stock Photo
**8.8** Sarcophagus (see **1.1** above) in its current location in Suitland, MD. Photo: Robin Cormack

# Index

Note: Page numbers in *italic* type indicate illustrations.

278; Virgil being read to, 16; vision of baby Jesus, 22–23, *22*; on walls of temple at Dendur, 67, *67*; wax relief panel, 127, *128*

Augustus beer, 23, *25*

Augustus 'the Strong', Elector of Saxony and King of Poland, 135–36

autocracy, associated with Roman emperors, 6, 8, 39, 47–48, 105–6, 156, 176, 242, 254, 259, 280, 283

*Baby Hercules*, 141–42, *141*

Baring-Gould, Sabine, 56

Baudry, Paul-Jacques-Aimé, *The Assassination of Vitellius*, 224–26, *225*

Beardsley, Aubrey, *Messalina and her companion*, 254, *255*

Beerbohm, Max, *Zuleika Dobson*, 142, 143–45

Bembo, Bernardo, 78, 116; commissioned manuscript copy of Suetonius's *Lives*, 89, *92*, 93

Boccaccio, *On Famous Women*, 263

Bolsover Castle, England, 14, 143, 182

Bonaparte, Letizia (Madame Mère), 31–32, *33*, 102, 104, 116, 259

Bonaparte, Lucien, 59

Bonaparte, Napoleon, 31–32, 136, 142, 151, 193, 218, 274, 276

Borda, Maurizio, 59, 61

Bordone, Paris, *Apparition of the Sibyl to Caesar Augustus*, 22, 23

Botticelli, Sandro, *Portrait of a Man with a Medal of Cosimo the Elder*, 80, *80*

*The Boy and the Goose*, 233–34, *234*

Brett, John Watkins, 151, 154

Britannicus, *245*, *246*, *247*, 264

Brodsky, Joseph, 49

Brutus, 215

Bryn Mawr College, 5, 285

Buchan, John, 57, 61

Buzzi, Ippolito, sculpture of Alessandro Farnese, 29–31, *30*

Byrd, William, 144

Caesar, Gaius, *66*

Caesar, Julius: from Aldobrandini Tazze, 120, *121*, 147; Arles (Rhône) *Caesar*, 43–44, *44*, 46, 61; assassination of, 43, 48, 50, 69, 107, 195, 197, 200–201, *201–2*, 208, 226–27; in *Astérix*, 24, *25*, 63; bust in British Museum, 56–59, *57*, 61–62, *61* (detail); Buzzi's sculpture of Alessandro Farnese incorporating body of, 29–31, *30*; in Camuccini's *Death of Caesar*, *54*, 63; coin images of, 44, *46*, 51–52, 84; in Deare's relief of Caesar fighting from a boat, 194, *194*, 208; Desiderio da Settignano's head of, *54*, 63; eighteenth-century figure of, 135; full-length sculpture moved by

Mussolini from Capitoline hill, 53, 55, *55*, 62; in Gérôme's *Death of Caesar*, 226–27, *228*; *Great Cameo of France*, 45; *Green Caesar*, 53, *54*, 62; head from Hudson River, 52–53, *54*; from Horton Court, Gloucestershire, 91, 95; identification/dating of images of, 43–47, 50–68; *Julius Caesar* from Pantelleria, 53, *54*, 61; *Julius Caesar* in Casali Collection, Rome, 53, *54*; Kenneth Williams as, in *Carry on Cleo*, 25; in 'King's Staircase', Hampton Court Palace, 190–91, *190*; in Mantegna's *Triumphs*, 63, 197; modern figures modeled on, 102; Mussolini's use of image of, 8; among Nine Worthies, 122; physical appearance of, 44, 50–52, 56, 59–60, 62–63; and Pompeia, 241; Pompey as enemy of, 140, 193–95, 200, 202–3, 207–10; portraits of, 48–50, 52–53, 309n21; related image from Camerino dei Cesari, 169; role of, in Rome's political history, 47–48, 192–95; Rubens caricature of, 213–14, *214*; Sadeler's print of, 186; sculpted head substituted on sculpture of Alexander the Great, 31, 49; Suetonius on, 48, 49, 50–51; on Table of the Great Commanders, 192–93, *193*, 195; in tapestries, 199–211, *201*, *202*, *205*, *206*; Titian's painting of, 102, 154, 176; Tusculum head of, 59–61, *60*; use of images by, 48–49; wax relief panel, 127, *128*

Caesar, Lucius, 66

*Caesar Breaking into the Treasury* (tapestry), *202*, 203

*Caesar Crossing the River Rubicon* (tapestry), 203, *205*

Caesarian tapestries, 199–211, *201*, *202*, *204*, *205*, *206*, *209*, 285

*Caesars* (Titian), 150–87; actual number of, 133, 167, 172; audience for, 170; *Augustus*, 158, 165, *165*, 170, 176, *181*; in Camerino dei Cesari, 156–71, *157*, 179; *Claudius*, 158, 176; destruction of, 152, 154, 179; dispersal of, 171–73; *Galba*, 158, *163*; influence of, 15, 24, 102, 154–55, 171–72, 179, 182–85; *Julius Caesar*, 102, 154, 176; links of other Titian works to, 39; in 'mini-Mantua' (Albrecht V's Kunstkammer), 161–62, 179, 181, 325n76; monetary value of, 199; *Nero*, *163*, 177; *Otho*, 103–4, 154, 158, *163*, 175, *184*, 185; prints after, *153*, 182–87, *183*, 326n78; reproductions of, 123, 151–56, *153*, 159, 161, 167, 172–73, 179–85; *Tiberius*, 152, 158; van Dyck's restoration work on, 103–4, 155, 172–73, 177; *Vitellius*, 172–73, 177

Caesonia, *251*

Caligula: from Aldobrandini Tazze, 147, *149*; Alma-Tadema's paintings involving, 227,

Phillips, Siân, 237
phrenology, 75–76
physiognomics, 75
Piranesi, Giovanni Battista, engraving of sar-
cophagus linked to Alexander Severus', 4, *5*, 7
Pisanello, bronze medallion of Leonello d'Este,
115, *116*
Pitt, William, the Elder, 110
Pitt, William, the Younger, 102
Plaudilla, 253
Pliny the Elder, 89, 233
Pliny the Younger, 89
Poggio Bracciolini, 192, 195
Poitiers Cathedral, France, stained glass window
with Nero, 12, *12*, 19, 112, 212
Pompeia, 241, *251*
Pompey the Great, 140, 193–95, 200, 202–3,
207–10
Portland Vase, 4
portrait books, 98–99
portraiture, Roman, 49, 70, 315n51
Poussin, Nicholas, 263
Powis Castle, Wales, 14
Prix de Rome, 16, 17, 36, 222–26

*Quo Vadis* (film), 284

Raimondi, Marcantonio: images modeled on
engravings of, in sixteenth-century metal
casket, 126, *126*; luxury series of the Twelve
Caesars, *91*, 93, 98, 131, *132*
Raphael, 93, 158
Renaissance: representations of Romans in,
111–17; sets of Twelve Caesars in, 122–31
Reni, Guido, Hercules on his funerary pyre,
173, *175*
restoration of images. *See* cleaning/restoration/
alteration of images
Reynolds, Joshua, 110–11, 113–14, 277
Rice Holmes, Thomas, 56, 58
Riddell, Chris, cartoon of Gordon Brown as
Nero, *25*
*The Robe* (film), 284
Rochegrosse, Georges Antoine, *Death of
Messalina*, 256, *257*
*Roman de la Rose*, 267, *268*
'Roman emperors', Sheldonian Theatre,
Oxford, *142*, 143–45
Roman emperors and their images: ancient and
modern cross-influences concerning, 23–32,
*25*, 63; assassination as theme in, 226–31;
Bolsover Castle, England, 14; Caesar's
initiation of, 48–49; coins produced by, 74,
82–83; in contemporary popular culture,
23, *25*, 277–84; exemplary function of, 186,
194, 215–18; guidelines on, 17; immoral and

excessive behaviour of, 42, 212–19; living
subjects represented in guise of, 100–111,
275; Long Gallery, Powis Castle, Wales, 14,
*15*; the 'look' of, 62–72, 244; number and
variety of, 9–23; political and other meanings
associated with, 6, 8, 17, 23, 32, 41–42, 73,
77, 105–7, 115, 117, 123, 133, 169–70, 173,
175–78, 211, 225–26, 274–75, 277–84; and
power, 222, 227–30, 234, 238–39, 274–75;
realism of, 73; Renaissance representations
of, 111–17; in Room of the Emperors, Capi-
toline Museums, 137–43, *138*, *141*; satiric
treatment of, 19, *21*, 188–92, 215; subject
matter of, 15–16; succession among, 69–70,
169, 226, 239, 241, 268–69; Suetonius's
*Lives* and other texts as source material for,
38; survival of, 10–11; Titian's depiction of,
157–58; use of images by, 65, 67. *See also*
cleaning/restoration/alteration of images;
coins; identification/dating of images; Twelve
Caesars
Romano, Giulio: Camerino dei Cesari, Ducal
Palace, Mantua, 158–67, 169, 171, 186;
*Domitian* attributed to, 167; figures on
horseback, from Camerino dei Cesari, 159,
*162*; Palazzo Tè, Mantua, 158, 195, *195*; story
from Augustus's life, from Camerino dei
Cesari, 165, *165*, 169; story from Claudius's
life, from Camerino dei Cesari, 159, *160*,
166, 169, 171; story from Galba's life, from
Camerino dei Cesari, 163, *163*; story from
Nero's life, from Camerino dei Cesari, 159,
*161*, 163, *163*, 164, 171; story from Otho's
life, from Camerino dei Cesari, 163, *163*;
story from Tiberius's life, from Camerino
dei Cesari, *164*; story from Vespasian's and
Titus's lives, from Camerino dei Cesari, 159,
166
Romney, George, 110
Room of the Emperors, Capitoline Museums,
Rome, 3, 31, 74, 123, 137–43, *138*, *141*, 250
Room of the Philosophers, Capitoline Museum,
Rome, 139–41
Roosevelt, Franklin D., *280*
Rosso, Medardo, *Emperor Vitellius*, 278, *281*
Rothschild family, 145
Rouget, Georges: painting of Titus and Vespa-
sian, 222, *223*; *Vitellius, Roman Emperor, and
Christians Released to the Wild Beasts*, 222, *223*
Rouillé, Guillaume, *Promptuaire des medalles*
(Handbook of coins), *91*, 99
Rovere, Guidobaldo della, 158
Royal Ontario Museum, 149
Rubens, Peter Paul, 41, 47, 213, 245–46; *Ger-
manicus and Agrippina*, 269–73, *270*; imperial
caricatures, 213–14, *214*; *Julius Caesar*, 134,

# The A. W. Mellon Lectures
# in the Fine Arts 1952–2021